Photography: Focus on Profit

Tom Zimberoff

ALLWORTH PRESS
NEW YORK

06 05 04 03 02 5 4 3 2 1

Published by Allworth Press
An imprint of Allworth Communications
10 East 23rd Street, New York, NY 10010

Cover design by Douglas Design Associates, New York, NY

Page design/composition by Sharp Des!gns, Inc., Lansing, MI

LIBRARY OF CONGRESS CATALOGING-IN-PUBLICATION DATA
Zimberoff, Tom.
Photography : focus on profit / by Tom Zimberoff.
p. cm.
Includes bibliographical references and index.
ISBN 1-58115-059-8
1. Photography—Business methods. 2. Photography—Marketing.
3. Commercial photography. I. Title.
TR581 .Z56 2002
770'.68—dc21
2001006569

Printed in Canada

What photographers say about

Photography: Focus on Profit
and PhotoByte®

"The days of the 'I only take the pictures, man' attitude are long gone. Photography is a different world right now, and more than ever you need the instruction manual. Fortunately you're holding it."
—*Peter Howe, former director of photography at* LIFE *magazine and, later, Corbis, Inc.*

"When I show PhotoByte to my students they expect to see computer software. Because of the way PhotoByte is structured and all that it includes, the demonstration quickly becomes a learning experience built around solid contemporary business practices."
—*John Retallack, professor, Rochester Institute of Technology*

"PhotoByte is precisely what it promises, as valuable to my business as a primary lens. I've been running much of my business through PhotoByte for years, and it's been invaluable in helping me earn more, save more, and work much smarter. It's helped me become more organized and my clients more mindful of usage. It's comprehensive, intuitive, and educational. I hope it continues to evolve and serve the photo industry for decades to come."
—*Bob Handelman, photographer*

"PhotoByte gives me time to think creatively because it handles all aspects of my photography business."
—*Robert Farber, photographer*

"I will spearhead a proposal here in New York to ensure that ASMP/NY members and creative content providers have the opportunity to benefit from [the] *Photography: Focus on Profit* seminar and the PhotoByte software. I appreciate what [they] have already done for me and the industry at large."
—*Michel D. Leroy, photographer*

Additional comments from members of the PhotoByte® Users' Forum

". . . a bullet-proof product that will enhance and simplify my business."

"PhotoByte is the best. I've seen and owned other management programs but PhotoByte is better than the rest because it is 100 percent applicable and pertinent to managing a commercial photography business in today's marketplace. Tom Zimberoff's insights into the real-world challenge of balancing the demands of management, productivity, and photographic creativity that photographers face resulted in PhotoByte's comprehensive effectiveness. Zimberoff's additional contributions of personal technical support and management of the Users' Forum have sustained the program's relevance and helped my own understanding of its continuing evolution."

"We currently rely on PhotoByte and [have] never found a system that better suited our needs in a commercial photo studio."

"I originally purchased the [PhotoByte] program back in 1997, and it has since become an integral part of my business."

"What a great product! Can't wait for the book to come out."

"[PhotoByte] is a priceless element of organization in becoming a photographer."

"Since PhotoByte was unveiled many moons ago at PhotoExpo I've been on board. PhotoByte quickly became the backbone of my business and has not failed me. Thanks for a great product. . . . Here's to many more years of clarity and intelligence in this crazy business."

"As a long-time user of PhotoByte, I certainly hope that you will continue its development. . . . [It is] the best program out there for running a photography business."

"I've tried several other so-called applications for photographers. I've even tried writing my own. PhotoByte is the most comprehensive application available for photographers. Virtual paper work is manageable and presented in a straightforward manner, with the rights licensed on the invoice and estimates. The confusion as to which rights I'm licensing is eliminated."

"I purchased PhotoByte almost four years ago when it was a 'for-sale' product. Even though it is a 'free' program today, I would gladly pay money for it again. It has changed the way I conduct my business and made the business side of photography much easier for me."

"I have been using PhotoByte software to run my business for about six years. *I could not run my business without it!* It has not only simplified the entire paper process that is needed to run the business but I believe it has made me a better businessman. No joke."

"PhotoByte software has proven to be an invaluable asset to my studio. It has streamlined my contact database and integrated it with a professional, businesslike estimate/invoicing system, and stock photo management. Its features are too many to mention. This program is a must-have for any serious professional photographer."

"PhotoByte is by far the best program for the photographer. I have been a PhotoByte user since its inception. Not only is it the only program for the experienced commercial photographer, but it will help guide new photographers to teach them proper business practices which will help the profession as a whole."

"I've been using PhotoByte ever since I started freelancing. It's become an indispensable part of my business, from estimating potential jobs to invoicing for my assisting gigs. Clients are always commenting on the professional look of my documents, and I haven't even begun to tap into the potential of this exhaustive program."

"PhotoByte is the Photoshop of studio management. Nothing else comes close to being as intuitive or powerful. I highly recommend it to every professional photographer."

table of contents

business automation exercises

acknowledgements

As anyone who sets out to do a brain-dump of information about any topic quickly discovers, we know very little ourselves. Lurking beyond our self-centered domains is an institutional knowledge—a photographic memory in this case—derived from the successes and failures of many other people. It is their collective wisdom that each individual leans on and learns from. It is a writer's task, merely as a guide, to sift through this material and create a useful compendium.

That doesn't mean a writer cannot take you in new directions. Knowledge is continually tested and, then, tempered by individual experience. This book, for instance, could only have been written by a photographer who quit shooting, someone who had "been there, done that, and got the T-shirt," who could take several years away from a successful career and look back before going forward. It is the indirect result of a decision made years ago to answer the knock of opportunity to embark on a new career only tangentially related to making photographs. But it is also more directly the result of all those people I leaned on for their wisdom.

The opportunity was created in part by a realization that my own photo practice could not grow without encouraging an across-the-board, radical change in the way my competitors thought about business itself. However, while you can lead a photographer to knowledge, you can't make him think! So I came up with a grand ambition to "make the world safe for photographers" by creating a more equitable business environment for all of them, one that was compatible with new economic theories and technology; something that made it hard *not* to be more productive and profitable. It began with the creation of computer software that gave freelance photographers the same administrative capabilities as large business enterprises.

My own new enterprise has been temporarily sidetracked. But since it still has merit, it precludes the continuation of my shooting career. In the meantime, the best thing to do was to put down on paper what I've learned—with the help of others—having spent three decades in this business. By creating a text that is inextricably linked to software that allows you to practice what we preach, this book is unique. In fact, without PhotoByte there would be no book.

I want to thank Tad Crawford, my publisher, who had the faith to stand by this project during a difficult evolution. John Retallack and Howard LeVant, professors both at RIT, believed in what I

had to contribute. My friends, Alan Schein and Chuck Mayer, were never too busy to offer encouragement. John Carvotta, never forgot to check for life signs while I was cloistered in my cubbyhole writing software code and scripts. I will never forget him or his lovely family. Hank Bannister kept me afloat when the seas were rough. Rick Cobb put much at stake in following my vision. Garry and Debbie Shaw always had dinner and a movie—and groceries, and bourbon, and a cigar—on tap. Robert Farber deserves kudos for his continuing support of this book and PhotoByte. Kyle Bunting has always been "there." I also acknowledge the important contributions of Bill Kennedy, Associate Professor of Photography. Portions of several chapters in this book reflect an insight and expertise gained from the business of photography curriculum he has developed at St. Edward's University, in Austin, Texas. I am grateful for Nicole Potter's patience as an editor. Kate Lothman, Birte Pampel, and Cynthia Rivelli have each given me great encouragement in the production of this book. John Sculley deserves thanks for inadvertently daring me to create PhotoByte. I must also thank all of the many hundreds of photographers and photographic educators who became early adopters of PhotoByte and helped pave the road to business automation. You gave me your precious feedback. Finally, I dedicate this book to Alyce and Ben, who would have been proud. I hope no one takes umbrage if I have inadvertently left you out by name. You know you have my enduring gratitude.

A last word about so-called political correctness: This text uses male pronouns for the sake of linguistic consistency. Continually switching back and forth between *he* and *she,* or using both, is an unnecessary contrivance in my opinion. No offense is intended for female photographers.

preface

My first job in photography was as a photographer's assistant in London in 1966. My weekly wage for services rendered was £11, equivalent at that time to $26. Everything has changed since then in photography. The impact of technology alone has revolutionized the way that photography is taken, stored, distributed, retouched, and licensed. Indeed perhaps more important are the underlying cultural and commercial shifts in the field.

Although the more successful advertising and fashion photographers in 1966 had their own "reps" to get them assignments, there were few agencies for the representation of the vast majority of photographers. At the time this didn't seem to matter much. There was an abundance of work, irrespective of whether you shot for the editorial or commercial market, and while resale was nice, it didn't significantly alter the level of your income. The French changed this view with the birth of two agencies, Gamma and Sygma. Both showed photographers that if properly marketed by an aggressive sales staff, secondary use could substantially improve a photographer's lifestyle. This led to a mushrooming of agencies throughout Europe and the United States that continued throughout the seventies and eighties. Photographers loved it. It meant that they could leave all the messy business dealings with nasty corporations—be they advertising agencies or magazine groups—to their agency, and they could lead a creative life freed from the burdens of commercialism. Not only that, the agency became like an extended family. They were "mom and pop" operations that had a personal relationship with each of their photographers. As well as getting you work or licensing that which already existed, they could be relied upon to pay your American Express bill or wire emergency money to some distant location. They calmed down agitated wives, husbands, lovers, and debt collectors. The photographer felt taken care of, and often only paid scant attention to the monthly sales reports.

Unfortunately the nineties changed this, in several ways. First, the markets became much tougher. Magazines were failing at an alarming rate, and those that survived were doing so on much smaller profit margins, and therefore much reduced budgets, with many fewer pages. The commercial realm was also under pressure. Print advertising was seeing more money heading towards television commercials, event sponsorship, and other non-photographic outlets that were deemed more efficient than print. This, coupled with a dramatic

improvement in the quality and sophistication of commercial stock photography, meant that photo assignments were qualifying for the endangered species list.

It also turned out that some of the agencies themselves were only slightly better at the business side than the photographers they represented. Sloppy accounting procedures, poor inventory control, and increasing costs, most of which were passed on to the photographers, were becoming apparent.

In 1989 Bill Gates had started a small Seattle-based company called Interactive Home Systems. Gates' initial reason for forming the company was to provide the necessary technology for the digital display of art on the walls of the mansion that he was about to build on Lake Washington. However, in the process of acquiring imagery for these domestic displays, he quickly and almost intuitively realized that there was an intrinsic value in a collection of digital imagery. The phrase "Digital Alexandria" was used to sum up the company's ambitions—this was a noble aspiration, but soon ran afoul of irritating little things like copyright and other speed bumps on the information super highway. Under two name changes, from IHS to Continuum to Corbis, and several management shifts, the company was transformed from a Platonic ideal into a strictly "for profit" gigantic picture agency that had gobbled up many of the smaller "mom and pop" stores to achieve its impressive girth. This transformation of several small and mid-sized agencies into a digital megalith further complicated the business and legal issues facing all photographers, not just those who had been formerly represented by the component parts.

While these developments were taking place in the Pacific Northwest, in 1995 in London's financial district, two investment bankers were also on the same path. Mark Getty, an heir to part of the Getty fortune, and partner Jonathan Klein put together a very similar superstore agency based upon a strategy of acquisition. This was good for the owners of the acquired agencies, many of whom sold their businesses at a premium for more money than they ever thought possible. The effect on the rest of the industry, however, was mixed. On the plus side, the presence of these two superagencies transformed the image licensing industry from a relatively minor operation run by talented (and some not so talented) amateurs to a much more aggressive global concern. The downsides included the fact that where in its previous incarnation there was not an M.B.A. to be seen among agency professionals, now among the leaders of these two large companies there's not a photographer—or even anyone with a photographic background—to be seen. Gone are the days when the photographer could call up his or her agency "mom" and ask them to deliver flowers to compensate for a forgotten anniversary or broken date. Gone indeed are the days when the photographer could select which of his or her pictures were available for sale. The wardens, having just bought the asylum, were in no mood to give it back to the inmates.

The changes were regretted and resented by many photographers. What used to be a handshake industry is now one where a twenty-page contract is part of the price of entry. Suddenly photographers were spending as much time with their lawyers as with their processing labs. And this was not all bad. The fuzzy days were gone, and along with them the feeling that the only thing that a photographer was responsible for was taking the picture. This excellent book is a detailed guide to the "post-fuzzy" era into which we have all been pushed. In it a veteran professional takes the mortgage-burdened, family-feeding, taxpaying photographer through all the steps necessary to maintain a happy state of financial comfort. The world of photography has become very complicated, but for all the numerous layers, the author's approach is based on simple and, one would have assumed, obvious principals. For instance, if your fee is less than the expenses incurred to earn it, then you're unlikely to make much of a living. Here's another one that I remember ignoring as a photographer: You will never have a positive cash flow if you don't do your invoices in a timely manner.

This book encourages photographers to take responsibility for every aspect of their photographic activities. The more responsibilities that you cede to other people, the less control you maintain—not only over your work, but also over your livelihood. A professional photographer cannot turn a blind eye to copyright violations, unfair contracts, or low prices. As goes one so go all. Photographers are getting more organized not only in their individual

working lives, but as a community as well, and it has been the advent of the Internet and its capacity for global communication that made this possible. Photographers were always the easiest people to divide and conquer. Naturally highly individualistic people in the first place, they also tended to work alone and out of contact with their peers. A lawyer often works with other lawyers, doctors with other doctors, but the advertising photographer, the photojournalist, and the portrait photographer nearly always work alone. E-mail and UseNet groups changed all this. Suddenly there was a way that the global community of photographers could instantly share ideas and grievances and unite behind a common front. The reaction to the contract that Getty Images launched in 2001 is an excellent example of this. When faced with a large group of contributors expressing common concerns on common issues, and *knowing that all the members of this group were in contact with each other,* Getty made substantial changes to the terms of the agreement.

Recently, a group of seven very high profile editorial photographers left some pretty powerful agencies to form their own organization called VII. One of their younger members, Ron Haviv, explained his decision to make the move:

> The appeal was this concept of self-empowerment. I realized that I was brought along to a certain point in my photography being represented by an agent but that I needed to take responsibility for myself not just as a photographer, but also on a business level. I think that photographers over the years have given too much responsibility to their agents and we've all wound up in this situation, and we've been complicit in it as photographers. Now is the time to fight back and take control back for ourselves. The amount of responsibility that we put into the taking of the images, the amount of concentration, of dedication, devotion and skill, those skills need to be put in all the way through from start to finish. Then we all feel much better about our work.

This succinctly articulates the situation facing freelance photographers today, and this is why this book is such an important tool. Does this mean that photographers shouldn't be represented by agencies? Does the advent of cheap, off-the-shelf photo marketing software and affordable Web hosting mean that a photographer can represent him or herself over the Internet? Should photographers sign contracts that give a variety of additional rights to magazine publishers for no additional payment? Is it better to have a rep rather than an agency? Is a small agency better that a large one? All of these questions will be answered differently by different photographers depending on the kind of photography that they do and on the stages of their careers, but none of them can be ignored. Going with a small agency no more relieves that photographer of the responsibility of reading, understanding, and, if necessary, amending the contract than if the decision made was to join one of the mega agencies. Just because it is now relatively inexpensive to create your own Web site complete with e-commerce doesn't mean that your business will run itself—in fact, it's quite the reverse. You will need to spend at least as much time paying attention to business as if you had the resources of an agency, probably more.

Today the photographer has to be an entrepreneur, a contract lawyer, a copyright lawyer, a salesperson, a marketing executive, a bookkeeper, a tax accountant, and have some of the debt-retrieval skills of a "repo-man." And you have to have all these skills even if other people are performing these tasks on your behalf, at least enough to check that they're heading in the right direction.

The photography industry today is in greater chaos and confusion than ever. But growth isn't possible without change, and within the apparent disarray lie huge areas of opportunity for the photographer who is prepared to take charge of the business side of life. As Ron Haviv said, it's about self-empowerment, and if you're prepared to take on the challenges, it can make the process of being a photographer much more rewarding and less frustrating for both you and your bank manager. The days of the "I only take the pictures, man" attitude are long gone. Photography is a different world right now, and more than ever you need the instruction manual. Fortunately, you're holding it.

PETER HOWE

introduction

Photography is a popular vocation. Thousands of people pick up cameras each year and join the throng. But their ambition, first and foremost, is to support their art, not to run a business.

When artists struggle with the unanticipated reality of becoming entrepreneurs, they do not—or cannot—always act like responsible business owners. That makes it hard to be taken seriously. Yet, they complain indignantly when they feel threatened economically by the leverage of a powerful corporate culture that seems unfairly poised against them. They wring their hands about meager cash flow, yet they are typically three days into their current photo assignments and six weeks behind on paperwork, including invoicing. That conundrum in particular has a disproportionate and adverse impact on the entire community of commercial photographers. One of its insidious consequences is a high rate of attrition, as many individuals fail financially. That has led to a steady decline in licensing fees and profitability for those who manage to cling to their careers.

Every beginner who goes out of business is likely to pull a more established colleague down with him. Novices can do a tremendous amount of damage to the profession if they haven't learned how to price themselves fairly and competitively in the marketplace. Therefore, the concern is not for those photographers who already know how to run a profitable business, but for those who do not yet have the capacity to do so.

The Old Formula

One simple calculation has defined economic success in small business since time immemorial:

$$Income - Cost = Profit$$

Photographers in particular have taken it for granted to mean that profit is what they live on, that if you take all the money you earn and subtract the amount you spend, what's left over is tantamount to salary. Unfortunately, that kind of thinking about income will lead to the wrong outcome, because salary does not equate with profit. Salary is, in fact, a cost.

Whatever conditions may have existed in the past, it is no longer possible for photographers to escape the consequences of a haphazard accounting for profitability; the nature of the photo business has changed too much. For one thing, it has become

more crowded and competitive, and that is reason enough for all photographers to reexamine how they work. With that in mind, one thing will never change—the criterion all the world uses to measure the success of any business: profit. Therefore, it is imperative to thoroughly understand the nature of profit, how it is accumulated, and how it can be used as a tool to enhance your success.

The fundamental precept of this book is that you cannot run a business for long without earning a profit. Photography is no exception. After all, once you've become addicted to using cameras and film, it is the business side of the equation that makes it possible to support your habit financially.

A New Formula for Success

It used to be hard for students of photography and working pros alike to acquire the particular knowledge that makes a business profitable. With little understanding about where profit comes from and how it can be used as a tool to grow a business, many photographers may have thought they were earning a profit just because they could expect to find enough money in their checking accounts to pay bills from month to month. Their self-confidence was buoyed by the occasional *really* big assignment. But they were actually just scraping by. They were working hard and surviving, but not thriving. In fact, they were often undermining each other's efforts to succeed. Therefore, photographers must be determined to define a new formula for success, one that includes a realistic definition for profitability that is simple to understand and practical enough to yield positive results for everyone.

This isn't rocket science, and the material itself isn't new. What's different is the effort to frame business management in a context specifically for photographers and then to combine that knowledge with the introduction of a technological innovation that makes it easy to actually use the information you acquire. That means moving it out of the realm of the theoretical and into a working system that any photographer can get his hands around.

By the way, none of this is meant to imply that the definition of profit is different for photographers than for people in other professions. It just means that misconceptions endured for so long within the culture of photography that they led to a decline in earnings, making it progressively harder to earn a living shooting pictures. There are three factors that contributed to this decline:

1. There once was a belief within the academic community that commercial success had a corrupting influence on photography, that photography was only about art, and that making money had to take a back seat if a photographer's work was to be considered respectable. No one really believes that anymore. No one can afford to, literally. But there used to be a stigma attached to the idea of striving too hard to be profitable. It was unspoken, of course, but neither did anyone in academia speak out for a curriculum that included teaching how to run a money-making business.

2. No one, neither the leadership of professional trade associations, educators, working pros, nor clients had until recently recognized and tried to institutionalize the administrative differences between the business of photography and other kinds of small businesses populated by freelancers. We now recognize that the business of photography has its own idiosyncratic administrative rules. These are called *best practices*.

3. The technology did not previously exist to help administratively overburdened freelancers put their knowledge, whether it was learned in school or on the job, to practical use. So, there was no consistency in the use of best practices—and without consistency of use, best practices do not effectively exist. Since the cost of computers has continually and dramatically decreased, all freelancers now have sophisticated business-automation options available to them. The examples in this book will make use of a technologically innovative software solution called PhotoByte®.

The "new" formula, therefore, merely helps you flag an all-important consideration:

$$\text{Income} - (\text{Cost} + \text{Salary}) = \text{Profit}$$

Fixing the Problem

Lower fees and many failed attempts to make a living at a cherished pursuit were the legacy of a lack-

adaisical attitude about business that once prevailed. It need not prevail any longer, because now that all three contributing factors are better understood, addressing them will effect positive change.

The Academic Relationship between Art and Commerce

Educators and commercial photographers have discovered that they have more in common than they had previously thought. First of all, they now realize why that old canard about "the nobility of the starving artist" is a lame duck.

It used to be that only a few commercially successful photographers received the embrace of academia, and then only because they happened to make art *in addition* to their commercial work. It seemed that their essential commercialism—their accomplishments in business, their knowledge about it, and the money they made—was hardly considered relevant, if not downright tainted. A belief prevailed that art and commerce were innately incompatible, that only a very few exceptional photographers might transcend "crass commercialism," and then only if they could achieve a parallel breakthrough in their reputations as artists. Such a breakthrough would have required either an exhibition, the publication of a book, or a photo-essay in, say, *Life* magazine. In that context, becoming successful in business was considered incidental to achieving recognition, first and foremost, as an artist. By itself, success in business didn't count for much, certainly not for garnering the esteem of educators. Consequently, because of this condescending attitude towards commercial success, there wasn't much of a dialogue between those who practiced commercial photography and those who taught others how to do it. But that has already begun to change.

Ever since colleges first began offering diplomas to photo students in the early 1970s, they have been allowed to graduate without any practical training in business. After leaving the campus and entering the marketplace, they have had to learn what they could by the seat of their pants. But with such a sudden influx of new photographers came increased competition. With the lack of an established business model to follow, there also came confusion, frustration, and very often failure, in spite of talent. Some of the photographers who survived, the tyros of the sixties and seventies, have

become or are now becoming instructors themselves. Among them are not just commercial shooters but also artists and "serious" photojournalists who found themselves exposed to peer competition for grants, commissions, exhibitions, print sales, and other publishing opportunities. All of them were just as concerned back then about earning a living as they were about getting published. But their relatively more recent and personal competitive experiences—the exigencies of making a living, in addition to their collective academic experience—triggered an evolution in thinking that is manifest today. It opened their minds to a larger economic issue, one that their ostensibly more "mercenary" colleagues had recognized all along: The market for art is no less commercial than the markets for editorial, corporate, and advertising photo assignments.

Now there is less aversion to teaching business courses right alongside courses devoted to both art and the technical side of photography. But there is a new problem. Photo instructors cannot teach business practices without requisite knowledge themselves, yet few are grounded in it. The responsibility is often foisted upon them anyway, because no one else is available to teach business in a way that is germane to photographers. If these instructors go to general business sources, they find little information relevant to photography, only advice about bookkeeping and legal practices that is generic to *any* vocation. That leaves a lot of ground uncovered, perpetuating generations of graduates who lack the explicit skills they need to succeed as commercial photographers. No emphasis is placed on the overwhelming importance of wrapping a course specifically around the way photographers work in real life. In other words, it is easier to earn an MBA than an undergraduate education about how to run a photo business.

Until recently there had been scant recognition that the business side of photography has developed its own idiosyncratic, administrative work flow, its own methodology for earning and collecting revenue. The upshot is that it is no more effective to let an ill-prepared photographer teach students about business than it is to ask Bill Gates to teach a course in strobe lighting at a community college. The photo instructor is always placed in an awkward position, having to teach subject matter

beyond his core competency, and, well, who knows what kind of photographer Bill is?

Furthermore, the role of many liberal arts colleges and universities traditionally had been to train young minds for the pursuit of intellectual fulfillment, not necessarily to prepare them for commercial success. That role has evolved, too. Increasingly, students and parents alike expect schools to provide a more substantial and practical preparation for career advancement. Schools now recognize that they must prepare students to become entrepreneurs. The importance of that fact is underscored by how relatively few photo students look for jobs in the corporate community after they graduate. For the most part, they start their own businesses after a brief stint, perhaps, assisting other established shooters.

Assisting is a lot like graduate study for photographers anyway, a form of apprenticeship. It's not often a career choice. So, to help meet this new demand, educators are keen to establish partnerships with experienced and commercially successful entrepreneurs, to open doors and to foster relationships with mentors in the world of commercial photography.

Leadership and Best Practices

There are many different kinds of professions, and there can't be much difficulty telling them apart. It's obvious, for instance, that plumbers and insurance brokers each represent a different flavor of small business, as does photography. But in addition to the clear distinctions that set one profession's products and services apart from those of every other profession with which it might be compared, it is defined by the way it collects revenue. That distinction is, perhaps, not so obvious, but it is the most important one from an administrative point of view.

Each profession has its own way of doing things, its own set of idiosyncratic procedures that has evolved over time. These procedures ultimately define how one gets paid for what one does. Each profession has its own documents and forms, trade practices, government regulations, and even its own jargon; in short, everything that makes a business "look good on paper." Although these procedures vary widely from one profession to another, they are exactly the same for each individual *within* one given profession. All media photographers use the same methods for conducting business, for example.

While there is no difference in the way photographers pay their bills and taxes as opposed to, say, dentists, carpenters, piano teachers, or attorneys, there are huge differences in the way they do their billing and track their work flow. A plumber doesn't need to track the whereabouts of film submissions and create copyright licenses for publishers. A photographer doesn't bill for pipes and spigots and hourly labor. A media photographer doesn't accept credit cards, because he doesn't operate a retail consumer business. Media photography is a business-to-business enterprise.

Certainly, all small businesses share some fundamental administrative aspects. But most of them have to do with starting up—hanging out your shingle, so to speak. After a while, these are no longer everyday concerns. But once you start competing in the marketplace to earn a living, there are certain administrative tasks that must be fulfilled day in and day out. That kind of responsibility requires one to follow some rules, no matter how much photographers like to do things their own way.

The leadership of the photographic community, which includes commercial shooters, educators, and those who serve on the boards of professional trade associations, has finally begun to recognize the differences between the administrative trade practices that support photography and those of other professions. Photography is unique. It has become clear that a collaboration is necessary between educators and working photographers to codify and institutionalize its differences, because to seed the industry with competent practitioners, it is insufficient to teach generic business practices. What must be taught are practices both crucial and singular to commercial media photography.

For freelance photographers who do not usually have a staff of administrative employees to help them, the flexibility to shift back and forth from creative image-maker to business manager simply does not exist in any practical sense. But, like a dog trying to bite a basketball, they keep on trying. While it's virtually impossible for a typically shorthanded freelancer to acquire the discipline and the time necessary to follow best practices all on his own, there is a next-best thing. It is a technological solution that automates the "administrivia" of running a business, one that puts office-keeping chores out of the way without sweeping them under a rug. The trick

is to make it as effortless as possible to manage a business without letting anything get in the way of creativity. That's why exercises using software play an important role in this book.

It used to be that students of photography had no opportunity to learn about best practices until they became working pros. They would eventually join a trade association and become exposed by their peers for the first time to new ideas about ethics, competitiveness, profitability, copyright law, and administrative responsibility. But by then, they would have already made a number of costly mistakes. While many photographers survived such mistakes, they were haunted by each new generation that was doomed to repeat them. Now, thankfully, business practices are being taught in school, so students can not only bring knowledge with them into the workplace, but also use it to sidestep the perils of reinventing the wheel.

Applied Technology

Learning about business management is both tiresome and, ultimately, ineffectual if only theory is taught. Nevertheless, a practical application of theory must be included in any course to make it worthwhile.

The inclusion of computer software as an integral part of this instruction provides readers with not only the *what*-to-do part of running a business, but also the *how*-to-do-it part. By integrating exercises based upon the use of dedicated computer software, it becomes possible to learn in a rich and contextual environment that systematically helps photographers achieve their goals.

For example, a "how-to" book about taking pictures naturally requires the use of a camera. What will prove invaluable while reading *Photography: Focus on Profit* is the inclusion of software that inter-

actively immerses you in the techniques of business administration while you are reading about them. By getting PhotoByte you are getting a "camera."

PhotoByte, the software included with this book, is a synthesis of all the knowledge about administrative skills that any photographer will ever need to know. It will keep you from becoming overwhelmed by office work. In fact, the software itself "knows" how to manage a photo business, and it guides you step-by-step through the process. At the same time, however, it is flexible enough to allow you to develop your own style of working, to let you determine the level of detail that is appropriate for the kinds of assignments you want to shoot. The combination of text and software in *Photography: Focus on Profit* is meant to prepare you to enter a world where you must compete every day for the privilege of making photos for a living.

Certainly, you have a right to follow your dreams and to fulfill your talent, but you must earn your status in the professional world with each and every assignment you shoot. The only other "rights" you have apply to guarantees of legal protection insofar as commercial interactions with buyers are concerned. Your competitors enjoy those same rights. So, the operative word is *earn*. PhotoByte can be a crucial ally in this process. It's hard to stretch one day into more than twenty-four hours. Even savvy shooters have sometimes ignored best practices, because they had no capacity to address the perplexities of business management while trying to shoot pictures at the same time. PhotoByte can automate best practices and speed administrative tasks. What works for the individual can, in turn, benefit the profession as higher standards become widely adopted through the powerful synergies of automation and photography business education.

Regarding
Your Success

People do not earn profits; businesses do.

For whatever reasons you have chosen to become a photographer, it's a sure bet that enthusiasm for running a business wasn't one of them.

1

Your Choice
to Become a
Photographer

Your decision to make a career in photography no doubt sprang from a series of actions that seemed insignificant at the time. You may have started out as a hobbyist. Then, maybe, your high-school newspaper or yearbook editor drafted you to take pictures. Gradually, you gained confidence in your work as friends and family began to tell you how much they enjoyed looking at your photos. Word spread. Then, one day you might have been asked to shoot a wedding, or perhaps your best friend's aunt needed a new "headshot" to accompany the announcement of a corporate promotion. She may have even offered to pay you for it. What a concept!

As time went on, you probably became increasingly aware of work by renowned photographers and began to watch for their bylines. You started collecting their books. You may have stood spellbound for hours, staring at the exquisite prints of a master photographer hanging in a gallery or museum. On the other hand, some of you may have been lured by the magic of the darkroom, watching images materialize on paper floating in trays of chemical elixirs. Or, you may have been fascinated by special effects. And, then, there are those of you who are obsessed with the novelty of gadgets, the cameras themselves,

plus all the electronic paraphernalia and mechanical gizmos that go with them.

Just about everyone who shoots pictures was initially seduced by the glamour and adventure that are commonly associated with the photo biz: celebrities, models, press passes, travel to exotic locations. . . . Then again, the camera may have been no more, at first, than a magnet to attract the opposite sex. But, ultimately, there is the attraction of being your own boss with the freedom to take a day off whenever you feel like it. The whole idea seems so much better than having an ordinary job. And if you are like so many other enthusiastic artists, you are secure in your optimism that, if your work is good, it will inevitably rise to public attention; you will get published and paid. That's just the natural order of things. Well, the passion for making pictures feeds on that romantic idea. It is actually quite dangerous to assume that simply being a gifted photographer will guarantee commercial success.

The Business of Commercial Photography

It used to be that if you loved photography, you could probably find an employer to support your passion. However, staff jobs for media photographers don't

really exist anymore, with the exception of unionized newspapers and the skeleton staffs comprised of "contract photographers" at some magazines. Today, most publishers believe they can save money by hiring freelancers instead. Indeed, most media photographers are freelancers running their own businesses.

Like other freelance artists, photographers are often insecure about working in a commercial environment. In fact, the day you hang out your shingle, something fundamental will change in your life: No one will offer you a regular paycheck. There will be no medical benefits, and no pension plan. You will live by your own wits from that time on. You are the boss, but you are also, probably, the only employee. *So who're ya gonna fire if things go wrong?* While you may rightly anticipate having more creative freedom by being self-employed, you will quickly learn that such freedom is dependent upon your capacity for handling a lot of administrative rigmarole.

Yikes! What happened? How did an interest in taking pictures lead so fast to becoming burdened with all the responsibilities of running a small company? Didn't you become an artist to avoid the "(corporate) suit" mentality? Just a moment ago you were daydreaming about the carefree life of an artist. Now you have to worry about lawyers, vendors, creditors, marketing, sales, profit margins, sales tax. . . .

Typically this new reality sneaks up on you until, suddenly, you discover that you are spending as much time doing paperwork as taking pictures. So in spite of all the "administrivia" you'll have to put up with, at what point does an ardent and, perhaps, self-indulgent interest in photography become the overriding factor in deciding to turn pro? The answer to that question is clear. If you have even once accepted payment of any kind to support your compulsion to shoot pictures, whether full- or part-time, you already *are* a pro. The commitment you make to continue along that career path is secondary to the responsibility you just took on by commercializing your aptitude for photography, by competing with other photographers. Even if you've just got your toes in the water, trying to decide if this is the right career for you by shooting some occasional assignments you must accept the responsibilities of a professional.

If all you want to do is take pictures without accepting these kinds of responsibilities, stop reading right now. You won't need to learn the lessons in this book. Start thinking instead about finding a salaried, corporate job as an "in-house" photographer. But, if you do that, don't expect to shoot whatever you want and whenever you want, because your creative license will belong, quite literally, to whomever signs your paycheck.[1] Freedom always carries a price, not just politically, but economically too.

The Advantages of Self-Employment:
> You are your own boss; the enjoyment of increased freedom
> You can make more money
> No federal or state taxes are withheld
> Increased tax deductions

The Drawbacks of Business Ownership:
> No job security
> Less dependable cash flow
> You must pay self-employment taxes or corporate taxes
> You provide your own benefits, including health insurance
> Time lost due to vacations and illness comes directly out of your bottom line
> You must fund your own retirement
> No unemployment insurance benefits
> No employer-provided worker's compensation
> No labor law protections; no unionization
> You bear the risk of loss from deadbeat clients
> You may be personally liable for business debts

A decision to become the owner of a full-fledged photo business does not boil down to whether the drawbacks outweigh the advantages of regular employment or vice versa. It is a calling.

Understanding Your Photographic Identity

Photographers seem to enjoy being labeled. They tend to associate themselves with what they like to shoot, as in saying "I'm a portrait photographer" or "I'm a sports photographer" or "I'm a car shooter." But even if you specialize in one branch of photography, you're out on the same limb with every other kind of commercial artist: You have a business to run.

It doesn't matter how many assignments you shoot, how few, or why you shoot them in the first place. Nor does it matter what you like best to shoot. Even if you consider yourself principally an *artiste* or a photojournalist and take exception to being pigeonholed as a "commercial" photographer, you will nonetheless have to engage in some form of commercial activity to support your photo habit and to support yourself personally financially. Your favorite tool may be either a Pentax or a Pentium, and you may call yourself a freelancer, a sole proprietor, a small practitioner, a one-man band, a lone wolf, or a corporation, but the devil is in those kinds of details. Regardless of how you define yourself, you are still a small business owner. Like a shark, you have to keep moving forward or else stop breathing. You have to learn how to survive in the world of capitalism!

Earning a Livelihood

However you picture yourself, you will initially choose one of three distinctly different models for earning revenue in photography: media publication, memorializing social events, and print sales.

Photographers who provide content for commercial and editorial publishing concerns are assigned work by ad agencies, magazines, newspapers, and either public or private companies that produce texts, financial reports, brochures, newsletters, or even Web sites. This is a business-to-business enterprise; i.e., for the most part it doesn't involve transactions with individuals or over-the-counter retail sales.

Other photographers run studios that are hired to shoot weddings and similar social events. They make money by selling prints (and albums) memorializing such events. They often operate a storefront, neighborhood studio soliciting off-the-street clientele. They may also contract with local school districts to shoot class and team portraits.

There is one last category of photographers who work according to very personal aesthetic criteria. They shoot whatever they wish. They are compelled to express themselves, not to interpret the demands of the marketplace. They, too, make money by selling prints, but to collectors, including corporations and museums, not proud parents. Some art photographers earn royalties from publishers who sell books, posters, calendars, or greeting cards featuring their images. You can pursue either media or social photography—or both—and be an art photographer too.

This book is focused on the issues facing media photographers, but all photographers can benefit from the principles and systems set forth here to achieve profitability.

Media photographers (this book will often substitute the term *commercial photographer* to help you keep a financial incentive in mind) are commissioned to create photographs by their clients who pay the costs of production plus several different kinds of fees in exchange for a license (permission) to publish the resulting images—they don't actually sell their photographs outright. However, some media photographers create their own archives of stock images. While the photographers have to invest their own money to do this, they have the opportunity to license these images repeatedly. For each image, another fee will be paid. But bear in mind that commissioned photographs too—those made on assignment—may also be accumulated and kept as stock archives that can be relicensed to other buyers down the road.

Media photography accommodates a wide latitude insofar as the size and scope of a business is concerned. Obviously there are differences between photographers who shoot freelance assignments "on location," working out of a home-office, or even out of a suitcase, and those who require a ten-thousand-square-foot, state-of-the-art studio loft, replete with a rep, a studio manager, a darkroom, and several full-time assistants. Nonetheless, the difference is only one of scale. Basic issues of business administration arise that must be addressed by *all* photographers, no matter what their circumstances.

Reality dictates that you will need to sufficiently capitalize your business; i.e., have enough money to buy equipment and supplies, set up your office or studio, and meet the exigencies of assignment costs and other day-to-day overhead. You will have to pay yourself a salary and make sure that your business earns a profit. You will of necessity come to embrace your role as a business manager. And you will have to define and live up to ethical standards in the pursuit of both art and commerce to feel good about yourself and to earn the respect of your clients—and your colleagues. How far removed these kinds of

professional concerns must seem from the simple enthusiasm that first moved you in the direction of a photography career!

Finally, of course, anyone can pick up a camera, look through the viewfinder, and snap the shutter. There is no real barrier to entry in this business. So what else on top of talent and a fierce competitive drive are required to succeed? It is almost always an accurate understanding of profitability that tips the scale in favor of financial survival.

NOTE

1 This brings up the concept of "work-for-hire," which will be discussed in detail in Part 5, Copyright. Basically, it means that as an employee, the photographic work you produce on the job belongs to the employer, not to you. The employer owns the copyright and the right to claim authorship.

2

Profit Ability

What does profit mean exactly, and how do you "make" it? Simply, it means taking in more money than you spend. So why hasn't that worked for freelance photographers? It's easy to explain. *They forgot to include their personal salaries as a cost of doing business.*

At first, the notion of paying yourself a salary might seem like shifting money from one pants pocket to another. But you will soon see that there are really two different pairs of pants. To correctly calculate a profit, you must factor in a personal, living wage on top of every other cost. It should be paid out just as if you had to hire someone else to shoot pictures for you.

When salary is not considered a cost, the result is predictable: However much money you need to run your business at any given time will be siphoned from a single checking account that is used to fund two separate and incompatible agendas: your business affairs and your personal affairs.

Do you expect your clients merely to reimburse you for what you spend—"even-Steven"—plus a *day-rate?* Some photographers work that way. Accordingly, those who believe they are making a profit after pocketing a handsome day-rate might not be making any profit at all, or they might be

making much less than they thought they were. It is a haphazard, seat-of-your-pants approach to finance. It's also dangerous, because the consequences are not obvious until they really do sneak up from behind and bite you.

When someone proposes an assignment that comes with a hefty day-rate attached, it might seem more than reasonable at first. In situations like that it's only human to make a mental bank deposit long before figuring out what the job will cost to shoot. But you can imagine how fast that money will disappear, leaving you high and dry, if you fail to account for all of the elements that go into planning, pricing, and executing a photo assignment. Figuring out how much it costs to run your business, including how much to pay yourself, is one of the skills you will master in learning how to become profitable and stay that way.

The Sole Measure of Success

Profit is the sole measure of success for any business. That correlation is as hard-wired as any law of physics. Profit is also the fuel that drives your enterprise and makes it possible to grow. Without the stability that comes from economic growth through

profitability you will find it very hard, in turn, to extend your creative growth. You'll be forced continually to choose between spending money to maintain a personal standard of living versus spending it to create new portfolio samples. Plainly stated, you will always be short of cash. Ultimately, that kind of stress will take a toll on both your career and your social—or family—life. Plenty of photographers barely scrape by, even though they shoot lots of assignments.

Keeping busy and running a business are two separate things. Your success will be measured by both the critical appeal of your work *and its demand in the marketplace.* No matter how many prints you might have hanging in the Museum of Modern Art, your success in business will be measured strictly by its profitability.

A Hard Line

The single most important lesson you can take away with you from this book is represented by this illustration:

Business Income | Personal Income

Draw an indelible line in your brain between what *you* earn and what your business earns. That is the first step towards profitability. Make the intellectual distinction now. Later on in part 3, chapter 7, you will learn exactly where to draw the line by creating a cost-of-doing-business budget. In the meantime, it's easy to sift through one month's current bills to see what it takes to "keep you in the style to which you are accustomed." That will determine what your minimum take-home pay needs to be. Obviously, you won't include bills related to business, such as your monthly camera-store statement. If you need help creating this personal, cost-of-living budget, ask a CPA (certified public accountant).

Profit Is Tantamount to a Fee

Many photographers utterly live and breathe their craft. They have chosen to ignore the distinction between a personal life and the business that

envelopes and supports it. But if you don't treat your business as a separate entity that, in effect, pays you to shoot pictures, it is almost impossible to earn a profit. That is because *people* do not earn profits; businesses do.

Profit has nothing whatsoever to do with the creative fees you charge for your vision, for problem-solving, or for snapping the shutter. Your business will compensate you for all of that, and the exact process will be covered part 6. For right now, it is imperative to understand that the nature of profit is tantamount to a fee. This *fee*—and, admittedly, some liberty is taken with the word—is separate from the kinds of fees you earn to take pictures. Profit is, in sum and substance, a fee that is earned *by your business.*

In assignment photography, profit is derived by billing one or more of three separate kinds of fees. They are separate, that is, from your assignment fee (a.k.a. shooting fee, creative fee, or day-rate, etc.). Assignment fees are paid to you, the person who takes the pictures. They are paid to you by your business. The three additional kinds of fees are:

- Mark-up Fees. *A surcharge on the cost of goods and services that are billed to your clients*
- Usage Fees. *Charges for reproduction and publication of your photos*
- Production Fees. *Charges for extra time spent on an assignment, but not shooting pictures; i.e., consulting, casting, scouting, supervising, traveling, and waiting, etc.*

Simply put, your business must charge more than it pays for every expense it bills to a client, from the film you shoot, to photo assistants and stylists, studio rentals, and every roll of gaffer's tape. Everything must be marked up and rebilled to ensure a profit. Everything! The less you mark up, the less profit your business earns. You, on the other hand, will earn *assignment fees* for shooting pictures.[2] Your business will earn *profits* for having the good sense to "hire" you.

The Unforeseen Consequences of Unprofitable Jobs

Some photographers think that any fee they can collect on a day that would not otherwise have been

booked counts as profit. At first that seems like a logical assumption, because the alternative is—well, zero. Even just a little income has to be better than nothing at all. Right? But there are really bad consequences to that line of thinking. It is delusional. Consider, hypothetically, a photographer just out of school who goes after the "Big Job" without looking at the bigger picture.

After many months of pounding the pavement and showing off a great portfolio he finally landed the assignment of his dreams. The results were beautiful. The client was pleased. But because he hadn't accurately anticipated all of the production costs and had to use his credit card to finance the shoot, and because he had to wait ninety days for a check that didn't quite cover all of his direct, job-related costs *plus* his fixed overhead, he went broke before the pictures were published. He crashed and burned on take off. It has happened many times in real life.

It has too often been said, "Well, the client will just ask someone else if I don't shoot this job. I wasn't booked, anyway; so I'll do it just to make *something*. I've got to pay the rent!" But, in spite of such "reasoning," two consequences are inevitable:

▸ The photographer who works for a less-than-profitable price has either intentionally or thoughtlessly—it doesn't make any difference—lowballed[3] the job. That photographer will never work for that client at a higher rate of pay. Never.
▸ The corporate CFO (chief financial officer, a.k.a., the top bean counter) will expect subsequent jobs to come in at no more than the windfall low price he was just billed. He will therefore impose correspondingly lower budgets on the art buyers who report to him, the same art buyers who hand out assignments. A lower budget will, in turn, be imposed on the next photographer in line for an assignment, and so on.

If you are that next photographer in line you have a choice to make. If you make the wrong one it may haunt you for years to come. Do you want to be considered only for jobs with paltry budgets, i.e., to be offered only the $500 assignments and never considered for the $5,000 ones? Or worse yet, do you want to be offered all the $5,000 jobs for $500?

If you accept an unprofitable assignment, your decision will have an indirect—but nonetheless adverse—effect on your fellow photographers as well as on yourself. All photographers will find it increasingly difficult to negotiate reasonable fees or to earn profits because the bean counters will be mandating lower budgets, now that they know "there's one born every minute." That's what causes the kind of pressure that keeps ratcheting fees down lower and lower, one job at a time, job after job after job.

This is based on a true story. It involves two photographers, Phil Flash and Otto Focus.

Phil, while visiting an art director's office at the Acme Advertising Agency in San Francisco, noticed a photo on the wall and remarked how superb it was. The AD said, "Oh yeah! Otto shot that for me. I love working with that guy. He only billed me five hundred bucks for an assignment fee, and I reimbursed his expenses at cost." With some consternation, Phil could see that it was a rather complex shot, produced on location for a major pharmaceutical company.

Phil listened intently as this agency honcho went on boasting about how popular he had become with the pharmaceutical company for finding such a "reasonably-priced vendor." It so happened that the picture was used nationally in a long-running ad campaign. The shoot lasted three whole days in Death Valley. It employed one model, a prop stylist, a make-up artist, several assistants, and a rented Winnebago dressing room plus other vehicles. It was obviously a fairly big-budget affair. Phil felt the heavy hand of innuendo upon his shoulder, as the art director seemed to imply to Phil that he might land such assignments too, if he was as economically cooperative as his colleague.

When Phil left the AD's office he immediately got Otto on the phone and asked him to explain why he virtually gave away his professional services for free. Otto replied that he had been cooped up in his studio shooting catalogs for a whole month, and, besides, he said he really enjoyed the desert. What he didn't say outright was that, when he was approached along with two other shooters to bid on the assignment, he decided to ensure that he would get it by underbidding his competitors. He rationalized that

he needed desperately to get away from his daily grind. A few days in the desert photographing a beautiful model would do him some good. Besides, this would make a great new piece for his portfolio—maybe even win an award, he thought—and put him in the good graces of his client.

Phil inquired about how much good that did for other photographers trying to earn an honest living. He asked what would happen to industry fees if there was always some photographer waiting in the wings who wanted to "get away for a while" or create a new portfolio sample every time an assignment came up for a bid. He went on to suggest that the next time Otto thought about financing a vacation that way, he would be pleased to donate the airfare to Palm Springs and a hotel room too; it would cost both of them less in the long run. Otto hung up on him.

Phil's comment was not entirely facetious. Did the price of Otto's popularity with the art director cost him his pride and his pocketbook? He certainly sold himself short. Moreover, he sold out his colleagues. That art director surely must have had a hard time trying to explain to the pharmaceutical company why the next shoot would cost thousands of dollars more. Of course, he still had the option of asking Otto to do it—but for the same ridiculously low price. Do you think Otto could afford to repeat his generosity?

Counting Beans

Battalions of bookkeepers are hired by corporations just to provide information they can use to control costs. You are a cost.

Consider two photographers hired by the same magazine for two different assignments. One shoots five rolls of film while the other shoots fifteen. The myopic bookkeeper sees only that Photographer B is a bigger cost to his company than Photographer A. It probably doesn't matter to him that Photographer B, who shot fifteen rolls, was covering a fast-breaking, action-packed basketball game, and that Photographer A who shot only five rolls was covering a chess tournament. He might also discover, while perusing the data in his computer, that different photographers bill different prices for the same kinds of film. So he will try to "flatten out the pricing curve," so to speak.

As far as the bean counters are concerned, photographers are merely outside contractors, and one is the same as another. They demand to know why Photographer B can't shoot fewer rolls of film, just like Photographer A. On the other hand, if the amount of film shot by each photographer is an issue they cannot control, they'll try to lower their company's overhead by insisting that the photo department mandate a limit on the price photographers are "allowed" to charge for film, essentially demanding that all photographers lower their profit margins.

Ignorance and Apathy

As freelancers who operate independently, outside the infrastructure of a corporate environment, photographers have always had difficulty reconciling their casual but chaotic way of life with the responsibilities of running a business. Competitive pressure makes it easier for buyers to leverage you against each other to keep their costs down. You have to make it harder for them to do that. But you cannot do anything by being either ignorant or apathetic about issues of commerce and profitability, an attitude that is, unfortunately, still worn like a badge by some photographers.

The ignorance part means not knowing how much profit you either need or currently have at hand to grow your business. The apathy part is illustrated by some shooters who still support a happy-go-lucky approach: "I'm just glad to get paid anything at all for what I love to do." There is nothing about that attitude that is even remotely compatible with being a professional photographer. It is unacceptable.

A Painful Legacy

On a regular basis any number of talented photographers will founder into debt and wash out of business—or nearly so—while the survivors, talented or not, float to the top for the time being in a pernicious churning cycle.

The photo business cannot survive as we know it if revenue continues to decline while the cost of operations continues to climb. Real competition based on the cost of production, volume of work, margin of profit, and market share will continue to

be preempted by ignorance and apathy until more individuals learn what it means to be profitable.

It is of no use to undercut another photographer's price just to take a job away. Your success does not depend upon someone else's failure. You only hurt yourself if you accept lousy terms and inadequate payments, no matter what the excuse. It is counterintuitive to say no to a job; but, if it will not generate a profit, then no it must be. If someone else is either too ignorant or too apathetic to care about profitability, there is nothing you can do about him except avoid sinking to the same level of depravity.

Expenses and the Relationship of Profit to Assignment Fees

You probably have a good grasp of this principle by now: A salary represents the money used to feed, clothe, house, educate, and entertain yourself (and your family, if need be). Profit is the money that your business recycles to create new revenue-earning opportunities. It will pay for that new lens you've always wanted, let you repaint the studio, purchase an advertising spread in a sourcebook, or let you travel to scenic locations in search of new stock photos. Profit pays for educational seminars, upgrading your computer, producing new test shots for your portfolio, and funding further marketing activities. However, for the sake of simplicity one might say that profit does only two things:

> Profit indicates recent growth
> Profit fuels future growth

If you use even a fraction of your salary to pay for business-related costs, you will reduce your standard of living in direct arithmetic proportion. In real terms that means a smaller salary, a pay reduction. It doesn't matter that you own the company; the money still goes for a different purpose. Conversely, putting profits into your pocket to pay for personal expenses may stagnate the growth of your business and, eventually, cause it to go bust.

Profits may be accumulated and reinvested in other ventures, too; for instance in the stock market. This can help finance a retirement investment strategy. It's hard to think so far in advance, but do it anyway! Profits can also be used to pay back investors who helped you raise money to get going in the first place. The list of things you can do with profits is endless. You can even pay yourself bonuses, give yourself a raise, if profits are high enough.

Making Money versus Creating Wealth

There is nothing crass about being in business to make money. Money is the fuel that powers the world economy. That explains why, in fact, you are not in business to be a photographer; you are in business to make money. Just don't confuse the prospect of earning a big salary or commanding impressive assignment fees with being wealthy. Making money is something you do while trying to *become* wealthy; being wealthy is a state of being.

It is useless to equate wealth with income—yours or anybody else's. Cash flows in and cash flows out, but wealth stays put. Wealth means security. It means the kind of money you have in the bank, but you don't need to spend. In other words, wealth is not represented by a hefty checking account that is depleted on the first day of every month when you pay your bills but, rather, it is money that sits relatively safely in money-market accounts, bonds, real estate, and other personal property making up your total net worth.

Wealth is money that goes to work every day, even when you do not. It is money that grows because banks loan it to other people who pay for the privilege of using it, and part of the revenue it earns is paid back to you as interest and dividends.

It is inaccurate to measure wealth by the size of your day-rate because your ability to earn day-rates could end abruptly, due to any number of haphazard circumstances. It is not unthinkable to earn as much as several hundreds of thousands of dollars in fees each year, only to be feeding all of that cash into the hungry jaws of a business beset by high production costs and low profit margins. You may live "high on the hog," taking advantage of expense accounts from one assignment to the next, and you may reside in fancy digs, wear fashionable clothes, and have all the requisite toys, including the most expensive photo equipment, but you're still only a few assignments away from standing on a street corner holding a cardboard sign that reads: "Will Shoot Weddings for Food." So every time you price a photo assignment, think about building wealth. Profitability builds wealth.

If you neglect to make the distinction between profit and personal income, between business success and creative success, you will quickly find yourself mired in an unfortunate predicament that is shared by all too many artists—just getting by, eking out a living but hardly growing and accumulating enough wealth to raise your standard of living. Your revenue will fluctuate up and down dramatically instead of increasing gradually and steadily over the long run. That kind of roller coaster ride will make you sick to your stomach, and it will be difficult to plan ahead without the stability and genuine growth of a vibrant business.

How Much Profit Is Enough?

In part 6, Pricing Photographic Services, you will learn how to calculate a profit. But you already know that it is based on a percentage of billed expenses. It's also logical that the greater your sales, the more expenses there are to bill. Obviously, there is a relationship between profits and sales. Therefore, some of the factors that affect profitability are the same as those which govern the volume of sales. They might depend, for instance, upon your geographic location (especially if you operate a studio), the size of the market you serve (e.g., local versus national), and the alternatives available to your customers (i.e., how many competitors there are in the marketplace). In general, you should not be satisfied with profits totaling less than 10 percent of what you invest in your business, including your own cash plus any capital that you borrow.[4] A return of 20 percent is a reasonable goal. Apply that goal to each and every assignment you shoot. But if that percentage doesn't amply provide for the sustainability and growth of your business, pick a number that does. There's no such thing as too much profit.

Factors for Success

It's easy to measure the success of a business because it's easy to measure the growth of profitability. But the quality of your work is measured far more subjectively and may not equate with being profitable. Maybe you'll decide to take a big salary out of your business. Or maybe you'll take a tiny draw, just enough to be comfortable, while plowing profits back into the company to expand the number and scope of your assignments. It is a fact that some photographers will simply command higher fees than others for a whole lot of reasons, whether it's because they're more talented, more organized, or just plain lucky. That will always be so.

Creative success is every bit as important as the financial kind. It is derived from public recognition for artistic accomplishments, and sometimes by an inner sense of fulfillment. It is measured by a cultural yardstick, not an economic one. But that's not the topic of this book. Just how successful you become overall, indeed how you choose to define your own success, is determined by an explicit relationship between the vitality of your business and what you get out of it personally as an artist. Success is relative to ambition too. Different people place more weight on one side of the equation or the other. You can set your sights as high as you wish. Whatever level is comfortable for you, let the proverbial journey be its own reward. In that light, personal success is a topic best left to philosophers.

NOTES

2 See Part 6, Pricing Photographic Services; The Assignment Fee, page 224

3 See Part 6, Pricing Photographic Services; Lowballing, page 242

4 Refer to Part 3, Starting a Photo Business; chapter 7, Financial Considerations for Your Startup.

The Role of Technology in Your Career

The software you put in your computer is as important as the film you put in your camera.

Little more than one hundred years ago, the farthest distance from which you could talk to someone was as far away as you could hear each other shout. Now, you can reach out and touch someone half a world away with a cellular telephone that fits into a shirt pocket. Leonard Nimoy,[1] Mr. Spock in the popular TV and movie series *Star Trek*, once commented that people would stare at him, point, and laugh whenever he got caught using his cell phone in public. He wondered about that for a while, until he realized that it looked just like the flip-open communicator he would use to hail the starship *Enterprise*, as in "Beam me up, Scotty!"

3

Taking Technology for Granted

In reality, it is already possible to speak with people aboard Earth-orbiting space stations and shuttlecraft. We take it for granted when we step into a cigar-shaped bus with wings that we will step out onto another continent hours later. Is it any less amazing that you can "nuke" frozen entrées in a microwave oven, drive your own car, or flip a switch to light your home? As for photography, the newest cameras almost take pictures for you; you don't have to manually focus a lens or read a light meter, let alone use your wrist to rewind the film anymore—assuming you use film, that is. But the question is: What lasting effects will new technologies have on your photographic career? Before the question can be answered, though, it might be useful to ask: What is technology?

To everyone born after World War II, inventions such as television merely represent "stuff"; they no longer seem like technological wizardry. That's because at least half of the American population alive today grew up watching TV, which has become a common part of life. "Stuff" is that which is taken for granted and doesn't amaze us any more.

On the other hand, a large segment of society is still trying to cope with the growing pervasiveness of computers, especially with the advent of the Internet. But Generation X-ers, who arrived on Earth after the first moon landing in 1969, think that computers are as ordinary as TV. To them, computers are just "stuff," too, while the Baby Boomers of the forties and fifties still think of computers as "technology." To even earlier generations, they would have seemed like the work of shamans and magicians. Well, if you go back far enough, so would the butane cigarette lighter!

The difference between "stuff" and "technology" is one of perception. Eventually, all technology becomes less amazing. After all, it's hard to imagine life today without telephones, airplanes, and even aspirin. How soon will your computer and the Internet become indispensable to you? Or are they already?

Technology, Productivity, and Time

The cultural myth is that technology is supposed to make us more efficient and productive. Therefore, productivity is reckoned not just by the quality and quantity of our achievements, but also by the criterion of time, how long it takes us to accomplish a task. We always expect technology to provide us with more time. We expect it to help us *save* time, to do

things faster. The reasoning is that, if we can only get our work done faster, we will have more time for recreation and relaxation. But sometimes, getting more work done in less time forces us to spend the time we have just saved to do still more work. Therein lies the irony. Rarely is the time we save used to allow ourselves to unwind from the stress caused by the work we have already done.

It follows logically that technology creates stress. It can make us feel "under the gun" and oppressed. But then again, technology can empower us to do things that we never even dreamed of doing before. It allows us to focus our creativity on new goals by helping us to complete the mundane chores of daily life in shorter order. Therefore, technology can also help us to do a *better* job.

Just as with everything else in life, most of us try to find a sense of balance between better and faster, between the *quality* of our work and the *quantity* of work we have to do. We look for equilibrium between those activities that make us feel oppressed and those that allow us the freedom to be creative. Sometimes we must balance our capability to handle a larger workload with a determination to do no additional work at all, so we can have some time to play.

The Computer as Essential Photographic Equipment

Apart from some aspects of technology that in recent years have helped us to focus lenses faster and set exposures automatically, photographers usually mean computers when they talk about technology. Of course, computers are the fundamental tools of digital image capture and manipulation. But they can do more than that. They can automate the burden of routine administrative chores. So, if we can have auto-flash, auto-exposure, auto-focus, auto-loading, and auto-rewind, why not auto-invoicing, too?

Barking Back at Digital Dogma

There is a difference between using computers for business and using them for creative purposes. Understanding that difference will allow you to change the way you work without changing the *kind* of work you do—unless you want to.

We are living in an era of dazzling, but sometimes bewildering, technological change. Change is inevitable, of course. But change does not necessarily mean growth and progress. That concept is entirely subjective. There will always be differing opinions about the results of change. However, our understanding of change is often colored by an assumption that technology is bulldozing a path into the future for the benefit of humankind and that everything demolished in its wake will be replaced by something new and improved. It is a philosophy implying that older, existing technologies are somehow tainted. But experience teaches us that it is more practical to be agnostic about the effects of change while accepting its inevitability at the same time. In other words, you can judge the results of change for yourself, whether they help or hinder your career or if they even matter to you at all. So, the next question is: Will the "electronic studio" be in your future?

Applying digital technology to help run a photo business more profitably is a good example of a progressive idea. It changes the way photographers think about using computers by pointing out new ways to improve productivity. But change does not mean eschewing the use of older, analog technologies.

Even though you can store, send, receive, and view images in something called cyberspace, rest assured that film-based photography will remain a part of the commercial publication process—and a part of your life—for a long time to come. But just for the record, whether conventional photography is overcome by digital imaging or not has no bearing whatsoever on how you run your business from an administrative point of view.

Your overall success will ultimately depend upon your ability to grow a business, to sustain its competitiveness and profitability. The rules of *that* game never change, no matter how the tools for creating pictures evolve over time. But the impression you might get from some of the analysts who write for popular magazines and newspapers, and from manufacturers through their advertising and publicity campaigns, is that photography is "going digital." They really mean it in the absolute, that a whole new game exists. Not true.

Why Film Will Not Become Obsolete

Unlike graphic designers and illustrators, who now routinely ply their visions with a keyboard and a mouse instead of the rubber cement, T-squares, and

X-acto™ knives they used in the past, photographers recognize that film is still the most practical, economical, and highest-quality medium for the capture and storage of images. It will remain so well into the twenty-first century, the amateur market notwithstanding. Retail catalog and news photographers will take greater advantage of digital imaging technologies, too. But for the most part, graphic designers and illustrators participate in the more technical side of pre-press production, a commercial enterprise that needs and can afford the latest digital input and output devices.

It must also be noted that, while digital imaging has become an indispensable adjunct tool for some photographers,[2] even helping them earn extra income, one can run a very successful business without directly taking advantage of such capabilities at all. However, as a corollary, if you become a freelance photographer and refuse to use a computer to manage your administrative chores (i.e., using digital technology for the tracking of customers, images and portfolios, accounts receivable, sundry paperwork, etc.), you will fall farther and farther behind your competitors who do, no matter how artistically innovative you are. Therefore, photographers—especially beginning photographers—are advised to consider computers as business automation tools first and foremost, while maintaining no less appreciation for them as creative accessories. Realistically, while digital-imaging solutions represent amazing technology, they are only tangentially related to the art and science—and business—of making photographs. It's simply a matter of getting your priorities straight.

From what you've heard and read in the media, you may already have begun to feel that if you don't change the way you *create* images, your career might never get off the ground. But in truth, only a minority of photographers uses digital technology firsthand in any significant way. Whether that statistic will change or not, only time will tell. But for now, most photographers still see "image manipulation" as the physical adventure of using cameras and film, lenses, lights, tripods, models, props, and interacting with people or nature, not necessarily rearranging reality on a desktop. They are distressed by the pressure they feel to "go digital." Although just about all pre-press technicians have embraced digital technology completely as a superior way to do

their jobs, that's a different industry. And that's the point.

None of this is said to disparage the use of computers for digital imaging (not to be confused with digital capture). On the contrary, the widespread accomplishments of many artists and technicians using a digital approach should be applauded. If that's the way you want to go, you are urged to embrace it. But from a practical point of view, you must also consider how hard it will be to make a profit on an investment of tens of thousands of dollars to buy a high-quality digital camera, some complex imaging software, plus enough computer horsepower to run it all. And when you factor in the time required to learn how to use all of that gear, you might find little time left over to build a portfolio of photographs!

Making a Prudent Investment

To hit the ground running when you jump into the world of professional photography, you must be well equipped with the tools of your trade. The economic wisdom of investing in any kind of new equipment can only be justified by the demands placed upon you by your customers and to what extent you can increase your profitability while satisfying those demands. In other words, you must ask yourself if finding work is really dependant on being digitally equipped. Unless there is a compelling economic reason to plunge into the realm of digital imaging right off the bat, it probably makes better sense to stick with conventional photographic equipment for the time being, because it costs less.

Rather than considering a lot of expensive digital cameras and computer-imaging equipment as a "must-have," obtaining a more pedestrian PC or iMac™ to run business automation software is best to consider for three reasons:

> It is less expensive by an order of magnitude
> It is easier to learn to use than a digital imaging system, also by an order of magnitude
> It will have a more immediate and positive effect on your business

According to Howard LeVant, Professor of Applied Photography at the Rochester Institute of Technology in New York, ". . . electronic photography and digital manipulation are doing very little to

change the basic concepts of photography. They are, instead, changing the way images are bought, sold, and used."[3] He went on to write, "But the technical skills, artistic passion, and business practices that have been the hallmark of the traditional commercial photographer are still very much at the root of professional photo illustration today."

Digitalization has quickly become an integral part of the modern pre-press process. Because of that, all photos destined for commercial publication are likely to be scanned and stored in digital format, at least temporarily. That's a very different proposition than capturing (i.e., shooting) pictures digitally and storing them indefinitely as binary code. Professor LeVant concludes that virtually all photographs will eventually be digitized, *although not necessarily by the photographers who created them*. That leads to the probability, at some point in the not-too-distant future, that all photographers will be able to *distribute* their work electronically. That means, instead of submitting original film (negatives or transparencies shot on assignment, or even prints) to your clients, you can send digitized, electronic facsimiles of images that were, nonetheless, shot on film. That means maintaining greater control over your production content, because you keep it.

Conventional photography is far from becoming obsolete. Perhaps the way you market and license your photos will change over time, and maybe more photographers will find themselves obliged to shoot stock photos from now on in addition to assignments. That means anticipating market demand (i.e., guessing what kinds of pictures will sell) and paying your own production costs. Certainly, the way you purchase supplies and services will change, as it becomes faster, easier, and cheaper to obtain them via the Internet. But again, to quote Professor LeVant, "The feeling I got from many respondents [to the survey] is not one of fear of the demise of traditional photography, but the expansion of possibilities digital imaging affords them."

The Value of Your Time

Since you have elected to do media photography for a living, you will be shooting pictures for commercial periodicals, corporate publications, and maybe advertising agencies, too. For the most part, they will require you to deliver photographic prints or transparencies as finished products that will be sent on to a pre-press technician or service bureau in preparation for final reproduction. No doubt, some of you will be obliged to submit digital files or shoot digitally on occasion, too. But that's irrelevant, because it's what happens *after* you snap the shutter that counts, as far as how much time—or how little time—you choose to spend employing what are essentially pre-press, digital-imaging techniques.

Every moment you spend looking at a computer screen is time *not* spent looking through the viewfinder of a camera. It is just as reasonable to assume that you would no more want to spend time in the darkroom developing film or dodging and burning prints than you would want to sit at a desk in front of a computer manipulating images, if the alternative is getting paid to shoot stock and assignments.

Of course, you might decide that it's just as well to be paid to process film as to shoot pictures. So why not perform digital pre-press work, too? Not a problem. Just remember that digital imaging is at least as time-consuming as processing film and prints in a conventional darkroom, if not more so. That's why most of you will probably forego both the chemical *and* the digital darkroom—at least in a professional context—if your clients keep you busy enough shooting pictures. Just for the record, though, there's no reason not to do photo finishing and digital imaging just for fun! But from the point of view of saving time to market your services and to shoot more assignments, image processing, whether chemical or digital, is best left to assistants, service bureaus, and outside photo labs.

Photography and Pixelography

There is another kind of digital imaging that, while just as time-consuming as pre-press, is every bit (pun intended) as creative as toning prints in a darkroom. There is a definite distinction between the profession of photography and what—for lack of an already-existing word—shall be coined as the profession of *pixelography*.

Administratively, photography and pixelography look very much alike in an office environment, so you will have no difficulty applying the lessons in this book to pixelography, if that's the direction you choose to take. Still, the creative practices involved are vastly different.

The ability to scan a photograph so that it can be viewed on a computer screen, whether for cataloging purposes, image distribution, or for retouching and color correction, does not mean that you are doing "digital imaging." Digital imaging—or pixelography—is a practice that is analogous to the way commercial artists and illustrators work. The difference is that pixelographers use computers and software to help them accomplish special effects that might be more difficult for an artist to achieve with paints or for a photographer to achieve using traditional "sfx" techniques. A pixelographer's primary medium *is the computer*, not the camera, and not the airbrush. A work of art created by a pixelographer, however, may actually include components appropriated (i.e., scanned) from existing artwork created the conventional way.

Pixelography is as rewarding as photography. And while they represent different occupations, there is no reason why you can't do both. For instance, some writers are also photographers and vice versa. But the axiom still applies: Whatever time you spend with one is time taken from the other.

Whether you send your processed film to a service bureau—just like you send unprocessed film to a lab—perform digital pre-press work at your own facilities, or immerse yourself in the realm of pixelography, the choices you make will ultimately affect the growth of your business and your cash-flow strategy for investing in new equipment. (Refer to part 3, chapter 11.)

Will a Digital-Imaging Education Help You Find Assignments?

As implied above, there has been some confusion concerning digital tools and their relative usefulness to photographers. Recently, almost every photo student at every college, university, and trade school in the country has been required to learn PhotoShop™ and to learn about the technology behind digital imaging in general. Will that help you find work as a professional photographer? Not necessarily. Will it help you find work in a service bureau? Probably, yes. It can almost certainly help you find work as an assistant for an already-established photographer.

Working as a photo assistant is a fine place to start your career. But even if you skip assisting altogether, it is still recommended that you learn how to use Photoshop and Live Picture™, along with all of the other imaging software and hardware products that contribute to art and to the commerce of art. A fundamental knowledge about digital imaging is crucial to your success, whether you intend to use it directly yourself or not. Here's why.

Just about every photographer has a familiarity to one degree or another with darkroom techniques, even though he doesn't necessarily use them on a regular basis. But it is very important to understand how all photo industry-related technologies work in order to gain a competitive advantage.

To clarify that point, some photographers have learned to make great pictures in spite of never having studied the Scheimpflug Principle[4], the Zone System[5], or color theory. But it helps to know what these things are and how they work, in the same sense that it helps to know how a mechanical, six-color Heidelberg printing press works, even though you'll never use one. Why? Because being able to speak with knowledge and conviction about color separations and to understand how different densities of ink translate into various colors on a printed sheet of paper will help you to develop a closer working relationship with the art directors and designers who hire you. You have to learn to speak their language.

Acquiring this kind of ancillary knowledge is not a technical consideration; it is a *marketing* consideration. It helps your career by adding value to your reputation as a well-rounded, informed, and capable professional. It means being able to communicate better with your clients. It does not mean that you must take pictures *and* operate the printing press.

The Client's Choice

Many photographers enrich their stock libraries with digitally manipulated images. They create special effects, change color balances, and much more. But that does not represent a paradigm shift; one can accomplish the same results by masking and sandwiching 35mm slides together and reshooting them on duplicating film with a bellows and a close-up lens. Using a computer with PhotoShop to do the same kinds of things is certainly more convenient, but realistically, pixelography is just another form of commercial illustration from which to choose when it suits the creative whim of an art director.

The client has an economic choice as well as a

creative one. The computer is a factory, and the scanner is a truck that delivers the raw material for manufacturing images. These represent additional production costs. In most cases, before you can plug in, turn on, boot up, scan, digitize, or otherwise process your first pixel, someone, somewhere, at some point has to run a roll or a sheet of good old-fashioned film through a camera. There are exceptions, of course; a process that goes directly from digital file to printing press is available in some circumstances. Regardless, it is safe to say that you can do things to images with a computer that are less easily accomplished with film, and some that might not otherwise be possible at all. But it is rarely less expensive or less time-consuming to opt for digital processes when film is the alternative choice.

The Difference between a Photograph and an Image

Incidentally, it is wise to remember one more fundamental and literal distinction: A photograph is more than an "image."

At some point, a photograph becomes a print. It is transformed from something concealed within a camera, a latent image, into a tangible object that you can behold and admire. It has an aesthetic beauty that reaches beyond its topical content and commercial value. The image of a photograph on a computer screen is merely an electronic facsimile of the physical photograph; it is not the photograph itself. The publication of a photograph in a magazine is a facsimile, too—a reproduction in the same sense that you can't really see the *Mona Lisa* in a library; you must go to the Louvre.

Electronic Capture

Some pundits presume that film-based photographic technology will inevitably "progress" to a digital-based technology and that digital capture devices will completely replace cameras that shoot film because they are somehow better. But digital is not better; it is just different. Technology is not about replacing one way of doing things with another merely for the sake of calling it progress. It's not about getting rid of the tried-and-true ways of doing things. It simply provides new options.

According to Eastman Kodak Vice President and Director of Digital Imaging Madhav Mehra, while digital cameras will not deliver the same level of quality *per square inch* as film, the issue of which system to use revolves around the exigencies of your assignment. That means, if you require the kind of image quality obtainable with a 4×5-inch camera, digital capture may not be the way to go. Another thing to keep in mind is that digital capture remains more expensive because of the additional hardware required, including optical laser and magnetic storage devices. This remains true in spite of the fact that one may forego the costs of film and processing. That factor is offset by another kind of processing: the time you or someone in your employ spends working at the computer.

It seems realistic to conclude that, while it has very real advantages, electronic capture is not appropriate for all kinds of commercial photo assignments. The exceptions are the coverage of news and staged publicity events with hotly competitive deadlines (for which you can set up your digital equipment in advance), as well as the production of retail catalogs with repetitive and somewhat static prop setups. Digital capture also helps corporate "do-it-yourself-ers" to save time and money by allowing them to shoot their own "grip-and-grin" shots for in-house desktop newsletters. The latter example might be discouraging news for some photographers who will no longer benefit from those kinds of simple, but lucrative assignments.

As stated earlier, it's probably only the amateur and, perhaps, social-event (weddings, etc.) markets that will experience a dramatic proliferation of digital capture devices, because the highest possible resolution is not a factor in those markets, nor is the permanent storage of images in their digital state. The final result will almost always be a print, and a print good enough for Aunt Mildred can be rescanned or copied from the CD you "burned" if a copy is required a few years or so after you've erased the memory chip in your digital camera. Mr. Mehra of Eastman Kodak says, "I believe that traditional and digital photography will coexist for some time to come in the commercial arena. They will be comparable on many attributes, such as image quality, photographic speed, and cost per image; however, the efficacy of one over the other will depend on the exact needs of the client. It is these needs, along with the different system advantages that the two provide that will determine the migration from one to the other."

Electronic Storage

The technology does exist to more or less "permanently" store digital images, but if you were to shoot with a digital camera as prolifically as a typical pro photographer shoots film, there is no practical place for you to *put* them.

Unlike text, where you have seen the equivalent of voluminous page counts stored on tiny CDs, there is no similar economy of space in storing images digitally, at least not at the highest possible resolution. While an entire encyclopedia might fit onto a single CD-ROM, digital images with a resolution even approaching that of film precipitate files so huge that there are not enough gigabytes, terabytes, bigabytes, zigabytes, gazillionbytes, or mosquitobytes of disk space on planet Earth to archive them in reasonable quantities. And a CD isn't really smaller than a sheet of film anyway. There is neither any convenience nor economic benefit to the wholesale scanning of images shot on film and then saving them to removable magnetic media such as Zip™ and Jaz™ drives, or even optical-laser media and CD- or DVD-ROMs, just for the sake of doing it. It only makes sense for a few images out of an entire take of film (i.e., those that will actually be published from a single assignment) to be stored that way. If you do the math, it would not be economically feasible to spend the time it would take to archive the images of just one moderately productive photographer at resolutions equivalent to film. If you ran a stock photo agency that was to become more and more dependent upon digital distribution, it would be a different story.

The Difference between Archiving and Cataloging

Admittedly, film needs to be stored carefully under optimal ("archival") conditions according to the manufacturer's recommendations if the images they bear are to survive for indefinite periods of time. But, indeed, they can survive. Besides, images stored on magnetic disks and CDs are not impervious to degradation. In fact, they must be carefully monitored and eventually, if not periodically, recopied onto newer media. And then, there is the issue of "machine" versus "human readability." Anyone one who has experienced the obsolescence of BetaMax™ video or eight-track audiotape and LP records understands that problem. There is no assurance that devices will exist in the future to view the data on

which they are recorded today. In spite of all that, for your purposes, it is more to the point to distinguish between a digital *archive* and a digital *catalog*.

A catalog is an electronic inventory, a laundry list. Creating a catalog is more easily accomplished and probably more useful to your business than creating a digital archive. A catalog exists simply to tell you what images you have on hand and where to locate the originals. For example, a catalog can be a visual database of stock photos; each image on your computer screen has a serial number and keywords that correspond to the actual film and its physical location in a filing cabinet.

The images in a catalog will not be used for reproduction purposes, so they need only be recognizable, very-low-resolution facsimiles of film originals. To that end, you can use an ordinary desktop scanner to create *thumbnails* from your slides, negatives, or prints. These low-res images take up little disk space. You can view and sort thumbnails by various categories of keywords in your computer catalog-cum-database. Cataloging thumbnails electronically with PhotoByte, for instance, will not only help you locate slides in a filing cabinet, but also help you prepare them for submission, help you get paid for licensing them, and help you retrieve them from clients. Incidentally, thumbnails can also be published on your own Web site to show buyers what you have available.

The cheapest way to catalog pictures is to buy a modest-resolution, small- to medium-format film scanner and do it yourself. But the most convenient—and maybe the fastest—way is to drop off your film at a service bureau for transfer onto a Kodak PhotoCD® or its equivalent.

Digital archiving, on the other hand, means storing images of high-enough resolution to use for book reproductions and making museum-quality prints. It also means storing them for indefinite periods of time. Insofar as a digital archive is concerned, a far costlier scanner is required, along with a costlier computer system with extra megabytes of memory (RAM). You also need the capability to create, or "burn," your own CDs. That's not a big deal anymore. But you will probably need vast quantities of magnetic or photo-optical (laser) storage devices, too—more than you might ever imagine being able to afford.

Digital Distribution

There is one other area of imaging technology alluded to earlier in this part: digital transmission, or distribution.

After you create your images on film, they will probably have a parallel life as scanned and transmitted digital files: electronic facsimiles, a.k.a. images. Eventually, you will have the routine capability to select images from any given photo assignment (ordinarily shot on film) and submit them electronically to publishers with the click of a mouse. Again, that gives you more control over your creations, because you hold on to the original film. That precludes any possibility of lawsuits and litigation over lost or damaged transparencies and negatives. That is very good news! It dramatically changes the way you do business without changing the nature of your work.

A Look into the Future

A typical scenario in the future might find you in San Francisco finishing an assignment, pretty much as usual. Then, after picking up the processed film at a commercial lab and editing it on a light table, either right there or at your own premises, you insert several "selects" into an as-yet-unnamed desktop appliance. This gizmo automatically scans the pictures into your business automation solution, creating thumbnails that become an integral part the "virtual paperwork" associated with that assignment. That is to say, the pictures are linked to the documents that describe how they were made and for what purpose. Then, without any extra work on your behalf, the software copies the selected images into your stock photo catalog, keeping all of the information about who, what, when, where, why, and how for inventory and captioning purposes. (It will also create slide labels on demand.) Another click creates a job delivery memo along with an invoice. With a final click, the selected high-resolution images and virtual paperwork are hurtled through cyberspace, all the way across the continent to Manhattan and directly onto the art director's computer screen. Simultaneously, the electronic invoice goes directly to the accounts payable department's computer, and you are immediately paid for your services as the funds are electronically transferred into your bank account. You might even accomplish this neat trick with a laptop computer and a wireless cellular modem[6] from a remote location.

After the editor goes through your electronic submission, your photos are "cut and pasted" electronically into a magazine layout on the computer screen. Any cropping or color corrections, as necessary, are made at this time right on screen, while you participate from across the continent via teleconferencing software over the Internet. You can watch! You can each see what's happening to the photo(s) in the layout—as well as see each other—on screen while discussing the publication of your assignment. Next, the art director sends the pictures and the entire layout electronically to the pre-press bureau with another mouse click. The art director and the press operator are also videoconferencing online by this time, so they can make any final changes. Ultimately, it's off to press. (Still ink, so far.) Next thing you know, it's a major newsmagazine cover circulating around the world.

More Help from Technology

It is recommended that you use a modem and telecommunications software with your computer. With a fax modem or through e-mail, an estimate can be placed on an art director's desk within minutes. And even though you've had no need to use a piece of paper or a pen, the document will still be signed with your name and you will still have a permanent record of the transaction in your computer.

If you don't like to read the fine print in magazine contracts or ad agency purchase orders, your computer can do it for you. Simply make a habit of running the fine print through your scanner. This is accomplished using a simple desktop scanner and optical character recognition (OCR) software. At the very least, the fine print can be made more legible; you can enlarge it and print it if you want to. You can keep copies of the text of your clients' contracts in your computer.

But most importantly, you can use your word processor to search for any insidious terms and conditions included in the boilerplate text that might jeopardize your rights. If you are aware, for example, that it's a bad idea to sign away your entire copyright by agreeing to a "work-for-hire" clause, you can have your software search for those onerous words

within a contract. All word processing software allows you to find specific words or phrases. Then, you can then use another feature found in most popular word processors (called "Track Changes" in Microsoft Word) to make A:B comparisons of your clients' terms and conditions with your own edited versions, superimposing your changes (i.e., allowing them to be highlighted) within a single document. Having done so, you can point them out to your clients and conclude your negotiations.

NOTES

1 Nimoy is also a talented photographer who occasionally exhibits his work.

2 The printing pre-press industry generally includes computer graphics and production service bureaus, page layout and production coordinators, graphic designers, and digital electronic printers. These are companies and individual contractors that provide services to prepare the images photographers shoot to be included in publications. They are represented professionally by DIMA, the Digital Imaging Marketing Association, a division of PMA, Photo Marketing Association International.

3 Professor LeVant polled a group of RIT alumni and members of the American Society of Media Photographers in 1997.

4 No, it is not the title of a Robert Ludlum novel. Austrian Army officer Theodor Scheimpflug patented several special cameras in 1904 for correcting the undesired distortion in photographs taken from balloons when the camera was not pointing straight down. The Scheimpflug Principle states that the film plane, the subject plane, and the lens plane must intersect along a single line to provide optimal focus, or depth of field. Scheimpflug's rule has been one of the guiding principles for view camera users ever since. It is also used in opthalmological science, regarding medical problems of the eye.

5 A method of film exposure and development first described by Ansel Adams and promulgated by Minor White that has to do with the "previsualization" of a scene. Various objects within the scene are assigned measures of luminance that correspond to a range of zones from one to ten. Each zone represents a measure of the luminance of a shade of gray.

6 "Modem" is a word derived from the terms "modulator" and "demodulator." It is a device that converts the analog signal of a voice going over a phone line into something digital that can be interpreted by a computer.

4

Principles
of Business
Automation

It was, no doubt, your desire to become an artist to avoid becoming a small cog in a big corporate machine. Now you find that you're the only cog in your own machine. You may have begun running a company reluctantly, but the problem remains: If you don't act like a businessperson, you won't be treated like one. You alone are responsible for keeping the wheels of commerce turning. If you find yourself continually disadvantaged in dealing with clients—that is, if you can't keep the gears greased—your ability to support yourself may come to a grinding halt.

Paperweights and Productivity

The routine management of a commercial photo business requires many special skills and, so it seems, an encyclopedic knowledge. On top of that, with both limited time and financial resources to deal with, it's hard to make room for all the administrative mumbo-jumbo that goes along with taking pictures. Unhappily, you're forced to juggle photo assignments with obligations like marketing, sales, and back-office paperwork. One quickly learns how hard it is to keep all those balls in the air at the same time.

Lessons in business administration are ineffective and tedious if they are presented strictly as theory. By introducing a new tool into your arsenal of photo equipment, one made possible thanks to recent technological developments, you will quickly discover how much faster and easier it has become to apply what you learn to actually getting the job done. While it's true that everything in this book, from building a business plan to writing invoices, can be done with a pencil and paper, a computer takes these tasks out of the theoretical realm and makes them practicable.

In the past, photographers used computers like glorified typewriters. Documents looked more presentable than those scribbled by hand, but the task was neither less tiresome nor time-consuming. Moreover, it was certainly not possible to link invoices to other documents in the paper trail, to create a de facto profile of your current state of affairs.

While it's clear that a photographer can no more get by today without using a computer than he can take pictures without a lens, business automation isn't really about computers. It's about the software that makes these otherwise inert and brainless machines *do* things. Without effective software, any computer is just an expensive paperweight.

Coping with the Photographer's Lifestyle

Freelancers suffer from a superficial, abrasive cranial affliction called "brim burn." It means that changing hats too often will rub you the wrong way, and typically, photographers continually have to swap their shooting hats for marketing-and-sales-manager hats, errand-boy hats, bookkeeper hats, secretary hats, lab-technician hats, and however many other hats are required on any given day. It's pretty hard to get organized under those circumstances. It's also impossible to remember every location lunch, cab ride, and Polaroid™ print to include on an invoice once a shoot gets underway. But incidental costs like those add up to considerable sums of money that seem to slip through a hole in your pocket.

Nevertheless, whenever a client calls, it's a no-brainer to rush right off to the next assignment the minute you hang up the phone. Any resolve you might have had to catch up with paperwork is immediately brushed aside. In fact, it is safe to say that your office-keeping chores will always play second fiddle to almost anything else that seems to be easier or more interesting to accomplish at any given moment, from picking up film at the lab to dropping off your laundry. As administrative burdens pile up, it becomes increasingly stressful to cope with simply trying to be a good photographer.

Hiring Help Won't Always Do

Even if you can afford to hire an office manager, a financial planner, and a rep, few of them have the kind of firsthand know-how about estimating and billing photo assignments that you do, let alone knowing how to track the whereabouts of film and electronically submitted images. How can non-photographers appreciate the nuances of language in a copyright license or catch the financial consequences of last-minute changes in a production schedule? Delegating the responsibilities for your entire administrative load to hired hands can sometimes make the hole in your pocket grow larger, unless your employees are specially trained and equally well-paid. Even with competent managers by your side, you still have a responsibility to stay in touch with current clients while prospecting for new ones. Then, there's all that promotional correspondence to keep track of, plus so many phone calls to return. There must be an easier way to do this!

A New Way to Think about Using Computers

Until recently—excluding its role as the primary interface to the World Wide Web—the personal computer was simply thought of as a more efficient alternative to the combination of a typewriter and filing cabinet for creating documents and storing them. Initially perceived by small-office and home-office proprietors as a device to help them become more organized, it was merely an appliance used to clean up the clutter. It will indeed help you get organized, but not by substituting high-tech paraphernalia (a monitor, a keyboard, and a hard drive) for something low-tech (paper, a typewriter, and a filing cabinet) just for the sake of saying that you are now "computerized." There should be a greater goal. Think instead about increasing your productivity and making more money. The organization part is just a naturally occurring byproduct.

A Business Automation Solution

The software you put in your computer is as important as the film you put in your camera. The combination of a computer with software that consolidates trade practices within any given profession is called a *vertical, business automation solution*. It quickly becomes indispensable by decreasing the amount of time you spend sitting behind a desk and maximizing the time you spend making photographs.

Good software takes the information you already have, the routine stuff you have already entered into the computer gradually, day by day, about all of your clients and assignments—information that you would have had to record anyway—and redistributes it everywhere else it needs to be automatically. You don't even have to think about where the information should go to next (i.e., into which other documents, lists, and reports). It flows wherever it needs to be all by itself, ending the drudgery of repeated data entry. For example, an estimate turns itself into an advance-payment invoice, then an assignment log, then a confirmation, followed by an invoice, and finally, a film delivery memo, all without the need to retype anything, unless you want to make changes. The added benefit is, of course, that you are reminded of the next steps to take along the "virtual paper trail" for each assignment, even if there are several assignments going on at the same time. Nothing is left to chance

or the vagaries of personal memory, except to turn on the computer.

All of the facts about an assignment, both financial and logistical, are linked together into this virtual paper trail, virtual in that documents only exist inside your computer until—and unless—you decide to print them out. This paper trail can easily be navigated backward and forward, as if each assignment were represented by one macro document. The software correlates the data about current and recent assignments with every other assignment entered previously. The same goes for stock photo submissions.

To create reports, you don't have to perform any additional data input. You need not format any layouts for viewing and printing. You just have to choose which button to click. All the information you need to make important decisions about the direction and growth of your business is right at hand.

Single-Task Software versus Automated Solutions

The inability to integrate documents and reports in accordance with the trade practices specific to any given industry is a limitation of generic software.

The Swiss-Army-knife approach to software is represented by such popular "software suites" as Microsoft Office™. But if you want to write letters, cut checks, send estimates or invoices, and look up telephone numbers, you will have to cobble together a solution from amongst a number of disparate, "single-task" tools that were simply *packaged* together. While they might be labeled "small business software," such a cobbled-together solution cannot meet the needs of your profession.

For a photographer trying to create documents as highly specialized as those relating to photo productions, using any combination of single-task tools—say, using a word processor to create a stock photo delivery memo—is like trying to slice bread with a spoon. Still, some single-task applications, such as check-writing software, are useful no matter what business you are in. Bookkeeping applications like Quicken®, QuickBooks®, and MYOB® are very helpful, but they cannot be reengineered to produce estimates and invoices that correspond to the complexities of a photo assignment.

The Learning Curve

How, you might ask, will adding new software, which you will have to take the time to learn, help you get more organized instead of more bogged down and confused? You may already be thinking that you don't have time for all this rigmarole. Ironically, but happily, business automation can take the tedium away from office chores by allowing you to use your computer *less*. Here's how that works.

Simple Computerization versus Business Automation

Remember: once you get beyond the idea that computers are high-tech typewriters, you will become better organized in spite of yourself. The real benefits come from increased productivity and—most importantly of all—profitability.

The idea of simply computerizing business forms is not the same thing as creating an integrated solution. A solution ties the information in many different, but job-related documents together as described above. Computerizing existing forms merely helps decrease the space you need to store an inventory of paper documents. But you must still do all of the work manually. Offering photographers a different way to do the same old thing merely delays them from coming to grips with the true advantages of a professional solution. Once the novelty wears off, photographers still won't do the paperwork. More to the point is that such a form—a template really—cannot compose copyright licensing language, nor with the click of a mouse can it turn an estimate into an assignment log, a confirmation, an invoice, or a delivery memo. It cannot tell you what your profit margin is or how competitively you are pricing your work. PhotoByte, a software solution created specifically for photographers, can.

Getting Started with PhotoByte

You are about to create some simple documents. First, some basic assumptions about "computer literacy" will be addressed.

The exercises and tutorials involving PhotoByte interspersed throughout this book assume that you have a working knowledge of your computer and whatever operating system it uses. You should already know how to choose menu commands and how to open, save, and close files. You should also

know how to select both text and graphic (i.e., image) files and how to "cut and paste" those data from one application into another. You should know how to scroll through windows and what it means to "click," "drag," and "select" objects on a screen with a mouse. If you need to review any of these terms or techniques, refer to the documentation that came with your computer.

EXERCISE -

Entering Data in PhotoByte

This exercise will familiarize you with the PhotoByte interface and how to interact with the software. You will learn about:

> ▸ Filling in Preferences screens—tell PhotoByte what information it will use to describe your own business
> ▸ The Main Menu—the hub of all operations
> ▸ The Profile and List View screens—where you usually enter information about your clients, prospects, and the other people you deal with

note For PhotoByte installation instructions, refer to the Installation Appendix. For last-minute changes, refer to the "Read Me!" file on your CD-ROM.

To start PhotoByte on a Mac, select *PhotoByte* from under the Apple menu, after having run the installer application. To start PhotoByte on a PC, open the PhotoByte folder and double click the *PhotoByte.exe* icon.

> ▸ From the Welcome screen, read the trademark and copyright notice, then click the *Click Here or Press Enter* button.

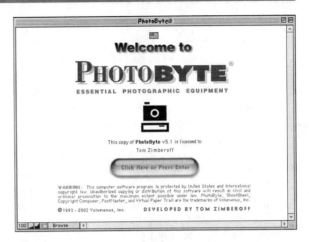

> ▸ Click the *Proceed* button.

This brings you to the General section of the Preferences screen. Tell PhotoByte what it needs to "know" about your business.

> ▸ Fill in your company information.

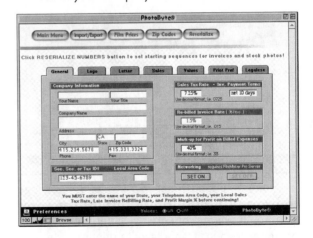

> ▸ Type your own name, company name, and address in the appropriate fields. You may press Tab to navigate through each field.

‣ Type your telephone and fax numbers in their respective fields. It isn't necessary to enter hyphens, parentheses, or slashes; PhotoByte automatically formats telephone numbers.

‣ Click in the *Sales Tax Rate* field. Sales tax is automatically added to invoices, unless the client has a state-exempt permit or is located out of state. More about that later in part 3.

‣ Type your local sales tax rate using the decimal format, for example **.0725** to represent 7.25%. Press Tab.

‣ Click in the *Re-billed Invoice Rate* field. This is the rate applied to the balance of a late-paying customer's bill, typically 1.5% or 2%. Type **.015** or **.02**. Press Tab.

‣ Click in the *Mark-up for Profit on Billed Expenses* field. This determines your profit margin on expenses that are billed to your clients, such as travel, rentals, assistants, models, and other expendables or outside services. Type **.5**, representing 50%. Press Tab.

note You might ask a certified public accountant about the percentage of mark-up you need to apply for your particular circumstances. (More about that in part 3.) For now, enter **.4** for a 40% mark-up.

‣ Click the *Logo* tab.

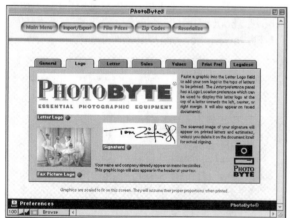

You may import either your own photo or a logo created by a graphic designer into the *Letter Logo* field. You may scan your existing letterhead to appropriate the logo, or scan a favorite print or slide. This enables you to create an image file that can be cut and pasted directly into this field. PhotoByte will subsequently place it on appropriate documents.

The *Fax Logo* field works the same way. It will accept a graphic file that will appear exclusively in the headings of PhotoByte fax memos.

The *Signature* field will contain a facsimile of your handwritten signature, scanned the same way from a plain, white piece of paper on which you sign your name.

You may create and add these image files later, if you wish.

Leave the *Edit Boilerplate Text* button alone for now. If you clicked it accidentally, click the *Main Menu* button, then the *Preferences* button to get back where you left off. This feature is also explained in the on-screen User's Guide.

‣ Now, click the *Letter* tab.

‣ Click the field below, where it says *Logo Location*. It currently displays *Top Right*. Select *Top Left* instead. Notice how the logo in the letter moves to the left. You may also click the other two pop-up fields to tell PhotoByte how you want the paragraph formatting to appear in your letters and how you want to sign your letters, e.g., **Cordially yours** or **Sincerely yours**.

‣ Click the *Stock Sales* tab.

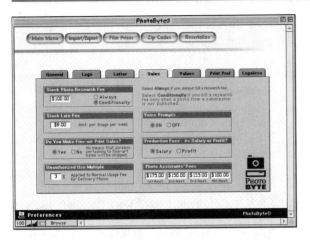

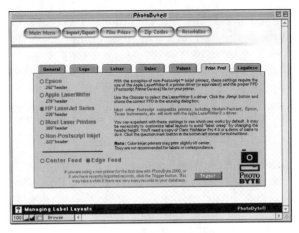

> ‣ The *Stock Photo Research Fee* is what you charge for the time and effort it takes to catalog and search for filed photographs when fulfilling a request for submission. Fill in an amount. (See part 6, chapter 34.)
>
> ‣ If you will never make fine-art print sales, click the *No* button. This simply blocks default access to screens that you won't want to be bothered with. It's fine to leave it alone for now.
>
> ‣ Click the *Values* tab.

This is where you configure your printer to work with PhotoByte. Please note that not every printer on the market could be tested and listed. The model you use may not be included here, and you may have to experiment to determine which setting works best for you. Mainly, these settings have to do with printing labels. More information about printing can be found in the tech support documents found on your CD-ROM.

> ‣ Click the *Legalese* tab.

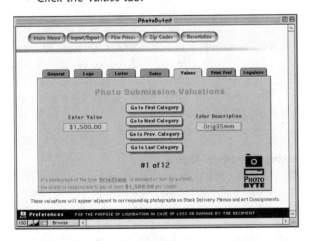

If a photograph is damaged or lost by a buyer, the buyer is responsible to liquidate that loss or damage by paying you the amount established here. These valuations are looked up by PhotoByte and used in the *Stock Delivery Memo* and *Art Consignment* documents.

> ‣ Click the *Print Pref* tab.

Each button illustrated on the screen above corresponds to a different set of terms and conditions, a model release, or an agreement that can be edited on screen. In case a tiger bites off your model's hand during a photo session, make sure an Indemnity Agreement was signed first! There is also an Independent Contractor Agreement that you might ask freelance assistants to sign, along with a Non-disclosure Agreement, so they don't reveal all of your trade secrets to another photographer. Incidentally,

the Job Inv. Terms and Conditions, and those for stock photos, too, are programmed to print on the backs of their corresponding documents (i.e., by clicking the *Terms* button on the face of an Invoice/ License of Rights screen).

note It is a good idea to print out one copy of each of these documents and study them.

Setting a New Film Lookup

The FilmList is a reference file. From here, PhotoByte looks up film descriptions and prices that are used in automating data entry on Job Estimates, Job Confirmations, and Invoices.

> Click the *Film/Print Prices* button at the top of the screen above the Preferences tabs.
> You will see the FilmList lookup screen.

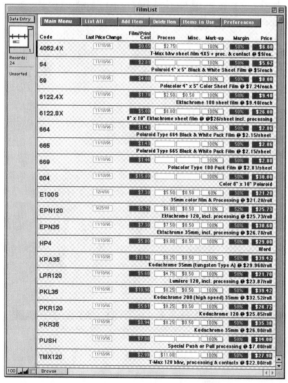

> Click the *Add Item* button at the top of the screen.
> Your cursor should already be blinking in the *Code* field. Type **XYZ35**. Press Tab. Then click in the *Film/Print Cost* field. When you go to the camera store you pay $4.71 to buy one roll of this film. Type **4.71**. Press Tab.
> Your cursor should be blinking in the *Process*

field. This is what it costs to process one roll of that film. Type **4.5**. Press Tab.

note You can make up and add codes, prices, and descriptions for digital services, too.

> Your cursor should be blinking in the *Misc.* field. This field represents the incidentals that you might want to bill for. If you deliver your slides to clients in plastic pages, for example, charge for them! Type **.75**. Press Tab.
> Click the *Mark-up* field. Select the mark-up rate from the list. Select **50%**.

The *Margin* and *Price* fields are now complete. Your profit margin is 33%, and the price to the client is $14.94 for each roll of XYZ35 billed. (See part 6, chapter 30, for more on pricing.)

note Film is marked up at separate rates, which are indicated here, instead of the global or overall rate you entered in the previous Preferences screen for other line item expenses.

> Click the *Description* field. Type **Superchrome XYZ, 35mm color film and processing**. From now on, when you make an estimate and click on the film *Code* field and select **XYZ35** from the list, the phrase "Superchrome XYZ, 35mm color film and processing" appears as a line item description.

You have completed entering your preferences. Move on to the Main Menu.

> Click the Main Menu button.

Using the Main Menu

This is the central hub of PhotoByte. You can find information about clients, navigate to sales reports, or look at scheduled telephone calls and meetings, past or future. You can track who is holding the film you shot on assignment, as well as portfolio and stock photo submissions. The idea is to have your property returned promptly. Each button is self-explanatory. Go ahead and click some of them!

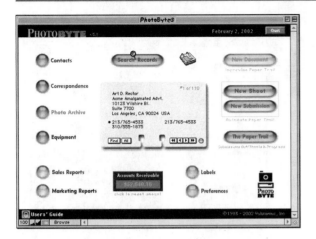

> tip If you get lost after clicking buttons randomly on the Main Menu, you can always get back to where you started with a shortcut by pressing Command–1 (Mac OS) or Ctrl–1 (Windows).

> tip As you use PhotoByte, you will learn to remember a number of handy keyboard shortcuts. Until then, you can use the Shortcuts menu. Incidentally, you will rarely need to use the other menus at the top of your screen. *Make a practice of using the buttons on your screen instead of menus!*

On the Main Menu, the rotary card works pretty much as you would expect; it's just a quick way to find names and addresses. For example, if you want to find someone whose name you don't even remember, but you think the street name begins with an *M* and the address is *31*:

> ▸ Click the *Find* button.
> ▸ Press Tab. You can use anything in the address as a Find criterion. In this instance, type **31 m** and click the *Continue* button. The card for Tom Zimberoff appears on the Main Menu. You found *31 Main Street*.
> ▸ Click any telephone number on the card. Photo-Byte will automatically dial the number for you if you have a fax modem attached to your computer. Of course, you must dedicate a separate phone line for this feature to work. (For information on using this feature, refer to the on-screen User's Guide topic, *How to Set-up the Phone Dialer*.)

Let's say you now want to find someone whose name you know, but you don't know how to spell it. How about Xavier L. Wampaut?

> ▸ Click the *Find* button.
> ▸ Press Tab.

> ▸ Type **wam**. Then press *Enter* on your keyboard or click *Cont.* on the card. You will see Xavier *Wam*paut's card.
> ▸ Click the *All* button on the card. Click the arrow buttons to scroll through various cards.
> ▸ Finally, click the double arrow on the left. This will take you to the first card.
> ▸ The rotary card should display Art D. Rector. His nickname is Artie. Click on Artie's card, but not directly on a phone number.

Viewing a Profile Screen and Entering Contact Data

When you click anywhere on a rotary card other than a phone number, the Profile screen for that person is displayed.

This is Artie's Profile screen:

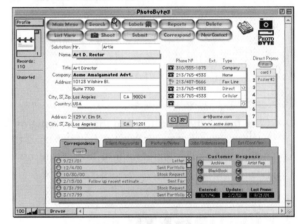

There are five separate views of the Profile screen: Correspondence, Clients/Keywords, Picture/Notes, Jobs/Submissions, and Est/Conf/Inv. Each view is accessed with a mouse click on a correspondingly-named tab that resembles a filing-folder tab.

The default view is the Profile > Correspondence screen. A prominent feature of the Correspondence view is its scrollable history of communications. It lists each phone call, meeting, e-mail, fax, and letter you've addressed to the person whose Profile you are looking at.

> ▸ Click the *Sort* button under the *Correspondence* tab. Notice that the records are sorted by type of communication.
> ▸ Click *Sort* again. This time the records are sorted by date, with the most recent entry at the top of the list.

❯ Click the tiny yellow button on the left, adjacent to the 9/21/01 letter.

❯ A letter appears on screen. It looks just like it would on paper.

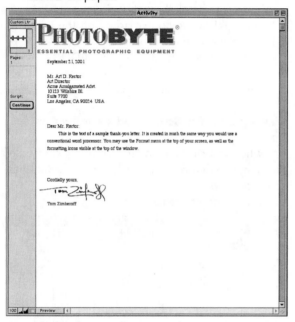

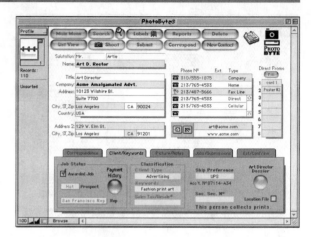

❯ Click the *Continue* button and the letter remains, but the screen now displays the buttons used to navigate to other screens and to execute new functions.

❯ Click the *Return* button (this is the round button with an arrow on it) to return to the Profile screen.

❯ Click the tab for the Client/Keywords view of Artie's Profile.

Here you will see a *Payment History* button. This button appears only if there is, indeed, a history of invoices having been billed to this client. If you have never billed the client, this button will not appear.

How PhotoByte Works with *Client Type* and *Keywords* Fields

In Profile > Client/Keywords, there are two important fields called *Client Type* and *Keywords*.

In *Client Type*, you will enter one of three basic client categories: Advertising, Corporate, or Editorial.

There are other choices and the list is editable, but it is recommended that you use one of the three basic categories. Almost every commercial job falls into one of them.

This field works in tandem with the *Keywords* field to describe what kinds of jobs a particular client is most likely to hire you to shoot. It will be used to create reports. For example, if a Corporate client is most likely to assign you to shoot **people** or **industrial** or **aerial** pictures, enter one or all of those words in the *Keywords* field. If an Advertising client is most likely to assign you to shoot jewelry, enter **jewelry** in the *Keywords* field. If an Editorial client is most likely to assign you to shoot **people** or **fashion** or **aerial** or **architecture**, enter those words.

Do not use the *Keywords* field to indicate that a contact is a client. In other words, client is not a practical keyword. PhotoByte already knows that a record represents a client if data exists in the *Client Type* field.

An exception to that rule is to select **Not a Client or Prospect** in the *Client Type* field. The exception applies when the Profile record represents the pro-

prietor of a restaurant, your dry cleaner, or a family member. Insofar as those other examples are concerned, you can type **restaurant Italian**, **dry cleaner laundry**, or **family cousin** in the *Keywords* field for those records, respectively.

The system of data entry suggested for the *Client Type* and *Keywords* fields makes it easier to use two special features from the Market Reports screen: the Customer Referral Report and the PostMaster™.

With the Customer Referral Report, you can see to what extent your various self-promotion campaigns are getting the most bang for the bucks you spend. You can also see a breakdown listed under each category of "hits" (a percentage of responses to various media in which you have placed your ads) for the types of photo assignments each client/respondent is most likely to hire you to shoot. (This feature will be explained in more detail in an exercise in part 4, Marketing and Selling.) As for utilizing the PostMaster report, you can fine-tune your self-promotion mailing lists so as to target clients in specific geographic regions *and* to those individuals who might assign you to shoot the specific kinds of jobs you wish to promote. You will quickly learn how this feature is invaluable for qualifying and quantifying your marketing reports, as well as for finding and sorting groups of clients and personal contacts. It, too, will be explained in a later part.

Now, look at the *Sales Tax/Resale #* field. If a client is exempt from paying sales tax on invoices, you will select one of the categories in this field or enter his state resale license number. This field is empty on Artie's Profile. Therefore, Artie will automatically be billed for sales tax, but only if your business is located in the same state and sales tax applies in that state. (You will learn more about sales tax in part 7, Operations.)

note If the *Client Type* field is left blank and the client's company address is in the same state that you are, sales tax will be applied at the rate you indicated in Preferences.

▸ Click the *Picture/Notes* tab.

You are now looking at the Picture/Notes view of the Profile.

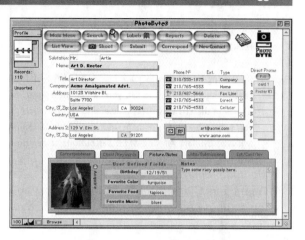

You can paste a picture of your client here.
▸ Record additional personal information, such as a birthday, in the user-definable fields.

▸ Click the *List View* button on the Profile screen (or press Command–2/Ctrl–2).
▸ Then click the *Show All* button.

You will see a spreadsheet-style view of all the contacts in your database. Click on any name in the list to see that person's Profile.

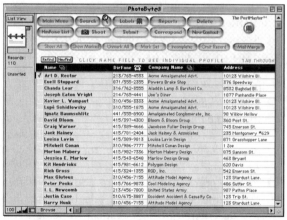

▸ Click List View again to return to the list of contacts.

note This is what is called a "screen report"; it is not designed to be printed. To see better information—and more of it—about the people and companies on this list in a

printed report, click the *Reports* button at the top of the screen.

tip By clicking in the small square field at the left and adjacent to each name in the list, you can create subsets of names in the List View. This is useful to "refind" records you have marked. Experiment with the *Show All, Show Marked, Unmark All,* and *Mark Set* buttons to see how this feature works.

> Create a new Profile. Click the *New Contact* button at the top of your screen. Click *OK* to proceed.

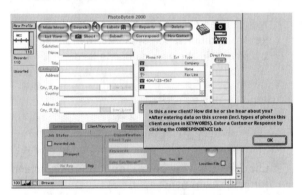

> The cursor will be in the *Name* field. Type **Fred Smith**. Press Tab.
> The cursor is in the *Title* field. Type **Chief Art Buyer**. Press Tab.

The cursor is blinking in the *Company* field. You could enter a completely new company name and address here. Instead, you will use a shortcut to enter a company that already exists, because Fred Smith works for the same company as someone else who is already listed in the database.

> Click the *Existing Co.* button on the left side of the *Company* field. A pop-up list appears, displaying all of the existing companies in your database. Type the letters ac. You will see *Acme Amalgamated Advt.* in the list.
> Press Return. The complete address for this company, its name, and its telephone number will be entered in their respective fields automatically.
> Enter data into the *Client Type* and *Keywords* fields.
> Click the *Activity* tab to go to the Correspondence/Profile screen.
> Click on *Customer Response* Field N° 1. (Do not

click the red button next to it.) Select **BlackBook** to indicate that this is where Fred first became aware of your work and found your phone number.

The Discipline of Business Administration

Discipline is a loaded word. It conjures up a mental image of self-righteous acts of punishment dished out by evil stepparents, third-grade teachers, and army drill sergeants. But have you ever considered the origin of the word *discipline* and what it means?

The root is Latin, and it means to instruct. It has since come to mean one kind of training or another, or to act in accordance with that training. Discipline implies the establishment of a sense of order and organization based upon rules. So, yes, if you break the rules you might be punished—well, sort of. While it does imply punishment, you are likely to only punish *yourself* by failing to adopt some basic rules about commercial transactions. Discipline in this context refers to the rules part, not the punishment part. Discipline means showing you an easier and better way to accomplish the things you already know you have to do.

Another word that is derived from discipline is *disciple*. It means one who follows a particular path of learning. That path could very well be thought of as the paper trail. Technology, through business automation, can give you the discipline to pursue this path, to be better able to use the knowledge you have gained to grow your business.

Consistency Fosters Higher Standards

Certainly, there must be any number of successful photographers who don't use business automation at all, who may not even use a computer. However, if they act professionally and have no serious cash flow complaints, there is no reason to be concerned about them. It is obvious, however, that the preponderance of photographers who would like to embrace best practices have no way to do so. It is they who are a concern. They represent the weak links in a chain. The good news is that, by automating your business, it becomes more difficult *not* to use best practices. That can only lead to greater profitability. The proliferation of best practices, therefore, is a compelling reason for all photogra-

phers to embrace the use of computers and business automation software.

Establishing Standards

Best practices, by the way, are not the same thing as standards. Higher standards are the *result* of best practices. It follows that as the number of photographers who automate their businesses grows, the number of photographers using best practices grows, too. When that number reaches critical mass, a standard will, in fact, already exist. It could not be otherwise.

At a certain point, then, the right way to do business becomes the way everybody already *is* doing business. The widespread use of a business-automation solution guarantees peak efficiency and profitability for each individual freelancer, while it achieves a higher ethical standard for the entire community of commercial photographers. At that point clients will take it for granted that they will *always* receive a delivery memo with submissions, that the terms on the back of an invoice *always* supersede work-for-hire language in their purchase orders, and that photographers will *always* include a mark-up on billed expenses. Consistency means universally defining your rights by exercising them on a regular basis. Ultimately, the more of you who *adopt* best practices, the more buyers will be obliged to *adapt* to them.

Business Automation from a Client's Point of View

Michele McNally, Picture Editor of *Fortune* magazine, made an interesting revelation. Fully 30 percent of the invoices she receives from ostensibly professional photographers are so crude that they are indecipherable and unverifiable. She can't figure them out! They must be returned with instructions to be resubmitted. What a scary thought! How do you suppose those photographers' cash flows are affected?

With the capability to automate your business administration chores, you will always be able to submit invoices and other documents in a timely manner and in the most professional-looking format. Not only does that reflect well on you, it makes your client's job easier, too, because the documents are easier to process for payment. That means an invoice goes from the photo editor's in-box to the accounting department's out-box more rapidly.

Not only will it take less time for you to receive payments, but there will be fewer chances for disagreements and misunderstandings about the contents of invoices, because every expense and usage right granted will be legibly, concisely, and neatly presented. In short, they will be professional-looking. In addition, since you have been following the paper trail throughout the course of your assignment, all agreements between you and your client will have been made (and disagreements resolved) at a much earlier stage. By the time an invoice lands on your client's desk, there is little left to dispute.

Convenience and the Relationship of Consistency to Trade Practices

The two most important aspects of business automation are *convenience* and *consistency*.

Consistency is the result of convenience. Another way of stating that is: *If it's easy enough for you to do things the right way, you will!*

Real and Virtual Documents

Each document in the paper trail is a milestone that guides you to a final destination: payment. Some of these computer-generated documents are "real," in the sense that you will submit printed, paper copies to your customers. However, it is useful to characterize other documents in the paper trail as "virtual," simply because they exist within cyberspace on a computer hard drive, viewable, for the most part, on screen. Of course, you still have the option to print them at any time, if you wish.

Some of these documents, such as estimates and business memos, may be delivered electronically, instead of by postal service. With the aid of a modem and telephone lines, they are submitted as e-mail or faxes. The recipients can choose to view the documents on screen, save them, delete them, or print them on paper. Either way, you have not used any of your own paper supply. You have, in effect, used either the recipient's fax machine or modem as an off-site printer. The recipients will decide if they need paper copies or not, not you.

This procedure works well, because the software

puts your company logo and signature on each virtual document. The scanned facsimiles of your logo and signature that you input in an exercise earlier in this chapter "live" inside the PhotoByte software. That way, you save the cost of having a commercial printer create an inventory of extra forms, and, as already stated, you save space otherwise needed to store them. The result, as far as the recipient is concerned, looks like you faxed a printed paper document on your company stationery.

EXERCISE

Faxing a Memo

> From the Main Menu, click the *Find* button in the lower left corner of the rotary card.

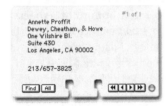

> Type **annette** where the cursor is blinking, then click the *Cont.* button, which is where the Find button was before.

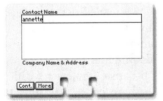

> You will see a card belonging to Annette Proffit. Click on the card itself.
> You will see Annette Proffit's Profile screen. Click the *Correspond* button.

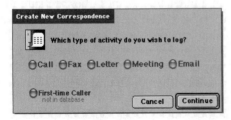

> You will see the Create New Correspondence

screen. Click the *Fax* button. Then click the *Continue* button.

That will take you to the Fax Memo screen. The cursor will be blinking in the Subject field.

> Type **Upcoming Meeting**. Press Tab on your keyboard and then type **I am looking forward to showing you my new business plan . . .** That's enough text for now.

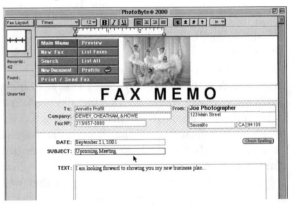

> Click the *Preview* button to see what the fax will look like when transmitted.

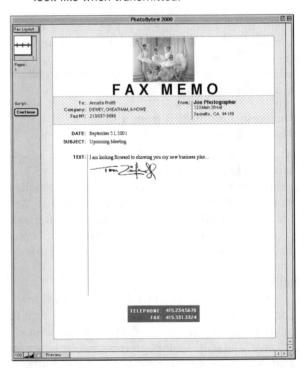

At this point, you will follow the instructions for using your fax modem to send the fax, or else print it to send through a regular fax machine.

note Most fax software allows you to augment the Print command with a keyboard command that shunts your document from the printer driver you use for hard copy to a fax driver instead.

> Click the *Continue* button. Then, click the Profile button.

You will be returned to the Profile screen. Notice that the fax memo has automatically been logged in the correspondence list.

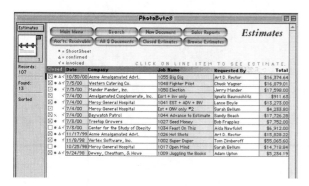

Faxing an Estimate

Now, you will fax an existing estimate.

> Click the *Main Menu* button in the top left corner of the screen.
> Click the *Paper Trail* button on the Main Menu.

> Click the *Estimates* button at the top of the Virtual Paper Trail screen.

You will see a list of existing Job Estimates.

> Click the topmost record (anywhere on that line).

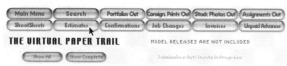

You will see the Job Estimate just as it would appear on your own stationery.

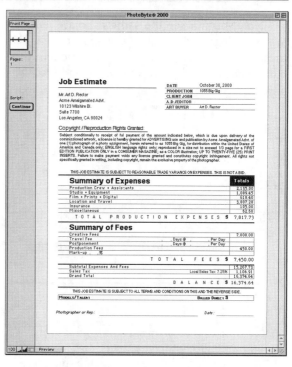

> Since the view of this Job Estimate defaults to the Preview mode, click the *Continue* button to view it in Browse mode, so its navigation buttons are visible.
> Click the *Logo View* button at the top of the screen. Then click the *Preview* button

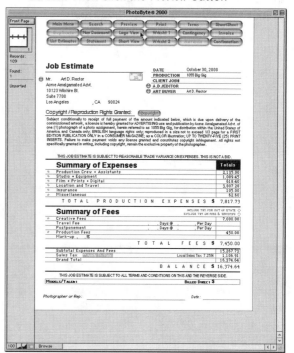

Now you will see the same estimate, but this time your logo and signature will appear on it. That means you can fax directly from your modem without the need to print onto your letterhead first.

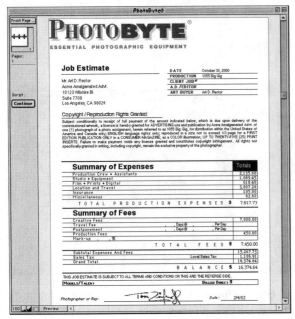

At this point, you will follow the instructions for using your fax modem to send the Job Estimate. You will notice, when you return to the Profile screen, that the correspondence log has been appended to include the submission of this Job Estimate by fax.

- - - - - - - - - - - - - - - - - - - -

Starting a Photo Business

Whatever you can do, or dream you can, begin it.
Boldness has genius, power, and magic in it. —Goethe

Once you have achieved the formal status of a real business with all the trappings and prestige that go with it, you have harnessed a dynamic, motivating force. Having been recognized, first, as a legal entity by the bureaucratic powers that be and then by your customers as a going concern, you will have reached both a practical and psychological jumping-off point. From there, you can promote your new identity as an entrepreneur. You can open bank accounts, buy or lease camera equipment, print business cards, obtain telephone lines and voicemail facilities, set up a Web site with e-mail, and actively solicit clients. In short, you're in business!

5

Location, Location, Location

It used to be essential for commercial photographers to set up their places of business in a big city, because that's where all the action was. That's where all the clients were. It was—and still is—advantageous to be close to your clients and in the thick of things. But the advent of the Internet has provided some new options, allowing photographers to remain closely connected to their clients without the geographical imperative.

With so many new technological resources at their disposal, and with enough capital to produce effective marketing campaigns, photographers can live virtually anywhere (emphasis on the word *virtually*) and stay on top of business. The only additional requirement to being "wired" to the Internet[1] is your proximity to an airport, so you can either ship your film conveniently or slip off yourself to a remote location shoot. But then, not only are photographers dispersing into more remote locales, so too are buyers.

The Boondocks

So-called boutique ad agencies—smaller, but no less creative and influential—are sprouting up all over America, along with public relations firms representing smaller business accounts. Small businesses—their numbers are continually growing—often work directly with local photographers. Their money is the same color as the big players in the big city, and while the jobs they offer may be more modest in scope, you may find more assignments to shoot.

Not only are some of the hottest and most creative agencies located in what were once considered areas of marginal market opportunity, wherever you go, you can find a greater diversity of clientele today than in the past. On top of that, many manufacturers produce regional advertising campaigns "in-house," which means they don't use an outside ad agency. They create catalogs, public relations material, and corporate brochures, too, which provide work for photographers situated nearby, as well as all over the country.

The same artists who were once compelled to live near a city center are now likelier to exercise their freedom by living in less confining environments. This is especially true for editorial photographers, who are less hindered by ties to a studio. It's easy to see why a magazine photo editor in Manhattan would feel more comfortable about hiring a photographer in Whitefish, Montana, now than he might have been just a few years ago. In a

world shrunken by communications technology and personal mobility, one is just as likely to find great talent in the hinterlands as within the confines of a metropolis. Furthermore, it's often cheaper to hire local talent than to pay the high cost of travel to send—or bring—big-city shooters to far-flung locations.

Again, on the editorial side, you are more likely now to find glossy magazines based in suburbia and published for the benefit of regional readers who have themselves emigrated to the wide-open spaces. Add to that the fact that even truly provincial photographers have the means to make far-flung buyers aware of their work and availability, and you can see that no one is truly isolated. Everyone can enjoy the benefits of advertising ("self-promotion") coupled with fax machines, satellite pagers, the World Wide Web (see part 2) and the postal service to make their presence felt wherever they wish.

Photo Districts

Regardless of new trends to geographically decentralize, photographers are still drawn together for economic reasons as they gradually discover, one after another, a particular urban area where studio and office space is not only available, but close to design firms, advertising agencies, and manufacturers. Centers of urban commerce, such as Manhattan and San Francisco, still play host to "photo districts," where talent tends to congregate as closely as possible to buyers of photography who were situated there before them. Buyers, in turn, are comfortable knowing that photographers are clustered close by. They appreciate the convenience of finding a large assortment of talent in adjacent communities, so they can art-direct any number of photo sessions, summon portfolios on short notice, spontaneously schedule creative meetings, or just hang out socially at a studio. Photographers, in turn, enjoy the economic efficiency of having buyers centrally located; it's easier to reach them with marketing messages and to establish personal relationships.

After photographers become concentrated within a given area, vendors will move in, too. Soon you will find camera stores, stylists, film labs, prop warehouses, etc., all within a short distance of one another. Soon, a sort of inner city "creative ghetto" materializes—but all the richer, for proximity is a matter of productivity for both buyers and photographers alike.

Selecting a Site

Just because you have more options available now than in the past doesn't mean that choosing a site for your business is a simple matter. It doesn't mean that location isn't relevant anymore. If anything, the additional freedom you have may make it harder to choose. Where you base your business will have a significant impact on the kinds of assignments you shoot, and vice versa.

These are some of the most important factors to consider before choosing a location for your business:

> Range of Potential Clients—ad agencies, graphic design firms, corporate headquarters, manufacturing facilities, editorial-publications and their bureaus, etc.[2]
> Concentration of Potential Clients—the number of buyers
> Concentration of Photographers—the number of competitors
> Prevailing Industries—affects the nature of what subjects you shoot
> History of Business Practices—affects pricing
> Geographical and Environmental Characteristics—affects quality of life and what subjects you might shoot

Sometimes the most practical decision you can make is to match the types of assignments you want to shoot with opportunities that exist where you already happen to live. It's self-evident, for example, that if you live in the area of Detroit, Michigan, you might think about specializing in shooting automobiles. You might even take that idea a step further, although on a smaller material scale: Realizing that the auto industry supports a number of subsidiary manufacturing businesses, you might concentrate on tabletop and catalog photos for upholsterers, glassmakers, plastics molding makers, chrome plating companies, or just motor parts in general instead of entire vehicles. If you specialize in editorial assignments, you might emphasize your skill at shooting industrial facilities and the people who run them. But if you happen to be that photographer in

Whitefish, Montana, with access to extraordinarily scenic roads and panoramic vistas, you might persuade Detroit to bring the cars out to you! That would require a compelling marketing campaign, but capitalizing on the fact that the great outdoors and the Rocky Mountains *are* your studio won't hurt. So what if it's not walking distance from a subway?

If the rural life doesn't suit you and you're "city folk" instead, then having one of the best studio facilities in town—perhaps near an assembly plant and with a cyclorama large enough to accommodate a half-dozen sport utility vehicles—might be the way you get to shoot cars. If you like working on the road and are partial to competitive sports, speed, thundering decibels, iron, rubber, and nitro—and on the camera side, fast glass and motor-drives—then perhaps racing photography is your ticket. Maybe monster-truck bashing and tractor pulls! Who knows? The possibilities are limited only by your imagination and by your choice of location.

Synergetic Relationships

In any locale where a significant population of working photographers can be found, you will also find a corresponding retinue of specialized service providers. These are businesses, often freelance practitioners just like yourself, who help support the work you do and each other. They include stylists, assistants, photo finishing labs, rental studios, prop-rental houses, etc.

To use Detroit again as an example, there you will no doubt find a "vehicle prep" industry that exists solely to make cars look as pretty as a picture, even before they are wheeled in front of a camera. Similarly, where still life and tabletop photographers abound, a coterie of highly skilled food and prop stylists will cluster, working interdependently within the community of photographic talent. Where else but in such a concentrated cauldron of creativity could you find someone with just the right know-how to make a raw turkey (there isn't time to cook it!) look perfectly roasted by blasting it with a butane torch and then basting it with motor oil? Of course, that bowl of soup in the foreground was filled with marbles to give it volume and the beer laced with salt to keep its foamy head. Maybe you'll need to hire a Valkyrie, replete with spear, horns, and a breastplate, singing Wagnerian opera in the background. If so, you're going to need stylists who specialize in

wardrobe, makeup, hair, and props, plus a rather Rubenesque model. You might even need a casting agent and a production supervisor.

With the benefit of support services, photographers are able to do better and more sophisticated work. This kind of synergy has allowed some urban areas to evolve into hotbeds of photographic creativity with competition focused on specific markets, such as food, cars, or fashion.

Only a few locales, for example, can support fashion-and-beauty assignments.[3] As a rule, you will find fashion photographers concentrated in large cosmopolitan cities where you find the purveyors of haute couture apparel, and where you will also find garment manufacturers, distributors, and the corporate headquarters of retailers. There, too, you will find the publishers of magazines devoted to fashion and the advertising agencies that fill their pages with content depicting clothing, jewelry, accessories, and cosmetics. Of course, the glamorous models, the makeup and hair stylists, and other specialists can be found nearby as well. Unless you are satisfied with the local haberdashery or department store for a clientele, you won't get far in fashion photography if you plant roots in, say, Des Moines, Iowa. That's why the location you choose can sometimes dictate what you shoot, or vice versa. So it follows that if you live in Rochester, New York, you'll probably do some shooting for Eastman Kodak, Xerox, or Bausch & Lomb. The point is that Rochester long ago became the center of an entire industry, because that's where the dominant player, Eastman Kodak Company, was founded and remains located today. It spawned new companies that catered to the manufacture of film, optics, and other photographically-related technologies.

Wherever the constituents of an industrial complex converge, you will find corresponding congregations of service providers, including photographers, supporting that industry. The upside is that you can easily find the creative resources you need to do your best work in such a place. The downside is that such a rich pool of professional support and talent exists only because there is an abundance of photographers with whom you must compete for assignments.

Coping with Competition

The greater the concentration of photographers, the fiercer your local competition will be. Therefore,

another factor to bear in mind when choosing a site for your business is your personal fortitude. You must be both willing and prepared to fight for your share of the market. Your willingness is probably taken for granted. It is less obvious, however, what you must be prepared to do.

If you invade the other guys' turf, you can expect them to try to drive you away by denying you a share of the existing market. You will be engaged in the commercial equivalent of warfare with other photographers to win clients and assignments. If you're not prepared to fight for your share, or to create entirely new markets by offering new services, you won't survive. (That's a concern to be discussed in part 4, Marketing and Selling.) If several other photographers already have the "blasted-and-basted turkey" business sewn up as tight as a drumstick and the only Valkyrie in town is another photographer's wife, then you owe it to yourself to consider some alternative subjects to shoot or doing so in a different locale.

You can always pick a place where there is less competition and try to become a bigger fish in a smaller pond. But even if you decide to live out in the woods somewhere, you still have to compete for jobs at the national level by means of the Internet. Just because you've fled the rat race of rush-hour traffic and nightly crime reports on the ten o'clock news doesn't mean you've escaped the exigencies of a global economy.

Once you've decided to engage in the fevered pitch of commercial battle, it might take you a while to establish a beachhead. So before you raise your sword and sound the Charge of the Light Brigade, make sure you have enough money in the bank to sustain the coming campaign. You don't want to run out of ammo on the verge of victory.

For example, if you move into a small town and decide to open its first full-service studio, can you anticipate a quick enough return on such a substantial investment to avoid a cash-flow crunch? You can't afford to let a studio sit idle while you take time to convince local clients to use it. So, can you generate some non–studio-related business in the meantime or borrow enough cash from friends and family or the bank to stay afloat until your bookkeeper starts using black ink? (Refer to part 7, Operations, for more information about cash flow.) As soon as you are confident that you have enough

money to finance a long, drawn-out marketing campaign, as well as to cover the costs of remodeling and furnishing your new studio space, it's time to consider whether winning the battle will be worth the fight.

If you win the battle to build your studio, you have to be sure that the market can support its sustained operation, or you'll lose the war. In other words, even if you wind up as the only photographer in town with a studio, will there be enough work over the years to recoup your initial investment and then continue to make profits? If no studios currently exist to support the economic base of your community, there might be a reason to open one. It's your responsibility to find out before you get in over your head. You might discover that no one before you knew how to raise the money to build a studio, even though there was a demand for one. On the other hand, there could be a more onerous explanation: not enough work available to keep the doors open.

The cost-effectiveness of being first to market with a new service, such as a new studio, can be high compared to competing out of a home-office. So take a survey of the local buyers before you make a financial commitment. Determine, first, if they foresee the need for a studio. Just make some phone calls and pick up the tab for a few lunches. (It's a tax write-off anyway.) Get a feeling for the investment opportunity before you start writing checks. It is possible, however, that just by asking around, you might spark some interest in new assignments, considering that having a new studio at their disposal represents a fresh resource for art directors to play with. They may have been itching for just such a chance.

Again, on the cautious side, consider the cost of food, transportation, and housing in relation to the projected revenue you expect to earn—studio or not—and how quickly you can ramp up to speed, i.e., how soon you think you can break into the market. Without a steady stream of business, you will run out of groceries, let alone capital. Never jump in head first, unless you know how deep the water is.

Markets change continually. The impact of such a change can be profound. Some years ago, quite a number of food photographers and stylists were competing in Rochester, because that city played host to a major food-processing company, a sizeable employer. When that company moved its headquar-

ters, the local photographers had three choices: 1) develop new clients, competing with the same number of photographers for fewer assignments in industries other than their own specialty, food; 2) move to a new location; 3) go out of business. As the market evolved, some studios survived. Some did not. The lesson to learn is that financial preparation is not always enough; flexibility is also a key to your survival.

Research Your Prospective Locale

Before you move away from home, consider the availability of support production services, or lack thereof, at your proposed destination. The services you find must be compatible with the types of assignments you intend to shoot. If you shoot primarily portraits, a scarcity of makeup artists could hurt you. If you anticipate building complex sets, and there are no prop-rental houses or stylists nearby and, as it happens, the local contractors can't hire enough carpenters to finish an office building that's six months behind schedule, you'd better start learning how to bang nails and make miter joints. Otherwise, consider someplace else to start your business.

To scope out this kind of intelligence, contact the local chamber of commerce as well as the local or regional chapter of a trade association such as the American Society of Media Photographers (ASMP), the Professional Photographers of America (PPA), or the Advertising Photographers of America (APA).

Consider local camera stores as a source of information. Visit their proprietors; you'll need to establish credit accounts anyway. You also need to know if special rental equipment is available in town and if they're willing to stock your favorite film emulsion. There, you might also find locally published directories that list the names and addresses (or Web sites) of photo assistants, stylists, model agencies, and all other kinds of production resources. The owner or manager might even make some personal introductions for you.

One more not-so-obvious consideration that you can ill afford to overlook is the availability of a reasonably priced printer. You're going to need business cards, posters, postcards, letterhead stationery, and other specialized promotional pieces for mailings and handouts. Yes, you can do some of this work yourself with a personal computer and

desktop-publishing software. But if you want the best quality, or if you need special services like embossing, and you have to produce any of these items in large quantities or large sizes, it is indispensable to have a proficient lithographer and his facilities at your disposal. Such a technician can also offer you advice about creating effective layouts if you want to publish your own newsletter.

Some photographers survive successfully with little more than a few 35mm cameras and a source for film. As long as you live within the route of a UPS or FedEx truck driver, you can obtain all kinds of essential business goods and services by ordering them on the Internet. But the kind of personal service you get by walking into a store has a value all its own. A quick turnaround time is one thing to think about if you're on a deadline and can't wait for deliveries. But, moreover, establishing personal relationships with local merchants will prove to be invaluable.

Here are some examples of support services your business may require:

> Attorney
> Camera repairman
> Camera store
> Carpenter
> Digital service bureau
> Food stylist
> Graphic designer
> Location-finding service
> Makeup stylist
> Model agency
> Photo assistants
> Photo lab
> Picture framer
> Pilot (helicopter or fixed wing)
> Printer
> Production manager
> Prop stylist
> Rental house (props and camera gear)
> Tax accountant
> Travel agent
> Truck or van rental
> Wardrobe stylist

Local Business Practices

The size of a market and its relative receptivity to new photographers who enter the competitive scene

cannot be ignored in determining a site for your business. Therefore, make it a point to learn about local business practices, especially about the prevailing market prices for various types of assignments. For instance, if you enjoy working for public relations clients and you discover that the local PR shooters are satisfied with, say, two hundred dollars for a typical job, is that enough to support your own overhead?

Think about that carefully. The way you manage your business economically is not necessarily the same way someone else might do it. Your marketing plan, operating costs, profit margin, and even your talent are all variables in the equation for success. Only the administrative aspects of the photo business are the same for all of its practitioners. So, while two hundred dollars may sound like a reasonable sum of money for a quick-and-easy PR shoot, it may not be enough if there are three other photographers in town vying for the same four assignments each week. You won't always get the job.

If you can capture 25 percent of the market, you'll earn just $800 for an entire month's work. In order to survive, you will have to consider if it's possible to either raise the market price for PR jobs or take more business away from the other three shooters by competing at a lower price or convincing buyers that you can do a better job.

note Billing a lower price *never* means billing a *less profitable* price. (There will be more information about profitability and pricing practices in parts 4, Marketing and Selling, and 6, Pricing Photographic Services.)

If it proves too difficult to nudge the market price higher, and if you can't take market share away from your competitors, you must either augment your PR work with other kinds of assignments or else abandon that idea and compete for everything but PR assignments.

Real Estate Prices

If the cost of renting, leasing, or buying real estate is high, you'll need to predict the number of assignments you can win in direct proportion to the amount of revenue they might bring in. This will determine if you can afford a roof over your head before you move headlong into an area saturated with competitors. This is a particularly serious con-

sideration if you plan to live in either the San Francisco Bay Area or Manhattan. Those are just the two most obvious places where the price of a roof over your head is not only through the roof, but way over the heads of many wannabes. Where there is a great demand for real estate coupled with a short supply, property prices skyrocket.

Go online again to look for information about the average rental fee for an apartment in your favorite locale. Look at food and entertainment prices, too. A realtor can help. You might even find a general cost-of-living index online. And speaking of a roof over your head, you have to decide if you can afford separate living and working quarters. If you want to combine your living and working space, you must pick a place with zoning laws that accommodate your choice.

Zoning Restrictions

Zoning ordinances differ radically from one community to another within the same county, let alone from city to city throughout the fifty states. Some hoity-toity suburban gated communities won't allow you any peace if you're seen working at a desk in your own home every day. So just think how they will react to strobe lights going off! Someone will report you. Count on it. Your homeowners' association might have the authority to levy a fine. At the very least, you'll be nagged to death by the zoning zealots.

Get the facts first. Do not assume that zoning laws have anything to do with logic or fairness. They can be purely subjective and based upon quirky politics, social perceptions, and local history. Don't let yourself fall into the hypothetical—but not at all far-fetched—predicaments described here:

You have leased a five-thousand-square-foot studio in the heart of a bustling, urban manufacturing district surrounded by clients. It is also close to theaters, restaurants, public transportation, freeways, and parking. You have spent thousands of dollars to outfit the place with a cyclorama, a darkroom, a commercial kitchen, and an equipment vault. You even hired an architect and an interior decorator to bestow the trappings of success throughout your new space. Its fabulous style will surely attract clients. And there is all that room for throwing parties!

Of course, having spent all that money, you can ill afford to rent a separate apartment. There is

plenty of room to set up housekeeping in the back of the studio anyway, so you're all set. Right? Well, what happens when your landlord discovers you cooking dinner and doing laundry? He will no doubt inform you that the municipal authorities prohibit dwelling in a commercially-zoned building and that he can be fined for allowing you to keep house in the studio. It says so right in the lease you signed. Therefore, you can count on an ultimatum to either get rid of your bed and other residential belongings or be evicted.

Alternatively, if you live in a house in an upper-middle-class suburb, you may have decided to turn your garage into a studio. That's fine, as long as you use it unobtrusively. But what happens when clients begin to visit on a regular basis? Their vehicles take up parking spaces that your neighbors rely on. Effluents from your darkroom drain into the sewers. Delivery vans come and go at all hours, disturbing the tranquility of the neighborhood. Someone will probably call the police. Then, you'll get a warning from the city attorney about conducting business in a residential neighborhood. You will face fines and a possible civil action in court. You're in a real pickle, unless you abandon the use of your home-studio and set up shop somewhere else that is not zoned exclusively for residential use.

Before you sign a lease, have a lawyer examine it for zoning restrictions. Check with the town council or local zoning authority yourself to make sure you can work in a residential neighborhood or reside in a commercial space. Look again for a Web site that links to the information you need. If you wish to live and work in the same space, zoning laws notwithstanding, make sure that that option is reflected in your lease and that the landlord knows your intentions. The same goes for buying a house; make sure that any existing homeowners' association agreement doesn't prevent you from working at home.

- - - - - - - - - - - - - - - - - - - -

Checklist for Leasing Commercial Property

When you are ready to lease, in all likelihood, you'll be presented with an agreement prepared by the landlord. The terms of that lease agreement will surely favor the landlord significantly. Be advised that you can almost always negotiate improvements in your favor.

Discuss these issues with an attorney *before* you sign a lease:

- Is there enough parking space available for you and for your clients, and is there a loading area?
- How much space is available for expansion?
- If there are common areas of the building that will be frequented by your clients, they must be routinely cleaned and maintained. These areas might include a public lobby, stairwell, elevator, etc.
- Do you have twenty-four hour access to the building?
- Is a security guard provided or a burglar alarm installed?
- May you live in the space? What is the zoning?
- Are there any restrictions or regulations regarding the disposal of waste, including photo chemicals?
- Who pays for waste disposal?
- What control do you have over business signage? Can you use your company name and logo in the building directory, the hallway, the elevator, on your door, or in your window(s)?
- Who pays for renovations, such as adding new walls and room dividers, doors, windows, or a kitchenette?
- Who pays to install or repair electrical wiring and plumbing as required? (For a typical shooting space, you need at least three phased, 100-amp service and lots of wall plugs.)
- Is hot water supplied, and is there an additional flat charge, or will you be billed for only the quantity you use?
- Does the lease specifically state the square footage of the premises?
- Is the tenant's share of expenses based on total square footage of the building or the square footage leased by the landlord? (Your share may be lower if it's based on the total square footage.)
- Do the base-year expenses reflect full occupancy, or are they adjusted to full occupancy? (Base-year real estate taxes on an unfinished building are lower than in subsequent years.)
- Must the landlord provide a detailed list of expenses prepared by a CPA to support rent increases?
- Does the lease clearly give the tenant the right to audit the landlord's books or records?

▶ If use of the building is interrupted, does the lease define the remedies available to the tenant, such as rent abatement or lease cancellation?

▶ If the landlord does not meet repair responsibilities, can the tenant make the repairs, after notice to the landlord, and deduct the cost from the rent?

▶ Does the lease clearly define how disputes will be decided?

▶ Can you assign the lease, i.e., sell the balance of your lease to a new renter should you decide to move? No lease should be without a sublease clause.

▶ When the lease is up, will you have to return the property to its original condition?

▶ If you paid for renovations and permanently installed fixtures, will you be able to sell them to the landlord when you move on?⁴

▶ If you can't find a new renter but must move on, can the lease be broken, and what is the cost?

▶ Obtain an option to negotiate an extension on the lease when it has expired.

▶ If utilities must be paid to the landlord, is there a surcharge (mark-up) and is it negotiable?

▶ Is there a non-disturbance clause, whereby you cannot be forced to move or sign a new lease if the property is sold or undergoes foreclosure?

Quality of Life

Your life is more than just work, so you'll want to know what kinds of entertainment are available wherever you decide to settle down. That includes restaurants, art galleries, and theaters, as well as outdoor sports and recreational facilities. Find out what seasonal weather variations there are. What drives local politics? If you have—or anticipate having—a family, are there good schools nearby? Is there a shady park to visit in the summertime? In case you live with a pet ferret or a boa constrictor, what are the animal ordinances? Is there anything special about the place historically or geographically that appeals to you? Is there a lake close by to keep your kayak? Is there an airport, train station, or ferryboat dock nearby? What about medical facilities? Here, too, the chamber of commerce (or its Web site) is a good place to find answers to these kinds of questions.

Working Out of a Home-Office

Every business needs a headquarters, a place in which to work, to reach out to the marketplace, and to be reached by customers. It is a place in which to keep separate the tools of your trade from your personal habiliments. That becomes harder to do once you decide to work at home.

An office exists to give you space in both a figurative and a literal sense. It is a place you are going to want to get away from. Therefore, one decision every startup entrepreneur has to make is how much distance, literally, to put between living space and work.

If you work at home, that might merely require a token gesture, something as minor as screening off part of a room. Alternatively, you can utilize an entire spare bedroom, an attic, or a basement as an office. You can convert a garage into a studio. Ultimately, the decision is based on economic circumstances; it's often cheaper to work at home than to buy or lease separate facilities—*often*, but not necessarily *always* cheaper, because your personal taxes or family situation may make it affordable, and perhaps preferable, to work in separate quarters. (The tax situation will be discussed in part 7, Operations.)

Stress, Privacy, and Professionalism

Some people consider it an advantage to work at home. Others do not. Some people enjoy rolling out of bed and walking just a few paces to an office whenever that inner light bulb clicks on and the urge to work suddenly strikes. But that apparent convenience can take a toll on your health if you don't have the discipline to set aside some time for rest and relaxation, to distance yourself mentally from work while retaining physical proximity to your office. The psychological advantage of commuting to a separate workplace is appreciated by as many entrepreneurs as those who enjoy doing business in their pajamas.

Another factor to consider in making the work-at-home choice is your professional esteem. Some of your clients may be more comfortable dealing with you in an office environment that is completely segregated from your personal living quarters.

If you work at home, make sure you can keep noise levels manageable and avoid interruptions. If

you have either a family or housemates, set some artificial boundaries and enforce them, even if that means simply closing a door and asking not to be disturbed during work hours. Make sure you can guarantee your own privacy. And don't forget to tell the housekeeper not to disturb the papers on your desk!

Finally, don't forget to consider how much time you might spend alone if you work at home. If solitude doesn't suit you, make plans for regular get-togethers with your colleagues and friends.

NOTES

1 Actually, "wireless" is more like it, as technology increases our capabilities to remain "connected" without being tied town to a desktop, metaphorically or otherwise. Eventually, the distribution of images will take place in cyberspace, too, as you can scan your film at ever greater resolutions and ever greater compression ratios, to transmit it faster electronically at ever greater bandwidths. (A bandwidth is, in this context, the load-carrying capacity of the Internet in conjunction with the devices sending and receiving the data.)

2 *The Standard Directory of Advertisers* and *The Standard Directory of Advertising Agencies* list corporations and advertising agencies throughout the country. They were once known as *The Red Books,* because they were, in fact, red. And whereas they were once actually books, each volume of which used to be about six inches thick and supplemented with two-inch-thick quarterly updates, the contents of both directories today are contained on a single CD. The subscription cost is high, but it can be found in many libraries, updated regularly. In *The Red Books,* you can learn in which media an ad agency spends most of its budget; examine client lists; or look up a particular company and find out which ad agency represents that account, how much it spends on advertising, and for which products or services. You can, for example, determine that there is three times the amount spent on advertising per photographer in one city as opposed to another, and that more is spent photographing durable goods than service-industry accounts.

3 New York, Paris, Milan, and Tokyo are the fashion photo centers of the world. One lesser contender is San Francisco, where the headquarters of Levi's, The Gap, and Esprit can be found. But even those few but influential clients, heavy advertisers though they are, can't support an entire fashion-photo district.

4 The improvements to the space that you have made and paid for yourself (darkroom, kitchen, office space, living space, etc.) are called leasehold improvements.

6

Your
Office
Layout

In their book, *Running a One-Person Business,* authors Salli Rasberry and Claude Whitmyer describe the best office environment as looking, metaphorically, like an airplane cockpit. All of your controls are within easy reach, allowing you to get off the ground, fly where you want to go, and land safely. All the gauges and dials are right in front of your eyes, with continual readouts to tell you how fast you are moving, how high off the ground you are, whether you are climbing, falling, or leveling out. If there are other airplanes in the vicinity, you can see how to avoid colliding with them.

The computer on your desktop will give you most of the capabilities you need to run your business and oversee its progress as effectively as any pilot. In addition to all the organizational help you'll get from your computer, you will need adequate and easily accessible storage space, a systematized means to file paper documents, and a backup device for computer-generated documents.[5] Whether or not you require a shooting space in addition to an office will be determined after you create the business plan discussed later, in chapter 7 of this Part.

The Essentials

In order to set up a practical and comfortable workspace, you first need to address a few essentials.

Furniture

If you're just starting out, flexibility and portability are two attributes to consider for the furniture and fixtures you intend to purchase. That goes for both office and studio furnishings. For example, think about buying a pair of two-drawer file cabinets instead of one four-drawer unit. You can either stack the two-drawer units on top of each other, if you need to conserve floor space, or lay a board across both of them, side by side, to make a worktable or desk. That will leave more wall space available. Think, too, about purchasing modular shelves that can either be adjusted for height or grouped closely together horizontally to provide additional space. Also consider purchasing a set of stackable flat files, the kind that have very wide and long, but extremely shallow drawers. These are the kinds of cabinets seen in galleries and museums, in which large prints are stored. Keep in mind that you will be learning how to be more efficient as you go along, so don't buy furniture and fixtures that cannot be

adjusted or easily moved. You will probably change your mind more than once!

Here are some further tips about budgeting to furnish your office or studio:

> Don't skimp on comfort and health by buying a cheap chair to go with your desk. You'll regret it. Buy an ergonomically adjustable model with good lumbar (back) support, so you can feel comfortable sitting in it for long periods of time. Make sure it adjusts up and down to coordinate with the height of your computer screen.
> Get a desk with a large surface area. The more square feet to work on, the merrier. Make sure it is sturdy enough to support the weight of everything you plan to put on it; a heavy computer monitor, for example, might bow it in the middle.
> A lockable cabinet is a must for your camera equipment. If you can afford a safe, buy one. It doesn't hurt to install a burglar alarm either. That might qualify you for an insurance discount.
> You will need a light table, whether you have a studio or not. Buy the largest one you can afford, or make one yourself. The bigger the light table, the easier it will be to edit film, especially when you shoot a lot of slides. A small light box is not satisfactory, unless used as an adjunct device for the sake of portability. Only use the types that have a thick, frosted Plexiglas surface. Anything less will crack and tear after a few uses. Make sure it is color-balanced for 5500° Kelvin (daylight).

For the sake of efficiency, remember these additional common-sense suggestions:

> Keep heavy objects close to the ground. It's easier to lift them up than to take them down. You don't want heavy objects to fall on you either.
> Make sure your computer monitor is adjusted to a height that is slightly below eye level, so you don't continually strain your neck and shoulders by looking up while typing.
> Use a hands-free telephone whenever possible, especially if you're working on your computer while talking.

> Make sure your office space is well ventilated, comfortably heated, and that you have a window.

Office Lighting

You are a photographer. You know about lights. Your office should be well lighted. You'll need overall incandescent room light and a good-quality, adjustable, directional desk lamp for reading and for illuminating your computer keyboard. Your lights should all be of the same color temperature. Steer away from fluorescent lights. The light they emit is green, unless you use the so-called "full-spectrum" variety. But they are more expensive. All fluorescent lights pulsate and flicker increasingly with age. If you can get by during the day with just a skylight and windows, that's the best solution of all.

Fire Protection

Fire is a threat that should never be ignored. Your home is probably equipped with smoke alarms. (If not, get them!) Make sure you include them in facilities you use for business away from home, too.

Most homes do not have fire-protection sprinkler systems, but a rented studio might. Do not store photographs or computer backup devices under a sprinkler system. It's possible that a false alarm could inundate your precious pictures and digital data. If you have a choice in the matter, there are dry, chemical fire-retardant systems available that will not destroy your invaluable archives of photographs and business records.

Some people believe that by placing their film and cameras in so-called "fireproof" safes, they will be protected. Don't fool yourself. The intense heat from a fire will melt your film and turn your cameras into blobs of metal and glass in no time. Fireproof cabinets merely keep paper documents from igniting. The best protection you can provide for your cameras is to keep them packed in portable cases that can be removed from the premises instantly in an emergency. As for your film, prevention is practically the only strategy you can employ. Other strategies are cost-prohibitive and involve creating sealed concrete vaults underground. That's what Ansel Adams did.

Filing and Storing Transparencies and Negatives

The more you shoot, the more transparencies and negatives you will accumulate. If you add a digital camera—a "capture device" in techno parlance—you'll need terabytes of electronic storage, too. The latter takes up less physical space by an order of magnitude, but it is expensive. For now, just concentrate on storing images shot on film.

You will need to start out with at least one large file cabinet. It is advisable to buy the best quality cabinet you can afford, because cheap units tend to have drawers that derail and bow out of alignment, and they become hard to open and close. (Don't forget how heavy film and photographic paper are.) It may also be more convenient for you to use a lateral (sideways) drawer system, which will give you greater accessibility to plastic slide pages and negative sleeves. Lateral file cabinets come in two-, three-, and four-drawer units, in both legal size and letter size. Legal size will give you much greater latitude for storing oversize contact sheets and the like. You will also need a sufficient quantity of transparent tabs to label the folders that contain your photos and a corresponding number of hanging frames to hold the folders (e.g., Pendaflex™). You'll probably want a unit that can be locked, too.

EXERCISE -

Learning the PhotoByte Image-Filing System
 ▸ From the Main Menu, click the *Photos* button.
 ▸ Click the *Stock Photos* button on the next screen.
 ▸ You will see a list of stock photo captions. Click on any item in the list.

You will then see an individual stock photo record, displaying a facsimile of the photograph.

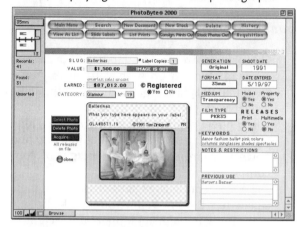

 ▸ On each stock photo screen are two fields: *Category* and *N°*. Clicking on *Category* displays a View Index window. It will "remember" and display as many categories as you have previously entered in that field. Go ahead and try it.

The first three letters of the category entered in this field will be added to the beginning of your serial number.

The *N°* field is a pop-up list that displays the numbers 1 through 20, corresponding to the number of sleeves on a plastic slide file page. Click on the *N°* field.

If you choose a number, it will appear after a "dot" at the end of your serial number. For example, you might have a category called "Glamour," as illustrated above, so a typical serial number for that slide, which might be located in the nineteenth of twenty sleeves on a page, will now look like this:

GLA#8671.19

You can tell at a glance that it belongs in the drawer labeled "Glamour" on page number 8671 in sleeve number 19.

Here's what that means in practical terms: If you want to search for a particular image in your catalog, you would normally do that by looking up either one or more keywords or by its title (a word found in its caption). You could also use a combination of these criteria to narrow the results of your search to fewer images. (The results of a search are called a *Found Set.*) Then, by looking at a serial number on screen, you can tell precisely where to find the corresponding original in your file cabinet. Or, if an image had been logged out and subsequently returned, you'll know exactly where to put it back, so you can find it another time. Here are the steps involved:

> From any PhotoByte screen (use the Main Menu for the sake of example), click the *Search* (or *Search Records*) button.

You will see the Search screen.

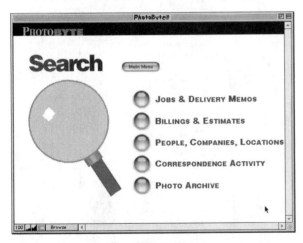

> Click the *Photo Archive* button.
> Type the words **shrimp** and **boat** in the *Keywords* field (with a space between each word, of course). Then click the *Continue* button.

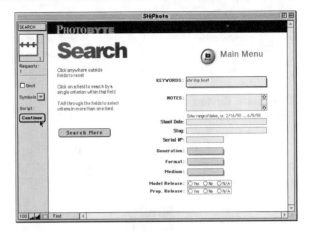

You will see a single stock photo record that matches your criterion.

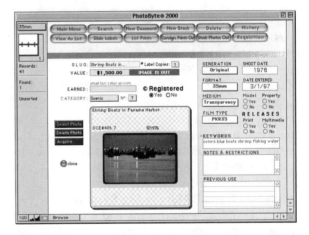

The serial number you see on screen is "SCE#406.7," which means that this slide will be found in the drawer labeled "SCE" (for Scenic) on slide page number 406, in sleeve number 7 of that page. The number "406" should correspond to a thumb tab on your hanging file folder displaying a range of page numbers (e.g., N° 400–420.) Those twenty pages will be found inside that hanging folder.

As you can see, this is a simple, yet extremely efficient numbering system. However, you are free to dispense with this system altogether and pursue either one of two additional serial numbering options:

> Use the default numbers entered in sequence (described below)
> Manually enter any alphanumeric serial number you wish "on the fly"

note You should not use the N° field for prints or larger-size transparencies, because they aren't sleeved in plastic slide pages. You can still make your own alphanumeric entries by typing directly into the Serial Number field.

The Clone Button

There is a feature in PhotoByte for filing duplicate slides and similars. It is accessed by a small, red *Clone* button on the left side of the slide mount depicted on your screen, under several other rectangular buttons.

Clicking this button creates a duplicate record of the slide, but also increments the serial number. It does so by first incrementing the *N°* field (corresponding to the sleeve) until it hits 20, and then it starts over by decrementing to the number 1 while, at the same time, incrementing the page number. The process will repeat itself as long as you continue to click the *clone* button, until the *N°* field hits 20 again.

Alternate Default Numbering System

If you leave the *N°* field blank and do not use the *clone* button, PhotoByte will enter consecutive integers, or whole numbers without the "dot" or decimal representing the sleeve number. PhotoByte will start with whatever number you tell it to in the Preferences section.

- Press Command–8 or Ctrl–8.
- Click the *Reserialize* button at the top of the Preferences screen.
- Click *Invoices and Stock Photos* in the middle of the next screen.

 You will see this tiny window:

- Click the button as indicated, and type in the starting serial number you wish.
- Finally, click the *Preferences* button.

The PhotoByte numbering systems will allow you to automatically track the whereabouts of your stock photo submissions, log them out and in, send late notices to retrieve them, and invoice them for their publication. That process will be explained in part 7.

Accumulated Revenue

When you first enter a new stock photo record, the *Earned* field will look up the initial usage fee from its associated assignment log (ShootSheet). Subsequently, when you enter a new revenue figure in the *Earned* field for a stock image and click *Continue*, PhotoByte will add that amount to the accumulated total for that image. This figure can be reset by selecting *Clear Cumulative Earnings* from the Shortcuts menu at the top of your screen.

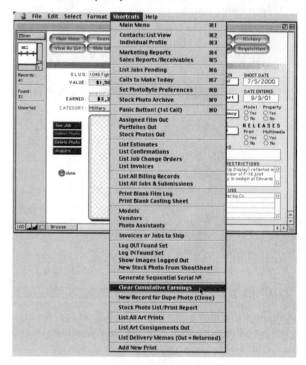

Filing and Storing Administrative Records

Set aside some of your office space for storing business records, in addition to your photographic files. Make this area easily accessible to allow the efficient transfer of documents back and forth to your desk. Here, too, you have a choice: legal-size or letter-size cabinets.

For the most part, you will be filing documents you *receive*, including signed agreements. Hanging folders with tabs filed alphabetically will usually do the trick. Almost everything generated on your end can be filed on your computer hard drive, since that's how they were created. Just don't forget to make regular backups! Keep a backup copy (on disk or CD-ROM) of your most important documents at a separate location, such as in a safe deposit box, in case of fire or flood. Alternate that remotely-stored backup with an updated copy on a regular basis. Generally, your business records will be safer when filed digitally. They will certainly be more easily accessible and take up less room than paper.

note All your job records will be generated by PhotoByte and stored therein.

What to File

- Model releases—these can be cross-indexed with photo serial numbers. (See exercise above.) In part 8, Operations, you'll learn how to cross-reference model releases with particular jobs using the ShootSheet™ form.
- Insurance policies and correspondence
- Stock photo requisitions
- Tax records and IRS correspondence
- Sales tax correspondence
- Bank records and canceled checks
- Expense receipts
- Legal agreements and correspondence
- Lease agreements
- Deeds
- Client correspondence
- Professional correspondence (e.g., letters from trade associations and other photographers)
- Vendor correspondence
- Commercial product warranties (e.g., camera and computer repair)
- Personal correspondence
- Examples of marketing material
- Educational material
- Technical reference articles
- Magazine tear sheets (can also be scanned into PhotoByte and stored with corresponding art director)

Creating a Floor Plan

If you don't have any drafting skills, and you cannot afford to hire an architect, there are software products available that can help you automate this task on your computer.[6]

Depending on the type of work you intend to shoot, these are some of the design criteria to consider in planning your workspace:

- Administrative office space
- Darkroom—includes a chemical-free film-loading area and segregated facilities for processing film and making prints, i.e., both a dry and a wet space
- Digital station—your computer and peripherals
- Dressing room(s)—includes a restroom for guests
- Entryway—sets the stage for a strong first impression, perhaps exhibiting prints and, as you get a few assignments under your belt, tear sheets of your work
- Heating and air-conditioning facilities
- Kitchen—for catering or executing food shots, or a simple coffee station and refrigerator
- Office space—for guests, clients, or assistants to work in
- Shooting floor—includes a cyclorama, if necessary
- Sound system
- Storage space—includes secure storage for your camera equipment
- Waiting area or lobby

What will clients see when they first enter your space? What first impression do you wish to create? Are telephones and, perhaps, even a computer terminal located conveniently for guests? Can you isolate visitors from the shooting space, yet still allow them to watch productions in progress? Allow yourself enough time to figure out your design criteria *before* you start spending money to design your space. Look at other studios first.[7]

Obviously, the results of this endeavor will reflect your personal style and the types of assignments you intend to shoot. For instance, a location-only photographer will not need to design a shooting space with its accompanying client accoutrements, but will be concerned primarily with administrative office and storage space. Nonetheless, an expectation for clients to visit will have an impact on your workspace design no matter how you intend to use

it. Of equal importance is the fact that you will spend a lot of time there yourself, whether clients come or not. Therefore, your personal comfort has a tremendous effect on your attitude and outlook, and that, in turn, may influence how you are perceived by visitors and clients.

Getting Wired

To ensure quality connections, it's necessary to choose telephone and Internet providers carefully.

Business Telephones

Everything in a business costs more than its counterpart in personal life, especially telephone service. If you work out of your home, you may, nonetheless, have to list your telephone as a business line. That may turn out to be an important way for people to find your business, by dialing 411 and asking for it by name. You'll need a business listing if you want to advertise in the yellow pages, too. Expect to see your phone bill rise.

Just what level of business activity will make it necessary for you to list as a business varies from one local phone company to another. It may also depend upon state law. If you are in doubt about whether you'll need a business listing or not, you can always ask the phone company itself (anonymously, if you want).

Using More Than One Telephone Line

You'll want to have an additional, separate telephone line (and number) dedicated exclusively to a fax or fax modem. That way, your operations won't be hamstrung, tying up your only line talking while someone else is trying to send you a fax or vice versa. With two lines, you can speak with an art director on the voice-dedicated line while faxing him an estimate on the fax-dedicated line.

If you don't know the difference between a fax machine and a fax modem, ask a salesman to show you at your local electronics or computer store. A fax modem may offer you both price savings and efficiency, by enabling you to use your scanner and computer in tandem, in lieu of a separate fax machine. You'll save on paper, too, because you can preview incoming faxes on your computer screen before deciding to print them or not.

Documents can be transmitted directly from your computer with a fax-modem. If you've written a letter or an estimate, you don't have to print it to paper before you fax it. Also, if you connect a scanner to your computer and printer, you can make copies of documents that other people send you without the need to buy a stand-alone photocopy machine.

Selecting an Internet Service Provider

Some of the same companies that now provide local and long-distance telephone service also provide connections to the Internet through digital subscriber lines (DSL), using the same copper wire connections to your home as your telephone. This provides a very fast, direct Internet connection that will quickly become indispensable to your business. A DSL connection is well worth the additional cost, as an alternative to connecting to an Internet service provider (ISP) through a conventional modem—which you want to leave available to receive faxes anyway. Unfortunately, this service is not available in every part of the country. The technology has been rather slow to proliferate. But it is expanding.

An even better alternative to DSL is a cable modem. This kind of Internet service works very much like cable television. A "box" (the cable modem itself) is installed in your house and connected to your computer. The connection is always open, so the Internet is always up and running—and won't tie up a telephone line, including the one connected to a fax modem. The disadvantage to cable is that, as more customers in your neighborhood use it, it can become congested, and peak-use operation can crimp the upload and download speeds. But these problems will diminish as more and higher bandwidth technologies (called "broadband") become available.

Use the same criteria to choose a DSL or cable ISP that you use to pick a long-distance service provider.

Selecting a Long-Distance Telephone Company

To choose a long-distance service provider, first analyze your calling patterns. Unless you have some previous business phone bills to look at, ask yourself the following questions:

> ❯ How many long-distance calls will I make?
> ❯ How long does a typical conversation last?

> What time of day will I be making most calls?
> Where will I be calling most of the time?

Describe your calling patterns to several long-distance sales representatives by calling their advertised "800" numbers. Some of them, instead, allow you to make comparisons on a Web site. Compare each company's plan to your calling style. The whole idea is to cut costs, so watch out for hidden fees and charges. Ask the sales reps if there are any such hidden costs and exactly what they are. For instance, is there a monthly fee, and is that fee high enough to cancel any savings elsewhere in the calling plan? Do discounts only kick in after you've made a minimum dollar amount of calls? Will a business discount apply to calls made away from your office, say by using a calling card at a pay phone when you're on location? If you are on a flat-rate "minutes" plan (e.g., two hundred long-distance minutes at $25 per month), will unused minutes carry over to the next month, increasing the amount of flat-rate calling time? In fact, can you even obtain a business line on a flat-rate plan? Will the best rates also apply to a cell phone, and how many minutes do you get?

Don't skimp on quality and reliability just to save money. Great savings aren't much use if calls are disconnected too often or if they sound like you're talking under water. If customer service and technical service aren't reliable and courteous, choose another company. And if they don't start treating you well right off the bat, it's not likely that they will change later on. So look further.

NOTES

5 For the most part, you will only need physical storage space (i.e., a filing cabinet) for documents you receive in the mail. Those you create yourself and send out can be filed electronically on the hard drive inside your computer—and backed up to a separate, removable storage device, of course!

6 Some examples of floor plan drafting software can be found at: *www.floorplan.com/store/free.cfm; www.winsketch.com/; www.showoff.com/index.html; www.msbcd.com/catalog_type.asp?ProductCode=25105&Session=324265159.*

7 The magazine *Photo District News*, or *PDN*, regularly publishes a pictorial review of photographers' studios, including rental studios from around the country. Here you can see what they look like. See: *www.pdn-pix.com/studioguide/.*

7

Creating a
Formal Business
Structure

Merely setting up an office and a telephone line doesn't mean you're ready for business. Even after deciding where to put it, what it will look like, and what goes inside—even after deciding what kinds of photographic clients to pursue—you will still have some legal as well as practical issues to consider. For example, start with what you are going to *call* your company.

Naming Your Business

John Doe Photography works. Then again, you might try for something that better describes the nature of what you shoot, e.g., Negative Inspirations. Okay, don't use that one! Focus Pocus Pictures is cute. How about Cam-O-Rama? Insight Photography? LightWorks? The f-stops Here? If you're into wildlife photography, then Fred Jones Shoots Animals might be somewhat misconstrued. Tripod Travel kind of makes a point. The real point is that you can call your business anything you wish. Be straightforward, be creative, or be whimsical. (Who would have believed that a business called Yahoo! would become one of the largest publicly-traded companies in the history of Wall Street?)

Whatever you decide upon, there is no legal requirement for your business's name to be unique, so long as you are not in direct competition with any other business—specifically a photo business—using the same name. If that is the case, another photographer might bring a lawsuit against you in civil court to protect his trade name and identity (more about that in part 5, Copyright).

Making Your Business Name Official

There are a few administrative concerns that have to do with naming your business. Registering its name is one of them.

Your customers, vendors, and creditors all have a right to know who is responsible for the actions and debts of any business. If you are doing business under an assumed name, i.e., if your business name is different from your given name, you must fill out a brief form to be filed with your local town hall or county clerk. Partners doing business under an assumed name (e.g., Johnson and Smith Photo-Graphics) must also disclose their true and complete identities to the local authorities by filling out a form. It is called a DBA, and the acronym simply stands for *doing business as*. Alternatively, such a form may be called a *Statement of Fictitious Business Name*. They are the same thing. A one-time filing

fee is usually required, but it is just as usually quite minimal, often less than $50.

See if you can obtain a DBA form from your county clerk's office and pay the fee at the same time. If not, you can find a DBA form in almost any office-supply store and file it at your convenience.

Bear in mind that the rules are slightly different from state to state, and even from county to county. Some authorities may additionally require you to publish a fictitious-name statement in the local newspaper. That's about as complicated as it gets though. Generally, you will receive a copy of the DBA stamped with an official county seal to give to your banker, plus another one to post publicly in your office. Your banker will probably ask for a copy of the DBA when you open an account, before you can deposit, write, or cash checks made out to your business.

Obtaining General Business Licenses and Permits

As you already know, photographers are not required to be licensed to practice their trade. Nonetheless, any business can be required to obtain a general operating permit. Call it a business license, if you will. It involves no more than paying a commercial fee, a kind of "nuisance tax." There is no examination to pass.

Fees for business permits are earmarked, ostensibly, to defray maintenance costs for public streets and utilities, which presumably are used to a greater extent, undergoing more wear and tear, by businesses than by private individuals. Depending on local ordinances, you may pay either a one-time fee or an annual one. It may be imposed by either a municipal or a state authority, or both. Sometimes these fees are referred to as either a *commercial occupancy tax* or an *unincorporated-business tax*. To find out if the legal operation of your business is subject to obtaining a permit, a business license, or paying a special tax, check again with your local city or town hall.

Obtaining a Federal ID Number

All businesses are required by the Internal Revenue Service to have an identifying number for tax purposes. It must be included on all documents and tax returns sent to the IRS. It will suffice for state income-tax purposes, too. Unless your business is a

corporation or partnership (more about that coming up), or if you never intend to hire employees, you may simply use your Social Security number.

Incidentally, you must furnish your number to third parties who use your identification number on returns or reports that they file with the IRS, including:

> ‣ Interest, dividends, and royalties paid to you
> ‣ Any other amounts paid to you that total $600 or more annually

If you plan on incorporating, forming a partnership, or hiring employees—and it's likely that you will have one or more photo assistants working for you—you must obtain a separate federal ID number from the IRS called an *employer identification number*, or EIN. To do so, you must file IRS Form SS-4. You can pick up a copy of this form at any local or regional IRS office, or you can obtain it online (see *http://ftp.fedworld.gov/pub/irs-pdf/fss4. pdf*). You will need an EIN if you:

> ‣ Hire at least one employee
> ‣ Have a Keogh plan
> ‣ Operate your business as a corporation or partnership
> ‣ File returns for:
> > ‣ Employment taxes
> > ‣ Excise taxes
> > ‣ Alcohol, tobacco, or firearms taxes

Obtaining a Reseller's Permit

There is no federal sales tax in the United States. Sales tax is the domain of state, county, and municipal government authorities. Unless your business is located in one of the five states that do not impose a sales or use tax,[8] you've probably had some exposure to sales tax already when purchasing products at retail stores. Since your business may be obligated to *charge* sales and use taxes, you don't want to *pay* tax on merchandise you purchase that will be billed back to your own customers. That would allow the government to "double dip" by taxing the same items twice. You can avoid this problem by obtaining a reseller's permit.

A reseller's permit (alternatively called a resale license, seller's permit, or sales tax permit) exempts your business from paying state sales and use taxes

on certain kinds of purchases. It allows you to buy supplies at wholesale prices without paying tax, as long as you pass the taxes you save on to your customers (see part 6, Pricing Photographic Services). Tax is collected by billing it to your clients, i.e., including it on invoices. Ultimately, you are required to submit the sales taxes you collect from your clients to the state government (see part 7, Operations).

Your business may be subject to a use tax for items you purchase, but do not sell. In most states you are required to bill a use tax, in lieu of sales tax, to clients who intend to reproduce—and thereby use—your photos. The rules vary from one state to another and often seem to follow no particular logic. So check with a certified public accountant (CPA) to determine how the rules in your own state will affect your business.

There is no fee required to obtain a reseller's permit. Once obtained, it must be displayed publicly at your place of business. The permit has a corresponding reseller's number. This number is used when filing mandatory tax returns. Ask your accountant from which state agency to obtain a reseller's permit.

When applying for a reseller's permit you may be asked to provide the following information:

> A photocopy of your social security card and driver's license to ensure the accuracy of the information provided and to protect against fraudulent use of your identification numbers. If your social security card is not readily available, a copy of another document with your social security number on it, such as a printed income tax return label, is a suitable alternative.
> The name and location of banks where you have an account.
> Addresses of property owned, its value, the amount owed, and to whom payments are made.
> Names of suppliers.
> Name of bookkeeper or accountant.
> Names and addresses of three personal references.
> Estimated monthly operating expenses for your business (rent, payroll, payments on equipment, and so forth).
> Anticipated average monthly sales and the amount of those sales that are not taxable.

note If you have a business partner, or if the business is managed by corporation officers, those persons may also be asked to furnish some of the same information listed above.

Statements must be filed either weekly, monthly, quarterly, or annually, depending upon how much revenue you collect. At the time a permit is issued, you will be asked to estimate your volume of taxable sales to determine how often to file. If all you can do is make a reasonable guess, that's okay for the time being. You can be more accurate later, as soon as assignments start to roll in and revenue begins to flow.

Start out by electing to file statements quarterly. The forms will be mailed to you. If business starts to boom, you will be required to file returns more frequently. If you shoot only a few assignments per year (e.g., highly-paid jobs that last for weeks or even months), you can switch to filing an annual sales-tax return. If you only shoot stock photos and collect all of your income in the form of royalties, you will not likely have to deal with a reseller's permit or billing sales tax. However, in that case, you will have to pay sales tax on all of your purchases. Even if you only bill one short assignment for the whole year, you must still obtain a reseller's permit and file a return.

Your Graphic Identity

Now that you're almost ready to hang out your shingle, have you thought about what it should look like? You have already given your business a name and a legal identity, but you have to establish a *graphic* identity, too—something both easily recognizable and stylish enough to enhance your marketing efforts. It should be something your clients can readily associate with your photo business, becoming a symbol, even if it means no more than picking out an attractive and distinctive typeface for your company name. But it could also mean developing a logo to appear on your stationery, Web site, business cards, labels, and even your portfolios. Maybe you'll literally need a shingle, too, or some other kind of signage.

Working with a Graphic Designer

Some people have an innate talent for creating their own company identity. By all means, do it yourself

to save money, if you can. Actually, one of your own photos might make a suitable logo. To get some further ideas, though, look through some of the publications that cater to design professionals. They often publish collections of award-winning letterhead and business-card designs from issue to issue and in special annual editions.

If your talent doesn't extend to graphic design, perhaps you can avail yourself of some professional help. You may already know a designer whose work you respect and with whom you might trade photography, either prints or services, for a logotype design. The process of bartering work is an interesting collaboration. It often results in a working relationship that goes on for years.

The names of three leading design publications are *Communication Arts* (*www.commarts.com*), *Graphis* (*www.graphis.com*), and *Print* (*www. printmag.com*). Several of the larger paper manufacturers, such as International (*www.internationalpaper. com*), Mead (*www.meadpaper.com*), and Mohawk (*www.mohawkpaper.com*), publish beautiful promotional publications of their own, featuring some of the best logotype design in the country. You might try to contact them about obtaining copies. Check your library, too.

The research you do on graphic design will not only point you in the direction of some designers to talk to about a business identity, but may introduce you, as well, to some potential new clients. Designers are often hired by large corporations to art direct annual reports and other corporate publications, as well as to create their own corporate identities. The designers, in turn, hire the photographers to illustrate these publications.

Establishing a Legal Structure for Your Business

There are legal formalities involved in setting up the structure of any new business. In choosing which structure to adopt, there are really only two criteria to consider:

> ▸ Protection from personal and financial liability in case the business fails
> ▸ The manner by which you and your business will be subject to income-tax laws

Choose whichever one of the following formats that provides the best combination of benefits for you and your business. There are three fundamental ways to configure a business to comply with the law:

> ▸ Sole proprietorship
> ▸ Partnership
> ▸ Corporation

There are two different kinds of corporations, as classified by the federal government:

> ▸ Subchapter S corporation
> ▸ Subchapter C corporation

There are also two hybrid configurations recognized by the government:

> ▸ Limited partnership
> ▸ Limited liability company

The structure of your business is your own choice to make. The one you choose will become the legal basis for all operations. Each format has its own benefits and detractions. (For obvious reasons, this treatise will not deal with not-for-profit companies.) Your accountant or financial advisor will help you decide which structure will best help you to minimize your financial liabilities, taxes, and administrative chores.

A corporate structure makes the distinction between what you earn and what your business earns clearer, because you are essentially under legal obligation to pay salaries to its officers. That includes yourself, of course. You can write that off as a tax deduction.[9] As either a sole proprietor or partner, you must do it artificially.

Sole Proprietorship

A sole proprietorship is an unincorporated business that is owned by one individual. It is the most prevalent format for all small businesses, not just photography. That does not mean it is the best choice. It is, however, the simplest business format to set up and maintain.

Under a sole proprietorship, there is no legal distinction between the business and its owner.[10] Its liabilities are your liabilities, and you personally

assume all of the financial risks of business ownership. Your personal assets are at stake, whether or not they are used in the business or associated with it in any way. Your only possible protection from liability is insurance. (Insurance issues will be discussed later in this Part.) Moreover, all business revenue is considered personal income by the IRS, and all business deductions must be itemized on your personal income tax return. There is no separate return to file for your business if it is a sole proprietorship.

When April 15th rolls around, you will use a form called "Federal Schedule C, Profit (or Loss) from Business or Profession" in addition to your regular Form 1040 (U.S. Individual Income Tax Return). Schedule C is used to make itemized tax deductions for business-related expenditures when you are self-employed. Some commercially available software programs, such as Quicken™ distributed by Intuit, can automatically track your costs and note which ones are tax-deductible by recording your check-writing and credit-card activity. In combination with other applications, such as TurboTax™, it will apply those deductions to your tax return and fill it out for you.

Because you are self-employed, you will also have to pay self-employment taxes and make a sizable contribution to Social Security. However, a sole proprietorship operates simply enough for you to do your own day-to-day bookkeeping. It is advisable, though, to consult with either a CPA or a certified financial planner (CFP), who will advise you about how often to pay estimated taxes and file returns. (See the section on Income Taxes later in this Part.)

General Partnership

A partnership is a financial relationship existing between two or more persons who join together to operate a business. Each partner contributes money, property, labor, or skill and expects to share in the profits and losses of the business.

A partnership does not pay income tax. Instead, all income is "passed through," including all profits and losses, directly to the partners. Each partner includes his share of the business's profits or losses on his personal income tax return. As far as your individual taxes are concerned, a partnership provides neither any advantages nor disadvantages to a sole proprietorship. There is a bit more paperwork, however.

A partnership must file an annual information return to report the income, deductions, gains, losses, etc., from its operations. A portion of this filing, in the form of a document prepared by your accountant called a K-1,[11] must be sent to each partner at the end of the year. It indicates the amount of revenue distributed to each partner, who, in turn, will use that information to prepare his personal income tax return. Profits and losses are shared equally amongst the partners, unless the partnership agreement specifies a different percentage of sharing, or ownership.

A partnership carries with it the greatest exposure to personal liability of all business formats. Each partner is liable for not only his own actions, but for those of his partners, too, even if one partner incurs debts without the others' knowledge or permission. Creditors can sue any one of the partners—or all of the partners individually—and recover damages if the partnership doesn't have enough assets to pay its debts. They can take cash sitting in bank accounts, cars, real estate, or other property belonging to any partner. Worst-case scenario: If only one partner has assets, he may have to pay all of the debts run up by all the other partners.

So why would you ever consider a partnership, given the risk? Well, every venture carries at least some risk. That risk must be weighed against the potential rewards of the venture and the odds of achieving success. For instance, if you don't have much capital starting out, it makes sense to pool your resources with one or more photographers in the same boat, or bigger boats. Perhaps one of you can supply the strobes and another partner the cameras. Maybe a third partner can provide a cheap lease for studio space. Maybe one of you is a talented negotiator and another a fabulous shooter. There are all kinds of combinations of assets and attributes to consider. A partnership can increase your odds of achieving success, the whole being greater than the sum of its parts. Just as in a marriage, however, make sure you know whom you're getting into bed with. Don't do this with strangers and expect a lasting relationship.

note If you work with your spouse, it is possible for either one of you to be the owner of the sole proprietor business, while the other works as an employee. If your spouse shares in the profits and losses of the business—not merely the salary you allot yourself—then you have technically formed a partnership.

Partnership Agreements

While there is no legal requirement to do so, you should have a written agreement with your partner(s). It should be drafted by an impartial lawyer. The agreement should then be reviewed by each partner's personal lawyer.

The partnership agreement can be as general or as specific as the partners wish, however, the key stipulations to include regard the following issues:

- Amount of equity invested by each partner
- Definition of specific duties and responsibilities of each partner
- Distribution of assets on dissolution
- Distribution of profits or losses
- Duration of partnership
- Partners' compensation[12]
- Procedure to settle disputes[13]
- Provisions for changes or dissolving the partnership
- Purpose of partnership
- Restrictions of authority and expenditures
- Settlement in case of death or incapacitation

Limited Partnership

This variation on the partnership structure is useful if you know an investor—or several investors—willing to bankroll your startup. In this case, your partners share in the profits without taking an active role in running the business.[14] Call them silent partners, if you will.

As the photographer running the show, you are the *general partner* and assume personal liability for any debts the partnership might incur. Your *limited partners* do not share that risk. They do, however, assume the entire risk of losing the money they invested in your photographic talent and in your ability to manage a business. Therefore, the limited partners are usually entitled to share profits equally with the general partner.[15] To hedge their bets (their capital investment), they usually demand a disproportionate share of the partnership's losses (as high as 90 percent is sometimes considered fair), thereby receiving a potential tax break as an incentive to put their money to work for you. Of course, it is preferable for everyone involved if the partnership incurs only profits.

For obvious legal and financial reasons, a limited partnership demands a comprehensive written agreement between the partners. Although not required by law, it would be foolish to neglect having an agreement between partners. The advice of an attorney in drafting this agreement is highly recommended. Refer to the General Partnership and Partnership Agreement sections above for information about legal filing requirements and drafting an agreement.

Sharing Space

Short of forming a partnership and still remaining a sole proprietor, sharing space is an option that works for some photographers. Several shooters can share a single studio if they and their shooting schedules do not conflict with each other and there is enough private office space.

Sharing space without forming a partnership means maintaining two separate businesses at the same premises. This is most likely to succeed if the photographers work in different genres, e.g., one specializes in tabletop and the other in fashion. The idea is to keep separate client lists, thus avoiding professional conflicts and jealousies. It may also be practical in some circumstances for strictly-location photographers to rent office space or the use of a darkroom from other shooters with large studios.

The Subchapter C Corporation

A corporation has a life of its own, almost literally. It is treated as a separate entity—almost like a person—under the law. It can hold assets, be taxed, sued, and even wind up bankrupt. Unlike a person, however, it can't die of old age. But you can kill it. It can also be bought or sold.

For the purposes of this book, it will be assumed that you plan to keep your corporation "privately held." That means you do not plan to sell shares of corporate stock on the retail market, which would mean "going public" (i.e., the whole IPO-investment banking rigmarole). That would subject you to the regulatory scrutiny of the Securities and Exchange Commission of the federal government and the

whims of Wall Street. Anyway, if you have a photo business that attracts that kind of action, you don't need this book!

Many people about to start a business of their own discover great pride in the prospect of putting an "Inc." after their names. Incorporation comes with lofty-sounding titles, too, such as Founder, Chairman of the Board, Chief Executive Officer, and President. But with the titles, no matter how small the corporation, there comes more work to do.

In forming a corporation, prospective shareholders transfer assets (money, property, or both) to the corporation's capital stock. A corporation generally takes the same deductions as a sole proprietorship to figure out its taxable income, but it is taxed at higher corporate rates. It is also subject to being taxed twice on its income. To counteract those circumstances, a corporation is entitled to special deductions. There are thousands of individual lawyers and institutions of jurisprudence aggressively dedicated to helping you apply those deductions and avoid paying taxes in exchange for steep fees.

Although a corporation can be sued, its owners, the shareholders, are generally protected by civil law from personal liability. They cannot be sued as individuals for the actions of the corporation, for which the corporation may itself be held liable. This kind of protection is popularly known as the "corporate veil." The legal principle holds true even if the corporation and you are virtually one and the same (which is possible in all states but Arizona as of this writing).

Only assets belonging to the corporation are vulnerable in case of any court judgment against it. However, that's a moot point if you, personally, own all or most of the stock in the corporation. There are other exceptions, too. Your personal finances are vulnerable if you neglect your fiduciary, or legal, responsibilities to the corporation. For example, it must be properly formed, following all guidelines to the letter of the law. Each corporate officer must be appointed and perform his duties, even if you keep all the titles and appoint yourself to perform all the work. The corporation must hold regular board meetings documented with minutes. Also, bear in mind that, as a one-person corporation (i.e., if you are the only shareholder), you must foot the bill to defend the company against lawsuits. That could put you in the poorhouse all by itself (although there are insurance alternatives).

It is also likely that lenders will require you or another shareholder to personally cosign on any loans to the corporation. That exposes you to personal liability, too. But it's best not to focus on the negative aspects of incorporation. No one plans to commit egregious wrongdoings, to be sued, or to go bankrupt. It's more useful to consider the tax advantages and any savings that might accrue related to health care, insurance, and pension plans.

Because corporations are taxed by both the state and federal governments, you have to file additional returns, separate from your personal income tax returns. What was meant earlier by "taxed twice" means that corporate profit is taxed when earned, and then it is taxed again as personal income to each shareholder when it is distributed as dividends. Shareholders, unfortunately, cannot deduct any losses of the corporation from their personal income.

In some states, there is also a minimum corporate tax to pay each year, even if the business suffers a loss. It is usually a flat fee, relatively modest, and, as with all other regulations and ordinances, it varies from state to state. Incidentally, the founding of corporations is subject to state, not federal, law. Your accountant will advise you about the minimum corporate tax, if applicable.

If you start a corporation, you will no doubt become an employee (even with all those lofty titles). You will receive a salary (you'll probably sign each check yourself), which, as a cost, is tax-deductible to the corporation. Your salary might consume the entire amount of corporate profit, if that is what you wish. On the other hand, you will still be required to file a personal tax return and declare that salary as income. The corporation will also withhold part of your salary to pay estimated taxes, and you must fill out a W-2 form. The same goes for any other employees of the corporation. The corporation is also liable for payroll taxes.

One thing in favor of incorporating is the receipt of personal fringe benefits paid for by the corporation, because, as costs, they are tax-deductible. That means a corporation can write off the cost of your personal health insurance, and you do not have to declare it as income.

As you can see, the major disadvantage of

incorporation for a small business is the increased amount of administrative complexity. Sometimes the financial benefits of incorporating outweigh that burden, especially if the corporation can afford to hire expert administrative help.

The Subchapter S Corporation

Whereas a Type C corporation might be referred to as a "normal" corporation, the Type S corporation represents a special kind of corporation that often works to the advantage of very small business owners, including freelance photographers.

First and foremost, a Type S corporation circumvents the double-taxation problem. A Type S corporation is generally exempt from paying federal income tax, so profits and losses are "passed through" directly to the shareholders. Shareholders are taxed individually on their personal income, just like a partnership, even if you are the only shareholder. At the same time, you can enjoy three benefits that are unavailable to both a sole proprietorship and a partnership:

▶ Protection under the corporate veil from personal liability
▶ Business deductions that are denied to sole proprietorships and partnerships
▶ Stronger asset protection, e.g., a trademark

As far as business deductions are concerned, a Type S corporation allows you to make greater deductions for medical and life insurance than you might be allowed as a sole proprietor or a partner. The corporation can also deduct contributions to your individual retirement plan from its tax burden.

If your business loses money in its first year, which is not uncommon, you might be able to offset other personal income (e.g., from a separate business or moonlighting job) with that loss and avoid paying tax altogether. If you're married and file a joint return, you might be able to offset your spouse's income, too. In other words, if you plan to receive any royalties or additional income from teaching or consulting work—even income from something as unrelated to photography as part-time carpentry work—you can offset that income against corporate losses.

On the downside, there is a tremendous amount of extra paperwork and bookkeeping involved with becoming incorporated. You will need an attorney who is well versed in small-business corporate law. So, it's up to you to decide if any potential savings justify the added administrative workload. The fiduciary rules regarding bylaws, board meeting, and minutes still apply to a Type S corporation. You are still entitled to all the fancy titles and the "Inc." after your name, if you wish.

A Limited Liability Company

A Limited Liability Company, or LLC, combines the protection from personal liability of incorporation with the tax advantages and access to capital of a partnership, while maintaining the simplicity of a sole proprietorship. Yet, it is none of those. It is a relatively new form of doing business. Its owners are called *members*, not stockholders or partners.

Like a corporation, an LLC is a separate legal entity. But it pays no taxes. Taxes are treated the same way as a partnership. Without the "double taxation" imposed on a normal corporation, profits and losses "pass through" directly to the members of an LLC, just like with a Type S corporation. Unlike either type of corporation, however, there is no legal requirement to keep minutes, hold board meetings, or make resolutions and bylaws. Moreover, no member is individually liable for the company's debts. A limited liability company is almost as flexible and easy to run as a sole proprietorship.

The paperwork involved in forming an LLC is relatively simple. Most states require the filing of a single-page form (usually called *Articles of Organization*) with the secretary of state. You pay a filing fee that varies from state to state, and that's about all there is to it. As far as ongoing paperwork, most states require an annual statement to be filed, which is another one-page form that merely updates company information. It, too, requires a nominal filing fee.

Some states require that the operating agreement for an LLC be in writing, and some do not. Check with your own secretary of state's office. However, to be in compliance with the IRS, a limited liability company must adhere to some fairly complex guidelines.

The IRS considers a certain number of specific characteristics that distinguish a corporation. As long as the LLC's agreement expresses only two of them, you fall within acceptable guidelines and will

not be considered a corporation. But if three of them are described in the agreement, the LLC looks too much like a corporation and will be taxed as such. To complicate matters even further, the guidelines take a sort of a la carte menu approach, allowing the members to choose which corporate characteristics they want and which ones they don't. Therefore, it is recommended that you consult a CPA, financial planner, or tax attorney to explain how these corporate characteristics can be variously separated or combined *before* you draft the operating agreement.

With an LLC, the need for special legal expertise is the only drawback, albeit a minor one. All in all, it is a business structure that can be very beneficial to commercial photographers.[16]

note The business structure you choose does not have to be final. You can always elect to reform its structure in a forthcoming fiscal cycle. An alternative structure may be better suited to your financial and administrative needs as they change over time.

NOTES

8 Alaska, Delaware, Montana, New Hampshire, and Oregon are the five states that, as of this writing, do not impose general sales taxes. Some towns and cities in Alaska have their own discretion, however, as far as sales taxes are concerned. The remaining four states impose a tax on specific transactions only, such as hotel accommodations.

9 This is simple to reconcile from an income-tax point of view if your business is incorporated; you pay your personal income tax to the IRS, and your corporation pays its own. If you are simply doing business under your own name or an assumed name (DBA, or doing business as), you only pay one personal income tax based on the combined net earnings (after expenses) of your business; *but that does not diminish your responsibility to keep your personal and business earnings separate, in different budgets.*

10 That does not contradict the informal financial distinction between the business and the business owner that exists for the sake of defining profitability. That is, of course, the premise that has been promulgated throughout this book.

11 Form 1065, also called a K-1. Filing this form will be discussed in Part 7, Operations. See: *www.IRS.gov/forms_pubs/pubs/p54105.htm.*

12 This might include how to divide assignment fees or salaries.

13 For example, a mediation clause.

14 If your limited partners have experience running successful businesses, it would be smart to let them mentor you. They would be wise to offer their help. But the general partner has the final word in management, until and unless, that is to say, the partners pull the purse strings.

15 In a case where there is more than one limited partner, whether each one of them receives the same percentage of the profit pie as the general partner or whether the limited partners as a group must split a 50 percent share of the pie (or some other percentage) is a matter for negotiation. For example, if there is a general partner and two limited partners, will they each receive $33^1/_3$ percent, or will the general partner receive 50 percent, leaving each limited partner with a 25-percent share?

16 For more detailed information on LLCs, see: *www.roninsoft.com/llc.htm, www.nolo.com/encyclopedia/sb_ency.html#Subtopic164,* and *www.4inc.com/llcfaq.htm.*

8

Financial Considerations for Your Start-Up

Now that you have a place in which to conduct business and a legal structure to support it, you have to look at the financial picture. In this chapter, you will learn where to find the money it takes to get set up.

Creating a Budget

Budgeting is based on making intelligent predictions about money coming in and money going out. Zooming in more specifically, these predictions have to do with:

> ❯ Administrative costs
> ❯ Production costs
> ❯ Expectations of job availability
> ❯ How much money you think your business will earn
> ❯ How quickly you think it will turn a profit
> ❯ Other photographers' experiences

Budgeting is a key component of financial planning, because until you create a list of foreseeable costs, it is impossible to make predictions about growth. So the overriding factor in budgeting is recognizing what your costs will be.

If you don't anticipate your costs accurately (i.e., what they are *and* how much they are), your budget will be too low, and you won't raise enough money to launch your business successfully. Estimating too high, leaving you with additional money to invest, is hardly a problem. But the "Goldilocks Factor" plays a key role in planning a budget: You don't want to come up with a dollar amount that is either too low or too high, the latter being more difficult to raise. The amount of money you ask for from your lenders or investors must be "just right."

The result of having too little capital invested means watching bills pile up as you fall just a little farther behind the eight ball each month. The term for that predicament is *undercapitalization*. It leads to failure and bankruptcy. If you find your business faltering, it doesn't necessarily mean that it is bound to go under, or that you are guilty of gross mismanagement, or cursed with a character flaw. It could simply mean that you either made a mistake in planning[17] or became a victim of unforeseen economic circumstances.

Investment capital is life support for your business. Until it starts making a profit on its own, it must be kept alive artificially, just like a premature baby in a hospital incubator. But an infant cannot

stay in an incubator indefinitely. Ultimately, if it cannot breathe on its own, it will not survive. The same goes for your business. When it starts making a profit, it starts breathing on its own. It is free to grow.

There are exceptions, but just about all businesses go through a start-up phase during which they lose money. That phase may last as long as a year or even longer. Therefore, your budget must reflect the amount of time you predict it will take to get off life support. How long or how short a time that will be depends somewhat on chance. It depends on the existing state of the economy. So you have to build in a contingency factor, a "fudge factor," if you will, as explained in the section, The Break-Even Point, later in this chapter.

Understanding the economic environment is so essential to good planning that the importance of enlisting either a professional financial planner or an accountant to help you list and then estimate your costs should be reemphasized.

Costs

Some costs are incurred only once, when you first start your business. As discussed previously, some of these one-time costs correspond to unavoidable permits and the legal fees involved in creating a legitimate structure. Other one-time costs may go toward furnishing a studio, buying camera equipment, and paying for a financial consultant's advice. However, some costs recur repeatedly. They may fluctuate up or down in accordance with the economy. Such costs range from lease payments to the price of film, and how much film you shoot on any given day.

All of these costs, when added together, will help you arrive at a total figure for your budget. By examining each cost individually, you should have some wiggle room to manipulate its total. After all, a budget is merely a prediction. Costs go up, and costs go down. Some you can cut out entirely. But your prediction has to be reasonably accurate, because it may determine all the money you're ever going to get to make or break your business.

The importance of a budget can be understood with the help of some rocket science. If your business is a guided missile, then start-up capital is the fuel that propels it skyward until it gathers enough momentum (i.e., revenue) to keep going on its own,

all the way into orbit or beyond. If there isn't enough fuel to burn for as long as it takes to reach escape velocity, then gravity (i.e., costs) will cause it to fall back to earth. The reason for calculating a budget before blast-off is to ascertain how much thrust (i.e., how big a budget) a rocket of your size will require to escape the pull of gravity. Furthermore, you have to predict a "burn rate" for the amount of fuel that it will take to get you as far as you have to go, and in just the right amount of time. Once you're up and going, fuel can be conserved. It need only be applied in small bursts (thruster jets) to maneuver in its path.

There is another reason for creating a budget. If you need to either borrow start-up capital or persuade investors to give you the money, they will demand to know precisely how that money will be spent, what it will be used for. They have a right to this detailed information to help them assess their financial risk.

The formula for calculating your own budget is simple: List all of your one-time costs plus every additional cost you predict it will take over time to get to a point where your business is earning enough revenue to pay its own way. The hardest thing to do—it's not really *that* hard—is to identify every item associated with a cost. That means listing all of the things you need to spend money on to start your business and then adding them up. The total represents the amount of money you have to raise, either from investors or by liquidating your personal assets, to give you the thrust you need.

note Don't forget to allow for some of that wiggle room to account for unpredictable contingencies and planning errors. You can do that by multiplying your total budget by 1.25, which allows an extra 25 percent to cover unexpected emergencies.

Even after a successful launch, having too little cash in the bank to sustain you through the trials and tribulations of a start-up period is the biggest cause of failure among small businesses. Without enough cash, you cannot buy enough time to build up a steady stream of clients and revenue. If you run out of money, you're out of business. There are two steps involved in calculating a budget:

▸ Anticipating all products and services you'll need over time

> Estimating the costs of those products and services

A partial list of one-time costs to consider specifically for your start-up budget will include:

> Construction and decoration of office or studio
> Financial consulting fees
> Legal consulting fees
> Licenses and permits
> Office furniture and fixtures
> Photographic and lighting equipment
> Portfolio development
> Security deposits on real estate

The short list above does not include the day-to-day and month-to-month costs of keeping the doors of your business open. Those costs must be factored into your budget, too.

A partial list of recurring costs to consider for your start-up budget will include:

> Administrative
 • Rent/mortgage
 • Telephone
 • Gas and electric
 • Cable
 • Water
 • Security
 • Building repairs
 • Janitorial
 • Furnishings and fixtures
 • Camera and lighting purchase
 • Camera and lighting repair
 • Property taxes
 • Office supplies
 • Accounting fees
 • Legal fees
 • Business manager fees
 • Credit and finance charges
 • Telecommunications (telephone, ISP, and cell phone)
> Travel
 • Airfares and excess baggage fees
 • Taxis
 • Car rental
 • Lodging and meals
 • Parking and tolls
 • Gratuities

• Entertainment
> Business Vehicle
 • Car or truck payments
 • Registration
 • Repair
 • Gasoline
> Production
 • Catering
 • Models
 • Messengers
 • Locations fees and permits
 • Equipment rentals
 • Film stock
 • Lab costs
 • Assistants' salaries
 • Makeup, hair, prop, and wardrobe stylists' fees
 • Location scout fees
 • Production manager fees
 • Sets and props
 • Wardrobe
 • Contractors
 • Insurance riders
> Marketing
 • Promo cards and posters
 • Sourcebook media
 • Other advertising media
 • Printing
 • Portfolios
 • Gifts
 • Postage and shipping
 • Rep commissions
 • Entertainment
> Insurance
 • Disability
 • Automobile
 • Camera
 • Liability
 • Worker's Compensation
 • Production
> Miscellaneous
 • Professional dues
 • Publication subscriptions
 • Educational seminars

note Payments you make to yourself for services rendered in the capacity of business or studio manager must also enter into the budgeting process, unless you actually pay someone else to manage things on your behalf (a tax-

deductible expense). A management salary is quite separate from what you pay yourself to take pictures. Those are two separate hats. You should be compensated for wearing both of them.

The Break-Even Point

Basically, adding up all of your predicted costs will indicate a *break-even point*. It is a dollar amount, the total of all the costs that must be paid each month, whether you have work coming in or not. It is the amount of revenue you must take in before your business starts to earn a profit. It's what you need to keep the door open.

It is not difficult to figure out your break-even point. In fact, PhotoByte will do it for you, as explained in the following exercise. Once you have determined your break-even point, it can be used to create a budget, which will, in turn, be used in your business plan. With a business plan and this budget, you have the basic tools you need to start raising capital for your new business. First, of course, you have to know how much money you are going to need.

If you think, for example, that it will take six months to start seeing work come in the door, then you will multiply your monthly break-even figure by six to come up with a start-up budget. If you determine that your "monthly nut" is $5,000, you will need at least $30,000 in start-up capital. Add a little wiggle room in case there are any unforeseen costs, or in case it takes longer than you predicted to get your first assignment—enough cash to cover operating expenses for an extra month or two. So, you should probably try to raise something in the neighborhood of $40,000 to $50,000 to ensure every opportunity for success.

EXERCISE --------------------------------

Determining Your Break-Even Point
- Open PhotoByte and click the *Sales Reports* button on the Main Menu.
- Click the *Profit/Fee Analysis* button on the Sales Reports screen.

You will see the Profit vs. Creative/Usage Fee Analysis screen.

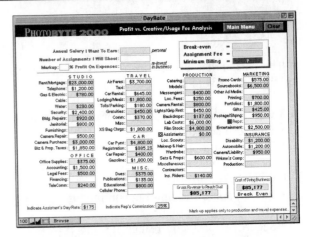

In place of the sample numbers you see on your screen, copy the numbers from the Schedule C itemized list on your last federal income tax return into the corresponding fields on the Profit vs. Creative/Usage Fee Analysis screen. Don't forget to add how much salary you think you deserve at the top of the screen. If you haven't had to file a Schedule C before, that's okay. Enlist the help of a financial adviser or accountant to estimate what your costs are likely to be. For the purposes of this exercise, you are free to start by using the sample numbers, or feel free to make your own educated guesses.

Once you are satisfied with the numbers entered on screen (either sample or real), PhotoByte will immediately show you your break-even point. It is visible in the bottom right corner of your screen.

Think of the screen illustrated in the exercise you just performed as a graphic tool designed to show you the difference between earning a profit and earning a salary. The lesson, of course, is that one of the costs to be included in both your break-even point and your budget is your salary. You have to pay yourself a living wage.

This tool is *not* supposed to show you how much to bill for an assignment, even though it does give you a figure for a typical billing, based upon annualized production costs. (The rationale for pricing photo assignments will be discussed in part 6.) Its real purpose, in addition to determining a break-even point, is to help you grasp the economic principles that define the difference between revenue and costs in general.

❯ *Cost* = Money your business pays
❯ *Revenue* = Money your business collects
❯ *Analysis* = What it all means to you

"What-if?" Scenarios

Click the *Clear* button at the top of the Cost/Revenue Calculator screen to erase the sample figures on the Profit/Fee Calculator screen.

All the fields will be left blank, ready for you to type new numbers that reflect your actual costs. It isn't necessary to re-enter these numbers over and over again. Once is enough. However, since costs change over time, feel free to modify them as often as you wish. By continually referring to this screen, you can experiment with entering new figures, providing you with an infinity of "what if?" scenarios.

Change your costs and percentage of profit until you find a billing rate that you feel comfortable with, one that seems reasonable in the current market. (More about that, too, in part 6.) Don't be frightened by the "minimum billing" figure you see in the upper right corner of the screen if it seems particularly high. It may go down as you redefine your costs. But be prepared for it to go up, too! It quite objectively indicates what you must bill each time you pick up your camera, based on your actual costs, including salary, and the necessity to make a profit.

note The calculator is not intended to determine something that might be called your "day rate." It is only supposed to give you a rough idea of how much you have to bill on a regular basis to sustain business operations and pay yourself a salary. The cost figures are meant to be changed regularly, to help you plan financial strategies based upon whatever market circumstances exist at any given time.

Paying Yourself a Salary

Think of the factors that contribute to your salary requirement as a completely separate budget, the total of all your personal expenditures, not related to the photo business. But think of it, nonetheless, as a line item in the budget for your business. Your salary represents, perhaps, the biggest cost your business incurs.

Here are the items you need to consider in your personal budget to determine your salary:

❯ Automobile payments/lease
❯ Automobile insurance
❯ Automobile repairs and gasoline
❯ Clothing, cleaning, and laundry
❯ Entertainment and travel (vacations)
❯ Family care (education supplies, tuition, baby sitters, allowances, etc.)
❯ Gifts and charitable contributions
❯ Groceries
❯ Health insurance payments
❯ Home furniture and appliances
❯ Home maintenance, landscaping, and repairs
❯ Home payments (including property taxes) or rent
❯ Life insurance payments
❯ Medical and dental payments
❯ Newspaper and magazine subscriptions
❯ Personal credit card payments
❯ Personal loan payments
❯ Pharmaceuticals, cosmetics, sundries
❯ Restaurants
❯ Savings and retirement fund
❯ Taxes
❯ Telephone and Internet communications
❯ Utilities (gas, electricity, water, refuse)

note Save the total of this personal budget. You will use it again in part 6 to figure out your assignment fee.

Raising Money to Start Your Business

Your budget represents the amount of money you must have in the bank *before* you start doing business, because, by obvious reasoning, you cannot earn revenue—let alone profits—if you haven't set up shop yet. If your personal savings won't do the trick, there are basically two other ways to fund a new business: *debt financing* and *equity financing*. Simply speaking, that means either *borrowing* money you have to pay back or accepting *investments*, not paid back, but accepted in exchange for a part ownership of your business.

Lenders and investors alike recognize the familiar aphorism: "It takes money to make money." Therefore, they realize that money is a tool. They are in the business of selling access to their tools, to let other parties use them to make money. Think of it as "renting" money. Insofar as funding a new business is concerned, that money is called *capital*, and

just like any other product or service, it comes at a price.

Not only do you need to find enough *working capital reserve* to stay in business when the economy dips and there are fewer assignments to go around, you also need *longer-term capital* to pay for new equipment, produce new portfolio pieces, and add images to your stock photo archive. Furthermore, there will always be emergencies that require cash; they occur when you least expect them.

Since it is assumed that you have created a budget by this time, don't be dismayed by the figure you came up with. It may be daunting at first, but lots of other photographers have been able to raise that much start-up capital before. It really is a manageable task.

Debt Financing

Lenders are assured of making a profit because of the interest rates you pay. They make money whether your business succeeds or not. If it fails and you default on a loan, the lender is entitled to take whatever personal assets were pledged as collateral instead. A lender may demand that the collateral be valued about fifteen percent higher than the principle of the loan. Overall, however, the cost of borrowed money is relative to the lender's risk. It is the borrower—you—in this case who assumes most of the financial risk by putting up collateral against the loan.

It is a serious mistake to borrow money without knowing, first, exactly how and when you can pay it back. The payback must come from the revenue your business earns, i.e., from cash flow, not by borrowing more money. This is no hit-or-miss proposition. Once you start to borrow money to pay back existing loans because your cash flow is sluggish, your dream will slide into the abyss of bankruptcy.

Sources of debt financing include:

> ‣ Friends and family
> ‣ Banks
> ‣ Small Business Association
> ‣ Vendor/trade credit
> ‣ Credit cards
> ‣ Customers (offering future rebates)

Equity Financing

Before you can fund, you have to find. The biggest problem with investors is that they are hard to find. Once you do find them, they want the moon and the stars in exchange for loosening their purse strings. It's harder still to find investors for a business as small as yours.

The strategy of investors is that they will actually buy a part of your business. They become co-owners. That lowers your financial risk. But investors demand a proportional share of the profits, because they take on much of that risk themselves. Depending upon the structure you choose, they may also demand some influence over the way you run the business.

If investors can substantially increase your prospects for success, it may well be worth the moon and the stars. It is, after all, better to have a small piece of a large pie than a large piece of a small pie. Owning 50 percent of a $500,000 business is better than owning one hundred percent of a $50,000 business stunted by lack of capital. Investors are gambling on the success of your business. If it fails, it's their tough luck. So how much are you willing to give up in exchange for taking some of the financial risk off your shoulders?

Sources of equity financing include:

> ‣ Partners
> ‣ Angel investors

Personal Assets

Before you seek out investors, tap into your own resources first, if possible. Do you have any savings? Can you get a second mortgage on your home?[18] Can you sell the stamp collection you've had since you were a kid? If you don't believe strongly enough in your business to risk everything, you don't stand a chance of convincing others to invest or make a loan. They will flinch if they sense any lack of confidence on your part. That notwithstanding, debt financing and equity financing each carry a price. Money borrowed must be paid back with interest, whether your business succeeds or not. On the other hand, investors will take a share of profits that would otherwise belong entirely to you. You must weigh interest charges on loans that can shackle you to years of monthly payments against equity investments that can chip away at your control. If you have enough of your own capital to begin with, it may be cheaper and less stressful to use it than someone else's.

By using your own capital, just because there's no deadline to pay back the principal and no interest to pay back at all, don't think it comes completely free of cost. That money could conceivably fetch a more secure return if invested in a mutual fund or retirement account. So why not let others take the financial risk? That's a legitimate question. But when you weigh security against self-confidence, talent, and determination, you may come to the conclusion that your own business is one of the best places to watch your money grow.

More realistically, not that many aspiring photographers have the kind of cash it takes to start a business. Although you might be obliged to solicit outside loans or investments, they sometimes come with expert managerial advice that can increase your chances for success. There may be strings attached, but outside capital can be entirely worth the price you pay for it.

Borrowing from Friends and Family

After your own resources, your family and friends are the best source of capital. They probably won't demand as high a return on their investment as a bank. They may also have a greater emotional commitment to your success than strangers. That will augment however much cash they bring to the table. They tend to overlook your lack of a track record in business and are usually more flexible about payback deadlines, too. With family and friends, it is obviously not necessary to provide personal references. You won't get that kind of slack from a banker. Finally, you are likely to experience less pressure to perform and expand profits—although such pressure can be a good thing.

A relative or a friend may be willing to lend you money on a handshake. But that's not a good idea for either of you. Once a loan is made, relationships can become somewhat more fragile, and you may be pestered with unwanted advice. To avoid any confusion or misunderstandings and to preserve good will, it is always a good idea to memorialize a loan agreement in writing, *especially* because you are dealing with a family member or a friend. Then you can all show up at the next Thanksgiving dinner with smiles on your faces. It need not be as formal as an agreement written in legalese by a lawyer, but you should at least compose an informal promissory note[19] that stipulates four points:

- Purpose and amount of loan, including interest
- Repayment terms
- Alternative method of repayment in case of business failure
- Mediation procedure to handle serious disagreements

Each party should sign only the *original* promissory note. The lender keeps the original. He should return it to you when the loan is paid back. Make a copy for your records, but don't sign it. If it turns up unexpectedly far into the future, it could cast doubt on whether the debt was paid in full.

It is also strongly recommended that you keep lenders up-to-date by providing them with regular financial statements. Even if you are late with a payment, send the statement! That will not only make you look more professional, it will head off some of those pestering phone calls and give everyone involved a feeling of participation. It will reinforce their good judgment in trusting you. Their continued trust is imperative if you ever need their financial help in the future.

Arrange with a CPA to prepare loan statements each month and mail them. If you really want to make a good impression, include some of the financial and marketing reports that are produced automatically by PhotoByte (see part 7, Operations). Bottom line: The price of capital from friends and family is cheaper than the institutional kind.

Borrowing from a Bank

Banks, thrifts, and credit unions are all in the business of lending money. They earn profits by granting access to the collective funds of their investors and depositors in exchange for interest payments on the principal amount of each loan they make. You might construe interest as a banker's mark-up.

Incidentally, banking is not all that different, financially speaking, from the photo business. For instance, if Acme National Bank wants to use one of your photos in a brochure, it has to pay you a usage fee and then return the photo after publication. Similarly, you have to pay a usage fee (i.e., the interest) to spend the bank's money (i.e., the principle) and then pay it back.

Qualifying for a Loan

Traditionally, bankers look at three criteria. These are the Three *C*s:

> Character
> Credit
> Collateral

Character means that you are an upstanding citizen of the community with acquaintances who can vouch for you. Your banker needs to feel confident that you won't bolt the county at the first sign of financial trouble. Specifically, bankers look for community ties, such as long-time residence, local family members, and best of all, home ownership. A clean credit report is important, too. Two or three late credit-card payments shouldn't keep a loan from going through, but missing mortgage or rent payments for several months in a row will require some fast talking and fancy footwork. Of paramount importance to a banker is solid collateral. Photo equipment, appraised art, stamp and coin collections, and especially real estate are what bankers demand for collateral.

Most of a bank's loans are made to going concerns, not start-ups. The proceeds of a loan to an up-and-running business are usually earmarked for expansion. In that case, a banker can look at a track record of prudent management to ascertain the odds of seeing the money put to good use with a prompt payback. An established business is also more likely to have enough collateral[20] to secure a loan. The discretionary standards by which bankers judge a "good risk" are quite conservative.

It's probably safe to assume that many bankers have a prejudice about photography. They believe it to be an inherently risky business. That said, it is not impossible to obtain a start-up loan if you have collateral, enthusiasm, resolve, and perseverance. It is not as easy to obtain a bank loan for a photo business as it might be for, say, a restaurant, but there are certain things you can do to increase your chances of success.

The most effective thing you can do is to create a business plan. A business plan will make it clear to any loan officer that you take your business seriously. It will support your contention that you will be able to repay the loan. And since bankers cannot translate your portfolio into dollars and cents, a formal business plan is written in a language they can understand: economics. Just how to write a business plan will be discussed later in this part. But for now it can be said that a very important element of any business plan is the budget that you have already read about.

Obviously, having an accurate budget is more important to satisfy a banker's concerns than for those of trusting friends and family. You must be able to confidently tell a banker precisely how much money you want (avoid the word *need*) and why. A budget will make motives clear to both of you. Being wishy-washy, asking for an indiscriminate amount of money (e.g., "I need a loan to buy some cameras") is a waste of time. That will result in an immediate denial of your loan application. A budget in the financials section of a business plan makes the reasons for the requested loan self-evident.

Finding the Right Bank

Here's a hint: Put on your most conservative-looking capitalist's uniform (i.e., a suit and tie) and go meet some bankers!

Shop around. Start out by looking for the best deal on a—preferably free—checking account. Ask questions: Is a minimum balance required to eliminate check charges? What is the bank's policy if you deposit a check that bounces; will it cover you for a day or two without a causing your own checks to bounce in a chain reaction? Which bank in your neck of the woods has the friendliest tellers, the best hours, or the best coffee, all other things being equal? Which one offers the best interest rate on a business line of credit? Does it offer both personal and business credit cards? Which one has the most ATM machines located around town? Which loan officer is most willing to spend some time with you?

Put the ball in the bank's court. Let it attract you as a customer. Check out what interest rates it offers on savings accounts, too, and inquire about lending rates without necessarily showing your hand. You don't have to blurt out that you're interested in a loan right away. Instead, cultivate a relationship with the loan officer at the branch office you choose. Make friends. Offer a print to hang in the bank. Maybe the bank will agree to a small, mutually beneficial publicity campaign by hanging an entire show of your work in its lobby.

When you are actually ready to meet with a

banker, don't just show up; make an appointment by telephone first. Ask the receptionist for an opinion: Who is the most pleasant loan officer to deal with? Obviously it would be helpful to have a referral or an introduction from a friend or business advisor, such as your lawyer or accountant. But it's not necessary.

Once you have a person's name, ask for an appointment. You may have to speak with the loan officer over the telephone before he agrees to meet you. If so, avoid offering any detailed information at this time. The more you divulge over the phone, the less the chance that the loan officer will agree to sit down with you in person. Be confident, but don't boast. Sound as businesslike as you can. Remember not to use the word *need*. Explain, instead, that you want to discuss a proposal to increase your profitability, and you want to discuss the possibility of a loan to finance it. Don't talk about start-ups over the telephone.

If you sense too much friction with your loan application, some creative maneuvering may be in order. Banks use more lenient lending standards for consumers than for businesses, let alone start-up businesses. So, consider applying for a consumer loan. Then personally invest the funds in your business.

Be careful not to lie how about how you intend to use the proceeds when you fill out an application. For example, you could apply for a home equity loan to tap any available equity in your property. There is nothing illegitimate about investing the proceeds in your business. Just don't telegraph what you plan to do ahead of time! Bankers feel safe making home equity loans because statistics show that they are more likely to be repaid than loans for spanking new business ventures. If you don't have any equity in a home, try for a car loan. Be creative.

The Small Business Administration

If you have no luck after visiting several banks, even with a consumer loan, then contacting the Small Business Administration is your next step. It is an agency of the federal government.

The government has different objectives than a bank. Surely, it wants to be repaid, but it is not a for-profit enterprise. The SBA's charter is to help create new jobs, develop new employment skills, expand industries and services, expand export potential, replace imports with domestic products, and gener-

ally to encourage American technology and manufacturing growth. The SBA looks at the "bigger picture," with the growth of the number of small businesses contributing to the American economy as its primary concern.

Whereas a bank doesn't care if your new company creates jobs or not, the U.S. government recognizes that each new job created is worth about $50,000, as follows:

> ‣ A new employee may have previously been on welfare or the unemployment rolls
> ‣ A new employee expands the tax base by becoming a taxpayer
> ‣ A new employee becomes a new consumer who purchases items made by other companies, further expanding the economy and creating demand for more products, services, and, ultimately, even more jobs

Ask yourself what you might include in your business plan that might appeal specifically to the SBA that wouldn't have made any difference to a banker. For instance, if you open a new studio in a run-down urban manufacturing center, will it help revitalize the surrounding neighborhood? If you think so, make that a point to bring up with your SBA representative. Do you offer the possibility of job training for local residents, perhaps as lab technicians or photo assistants? In applying for financial help from the SBA, any emphasis you can place on your contribution to social and economic benefits resulting from your new business will increase your chances for a loan approval.

Here's how it works: The SBA does not usually fund businesses by making loans directly; it guarantees loans made by private institutions, mainly banks. In effect, the SBA acts like a federal insurance agency, protecting the lenders from default by their customers. It's not that the SBA *never* makes direct loans, but they are hard to get, especially for start-ups.

Suppose your application for a bank loan was denied, either because you couldn't demonstrate your ability to pay it back as quickly as the bank would like, or perhaps you lacked sufficient collateral. Maybe your managerial experience didn't measure up to the bank's standards. Neither of those reasons would rule out your chances with the SBA.

So ask your banker if he's willing to reconsider lending you the money if the loan is either guaranteed by the SBA, or by inviting the SBA to participate directly in the loan with partial funding, in effect splitting it with the bank. If the bank is interested in either possibility, ask your loan officer to contact the SBA directly to discuss your application. It's possible that the whole transaction may be worked out between the bank and the SBA without your personal involvement, and you'll have your loan. Of course, the bank must agree to authorize its portion of the total proceeds of the loan in conjunction with the SBA guarantee. The lender will then forward your loan application and a credit analysis to the nearest SBA district office for further scrutiny and, with luck, final approval. Ultimately, the private lending institution closes the loan and disburses the funds.

By working with the SBA, a bank's risk is reduced, so it is likely to look at your loan application more favorably. The SBA guarantees many tens of thousands of loans for American small businesses every year. But that doesn't mean obtaining SBA underwriting is a cinch.

Repayment ability from the cash flow of your business is a primary consideration for the SBA. They think like a bank in that respect. They, too, require evidence that you already have—or assuredly *will* have—enough customers to provide revenue to pay back the loan. Again, as with a bank, your good character, management capability, and collateral are important considerations.

Speaking of collateral, if you own 20 percent or more of your business (as you almost certainly do), you are required to personally guarantee an SBA-approved loan. That means coming up with security for the loan against your personal property or that of a cosigner. The prospect of receiving a loan may become even more daunting with the next requirement: You will additionally be required to come up with at least one-third of the total capital investment, to show your good faith or that of other private investors in the start-up. That means, even under the best of circumstances, the SBA will only provide two-thirds of the money you need to start up your business. The remaining one-third must come from somewhere else. If you are physically disadvantaged, are a member of a minority group, or have been the victim of a natural disaster, you will have a better chance with the SBA.

By accepting an SBA-approved loan, you are exposing yourself to personal financial liability, even if your business is incorporated. Incidentally, the SBA does not deny approval solely due to lack of collateral. But a lack of collateral can affect the outcome of your application if it is merely one reason cited amongst other cumulative, negative credit factors.

The SBA application forms are complex, but you can find help from either an accountant or the SBA itself. If you go through a bank, a loan officer will help you. Except for the loan itself, all SBA services and information are free, paid for by your taxes. Unfortunately, what the Small Business Association considers "small business" is often larger than a typical sole proprietorship. That means photographers often fall into the cracks. Having your business incorporated may be of some benefit in that regard. But a viable and clearly written business plan is always the most important way to get the attention of the SBA.

The SBA has regional offices all across the country. Some may be more sympathetic to photographers than others. It's worth a try. The SBA Web site contains a wealth of information about starting and funding a new business.[21]

Loan Checklist

General requirements:
> Credit request
> Business plan
> Federal income tax returns covering the last three years for each proprietor, partner, or shareholder owning at least 20 percent of business
> Projected income statement for three years—monthly for the first year and quarterly for the second and third years
> Projected cash flow for three years—monthly for the first year and quarterly for second and third years
> List of all fixed-term personal and business debt
> Résumé for each owner, partner, major shareholder, and top manager
> Source-of-equity statement

Other potential loan requirements
> Estimated costs of construction, remodeling, and improvements

> List of photographic equipment by major items or categories and their estimated costs
> Articles of incorporation
> Corporate bylaws
> Resolution of board of directors on borrowing
> Certificate of corporation in good standing issued by your state's secretary of state
> Partnership agreement
> Personal budget
> Life insurance policy covering the amount of loan, with the bank as beneficiary
> Hazard insurance for collateral on the loan, listing bank as beneficiary

Borrowing with Credit Cards

Think of credit cards as a means of short-term financing once you are a going concern. They're not the means to fund a start-up. Nonetheless, they can be useful during the start-up phase. In an emergency, you can have immediate access to funds without waiting for a loan application to be approved.

Because of the ease with which one can acquire a modest credit limit (which can be increased as you build a positive payment history), and because you can multiply that limit by acquiring a number of different credit cards, don't be tempted to build your borrowing power this way. The interest costs are too high, often as much as 22 percent. You can wind up paying huge interest fees every month without seeing the principle paid down at all, keeping you in constant debt. It is impossible to turn a profit that way.

If your business is incorporated, then, of course, you are protected from personal liability if the business goes south; just make sure the credit card account is in your corporation's name, not your own. Even if you are a sole proprietor or a partner, it is wise to maintain separate credit card accounts for business and personal use. Business credit cards and lines of credit[22] are usually available at better rates of interest than personal plastic. It's also easier to separate business expenditures from personal ones when tax time rolls around, because the accounts are independent of each other.

A credit card is most useful when you have to make an urgent purchase, perhaps a piece of new equipment that will make you more competitive, or to take advantage of a discount available for only a limited time. (Make sure that's not just wishful thinking. If that new equipment doesn't pay its own way, you should rethink its acquisition and rent it assignment by assignment instead.) If you know for sure that you'll be paid for your next assignment promptly and within the interest-free "grace period" billing cycle of the credit card, and if you foresee enough profit to pay for the new gear without skimping on other financial commitments including your personal salary, then you can avoid paying interest on the purchase. Buying on credit will have made it possible to use the equipment on your current assignment and for the entire month at virtually no cost.

Other benefits to using credit cards—actually, they are commercial incentives that banks use to persuade you to use them—include consumer protection plans and frequent-flyer bonus-mile promotions. You can also find what are called "affinity cards," which are co-branded by two organizations, one of which is a lending institution, the other a marketing partner. Every kind of group, from professional wrestling associations to universities—and, of course, airlines—are featured on affinity cards. Usually, use of the card entitles holders to discounts or special deals from the marketing partner.

Consumer protection plans are essentially insurance programs that allow easy redress for the receipt of damaged or falsely advertised goods, and they protect you from liability for payment if a newly-purchased item is lost, stolen, or broken. Credit card accounts also provide you with neatly summarized purchase statements that are handy at tax time for noting deductions.

The credit card business is highly competitive itself. There are about six thousand issuers making a multitude of special offers nationwide.[23] Interest rates and annual fees vary greatly. Some of them require no annual fee. Many extremely low introductory rates—or "teaser rates"—are available. But be careful: One late payment and the rate goes way up. After a given number of months, it may go up anyway. Read the fine print carefully!

The credit card companies want you to use their cards as often as possible, on the assumption that you will eventually slip up and fall behind your budget, thereby becoming susceptible to exorbitantly high interest payments. Once you have a balance outstanding, they couldn't care less if you ever

use the card again for another purchase. They know they've got you hooked making interest payments, while the principle balance hardly goes down at all.

It's a nasty game, but one that you can win. For instance, with all the solicitations and "special offers" available, it's possible to play "musical chairs" by continually transferring your balance to a card with a lower rate. Before the "special introductory rate" expires and goes up, transfer it again. The issuers don't like that, but they made the rules.[24]

Watch out for this trap: After a balance transfer, any savings you might realize from the low introductory interest rate may be canceled out by transfer fees in tandem with a higher interest rate that applies to new purchases you make with the card. The trick is to pay down both your interest and principle for the duration of the teaser rate without using the card for new purchases. You can find deals with no transfer fees, too. Finally, make sure that you are clear about when interest stops accruing on the old card's balance and starts accruing on the new one. During the transition, you don't want to find yourself paying for a balance on two cards at once, however briefly.

Bear in mind that in addition to the Master Card, Discover, and Visa "revolving credit" plastic, the kind that has been described so far,[25] companies such as American Express and Diners Club offer cards that charge no interest rates, but demand payment in full at the end of every billing cycle. They are useful to carry instead of cash, especially while you are on assignment, to cover production costs. These kinds of cards make their profits on annual users' fees and from transaction fees billed to the merchants who subscribe to the service. They also solicit their cardholders for additional product offerings and services.

Bottom line: Try not to carry a balance on your credit card(s) for any significant length of time, if at all. It is just too expensive. If you find that you are constantly bailing out your business with credit cards to stay afloat, it's time to rethink the way you do business altogether.

Key Questions to Answer Before Accepting a Credit Card

▶ Is there an introductory rate? What is it, and how long does it last?

▶ After that, what will your rate be?
▶ Is there an application fee?
▶ Are there processing fees?
▶ Is there an annual fee?
▶ Is there a fee for each late payment? How much?
▶ Does a penalty interest rate kick in?
▶ Is there an over-the-limit fee?
▶ Are there any other fees, such as account termination fees or balance transfer fees?
▶ When and how can a variable rate be changed?
▶ When and how can a fixed rate be changed?
▶ What is the grace period before interest is applied?
▶ How will you be informed of any changes in your contract?
▶ Will you be informed if you are about to go over your limit?
▶ If you go over your limit, what happens?
▶ What is the company policy if you have trouble paying your bill?

Angels and Private Investors

Angels, so named because they appear with money just in time to save you from the hellish experience of further begging, are the kinds of people who make good limited partners or, on the other hand, good investors, if you decide to incorporate. Angels can be lenders, too. They will watch over you—mentor you—to protect their investments. Once you find an angel, or one finds you, you'll feel like you've gone to heaven. But life just begins!

An angel might be an acquaintance who believes in you and simply offers you a low-interest loan, someone who comes to your rescue if your application is denied by a bank or the SBA. Angels are usually retired, successful business owners who are eager to keep the ball in play by taking a limited involvement in new ventures. They enjoy passing along their expertise by counseling less-experienced entrepreneurs. They often feel compelled to "give something back" in exchange for their good fortune.

Just as often, however, angels are motivated by something more than simple altruism. By investing in new businesses, they can take tax write-offs. Start-ups don't always make profits right out of the gate. In fact, they often report losses. If a business fails, they can write off their losses against gains in other

business ventures. That's no excuse to try to sell a lousy business plan to an investor! Angels don't seek out potential failures; they just like to hedge their bets.

So how do you find an angel, other than by prayer? Serendipity plays a role. But serendipity— and luck—are often the result of hard work. Angels value privacy. They keep low profiles. But you can find them by networking and by just sticking your neck out. If you stick it out far enough, they may find you.

Business advisers, especially attorneys, financial planners, and accountants—with whom you have already been advised to consult—sometimes know an angel or two. Angels often rely on such professionals to screen ventures and steer them their way. Further networking can be accomplished at entrepreneur forums and seminars. Ask your local chamber of commerce if there are any planned in your vicinity. The angel-investor associations you'll find on the Internet are looking for high-stakes ventures, poised for exponential financial growth. But the more you try, the more likely it is that you'll bump into an angel, maybe someone who has a personal interest in photography.

Trade Credit

The term *trade credit* refers to the prerogative of your vendors to extend credit to you to purchase products and services and be billed monthly. It's like having a number of credit cards, each one valid with a different vendor. You are responsible to pay late fees on past-due balances, just like with a credit card. However, since the vendors are not technically financial lending institutions, they cannot bill actual finance charges based on interest rates, but merely processing or re-billing fees. Unlike using a credit card, you may have a personal relationship with the vendor, who may be more lenient with your account.

Trade credit is established gradually. It is extended in limited but increasing amounts until you build up a credit history with each merchant by promptly paying your bills each month. Trade credit can be a form of short-term financing, too. It's not sufficient to fully fund a start-up, but it is a tool that every new business can rely on to a limited extent. By taking up to thirty days to pay a bill, you have the financial leeway to fund your next photo assignment while waiting to get paid for the previous one.

Extending Credit to Your Own Customers

Just as your vendors extend credit to you, you will often extend credit in one form or another to your clients.[26] Although you might take it for granted, something as routine as waiting thirty days to be paid for an invoiced assignment equates to granting credit.[27] But if you cannot afford to carry your clients' bills for any length of time, you can support the production of current photo assignments by requesting an advance payment to cover production costs.

One eventuality of extending credit to your customers is the creation of accounts receivable. Assuming that your customers are good risks who will pay when the time comes, these unpaid invoices are assets. They can be used in part as collateral for a loan, or you can actually sell them.

Funding by Offering Rebates to Customers

If you are either lucky enough or skillful enough to have lined up enough customers to jump-start your revenue stream before you open up shop, more power to you. Actually, some sharp entrepreneurs have persuaded their own potential clients to invest in their businesses by offering them a rebate on photographic services that corresponds directly to the amount of their investment. This is a very creative source of funding.

This practice should not be mistaken for a one-time rebate. Think of it, instead, as offering a discount, so the investment is spread out and paid back (rebated) over time. In other words, if a potential client invests $5,000 in your business, you will deduct $5,000 from your fees over a predetermined course of time, covering a predetermined number of assignments. The terms should be written into a contract specifying the exact amount of the investment, the maximum and minimum discounts applicable per assignment, and a deadline for paying back the entire balance (i.e., if, after discounting ten assignments by 20 percent over two years, the balance of the investment has not been rebated, then a "balloon" payment would come due (or the number of assignments to which to the rebate is applied would be renegotiated). It is neither necessary nor wise to return the investment all at once by shooting a single assignment with a $5,000 rebate, because you'll be right back where you started, without operating capital.

Not only is this a creative way to fund your busi-

ness, it's a fabulous way to entrench yourself in the marketplace by making lasting relationships with buyers. At the same time, you will be building up your portfolio with new photos from new assignments.

The Hard Truth about Funding

Right from the start, the odds are stacked against photographers when applying for loans:

▸ With no prior entrepreneurial experience, you represent a higher risk.

▸ Bankers will often demand that first-time entrepreneurs cover 50 percent or more of their start-up costs from sources other than the proposed loan. They like to know that a business owner believes enough in his own venture to have made a substantial personal equity investment, including both the financial kind of equity and "sweat equity," too. Bankers feel even more comfortable when they see that other investors have participated in earlier stages of the funding process.

▸ Any history of bad credit will hurt you. An explanation of mitigating circumstances, such as a death in the family, a divorce, or unexpected medical bills, is no guarantee that bad credit will be ignored.

▸ Your business plan will have to be compelling. It must show evidence, not just hunches, that your new business will be accepted in the marketplace and that you have a promotional strategy to succeed in spite of stiff competition and the whims of the economy.

▸ You will need collateral: at least 115 percent of the loan amount based on the current market value of collateral, or about $1.15 of collateral for each $1.00 of loan proceeds, assuming that the bank accepts the form of collateral you offer.

Angels and venture capitalists invest large sums of money because they expect explosive growth. Yet, the income potential of a freelance professional's practice is limited. So, if you have no track record to impress a banker, if your friends and family aren't wealthy, and you—perhaps just getting out of college—haven't socked away any assets or built up a credit history, what can you do? The truth is that you may have to either bootstrap your start-up with what

little money you have, or in a more likely scenario, bide your time and wait.

This might be an opportune time to learn first-hand about the skills of your trade by assisting an established pro for a year or two. Maybe you'll have to live at home during that apprenticeship, until you build up some capital and some credit. Besides, that will give you some extra time to create a compelling business plan. Sooner or later, though, your perseverance will see you through to the successful start-up of your own photo business. If it were easy, everyone would do it.

NOTES

17 It's not a good practice to run out of money and ask for more, but if unforeseen circumstances cause your startup to run out of money while there is still a clearly defined opportunity for ultimate success, it is not unheard of for lenders and investors to put in further rounds of financing.

18 Mortgaging personal real estate can actually be a very good method of financing a sole proprietorship, since the interest payments are usually tax-deductible. Talk to your CPA about this alternative, if it exists for you.

19 Nolo Press is a publisher of legal self-help books and templates. Their Web site includes some sample promissory notes: *www.nolopress.com/encyclopedia/articles/sb/borrowing.html*.

20 You may have some collateral already, probably in the form of camera gear. If you make a list, you may be surprised.

21 See: *www.sba.gov/*.

22 A line of credit, issued by a bank, is similar to a credit card, but you can write checks against your credit limit as well as use the plastic card you receive.

23 Not every MasterCard, Visa, or Discover card is issued by the same bank. Many different banks have franchise arrangements with the credit card companies.

24 Here's a Web site that ranks credit card interest rates: *http://asque.com/creditcards/cci_faq.htm*, and one that rates business credit cards specifically: *www.bankrate.com/brm/rate/brm_bizcsearch.asp*.

25 Proprietary credit cards are also available from private merchants (e.g., Macy's, Sears) that offer the same kind of revolving credit at exorbitant interest rates.

26 Compensation for extending this credit comes to you in the form of profits on marked-up expenses, as explained in part 1, chapter 2: Profit Ability and 6, Pricing Photographic Services.

27 See the section, Granting Clients Permission to Use Your Photos, in chapter 25, part 5, Copyright.

9

The Business
Plan

Think of a business plan as a financial document that has two purposes: (1) To explain to potential investors or lenders how they will make a profit by offering you money, and (2) To teach you where money comes from and where it goes.

Recognizing the Need for a Business Plan

No lender is enthusiastic about the prospect of your defaulting on a loan so they can become the owners of a collection of used camera equipment (your collateral, perhaps). So there is no way around the need for a solid business plan with a credible financial forecast. It is just as necessary as the application for a loan itself. In fact, one won't do without the other; they work in tandem. Without a business plan, your loan application or investment proposal is dead on arrival.

In the plan, you must explain:

> From whom you expect to receive photo assignments
> How much money you can earn by shooting those assignments
> Why you think you will receive them (i.e., it must be crystal clear how your new business

will succeed in light of all the other photographers competing against you, who are, for the most part, trying to do exactly the same thing)
> When you can expect to start receiving payments for those assignments (i.e., cash flow)
> How you will pay back the investors or lenders (i.e., show them an "exit strategy")
> When the investors or lenders can expect a payback

Okay, that's what the money guys expect to see in a business plan. But there are other reasons to write one. To give you an idea, think about what would happen if you tried to build a house without a blueprint. It might be uncomfortable to live in, with crooked walls, an unlevel foundation, and maybe a missing bathroom or unsafe wiring. It could tumble down or burn to the ground. The same goes for a business. Its plan is its blueprint. Whether you need outside capital or not, the exercise of writing a business plan will contribute to your success by helping you to:

> Determine goals
> Be forewarned of possible roadblocks along the way

> Formulate responses to contingencies
> Keep the business on track to reach its planned financial goals

The ability to continually refer to a "living and breathing" business plan will increase your efficiency, reduce your financial risk, and keep you focused on the goals of your business. It turns disordered thoughts into a coherent outline that you can follow. That not only makes it possible for you to see, literally, how your business looks today, but according to the blueprint you've created, you can predict what it will look like in the future. For intended readers, it identifies problems and shows how you intend to resolve them. It indicates that you actually understand your business and know how to run it. No one will give you money to watch you learn on the job at his own expense.

While all business plans share a similar layout for information, your plan will be distinguished by characteristics that are unique to small businesses in general and commercial photography in particular. It must nevertheless follow a format that is appropriate for any business-to-business, service-oriented industry, as is commercial photography. Just as a résumé reflects the experiences of an individual yet follows a recognizable format, so too will business plans differ in substance but remain similar in form. Whatever you have to say, whatever you write down, must be immediately recognizable for what it is: a business plan. An essay won't do.

note One photo business seems pretty much like any other when you are limited to describing it conceptually. Start-up and operational costs are also pretty much the same for most photographers. So, creativity and style notwithstanding, that leaves marketing and execution to make one photographer's business stand out from the competition—that and the amount of revenue you can generate. In other words, the distinguishing business-plan characteristics for a typical freelance photo practice lie primarily in the way you present yourself to your customers—your image.

If you don't need to raise start-up money, you don't really need a business plan per se. But that doesn't mean you should forget about writing one altogether. Planning is required for any business to run well. Nevertheless, you can rely on a fully fleshed-out marketing plan instead to help keep your business on the beam. Of course, if you are looking for seed money, a description of your marketing efforts must be included in the business plan anyway. In either case, you will learn how to write a detailed marketing plan in part 4, chapter 16. And just to give you one more reason for the usefulness of a business plan, showing all of it or selected parts to potential vendors, contractors, employees, and key customers—even a commercial landlord—is a fine way to introduce yourself and secure trade credit arrangements.

Getting Started with Writing a Business Plan

The hardest part of writing a business plan is overcoming inertia, to stop thinking about it and just do it. That's no easy task. But it's straightforward enough, once you get over the fear of not knowing what to do first. As soon as you begin, it takes on a momentum of its own. The relative ease with which it flows comes from your familiarity with—and enthusiasm for—photography itself.

There are three options to help you develop a business plan:

> Purchase any one of a myriad of "how-to" publications from a bookstore. Read it, and prepare your plan using a computer with a word processor and a spreadsheet.
> Purchase one of the similarly numerous business-planning software templates available on the Web, and use it to guide you through the preparation of your plan.
> Hire a professional consultant to assist you in developing the plan, with or without software. This will cost some extra money, but it will save you a tremendous amount of time and frustration,[28] especially with the financial projections.

Presentation

The familiar aphorism, "a picture is worth a thousand words," is particularly appropriate for people who communicate visually. It is, therefore, a given that not all photographers are great wordsmiths. But excellent writing skills will make a huge difference in crafting a compelling business plan, one that will give you the best possible chance to launch your career.

A business plan is useless if people won't read it. Therefore, to make your presentation not only attrac-

tive, but as thoroughly readable as possible, get some professional help. Consider hiring a freelance writer to give your text a "once-over" for style, clarity, and brevity. Similarly, if you are challenged by crunching numbers, hire an accountant to help you polish your plan with charts and graphs. But don't let someone else completely do the writing for you. It is *your* business plan. It requires the stamp of your own unique vision and enthusiasm to make it convincing.

Here are some additional presentation guidelines:

▸ Print the plan on high-quality paper, one side only.

▸ Include a cover page with your logo[29] and a company slogan if you have one. Be sure to include identifying information, i.e., address, telephone number, Web site, e-mail, and your name as the person to contact about the plan.

▸ Use a table of contents

▸ Include an executive summary, no more than two pages long.

▸ Use the formatting capabilities of word processing software, or else have it done professionally by a graphic designer.

▸ Use a typeface that is easy to read and a font size that is large enough to prevent eyestrain. This may require financial projections to be spread over several pages in order to maintain readability.

▸ Maintain reasonable borders (usually one inch on each side).

▸ Number the pages, and be sure that the page numbers are accurately reflected in the table of contents.

▸ Keep the plan short and concise. Limit the inclusion of extraneous material. You can always provide additional detail in an appendix, if required.

▸ Include samples of any ads, marketing material, print pieces, and even a portfolio to aid in the presentation of your plan.

▸ Proofread and edit the document carefully. Spelling and grammatical errors do not make a good impression.

▸ Bind the plan so that it lies flat when opened.

▸ Don't allow your plan to become too flashy. Expensive binders, fancy embossing, and the like may elevate form over substance, raising

doubts about the integrity of the ideas contained within. Nevertheless, avoid looking too cheap, and *never* allow it to be sloppy.

Know Your Audience

Depending on who its intended readers are, your business plan may take on a different slant. If you are writing for lenders, their needs and expectations will dictate the type of information and level of detail to include. Potential partners have different concerns than lenders do. Bankers will be more concerned about revenue and cash flow than the salary structures you propose for a photo assistant or studio manager. If you are going after a loan, you must emphasize how and when it will be repaid, and you must write confidently to address that issue. It remains an important issue, even if the lender is a family member.

If you are writing for angel investors, they will immediately look for an exit strategy. That means a way to extract profits—larger profits than lenders look for, incidentally—and to disengage from the business. Although you will want to emphasize the likelihood that they will earn large profits, you are obliged to responsibly disclose any risks and uncertainties about investing in your business to avoid legal wrangling in the future.

Don't assume that those who are reading your plan are familiar with photographic jargon and acronyms, any more than you can easily explain a P/E ratio or a break-even analysis without the help of an accountant. Don't expect a banker to know the difference between editorial and advertising "day rates," stock photography, or what the initials "ASMP" stand for. Spell it all out. Use layman's terms. Feel free to use some of the explanations found in this book, including the rationale for commercial, media photography discussed in chapter 24 of part 5, Copyright.

The Parts of a Commercial Photography Start-Up Business Plan

▸ Executive Summary
 • Mission or vision statement
 • Concept (description of how the business will work)
 • Costs and capitalization (start-up budget indicating amount of money requested)

- Current situation
- Key success factors (what will contribute to or lead to early profitability)
- Milestones
- Exit strategy (how and when investors or lenders will be paid back)
❯ Market Analysis
- Industry description
- Target market and customers
- Customer characteristics
- Customer needs
- Customer buying decisions
❯ Competitive Analysis
- Nature and number of competitors
- Changes in the industry (e.g., digital content vs. film)
- Opportunities
- Key strengths
- Key weaknesses
- Threats and risks
❯ Marketing Plan
- Marketing strategy
- Sales strategy
- Strategic alliances
- Service
- Publicity
- Promotions and incentives
- Advertising
- Trade shows
- Lectures and seminars
❯ Overall Strategy and Execution
- Structure of business
- Operating timetable
- Operations
- Ownership (include partners or other investors)
- Management (if there are partners, or mentors, etc.)
- Personal résumé
- Location and facilities
- Employees
- Description of products and services (including portfolio)
- Growth: future products and services
- Literature, promos, brochures
- Implementation (how you will fulfill assignments and stock requests)
❯ Financial Projections
- Assumptions and comments

- Starting balance sheet (personal balance sheet indicating what your assets and debts are, i.e., net worth)
- Break-even analysis
- Profit and loss projection
- Cash flow projection
- Balance sheet projection
- Ratios and analysis (including Return on Investment)
- Appendix (contains your portfolio, press clippings, and promo material)

The following sections represent further guidelines to use in writing specific parts of your business plan.

The Executive Summary

A business plan begins with an executive summary. It is preceded only by a cover sheet and a table of contents, both of which are recommended to conform to a recognizable format. Although it will be the first part of the plan that is read, it should be written last. It should be no more than two pages long. Within those two pages, it must spotlight those factors that will make your business a success. It should explain how customers will benefit by publishing your work. It should include a concise statement of your vision; use a brief phrase or two to explain why you want to start a business in photography and what difference it makes to the industry. Go on to explain how the work you produce will fuel the local economy by providing work for assistants and stylists and in the way your product will used in advertising campaigns that persuade consumers to spend money.

The executive summary is arguably the most important section of the plan, because it has to capture the interest of the reader immediately or he will read no further. A quick twenty- or thirty-second skim will determine whether a plan is read thoroughly or summarily discarded.

List any factors you can think of that will assure your success. You'll probably come up with a series of personal traits and photographic capabilities that are uniquely your own, that your competitors can't quite duplicate. Include references to your portfolio, its exclusive content and its beauty. Make sure your readers understand the difference between the kind

of work you do and the local Sears portrait studio.

Talk about your personal experience, your talent, and the number of assignments and stock photo sales that you expect to bring in as revenue. Indicate who your potential clients are and how many of them there are (i.e., the size of the market). Point out identifiable trends (i.e., "going digital" or illustrating your clients' Web sites), personal goals, the total amount of funding required, capital expenditures, and an expected return on investment (i.e., how much profit the reader will make). The executive summary should clearly state why this is a sound investment and why its current reader, specifically, is well advised to make it. It must also advise the reader of an exit strategy, for disengaging and taking profits out.

For a new photo business seeking funding, your personal enthusiasm and excitement tempered with the credibility of sound numbers are the critical elements of an effective executive summary. Another suggestion: When you write a mission statement, be specific. Something like: ". . . to become the biggest photo studio in Peoria" will immediately result in your plan being tossed in the trash. You need to say something like: ". . . to become the leading provider of architectural photographic services within the tri-county region by linking high-quality production standards with a high margin of profit to create the region's first in-house film-to-digital service bureau." And one last thing: Don't forget to come right out and ask for the money.

Describing Your Business

The entire first part of your written plan is designed to introduce yourself as both a responsible manager and a key creative employee. Emphasize both of those talents. If anyone has ever passed judgment on your capabilities, attesting to the likelihood of your being in great demand as a photographer, say so. In other words, include some testimonials. Go on to write about the clientele you are aiming at, i.e., ad agencies, consumer magazines, or corporate publications. The idea is to make you look both knowledgeable about your market and effective in executing sales. You may even emphasize your management efficiency and execution skills by pointing out how you have implemented software to automate your back-office tasks without the cost of hiring extra employees (see part 2, chapter 4).

Include your educational background, too, citing any assisting experience you might have had.

Assessing Your Current Position

All of your accomplishments and experiences are valuable and should be mentioned early on. But be frank in explaining your current stage of development. Investors are entitled to no less than a thorough and brutally honest appraisal of your current status. But since you're only just approaching the starting gate, your current status is—well, loaded with optimism and not much else. You've got a great horse (i.e., photographic skills), but it wouldn't do well to start the race until he is fed. So talk about how great the horse is and why it deserves to be fed.

Be prepared to talk about each of the following items, because you will surely be questioned about them by prospective lenders and investors:

- Products—how a strong portfolio illustrates your available "product line," if you will
- Distribution—how you will acquire customer mailing lists (part 4, chapter 18); Internet and Web site channels
- Market share and influence—the number of photographers versus the number of available assignments
- Customer loyalty—or lack thereof to your competitors
- Technological innovations and advantages—digital experience and application of specialized photo techniques
- Management talent—such as PhotoByte automation and professional help from advisors and mentors
- Employee capabilities—Is there a suitable pool of experienced freelance assistants and stylists, as well as full-time help?
- Photographic equipment at your disposal
- Pricing—how your keen attention to overhead costs will keep your prices competitive and profit margins high (refer to part 6)

Exit Strategy: Payback

Both debt and equity lenders want to know how they can "cash out." On the one hand, lenders want to know how long it will take for you to pay back the interest and principle of a loan. On the other hand,

investors want to know when they will start receiving dividends or be free to sell out for cash.

Most angels want to exercise a cash-out option within three to five years. They will be worried that, even if the company becomes profitable, it may be difficult for them to sell out their shares to you at a good price and make a profit. That's why you have to spotlight an exit strategy.

Whereas really big companies look forward to "going public" so their shares can be sold at a hefty multiple of earnings in public markets, that is not realistically going to happen to a photo business. Medium-size companies often look forward to being bought by larger companies. That's not going to happen either. As a matter of fact, that's why loans are a more viable option than investments when it comes to funding start-up photo businesses. But if you do have some investors, or even a limited partner or two, you need to tell them exactly how they can take their profits out and when. You can construct various exit strategies with your accountant or financial planner and include them in the business plan.

Analyzing Success Factors

Soon, your business plan will leave the fuzzy world of mission philosophies, and accurate financial predictions will take precedence instead. Suppose that one of your financial targets for the coming year is to reach a ten-percent *return on capital*. That's a reasonable goal to state in your business plan because it is quantifiable. You can track your progress each month with the help of an accountant. There is a formula to determine if you have reached it:

$$\frac{\text{Cash Available for Owner Distribution}}{\text{Total Capital}} = \text{ROC}$$

Here's where the concrete factors necessary to reach a goal become evident. Analyzing success factors is an exercise that consists of working back from a defined goal to see how best to accomplish that goal. Say, for example, that two things need to happen to reach your 10-percent ROC target. Your spreadsheet will indicate what they are:

> Revenue must increase annually by $8,000
> Production costs must decrease by $3,000

As you can see, the proposed scenario calls for subdividing your main goal into two separate figures. A forecasted sales increase might logically call for a number of extra assignments to shoot. (You hope you will get to shoot them.) But by indicating additional income from stock photo royalties, you can predict increased revenue without making unrealistic assumptions about the number of available assignments. Such a scenario might seem more reasonable to lenders, and they like to see evidence that you can think in such a rational financial context.

To continue, you might decrease production costs by purchasing—investing in—new production equipment, say a special-purpose lens. While that represents an additional cost, you will no longer have to pay to rent that lens each time you need it. Instead, you can bill clients every time you use it on their behalf until it has paid for itself, and then continue billing it out to make a profit. If you decide, instead, that an outright purchase would use up too much of your capital reserve, taking your projection in the wrong direction, the answer might be to lease the lens instead of buying it, still with the idea of billing its use to clients at a profit.

You might further cut costs by renting out office space in your studio to another photographer, or eliminating the studio altogether. Maybe you can find a vendor who sells film at cheaper prices. There are many possible sales-enhancement and production-cost-cutting measures to consider. An accountant can show you how to put all of these "what-if" scenarios into a financial spreadsheet that an investor can appreciate. More ideas about increasing revenue and cutting production costs are discussed in part 1, chapter 2 and in part 6, chapter 28.

Market Analysis

As previously mentioned, there will be an in-depth discussion about developing a marketing plan in part 4, chapter 16. You may want to refer to that section now, because some aspects of marketing need to be addressed in any business plan. And again, if you don't need seed money and decide to skip writing a business plan altogether, you will still need a marketing plan to effectively operate your business.

Almost every market in every business has at least a few distinctive segments. Photography is no exception. You read about the three primary seg-

ments in part 1: art, social, and media photography. Media photography, in turn, is subdivided into a further three segments: advertising, corporate, and editorial. The latter three segments are distinguished by issues of quality and price, length of assignments, ancillary income through stock photo royalties, and other factors not necessarily having to do with how images are published. These distinguishing characteristics need to be described in your business plan for the benefit of the reader and yourself. You will most likely be specializing in one segment of the market or another. Deeper segmentation means further specialization in the kinds of subject matter you shoot, as described in part 1. Your plan needs to discuss this segmentation and how you intend to cope with any positive or negative affects it may have on your particular practice.

Customer Analysis

It will be necessary to evaluate the various kinds of photo buyers you are targeting. Remember: You will be working in a service-based industry, a "business-to-business" industry. The photographic services you provide are generally targeted at the publishing media. You should describe the nature of those services in your business plan.

In photography, there are not as many variables to consider when analyzing customer behavior as there would be in a business plan that targeted ordinary consumers. Buyers of photographic services are narrowed down, roughly, into the following categories:

> - Advertising agency art buyers, art directors, and creative directors
> - Architects
> - Corporate publicists and media directors
> - Graphic designers: agency and freelance
> - Magazine photo editors and art directors
> - Publicists: corporate and freelance
> - Small business owners

Incidentally, there is a whole range of potential clients who fulfill the definition of a "corporate buyer." They run the gamut from media affairs managers at TV stations, to government bureaucrats, publicity managers for sports teams (little league to major league), chief information officers at Fortune 500 companies, museum curators, and insurance

adjusters. There are, of course, lots of additional categories that fall under the rubric of corporate art buyer. All of them ultimately need photos for one sort of company publication or another.

Since your client base will be comprised of media-related businesses, you may decide to specialize in any one—or in all—of the subcategories listed above. Even if you specialize, you will always encounter clients from time to time for whom you will make an exception, if the job is interesting and profitable enough, including private individuals who may ask you to shoot a portrait. It's a likely bet, though, that that individual will want to use your portrait in a publication, not to hang on the wall.

Within the three major categories (advertising, corporate, and editorial), however, there are hundreds of thousands of possible clients. It's up to you to decide which of those three—and their subcategories of specialty subject matter—you wish to target and in which regions of the country—or the world—that will include. Once you decide, you should explain your criteria in the marketing section of the business plan.

You also need to explain the following:

> - How your photographic services will appeal to the market segment you have chosen
> - How buyers make choices between competing photographers
> - What marketing promotions and media advertising will help you reach the existing base of photo buyers
> - How you will exploit new ideas and technologies for expanding your list of buyers (customers)
> - What size budgets clients have to spend on photographic services
> - How your clients reach buying decisions
> - How your clients will find you

If you don't know how to explain everything listed above, skip that item for now. Come back later, after you have finished reading the sections in this book that give you this knowledge or, at least, greater insight into these topics.

Photographic Services and Benefits

In the concept section of the plan, you briefly described the key features of the photographic serv-

ices you intend to provide. In this section, you should explore those features in greater depth. It is not only important to clearly distinguish your work from that of your competitors, but here is the place to point out any benefits that you can offer your customers in terms of production services. Explain why picking your portfolio represents a significantly greater opportunity for your clients to get the photos they need than the competition can provide.

Positioning

Positioning is kind of a "class-recognition thing." It means: Do you want to be the McDonald's of photography at the low end, a Chili's somewhere in the middle, or Spago at the high end of the scale?

"Low end" is not used in a derogatory way; McDonald's sells "billions and billions" of burgers, and profit on sales is the bottom line. The point is that positioning has to do with deciding, first, which kinds of customers you want to serve, perhaps based on how many of them there are in a particular market segment and their buying habits. Once you make that decision, the best minds in marketing will tell you to offer them whatever it is that they want, whether it's burgers or pâté de fois gras. That decision will help you determine the content of your portfolio, as well as what your prices will be.

This whole process is about picking a marketing strategy. Are you going to shoot lots and lots of jobs at prices that beat the competition, or will you opt for creating an aura of exclusivity, shooting fewer jobs at premium prices? Will you be a low-cost substitute, the quality leader, or merely an equal alternative? Whichever direction you take, you have to explain your intentions in the marketing section of your business plan.

Incidentally, start-ups in particular are more likely to be successful when they focus on a single, highly specific, very narrow target market. Only when you see where the bull's eye is can you take aim and hit it. The investor or lender who reads your plan is fully aware of that, too. The reader will want to see that you know how to direct the full force of your capital resources, as well as your creative imagination, to turning as many members of that market segment into clients as you can. Often this group will not be the sole—or even the largest—market for your product, but it will be the market that, based on competitive factors and product benefits, you feel you can

most effectively reach. You don't have to sell the best if you can sell a lot. If you're aiming for the best quality, you'll have to demonstrate that your margin of profit is high enough to offset a smaller market. That's a practical approach that impresses investors.

Advertising and Promotion

Provide an overview of your promotional ideas. Describe the methods and media you intend to use to tell prospective clients about yourself and your work. Explain why you have chosen these particular methods and media. Quantify your reasoning, e.g., "it has been shown that the response rate is greater by a 12 percent margin for the number of assignments awarded by art buyers who receive postcards instead of calendars." That statistic is fictional, but you can do similar research to come up with real statistics.

If you have developed an advertising slogan or unique selling proposition, mention it here. Outline your proposed mix of advertising media, publicity, and/or other promotional programs:

> ▸ Explain how your choice of marketing vehicles will allow you to reach your target market
> ▸ Explain how they will enable you to best convey the features and benefits of your services

You can choose from amongst a vast assortment of opportunities for promoting your business, from advertising in creative sourcebooks and direct mail to public exhibitions. All kinds of options will be discussed in part 4. But start thinking about them now.

Strategy and Execution

Your business plan will help you develop an outline to support a solid strategy. It will examine the components of the marketplace, describing the way the photo industry works, and point out who your customers are likely to be. It will look first at their needs and then at the benefits that your particular brand of photography can bring them. It will evaluate the strengths and weaknesses of other photographers competing with you and point out specific opportunities in the marketplace that you can take advantage of.

While these steps are aimed at creating a strategy, other parts of the plan describe how to execute that strategy, or how to make it all happen. In this section, you will tell what business structure you have chosen and why it suits you best. Write about

why you have chosen a particular location and about the facilities you have now and will have in the future. Describe the disposition of vendors to work with you, from film labs to camera rental facilities, and their willingness to extend credit. Discuss the opportunity to work with freelance contractors instead of full-time employees to cut overhead costs and administrative burdens. Tell the reader how the photo business works. (You may need to refer first to parts 5, 6, and 7—Copyright, Pricing, and Operations, respectively.) Make it evident that you know your topic well. Anything you can show that saves money and increases profit will do you a world of good. Finally, in this part, you must tell the reader exactly how you will spend the proceeds of your funding; in other words, tell what you will buy (including services), what advantages that will bring, and over what period of time. This description will be reflected in the cash-flow statement in the financials section of the plan.

Competitive Analysis

In today's crowded marketplace, you will encounter serious competition. No matter how great your talent or innovative your marketing concepts, you will lose jobs to other photographers. Your objective is to minimize that loss by maximizing your strengths.

Throughout your plan, you must show that you are thinking realistically about the impact of competition on your own revenue. It's okay to recognize your competitors and even to specifically name them, as long as you have a strategy to deal with them. In fact, anyone reading your business plan would find both you and your plan less credible if you didn't make mention of dealing with the competition.

Turn your competitors into a part of your strategy. Identify circumstances that require you to do things similarly to your competitors, as well as those that allow you the freedom to act differently. You must point out where you will excel and where you anticipate struggle. Then explain how you will maximize opportunities for excellence and minimize difficulties. Don't paint too rosy a picture; investors realize that nobody is perfect. Nonetheless, it's perfectly all right to accentuate the positive differences you bring to the marketplace without disparaging the competition.

This section is important, because you will typically be up against proven photographers who have greater financial strength, name recognition, and established clients. You must explain how you will overcome that handicap, even with the right amount of funding. Describe how you will gain a foothold in the market, and then tell how you will begin to dominate it.

Making Financial Projections

Besides describing how the photo business works and how yours in particular will attract hordes of clients and terrorize the competition, you have to demonstrate how your efforts will translate into dollars and cents. Nothing you can say or write will demonstrate profitability, unless you have numbers to back you up.

It's not really all that difficult to do the numbers. All that's necessary is to make some reasonable assumptions based on readily available market statistics about how much money you will have to spend. (Make a list of what you need, then ask the vendors and service providers what it costs.) Then you can predict how much money you will have to earn (the number of assignments you predict you will shoot, and at what price) before it becomes possible to turn a profit. As a part of that process, you also have to know what your personal living costs are, because they get plugged in to the equation, too. And finally, you have to know a little bit about the techniques of pricing and the strategy underlying those techniques to enable you to predict revenue. You will, of course, read all about pricing in part 6. But in the meantime, and perhaps with the help of an accountant, you will simply plug the numbers you have into a business-plan template, which will spit out some results. These are your projections, or predictions.

These numbers tell you if your business will be sufficiently profitable and when. If at first the results are discouraging, you can go back to the drawing board and adjust the numbers while you are still in the planning stages by substituting either higher prices or lower costs. It is advisable, for instance, to create three different scenarios and present all of them within the plan as contingencies.

The first scenario should be based on the most likely course your business will take. The second should illustrate weak sales, coming in well under expectation. The third and final scenario should show projected sales well over expectations. Each scenario, in the form of a spreadsheet, should proj-

ect figures at least three years into the future.

It is suggested that you obtain professional financial help, not necessarily to make the results of your calculations as accurate as possible, but to make sure you don't exclude any information that a lender or investor might want to see. A professional can also help you format the results in a manner that can be readily understood.

Assumptions and Accuracy

Income statements are included in your plan to illustrate projected sales, operational costs, and profits on both a monthly and an annual basis for each plan year. As for a balance sheet, only an annual one will be necessary. Cash flow statements should be projected both monthly and annually. Don't forget to include any assumptions or additional information you can think of that will assist your readers to understand your projections.

The Assumptions section may precede your spreadsheet projections in the form of a list. Here is an example of the kind of assumption that might be applied to a financial projection: "Sales are expected to drop slightly for the third quarter due to the fact that buyers will be taking summer vacations," or what have you. Lenders will give as much credence to the assumptions on which you base your projections as upon the numbers themselves.

Don't be overly concerned about accuracy. This is not a science; it is an art. It is imperfect. Even if you accept that your predictions are not spot on, you'll learn a lot about the financial side of the photo business, the underlying mechanics, so to speak. Without that kind of understanding, you'll be flying blind. Even a somewhat inaccurate picture is more helpful than none at all, to you and your potential funders as well.

note Two downloadable templates are offered on the Office Depot® Web site.[30] One of them is a text file illustrating the content of a typical "service industry" business plan representing a fictitious company. The other one is a Microsoft Excel® spreadsheet illustrating its financials. It can be modified by you or your accountant for your personal use.

While neither of these examples is designed specifically for a commercial photography business, there are enough similarities for you to get a better idea of what you are trying to accomplish than can be illustrated by this text alone.

See: *www.officedepot.com/BusinessTools/Hot/cds_plan.rtf?SID=3WHWH3G5Q9HN1G3V898UFJV2AD30& PP+ 501001*

Business Counseling and Advice

The Service Corps of Retired Executives (SCORE) is a volunteer organization affiliated with the Small Business Association. Its members provide mentoring and advice on the full range of business topics, including how to develop an effective business plan, analyzing financial reports, creating strategies for growth, securing bank loans, hiring employees, and finding the right accountant. Their services are available twenty-four hours a day, seven days a week via e-mail, and they are both free and confidential. You can search online using keywords to find a counselor with the right experience to help you, including experience in photo-related businesses. If you wish, you can schedule face-to-face meetings. The SCORE Web site[31] features a service that will locate a chapter near you and allow you to make an appointment to meet with a business counselor.

SCORE members may also counsel in teams, with each counselor bringing a specific strength to the table. They may even be available to visit you at your place of business, making them better able learn more about issues pertaining specifically to the business of photography. Contacting SCORE may, in fact, be the best way to objectively evaluate your business plan before you show it to lenders or investors. And, if someone at SCORE likes it, you may get some referrals.

NOTES

28 Word-of-mouth is a useful way to find a business consultant to help you write your plan. With no referrals at hand, however, try the yellow pages under "Business Consultants," "Business and Economic Development," and "Financial Planners."

29 If you have no logo yet, don't worry. It's a plus, but not yet necessary. You will learn later how to obtain one.

30 See: *www.officedepot.com/BusinessTools/Hot/cds_plan.rtf? SID=3WHWH3G5Q9HN1G3V898UFJV2AD30&PP+501001*

31 See: *www.score.org/online.*

10

Accounting versus Bookkeeping

Accountants offer financial advice, mainly about taxes, but they can't tell you how to run a photo business. You don't want to give bookkeeping chores to an accountant, because it would be like paying a brain surgeon to do the work of a paramedic. You must be the manager of your business and either do the bookkeeping yourself or make sure that you assign bookkeeping duties to an appropriate employee (or, in some cases, an outside bookkeeper).

No offense is meant to bookkeepers—or paramedics for that matter—but their task is elementary, especially with software programs like Quicken™ or M.Y.O.B™ to help make it less tedious. However, since bookkeeping is the most direct way to monitor the success of a business, it is recommended that you do your own daily bookkeeping, at least for the first couple of years. (For information about bookkeeping procedures, see part 7, Operations.)

Whether you do your own books or hire a bookkeeper, you will still need the services of an accountant. Tax laws have become so complex that hiring an accountant to prepare your state and federal income tax returns is the best way for a new business to keep up with changes in the tax codes. (Of course, you will use the books you have kept to gain the information needed for filing.) State sales tax laws, too, change often. Moreover, you need to sit down with an accountant at least a month or two before officially starting your business.

Here are some of the issues you must help your accountant understand in order to offer you the most effective financial advice about your start-up:

- ❯ What you do and who you do it for
- ❯ How you do it and who you hire to help do it
- ❯ What you bill your client for: film, props, assistants, stylists, location fees, travel expenses, assignment fee, usage, etc.
- ❯ How long your clients take to pay you

In short, your accountant should read your business plan—or help you prepare it—to completely immerse himself in the nature of your work, to understand its operational strategy. This is when you will decide which legal structure your business will adopt. You will also set up guidelines for keeping records, keeping "the books." Once that is done, you can schedule a regular series of meetings. They don't need to be too often, and your accountant will be sensitive to the issue of your available capital, that you probably can't afford too much of his time at the

very beginning. But you should schedule at least enough time together to make sure you're set up securely, to avoid compromising future operations. A quarterly meeting will most likely be adequate for your first year in business. In the meantime, if you have questions you can always call.

Choosing an Accountant

Not all accountants are certified public accountants. Make sure yours is a CPA.

All CPAs have passed a test given by a government agency of the state in which they practice. They have received a license to practice, just like a doctor or a lawyer. They are, in fact, "certified" by the government to be competent.

To find a CPA, ask your colleagues and other professionals with whom you work. Ask your banker. Look in the yellow pages under "Accountants" or "Financial Services," and interview several CPAs in their offices to determine who fits best with your business.

11

Buying
Equipment

The best advice about buying equipment is financial advice: Don't spend money to acquire any equipment that your business doesn't need right now. The qualifiers are the words *need* and *now*. That means, if whatever you are considering to buy can't be used to make an immediate profit, you really don't need it.

Photographic Equipment

The photo equipment you buy represents the largest chunk of start-up capital you will invest in business hardware, or *fixed assets*. It will be a long-term investment, too, one that will tie up, or use up, much of the money you just worked so hard to raise. You probably won't recover the money you spent to buy that equipment for several years. (That should be reflected in the financial section of your business plan. Talk about it with your CPA.) Accordingly, you should avoid spending money on anything you can't be reasonably sure will bring in a significant increase in either revenue or productivity over the course of its useful life, even if not right away.[32]

Most beginning photographers are eager to acquire cameras and all of the paraphernalia that goes with them. Well, of course, you can't *be* a pho-

tographer without having enough equipment to shoot your assignments. In fact, the minimum setup you will need is discussed at the end of this part. Nonetheless, be very careful about tying up too much of your capital resources in photo gear that you may be proud to own, but doesn't pay its own way. If it won't help bring home the bacon, you don't need it.

For example, if you want to be a photographer of racecars, you may need an especially long, fast lens. You know you could create wonderful pictures if you had that 1,000mm f/1.0 Darklux lens that costs umpteen thousand dollars. But, first of all, the next big race within range of your travel budget is a year off. You are not even sure you can get credentials and an assignment to shoot it. Besides, before anyone will consider hiring you to cover a big race like that, you have to pay your dues by shooting some of the local flat-track events and the county stock-car circuit. Then you'll have a racing portfolio to show. If, on the other hand, you spent all of your money up front on the Darklux, you might not have enough working capital left over to build up your portfolio. In that case, you probably won't be offered a chance to shoot the kind of race where you'd need a lens like that anyway.

Now, look at the other side of the coin. For whatever reason, *you* have been chosen to photograph *the* souvenir brochure for the Indianapolis 500 Motor Speedway. If you already know the following two things are true, you might just want to go out and buy that Darklux lens right now, with no pangs of guilt whatsoever:

> ‣ You are going to make a huge profit on this job, enough to pay for the lens and then some
> ‣ You have a contract to shoot seven consecutive Indy-type car races with just as high a margin of profit

If you know you're only going to get a crack at shooting the brochure, but with no guarantee of more than a single additional race, you should consider renting that Darklux instead of buying it. Even if you know you will be shooting lots of races, it's still a good idea to rent, because you can make a profit every time you bill it back as a line item expense to your client. (More about that in part 6, Pricing Photographic Services.)

Learn to honestly assess whether the acquisition item in question is something your business really needs or something that you, personally, merely want. It's hard to make that kind of decision, but you must. Your primary responsibility is to earn profits now that you've become the owner of a start-up business. You've got enough debts to pay already.

Practical Considerations

While it's not likely that you'll be lucky enough to start out with every piece of equipment on your wish list, there are certain things you cannot do without. The subject matter you intend to shoot has already been described in your business plan, and that will dictate exactly what you need. Your start-up budget will include enough capital to buy it.

Unfortunately, no one has yet invented a practical 4×5, roll film, motor-driven, lightweight, hand-held, auto-focus, auto-exposure, perspective-control view camera. Consequently, photographers need to choose between various types of camera formats and systems to suit their needs and the needs of their clients. That means they need more than a single camera and lens to solve a myriad number of photographic problems. Generally, it is expected that

you will own enough basic equipment to support the type of work you show in your portfolio. Additional or rarely needed equipment, that which is used to produce out-of-the-ordinary shots, can be rented and then billed to your clients.

To illustrate, consider a hypothetical situation. You have been assigned to photograph an environmental group portrait of a basketball team inside a gymnasium. That in itself is not unusual, because you have been showing group portraits in your portfolio. You often work on location, too, and routinely use electronic flash. You own a modest system of one power pack and three lamp heads. Since that is obviously not enough "juice" to illuminate both the gym and the team, you have to rent some additional lighting and grip equipment. No client would consider it unusual to be billed for the rental of that extra equipment. Of course, this aspect of the assignment would have been approved beforehand.

Your primary consideration must be obtaining the basic equipment you need to do routine assignments. You'll want to consider having some degree of backup capability, too, because as a professional, there is absolutely no excuse for not executing and delivering a publishable photograph. If equipment fails in the middle of an assignment, you have a responsibility to keep on shooting. Any mistake that causes you to miss *the* shot could prove inordinately expensive to your client. And in this business, you rarely get a second chance.

Some photographers specialize in shooting with one film-and-camera format as a matter of style. Others choose a different format to match the assignment at hand from amongst a large array of gear. Referring back to the hypothetical example above, it's a common-sense choice that, if you also intend to shoot the basketball team in action, it would be impractical to use a 4×5 camera (unless you have something special up your sleeve). It's more likely that you would turn to a 35mm setup for speed and efficiency. You have the option, however, to shoot the action on 35mm and the portrait on 4×5, using both formats as appropriate. But that might require even more rental strobes, because the smaller apertures of a view camera lens require more light.

The decisions you make about equipment will not only affect your start-up capital budget, but your shooting style and your pricing, too. If you intend

to shoot more than one format, you will increase your overhead, (i.e., the cost of operating your business), by spending more money on cameras. At the same time, however, you can show your clients that you have the increased capability of shooting in different formats. Some buyers might consider that a competitive plus, and some could not care less. Those are the kinds of factors you have to weigh when pricing jobs, which will be dealt with in part 6. The point for now is that there is no cut-and-dried formula for choosing what equipment to buy *first*. The only generalization one can make is that the longer you're in business, the more equipment you'll accumulate.

It is practical to make two fundamental distinctions that will help you narrow down your selection of an affordable and basic set of equipment. First, you will either be a studio shooter, a location shooter, or both; and second, you will either have your own darkroom or not.

Basic Setup for Both Studio and Location Shooters

Even if you're just starting out, it's likely that you already have a 35mm camera. It can become the backbone of a system that accommodates either studio or location photography. (Certainly, you can use small formats in the studio as well as large formats on location.) Along with that first camera body, three lenses are mandatory: wide-angle, normal, and telephoto. They will each have a modest maximum aperture to keep costs down; faster lenses are more expensive. The wide-angle and telephoto will be modest in focal length for the same reason. These are your typical choices:

> - 35mm f/2 or 28mm f/2.8
> - 50mm f/2 or f/1.4
> - 105mm f/2.5 or 135mm f/3.5

If you are, indeed, limited to three lenses, it's a good idea to stretch out your focal-length selection by acquiring the wider 28mm and longer 135mm to get the maximum differential in effect; although, if you anticipate shooting in low light on location, the 35mm and 105mm lenses will be more useful, with their wider maximum apertures.

You will also need three basic black-and-white filters: red, yellow, and green, plus three skylight filters to protect each of your lenses when you're shooting color. Don't forget lens shades to eliminate flare and keep fingerprints off. You'll need a small electronic flash unit that can either be attached to a hot shoe or used off-camera with a sync cable. Get a cable release and a tripod for long exposures, too. Incidentally, the tripod, as you will discover, is just as valuable for helping to carefully compose images in the viewfinder as it is for holding the camera steady. And don't forget a light meter, probably one of the combination incident-and-reflected variety. A spot meter can be acquired later.

Eventually, you should add a second camera body. A motor drive to go along with it would be a good idea. It should fit onto either camera body. (Stick with a single manufacturer's system for all your cameras and lenses of the same format.) Eventually you will add a set of close-up rings or a rail-bellows for close-up work with your existing lenses. A better choice, when you can afford it, is a macro lens. The next lens to buy might be a zoom, to more quickly fill in the missing links in your focal-length repertoire and provide you with a means to do some special effects by changing focal lengths at slow shutter speeds. A waist level finder for your camera body will come in handy whether you're looking at a tabletop setup in the studio or crouching on the ground for a low level shot on location. You'll need a sturdy case or camera bag to transport it all, too.

Eventually, you will begin to round out your arsenal of lenses with additional individual focal lengths of various apertures. There will be wider ones, longer ones, and faster ones, even special effects lenses, such as perspective control lenses that allow shifts or swings like a view camera to control perspective in still life and architectural shots. You may eventually acquire a radio-control device for the remote operation of your camera, or a special body capable of shooting hundreds of frames of film per second. And there are lenses so long or so wide that you can a completely annihilate perspective and distance. Then, there's the world of digital cameras to think about.

Basic Studio Setup

In addition to the basic setup listed above, you will probably want to furnish your studio with a 4×5 view camera and a normal lens, e.g., 150mm f/5.6. These

two items are the preeminent studio instruments, the real workhorses. The camera is capable of maximizing image control with swings, tilts, and shifts of both the film and lens planes.

View cameras vary in price quite a bit, with difference determined by their quality of construction as well as any number of extra features to control the precision and the extent of movements. It's probably wiser to stick with a monorail design instead of the folding kind (either wooden or metal), because the former gives you greater perspective control capabilities. However, the folding kind is more portable, if you plan on doing any work away from the studio. You'll need at least a dozen or so sheet film holders, a dark cloth, a focusing loupe (magnifier), and the always-indispensable Polaroid film back for testing exposures and compositions.

The next most important items to acquire are both a wide-angle and a long lens (plus lens boards and shutters) for your view camera. A 90mm and a 250mm will probably do. Don't pay a premium for the fastest glass. Apertures of f/6.8 and f/12 will be adequate for now, especially if your budget is tight. Eventually you will acquire an extreme wide-angle lens, say, 65mm f/8 with its accompanying wide-angle bellows, or a specialized wide-angle, large-format camera. Maybe, one day, you'll enjoy the convenience of using of a focusing prism instead of a dark cloth. You can also think about acquiring a larger, 8×10 camera and its accoutrements in the future. Since you're shooting with a bigger camera, you'll need a bigger tripod, too.

But don't think you have to go bigger. Taking a step down to a medium-format camera may give you just the technical advantage you need in many studio situations. What that means is that, for instance, if you need more resolution in the film than you can get from a tiny 35mm transparency, but the cost of 4×5 and bigger is either prohibitive or not necessary from a profitability point of view, a 6×6cm transparency might just fit the bill. Medium format might provide all the creative advantages you need over 35mm, with a considerable cost savings over larger formats.

There are all kinds of specialized furnishings to include in a studio, if you have one. But one that cannot go without mention is a rollable, stand-up tool case (the kind you find at Sears) that will prove to be indispensable for holding filters, light meters, tape, rulers, small electronic flash units, clothespins and clamps, etc., as well as regular tools. You will also need a small refrigerator to store film.

Lighting and Grip Equipment

The word "photography" means, in Greek, "to write with light." There is no particular kind of light that is better or more important than another, although there are many different qualities of light. Quality ranges from color (color temperature) to duration (continuous incandescence or short-duration, stroboscopic flash). When asked what kind of light he uses, the great portrait photographer Arnold Newman has always answered, "I use 'available light.' Whatever is available, I use it, whether it's candlelight, fluorescent light, sunlight, moonlight, flash, or a table lamp."

You can shoot outdoors with strobe lights or indoors with natural light coming through a window. You have to consider whether your subject matter is inanimate or alive, and whether it may or may not be necessary to stop action (e.g., will it move or can it wilt?). If you're shooting ice cream, it's more likely you'll need to choose electronic flash over hot incandescent lights. The kind of film you shoot will play a role in your decision, too—whether you shoot primarily color, black-and-white, or both. Owning lights, either the incandescent variety or electronic flash, is not a requirement—*unless* the kinds of jobs you will be hired to shoot demand it. That's something only you will know. It's a creative call. Again, this should be thought out ahead of time, written into your business plan, and included in your capital budget. Therefore, at the very least, your lighting equipment might consist of a few collapsible reflectors. At the other end of the spectrum, you could own tens of thousands of watt-seconds of electronic-flash capacitors (strobe packs) and dozens of flash heads.

The reflectors are a must no matter which way you go. But as an economic exigency, a fundamental choice must be made between artificial and natural light. This, too, is a creative call, because the effects you can achieve with one or the other are quite different. If you are primarily a 35mm location shooter—if you need lights at all—just keep them to a minimum during the start-up phase of business, using an assortment of small, battery-powered strobes in combination with reflectors and portable

stands. Later, you can start acquiring Dynalites, Balcars, Normans, and Elinchroms, or some portable hot lights.

If you have lights, you'll need grip equipment. That means stands, reflectors, clamps, gobos, flags, sandbags, umbrellas, gaffer's tape, colored gels, tripods, etc.

Location Photography and Photojournalism

Location photography means you can take your studio with you wherever you need it. Not to put too fine a point on it, but don't forget to budget for all the transportation cases and dollies you will need to move your equipment from place to place. That alone can cost thousands of dollars.

There are a number of different kinds of photo equipment cases. They range from canvas camera bags (you'll certainly need a couple of different sizes), to the aluminum suitcase variety, to molded fiberglass shipping cases with watertight seals, to custom-built, plastic-laminated, plywood-and-steel road cases. The latter evolved as a photographic specialty made by several companies in New York and Los Angeles who built instrument cases for traveling rock 'n' roll bands.[33] The photographers who shot those bands quickly realized the benefits of keeping their cameras protected in these kinds of cases, especially those who had watched airport baggage handlers drop their cameras thirty-five feet off a conveyor belt exiting a 747 jumbo jet. These cases are especially handy for lighting and grip equipment. They range in cost between about $150 and many hundreds of dollars apiece, depending on size and features. Some of those features include special locks, multiple handles, foam-padding, custom compartmentalization, and heavy-duty wheels. Although some manufacturers now keep common sizes and internal packing configurations in stock or distribute them through retail camera stores, these kinds of cases are mostly custom made to fit your equipment.

note Aluminum suitcases, the kind manufactured by Halliburton, are useful, but not recommend for air travel, unless you keep them in your sight at all times; thieves know what's inside.

Obviously, you have less to worry about if you shoot news instead of editorial illustration or portraits that require lighting. A news photographer working for magazines—or any kind of photographer whose style demands no more than a modicum of equipment—can travel with all his equipment fitting into an over-the-shoulder camera bag.

If your style of shooting requires less equipment than someone else, that doesn't mean you'll have less earning power. The other side of the coin, however, is that the guy with twelve cases is prepared to solve technical problems that cannot be addressed by Mr. Onebag. But that's a marketing issue, not a cost issue. It still boils down to buying only the equipment you *need*, not just what you want.

Darkroom

To process, or not to process: That is the question. Whether 'tis nobler in the mind to suffer the slings and arrows of outrageous isolation or take arms against a sea of sodium thiosulfate, and by opposing, end thy brown fingernails.

Well, you get the point. It's more a question of economics than bad smells and brown fingernails. The more time you spend in the darkroom, the more time you don't spend marketing your services and using them—*unless*, again, this turns out to be a profitable pastime for you. If you make loads of money processing film and making prints, do it! Of course, you may just enjoy it too.

There are so many variables involved in planning a darkroom—let alone deciding between Ektachrome and black-and-white or both, and let alone adding digital capabilities and a whole array of scanning, digital storage, and computer equipment—that they will not be discussed in this book, except to remind you, yet again, to figure out what you need ahead of time and include it in your capital budget. The alternative, of course, is to send your film to a commercial photo lab. Or you may decide to hire a lab technician to process your film in-house. (The exigencies of that decision are discussed in part 1, chapter 8: Outsourcing.) Even if you plan to outsource your film and print processing, remember to include those costs, too, in your budget.

What Brands to Buy

Another consideration is the cost of various brands of cameras, i.e., whether to go for the top-of-the line

Canons, Leicas, and Nikons or settle for "lesser" brands. Even the top brand names have models that are less costly than their high-end professional ones. The primary criterion to consider in that context is that the more expensive cameras are usually designed for the more rugged use a professional might subject them to. These top-end models are also designed around a systems approach—that is, a complete interchangeability of parts. They also take advantage of more technology, such as auto-focus and auto-exposure. Do you need these capabilities? Again, that is for you to decide based upon the types of photographs you will be shooting. You get what you pay for. (See Deciding On a Major Purchase below.) Remember this: A great photographer can make great photos with a pinhole camera or a Kodak Instamatic. The only reason professionals use expensive equipment is for the versatility and reliability it provides. The reason they demand both versatility and reliability is that professionals cannot afford to make mistakes, and they must be prepared to shoot absolutely *anything*. That may be an oversimplification, but it is nonetheless true.

Computer Equipment

Computers have practically become commodities; they are relatively cheap, and almost any example on the market is capable of performing the tasks you expect. The rule of thumb in buying a computer used to be: Buy the software you need first; then buy the computer that runs the software. Well, insofar as the photo business is concerned, the software is free, and you will not find anything else that works as well as PhotoByte at any price.

Desktop computers are cheaper than laptops (or PowerBooks, in Mac parlance). But laptops are more convenient, because they are portable and can be used while traveling. A PowerBook even allows you to run around your office or studio while remaining connected to the Internet without wires. That's something no other computer can do, as of this writing.

You will not necessarily lose any features by using a laptop instead of a desktop computer. You can augment a desktop computer with a very large monitor, larger than even the biggest one available in the world of portable computing. But large monitors are expensive, costing anywhere from $1,000 to $3,000 for a top-of-the-line flat-screen 21 inch

model. Such a screen is capable of displaying a full 8×10 page of text (e.g., a letter) without cropping vertically, perhaps even two pages side by side. You can also view vertical, scanned images up to that size without cropping. Moreover, if you plan to do much digital imaging now or in the future, a desktop computer may allow you to attach more peripheral devices that relate to your graphic-manipulation capabilities. One day, you may need both kinds of computers, even several networked together.

As for printing, you might consider owning just one printer, opting for an inkjet color printer instead of a laser printer. However, despite the inkjets' capability to output near-photographic-quality prints, as well as their attractive prices, what is not immediately evident is the high cost of buying replacement color ink cartridges for those printers. If you use a color inkjet printer as your principal, or only, output device (for documents as well as images), you may be surprised to learn that the cost of replacing black ink cartridges (i.e., your letters and invoices are printed, for the most part, in black ink) could cost as much as the difference in price between the inkjet and a laser printer after about a year or so. On the other hand, that extra cost may be acceptable to you if you print your own color logos on your letterhead (although professionally-lithographed stationery will invariably attain a higher level of quality for a more professional look).

The point is, if you can afford it, the best choice is to have *both* an inkjet and a black-and-white laser printer, each to perform its own separate and appropriate task.

Deciding on a Major Purchase

First of all, what does a "major purchase" mean? It means that the item(s) in consideration will have a service period of more than a year. That certainly qualifies cameras and lenses. For anything that will have a significant useful life, do what is known as *capital budgeting*. Here's how.

Draw the line for your analysis, with the result being either a yes or no, at a certain dollar amount, depending on the size of your business. You can make it one thousand dollars or ten thousand dollars, or any other amount that makes sense to you. Anything below the amount you choose should be treated as a normal budget cost. Anything above will

warrant a *cost-benefit analysis*. If the item will last for less than a year, it's probably not worth analyzing the purchase at all. You might just decide to get it spontaneously. But never let impulsiveness rule your decision. And don't fool yourself by applying the capital-budgeting criterion to multiple, individual items over the course of several weeks or even months! If you add them all together, you've just busted your budget and defeated the purpose of the whole exercise.

Cost/Benefit Analysis of Major Purchase

When you really are ready to make a major purchase in the thousands of dollars, commit yourself, first, to performing a thorough cost-benefit analysis. Ask your CPA, again, for help if you need it.

The analysis will indicate if the cost of the acquisition will be fully recovered through anticipated increases in earnings or savings throughout the equipment's useful life. In other words, you need to ask yourself if the benefits outweigh the costs. If not, don't buy it.

Keep in mind that the cost of equipment purchases goes straight to your bottom line. Therefore, depending on your profit margin,[34] a $1 savings in acquisition costs could have the same effect on your profitability as a $5 or greater increase in sales. From another perspective, saving that dollar will give you an additional dollar to spend on promoting your business.

Letting Uncle Sam Help Buy Your Equipment

One of the factors to consider in your analysis is your tax situation. The government wants to encourage entrepreneurs to invest in their own businesses.

Your CPA will tell you—although this is unlikely if you're just starting out—if you've earned enough revenue so that your tax bill will be too high unless you find some additional, last minute deductions. The federal government offers an allowance for equipment purchases that can be written off all at once instead of depreciated gradually over time. If you would rather buy that Darklux lens than pay its price in taxes to the government, and your CPA says it's okay, then you're a lucky photographer!

Leasing Equipment

This is a matter to discuss with your CPA or financial planner, but if you're strapped for cash, leasing may be a prudent alternative to buying, because you don't have to pay for everything up front. And since you're not really *buying* anything at all to keep, the total price of the lease may be less than the total price to purchase the same equipment. At the end of the lease, you can acquire the newest, latest, and greatest replacement models—especially useful if you're leasing computer equipment that seems to experience obsolescence every six months or so. The downside to that is that computers are so cheap, a lease might cost just as much as buying. Anyway, there may also be tax advantages to leasing, if you're earning enough revenue to offset the lease payments as business write-offs. The total amount of items purchased outright that you can claim as tax deductions is limited. Lease payments are not.

Always compare leasing to purchasing from a purely economic point of view, taking both cash flow and taxes into account. Most equipment leases—and vehicle leases, too—give you the option of purchasing the equipment at the end of the lease for a predetermined market value.

NOTES

32 *Useful life* is a term that has to do with *depreciation*, two more things to discuss with your CPA. Once you've paid off a piece of equipment, every penny you earn by using it from that time on is pure profit.

33 Anvil Case Company: *http://anvildealer.com/*; Big Deal Custom Casings: *www.bigdealcases.com*; SCS Cases Company: *www.scscases.com/main.htm*; Cases USA: *www.cases-usa.com*; Schauer Sales, Inc.: *www.schauersales.com*.

34 Profit margin is net profit after taxes divided by sales for a given twelve-month period, expressed as a percentage, whereas net profit roughly equals all the money you take in minus all the money you pay out, including salaries and taxes. So, if your business earns a net profit of $10,000, having billed a total of $100,000 on photo assignments for the year, your profit margin is 10 percent.

12

Insurance
Issues

A wise man once said, " It is not variety that is the spice of life. Variety is the meat and potatoes. *Risk* is the spice of life."[35] When you go into business for yourself, you're not looking for either security or conformity, and you do take a financial risk. Although the potential rewards outweigh that risk, it never goes away completely. And you will never come by any rewards unless you take some risks. The process of discussing insurance issues is all about assessing the amount of risk you are willing to accept for property loss.

An insurance policy can be explained as a financial device that allows any business or individual—for a price—to share some of that risk, to dilute it, if you will. In case luck doesn't rest on your shoulder, insurance is the best protection you can have from the worst financial consequences of foreseeable—but nonetheless sudden, regrettable, and not necessarily inevitable—events. It minimizes their impact on the operation of your business. In short, insurance acts as a hedge against accidents.

There are, of course, many accidents waiting to happen in any photo business. You could lose your film after shooting a big assignment, or the lab could screw up the processing. That diamond ring you were shooting for a jeweler's brochure just dis-

appeared. Your camera fell off a catwalk in a factory and landed on a worker's head. You suffered a debilitating illness or physical accident that keeps you bedridden and unable to work for six months. Someone broke into your office and stole your cameras. The lion posing with the fashion model mauled her face. Someone barely recognizable in the background of a photo published in a magazine story about child molestation is suing you. Your rep loses your portfolio. Your assistant runs over a pedestrian while driving your minivan. The airline loses your luggage on the way to a location shoot. Overnight, the fire-suppressant sprinkler system in your studio goes haywire and inundates all of your photo equipment, along with your client's merchandise. That'll feel like a pretty cold shower on you, too. Oh, yeah! That's just a taste of what could ruin your day.

The Reason for Insurance

Accidents can be minor, without any serious aftermath, or catastrophic. They can bankrupt you personally. The idea behind insuring against accidents is to prevent the worst possible scenario from putting you completely out of business. Insurance pro-

vides a source of capital, a backup, if a mistake costs you a significant sum of money. If you lose a lens, either by your own negligence or outright theft, it's probably better to replace it out of your own pocket than to file a claim. (See Deductibles later in this chapter.) Save any insurance claims for losses that could wipe you out. If you file too many claims, even small ones, the insurer may cancel your policy.

An insurance policy is best designed to help you survive a mishap and get you back on your feet. It's not necessarily worth paying the cost of premiums that protect the exact status quo of your business before it suffered a loss.

Choosing an Insurance Agent

Insurance agents are not claims adjusters. Nor do they work for the insurance companies. They are small business proprietors, just like you, whose revenue comes from commissions on the sales of policies to their clients. The insurance companies they represent pay them commissions, just as you would pay your rep a commission on assignment fees for the jobs they bring in.

The companies that an insurance agent represents are called *underwriters* (or sometimes *carriers*). The underwriters are the actual financial institutions that accept your premiums. This revenue is reinvested by the underwriters, for example in the stock market, to earn a profit. When you suffer an insured loss, payment comes directly from the underwriters.

To find a good agent, start by asking other photographers. You might also ask for a recommendation from professional associations to which you belong. Your last choice (which may sometimes be necessary) would be to go to the yellow pages. During the course of making telephone inquiries with various agents, ask how many photographer clients they represent. Make appointments to meet with several of the most promising contacts.

You will want to have insurance for many different types of risks. Policies you may need include basic protection, personal health coverage, disability, general liability, and workers' compensation. However, at the start of your career, you may not be able to afford full coverage. That's when having an excellent agent can really be a benefit. The agent can guide you through which policies you need right away, what amounts of coverage you should have, and what you can plan to add later on. Agents earn their living from commissions on policies sold, so they should be eager to help you and keep you as a satisfied client. In order to do this, they should shop among underwriters to find the best policies for your special needs.

All about Insurance

It's important to consider what your insurance needs might be before deciding on a type of policy and the extent of your coverage.

Types of Policies

Many new photographers working from home have relied upon a simple renter's or homeowner's policy to cover all of their belongings. They may have taken it for granted that their camera gear was included. A rude shock would have been in store, however, if they had not disclosed to their insurance agent that they were using that gear professionally. It might turn out, after making a claim and expecting to be reimbursed, that their equipment was not covered after all.

Such a circumstance would have required the purchase—ahead of time—of a *camera floater* on a nonbusiness policy to insure against the loss of or damage to any professional photo equipment. Floaters cover only property that is itemized on a list. That list, also called a *schedule* of insured items, must be updated regularly as you buy new items. It can also be updated temporarily, such as when you have to rent some special equipment. As long as you disclose the fact that you own (or are renting) this equipment and use it professionally, you should be securely covered. However, once you formally establish a business identity, you need to change your policy to reflect its status.

Basic Protection

A basic professional policy should protect your photo equipment and the contents of your office. At the very least, it should cover the cameras you own, your lighting and darkroom equipment, and your computers against fire, theft, and water damage. The amount of insurance you pay for is determined either on a "replacement cost" basis or on a "fair market value" basis. The former covers everything

for the amount it would cost to replace new (i.e., without any allowance for depreciation). The latter takes into account what the equipment is actually worth, based on its age. You would be able to replace it with like-valued used equipment.

"Replacement cost" (also called "stated value") is the more expensive choice, but it provides greater coverage. The replacement cost can be anything you say (within reason of course); your equipment does not have to be itemized on a schedule. You'll pay a premium based on whatever total value you declare. That also means, if you lose your equipment and want to replace it with all brand new stuff, your premiums will be higher, because it will cost more to buy new than used. Alternatively, with the "fair market value" method, your premiums will be lower, but you may have to shop around to find replacement cameras that are in good enough shape to suit your needs.

The lower premiums of a "fair market value" policy may be the best choice if capital is in short supply. When you weigh your options, don't lose sight of the fact that the idea here is merely to keep costs down, while, at the same time, preventing an unendurable loss that could keep you from getting back on your feet.

Incidentally, your insurance coverage should extend worldwide if you travel. Typically, such a policy will also protect owned office furniture against fire and water damage. Theft of furniture is often excluded from the basic price of such a policy.

Personal Health Coverage

Health insurance must be considered part of your basic coverage. If you do not already have health insurance, perhaps covered by a family plan, a basic individual hospitalization plan, such as that provided by either HealthNet, Blue Shield, or Blue Cross—or any HMO plan—will suffice in the beginning. But it is not sufficient to cover a major medical emergency. Therefore, you will eventually have to obtain major medical coverage, which includes extended hospital stays, prescription medicines, outpatient care (visits to the doctor), intensive care, and major surgery. Once you have obtained a policy that covers routine sickness, injury, and "wellness" checkups, the added cost of major medical coverage is not significantly greater. And don't forget dental care!

Disability

Disability insurance can be an extremely important issue for a small business owner like you. Unless you can generate enough income from the licensing of images in your stock photo archive, your physical ability to work and earn income is tied directly to your health. Becoming sick or disabled, even for a short period of time, can create a severe economic hardship. Your agent can advise you not only about disability insurance, but life insurance, too, and should be able to offer advice about how to start planning for retirement.

General Liability

A commercial, general liability policy protects you from lawsuits for either bodily injury or damage to someone else's property within the United States and Canada. It generally applies to third parties; that is, it excludes employees.

Even if you cannot be proved liable for damages due to an accident, it can be very costly to fight a claim against you in court. Anyone can sue you if they want to. Your legal defense bills will not be reimbursed, even if the plaintiff who sues you loses the case. Furthermore, as a matter of practical importance, your own clients may make it impossible for you to work without proof of liability insurance. They, too, would be exposed to liability if an accidental injury occurred on your shoot, since they hired you in the first place. Commercial photographers are also required to show proof of liability insurance before they are granted permits by government authorities to shoot on public property, e.g., city streets or national parks.

Although it sounds all-inclusive, general liability doesn't cover all the bases. There are explicit, and often critical, limitations inherent in most commercial insurance policies. As already mentioned, general liability does not pertain to employees, who are supposed to be covered by a separate workers compensation policy. (See below.)

Property damage or personal injury resulting from the use of an automobile or other vehicle is usually excluded from a general liability policy, too. Read the policy! Ask your agent to explain whatever you don't readily understand. You must watch out for language that excludes claims resulting from improper administrative paperwork, for instance, involving model releases, as well as copyright-

infringement or invasion-of-privacy issues. Your agent will recommend extended coverage appropriate to the nature of your work, if coverage is not typically included in the general liability policy. Additional types of coverage are listed at the end of this chapter.

Workers' Compensation

Workers' compensation insurance covers accidental injury to employees suffered on the job. If you have any employees, even one, workers' comp is not a choice; it's mandatory by law in most states. (Check with your insurance agent.) Furthermore, the circumstances under which someone you hire is considered to be an employee are subject to interpretation, insofar as assistants, models, and stylists are concerned. The distinction between an independent contractor and an employee is sometimes vague and subject to debate. Its importance is underlined by tax implications. That issue will be discussed in chapter 38 of part 7, Operations. Independent contractors are obliged to carry their own insurance.

Regardless of employment status, anyone on the set or on your premises can sue you for an injury. A photographer with both general liability insurance and workers' comp is better protected. Many agents recommend that professional photographers own both kinds of policies and that they be purchased from the same underwriter to avoid arguments about responsibility if a claim arises.

Premiums

A *premium* is the price you pay for an insurance policy. It is determined by the scope of coverage you require and by how much equipment you own. One usually buys insurance on an annual basis. It is paid in installments, either monthly, quarterly, or biannually.

A basic photo-equipment package like the one described above will typically cost between $800 and $1,000 annually for a beginning photographer without an extraordinarily large amount of professional equipment. Premiums increase proportionally to the amount of equipment you insure and the severity of risk. The premiums for a still life photographer who works primarily out of a studio will be lower than for a photojournalist who routinely covers war zones.

Figure on paying somewhere in the neighborhood of $1.80 to $2.40 for every $100 of equipment you want to insure. That rate drops to about $1.35 to $1.75 per $100 of equipment value for everything over a threshold of $15,000. The rates vary depending on where you live, even according to which neighborhood you live in. Higher rates apply to areas of higher statistical losses. Adding liability coverage will increase your basic premium, too. But it is important.

As for health coverage, prices vary according to age, but also by state, county of residence, and the size of the deductible you choose. (See Deductibles below.) Typically, however, a nineteen to twenty-nine-year-old photographer might pay approximately $100 per month for HMO coverage with $45 co-payments for visits to a doctor or an emergency room. To add catastrophic illness coverage to that policy would cost somewhat more. (The addition of a specific kind of coverage to an existing policy is called a *rider*.) As age increases, premiums may increase dramatically.

Workers' comp can range between $500 and $1,000 annually. A disability group rate for a photographer under thirty years of age[36], with a thirty-day waiting period (before benefits kick in) and two years of benefits, will cost $12 per $100 of benefits. Lab error coverage is about $170 annually. Because there are so many variables, it is difficult to make generalizations about the cost of premiums. Your agent can give you an accurate price quote tailored to your specific insurance needs.

Deductibles

As you just read, the purpose of insurance is to protect against catastrophic, accidental losses, not incidental losses that, while they might temporarily strap you for cash, won't put you completely out of business. Therefore, when looking for the best value in purchasing insurance, for both business and health coverage, it is best to obtain a policy with a relatively high *deductible*.

A deductible represents a predetermined but limited amount of money that you pay toward your own losses. When that amount is reached and surpassed in a claim, the insurance policy kicks in and pays the rest of it—everything, that is, over the amount of the deductible. For example, if you have an insurance policy worth $10,000 with a $500

deductible and you have an $8,000 loss (or an $8,000 medical bill), you must pay $500 out of your own pocket. The insurer will pay $7,500. When it comes to insuring camera gear (not health insurance), you should think twice before filing a claim for $525! The whole idea of business deductibles is to discourage you from filing claims for amounts too small to keep you from conducting further business. Small and frequent claims are an unacceptable administrative cost to the insurance companies. If you buy a policy that lessens that problem for them without jeopardizing your own survival, you will be offered a savings on your premiums in return. The rule of thumb is, the higher your deductible, the lower your premiums.

Buying Economically

Not all insurance underwriters charge the same prices for similar policies. Moreover, some offer coverage for certain things that others do not. That is particularly important to professional photographers who have unusual insurance needs such as photo-lab error protection. But you don't want to pay for insurance you don't need either. So make sure your insurance agent understands your special requirements. Explain them. Then the two of you will shop around for the best combination of price and coverage.

Discounted rates are available to groups of insurance buyers that might not be available to individuals. Some insurance agents have been able to consolidate their photographer-client base into large blocks, thereby enabling them to negotiate better prices. By representing a large number of customers, they have more buying power. If you cannot find an agent with such buying power, another alternative is to buy insurance through one of the two major professional trade associations: the American Society of Media Photographers (ASMP) or the Professional Photographers of America (PPA). Their buying power comes not through their status as associations per se, but by giving their respective agents the right to negotiate deals with underwriters on the strength of their consolidated memberships. The general idea remains that a large group of photographers with similar insurance needs can get better prices negotiating collectively.

Every photo-insurance package includes benefits offered by one underwriter or another—often several—who specialize in various types of coverage, from short-term medical, to life insurance, business liability, and personal accident. In other words, various types of insurance from separate sources are often combined into an overall policy to cover all the bases. While one underwriter may insure against camera loss, it may not cover business liability or health insurance. Therefore, an agent will put together a policy that combines several underwriters to provide coverage tailored to your business at the best price. The names of some of these underwriters include U.S. Life, The Hartford, Reliance Insurance Company, Allianz Life Insurance, Fortis Insurance Company, Framers Insurance, State Farm, and Fireman's Fund. There are others.

EXERCISE ----------------------------------

Creating a Schedule of Camera Equipment for an Insurance Agent

To create a new photo equipment record:

> From the Main Menu, click the *Equipment* button.
> Click the *Add New Item* button on the Equipment screen.

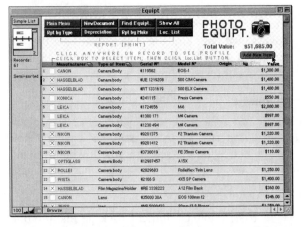

> Type the name of the manufacturer (e.g., Nikon), then Tab to the next field.
> Type the model number. Tab to the next field.
> Type a description.
> Click on the next field, *Use*, and you will see a pop-up list. From the pop-up list, select a use, such as **Accessories** or **Special Effects**. Or select **Edit** to type a use that is not on the list. Tab to the next field.

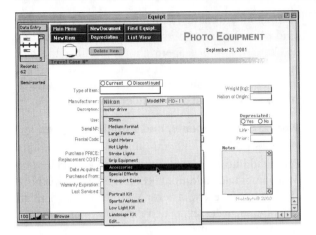

> ▸ Type the serial number. Tab to the next field.
> ▸ If this piece of equipment might ever be rented to a client during a shoot, assign a rental code and price. Tab to the next field.
> ▸ Type the purchase price. Tab to the next field.
> ▸ Type the replacement cost. Tab to the next field.
> ▸ Type the date of purchase. (Use this format: 11/23/01.) Tab to the next field.
> ▸ Type the name of the company or person from whom you purchased the equipment. To enter a Profile for that person, or if a Profile exists and you want to view it, click the button next to the *Purchased From* field. Tab to the next field.
> ▸ Type the date the warranty expires. Tab to the next field.
> ▸ Type the date of last maintenance or repair service. Tab to the next field.
> ▸ Type the weight. Tab to the next field.
> ▸ Type the country of origin (for customs purposes). Tab to the next field.
> ▸ Type any extra notes you wish to include. Tab to the next field.
> ▸ Type the number of the case into which this piece of equipment is packed for location shoots. Tab to the next field.
> ▸ Type the depreciation information.

To place a picture of the item on the record:
> ▸ Cut and paste a scanned photo of the item into the Picture field. Refer to the PhotoByte Help topic *Adding Photos to Documents* for instruction.

To add a new photo equipment record:
> ▸ Click the *List View* button. Then click *Add New Item*.

To create a list of the cameras and equipment you've entered:
> ▸ Click the *List View* button, and select items for inclusion on the list by clicking the check box on the left of the screen, adjacent to the manufacturer's name. Then click the *Loc. List* button. Click the *Continue* button to print the list.

To create a photo equipment depreciation report:
> ▸ Click the *List View* button, and select items for inclusion on the report by clicking the check box adjacent to the manufacturer's name. You can also create a printed report on all items by clicking the *Show All* button. Then click the *Depreciation* button. Click the *Continue* button to print the report.

To create a photo equipment report by type of use:
> ▸ Click the *List View* button, and select items for inclusion on the report by clicking the check box adjacent to the manufacturer's name. You can also create a printed report on all items by clicking the *Show All* button. Then click the *Rpt by Type* button. Click the *Continue* button to print the report.

To create a photo equipment report by manufacturer:
> ▸ Click the *List View* button, and select items for inclusion on the report by clicking the check box in front of the manufacturer's name. You can also create a printed report on all items by clicking the *Show All* button. Then click the *Rpt by Make* button. Click the *Continue* button to print the report.

To find a piece of equipment:
> ▸ Press Command–F or Ctrl–F, and type your search criteria in any field in the record. Then click the *Continue* button. You may also simply scroll through the list of records. Refer to the PhotoByte Help file for more information on searching your list of photographic equipment.

note Later on, in part 8, The Paper Trail, chapter 46, you'll learn how to print a location list of equipment to accompany you on assignment. This list will indicate only those items you take out of your office or studio, and it sorts them by which case they're packed in. That way, you know where everything belongs, so nothing is lost when

repacking. Additionally, this list serves as a U.S. Customs Service registration document, allowing you to "reimport" your foreign-made cameras without paying duty. This, too, is explained in part 8.

The Unacceptable Risk of Self-Insurance

You can save money by being "self-insured," which means that you just don't have insurance. Realistically, though, this is simply not an option for the self-employed.

If you are self-insured and your equipment is stolen or lost in a fire, you must replace it out of your working capital. Do you have enough money to take such an inordinately high risk? Don't let yourself fall into a situation where you can't afford to replace your cameras.

The same unacceptable risk applies if you become ill or disabled and you are not adequately insured. In that case, you not only lose revenue from the jobs you must forego, you will have to pay your medical bills, too. So, in that light, which is the greater risk: to spend some of your capital on insurance, or to gamble your entire wage-earning and profit-earning capability to save a few bucks in the short run?

It's probably a good idea to repeat now that if you don't have all the capital you need to start your business outright, then maybe you should wait until you've got all your ducks in a row. That said, it is sometimes the law that will help you make that decision. That's because, just as the privilege of driving a car is dependent upon your being personally insured, some kinds of business insurance are mandatory. In that case, without coverage, you either risk operating illegally or you could be prohibited from operating in the first place.

Extended Coverage

Most likely, you will start out in business with minimum coverage on your equipment and place of business to cover loss or theft, with some liability coverage thrown in. Be sure that your policy includes the protection of your equipment while in transit and on location. As for liability insurance, the amount and kind you need depend upon the nature of the assignments you shoot and what business structure you settle on. As mentioned earlier in this part, sole proprietors and partnerships do not enjoy the same kind of protection against liability that corporations do. Your insurance agent should be able to shed some light on that issue, if you have not yet decided upon a form of business. Eventually, you will want to talk to your agent about extended coverage.

Riders, Endorsements, and Additional Types of Coverage

For an additional cost, it is possible to extend a basic policy to provide additional coverage for any number of contingencies, whenever you decide such extra coverage is necessary. Such extensions of coverage are called *endorsements*.

The following is a fairly complete menu of the types of professional coverage that are available in addition to your basic photo-equipment and health-insurance policies. If you don't understand what all of them mean, don't worry. You should consult with an insurance agent anyway, who will explain each type of coverage to you and help you decide which types you need and which you do not, depending upon your financial circumstances and the nature of your business:[37]

- Photo-lab error insurance.
- Statutory disability benefits.
- Employment practices liability.
- Employment discrimination.
- Wrongful termination.
- Sexual harassment claims—limits of $5,000 are standard, higher limits are available.
- Personal excess liability—purchasing personal excess liability insurance is a way to protect yourself against catastrophic liability lawsuits. It provides large sums (in million-dollar increments) in addition to the sums available from your personal auto and personal liability policies.
- Workers' compensation and employers' liability—provides benefits including lost wages, medical expenses, and permanent disfigurement/disability payments for accidents or disease resulting from employment. You are required by state laws to have this insurance to cover any or all employees.
- Umbrella liability.
- Nonowned and hired automobile liability—bodily injury and/or property damage coverage resulting from claims or suits arising out of the

use of autos not owned by the photographer while in the United States and Canada. Does not cover physical damage to the auto you are driving.

▸ Nonowned and hired vehicle liability (nonautomobile)—such coverage would refer specifically to aircraft, watercraft, railroad equipment, etc. involved in a shoot.

▸ Foreign liability.

▸ Employee dishonesty—protects against an assistant, bookkeeper, or studio manager who steals cash, props, cameras, forges checks, or what have you. This is also called *fidelity coverage* and is, in effect, a procedure to legally bond employees and contractors.

▸ Political risk and confiscation.

▸ Animal mortality.

▸ Lost or stolen film—covers the costs to reshoot lost or stolen film.

▸ Weather delay—Protects against extra production costs for postponements caused by inclement weather when the extra costs cannot be passed on to the client, who is protected by a contractually-affirmed bid on the job.

▸ Bailee—protects property of others while it is on your premises or in your possession. This feature can be extended to include transit and location coverage for high-value articles, such as furs, jewelry, and other expensive props.

▸ Portfolio—covers the cost to reproduce prints, slides, chromes, tear sheets, and similar self-promotional material. The basic policy covers twenty-five images at $100 each.

▸ Commercial general liability—bodily injury and/or property damage coverage for your described premises and on locations in the United States and Canada. Copyright and trademark infringements, libel, slander, defamation, and other errors-and-omissions hazards are not covered.

▸ Professional errors and omissions liability—protects against human errors or omissions, such as:

• You blow a deadline

• You shoot only black-and-white, but the client wanted color

• You forget or misplace film

• You release film to the incorrect party

• You fail to show up for an event

• A customer challenges the quality of your work or your overall professional performance

Limits of $35,000 per claim and $75,000 aggregate are standard. There is usually no deductible, and legal defense costs are outside the limits.

▸ Accidental death and dismemberment—provides protection to dependents or business associates who would be deprived of income or other assets if you should be killed or maimed.

▸ Business overhead expense—covers the cost of staying open while recuperating from an accident or illness.

▸ Business income interruption and extra expense—provides loss-of-income coverage for your business by replacing your operating income during the period when damage to the premises or other property prevents income from being earned. It's like disability income for your profitability, not your personal salary. It pays the costs of meeting your business's financial obligations, including payroll, light, heat, advertising, telephone service, etc. If you suffer a business interruption and have to close for several months or operate at a reduced pace because of fire or other perils covered by your earnings insurance, income to cover your overhead may be either discontinued or reduced. Extra-expense insurance may cover the difference.

▸ Business liability—protects your business from claims arising out of injuries to your customers or from damage to the property of others. Protection extends up to your policy limits. Included is coverage for personal injury and advertising liability. Limits of $1 million per occurrence and $2 million aggregate are standard.

▸ Loss of accounts receivable.

▸ Backup of sewers and drains.

▸ Additional computers and media.

▸ Personal effects.

▸ Valuable papers and records/film coverage—this kind of coverage is usually limited sharply. Nonetheless, it can help to offset the cost of hiring extra help to rebuild lost tax records or reconstruct a damaged database containing references to your entire catalog of images. The best solution, however, is to keep all of this

material on a backed-up computer hard drive. The backups should be kept in a separate and secure location.

Finally, if the same agent who handles your business account also takes care of your personal insurance, you might be able to get a better package price on everything from car insurance to a term-life policy.

Obviously, life insurance is necessary only if you have dependants. Certainly that would include any family members for whom you are the breadwinner. However, in a partnership or corporation, your associates, too, depend upon your ability to earn revenue. It's not unusual for angel investors, lenders, or partners to require you to take out a short term life insurance policy, which is relatively inexpensive, to protect their investments.

note If you maintain separate premises for your office or studio, it will require a separate, commercial insurance policy from your residential one.

NOTES

35 The late environmentalist David Brower, founder of Friends of the Earth, and the Sierra Club's first Executive Director.

36 Group rates are available to members of professional trade associations, which, by virtue of the number of customers (members) they bring to the table, can negotiate lower prices with providers for insurance premiums.

37 A glossary of insurance terms is also provided online, courtesy of Lewis-Chester Associates, Inc., an insurance brokerage and financial services firm located in New Jersey: *www.coverageglossary.com/lcgroup_explanations.html.*

13

Legal
Issues

You've heard all the lawyer jokes. It's okay to laugh—or cry—but you're going to need one—or several—eventually.

From the moment you decide to start a business, you will be dealing with legal matters. Whether you are merely seeking advice about signing a commercial lease, writing an LLC agreement or a promissory note, suing to collect a delinquent debt, or defending your right to control the photographic work you create, you'll need a lawyer. And then, of course, there's that anonymous cynic who said, "Until you've been sued, you haven't been successful."

Choosing an Attorney

While being sued is neither inevitable nor a sign of success, it is unavoidable that your personal life will intersect with business affairs. Lawyers can help you with everything from creating a will to making sure your insurance company settles a disputed medical claim. An attorney can make sure your landlord keeps your premises maintained, if there's a problem you can't resolve alone. With luck, throughout all the trials (no pun intended) and tribulations of

your career, maybe you can altogether avoid litigation in court.

Generalists and Specialists

Some lawyers are freelancers, just like you, working in private practice, and some work at big law firms with long names. Some offer their services through inexpensive legal clinics.

Few lawyers are competent in all areas of the law. Just like doctors, there are general practitioners and specialists among them. You will probably consult both kinds at one time or another. Even if you don't need a legal specialist, it's still a good idea to know who the best ones are and where to find them. The best way to find them is by word-of-mouth. The next best way is through a legal referral service. Your local bar association usually provides such a service, as do the local chapters of professional photographic trade associations.

So how do you know whether you need a generalist or a specialist? How do you know if you should go to a huge law firm, a private-practice lawyer, or the neighborhood legal clinic? Actually, during an initial consultation, any lawyer should be able to answer those questions. Even the person who

referred you in the first place, or the local bar association, should be able to provide some "triage" advice. What you want to avoid is hiring an expensive specialist to handle a generic legal problem, like collecting a past-due invoice from a deadbeat client or simply writing a will. A more specialized problem, like examining a book contract or going after someone who copied and used a photo without your permission, would require someone with specific expertise in copyright law and a working knowledge of the publishing industry.

It is always a good idea to maintain a friendly working relationship with a general practitioner throughout your career, someone who can help you with routine matters as they come up and who can direct you to the appropriate specialists when necessary.

The Initial Consultation

When you contact an attorney for the first time, you have a right, as a consumer, if you will, to inquire in depth about his experience as it pertains to your case and to have an estimate of costs. Give him a thorough but friendly grilling. If you want to know what a lawyer charges, ask him. They usually bill by the hour (and in fractions thereof). Ask how many hours he expects it will take to handle your case to its conclusion. Just keep in mind that any matter requiring litigation—i.e., not just negotiation, but filing lawsuits, hiring paralegal assistants, taking depositions from witnesses, and going to court—will require huge amounts of time and cost many thousands of dollars. But few, if any, legal matters, especially during the start-up phase, will involve litigation. Another purpose for an initial consultation is to gauge your mutual comfort level. If you don't feel good about working with each other, there's no point in doing so.

An initial consultation isn't necessarily free, but it should be. Many attorneys will meet with you once at no charge to determine if the matter at hand is worth pursuing or, perhaps, to recommend someone else better suited to handle it. Sometimes hourly fees are a stumbling block, and some attorneys will kindly recommend a less-expensive associate or colleague. It's probably a good idea to avoid lawyers who won't offer you a free initial consultation.

note If you contact a bar association, you may be charged an administrative fee of anywhere from $10 to $45 for using their lawyer referral service.

There are three criteria for selecting an attorney:

> - Expertise (in a particular field of law)
> - Comfort
> - Cost

Once you find a lawyer capable of representing you effectively, you have to inquire about his fees. You should also inquire whether, given your particular situation, the lawyer might be able to guide you in doing work to help him and thus lower the total legal costs. Discuss with the lawyer whether paralegals (who are less expensive than lawyers) might be able to perform routine document examinations and filings. Don't forget the possibility of using computer software to aid you in legal matters.

On the Web, many legal forms can be found without a fee from the Internet Legal Resource Guide (*www.ilrg.com/forms.html*), as well as from Nolo Press, which offers inexpensive legal self-help software in partnership with Quicken® (*www.nolo. com*).

Creating a Will

Creating a will is a particularly good example of where software can be applied to save you some money.[38] But always have your attorney review the final document you prepare.

You should begin estate planning early in your career. Even if you have nothing, you need to make plans to protect your family, especially in the event of your untimely demise. A will, or a living trust and other more sophisticated arrangements, allow you to maximize the value of your business and control the disposition of your property after your death. If you see that you lack the assets to provide for your family, life insurance may become an important aspect of your estate plan (such insurance might also be acquired to pay for estate taxes). A will gives you the opportunity to choose who will be the executor of your estate, so you can choose a person (or people) with the special qualifications needed to treat your heirs correctly and also deal properly with your photography. Estate planning is complex, so an

attorney who specializes in that area will be a necessity for proper planning.

Free Legal Services

Believe it or not, some lawyers feel a moral obligation to volunteer their services part-time to low-income clients. This kind of free legal service is called *pro bono*, which is short for *pro bono publico*.[39] In Latin, that means "for the public welfare." Sometimes, junior associates at major law firms are required by their employers to devote a certain number of billable hours to pro bono cases. But even solo practitioners do volunteer work from time to time. If you don't qualify as a low-income client, it is still possible to avail yourself of pro bono services. If your attorney believes your case could have an impact on the greater community—either any number of private individuals or the photo industry as a whole—he may take your case.

Sometimes pro bono legal work is aimed specifically at the arts and artists, who have traditionally found themselves financially disadvantaged when they need to defend their rights, and whose mode of communicating is very much unlike the language of the law.

Although it is hoped that their successes are more prevalent than their name implies, a listing of volunteer legal groups can be found at *www-starvingartistslaw.com/help/volunteer%20lawyers.htm*.

It is also worthwhile to note that the American Society of Media Photographers maintains a legal defense fund to help individual photographers pay legal bills for cases that have an impact on their entire membership. It is supported by its members' donations.

➤ American Society of Media Photographers, Inc., 150 North Second Street, Philadelphia, PA 19106; TEL (215) 451-ASMP (2767); FAX (215) 451-0880; *www.asmp.org*.

NOTE

38 WillMaker™ from Nolo Press is a particularly good example: *www.nolopress.com/category/ep_home.html?t=0030LFNAV03202000*.

39 Sometimes, you may be required to pay court costs and expenses in lieu of the attorney's billable hours.

14

Trade
Association
Membership

A professional trade association is somewhat like the combination of a fraternal guild and a political lobby. Its charter is to promote the best business practices of photographers internally, amongst themselves, but also externally with regard to: (1) educating clients about how to obtain photographic services at fair prices, and (2) influencing both legislators and adjudicators about an agenda that emphasizes photographers' copyright issues.

Trade associations can become internally politicized, too, mired in internal disagreements. But by and large, they play a major role in educating photographers about conducting business in a principled fashion. They are less prepared, however, to provide you directly with specific administrative and economic advice on an ad hoc basis. Nonetheless, one of the benefits of membership in one of these associations is the opportunity to interact with other photographers. This provides the member photographers with a forum for the exchange of information and ideas. Therefore, by becoming a member, you become involved in an alliance of like-minded photographers pursuing the same interests.

Becoming a member of a trade association may provide you with additional benefits, including discounted insurance rates, attorney referrals, and access to legal funds for defending issues of concern to the entire community of photographic professionals, particularly those involving copyright disputes.

The cost of membership is not an issue; you can't afford *not* to join at least one association. Put it in your budget. Five organizations represent media photographers nationwide with local or regional chapters:

▸ American Society of Media Photographers, Inc. (ASMP), 150 North Second Street, Philadelphia, PA 19106; TEL (215) 451-ASMP (2767); FAX (215) 451-0880; *www.asmp.org*.
▸ Advertising Photographers of America (APA), P.O. Box 1647, Venice, CA 90294; (800) 272-6264; *www.apanational.com*
▸ Editorial Photographers (EP), P.O. Box 591811, San Francisco, CA 94159-1811; *www.editorialphoto.com/mainindex.html*
▸ National Press Photographers Association (NPPA), 3200 Croasdaile Drive, Suite 306, Durham, NC 27705; TEL (919) 383-7246; FAX (919) 383-7261; *www.nppa.org*
▸ Professional Photographers of America, Inc., 229 Peachtree Street N.E., Suite 2200, Atlanta, GA 30303; (404) 522-8600; *www.ppa.com*

Each organization publishes a newsletter. EP is the only group that does not provide discounts on insurance, although most EP members are ASMP members, too. The ASMP focuses on issues pertaining to copyright legislation and the publication of work in magazines and corporate brochures, with some emphasis on advertising. The APA, as its name implies, focuses almost exclusively on the rarified atmosphere that advertising photographers breathe. EP is a relatively new organization that is more of an informal association of photographers who shoot for magazines. It survives on contributions and does not collect dues.

The NPPA is devoted almost exclusively to photographers who work for newspapers. That makes many of them employees instead of business owners, but the group does participate in voicing its collective opinion on a broader range of issues involving photographers in the media. It also counts news editors and news videographers amongst its members. The PPA, while focusing more recently on issues including copyright and editorial publication fees like the ASMP, has traditionally been more involved in the social-event and wedding photography business. The PPA is, however, the largest and most venerable of all five organizations. Refer to each of these organization's' respective Web sites for information about membership and dues.

Final Checklist for Starting a New Photo Business

> **Background Work**
- Assess your strengths and weaknesses
- Establish business and personal goals
- Assess your financial resources
- Identify the financial risks
- Determine the start-up costs
- Decide on your business location
- Do market research
- Identify your customers
- Identify your competitors
- Write a business plan

> **First Steps**
- Choose an entity (e.g., sole proprietorship, partnership, LLC, or corporation)
- Line up sources of capital funding
- Consult attorney
- Negotiate and secure lease (if not home-office)

- Design and order letterhead and business cards
- Line up vendors, order start-up inventory and supplies
- Purchase telephones, a pager, and an answering machine
- Set up online communications, including a Web site, if you wish
- Acquire necessary equipment
- Develop security measures to protect your assets
- Consult insurance agent
- Determine the appropriate insurance coverage needed to cover inherent risks
- Acquire business liability and equipment insurance
- Join a professional trade association
- Set up office filing system

> **Business Registration and Forms**
- Contact the city tax collector to determine if you must register your business
- File a fictitious business name statement with the county clerk
- Contact the secretary of state's office to determine if business name is valid (for corporation only)
- As applicable, prepare and file incorporation papers with the secretary of state's office (or department of corporations), including articles of incorporation and corporate by-laws
- Apply for a taxpayer's identification number (or EIN) from the IRS and check to see which tax forms you'll need

> **Business Permits and Licenses**
- Check with city and state licensing divisions to see if a license or permit is needed to conduct your business, and obtain any required licenses
- Review local zoning regulations to determine if you can legally operate your business at your intended location
- Apply for a building permit if you plan to make structural improvements to your facility
- Check with the state tax board to see if you need a reseller's permit; obtain permit if required
- Register with the state employment development department if you intend to hire employees or assistants

- Obtain and display state- and federally-mandated employee information (applies only if you become an employer)
- Obtain worker's' compensation insurance (applies only if you become an employer)
- Set up payroll system with accountant (applies only if you become an employer)

▸ **Finance and Accounting**
- Consult CPA
- Select a bank and open a business account
- Obtain business line of bank credit
- Obtain credit card(s)
- Set up bookkeeping system
- Familiarize yourself with financial statements and their use
- Familiarize yourself with local, state, and federal tax requirements, and submit the required documents
- Prepare business plan financials
- Obtain capital funding
- Set starting date

Marketing and Selling: Growing Your Business

If you've got a niche, scratch it!

When the topic of marketing comes up, your eyes probably glaze over. The whole idea of marketing seems far too complex for a self-employed, freelance photographer to bother with. After all, taking pictures is your game. And if your portfolio is top notch, you'll surely find plenty of assignments. It's that simple. Right?

15

Myths about
Marketing

Marketing conjures up an image in many a mind's eye of cynical corporate executives conniving to sell products that no one really needs to a gullible public: another "new-and-improved" brand of dishwashing liquid, swank fragrances, designer underwear, sugar-coated cereal, fat-laden fast food, cigarettes, and Ginsu knives. Sitting in their suits around a large conference table, no doubt made of exotic wood wrenched from an endangered rain forest, they are muttering about demographic research and statistical analysis, while plotting strategies using charts and graphs based on arcane formulas and . . . Whoa! What does all that have to do with simply showing a stunning portfolio to an art director or photo editor?

First of all, that's not the way it is. Marketing is not a process of cynicism and hyperbole. Well, maybe a little hype. Nonetheless, it simply boils down to communicating with customers and making sales. The truth is that, if you want people to see your work and if you want to persuade them to hire you instead of someone else, you will have to master the techniques of marketing.

Once you understand how the process of marketing works, you will appreciate how much it contributes to the longevity and growth of your business by helping you create better photographs and provide services that address your clients' needs. Once you are able to demonstrate the kind of dedication to both quality and service that attracts buyers and then turns them into long-lasting *clients*, you will also be demonstrating how much they need you.

That's what marketing is all about: making your business stand out head and shoulders above the competition by identifying your customers' problems and then providing them with solutions. It means developing, packaging, and delivering products that people rely on to satisfy their own needs. Broadly, the process of marketing can be outlined in five steps:

1. Defining who your customers are
2. Researching what your customers want, including the prices they are willing to pay for it (how much value they attach to satisfying a need)
3. Producing what your customers want
4. Promoting the product, i.e., spreading the word about why customers should buy it
5. Selling and delivering the product to customers

Dreamers versus Visionaries

The creation of an effective marketing plan requires a crystal-clear vision of what, exactly, your business does and for whom. You cannot afford to blindly work your tail off, hoping one day to realize some vague idea about what it means to be a successful photographer. Without direction and purpose, not even hard work pays off. That's called spinning your wheels without any traction. Dreamers merely muse about the future. Visionaries take calculated actions (risks) based on solid intelligence, turning dreams into reality.

Visionaries have an innate and extraordinary ability to see things that are not at first obvious to other people. It's not that they are prescient; this isn't crystal ball hocus-pocus. They just have a tendency to keep looking for new opportunities, and because of their intellectual diligence and perseverance, they are often the first ones to see a ship coming over the horizon.

Entrepreneurs are visionaries. They set precise goals for their businesses, and then, they squeeze every ounce of opportunity from every resource at their disposal to reach them. Short of acting unethically, they let nothing stand in their way. That aspect of the entrepreneurial spirit is a matter of survival when you are a self-employed freelancer.

The Role of Freelancers

The word "freelance" dates back to the Middle Ages. Apparently, there were a lot of layoffs after the Crusades, and many out-of-work knights in shining armor wandered across a feudal European continent offering themselves and their weapons—would you believe lances?—to one ambitious baron or another. They were free in the sense that, being abandoned so far away from the kingdoms they called home, they had no allegiances, no loyalties. They became mercenaries. They would take on anyone else's battle if enough coin of the realm crossed their gauntlets. It was probably not a very glamorous life, though. Driven by a constant need for food and shelter, these freelancers wandered aimlessly from one battle to the next. They had no goals, and they were not the masters of their own fates.

Modern freelancers face a similar predicament, drifting from one assignment to the next, paying their bills, but often remaining insecure about where their next job will come from. Their capacity to earn money is limited by how much work they can find on any given day, and they have very little influence on the prevailing rates of pay in the marketplace. It becomes very difficult living hand-to-mouth to save up enough money to invest in the future growth of a business. In short, they have lost control.

How does one reconcile such a dilemma? How do you gain some measure of control over your professional life, so you have the freedom you crave in your personal life? Well, by implication, there is a bit of the visionary, as well as a bit of the mercenary, in every photographer. But you must reconcile the difference between those two traits within your own mind before you can hope to achieve control. The difference is that visionaries have a plan, and mercenaries do not. Visionaries see what opportunities lie ahead and make plans to take advantage of them, while mercenaries look only as far ahead as the next assignment. So the answer is: You must create a plan and follow it. The path to success is not a haphazard one.

The Difference between a Marketing Plan and a Business Plan

As you have learned, neither a banker nor a qualified private investor will be willing to help you get started without a compelling business plan. Essentially, that plan is a prospectus. It provides information that will be used to evaluate your potential for making enough money to pay off your investors plus allow them to realize a profit. Since most new photographers don't give much thought to creating a business plan, it takes them a very long time to get to the point of having enough equipment and the right kinds of facilities to take on the best assignments—*if* they get there at all. You know better than that, of course, now that you understand what it takes to be profitable. Nonetheless, in addition to helping investors recognize the value proposition of your business and its chances for success in a competitive environment, a business plan helps you, the business owner, to keep your hands on the wheel.

Having been reminded of all that, writing even the soundest business plan is an empty task if it relies on financial goals that don't jibe with what you want to get out of photography on a personal level. Therefore, it must contain an explanation of what

sets you apart creatively from everyone else and how you intend to capitalize on your differences, including your love for photography. Since freelance commercial photographers all conduct business pretty much the same way, how can you possibly describe those differences? The business plans for any five hundred photographers will look essentially the same—except for one part: the marketing section. That's the part that shows how you are different.

A marketing plan is contained within every business plan. It just so happens that, for photographers, it is the most vital part. What differentiates one shooter from another is the face you put on your business to attract and then to keep customers. It's a given that the joy you have for the work you do will contribute to painting your business a different color. That's why, among other things, you show your work.

A business plan is written for investors who need to analyze numbers, while a marketing plan deals with the means to achieve those numbers. Although marketing is less about dollars and cents than about defining relationships, it still costs money to implement a marketing plan. But, indeed, a marketing plan will help you make money, too. It does so by turning theoretical concepts into practices that make you stand out from the competition. It funnels your photographic ideals and your photography itself into a working strategy to generate sales.

16

Creating a Marketing Plan

Imagine all the money you're going to spend on sourcebook ads, brochures, portfolios, mailings, continually updating your Web site, and other forms of self-promotion. If you experiment randomly with marketing schemes, without trying first to determine which ones work and which ones don't, and without first understanding where your customers' interests lie as well as what motivates their hiring decisions, you could waste precious capital resources. The result of planning is a map that will allow you to maneuver your business in whichever direction your marketing relationships and profitability guide you.

No matter which way you go, you must also be able to turn on a dime to take advantage of unexpected opportunities and to avoid crashing into costly mistakes. Freelancers are lucky, because they have that kind of maneuverability. They can make snap decisions, because they answer only to themselves instead of large corporate bureaucracies. Being that streamlined is a huge advantage in business. An enormous ship is more difficult to stop and turn around than a speedboat. But add fog and no radar to that picture, and you'll know what it's like to go into business without a marketing plan. Uninformed decisions, quick or deliberate, are little

more than coin tosses. Fifty-fifty odds aren't good enough. Better odds for success come from knowing what your options are for changing course during emergencies.

The way to make quick decisions informed ones is to collect as many facts about the marketplace and your customers as you can. That requires a considerable amount of research. If you're worried about how much time and effort it might take, remember this: For every minute you spend planning an activity, you will probably shave ten minutes off of actually doing it. That's a ten-to-one return on your investment! Planning is an activity that pays huge dividends.

The Elements of a Marketing Plan

There are three elements to address in a marketing plan:

- Research—figuring out who you are and who your prospects are
- Strategy—figuring out how to reach prospects and turn them into customers
- Budget—figuring out how much it will all cost

It is important to note that a timetable for accomplishing your goals must be built into the budget.

Research

The first place to look for information is in the mirror. Self-examination will help you recognize your core strengths—what you do best photographically, as well as how disposed you are to the process of selling.

You have to recognize your weaknesses as well as your strengths. That will allow you to define the nature of the services you offer in specific detail. Next, you will take just as penetrating a look at the clients you wish to serve. That will allow you to better understand market demand. The idea is to make the services you offer fit the needs of your intended customers. Otherwise, it's game over.

Here is what you must do:

> Evaluate your own knowledge and skills as a photographer, listing strengths and weaknesses
> Describe the customers who need that kind of knowledge and those skills
> Determine how much customers are willing to pay
> Identify, locate, and list potential customers, according to the criteria above
> Define additional services that you can offer beyond basic shooting, e.g., photofinishing, digital services, a studio big enough to shoot cars, expertise in biology, a pilot's license, etc.
> Identify additional subsidiary market segments, e.g., if you shoot annual reports, you can shoot executive portraits on the side; if you shoot scenic landscapes or still lifes, create a line of greeting cards, posters, or calendars; and whatever you shoot, consider the possibility of stock relicensing, etc.

Evaluating Yourself

The best way to start your self-evaluation is to write down a list of all your talents, whether they are related to photography or not. Keep this list in a column on a piece of paper or on your computer screen. Include any special equipment you know how to use or that you have exclusive access to use. List your accomplishments, too, from your educational background to the skills you might have acquired, say, having served in the military, working as a carpenter, or selling products door-to-door. Include everything. Don't edit yourself. You can narrow things down later. If it helps, do this with a friend or family member who knows you and your capabilities well.

Weighing Features with Benefits

Your list should be a long one. It may even include some obviously silly items. But that's okay. Now, you're going to give your list a title. Call it *Features*. Next, create a second list in a column opposite the first one. It will be called *Benefits*.

Whereas it was okay to be frivolous in compiling your list of features, you have to be ruthless when listing benefits. Write down a single benefit to correspond with each feature in an adjacent column on the same line, right next to it.

If you cannot think of a benefit to correspond with a feature, cross out that feature. For example, if you own a motorized camera (a feature) that shoots twelve frames of film per second, yet you intend to shoot only catalogs, it's probably not a benefit for your marketing campaign. Therefore, cross out the motorized camera.

A benefit is defined as the immediate solution to an existing problem your customer has. That includes problems involving money, psychological perceptions, emotional feelings, and physical situations. They can be either significant or trivial, i.e., something that affects your customers' livelihoods or merely puts smiles on their faces.

The relationship between a feature and a benefit is called a *value proposition*. One immediate benefit to you, by the way, for having created a list of value propositions is that you can see right away if you've been making a common mistake: selling features instead of problem-solving solutions. If the products and services you have to offer (features) are of no particular use (benefit) to your customers, they don't need to be told about them. In fact, telling them about something they don't need will have a negative impact on your marketing message, driving customers away. So, if you can't describe a feature that makes your customers' businesses run faster, better, or cheaper, take it off your list.

Even when you absolutely *know* a feature is good for your customers, don't bring it up unless—in the same breath—you can mention a corresponding

benefit! For instance, if you have a studio in a crowded downtown location, make sure you mention the convenient parking lot next door where you validate. On the other hand, if the idea of your having a studio doesn't impress buyers at all because they only assign location shoots, don't bring it up. It's possible that they will assume you cost too much if you have the overhead of paying for a studio they don't need.

Now that you have identified the features you have to offer and their corresponding benefits, you can start highlighting the strongest combinations, putting the best ones at the top of your list. You can also focus on how to make the weaker value propositions more compelling. That process should be part of a monthly review. You must continually refine and redefine your value propositions to keep your business fine-tuned to the demands of the marketplace.

Considering Your Photographic Specialty

As you know, there are three distinct categories of commercial photography: advertising, corporate, and editorial. Those categories have more to do with the circumstances of how your pictures are published than with what kinds of subject matter you shoot. (This topic is discussed in chapter 41 in part 7, Operations.) But what you like to shoot does play a part in determining who your customers will be. If you shoot primarily food, you won't call on buyers who need portraits.

Strategy

Once you have determined which photographic services you will offer and to whom they will be offered by defining value propositions, the next step is to devise a strategy that ties the services you offer into a neat package for your customers, one that is as attractive as a big, bright box with a ribbon and a bow sitting under a Christmas tree. This is where advertising, or "self-promo," comes into play. Here is what you must do:

- Define a problem that exists in the market and offer a solution: *In Poughkeepsie there are few aerial photographers, and since I happen to be a pilot as well as a photographer, hmmm . . .*
- Explain how to make the value of your solution obvious to customers: *For the benefit of urban planning, aerial photography will help local devel-*

opers illustrate the impact of a proposed project on the community.

- Devise a strategy to reach out to clients, to make them aware of your solution, its value, and its availability: *Drop aerial leaflets illustrating your work. "Adopt a highway" to clean up the litter you created, so your name appears on a sign by the side of the road where the project will be built.*
- Choose the specific advertising venues you will employ to get your message across: *Consider bartering with the company from whom you rent the airplane to put their name on the leaflets in exchange for a free air-drop. Decide from which magazines, newspapers, or radio stations to buy advertising. Will you do a direct-mail campaign employing picture postcards? Will you buy space in sourcebooks? Will you stage exhibitions?*
- Resolve objections through salesmanship, perhaps employing the services of agents or reps
- Explain how you will close sales
- Explain how you will keep existing clients coming back with more assignments
- Plan the future growth of your business by setting goals

Budget and Timetable

Now you are ready to plot your marketing activities on a calendar to figure out how much time it will take to launch your campaign. By creating a budget, you will know how long you can sustain it. You will attach a cost to each marketing activity. This is where you hunker down to do the work, putting your plan into action, while checking on its progress as you go along.

Here is what you must do:

- On your calendar, create a day-by-day plan of marketing activities to perform
- Create a budget that corresponds to each day's activities in your calendar
- Set aside one day each month to reevaluate your plan and make any necessary changes

Putting Your Marketing Plan on Paper

Organization is the key to taking action. If you don't know where to start, you probably won't. A written marketing plan avoids uncertainty about what to do next. Without one, you are bound to lose the momentum that comes from moving forward step-by-step.

A written marketing plan helps you figure out how much capital you will need to spend for advertising and collateral promo pieces, including direct mail. It can be used to enlist and then leverage the support of marketing partners, such as graphic designers, by showing them how working together, perhaps through a barter arrangement, will pay off with more business for everyone. Once you have a finished plan, it may be continually reread and revised, helping you focus only on those activities that are proven to work best. Here are the sections of the marketing plan in which you will elaborate your ideas.

Goals

Describe your vision, including what you think your business will look like financially and organizationally in three years.

Maybe you will restructure your business as a corporation or an LLC after starting out as a sole proprietor. Maybe you will move into a new or bigger studio space. Maybe you will relinquish your studio and do strictly location work instead. Maybe you see an entire staff of administrative helpers. Or maybe you will see yourself just as you are today, working alone, but with a booked calendar of satisfying photo assignments.

Try to get some idea of your capacity to expand by predicting how many clients you can eventually service (without sacrificing quality) and what kinds of assignments you see yourself shooting. Ask yourself these questions:

- How many assignments can I shoot in a year?
- How many days each year will that keep me busy shooting?
- How many days do I expect to leave aside for marketing activities?
- How much time will I want to spend vacationing or shooting personal projects, and promoting myself as an artist?
- Can I leverage my work as an artist to enhance my reputation as a commercial shooter?
- Where do I expect to see my work published?
- Where is it most likely that buyers will see my work publicized?
- Will I do any speaking engagements?
- Will I teach or publish a book?

Description of Your Business

Buyers have a tendency to categorize photographers very subjectively. It may surprise you to know that the way buyers see you is not the way you see yourself, especially if your marketing message is inconsistent. It is always more effective to remain on point, e.g., my photographs of people employ bizarre backgrounds with pastel colors, or I will shoot corporate-industrial photos in large format with chiaroscuro lighting. That's it. Don't mix and match subject matter and styles. As you'll read later, you can have several different kinds of portfolios, but that's because you might target several different market segments with different kinds of work. Nonetheless, this section isn't just about the style of your photography, it's about describing the services you will provide that address your customers' needs.

By writing this section of the plan, your competitive advantages will come into focus. The first thing to do is explain exactly what your business does to solve problems. Be as specific as possible, referring to the list of value propositions you made earlier. Next, explain why someone would want to hire you, citing your special problem-solving talents as reasons. And most importantly, you need to explain what makes your beautiful pictures different from everybody else's beautiful pictures.

Obviously, beauty is not the only criterion. If you can't figure out why your pictures are better suited to a particular client's needs, they can't either. Both Irving Penn and Richard Avedon shoot fashion and portraits. But their work is easily distinguishable. Use them as an example. Try to explain their differences. Then, apply the same discriminating critique to your own work, comparing it to someone else's work that you respect—or even admire—whom you consider a competitor. Then, try to imagine what kinds of clients could get the most use out of exploiting your capabilities. Make a list of those clients. It will become the basis for a list of sales prospects.

Description of the Market

Describing your business by listing your experience and talents will show you what kinds of customer problems you can solve. Now the trick is to align your problem-solving experience with the right customers, the ones who need the benefits you can offer.

The more narrowly you can define what you do, the easier it is to zoom in on the clientele you will serve. Make a list of the clients you expect to hire you, once they hear about you and see your work. This depends somewhat on your preferences for working in either the advertising, corporate, or editorial genre. But based on your preferences, start your list in the order of greatest priority. Put buyers at the top who are most likely to hire you based upon how your photographic talent can be leveraged by your value-proposition list.

Strategy for Reaching Buyers

This is the section where you describe your ideas for getting your marketing message across, for telling your story. Everything else, so far, in the marketing plan is based on research, the incoming communications part. You should already know, for instance, what publications your target audience likes to read, because that's where you might choose to advertise. The next question, therefore, is: What do you have to say to your clientele?

Is the best strategy to try and impress people with your portfolios, or will an indirect, verbal approach be more effective? Will you employ direct mail, advertising, or a combination of both? Will you buy advertising in sourcebooks or the trade magazines that customers read? Will you send them gifts?

How do you want to get your message across to the public? Will your message be a slogan? Will it be a special photo that is readily identifiable with your business? Will it be based on testimonials and referrals? Will you employ comedy or be deadly serious? Whatever you choose to say, and however you choose to say it, your message must be compelling and easy to understand. Buyers should "get it" right away. It has to be in sync with their needs and desires.

Tactics to Make the Strategy Work

This is the section where you describe the channels you intend to use to communicate with your clientele. Channels are media. Media are tools. How you use those tools is defined as *tactics*. The next question, therefore, is: How will you get your message across to your clientele? You are the general, and tactics are the weapons you have at your disposal to wage a war of information. Given many choices, you must now decide which techniques work best.

The "enemy," so to speak, is your competition. You may use all sorts of techniques to get your message across. They include advertising in sourcebooks, the aerial bombardment of leaflets (mentioned earlier only in part as a tongue-in-cheek suggestion), public relations (i.e., getting "free" advertising space by asking your reporter friend to write about how much Big Client, Inc. loved your last job), personal sales skills (or those of your agent), your portfolios, and your personal comportment (all the way down to the way you dress and your manners). If you plan to be a photojournalist, it's probably all right to show up for appointments in army fatigues and boots. And if you're going to shoot fashion, you may be expected to be eccentric. But if you're photographing corporate CEOs, it would probably be best to wear a suit. In the end, it's up to you. You can dress like Madonna or an Elvis impersonator if it gets you work!

All of your tactics should overlap to one extent or another, adding depth to your message. They should reinforce each other. They will all have one consistent purpose: to get your marketing message across to the people you want to hire you.

Think again about what you want your message to say. Now, write it down. (It will probably change or be refined over time.) Finally, decide which combination of tactics you will employ to state your message. Keep in mind that you have to plan a campaign that lasts well into the future, while keeping your message on point with what you are doing today. Once your message starts to sink in, don't ease up on restating it. Its sustained impact will help you keep the clients you already have. But since no campaign is perfect, it will, at least, help you pick up as many new clients as you may lose to the competition. Marketing tactics include:

- Advertising—print ads in sourcebooks and the trade magazines your clients read, signage
- Identity/image—business name, slogan, logotype, personal appearance
- Collateral—direct mail (postcards, posters, brochures, letter-writing campaigns), portfolios
- Networking—referrals, word-of-mouth, building relationships
- Publicity—news releases, articles, "expert-source" quotations, exhibitions

‣ Sales—artist's rep, portfolio presentations

‣ Telemarketing—cold calls (see Dialing for Dollars in chapter 19, later in this part)

‣ Follow-up—customer-response reports and more research

In your marketing plan, explain briefly how you intend to use each tactic listed above. Even if you don't have the financial resources to use it right away, tell how you will use it when you do have the funds. Don't write off the possibility of using any of these tools to further your career.

Budget

Find out what it costs to buy advertising space in various sourcebooks by contacting their publishers. Rates may be posted on their Web sites, too. Ask a local printer how much it will cost to create a series of postcards for direct mail. Don't forget to include the cost of postage in your budget. You are certainly going to need business cards and stationery. How much will they cost? You must also have the means to present your portfolio. A simple clamshell box for prints or a custom-designed, embossed binder with loose-leaf pages might do the trick. Shop at your local art-supply store for the best prices. Don't forget to consider the cost of having prints made and mounted, or maybe laminated prints will work best for your purposes. Remember to budget for promos well into the future, too.

Especially while you are just starting out, you may wish to make greater use of tactics such as asking local retail establishments to exhibit your work. Leverage such events by asking local newspapers and TV stations to cover them (more likely to happen if the subject of your photos relates to a newsworthy topic), and get the proprietor to pay the costs by convincing him that a public exhibition will expose his own business to new customers.

Timetable

It's easy to put self-promotion on the back burner while you're busy. That's a big mistake, though. Employing marketing tactics while you are busy is the best time, otherwise you are guaranteeing a slow period as soon as you finish your last booking. There are a lot of other photographers bombarding buyers with their own marketing material. Once yours have been seen, it will likely be forgotten, unless you keep

it coming. "Out of sight means out of mind." The luster wears off even the brightest advertising campaigns very quickly if they are not sustained. So plan a little time at least once a week to pursue your marketing tactics and to review and adjust your plan overall.

Keep a calendar. Don't just use it to book and remind you of shoots, but to schedule marketing activities, too. Keep to your timetable religiously. Plan it out for a full three years—yes, three years!—even if it's only hypothetical, owing to the limited budget you have on hand right now. Expand your three-year budget, allowing for greater expenditures one quarter after the next, and you will begin to see results that are self-fulfilling economically. The more work you get, the easier it will be to pay for your marketing budget. You will be amazed at how your business grows as the effects of marketing kick in and begin to pyramid. Always keep in mind that marketing generates *future* business. This is the way to keep busy once the future arrives.

Outline of a Photographic Marketing Plan

‣ Market Summary
 • Describe your market: past, present, and future
 • Review changes in market share, leadership, players, market shifts, costs, pricing, competition

‣ Product Definition
 • Describe the kinds of applications your photographs will be useful for
 • Describe any additional and special photographic services you will be providing

‣ Competition
 • Provide an overview of competing photographers, their strengths and weaknesses

‣ Positioning: What part of the marketplace you will seek to win over, a place of recognition where the clients you expect to serve will know exactly what to expect from you when they come to that "place."
 • State what defines your photography in its market and against its competition over time
 • State your promise to customers
 • Summarize the benefits of hiring you to your customers

‣ Communication Strategies
 • Obtain target buyers' demographics

- Write your message to correspond to target audience
❭ Packaging and Fulfillment
 - Discuss pricing, look, strategy
 - Discuss your presentation style for portfolios and your personal image
❭ Public Relations
 - Strategy and execution
 - Explain how you plan to launch your business
 - Budget
 - Public relations plan highlights
 - Editorial features, speaking engagements, conference schedules, direct mail, etc.
❭ Advertising
 - Strategy and execution
 - Overview of strategy
 - Overview of media and timing
 - Overview of ad spending
❭ Third-party Marketing
 - Describe co-marketing arrangements with other companies
 - Joint promotions with graphic designers, retailers exhibiting your work, etc.

❭ Pricing[1]
 - Summarize specific pricing or pricing strategies
 - Compare to competitors' pricing
 - Summarize your pricing policy relevant to understanding key issues in the market
❭ Specialized Markets/Variegating Segments
 - Vertical market opportunities (i.e., working in architectural, aerial, underwater, sports, etc.)
 - Discuss specific market segment opportunities
❭ Success
 - First-year goals
 - Additional year goals
 - Measures of success/failure
 - Requirements for success
❭ Schedule
 - Three-year schedule, highlighted monthly
 - Timing
 - Isolate timing issues critical to success

NOTE

1 You will have to revisit this section after reading part 6.

17

Opening Channels
of Communication

At the beginning of this part, you read that marketing essentially means communicating with customers, which leads to making sales. Like any other form of communication, it's a two-way street. It means not only telling potential customers about yourself and showing them the kinds of photographs you make, but also asking what they need from you specifically to make their jobs more productive. Anything less, literally, won't sell.

Good Listening

Most photographers go into business to fulfill their own needs, not to satisfy the needs of others. But that's not the way your clients will see it. The channel of communication works like this: You find out what peoples' problems are, so you can offer them solutions. In a marketing context, solving problems for clients and fulfilling opportunities for yourself mean the same thing. In fact, at its most rudimentary level, that's a reasonable definition for all business in general. No problems, no customers. No solutions, no commerce.

Effective communication requires a keen aptitude for listening. Good marketers make it a habit to inquire, first and foremost, about the needs of

their customers. They do so regularly. It's not a good idea to wait until your first in-person interview to start asking questions. If you do some homework beforehand, you can walk into meetings armed with information that has allowed you to tailor presentations to impress specific buyers, showing them what you can reasonably expect will be of interest to them.

Whether you go into a meeting with a specialized presentation or not, it would be a mistake to spend most of your time talking about yourself and your work. Instead, find a way to turn the conversation around to the buyer's needs. Try to talk about a project that the buyer is currently working on. Let him tell you what he's looking for. Ask him what he needs to reach his milestones. Find out how you can help, if not this time, maybe next time. You will earn respect and be better remembered for asking sincere questions than for going on about how wonderful your work is. Your job is to listen, when given the opportunity, and to let your work speak for itself.

By earnestly paying attention to the needs of individual customers, you can tailor the kinds of pictures you shoot to the demands of the overall marketplace. That way you won't waste your time producing images that no one wants to publish, especially if you're shooting for stock. By giving

clients exactly what they want, you are more likely to be rewarded with more and better-paying assignments. Becoming a good listener puts you in the position of becoming a collaborator, not just another anxious hotshot looking for work.

Since marketing is designed to inform and then persuade people to take some kind of action with the ultimate goal of initiating a sale, it can also help stimulate a demand for something new or special that only you have to offer in the way of style and technique. That kind of innovation takes boldness. You will be leading, not following the pack. But you can use your own combination of courage, creativity, and perseverance to develop markets for photographic styles that may, at first, be unfamiliar to buyers. They still have to solve existing problems though.

Building Personal Relationships

Surely you've heard it said, "It isn't *what* you know, it's *whom* you know." The context for that kind of comment is usually grounded in either cynicism or envy. But it's true. It *is* whom you know that matters. Nevertheless, the cynics have it all wrong. They have misinterpreted the context of that cliché. There is nothing unethical about obtaining assignments from people you know, assuming you have the talent to back up their loyalty. The trick is getting to know the right people. In fact, you should make it your business, literally, to know the right people. It simply makes good sense to establish relationships—and even to make friends—with as many people as you can who are in a position to further your career.

As you continue to develop your communication skills, you will build your own network of personal contacts. The ability to do business with both new and repeat clients comes from continually tapping into that network. The better and more numerous your relationships, the more often people are likely to consider you when a project comes up. Once they know you and learn to like you, they are more likely to hire you, all other things being equal amongst the competition. That's just common sense.

Perhaps you are already beginning to realize that marketing is more than working the phones once a week, designing stylish promo pieces, and launching a home page on the Web. It certainly involves more than just hiring someone to show your book around. None of that will suffice to keep you in the hearts and minds of the people you choose to work for. Notice the use of the word *choose*. Not that you should turn down assignments that come from out of the blue, from buyers you haven't targeted in your marketing plan, but your marketing campaigns do have to target specific *people*, not necessarily specific *accounts*. That's because relationships occur between people, not between accounts.

Finding Your First, Best Prospects

It may seem rather self-evident, but most inexperienced photographers fail to acknowledge that jumpstarting one's career is a bit more involved than showing up with a fancy portfolio and the desire to shoot covers for *Newsweek*, *Sports Illustrated*, *Vanity Fair*, and *Vogue*, or national ads and annual reports for Fortune 500 accounts. Of course that's what you want to do! But so does everyone else who can spell "Hasselblad." They, too, covet the money, the recognition, and the prestige that come with those kinds of photo assignments.

Paying Your Dues

Maybe it's news for those just arriving at the party, but generations of photographers have already been working the crowd, busily establishing a network of commercial relationships, long before the latest wave of wannabes tried to crash the door. Get in line, buddy!

That's not to say you won't get lucky. Nevertheless, it's a sure bet that very few photographers have had any kind of quick success. It's unrealistic to defy the percentages, just as unrealistic as relying on winning the state lottery. Someone will win, just—in all probability—not you. So the question is: Are there opportunities to meet some less glamorous clients, the less obvious ones, at the outset of your career who can support you in business while you are still "paying your dues"?

It becomes easier to recognize who your best prospects for photo assignments are if you first look carefully for the most compelling *personal* reasons to work together. If you seek out art directors and picture editors in whose work you recognize a genuine affinity for your own personal tastes, you will

increase the chances of their responding to your solicitations favorably. Determine whom you want to work for, not because they represent big accounts, but because you share the same values and interests.

For example, one art director's consistent use of primary colors may work in harmony with your own use of high-contrast lighting combined with soft focus, or perhaps your asymmetrical sense of composition in black-and-white portraiture complements a particular designer's page-layout style. There may be any number of criteria. You will begin to recognize such affinities and similarities of style the more often you study periodicals at the local newsstand. There is an exercise later in this Part that will teach you how to go about doing just that, more effectively. As a result of the marketing campaign you devise, which will be based on the results of your research and planning, buyers will begin to seek you out as much as you seek them. In the spirit of the movie *Field of Dreams*, "build it (the relationships) and they (the assignments) will come."

Picking Your Battles

Maximizing relationships does not start with calling every art director in the phone book! There is nothing personal about that tactic. Good marketers choose their targets carefully. They pick only battles they know they can win. For instance, in addition to targeting photo buyers for whom you have an affinity of style, you'll learn how to introduce yourself to those who are working their way up the ladder of success just like you are. They are more easily approachable than buyers who are already at the top. As hockey legend Wayne Gretsky put it, "Most players skate to where the puck is. I skate to where the puck is going to be." You're not going to have much

success if you believe you can start out at the top. Relationships must be built from the ground up.

Getting Your Foot in the Door

No other professionals go on "job interviews" more often and more regularly than photographers, except, maybe, actors and models. Although you will never be immune to the pressure of hoping for and depending on that next assignment, you don't have to look for your kneepads every time you schedule a portfolio presentation.

Later on in this part, you'll learn how to make appointments to meet face-to-face with the kinds of people who will actually hire you. But remember this first: Once you are ushered into a buyer's office, the process of establishing a relationship begins with asking questions. That means you should be asking the buyer questions (and waiting for answers) *before* you open up your portfolio and start showing your work.

Experienced portrait photographers know how important it is to spend some time talking to their subjects before a photo session begins, before the presence of an artificial instrument like a camera is imposed between them. That's how they explore a sitter's personality, which leads to results that are more revealing than a superficial snapshot. This same kind of interrogatory process helps you dig for information that you can use to fit a presentation specifically to a buyer's needs. Those needs and your ability to fulfill them are the criteria used to determine if you get the assignment or not. Going through this process also makes an impression— one that must be honestly motivated!—that you are thinking beyond your own self-interest. It shows that you have an earnest desire to help your clients succeed.

18

Managing a List of Clients

A marketing list does not start out with *clients*. It begins with *prospects*. Prospects are potential buyers with whom you hope to do business, turning them into paying customers. And, of course, the word *customer* is derived from *custom*, as in an act performed on a habitual basis. In other words, once someone has hired you, you consider that person or company a client. Your goal, however, is to try to make clients come back to you over and over again. That means turning clients into customers. But before you have customers, you have to find prospects.

"Hit Lists"

Every photographer has access to lists of photo buyers that can be obtained at a price from companies that specialize in providing that service. Sometimes they are useful, especially if you narrow them down by including only names based on criteria that have been determined beforehand to be of use to you. For example, it's better to zero in on art directors who handle automobile accounts in Chicago, than to list every art director in the Midwest with a pulse. If the list you buy is too general, if it includes too many names, it can do more harm than good.

Art buyers and photo editors need to feel that they are more than just routine marks on a "hit list" that every photographer in town will eventually solicit in alphabetical order, hoping to call at the right time or show up with the right pictures to land a fortuitous assignment. It's much better to let your prospective customers know how special they are and that you ardently appreciate the quality of their work. To do that, you have to let them know how much you respect the value of their time, as well as your own. That's part of your marketing message, one that they should hear before you try to hit them up for a personal meeting.

By the time you are ready to meet in person, they should already believe that the time they spend with you will be time well-spent. Prepare them ahead of time by pointing out how you are interested in establishing a relationship based on mutual creative interests. Be assertive, but not pushy; it's easy for someone to spot deceit and trivial flattery. Be persistent, but don't appear to be too anxious about landing that first assignment. It might take many visits, many more phone calls, and multiple mailings for your message to finally sink in.

Assuming that your marketing efforts are going to pay off with inquiries from new prospects, what should be the first question you ask when a buyer

calls you on the telephone for the first time? It certainly shouldn't be, "What kind of work do you assign?" If someone makes a cold call to you, it's because your marketing campaign is working. Congratulations! Therefore, you should already know that he assigns the kind of work you want to do, because that's how you've been targeting your ads. Anyway, don't be presumptuous. A potential new client might be insulted by that kind of question. It might not only be your first conversation, but your last.

If you're spending a lot of money to buy ads and distribute promo pieces, and if you're doing more than one promo at a time, you should know what works and what does not. If one aspect of your advertising is more effective than another, it's time to prioritize your marketing budget. So how do you do that? First, you have to ask the question: "How did you hear about me?"

EXERCISE ------------------------------

First Call/Data Entry

This exercise will show what you can accomplish once you begin to accumulate some answers to that simple question. It starts out with a hypothetical call from someone who was not already in your Contacts database. You've never heard of this buyer before.

> From the *Shortcuts* menu, select **Panic Button!** (1st Call). (You may, alternatively, press Command/Ctrl–0.)

Your cursor should be blinking in the *Correspondent* field of the First Call screen.

> Type **Joe Blow**. Press Tab.

Joe works for the same company that Artie and Fred do.

> Type **ac** to find and select *Acme Amalgamated Advt.* Press Return.

The company phone is already entered for you. You need to enter Joe's direct line.

> Place your cursor in the *Direct* (phone) field and type **3105551234**. Press Tab.

tip Always enter an area code, even if the telephone number is within your own area code. That way you can use the area code as a Search criterion when you want to find— or exclude—all contacts within a specific location.

> Place your cursor in the *Notes about the Conversation/Message* field. Type **Interested in a shoot, middle of November. Needs estimate ASAP. Artie Rector will call. Send portfolio, too.**
> Press Tab.
> The *Type of Activity* is set as "Incoming Call." Leave that as is.
> Click the *Schedule Follow-up* field. Select **Today**.
> Click the *Action Item* field. Select **See Notes**.
> Click the *Priority* field. Select **Urgent**.
> Click the *Client Type* field. Select **Advertising**. (Actually, it was already set—looked up automatically—because PhotoByte "knows" that Acme is an advertising client. It is annotated as such in previous Profile records.)
> Click the *Keywords* field. Select **Architecture**.
> Click the *Prospects* field. Select **Hot**.
> Click the *Rep* field. Select **San Francisco Rep**. (Your San Francisco agent gets a piece of the action.)
> Click the first field in the *Customer Response* area. Joe called you because of your ad in *Archive* Magazine. Select **Archive** as the source of the referral. (You will see the significance of this in a moment.)

Here's what all that looks like on screen:

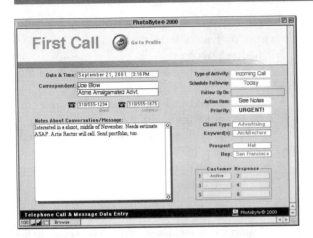

Had you really been on the phone with Joe, you'd say good-bye at this point and hang up. You have promised to follow up by sending him a portfolio, which you can do later.

tip Later on, from the Main Menu, click the Correspondence button and see this call in the list. It will remind you to send your portfolio. Then go to the New Document screen to create a portfolio delivery memo (a receipt for its drop-off). From the Main Menu again, click the Portfolios Out button to see a list of outstanding portfolio submissions and see which ones are due or past due to be returned.

> Click the *Return Arrow* button at the top of the screen to *Go to Profile*.
> You see a brand new Profile created for Joe Blow.

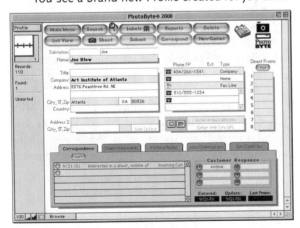

You remember Joe's fax number.
> Click the *Fax Line* field. Type **3105557001**.
> Click on the *Salute* field and select **Mr.**
> He mentioned that he prefers to be called Joey.

> Click the *NickName* field just above the *FullName* field and type **Joey**.

Customer Response Report

It seems like you have been getting many responses to your ad in *Archive*. You are thinking about spending some more money on self-promotion, but you must determine in what venues your ad is getting the best results. Are other self-promo sourcebooks as effective for you as *Archive*?

> Click red button, *Nº 1*, in the Customer Response area of the Profile screen to see Customer Response Report Nº 1.[2]

For the first time in your career—right in front of you!—you have the same kind of information that large corporations pay high-priced consultants to obtain. You can see, for example, how many people called you back because they saw your work in a particular sourcebook ad. And you can see the conversion rate, i.e., the number of people who called and actually hired you to shoot a job.

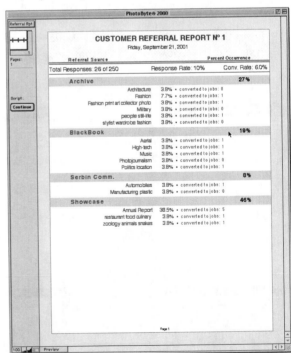

If you are spending thousands of dollars each year to market your work, you can see exactly where your self-promotional advertising efforts are getting the most bang for the buck. This will save you a tremendous amount of money by allowing you to abandon those sourcebooks and other venues that do not produce results—jobs!—for you.

> ❯ Click the *Continue* button to print this report.
> ❯ Press Command–1 or Ctrl–1.

You are back to the Main Menu and Joey's rotary card. It will be the last card in the set.

> ❯ To see the first card, click the double left arrow.

note It is a recommended practice to ask all of your clients what influenced them you hire you. That information should be logged in each contact's Profile > Correspondence screen in the Customer Response section. There are six separate response fields, so you can track the effectiveness of your first campaign and five subsequent campaigns without losing the data from previous ones.

Finding New Names for Your Client Database

Go to a newsstand or a public library and either buy or browse through twelve different magazines looking for twelve potential clients.[3] You'll be looking for either advertisements, well-edited feature layouts, or both. If you want to do this the most efficient way, write one paragraph about each one of your twelve choices explaining why it was chosen.

The reason for the written explanations is that you will refer to them later to help you define and, then, refine your marketing message. Keep these explanations attached to your marketing plan. Looking back at what you wrote will help you further distill your thoughts. By recognizing which kinds of published work appeal to you, your commercial instincts will take hold and new goals will pop into focus, helping you clarify and strengthen your own niche in the market. That, in turn, will help you initiate relationships with the kinds of clients who are most likely to get you where you want to go. Of course, you should never lose sight of the fact that the fastest way to realize your goals is to help your clients succeed with their own goals.

By the way, don't look exclusively for examples with photographs. This activity is just as valid with tear sheets utilizing all kinds of illustrative techniques, because the creator of the layout that caught your eye with a cartoon or a watercolor is just as likely to hire a photographer the next time around. Don't overlook less obvious opportunities. Look for the quality of the art direction, not the photographs.

There are two additional issues to avoid overlooking. Both of them were mentioned earlier in this part: paying your dues and picking only battles you know you can win. You already *know* you're going to find great layouts when you look in great magazines. That's a given assumption. So, check out some of the less popular ones, newer ones, regional ones, and specialty periodicals, where you are more likely to make some headway with the art-buying staff. They might be just as new to their profession as you are, eagerly seeking out innovative talent to solve creative problems. And if one of them is really quite talented, he's probably not going to remain on the masthead of *Idaho Potato Monthly* for long. When he moves up the ladder, he might take you with him. Remember: *relationships!*

Next, electronically scan the twelve tear sheets that caught your attention. Save them as digital files. Then, copy and paste them into twelve new Profiles (records) in PhotoByte, creating one digital tear sheet in a dossier for each of your twelve new prospects. How to do that will be explained in the next exercise.

Be advised that, if you have selected an editorial feature or magazine cover, the art director's and photo editor's names will be found on the masthead page of the magazine.[4] You'll usually find the masthead on one of the first few pages of a magazine, near the table of contents. For any advertising tear sheets you've selected, some additional research may be necessary to determine which agency produced the ad, if it wasn't produced in-house directly by the company doing the advertising. In either case, you have to find out who art-directed the layout and how to contact that person. You'll be spending some time on the Web and on the telephone playing detective. (See the section below on Using Industry Directories as a Resource.) Take a week to do this in your spare time. What spare time? Make some! You may as well learn how to do this sooner rather than later, because this *is* how you will find new clients as a pro.

Remember: Your ultimate goal is not to find the coolest-looking ads and features; that's too easy. Your assignment is to find the people responsible for creating them and then to articulate what it is about their work that appeals to you. Besides showing you how to find potential customers, the exercise is designed to teach you something about yourself. By acknowledging which kinds of published photography appeal to your personal tastes, you will better understand how to make yourself stand out from the competition.

Still, there is an additional advantage to this practice: It results in a list of new prospects. These people may eventually become real, paying clients. Therefore, you should create a new Profile (record) in PhotoByte for each of the persons you find in your research. (Refer to chapter 4, part 2 for further details about creating a new Profile in PhotoByte.)

EXERCISE --------------------------------

Tracking and Filing Client Tear Sheets

Because it is a good idea to keep track of an art director's work, you can attach digitally-scanned magazine tear sheets to any person's record.

> Open PhotoByte, and go to the Main Menu.
> Click the *Find* button on the rotary card. A blank card appears in Find mode. The *Find* button has changed to *Cont.*

> Type the name **Art**.
> Press Enter (or click the *Cont.* button on the card).

Art D. Rector's card will now appear on the Main Menu.

> Click on the card itself (but not on a phone number) to see Artie's Profile.
> Click on the *Clients/Keywords* tab.

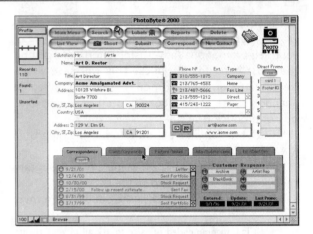

You will now see the same Profile change from Profile > *Correspondence* to Profile > *Clients/Keywords* view.

> Click the *Art Director Dossier* button.

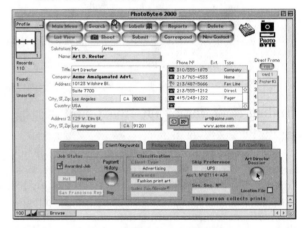

You will see the Dossier/Tear Sheet screen and on it, the image of a tear sheet from an advertisement. By simply copying a magazine page on your scanner, whether you save it to disk or not, you can cut and paste the image directly into PhotoByte. By using the horizontal scroll bar, there is room for a number of additional tear sheets. For more information about adding photos, refer to the on-screen User's Guide topic, Adding Photos to Documents.

> Click the *Return Arrow* button to return to the Profile screen.

Using Industry Directories as a Resource

While it's more prudent to first look for published work you admire, then add an art director's name to

it, and finally, connect that name to a person with whom you will try to establish a relationship, there are additional ways to find likely prospects:

> *The Advertising RedBooks™*, National Register Publishing, 121 Chanlon Road, New Providence, NJ 07974; (800) 521-8110; *www.redbooks.com/ Content/index2.html*

For more than eighty years, the RedBooks have been an encyclopedic reference for the advertising industry. They provide, in their own words, "competitive intelligence and prospecting data to media companies, advertising agencies, manufacturers, advertising services and suppliers, libraries and many more."

The information contained in these volumes (and now, on the Web) profiles more than thirteen thousand American and international advertising agencies and lists the accounts represented by each one. It categorizes agencies by their various fields of specialization, so you can approach only those that handle, say, health and medical accounts instead of automobile accounts. It also tells you the names of the people who work at each agency, so you can link the name of a specific art director to a tear sheet that you found in a magazine, just by cross-referencing the brand of the product being advertised. Another important piece of intelligence the RedBooks provide is the breakdown of gross billings by media. That means you can see how much they bill their clients for advertising space. That will, in turn, give you an idea of their overall budget for any given account, which will help you determine a commensurate usage fee. (See part 6, Pricing Photographic Services, for an explanation of usage fees.)

Any time you see an ad that strikes your eye, you can determine which agency and which art director produced it simply by looking up the brand name of the product being advertised!

> *The Guilfoyle Report*, AG Editions, Inc., 41 Union Square West, Suite 523, New York, NY 10003; TEL (212) 929-0959; FAX (212) 924-4796; *www.gronline.com/*

The Guilfoyle Report is a subscription newsletter for photographers and stock agents. It covers indus-

try news and offers articles that are built around one-on-one interviews with photo buyers, photographers, and stock agents. The *GR* newsletter is published ten times a year and is delivered to subscribers either via e-mail or by linking to a password-protected Web site.

The *Daily Photo Want* service (*DPW*) lists the immediate needs of photo buyers and ranges from requests for single pictures to want-lists for entire books. Buyers listed with these services include magazine and book publishers, freelance researchers, design studios, calendar and card companies, and advertising agencies. The *GR* and *DPW*, besides providing an incremental source of revenue, can be used to update a photo buyer database and stay on top of industry trends.

Using Corporate Annual Reports as a Resource

If you intend to shoot corporate assignments, one of the best ways to find new clients is to look through the thousands of annual reports available. They are free for the asking. Perhaps you—or someone you know—are an investor. If you own stock in a company, you will receive its annual report in the mail or be able to view it on the Web. In fact, you can look up most public companies on the Web and view their annual reports online, whether you are an investor or not. In particular, look for companies situated near where you live.

The following Internet sources will help you obtain physical copies or, alternatively, allow you to view annual reports on your computer. Most of these sites are interconnected. Best of all, these are free resources:

> Silicon Investor's World Investor Link: *http:// siliconinvestor.ar.wilink.com/cgi-bin/ start.pl*
> The *Wall Street Journal: http://wsjie.ar.wilink. com/cgi-bin/start.pl*
> Cornerstone Investor Relations: *www.reportgallery.com/*
> The *Los Angeles Times: http://latimes.ar.wilink. com/cgi-bin/start.pl*
> CBS MarketWatch: *http://marketwatch.ar.wilink. com/cgi-bin/start.pl*
> The Public Register's Annual Report Service: *www.annualreportservice.com/*

Once you have obtained a report, or access to view it online, look for a designer's credit printed somewhere within. It is usually found toward the rear of the report. If the publication was created by a graphic design studio, that will be your point of marketing contact; any assignments will come from the designer. There may not be an address, so use a Web search engine such as Yahoo™ or Google™ to look up the designer's name or company name. (If you have a Macintosh, the Sherlock™ feature will utilize all search engines on the Web simultaneously.) Most design firms have Web sites of their own that a search engine will find. An alternative source for addresses, phone numbers, and e-mail listings is the Web site of the American Institute of Graphic Arts (AIGA), which contains a search directory.[5] If no designer is listed, there are two possible reasons: Either the company chose not to give the designer a byline (similar to a photo credit) or the report was designed in-house. Either way, you can contact the corporation directly to find out whom to contact.

The place to start searching for contact information is in the report's listing of corporate officers and managers. Look for either a director of investor relations or a corporate media affairs manager. (Titles may vary.) Call the main telephone number listed in the annual report, and ask for the extension to that person's office. Ask for a mailing address, too. If you can't reach someone directly, someone else in his office should know who designed the annual report and be willing to give you that information. If you find out it was done in-house, ask how to contact the person responsible for corporate publications. Perhaps you will be able to find an e-mail address listed for that person, too.

While the best way to view the best work—work that you appreciate—is to look at published samples of annual reports and ancillary corporate publications, you can also try viewing the sites of any number of design firms who maintain a presence on the Web. Often, they will publish their portfolios online. This is an alternative way to see their work and decide whom to add to your database and contact directly. An online list of design firms can be found at this address: *http://dir.lycos.com/Arts/Graphic_ Design/Firms/*. However, it is by no means all-inclusive, and no representation is made by the author that it represents the best that graphic design has to offer.

Using Advertising and Design Annuals as Resources

If the idea of rummaging through actual annual reports and Web sites doesn't serve your purposes, you can look at any number of annually published digests in which experts in the field of graphic design adjudicate and publish the best work of their colleagues.

These publications provide an illustrated summary of the year's best work by commercial graphic designers and art directors. Some annuals are published by professional trade associations, such as *AIGA Graphic Design USA: The Annual of the American Institute of Graphic Arts*, in conjunction with the publishing firm of Watson-Guptill. Other publishers include *Communication Arts* and *Graphis* magazines, which pay tribute in separate annuals to the work of commercial advertising art directors, as well as designers and photographers. Usually, the publishers send out calls for entries, as in a contest. The winning entries, usually chosen by a jury of peers, become the contents of the annual. The prize is recognition, which translates into public relations. That, in turn, leads to more jobs. Each volume provides an index featuring contact information for the artists represented by their winning entries. There are cross-references to the commissioning clients (end users) and other contributing artists, including photographers. These annuals are terrific sources of contact information. They also help you to stay on top of trends and anticipate new ones by showing you what your competitors are doing for these same clients.

For a fairly complete listing of additionally available annuals and a source from which to view and buy them, visit this site on the Web: *www. designersbookstore.com/xp6/Print_Bookstore/annuals/ print_annuals.xml?SECTION=annuals*.

Updating Your List

Art directors play a game of musical chairs. Some of them don't seem to stay long at one job, moving from agency to agency instead. There are several ways to keep track of their whereabouts to update your mailing list.

The first way to stay in touch is to read the advertising trade magazines regularly. In each one, there is a column that reports on individuals changing jobs and positions within their agencies. This

method has the added benefit of informing you of other important industry trends and newsworthy events. A fairly complete listing of these trade publications can be found at this site on the Web: *www.business.com/directory/advertising/publications/ magazines_and_journals/.*

Along with more specialty-oriented periodicals, it includes such stalwart titles as:

> ❯ *Advertising Age*
> ❯ *Adweek*
> ❯ *Art Direction*
> ❯ *Mediaweek*

The second way to stay up-to-date is to subscribe to a list-updating service such as Creative Access (*www.creativeaccess.com*), The Workbook (*www. workbook.com/andmore/mailing_labels/index.html*), or AdBase (*www.adbase.com*). You can create your own custom criteria for including names of clients on a list and follow their movements, for these services regularly update their listings.

NOTES

2 Please note that the examples used in this exercise are hypothetical. No preference for any publication, real or imaginary, is intended.

3 Need you be reminded? Don't take tear sheets from the magazines in a public library!

4 As those who are placed at the top of a pedestal bask in the glory of their position, so, too, do publishers and editors at their topmost position on the masthead of a magazine. It's called a masthead because of its vertical composition, graphically resembling a ship's mast. Those at the top are supported by subordinates (with job titles adjacent to their names), who man the spars underneath. The most colorful description of a masthead is probably given by Herman Melville in chapter 35 of *Moby Dick*.

5 See: *http://member.aiga.org/ScriptContent/Index.cfm.*

19

Making Portfolio Presentations

Before you can show your book, you have to have an appointment. It's not always easy to get one. There are a few tricks involved. There are also some preliminary steps to take before you're ready for show time.

Dialing for Dollars

Once you have accumulated a list of valid prospects, inaugurated your promotional campaign, and allowed some time for your marketing message to stick, you are ready to start calling on individuals to arrange personal meetings. The objective, again, is to establish personal, professional relationships. Whether or not that involves showing your portfolio at first is immaterial. As always with new contacts, the goal is to strike up a dialogue.

There are two methods for making cold calls. One is a direct approach, where you try to set up a meeting as soon as possible. The other is an indirect approach, where you put your toes in the water to gauge the temperature before asking for an appointment. The latter is more comfortable for shy persons getting used to the process for the first time.

The Direct Approach
Step One

Pick up the telephone. You are going to try to make an appointment. Dial the number of someone on your list. It's not likely that, at first, you'll have access to many direct telephone numbers, so a receptionist will probably answer. Ask by name for the person you wish to speak with.

Step Two

The receptionist's job is to screen calls. It's going to be tougher to get by that person than a linebacker in a Super Bowl game. But screening calls does not mean denying access to everyone who tries to reach a photo buyer. A buyer's job, in part, is to meet new talent. He has to keep abreast of trends in the industry and cannot remain isolated. When you hear, "May I tell him what this is regarding?" from the receptionist, you must be ready with a specific and confident-sounding response. Speak from notes if you're afraid you might otherwise flub it; nobody is watching you. Say something like, "I want to meet with Joe Blow to discuss his needs for architectural photography." (By the way, if your prior research indicated that Joe has just been assigned a new architecture-related account, you have a great advan-

tage.) If you've already sent promo pieces to Joe, tell the receptionist that you want to discuss the samples he recently received. If your call was prompted by a personal referral, tell the receptionist who referred you.

Step Three

Remember: The worst thing that can happen is that someone will say "no" or otherwise deny you access. So, you won't get to speak with the prospect or make an appointment just yet. On the other hand—and there only *is* one other hand—you *will* get to speak with the buyer and set up an appointment. Your chances are fifty-fifty. If the receptionist tells you, "Mr. Blow is in a meeting" or "He's not looking at portfolios this week," it's the same thing as a no. Don't take it too hard. It's no big deal. Get used to it.

Step Four

If you are not successful in getting through, don't hang up right away! Set the stage for another call in the near future. The result of your next call has a better chance of achieving a favorable result if you can get some additional information from the receptionist to use on the next go 'round. So, ask some questions. *Schmooze* the receptionist. Turn him or her into an ally, if you can. For example:

> ‣ Is there anyone else available who can discuss architectural photo needs?
> ‣ Do you know when Joe will be available so I can call back?
> ‣ What is the best way to reach Joe, by e-mail or telephone?
> ‣ What's Joe like to work with? Do you know him well?
> ‣ Do you know if he keeps the promo pieces he receives?
> ‣ Which kinds does he tend to keep, and which kinds does he throw away (e.g., posters versus cards)?

The Indirect Approach
Step One

This time, instead of coming right out and asking for an appointment, you are going to tease out some information from the receptionist, to determine if now is the right time to go for the jugular or not. This approach is useful to cull those names on your list who are less-than-hot prospects. It may result in fewer appointments, but the ones you make will lead to better results. Again, ask the receptionist to let you speak with the buyer by name when you call.

Step Two

When you hear, "Will he know what this is regarding?" you tell the receptionist something to the effect that, "Actually, I don't really need to speak to him right now, if you could just tell me when he will next be reviewing portfolios." You might also ask if this particular buyer has any projects on the front burner involving, say, architectural photography, or any other specialty you think he is interested in based upon your research. Tell the receptionist that your company (studio) is updating its files and that you would like to know his e-mail address or fax number. Ask when the best time will be to check back.

Step Three

If the receptionist is cooperative and tells you that your prospect is, indeed, in the market right now for work like yours, go ahead and ask to speak with him. If that's not possible, ask to be connected to his voice mail. Leave a message saying that you understand he is about to start interviewing photographers for an upcoming advertising campaign and that you have taken the liberty of mailing him your latest promo piece. (Don't forget to do it!) Tell him you'll be calling back to see if he can arrange to see you in person with more samples. Make sure to mention that you think you can help him.

Show Time!

At last, you're in the door and ready to show your samples to an important art director. Having done your research, you already have enough information on the tip of your tongue to initiate a conversation as you enter his office and shake hands. That's because you know what accounts he works on, you've seen tear sheets of his ads, and you might even know some other photographers he's worked with. That article you found in *Communication Arts* magazine told you that he plays the saxophone in a pick-up jazz band on weekends and that he's an avid motorcyclist. All of that means that you are probably not going to—you *should* not—make the same kind of presentation to this fellow as someone with

different personal interests, and who also handles different accounts.

Every Presentation Is Different

Every presentation you make will be different, to one extent or another. That's because no two art directors or photo editors are exactly alike, nor are they looking for the same qualities in choosing a photographer. As often as not, the buyer is looking for something specific to illustrate a concept, not necessarily to judge your talent. Besides, you already know you're good. Right? You're not looking for praise; you're looking for work. That's why you should collect as much intelligence as possible about the client and the job before you show up for an appointment. In fact, many photographers have a number of different-looking portfolios and duplicates of each one of those. They are prepared for all kinds of clients and contingencies. They are ready at a moment's notice to grab the most appropriate one to show any buyer, based on both his tastes and his current commercial needs. By the way, it isn't necessary to completely rule out the idea of showing more than one style of work to a buyer, as long as your research indicates that diversity, flexibility, and a broad range of style are traits that will help you get the assignment.

Drop-Offs

Sometimes, you will not be allowed to schedule a meeting without first dropping off your portfolio for review. That's a setback. Drop-offs make it harder to practice relationship selling. Nevertheless, you will try again later, perhaps when you pick it up, to meet the person who requested your book.

Simply because your portfolio is in the hands of an art director doesn't mean you or your rep shouldn't be out and about, trying to score more presentations. The trick is to have more than one portfolio. The more the better. Having multiple, duplicate portfolios is almost like cloning yourself to be in more than one place at the same time. Besides, you may have to make several drop-offs on any given day. Incidentally, if you *are* represented by an agent, you will definitely need clones of your portfolio.

How Many Portfolios?

Some reps demand from three to seven portfolios. If only three are available to drop off at any given time, then only three buyers are likely to see your work that week. That's unacceptable, especially because one of them will probably be late returning it, having put it aside on a Friday, not looking at it until the following Tuesday. That could mean only two buyers got to see your work on any given week. The only solution is to have as many portfolios—both clones and variegated presentations—as you can possibly afford. Keep them—and yourself—in circulation.

Incidentally, a delightful synergy exists between "new-media" and "old-media" approaches to creating portfolios, in that you can use a relatively inexpensive scanner in conjunction with the also low-priced ink-jet color printers now available to make portfolio samples in your own office or studio without a darkroom. It's a matter of personal taste for you to determine if these rival the quality of conventional silver prints and color prints. At any rate, they can be printed on a wide variety and quality of papers, so you can experiment with various effects and techniques. The greatest advantage is the ability to create multiple portfolios yourself at minimal expense and in minimal time.

Prepare an Introductory Monologue

Certainly, you can prepare yourself with some kind of routine or introductory script, if you execute it casually (turn on the charm, but don't be smarmy) and make it seem real enough. But if you remember that you are there to listen and to offer creative solutions to your clients' production issues, you'll do just fine. Again, your pictures will speak for themselves. To the extent they do not, you will be asked questions.

Anticipate an Interrogation

Be prepared to get broadsided by some tough questions. Buyers need to feel you out one way or another to get a handle on who you are and what your capabilities are. They have an obligation to do no less, if they are to entrust you with the tremendous creative, tactical, and financial responsibilities of photographing a commercial assignment. (See chapter 42 in part 7, Operations.)

If you and your portfolio meet the buyer's criteria, you'll start hearing questions about your prices, personal experiences, other clients you've worked for, and your availability. If not, don't expect a call-

back anytime soon. But don't be too discouraged either. You just started a new relationship, which you can follow up on, and you learned more about exactly what this particular buyer's needs are. That is valuable information you can use to put together a better presentation the next time. And don't take rejection as a critical rebuke of your portfolio; the buyer may have already envisioned a completely different style that you were not able to show. If that style is going to make or break working with this fellow in the future, you have to decide to include the kinds of pictures he wants to see in your portfolio next time, or else conclude that this is a relationship with little chance of working out. Again, since you've done your homework before the meeting, the chances of that happening are lessened considerably.

Finally, don't be too disappointed when some buyers flip through your book so quickly that they hardly seem to pay any attention to the work at all. The fact is they are a bit jaded; they a see a lot of great books. They don't necessarily think less of your work by not taking time to admire it. All they need to know is that you are competent enough to solve problems. They have a practiced eye and can, indeed, tell quite quickly if you've got the right stuff. On the other hand, some art directors will spend a considerable amount of time looking at each image you present to them. It's a matter of personal style. But remember always: The fewer the images, the more likely they are to make a lasting impression.

The Impact of Portfolio Packaging

The first thing a buyer is going to notice about your work is how it is packaged, i.e., what the portfolio case itself looks like.

Everything about your presentation, including your portfolio case, should immediately reflect your professionalism. Don't use anything that looks like you picked it up cheap, merely to transport your samples. Your presentation case is as much an extension of what's inside as of your personality. At least, that's how buyers see it. Give them a good first impression.

A portfolio can be traditional and elegant, perhaps leather-bound with your name embossed on it, or high-tech, such as a custom-made aluminum box. There are companies that specialize in creating cus-

tom portfolio cases to suit your personality and your photographs. Most art supply stores carry a wide assortment of portfolio cases. The problem with the latter is that a competitor might be using the same case. Still, you might be able to do something to customize it, to make it special. Even companies that manufacture heavy-duty camera cases make custom portfolios that can be shipped while protecting their contents. You might also consider shopping in premium luggage stores.

Some sources for portfolio cases are:

> ▸ Advertiser's Display Binder Company: *www. adbportfolios.com*
> ▸ Brewer-Cantelmo, 350 Seventh Avenue, New York, NY 10001; (212) 244-4600; *www.brewer-cantelmo.com*
> ▸ House of Portfolios, 52 West 21st Street, New York, NY 10010; (212) 206-7323; *www. houseofportfolios.com*

There is one additional caveat: If you think there might be any reason whatsoever to make an excuse for the appearance of any piece in your portfolio (e.g., one of the mats is dog-eared, a transparency slid out of its mount that you cannot fix in time, or maybe the print is not the best one you could have made), *don't show it!* Clients expect nothing less than perfection. If they don't see it when you're trying to pitch an assignment, what gives you reason to believe they would ever hire an apologetic photographer?

Format

What will you have inside your portfolio case? Will your work be represented by transparencies or prints (i.e., reflective art)? It's usually just a personal decision. But during your initial marketing research, you can always take a survey. Ask what the preponderance of your prospects prefer to see. Incidentally, *transparencies* doesn't mean 35mm slides in plastic pages. Those little slides can be enlarged to proportions that are easy to view at a light box with the naked eye and mounted in black, 8" × 10" or larger boards for easy holding. It's always a nice touch to have your name printed or embossed on each mat board. It also helps avoid them getting lost. One thing you should always avoid is mixing transparencies with prints. That will confuse the viewer.

However, since you should have at least several separate portfolios anyway, you can have some consisting entirely of prints and some entirely of transparencies.

If you find that some buyers prefer looking at published tear sheets instead of "raw" images, these, too, can be prepared as either transparent or reflective art. Tear sheets can be photographed onto large-format transparency film and mounted (i.e., sandwiched) between boards with a window. Alternatively, they can be photographed and made into reflective prints mounted on single mat boards. Both methods allow you to preserve your original tear sheets and make an indefinite number of copies.

A number of photographers have high-quality portfolios printed and bound like books in various sizes, from miniature to large format. Essentially "self-promo" pieces, they make an excellent adjunct to your regular portfolios, if you can afford to manufacture them. Something of this nature requires the services of a designer, some very expensive premium paper, and an expert printer with a quality press. Your budget must be able to accommodate the cost, which can be many thousands of dollars. It is a capital investment, one that you must repeat at least once a year to maintain the effect. The effect, however, can be significant to your business, as this is a "giveaway" that seldom becomes a "throwaway." Actually, most people refer to these as "leave-behinds." You might also consider it a brochure. If it is well designed and the photographs in it are beautiful, buyers will keep it and refer to it for years to come. If you make the brochures into a series, they will become collectable. This is a "drop-off" portfolio that you don't have to, or want to, pick up.

The magazine, *Photo District News* (*PDN*), publishes a collection of award-winning self-promo pieces annually. They are culled from the contest it cosponsors annually with Nikon.[6] Many of them reflect this thinking about "disposable" portfolios. It would be wise to pick up some back copies of *PDN* at the library and research what kinds of portfolio-cum-promo pieces have been most successful throughout the years.

Number of Samples to Show

Any presentation will be more effective if you limit the number of samples you show. A dozen, give or take several, should be quite enough. You may be tempted to show more, but don't! And show only work that is appropriate to the buyer's current project. Do not include an image just because you think it represents your best work. Your "best" work is irrelevant. Assuming you would show *no* portfolio at all if it contained less than professional-caliber photographs, it must, nevertheless, contain only images that are relevant to the buyer's current interests. If you don't have twelve images that meet that criterion, show only as many as you do have. If you show more than, say, fifteen images, no matter how spectacular they each may be—perhaps even *because* they are all spectacular—the buyer is going to have a hard time remembering what he just saw fifteen minutes after you leave his office. Fewer images will always make a greater impact. If he wants to see more, let that be an excuse to come back, or pull up some additional images from your Web site on the art director's computer screen if he asks to see them.

note So many photographers make the mistake of showing their favorite work, not their best. If you value making a living more than massaging your ego, you must offer products that customers want to buy, not what you want them to see.

Make the Content of Your Presentation Appropriate

There can be adverse consequences if you show perfectly good work to the wrong person.

Let's say you have some experience under your belt as an editorial photographer. You've been privileged to shoot some extraordinary magazine assignments, including covers and feature articles spanning several pages in prestigious publications. Justifiably, you are proud of this work, and so you include it in a beautiful portfolio of laminated and mounted tear sheets. It's even sprinkled with some amazing photo-reportage on topics of current interest, plus a celebrity or two. The thing is, you've decided to break into advertising work, so you make an appointment to see Artie Rector at the biggest agency in town. Unfortunately, when he looks through this impressive collection of editorial work, he might say something dumbfounding like, "You're terrific. Wow! Look at all these tear sheets. With a successful career like this, why do you want to work in advertising?" If you're candid, you might say, "For

the money!" But that might be the last thing you'll get to say if he doesn't have a sense of humor.

Actually, there could be any number of reasons to dismiss you categorically, no matter how good your work is, if it is presented in the context of tear sheets. For one thing, consider the fact that he *is* an art director. Therefore, he might be distracted from looking at your photos by the layouts in which they appear, having been art-directed by a colleague or a competitor of his.

If tear sheets aren't the problem per se, he might realize that you didn't do your homework. You should have been prepared to show something he could relate to for an upcoming project, instead of trying to impress him with all the important people you've shot and the fascinating places you've been. For all you know, he's been deskbound for years, and he's bored with his job. You might have ticked him off.

The only time to show a portfolio like the one described above to an ad agency AD is when he specifically asks to see it and because he is looking for work of an editorial nature to lend that effect to a particular campaign.

It is also important for your work to be current. Don't show images that look dated, unless they are intended to achieve a specific purpose. Maybe your client likes to see daguerreotypes!

What to Say During a Presentation

First things first: Keep quiet! Really, don't talk too much. Let the buyer look at the book. When it is appropriate to make comments, let them be succinct. If there is an ingratiating story behind one of the shots in your book about how it came in under budget and on deadline, you should tell the buyer. Do be friendly and responsive, even witty if you can. But don't put on an act that is not natural. You don't want to make yourself more uncomfortable than you already are under the circumstances, which are tantamount to a job interview.

Buyers have all the experience they need with prima donnas, so don't go over the top when talking about yourself. Let your audience supply the superlatives when judging you and the quality of your work. Moreover, be careful what you say about other clients and competitors. Don't give yourself a nasty reputation by backstabbing or gossiping about competitors. If you are asked to speak about your own

capabilities, be assertive while avoiding any grandstanding. And don't worry; you will develop an increasing degree of self-confidence as you survive more presentations.

Wrapping Up Your Presentation

As you are preparing to end the meeting, try to determine your next action, i.e., what each party in the meeting is responsible for doing as a next step. Do not leave it up to the buyer to tell you when he will call you again or otherwise follow up on the meeting. That is your responsibility. Be proactive, but subtle. You don't have to be pushy to make one or more of the following suggestions, being as specific as possible:

- "I will call you in three days to see if you have reached any conclusions."
- "I like to keep in touch at least once every two weeks. I'd like to put in a call to check in with you on that basis, if it's all right with you."
- "I gathered from our meeting that you are interested in seeing more images of so-and-so. I have some I'd like to show you. I'd like to make an appointment for one week from today at 3:00 P.M., if that's convenient for you."

Those tactics aren't guaranteed to work. But if you don't keep the ball in your court, if your parting comments are too vague, you lessen your chances for arranging a next appointment sooner rather than later. For example, if you *ask* the buyer when you should come back, you have given him an opportunity to more-easily fend off a future meeting. He might suggest that you call his secretary in a week to see what his schedule looks like, in that way being vague himself, instead of agreeing to a definite date and time.

As you are wrapping up, you will probably hear some more questions. Address these concerns right to the point without beating around the bush. If you don't have the answer to a question right on the tip of your tongue, then your response should be: "I don't know, but I'll find out and get right back to you." At the same time, make a written note of the question, and keep your promise to follow up on it immediately!

As you are leaving, give the buyer your business card. Even better, if you have a distinctive promo

piece you can leave behind—something, perhaps, attractive enough to mount on a wall or bulletin board—do it now. And finally, never leave anyone's office without asking for a referral. For example: "Joe, I realize that the style depicted in my portfolio isn't what you're looking for right now, but would anyone else at this or another agency benefit by seeing it?" Get a name!

Finally, always remember that the presentations you make are not about you. They are not really about your photographs either. They are all about helping customers achieve their own goals. If you can demonstrate how you can help them do that, you will find work.

Closing the Sale

Photo buyers endure countless portfolio presentations because they have to. It's part of their job to familiarize themselves with the talent available in the marketplace. They are usually not ready to *buy* during a presentation. But if, in the course of your ongoing research, you find out that someone who is looking at portfolios actually has a job coming up to assign, the presentation becomes an opportunity for you to sell. The same goes for situations where you have been requested to submit a portfolio. Under those circumstances, *closing* is the final step to perform when wrapping up your presentation.

To *close* means to ask a buyer point-blank to take action and book an assignment with you. You have to ask outright, because art directors and picture editors on the verge of taking this step are, by human nature, timid about making such a commitment right in front of you. They prefer to hem and haw, to wait and interview other photographers, or to mull over their thoughts in private before calling the lucky photographer to make the booking. On the other hand, some buyers just don't want to say "no" to your face. It's always difficult to hear rejection, but it's best to get it out of the way and move on. Still, lots of photographers miss out on assignments because they simply fail to ask for the business when the moment is opportune. Don't give the buyer a chance to change his mind. Don't give another photographer the opportunity to get his foot in the door after you. Remember: "Dog don't bark, dog don't eat!"

While, of course, you have to ask for the assignment, don't blurt out the question after going through all the preliminary steps of a presentation by rote. It has to be asked at just the right time. So, during the presentation, you had better gauge how well you are doing to increase your chances for a positive response when that time comes. Try to flush out any objections lurking in the buyer's mind. This requires some delicacy and skill. You might try asking something like: "If I can work out the first issue of keeping pre-production costs down, and if I can address the second issue by showing you a photo on my Web site that is more along the lines of what you're looking for, would you like to proceed with me on the shoot?" If the answer is "yes," pull out a confirmation to sign.[7] (Open the champagne when you get home.) If it's no, continue to coax out the buyer's objections by asking further questions. He will likely clarify them for you. For all you know, the person you are speaking to may not have the responsibility to make hiring decisions. Ask!

If you can determine that a specific stumbling block exists and address it, you may happily find out that you are the first photographer who really listened well enough to understand the buyer's needs. In that case, closing may be just a formality.

One marketing expert says, "One of the secrets to closing is to let the customer say 'yes.'"[8] After you ask for the job as directly as possible—you can be disarming in that manner, as in: "May I have the assignment?"—say nothing further. Remain silent, no matter how tempted you are to talk. The first person to utter a sound gives something up. He will either say "yes," "no," or continue this "negotiation" by giving you an opportunity to address a lingering doubt in his mind. If the answer is "no" and there seems to be no more room for discussion, move on graciously.

Remember: Once you have made a successful closing, get a printed Job Confirmation signed before you leave the buyer's office, or you have no closing at all. He could change his mind. (See part 8, chapter 45, The Paper Trail.)

A Typical Situation

You finally have an appointment with the art buyer at a major ad agency. However, you've been waiting in the reception area for forty-five minutes, and you were on time. When the buyer finally appears, he explains apologetically that he has only five minutes

to look at your book. You have no choice but to honor his predicament. After all, it's not unusual in this line of work to suddenly become overwhelmed. But you should not show your book! Take that five minutes, and use it to start a dialogue.

If all you can do with your five minutes is make another appointment to come back at a later date, that's fine. Consider this an opportunity to extract some information that will make your presentation more effective. If you are urged to show it anyway, without allowing enough time to go through the stages of a proper presentation, demur politely, but with resolve. If he insists, you'll know you're about to be ushered out of the reception area. That's no better than a drop-off.

EXERCISE --------------------------------

Creating a Portfolio Receipt

The documents that you create by following the steps in this exercise will allow you to track the whereabouts of your portfolios as you drop them off with buyers and clients.

> From the Main Menu, click the *New Submission* button.

> Click the *New Portfolio Receipt* button on the next screen.

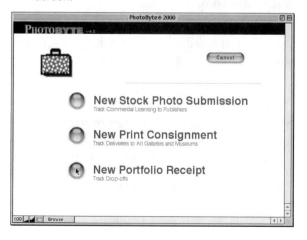

A new Portfolio Receipt will open and display a pop-up menu containing the names of all the contacts in your database.

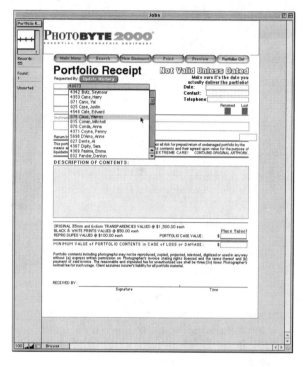

> On your keyboard, type the first letter of the person's last name to whom you will submit this receipt with a portfolio. For this example, type the letters **cl.** Then, scroll further down the list, if necessary, to select the name **Claus**.

The entire address will be automatically filled in.

> Place your cursor in the *Instruction for Return of Portfolio* field.
> Press Tab.

A pop-up menu will appear. Making a selection determines a deadline date for the return of—or notification of pick-up date for—your portfolio.

> Select **3 days**.

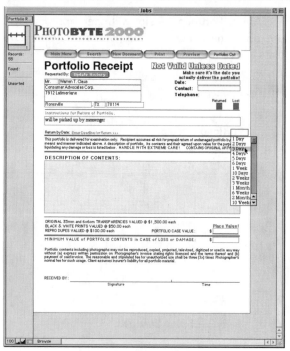

You are now ready to type a description of the contents of your portfolio into the *Description of Contents* field, which is already selected.

> Go ahead and type **twelve (12) laminated black-and-white prints; 16in. x 20in.**

You may further describe the subject matter, if you wish.

> Press Tab, and enter a value for your portfolio case, in case it is lost or damaged.

> Press Tab again, and enter a total replacement cost for your samples, in case they are lost or damaged.

> Place your cursor in the *Date* field at the top of the Portfolio Receipt. Press Command/ Ctrl–minus sign on your keyboard, which is a shortcut to enter today's date.

note Only enter a date when you actually, physically deliver the portfolio. Otherwise, the tracking feature will not be accurate.

> Click the *Print* button to make a hard copy.
> Return to the Main Menu.
> Click the *Submissions Out* button.

> Click the *Portfolios* button on the next screen.

You will see a list of all portfolios that have not been picked up or returned yet.

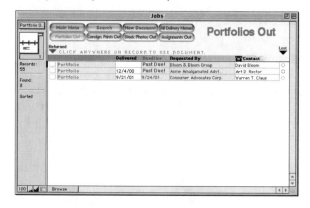

The Difference between Sales and Marketing

Often, people fail to make a distinction between marketing and selling. In fact, selling is merely a part of the marketing process, and sales are the net results of your marketing campaign. Sales always come after marketing.

Marketing, as you certainly know by now, is a process of communication that emphasizes research and learning, so that, in this case, photographic services can be tailored to fit the needs of your customers. It is also supposed to make them aware of what you have to offer and what sets you apart from the competition. Selling, on the other hand, is the

art of persuading buyers to go ahead and take the plunge, to actually buy something, whether it is tailored to their needs or not. Instead of focusing on the fulfillment of a marketplace demand—that is, instead of listening—selling is mostly talking. For a sale to occur (i.e., to book an assignment or to license a stock photo), you must talk the customer into doing something. The marketing activities in which you have engaged before making a sales pitch go a long way toward helping customers make up their minds and take action when called upon.

Communication Skills

Is a picture really worth a thousand words? The fact is, it's tough to get work without employing the gift of gab—at least a little bit—no matter how eloquently your portfolio speaks for itself.

A little salesmanship goes a long way. But many photographers are "visual people," not "verbal people." One way or another, though, you have to come face-to-face and telephone-to-telephone with live clients. Photographers who haven't mastered the skills of selling (including negotiating) will be passed over for those who have, in spite of their gorgeous work. It is a competitive situation. The only way around this dilemma is to learn the selling skills you don't have. Unfortunately, even visual people can't survive without them. The good news is that anyone can become good at sales with a little practice. The hard part is just getting started. The best way is to try some role-playing with friends and family.[9]

Working with photo buyers requires a great deal of interaction. But there's more to communication than verbal skills, although it may seem quite ordinary and obvious what that is.

For example, as a business owner, you are expected to be reasonably literate, as well as articulate. You must be able to write sentences that express ideas succinctly, coherently, and with a certain degree of sophistication. Nonetheless, they must be easy to understand and grammatically correct. You must be able to spell correctly, too. You must know how to write comprehensible e-mail messages, as well as comport yourself on the telephone. You must be able to properly compose and format a business letter. You must know how to write proposals, take accurate notes, and create outlines. And finally, you must be acquainted with the etiquette of returning correspondence and telephone calls, as well as sending thank-you notes. If you cannot, or will not, pay attention to all of these things, it will be hard for others to take you seriously.

None of these skills is peculiar to the business of photography. You may have—should have—learned them in previous areas of study and in the course of everyday experience. However, upon self-examination, if you think you've come up short in any category, now is the time to sharpen your skills. Get remedial help if you think you need it.

NOTES

6 See: *www.pdnonline.com/contests/selfpromo/16/*.

7 If you've already estimated the job for which you're presenting, it's easy to create a Job Confirmation based on that Job Estimate using PhotoByte. (See chapter 45 for instructions.) Be prepared for success. Carry a printout with you to your appointment.

8 Edic, Martin. *Marketing for the Self-Employed*. Prima Publishing, 1997.

9 *Professional Photographic Practices* is available on the American Society of Media Photographers Web site: *www.asmp.org/foundation/curriculum.html*. This academic curriculum, more than anything, describes how to effectively stage and perform role-playing exercises to simulate the process of communicating with photo buyers.

20

Working with an Artist's Representative

An artist's representative, or *rep* for short, is an agent, someone who works on behalf of a commercial artist to generate new business and negotiate creative fees. A rep is not altogether unlike either a literary agent, a sports agent, or the kind of agent who manages entertainers.

A rep is the marketing arm of a photographer's business. A rep is, essentially, your partner (but usually on a nonexclusive basis), whose job it is to build your reputation, cement your relationships with clients, and increase your income. In short, a good rep will help you engineer and execute a marketing plan that will keep you busy shooting at top dollar as often as possible. Needless to say, such a person is hard to find. More about that later. Actually, not all photographers have—or even need—a rep.

The Territorial Imperative

It is both traditional and practical for reps to work within geographical boundaries. That means they do not extend their influence beyond a particular territory for any given photographer, i.e. a particular city or a regional market. They would otherwise spread themselves too thin, becoming less effective. There is a limit to the number of clients and

prospects one can service productively. In turn, that means a photographer may want or need to have more than one rep, one in each of several different areas of the country, even internationally, to establish a presence in multiple markets. That will expand your opportunities to find lucrative assignments. One photographer may have multiple reps covering the San Francisco Bay Area, New York City and the Northeast, the Midwest and Chicago, Los Angeles and the Southwest, and Miami. That's a rather extreme example. But someone very much in demand could, indeed, require such representation. Each rep earns a percentage of the photographer's fees as compensation, but only those fees that come from his territory. It is highly unlikely, and probably undesirable, for a photographer to have more than one rep within a given regional market.

Working with a Rep
How to Get the Most from Your Rep

Photographers aren't inherently lazy, but for the same reasons that they appear to be maladroit at managing businesses without either full-time staffs or the automated capabilities of PhotoByte, they are, by nature, uncomfortable making cold calls, mas-

saging egos, dropping off portfolios, and meeting with clients. They don't mind socializing or discussing the creative aspects of actual assignments with their clients, but all they really want to do is practice their craft. They want to shoot pictures, not negotiate prices and push paper.

If your only expectation from a rep is to haul your portfolio around town to show to art directors, because you don't like that chore personally and you don't have time, you will be gravely disappointed. First of all, you won't find work—and no one else can find it for you—by simply showing off a pretty portfolio. Secondly, you can hire almost anyone who showers regularly to do that job for a minimum wage; it's not worth 25 percent of your creative fees. And then, if that's what you think a rep's job is, you don't understand what a rep can really do for you.

It is a fallacy to think that a rep can look after your best interests by taking care of the estimating and billing that goes on from day to day. Reps are as ill suited to administrative tasks as you are. Their talents are wasted when acting in the capacity of clerical assistants. They are not supposed to be bookkeepers either. So, if you find a rep who is willing to do that kind work for you, you may be wasting each other's time.

Although many photographer-rep relationships operate as described above, it is debatable how *well* they work. But again, it is a perverted notion to believe that administrative work is worth a quarter of your revenue. Marketing *will* open up opportunities, and salesmanship *will* book the shoots, but finding a rep is not the remedy for a lack of assignments. A rep, a *good* rep, is an expert in marketing and sales. That's what you want your rep to be doing all the time: marketing and sales. With business automation, you don't need to hire someone else to do estimates and billing. But if you must because you are *that* busy, make sure that person knows as much about photographic production as you do.

Once a great photographer finds a great rep, he shouldn't sit back and neglect his own self-promotion. You can't dump all of your marketing and client-support responsibilities on a rep. That is a formula for failure in any kind of creative partnership.

A photographer cannot isolate himself with his cameras and expect to succeed commercially. Nevertheless, some clients refuse to talk to agents,

at least during the initial stages of a professional relationship. They believe, rightly so, that it is part of their own creative process to communicate directly with the talent they will be hiring. They want to know that a photographer is enthusiastic about his work. They also want to know that you are not a dolt. This *is* a communication business, after all. Therefore, the photographer must directly participate with the rep in the process of sales and marketing. It takes a team effort to succeed. It is the rep's job to set the strategy.

What to Expect from A Rep

Again, it's not just what you know, it's also whom you know that counts. A rep should be expected to get you and your portfolio in front of the right people. And that means the *right* people, not just any people.

Just having a rep is no guarantee of work. Of course, if you already have an established reputation, or your rep does, things might develop more quickly. But don't count on overnight success. Even an established rep has to prove the worth of a new photographer to the clients with whom he already has relationships.

Rare is the rep who is so well-connected—and who wants to take you on as a client—that he immediately starts setting you up with well-paying jobs. It's not impossible though. Maybe you'll be lucky, or, indeed, your work may be so extraordinary that it attracts even the most jaded buyers. But if you are not that lucky and your work stands to gain depth through experience, you can do just as well to find a young sales-and-marketing genius, perhaps just out of business or law school, who is as eager as you are to embark on a successful career path in the arts. Therefore, if a rep doesn't already know which buyers to pursue, he can learn.

With or without a rep, it may take anywhere from several months to a couple of years to hit your stride and start raking in assignments. In the meantime, weekly meetings, at least, are required to discuss marketing strategies. Give your rep enough time and enough freedom to achieve results. If you become impatient, don't start jumping from one rep to another. You'll develop a poor reputation and be stuck ultimately with no representation at all. It will also confuse your clients.

By the way, you don't want to work with a rep who takes on too many photographers. Especially

avoid anyone who represents one or more photographers whose shooting style is similar to your own or who targets too many of the same prospective buyers for his "stable" of shooters. Such a rep is hedging his bets at your expense by taking a commission from you and from your competitors. A rep who works with multiple photographers would be wise to segregate their styles and the accounts he targets for each. Each photographer he represents should be noncompetitive. You will be smart to hook up with such a person.

Career Management

You can see that a rep is more than just a hired hand. You may come to rely on a rep to manage your career. Even if you have not set up a formal partnership structure for your business, a rep *is* your partner.

A great rep is a combination in-house creative director, marketing director, and business manager. Note that some reps are more than one-man bands themselves. Some may run their own agencies, employing any number of administrative staff and associate agents. Others may work as a member of a collective representing multiple photographers. Bigger repping agencies sometimes offer additional services, which might include financial planning, in addition to sales and marketing. While you shouldn't expect a lone rep to offer those extra services, as he might become distracted from his primary sales and marketing responsibilities, a larger repping enterprise might be able to help you do estimates and collect accounts receivable by acting in the capacity of a business management service in addition to the traditional role. Bear in mind, however, that such relationships are rare. Even the need for a rep in the first place is relatively rare. It is usually, but not necessarily, limited to photographers who work in advertising on big productions, with some spillover into corporate and high-end editorial work, such as magazine covers. You have to be able to offer a sufficient economic incentive to grab a rep's attention.

What Reps Expect from Photographers

Foremost, talent is what a rep expects to see in a photographer's work. Talent is often synonymous with an individuality of style. Then he's going to look for ingenuity, the ability to solve problems by

thinking on one's feet, and professionalism, which includes ethics and integrity. Finally, a rep is going to seek not only a likeable personality, but also a strength of character. He will look for an artist with both ambition and leadership qualities. Here, then, is a checklist for you to consider the next time you look in a mirror:

> ▸ Talent
> ▸ Ambition
> ▸ Leadership
> ▸ Ingenuity
> ▸ Professionalism
> ▸ Integrity

The kind of photographer who needs a rep will be going after big jobs, the kind that utilize large crews of stylists, models, and assistants, big budgets, and nervous art directors. Your rep has to feel assured that you can handle the load and the stress before he stakes his own reputation with a client by vouching for your capabilities. You must have the wherewithal to act like God on the set, but a god without attitude. Your rep wants to know that you can make everyone happy, as well as make great pictures. Otherwise, if clients don't want to come back for more, he's wasted his time trying to cultivate a relationship.

How to Find a Rep

Most "name reps," few as they are anyway, will tell you that they only consider working with photographers who've had a chance to do some marketing for themselves for a few years. That kind of experience, one must suppose, will help you both see eye-to-eye. It makes reps comfortable to know that a photographer has had some experience dealing directly with clients and that he has a few smoothly-run productions under his belt. They have to contend with too much client stroking to worry about holding hands with insecure photographers.

If you've already been around the block a few times with a fair amount of success in the past, but your career is currently in the doldrums, in all probability, you're still not ready to talk to a rep, at least not an established one. It may be a bit of a catch-22, but top-tier reps only want to work with photographers who show signs of either ongoing or immi-

nent success. They look for shooters who aim to sustain and solidify their businesses, not crawl out of a slump. The best time to make a business proposition to a rep is on the upswing. You should be at a point where you are shooting so much that it's hard to find time to service your clients and to look for new ones. That's the time to see a rep about putting together a coordinated marketing plan. A rep will also know at that point that you have enough cash flow to sustain an ongoing marketing campaign. Without working capital, he can do you no good.

There are actually places to look for and find reps. One resource is a professional association of reps based in New York City. It's called the Society of Photographers and Artists Representatives.[10] Perhaps the most intelligent way to look for a rep, before you contact SPAR, is to find out who is already representing whom. You might be able to infer where reps' current interests lie by seeing for yourself which other photographers they represent. The photographers' work will tell you that. To that end, you can peruse the sourcebooks, e.g., *Work-Book*, *Creative Black Book*, and *Select*. The photographers who advertise in them often publish the names of their reps, because that's whom they want the buyers to call. In fact, many reps take out their own ads, listing and showing work by all of the photographers they represent. Articles in trade magazines, such as *Photo District News*, *Adweek*, and *Communication Arts*, are also useful sources of "inside information." The *WorkBook* (*www.workbook.com/splash.html*) actually publishes an annual directory that lists the names of reps and whom they represent, along with contact information. Another source of reps and repping agencies can be found on the Web at this address: *www.photoresource.com/resourcereps.html*.

One more approach is to look for potential candidates at community colleges offering business courses. Some colleges even sponsor career nights you might attend, so you can make a presentation aimed at soliciting qualified graduates. It's hard to say how many would-be tycoons might have a penchant for promoting art, but it's worth pursuing. At the very least, you'll be doing some networking.

Whatever resource for finding marketing and management talent you pursue, once you find someone worth cultivating, you must go through a process called *due diligence*. That means checking

each other out, doing a little detective work. If a rep is smart, he is certainly going to check you out thoroughly. You need to do likewise. Both of you must determine to your mutual satisfaction that you are who you say you are, that your talent and integrity are real, not misrepresented. You will interview each other and exchange references, giving each other the names of professional associates who must be instructed to be entirely candid about describing both good traits and bad. If your rep candidate is a member of SPAR, see what you can find out about this person from other members. If he's a student, talk to his friends and instructors. Let him talk to your colleagues, as well, in your professional association and with some of your clients who are willing to vouch for you. It is imperative that you get to know each other as well as possible before you decide to start working together. It is also important for the person or agency that is going to represent you to appreciate the style of photography you create. He has to like what you do.

A Rep's Contract

As does every other business relationship, this one requires a contract. (See part 8, The Paper Trail.) Not every rep insists on having a contract, but *you* should. It will clarify issues of potential disagreement or memory failure regarding severance pay, what constitutes a "house account," and who is responsible for paying which marketing costs and at what percentage. A contract also spells out some alternatives if things don't work out for either you or your rep. Actually, it will often be the rep who presents you with an agreement to sign. In either case, a standard contract template is available within PhotoByte. Have your lawyer look it over before you use it.

What to Pay a Rep

Most reps are entrepreneurs, just like you. They run their own businesses and represent any number of freelance artists. For the most part, just as an agent does in any other business, a rep earns commissions on the jobs he procures for the talent he represents. Twenty-five percent has been the going rate for a long time for photo assignments, give or take five percent. The actual rate will depend on the nature of your relationship and the result of your negotiations.

If a rep can really be your partner in the formal, legal sense—and there's no reason why not—instead of representing other photographers, too, you might consider offering him a higher percentage, perhaps as much as 50 percent to work with you exclusively. After all, you will depend on that person to bring home the bacon. Some married couples starting photo businesses rely on that arrangement; one spouse takes care of shooting pictures and the other handles marketing and financial negotiations. While most reps are indeed freelancers, some of their businesses have grown into large agencies, employing numerous reps working with dozens of photographers and other artists. On the other side of the coin, a photographer or studio may wish to retain the exclusive services of a rep and, therefore, actually hire a marketing director as a full-time, salaried employee.

If the commission you pay your rep is other than twenty-five percent, you may indicate the figure on your ShootSheet™. Incidentally, it is impossible to track rep commissions unless you create a Shoot-Sheet for each associated assignment. "ShootSheet" is the term used in PhotoByte to represent a job log.

Traditionally, a rep's commission is calculated on the net revenue received for each assignment he brings in. It includes all creative fees, including usage fees, as well as travel fees and postponement fees. If mark-up is included on the face of an Invoice/License of Rights as a separate line item, instead of or in addition to having been built in as a percentage of overall costs, then that figure is included in calculating a rep's commission, too. All other production fees, billed expenses for overhead, and taxes are excluded. If you are including all or part of your production fees as salary (technically a cost), you need to discuss that with your rep and perhaps renegotiate your contract.

Sharing Marketing Costs with a Rep

If working with a rep is a partnership of sorts, it stands to reason that your rep should pay part of your marketing costs. That used to be the rule. However, some reps now balk at sharing these costs. In effect, it means they have tried to increase their commission rate.

Every relationship is different, just as every assignment and every negotiation over price takes its own twists and turns. The same applies here. If it's worthwhile to shoulder all of your marketing costs just to obtain the services of a particular rep, that's up to you. But get the best deal you can, just as in any other kind of negotiation. If the rep is as talented as you are, and you believe in each other's character and capabilities, you will probably come to terms. It is best, though, especially with a less-experienced rep, to share those marketing costs at a rate commensurate with the rep's commission, i.e., if your rep takes a 25 percent commission, he should pay 25 percent of your marketing costs.

House Accounts

A *house account* means a previously-existing account, a client relationship that was fulfilled by the photographer before he started working with a rep. The rep receives no commission (or, in some cases, negotiates a smaller commission) on jobs originating from house accounts. Alternatively, a house account might simply refer to a specifically-defined type of account in which the photographer and rep have agreed not to share revenue. That could be because there is little work for the rep to do and not enough revenue to split anyway. Many kinds of editorial assignments fall into that crack.

Some reps, however, demand a standard percentage on all accounts across the board, including both house accounts and editorial jobs, on the premise that, as partners in the business, they are entitled to be compensated accordingly, especially at the beginning of a relationship when revenue is likely to be weakest. Conversely, they share proportionately in their photographers' losses. House accounts and percentage exceptions should be spelled out in the written agreement with your rep.

EXERCISE ---------------------------------

Creating an Artist's Rep Agreement

> From the PhotoByte Main Menu, click the *Preferences* button.
> Then, click the *Legalese* button on the next screen that appears.
> You will see this screen:

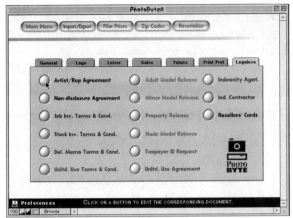

▸ Click the *Artist/Rep Agreement* button.

You will now see the first of four pages of a contract on your screen.

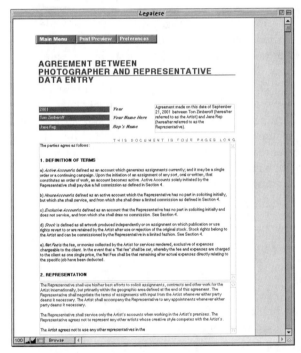

▸ Replace the sample data by typing your own name, house accounts, etc., in the solid blue fields as indicated, scrolling down as necessary to see more of the agreement.

If you wish to edit any of the text, you may do so. Simply click inside the text field with your mouse, then cut and paste or type new text. Of course, you should rely on the advice of your lawyer to make any changes to this standard rep agreement.

▸ When you are finished editing, scroll back to the top, and click the *Print/Preview* button.

AGREEMENT BETWEEN PHOTOGRAPHER AND REPRESENTATIVE DATA ENTRY

Now you will see the four-page agreement in Preview mode, as it will appear formatted for printing on a piece of paper, ready to be signed.

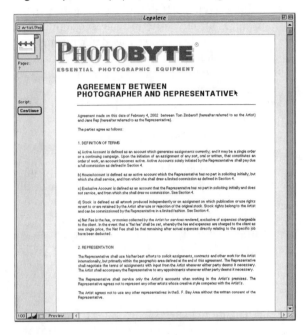

▸ Click the *Continue* button to print the agreement.

Working with Freelance Marketing Consultants

If your career is still young and you haven't yet found a rep, or if you do not need one, you can still—you probably should—avail yourself of the services of a consultant who can help you as much with planning a marketing campaign as a CPA can help you plan the financial parts of your business. A visit with a marketing consultant is like having a "rep for a day." If the consultant is knowledgeable and competent, you should be able to take away enough information to improve your marketing and sales skills for quite a long time to come. Periodic visits will prove to be even more beneficial, as you are coached through most of the techniques discussed in this part.

Remember: You are a running a business, and there are independent marketing consultants all across the country devoted to helping small business owners stand out in their industry. Can you afford not to consult an expert?

Some of the services a consultant will provide are to:

> Evaluate your portfolio, discussing the visual strength of its contents, its sequencing of images, and style, as well as determining how many portfolios you need
> Determine creative, financial, personal, and professional goals
> Help you devise a personalized mission statement
> Strategize your marketing campaign
> Outline research projects
> Develop a personalized promotional campaign, along with a budget, to include direct mail, public relations, advertising, and follow-up

While marketing consulting companies are surely available in your vicinity (check the yellow pages), the following individuals from around the country cater to commercial photographers:

> Bernadette Rogus, P.O. Box 12963, Prescott, AZ 86301; TEL (520) 541-0962; FAX (520) 541-0957; bbr@cybertrails.com.
> Brian Seed, 7432 Lamon Avenue, Skokie, IL 60077; (847) 677-7887.
> Deanne Delbridge, 499 Marina Boulevard, #206, San Francisco, CA 94123; TEL (415) 346-3621; FAX (415) 346-1193.
> Elaine Sorel, 640 West End Avenue, New York, NY 10024; TEL (212) 873-4417; FAX (212) 874-0831.

> Ian Summers, 430 Rosemont Ringoes Road, Stockton, NJ 08559; (609) 397-8601; *http://websiteworkshop.org/create1.html.*
> Maria Piscopo, 2973 Harbor Boulevard, #229, Costa Mesa, CA 92626-3912; (888) 713 -0705; *www.mpiscopo.com.*
> Selina Oppenheim, 368 Congress Street, Boston, MA 02210; TEL (617) 350-0116; FAX (617) 350-0310; *info@portauthority.com; www.1portauthority.com.*
> Suzanne T. Donaldson, 433 Third Street, #2, Brooklyn, NY 11215; *sdphoto1@aol.com; www.artandphoto.com.*
> Tom Zimberoff, 92 Bret Harte Road, San Rafael, CA 94901; (415) 461-9292; *tom@zimberoff.com.*

You might also check with your local trade association chapter to find out if they are familiar with additional marketing consultants in your area who have dealt with photographers.

One last resource to mention is this site on the Web: *www.sell.org/sme-fr5-advertising.htm.* It links to hundreds of useful articles and tips about sales and marketing from various experts and authors. They are free for you to read. The information is not specific to photography, but this profession has no monopoly on pragmatic marketing strategies. Many of these articles will apply just as well to you as any other kind of small business. Many articles list the means to personally contact the author to arrange for a consultation or tell you where their books are available.

NOTE

10 60 East 42nd Street, Suite 1166, New York, New York 10165; (212) 779-7464; *www.echonyc.com/~mcghee/spar/.*

21

Self-Promotion

For the most part, self-promotion consists of three disciplines:

> Public relations
> Advertising
> Direct mail

Advertising means paying for space in which to expose your message in a medium where a targeted audience is expected to see it, and you are assured of reaching a certain number of select viewers. Public relations, or PR, means acquiring the benefits of advertising without paying for them directly. Direct mail, instead of using mass media publications to reach a large audience, targets a smaller and more systematically-defined segment of buyers. It uses a personalized one-to-one approach, unlike the one-to-many technique of advertising. This is usually accomplished through the U.S. Postal Service, but may also employ e-mail.

The Purpose of Advertising

Not every photographer needs to advertise. But sometimes, despite your use of research, direct mail, networking, and personal presentations, it seems like you are the proverbial tree that fell in the forest when no one was there to hear it.

All marketing is communication. All marketing requires an audience. If your marketing strategy requires reaching out with a sophisticated message to a broader audience, one that you cannot reach through direct marketing alone, advertising may be just what you need to be heard in the forest of photographers.

Advertising is considered an indirect form of communication, indirect because it reaches buyers, not one-to-one, but on a one-to-many basis. However, the cost is generally higher for advertising than direct marketing. Advertisers must pay to be included in the media. Fees are commensurate with the size and quality of the audience amassed by a particular publication, an audience that the publishers can assure you statistically will pay attention to your message.

After your salary, advertising may be the biggest cost your business has. But, like all other capital expenditures, it is an investment in the sustenance and growth of your business. Because the cost is so great, however, you must be quite sure that your advertising is effective, i.e., its bang must be worth the bucks. You must determine, foremost, that you are advertising in a medium that produces results.

The way to determine if advertising is working is not by how busy you are, especially if you are paying for ads in more than one publication, but by looking at substantive facts. The only way to determine how well an ad is working is by referring to the customer response reports prepared for you by PhotoByte. (See the exercise, First Call/Data Entry, in chapter 18.)

By the way, please remember that this report is only effective if you ask each respondent what part of your marketing message prompted their call. You may have done something like that in the past (or it may have been suggested to you), but what's new is that these reports make the information more valuable, because now you can quantify the information and learn something practical from it.

Ask first-time callers how they heard about you. It might have been by word-of-mouth, a direct-mail postcard, or a published ad. The technique described in the First Call/Data Entry exercise is particularly useful if you are trying to determine which one of two or more ads is producing the better results, so you can cut the ineffective ones out of your budget.

Advertising, at its most extreme example of simplicity, can be a paid listing in a sourcebook, even the yellow pages. At its most sophisticated, it can approach a level of extravagance, including four-color illustrated print campaigns, beautifully art-directed and appearing in multiple media outlets from magazines to billboards to television. Cost-effectiveness is the key to deciding how big a splash you need to make.

Theoretically, if you had personal access to millions of dollars for a minute of Super Bowl airtime, but were confident it would bring in ten times what the ad cost, it would be foolish not to run it. Whatever it costs to run an advertising campaign, no matter how exorbitant it seems, if you can reasonably be assured—or assure your investors—that the odds are in your favor for new and lucrative business to result from that exposure, it is more costly *not* to run the ads. If you don't have the money, reread part 3, Starting a Business, and create a business plan that will show a lending institution how their investment can be both safe and profitable. Get the money!

Hire the Best Talent Yourself

By the way, it's not just media space you have to pay for. You need the best art and creative direction you can afford. Without it, you can do more harm than good by exposing yourself to the public in a less-than-complimentary way. You may already have contact with some of the best talent in the industry, because they are the people with whom you hope to build client relationships. If you've already started contacting them, don't be too shy to ask for a deal or a barter arrangement to have one of them help you design an advertising campaign. One photographer jokes, "I only hire the most expensive art directors, because they know up front I can't possibly afford to pay them."

A Call to Action

At its most naive, advertising is an exercise in self-gratification that can make you go blind.

Most of the aforementioned photographers think that an ad consists of no more than a striking image accompanied by their name and telephone number. It must make them feel self-confident to see their photos and their names in print right next to the ads of some of their colleague-competitors who seem to get all the plum assignments. They figure: "What works for the big guys will work for me, too. My pictures are as good as theirs are. All I have to do is show them in the right places!" They believe in the power of their own images to influence peoples' hiring or buying decisions, so they ante up all the money they can scrounge to pay for big spreads in sourcebooks that are supposed to make them well known. In many cases, unfortunately, it is a vain attempt—in both meanings of the word—to buy prestige. The so-called big guys are engaged in a different kind of activity that is more sophisticated and bound to be more effective than any attempts by young upstarts to usurp attention on the strength of a mere photograph.

The big guys have already attained name recognition by virtue of their track records of published assignments and individual histories of marketing activity. Therefore, when you see their ads in sourcebooks, their purpose is to reinforce ideas that already exist in buyers' minds, not to create a new one. These shooters are known quantities. Someone just breaking into the business, hoping to make an impression with a lovely picture, is not going to find much satisfaction, because sourcebook ads do not work in an isolated context. They work best when they are integrated with a broader, ongoing cam-

paign. They are parts merely alluding to the whole. If you are just starting out, you've got nothing to remind buyers about yet. You need a *call to action.*

At the end of a portfolio presentation, you have learned to ask for something specific to achieve results. Your ad must do the same thing. Obviously, the copy can't just read, "Hire me!" But your ad does have to solicit a response, such as "Call me for a special offer." One photographer, who shall remain anonymous, created an ad that looked like the concoction of a kidnapper's note complete with typographics cut from various magazines and newspapers and pasted in a ransom demand. It was accompanied by a picture of an adorably cute little dog. The note read, "Call or we'll kill this puppy!" It may have been of questionable humor, but it worked. Anyway, that certainly illustrates a call to action. Every ad (and every piece of direct mail) must have one, unless it's a so-called *image ad.* Image ads require you to have either a preexisting industry-wide reputation or to establish a personal identity from scratch, a long and patient wait requiring a sustainable budget.

Obviously, it does little good to copy someone else's advertising strategy. Likewise, it does little good to throw as much money as you can—or cannot—afford at a disjointed ad in a popular sourcebook, unless you have an ancillary and coherent marketing strategy working for you right alongside, and unless you are prepared to run that expensive ad for several years before expecting it to pay off. As always, there are exceptions. You might get lucky and see your ad produce results right away. But it's a gamble. It's your money.

Where to Advertise

While some photographers have achieved results with limited advertising, others recognize the effectiveness of advertising in multiple media to reach different segments of the market.

Creative Sourcebooks

Sourcebooks have been mentioned extensively. They are the most common place to advertise for photographers. You can count on the marketing efforts of the sourcebook publishers to get buyers to see the ads inside. At least you hope that's what they're doing, because they are spending at least as much effort marketing to you, to get you to pay for the ads

in the first place. Sourcebooks are distributed free of charge to photo buyers.

Whereas having your work published in an annual is a form of public relations, because you haven't paid to guarantee yourself space in the book, publication in a sourcebook is strictly paid advertising. Creative sourcebooks fulfill the role of a specialized and extravagantly illustrated yellow pages used by buyers to find photographers. They, along with annuals, are not only useful to promote your photography, but they are useful research tools, because you can see what the competition is doing, including whom they have been shooting for.

Not every photographer will be represented in any one sourcebook. For that matter, not every photographer can afford to buy space in sourcebooks. Some photographers who advertise rotate their advertising amongst the sourcebooks. They are in one book this year and a different one next year. The shelf life (in an art director's office) of a sourcebook is about three years.

Following are some of the more popular creative sourcebooks:

- *Adweek Directories,* 1515 Broadway, New York, NY 10036; TEL (800) 468-2395; FAX (212) 536-5321
- *The Alternative Pick,* 1133 Broadway, #1408, New York, NY 10010; TEL (212) 675-4176; FAX (212) 675-4936; *altpick@aol.com*
- *American Showcase,* 915 Broadway, New York, NY 10010; TEL (212) 673-6600; FAX (212) 673-9795
- *The Creative Black Book,* 10 Astor Place, 10th Floor, New York, NY 10003; TEL (212) 539-9800; FAX (212) 539-9801; *www.blackbook.com*
- *California Image,* 511 Olive Street, Santa Barbara, CA 93101; TEL (800) 876-6425 or (805) 963-0439; *www.serbin.com*
- *Chicago Creative Directory,* 333 N. Michigan Avenue, Chicago, IL 60601; TEL (312) 236-7337; FAX (312) 236-6078
- *Chicago Creative Sourcebook,* 7002 East First Street, Scottsdale, AZ 85251; TEL (773) 486-5999; FAX (773) 486-6944
- *Creative Sourcebook,* 4085 Chain Bridge Road Fairfax, VA 22030, TEL (703) 385-5600; FAX (703) 385-5607
- *Direct Stock,* 10 East 21st Street, 14th Floor, New

York, NY 10010; TEL (212) 979-6560; FAX (212) 254-1204; *www.directstock.com*

➤ *Klik! Showcase Photography,* 915 Broadway, 14th Floor, New York, NY 10010; TEL (212) 673-6600; FAX (212) 673-9795; *www.showcase.com*

➤ *New York Gold,* 10 East 21st Street, 14th Floor, New York, NY 10010; TEL (212) 254-1000; FAX (212) 254-1204

➤ *Single Image,* 940 North Highland Avenue, Los Angeles, CA 90038; TEL (213) 856-0008; FAX (213) 856-4368; *www.workbook.com*

➤ *The Stock Workbook,* 940 North Highland Avenue, Los Angeles, CA 90038; (800) 547-2688; *www.workbook.com*

➤ *The Workbook,* 72 Spring Street, 2nd Floor, New York, NY 10012; TEL (212) 674-1919; FAX (212) 274-0842; *markw@workbook.com*

Some creative sourcebooks that solicit ads from photographers offer them free listings of their names and phone numbers. This is a service aimed at art directors and other readers who need to find a photographer, perhaps to cross-reference a photo credit. It helps to be listed in every directory you can find, including noncommercial ones. You never know when you might get a job just because someone found your name in the ASMP members' list, for example.

The only other obvious places for photographers to advertise are within the pages of the magazines that designers, PR executives, and art directors read. A number of those kinds of publications were listed earlier in this part, cited as references for finding new contacts. Your own research may turn up additional resources that exist in your area. Maybe your local chamber of commerce publishes a newsletter that business owners read. If so, that might be a fine place to advertise. Just determine first, to your satisfaction, that the kinds of clients you are looking for are, indeed, reading it. Again, in smaller communities, small business owners resort to the yellow pages. But who's to dictate where your imagination should leave off? If you happen to know the route an art director drives on his way to and from work, sponsor a local "Adopt-a-Highway" program, and put your name by the side of the road. Send the guy a card every week, and remind him how nicely you keep the scenery for his drive each day!

How Often to Advertise

Few people remember the message contained in an advertisement until they see it many times. If you plan to advertise, plan to do it for a long time without letting up. And don't fiddle around with different messages. Stay on point with each ad. An ongoing campaign should have a theme. This is not a hit-or-miss proposition.

You are going to have to budget for the long haul. If you only buy ads one at a time and make their publication dependent upon cash flow, you are wasting your money. (Either that or you are not managing your cash flow well enough. Refer to chapter 37, part 7, Operations, for a discussion of cash flow.) You should have the money to pay for the entire campaign in your war chest, a special business account set aside just for this purpose, from which you will not allow yourself to pilfer funds for personal purposes. If you can't find outside investment capital or a loan, the money to pay for your ads has to come from the profits your company earns. It must not come out of your salary. If you have to wait, then learn to be patient and grow profitable more slowly, until you can afford to advertise. Then you can grow your business more rapidly.

The Purpose of Public Relations

Public relations embody a variety of marketing activities that strengthen your credibility and enhance your public image. These activities build awareness of who you are and what your work represents to the industry. PR is designed to develop goodwill with the people whom you consider important to your success.

Marketing stimulates the buying process, of course, and marketing is achieved through communication. However, since it's a two-way street, there is more to marketing than collecting information about your customers. The more facts you put "out there" about yourself, the more dynamic you become in the marketplace and the more prospects you will reach with your message. Yet, while PR sets the stage for winning photo assignments and for the publication of your work, it is not a substitute for the activity of selling itself. Its objective is to ensure that buyers appreciate the characteristics that set you apart competitively. PR tells them how you can make a difference.

note PR is free (unless you count your time and, of course, unless you hire a PR company), but it is not an entitlement. Always keep this fact in mind: You don't get publicity because you deserve it; you have to ask for it!

Each time you accomplish something even remotely associated with your business, write a brief press release on your business stationery, and send it to all the photo magazines and industry newsletters. Make this a habit. It's simple enough to create a press release template on your word processor, so you can just fill in the blanks.[11] Follow it up with e-mail reminders too. Press releases, which, in essence, solicit publication from media with voracious appetites for information, are useful when you:

> Win an award
> Acquire a specialized piece of equipment that will expand your business
> Teach a seminar
> Get elected to a board of directors
> Complete a magnificent job
> Participate in community service
> Open a new studio

The more clever a press release is in providing information, the more likely it is to be published. For instance, there once was a photographer in New York City who lost his lease on a penthouse studio and was forced to move onto the ground floor of the same building. He made the most of announcing his change of address with the headline: "Photographer Falls 13 Stories and Lives!"

The Purpose of Direct Mail

Direct mail is designed to elicit a response, but not necessarily a sale. The response you try to elicit will range from anticipation to demand—anticipation that more information will be forthcoming and demand to see your portfolio. But before you send out a direct-mail campaign, you should know specifically what kind of response you want to get. While it's probably too early—and too risky—to ask for an assignment, your potential clients need enough information about you to include you in

their deliberations. You need to constantly keep your name and your work on the front burner. That's why the regularity and frequency of direct mail is so useful.

Frequency of Mailing

Whatever you send, you have to allow sufficient time for your message to sink in before you can expect to receive a significant number of responses. That means you have to mail often and to the same group of people. That doesn't mean mailing the same thing—which is all the more reason to plan a campaign, a series of related mailings, all with the same message stated in different and entertaining ways. Once you start, you can't afford to lose momentum. Not only must you send an entire series of mailings, they must be regular, e.g. every three weeks for one year before you change your message. That's just an example, of course. Nonetheless, they must appear on peoples' desks like clockwork. A lack of consistency will destroy the effectiveness of any self-promo campaign.

To be consistent, you have to plan ahead. For instance, you have to work around your designer's and printer's schedules, making sure that your promo is in production with enough lead time to assure that it will be mailed in time to arrive where you want it and when you want it.

Size of Mailing

Earlier, in explaining how to compile a mailing list, it was mentioned that you are more likely to receive responses from a smaller number of handpicked prospects than from a commercially bought list with so many names on it that the postage alone costs a bundle. In fact, if the cost of postage is high enough, you might be forced to decrease the number of *times* you do mailings. That's not a good trade-off. So, instead of scattering your marketing message like buckshot in a hit-or-miss fashion at a whole flock of anonymous art buyers, take aim at the sitting ducks.

With larger, indiscriminate mailings, you also diminish the number and quality of responses you are more likely to get with a tighter, targeted list, because you know less about individual prospects and the types of shoots they assign. However, you can weed out some names for future mailings by soliciting responses with a very brief questionnaire. By including an additional postage-paid card, you

give each recipient of your mailing a chance to "unsubscribe" from your list simply by returning it. It should contain no more than half a dozen questions that can be answered "yes" or "no" in a check box, plus a space soliciting comments. If someone knows that your work is inappropriate for the kinds of assignments they make, they may let you know you're wasting your time, if you make it convenient enough for them to do so.

You can further increase the chances for a response by offering each recipient more than one way to reply. For instance, it may be either less intimidating or more convenient for someone to obtain further information from you by responding to an e-mail address or a fax number than to pick up the telephone. People need choices to feel empowered enough to take action. Also, by including the kind of card mentioned above in a tightly targeted mailing, your chances for having them returned with favorable feedback are increased, thereby narrowing your next mailing list even further and making it more valuable. The hottest prospects will have identified themselves for you. By the way, make sure you have a dedicated fax line if you solicit faxed responses in addition to e-mails and telephone calls, so you don't pick up the phone and startle someone when a fax comes in.

Anything you can do to make your promo interactive with the recipient will increase its effectiveness. As another example, if you provide an accordion-foldout piece that opens up to an extended, horizontal portfolio after removing it from an envelope, you actually give the recipient something to do.

A simple interactive call-to-action may consist of little more than a tear-off, perforated card, similar to that described above, with no more than a few questions to answer by checking off multiple-choice boxes. For instance, they might include simple statements, as if uttered by the recipients themselves, such as:

> Great photo. Keep 'em coming!
> Sorry. Not our cup of tea.
> Please send us your portfolio.
> Call for a personal appointment.
> Take me off your list. I only hire wedding photographers.

Of course, you have to include return postage and your own preprinted address on a piece like that—it's okay to use bulk rates in this case—so that all the recipient has to do is drop a card in the nearest mailbox. You will gain invaluable information about your market and gauge the effectiveness of your mailing at the same time by using this technique. It is the best kind of research. The rate of response for an interrogatory card is approximately 2 to 4 percent. But it will be higher—perhaps significantly higher—if you have done your homework and carefully screened your mailing list to contain only the most low-hanging fruit.

Postal Rates

Always send your mailings, whether letters, postcards, or anything more elaborate, with first-class postage. It's more expensive, but the advantages far outweigh the additional cost.

Each piece of first-class mail is treated by the postal service as though it were a separate piece of personalized and personally addressed mail, not part of a mass, indiscriminate mailing. It receives priority treatment over lesser classes of service. When you buy postage at bulk rates, for instance, the postal service is under no obligation to guarantee delivery within a specific time frame. It will sit in bags on the loading dock of the post office until all other priorities have been fulfilled. That means that if there is a lot of first-class and priority mail to deliver, it will go out first. The bulk mail will be sent whenever there is a lull in activity. You have no way of knowing how long that will take.

Bulk mailings require you to do a lot of "preproduction" work too. That is, to take advantage of your discount, the postal service expects you to sort and bundle your mail by zip code (or zip+4) before you drop it off. You also have to prepay for the postal permit that must be preprinted or stamped on each piece of mail you submit for delivery. That's no less—if not more—work than putting on first-class stamps. Incidentally, it may be cost-effective for you to lease a postage meter, which saves considerable time and effort when placing postage on envelopes. On the other hand, some people believe that the beauty of a postage stamp and the personal touch it conveys is worth the extra effort to affix them.

There is a tremendous advantage to using first-class mail insofar as updating your mailing list is

concerned, too. If an addressee has moved, your piece will be returned to you with a notification of the person's new address, if he left forwarding instructions. Conversely, if your mail is not returned, you can feel fairly confident that each addressee received it. That simply doesn't happen with bulk mail. Finally, think about how you feel when you receive a piece of mail marked for bulk delivery and how much attention you pay to it.

What to Mail

There are many different kinds of self-promos to send via direct mail. They range from postcards and posters to small, but elaborate and beautifully-printed portfolios of boxed prints. Again, the *PDN*/Nikon Self-promotion Awards mentioned previously in this part displays an excellent archive of examples on its Web site (*www.pdnonline.com/contests/selfpromo/16/*).

Obviously, the larger and more elaborate your piece, the more expensive it will be, both to produce and to mail. So include size in your budget planning. It's okay to start out with one fairly-elaborate piece followed up with something less so, but the pieces must still go out on a regular basis. What you choose to send and what images(s) you include will be a big creative decision for you to make. It's a decision you can consider along with the art director or designer you work with. You will need to find an excellent printer, too. Keep this one thing in mind though: Elaborate does not always equate with stylish. The latter is more important.

If you are mailing postcards, there are a number of companies that provide a service to photographers called "gang printing." That's where a number of promo pieces are produced all at the same time and at certain scheduled times throughout the year. By printing your work along with that of other photographers simultaneously, you keep your costs down. Alternatively, you can gang-print an entire campaign all your own, deriving a discount. Look in the classified section of your favorite photo-trade magazines to see where some of these printers advertise. If you are strictly looking for quality, graphic designers know where to find the best printers and how to minimize production costs. You don't have to spend a lot of money at first, but spend what you can afford wisely. Quality counts, even it's merely reflected in a series of low-cost postcards.

Another effective gambit is to create a portfolio of photographs printed in the form of a small book that is part of a continuing collectible series. Buyers are likely to keep something like that for years to come, referring to it and showing it to their colleagues. Ultimately, it could win an award, generating additional exposure (public relations) by appearing in a published annual. The idea, of course, is to compete for attention with all of the other thousands of promo pieces that arrive on buyers' desks each day. If you're successful, they will keep yours and look at it more than once. If you are wildly successful, they will respond to it. Most pieces wind up immediately in the trash. You must be determined to persevere.

The problem with starting out is that you can usually afford little more than a regular series of postcards. And, yes, you can be assured that most of them will be put in the round file as quickly as they are received. But the importance of frequency and regularity becomes more apparent when you consider that fact, because as long as the targets of your promotion see your name with a new photo like clockwork every few weeks or so, your message will eventually sink in.

Which Images to Choose

The main thing to watch out for in selecting images for a self-promo campaign is too much variety. Remember to stay on point, to keep hammering home the same message. Show only the kinds of images that conform to the kinds of assignments you hope to receive. That goes for "leave-behinds" as well as mailings. Even though you have to limit your range to attract a specific clientele, you can target several different niche markets at the same time with different sets of images. That means running two or more direct-mail campaigns at the same time. Even so, you will have crossover images that apply to more than a single market segment. For example, portraits that target advertising accounts work just as well with corporate annual report assignments that utilize "people photography." Here, uniformity of photographic style is just as important as consistency in terms how regularly the pieces are mailed.

Packaging Your Mailings

Experienced businesspeople know how to deal with the mail they receive, especially if they receive a lot

of it. You should follow their example. First of all, they don't let it pile up. They sift through it as soon as they receive it. They open it while standing right next to the nearest waste bin. This discipline is carried out with pious regularity for the brief time it takes each day. What doesn't immediately capture their attention is tossed away unopened. What is opened is sorted into two piles:

> That which is filed for reference
> That which is earmarked for immediate response

Patience is a virtue you cannot count on busy people to have. If the package arriving on a recipient's desk doesn't evoke an instant and positive reaction, it was a wasted effort. Therefore, every ounce of creativity must go into packaging a mailing to grab the immediate attention of its addressees. If your mailing is shipped in boxes or envelopes, make sure they can be easily opened. Even if you sent the most exquisite and expensive promo piece, so precious that you wrapped it in three "protective" layers of impregnable cellophane tape so it wouldn't be inadvertently opened during shipping, you can bet it won't be opened at all. If it's too much trouble, it goes into the round file. Packaging must be "user-friendly" as well as attractive.

The quality of packaging represents your professionalism and style when you are not physically present. It is your surrogate, your company identity. It makes a lasting first impression. No one can define absolutely what a "quality presentation" means. But, as Supreme Court Justice Potter Stewart said about something on the opposite end of the spectrum of good taste, ". . . I know it when I see it."

Generally, a professional-looking mailer has an overall appearance that's hard to mistake. It is a result of stylish design combined with fine printing. Obviously, addresses handwritten with a Sharpie™ are not going to escape the waste bin, unless you are a calligrapher. A well-designed printed label, typewritten and displaying your company logo, will be more effective. Put that label on a classy-looking envelope, too, unless you are mailing postcards. Plain manila-yellow envelopes look cheap, unless you are creative enough to apply an innovative approach to labeling. For the most part, colors work best. (Try to avoid Day-Glo orange, though.)

Postcards, as already cited, are an economical and effective way to get your message and your images in front of buyers. Just be sure they are printed on quality paper stock that augments the appearance of your photos. Try to stick with only one photo per card if it is standard size. Even larger cards benefit from fewer images (just as do portfolios), so that they can be remembered. If you want buyers to see more images, send more cards more often. Just as with every other kind of promo, make sure you tell the buyer who you are, where you can be reached, and *ask him to do something!*

Neglecting some kind of call-to-action can be fatal. It doesn't need to be complicated. It can be as simple as asking recipients to watch for more cards or to rub the "secret spot" with a coin to see if they won a free framed print. Ask buyers to visit your Web site. Ask for some feedback. You won't always get it. But when you do, it's worth a million bucks.

Tracking Self-Promo Mailings

Each time you produce a mailing targeted at a particular set of prospects and clients, it is imperative to make note of what piece was sent, to whom it was sent, and when it was sent. Otherwise, it's hard to follow up, and you will be ill prepared to mail the next promo in your campaign. You need to track the intervals between mailings, too, so they are consistently spaced. And when you make personal contact with individual clients or prospects, you must be able to tell quickly which promo pieces they have already received.

note　Obviously, it is more efficient to send out many pieces in a single mailing. Nevertheless, as you augment your list with new names, one at a time, you may have to send out individual pieces occasionally to allow recent additions to "catch up" with your mailing schedule.

Tracking "mass mailings" used to be cumbersome and tedious. It wasn't practical to make individual entries in an ordinary database, let alone on hundreds of individual 3×5 cards. Sorting data to provide useful information was virtually impossible, i.e., 87 art directors specializing in food assignments in New York City were sent Promo Poster A on July 17, 2001, and their names are. . . . Or, on July 28, 122 art directors who assign "people shoots" in New York City were sent Promo B and C. The same two

groups were sent Promo Cards D and E, respectively, three weeks later, etc. You need the capability to collate those names with phone numbers in an orderly fashion, so you can make follow-up telephone calls without confusion, especially if the mailings contain "personalized" notes. More about that coming up.

Of course, you could purchase a computer-generated list on preprinted labels every time you had a mailing to do. But those lists are rented; you neither own the list nor have the means to enter the names and addresses into a database without typing them one after another. In fact, doing so is probably a violation of the list owner's rights, making you legally culpable. Even if you could dump the list into a PC, it wouldn't be the kind of carefully managed and targeted list that you learned how to compile by doing your own research. And *still*, you would have no way to accurately track the outflow of your promo campaign and solicit responses by making follow-up calls. You couldn't easily keep track of unsolicited responses (the best kind) either.

Well, that was the bad news. There is much more good news. You can track large mailings quite easily with the software you already have. PhotoByte utilizes an eight-section column (it's actually a multipart field called *Direct Promo*) found on every Profile screen to accomplish this task for all of the records in a Found Set of contacts in one fell swoop.

EXERCISE ---------------------------------

Tracking a Mass Mailing

For the purpose of this exercise, you have decided to send a postcard (for which you have a created a code called "card 2") to all of the advertising art directors in your Contacts database.

> Open PhotoByte to the Main Menu, and click the *Search Records* button.
> You will see the Search screen.

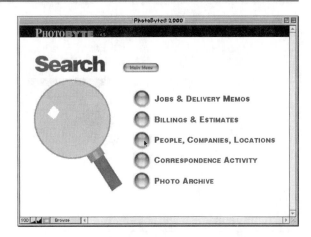

> Click the *People, Companies, Locations* button. You will see the Contacts Search screen.
> Tab to the *Title* field, and type **art director**.

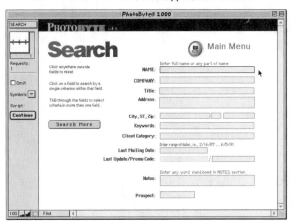

> Tab to the *Client Category* field, and select **Advertising**.

note Clicking on—instead of tabbing to—either of the above two fields will present a View Index window listing all previously-entered choices, from which, as an alternative method, you may select the criteria to enter. This method prevents typographical errors in data entry.

> Click the *Continue* button.
> A list of all the people in your Contacts database fulfilling those two criteria will appear on your screen. This is the Found Set of records for your search.

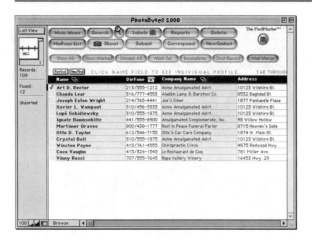

> Click on any name in the list to take you to that person's Profile screen.

On the right side of the Profile screen, notice the eight-section *Direct Promo* field. It will have some data in it already. The first two sections will contain "card 1" and "Poster 3," respectively.

> Click on section 1, reading "card 1," and Tab to section 3, which is empty.
> Type **card 2** in section 3.
> Click the *Fill* button located directly above the *Direct Promo* field.

You will see the Replace window appear.

> Read the contents of the window, and click the *Replace* button at the bottom of the window and to the left of the *Cancel* button.

When you click the *Replace* button, the entry **card 2** will appear in section 3 of the *Direct Promo* field on all of the records in the current Found Set.

> Next, click on the *Last Promo* field at the bottom of the Profile screen. (This is one of the three Date fields on the Profile > Correspondence screen.)

> Enter the current date.

tip A shortcut is to press Command/Ctrl–minus sign to yield today's date.

> Leaving the *Last Promo* field selected, click on the *Fill* button again.
> Click the *Replace* button again to fill in the same date for a last promo mailing on all the records in this Found Set.

All of your selected records are now coded to show that they have been sent "card 2" in the mail. Here's how to search for a set of contacts, all who have been sent the same mailing on the same date.

> From any Profile screen, click the *Magnifying Glass* button.

You are still looking at the Profile screen, but it is now in Find mode. That means you can use each field to enter search criteria.

> Enter the date of the mailing you wish to specify in the *Last Promo* field.
> Click on the *Direct Promo* field and type **card 2** (or whatever mailing code you wish to find).
> Click the *Continue* button on the left side of the screen.

You will have created a Found Set of all the contacts who were sent that mailing on that date. You may use the Flip Book to scroll through each Profile record of the Found Set . . .

. . . or view the entire Found Set as a list by clicking the *List View* button. (Command/Ctrl–2).

Either way, you have separated those records indicating recipients of your specified self-promo from all of the other records in your database. You now also have the capability to produce a printed report, as described earlier.

Form Letters

Form letters are also called *merge* letters, because you merge the text of a single letter with the names of multiple addressees, thereby making them appear to be personalized. This is one inexpensive form of self-promotion.

You are going to practice creating a form letter to tell a specific group of prospects about a special offer. Let's assume that you live on the east coast. You specialize in shooting annual reports, and you are planning a marketing trip to San Francisco. It would be wise to try to visit as many Bay Area design firms as possible while you are there, and maybe

even pick up an assignment or two if you can. So, several weeks before you leave on your trip, you decide to send out a letter. You will not only be soliciting appointments to show your portfolio, but also telling these potential clients that they can save money by hiring you now, because they will not have to pay your transcontinental travel expenses. To accomplish the creation of a form letter, you will start by using the PostMaster™ feature in PhotoByte. Here's how it works.

EXERCISE ---------------------------------

Sending a Form Letter to a List of Clients

> From the Main Menu, click the *Contact* button to display a List View of the current Found Set in your database.

> Click the *PostMaster* button at the top of the List View screen.

You will see the PostMaster™ screen.

> Click the *Client Category* field, and hold down your mouse button to see a pop-up list of options. Select **Corporate**. Click the *Region* field (holding down the mouse button), and select **San Francisco Bay Area**. Click the *Keyword* field, and select **Annual Report**. Now, click *Continue*.

A Found Set of clients, any one of whom might hire you to shoot an annual report job in the Bay Area, is displayed in the List View screen. In this case, nine contacts were found. You may have more or less, depending upon how many you entered previously and how they were keyworded. PhotoByte "knows" that their keywords contain the word *design* as a common denominator and that the *Client Type* field has **Corporate** selected. It correlates those data with postal zip codes that correspond to the San Francisco Bay Area without the need for you to remember how to format all of these search criteria.

note If you click on any individual's name, you will display his or her Profile. From the Profile screen, click the List View button to return to the List View screen.

› Now, click the *Merge Letter* button in the header of the List View screen.

PhotoByte displays the "boilerplate" text of a letter that has, ostensibly, already been composed. You may change or rewrite the text right on the spot, if you wish, or leave it alone. Don't bother to format it. You have already done that in Preferences!

› Click the *Print Letter with Logo* button.

Your letter will appear formatted on screen. Notice that your logo is at the top and your signature appears at the bottom. Use the Flip Book (click on the bottom "loose-leaf page") to scroll through each letter corresponding to an addressee from your Found Set of contacts. You will see that every person on your list has received a personally addressed but otherwise identical letter.

tip Because your logo and signature appear on each letter, you may choose to fax these letters, if you wish, instead of printing and mailing them. This eliminates your need for paper altogether. Still, you have a permanent record of each letter sent to each person. Otherwise, print the letters without your logo and signature, and then print them on your letterhead and sign them.

› Click the *Continue* button to go on to the Printer dialogue box. (You may avoid actually printing or faxing the letters this time by clicking the *Cancel* button in the Printer dialogue box.) You will be returned to the List View screen after printing.

› Now, click on any person's name in the list, and notice that the Correspondence History has been updated by listing the letter corresponding to today's date on the Profile > Correspondence screen. You can view the letter by clicking the button on its left side in the list.

Next, you will address the envelopes or, alternatively, the labels you will affix to the envelopes.

> From either the List View, a Profile, or the Main Menu, click the *Labels* button.
> This is the Mailing Labels & Envelopes screen and a Preview of the labels.

Although you might choose to print directly onto an envelope, this time you will choose three-across/ten-down labels.

> Click the *5160 Labels* button.

You have just completed the automated task of creating a form letter, or mail merge, marketing campaign. Normally you would click *Continue* to print the labels or envelopes. But go back to the Main Menu instead for now.

tip Use a shortcut of **Command/Ctrl–1 to go to the Main Menu.**

Preparing for Slow Periods

Some photographers find themselves so busy shooting that they don't set aside time to plan their next self-promotion campaign. They figure on doing it when work slows down a bit. Where's the logic in that? The whole idea of using advertising, direct mail, and publicity to promote your career is to *avoid* slow periods!

One of the biggest mistakes you can make is to shy away from promoting your business during good times, while, instead, trying to hustle new business when jobs are few and far between. They'll only become fewer and farther between that way. Even if you feel like you're busy enough, *never* slacken, let alone discontinue your marketing efforts. If you're too busy shooting to handle the implementation of your marketing plan, that's a sure sign that you need a rep or a freelance marketing consultant to do the work for you.

Repeat Business

Finally, the best business is repeat business. It is a sure-fire indication that you are pleasing your customers and making money. But don't expect repeat business to come if you give up wooing existing clients as if they were still only prospects. Sure, relationships will develop. That's how you got your first assignment. But just as in a relationship with a significant other or a spouse, you'd better send flowers or candy every once in a while to keep the flame burning. Marketing doesn't just help you find more clients, it helps you keep the ones you've got. "Out of sight is out of mind."

It's a good idea to include the occasional gift— a promo campaign in itself—for current clients. It should not be extravagant, but remembering birthdays with a card and a bottle of wine is a nice idea that will be remembered. A follow-up with some kind of thank-you present after a successful shoot is always a nice touch. And keep your regular promotions coming, too.

If you ever find that business has slowed down somewhat, the first place to look for new assignments is with old clients. There must have been a good reason for them to have hired you before. Remind them. If further assignments are not forthcoming, it could be a sign that something is amiss that you were not aware of. In that case, it's your job to find out what it might be and to correct it.

EXERCISE ---------------------------------

Utilizing User-Defined Fields for Self-Promotional Purposes

As mentioned above, it can be fruitful, if not simply courteous, to remember a client's birthday with a card or a modest gift. This can be accomplished more easily by keeping records of special information, birthdays included, in the *User-Defined Fields* on PhotoByte's Profile > Picture/Notes screen.

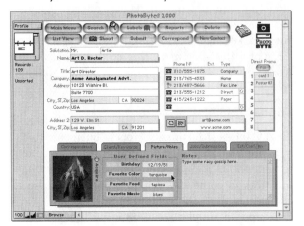

User-defined fields can be edited to contain whatever information you wish.

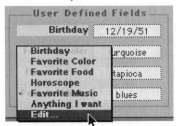

By selecting **Edit** (at the bottom of the list), you can add or delete criteria listed in the pop-up menu. When you wish to create a Found Set of records listing only those clients whose birthdays occur in June—or even birthdays in June whose favorite vegetable is spinach and favorite color is blue—simply click the *Magnifying Glass* button at the top of the Profile > Picture/Notes screen, and enter your criteria in the corresponding field(s). When you click *Continue*, as in many of the exercises you've performed earlier, you will create a Found Set of records that match those criteria.

The Found Set may be displayed in List View or as separate Profiles, through which you can scroll

one at a time using the Flip Book. And as always, you can print a report or create mailing labels or a form letter specifically addressing the sentiments you wish to express.

For example, if you are looking for clients with birthdays in June, you would type a single criterion in the field designated for birthdays (while in Find mode) that will find the right records, no matter what day in June or what year the person was born. Typing the figure "6" (for June, the sixth month in the year) followed by a slash mark (as in the way dates are formatted in PhotoByte, i.e., 6/12/73) and putting both the six and the slash in parentheses, i.e., **(6/)**, you will return the Found Set you are looking for.

Other special characters used in searches of this kind (using the Profile screen in Find mode with the *Magnifying Glass* button) can be seen when you click on the *Symbols* button while in Find mode in the Profile screen. Remember: You can search on any single field or combination of fields on the Profile screen when you are in Find mode.

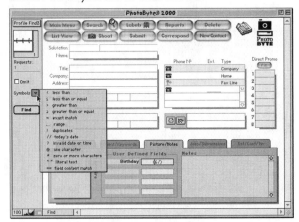

Looking for Hot Prospects

One final example is performing a search to look for "hot" prospects. Let's assume that you have been tracking the "temperature" of prospects in your database from the time you first entered each person's

record. (See the exercise, First Call/Data Entry, earlier in this part, in chapter 18.)

> From the Profile > Client/Keywords screen, click the *Magnifying Glass* button again.
> Click on the *Prospect* field, and select Hot.

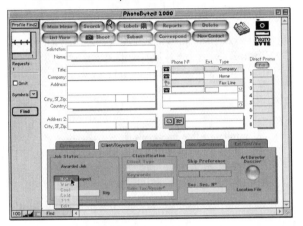

> Click the *Find* button.

Again, you can display a Found Set of records, this time exclusively "hot" prospects, in a List View or by individual Profiles, through which you can scroll one by one. You can also add additional criteria to the search by entering criteria into the *Client Type* or *Keywords* fields, etc.

Rules for Effective Self-Promotion

> Never tell anyone you're not busy. Clients want to believe they're hiring you away from their own competitors. They hire photographers who appear successful, not needy.
> Put your name, address, phone number, and e-mail on every single promo piece you send out, from business cards to posters.
> Ask someone to write an article about you, illustrated with your photos, and submit it to magazines. If it gets published, do a direct mailing of reprints. Attach a note or short cover letter to personalize the mailing.
> Advertise your work in publications that art directors, designers, and public relations professionals read. That includes not only creative sourcebooks, but client trade magazines such as *Communication Arts*, *Print*, and *Adweek*.
> Use direct mail to generate new leads. A suc-

cessful mailing of only a hundred letters or postcards to carefully selected targets can yield five to ten qualified new prospects who call back for more information.

> If that one letter or postcard doesn't actually get you a job, keep sending to the same people every few weeks or so. Don't stop! Consistency will help your message sink in.
> Take advantage of "co-marketing" arrangements (also known as "strategic alliances") with other companies. For instance, try to get a film or camera manufacturer to feature your work on their Web site or other promotions. Maybe you can obtain equipment in exchange for a public endorsement of their products or for participating in an educational lecture series sponsored by the manufacturer.
> Create a "press package" of literature describing your services, fees, methods, and so on. Include a brief bio, some samples of your photographs, and a list of your distinguished clients. (They are all distinguished.) Mail this package to people who request more information in response to your ads and other mailings.
> Publish your own newsletter. It will help people get to know you. Let people know about your recent successes and your future plans, even if it's to announce a visit to a new market region and your availability for assignments.
> Don't skimp on the cost of classy letterhead, envelopes, and business cards. Your letterhead design and the quality of the paper you use will convey an image of success. Try to barter an arrangement with a graphic designer, if you don't have the capital.
> Offer to speak and give seminars before professional groups. But be selective. Not every opportunity to speak is worthwhile. Try arranging for potential clients to be in the audience.
> Teach a course in photography at a community college or university. This gives you added credibility you as an "expert" and the prestige of an academician.
> Go to lots of meetings and seminars. Socialize as much as you can. Do volunteer work, if you have time. Become visible in the photo-business community.
> Keep your name in front of clients and prospects by giving away "premiums" (e.g.,

pens, photographic screen savers) The right one might be kept in the office for years, serving as a daily reminder.

› Let people know about your recent successes. If your latest magazine cover was a big hit, send copies to everyone on your list (in that market). Include a cover note that says, "Here's what I've done recently. Let me do the same for you!"

› Save letters of praise and thanks that you receive from clients. Selected quotations from these letters, or even reproductions of the actual letters, can dramatically add to the selling power of your next mailing. (Be sure to get permission, first, to use the letter or a quote).

› Publish a book. (That's the topic of a book itself!) It doesn't have to be a retrospective of your work as an *artiste*; in fact it's probably too early in your career for that. But if you have a good idea that combines photography with a topic of popular interest, you might be able to interest a publisher, and maybe even a writer to collaborate with you.

› Examine reports of your marketing activities by reviewing the Customer Response Reports in PhotoByte to see what works and what doesn't (see the exercise, First Call/Data Entry, in chapter 18.)

NOTE

11 A number of free press release templates for Microsoft Word™ are available at this Web site: *http://search. officeupdate.microsoft.com/TemplateGallery/ct93.asp.*

22

Marketing
and the
World Wide Web

It has been said that the photo marketplace is going through a firestorm of changes that threatens to toast your livelihood if you don't share a burning desire to put a home page on the World Wide Web. But you won't hear anyone trying to make a case for being "on the Web" in lieu of conventional marketing techniques.

The Internet is a vast reservoir of information, a great convenience for assignment and marketing research. Many of you may already depend on e-mail to correspond with colleagues, clients, and friends. No doubt, you have bought something on the Web, a book or something from a catalog perhaps.

There is no doubt that the Internet is a great resource for you and your business. But keep in mind that creating your own personal Web site on the Internet might not be all it's cracked up to be. While it can improve your productivity in a number of different ways, its impact on your financial circumstances may be just a little exaggerated.

A Brief History

Venture capitalists, investment bankers, and the founder-entrepreneurs of high-tech start-up companies on the NASDAQ stock exchange quickly accumulated vast amounts of paper wealth—and some lost it—thanks to the Internet. A lot of dot.coms became dot.bombs. Their early success, coupled with a human capacity for greed, incited a frenetic Internet fever, the modern equivalent of the California Gold Rush.

But their investment strategies, the ones that continue to pay off, are all about developing an electronic infrastructure, to provide new channels for consumers to participate in e-commerce. That means creating new ways for consumers to *buy* things—not sell things—on the Web.[12] That's because there are more buyers than sellers. The big moneymakers are the corporations who provide both the economic and engineering infrastructures for the Web, not the people who use those infrastructures.

Changing the Photographic Marketplace

The Internet is a conduit, no more and no less. It is a pipeline for data to flow from point A to—well, yes, points B through Z, and then all over the world in the blink of an eye. It is a magnificent medium for the distribution of information (if you have a high-bandwidth connection). But most of the fuss

you've heard about the Internet has to do with consumer sales.

The trick to getting the most out of the Internet is to understand that, while you can broadcast information about your business and your photos everywhere—well, sort of—no one is predisposed to "tune in" to your site. You've got to persuade people to look before you can reap any of the rewards of e-commerce. It's the getting-them-to-look part that involves conventional marketing.

The Internet has become tantamount to a commercial broadcast medium, somewhat like television. But there is a new twist. Anyone with a modicum of graphic design talent, some content, a PC, and fifty dollars a month for both a hosting service and an Internet connection has equal and unlicensed power to broadcast whatever they want.

There has been a lot of recent talk about the "democratization of information" as facilitated by the Internet. But if you look closely at what has happened from a pecuniary point of view, it isn't very democratic. The companies with the most money have been playing a game of King of the Mountain. In this high-stakes game, many smaller Internet companies are being knocked off as the bigger players consolidate. Another way to put it is that the bigger fish are eating the smaller fish, leaving just the few biggest fish to rule the pond—or the sea. There's nothing new about that strategy. It resembles the institutionalization of the telecommunications and broadcast industries a couple of generations ago (or, previously, the oil industry, and railroads before that). Only a few major networks dominated the content on television, forcing you to look at advertising for which they collected revenue. It still works that way. *Portals* are the Internet equivalents of TV networks today, e.g., Yahoo!, Excite, and AOL Time Warner, instead of NBC, CBS, and ABC. In fact, the portals are gobbling up the old establishment of broadcasting, publishing, and telecommunications companies.

Insofar as photographers are concerned, you still have to advertise in sourcebooks, such as *Showcase*, the *Workbook*, *Klik!*, and the *Creative Black Book*. You still have to mail posters and postcards via the postal service. And you must still work the phones. Ultimately, anybody who wants to sell something on the Web must include a "call-to-action" in his ads and Web sites alike. That means

an outright appeal to buy something right on the spot. It helps facilitate a transaction if one can pay for what one wants to buy with a credit card or an electronic bank transfer. But you must decide if the quantity and quality of sales you get is justified by the amount of time and money you will have to spend to advertise your "presence" on the Web, to lure people there.

It might be useful to think of the Internet less like an "information superhighway" and more like an ocean of information. Trying to advertise a photo business on a Web site is like putting a message in a bottle and tossing it into the sea. The likelihood that either a beachcomber or someone on a passing ship might spot it and pick it up—and call you with work—are remote. If you prefer the highway metaphor, consider leaving your bottle by the side of a well-traveled road. It might be a very shiny bottle that will surely catch the attention of passersby, just not necessarily the people you need to reach.

Therefore, contrary to the conventional wisdom of many in the photographic community, the Internet is not a very effective self-promotional tool. Those who believe that the act of simply publishing a Web site or a Web-based portfolio will inevitably lead to increased exposure for their work and greater income will be disappointed. Nonetheless, besides research, the Web does, indeed, do two other things very well:

> It facilitates distribution
> It facilitates sales

Those two factors are what make e-commerce possible, especially for images, because unlike a pizza or a bouquet of flowers, you can deliver an image over the Web.

A Web site is where consumers place orders for products. By the time they get there, they should already be committed to *buy* something. If they are not ready to do so, and if their credit cards are not in their hands, they are just window shopping. The software that is used to surf the Web isn't called a "browser" for nothing.

The point is that the Web is not necessarily the place for individual photographers to sell products to consumers. Maybe you can sell to the media, but you'll be competing with high rollers like Corbis and Getty Images. How, for instance, will buyers find

you and your work on the Web? The answer is, you've got to tell them where to look and why they will profit by going there. But that, supposedly, is how you already market your services, through publicity, word of mouth, direct mail, and paid advertising. On the Web, it now becomes a matter of scale. Finding you by accident via a search engine doesn't happen often enough to make a difference economically.

As far as your business is concerned, it doesn't make sense to spend large amounts of money to advertise a Web site directly to ad agencies, magazines, designers, and other companies; they rarely make impulsive purchases. Besides, if every photo buyer in the industry were suddenly bombarded by the solicitations of tens of thousands of photographers, each one trying to get them to look at images on the Web, they'd give up looking at the Web altogether. It's hard enough already just to get them to look at a conventional portfolio. A photographer's Web site will have no significant impact on sales. It can only provide incremental and incidental sales, unless your business exclusively promotes the sale of stock images with a large advertising budget of your own.

Of course, there is always anecdotal evidence from one photographer or another who swears that, if he hadn't had his delectable picture of an artichoke on his Web site, just sitting there in cyberspace, he would never have had that portentous first "hit" and a subsequent telephone call from Amalgamated Artichoke Growers of America, Inc. that led to his continuing relationship with his, now, biggest client. One can't disparage serendipity and the chance of earning "found" money, no matter how large or small the amount. Just don't set your hopes too high. Every photographer would like to have his own artichoke story to tell, but there aren't too many "Amalgamated Artichokes, Inc." out there.

The Relationship of Technology to Marketing

Reality paints a picture of a market that has not really changed at all. Only the technology to help you *do* marketing has changed.

Technology is no substitute for putting sound marketing principles to work. Fundamentally, the way your photos are published, including CDs and online publishing, remains the same. So do the means for determining how you will be paid for cre-

ating and licensing them. But too few photographers, it seems, understand the difference between what a *market* is and the process of *marketing*.

You've read that marketing is not the same thing as selling. Marketing is a process of determining who your customers are, how to reach them, what products they want to buy, and at what price. It helps you recognize your competitors, determine what messages appeal to prospects, and where those messages should be placed to optimize their effectiveness in making sales. It also means trying to exert some influence over those people who exist within a market (consumers), to make them want to buy *your* pictures instead of someone else's. So how does all this relate to your having a Web site?

Well, on a more positive note, a Web site can help land assignments once you've established a rapport with potential buyers the traditional way. Let's assume that you have established a new relationship with an important buyer. At that point, your Web site can bolster your new relationship as a convenient source of information about you and your business. If, for example, in the course of a discussion about a pending assignment, a buyer wants to see a particular image, or you want to reinforce an idea or suggestion with an illustration, you can point him to your Web site. But you wouldn't be in a position to make that referral if you hadn't already established the relationship and begun a dialogue through traditional marketing channels.

The Effectiveness of Portfolios on the Web

Some people believe that the Web will replace printed sourcebooks, such as the *Creative Black Book*, and the *Workbook*. But that kind of logic seems to imply that sourcebooks have already replaced portfolios, which, of course, they have not. Sourcebooks and portfolios coexist quite well, as they have since long before Internet. The fact that you can now display images on a Web site does not spell the demise of either sourcebooks or portfolios. One medium does not trump the other.

It's unlikely that low-resolution electronic facsimiles of photos viewed on a Web site will ever supplant the kind of impression you can create with a distinctively beautiful print portfolio. Besides, since your work will, for the most part, ultimately appear in print, it makes sense to present it that way to the buyer.

The beauty and usefulness of a portfolio lies precisely in the fact that it consists of *prints* that are beautifully packaged and presented. They can be held physically and admired. They are not merely "images" on a screen; they are indeed *photographs*. Often, they are accompanied by a real human being, too, with persuasive powers that somewhat surpass those of a Web site.

NOTE

12　That doesn't include Web auction sites, of course. But it's obvious that the auctioneer's site makes the big bucks by taking commissions from millions of customers. The individual customers who submit one or two items for sale receive a service, a marginal benefit compared to the service providers.

Copyright

Photographers do not sell photographs;
they license copyrights.

Congress has the power to ". . . promote the Progress of Science and useful Arts, by securing for limited Times to Authors and Inventors the exclusive Right to their respective Writings and Discoveries."[1]

With those few words, the United States Constitution laid the groundwork for a system designed to advance the cause of creativity. However, you may be surprised to learn that the ultimate purpose of protecting individual rights to arts and letters (and technological inventions) is not to financially enrich their creators, although that is the carrot held out by the government. Its ultimate purpose is, in fact, to make the innovations of the few accessible to the many, to further the nation's cultural growth.

23

A Historical
Perspective

The Constitution doesn't offer anyone or any class of people special privileges just because they happen to have some extraordinary knowledge or talent. Photographers aren't entitled to earn more money than other professionals who might not know a lens shade from a beach umbrella; the Constitution is more egalitarian than that. But in their wisdom, long before the advent of photography and other technologies for creating works of art, the Framers foresaw how they might encourage innovation for the common good by allowing a broad degree of exclusive rights for those who would share the fruits of their intellectual imaginations with the rest of us. To that end, the Constitution offers a quid pro quo—one thing in return for another to those who share their innovations. It is meant to be a reward. It clearly implies that innovators are entitled to a financial reward for their efforts in exchange for stimulating cultural growth. It sanctifies a limited monopoly for them to exploit their ideas in exchange for "keeping up the good work." It institutionalizes a means for the government to protect the expression of their ideas as if they were, in aggregate, private property by building a fence around it. If it seems like that philosophy is at odds with the underlying principle of guaranteeing public access to new

works, then it must also be understood that the government will not allow that fence to stand forever. And in the meantime, it has also built a gate.

Without a financial incentive and the protection of a monopoly, it isn't likely that enough people would participate wholeheartedly in the creative process. They would be forced to eke out their livelihoods by more commonplace means. It wouldn't be worth their time to write, paint, draw, choreograph, sculpt, compose, invent, and make photographs if anyone else could freely take what they created and use it—even profit by it—as soon as it came into being. Nor would it make sense from a standpoint of the intellectual integrity of art if others could take your work, modify it only slightly, and claim it as their own. It would be impossible to trace authorship. Imitation would abound. Originality would be stymied.

The idea behind protecting new and original works is straightforward: If you are prevented from copying something, you either have to invent something new or pay to remove the restrictions placed on copying what already exists. When a financial incentive is introduced in combination with restrictions on existing works, the perpetuation of always-newer works is assured. In that sense, copyright is a

catalyst for change to occur. It prevents intellectual and cultural stagnation. It represents the imposition of an artificial irritant into the creative process, if you will, like the grain of sand in an oyster that leads to a pearl.

While the Constitution laid the groundwork, it became the responsibility of Congress to set up a practical mechanism for artists and innovators to legally enforce their rights, their *copy*rights. Therefore, copyright is defined by legislation under Title 17 of the United States Code.[2] But simply stated, it is a protection established by federal law to help artists avoid losing control of their ownership and over the distribution or display of whatever they create. Specifically, as the creator of a photograph, you have the exclusive rights to:

> Reproduce your work
> Create derivative works based on your original work
> Distribute copies of your work
> Display your work in public
> Decide who else may do all of the above

You can rely on these rights to help you:

> Identify assets to sell in the marketplace
> Establish the value of your assets, i.e., creative products and services
> Define the concept of authorship as it pertains to negotiating contracts for the use of your assets by other parties

Ownership of Copyright

According to the Copyright Act of 1976, passed by Congress to supplement and amend its first copyright legislation of 1909, it is a clearly established fact that freelance photographers are the owners of the images they create *from the moment of inception.* They belong to you from the instant you press the shutter, whether or not the film has been developed. If you use a digital camera, the situation is the same. It doesn't matter whether or not the data recorded digitally on a silicon chip has been saved as an electromagnetic file to a hard drive or inscribed by laser beam onto a disk; the image you recorded is considered to have been "fixed." From the moment that such a latent image exists inside a camera or else-

where, no matter how it was made, it is protected by copyright.

Neither official registration with the federal Copyright Office nor media publication is required to establish ownership. Copyright protection kicks in automatically. It is also immediate.

The Inclusion of Moral Rights

In addition, visual artists have the dual rights of *attribution* and *integrity*. These are collectively referred to as *moral rights.*

Again, according to the Copyright Act of 1976, and as amended by the Visual Artists Rights Act of 1990, photographers have a right to not only claim exclusive authorship to the works they create, but to prevent the use of their names in conjunction with any work of visual art they did *not* create.[3] That includes the right to disavow the use of your name in conjunction with any distortions, mutilations, or other modifications of your photographs if such acts might have a prejudicial, or negative, influence on your professional reputation. There is one catch, however. The rights of attribution and integrity apply only to "one-of-a-kind visual art and numbered limited editions of two hundred or fewer copies," according to the Copyright Office of the Library of Congress.

The Visual Artists Rights Act also gives you the right to prevent anyone else from distorting, mutilating, modifying, or even completely destroying your work, whether by intention or an act of gross negligence. The transfer of a physical copy of a limited-edition or one-of-a-kind photo (e.g., by the sale or gift of a print) to another party does not affect the moral rights accorded to the photographer, the creator of the work. If one of the aforementioned destructive or unjust acts does occur, it is a violation of copyright, for which you are entitled to seek a legal remedy. Legal remedies are explained later in this chapter.

note Obviously, the provisions pertaining to moral rights in the copyright law have limited bearing on the commercial use and licensing of photography. They apply for the most part to photographers who make their livings as artists selling prints.

A final but very important distinction of the Visual Artists Rights Act provides that only the orig-

inal author of a photograph may claim the rights of integrity regarding its destruction, modification, or distortion mentioned above. Therefore, if a copyright has been sold or assigned to someone else, the acquiring party has no moral rights to the work in question. Those specific rights may not be transferred—not even deliberately—by the author to any other party. They remain the exclusive rights of the photographer forever, unless they are waived in a written legal document. In that case, *nobody* will have moral rights to the work in question.

Duration of Copyright Ownership

These are the criteria used to determine when a copyright is deemed to exist and when it expires, based upon the creation date of the work in question.

Works Created on or after January 1, 1978

Copyright exists from its time of creation throughout the life of the author plus seventy years after the author's death. In the case of a joint work prepared by two or more authors who did not do a "work-for-hire" (see the sections on Joint Works later in this chapter and on Work-for-Hire in chapter 26), the copyright endures throughout the life of the last surviving author plus seventy years after the last surviving author's death. For works made for hire, and for anonymous and pseudonymous works (unless the author's identity is revealed in Copyright Office records), the duration of copyright will be ninety-five years from publication or one hundred-twenty years from creation, whichever is shorter.

Works Created, but not Published or Copyrighted, before January 1, 1978

Copyright exists and lasts, again, for the life of the author plus seventy years. The author's surviving relatives or estate are entitled to inherit the copyright for that period of time. Section 304 of Title 17 explains all of the details, exceptions, and extensions of the duration of copyright as it pertains to the death of the author and the subsequent disposition of copyright assets to the author's surviving relatives or estate.[4]

Works First Created and Published or Registered Before January 1, 1978

Under the law in effect before 1978, copyright was secured either on the date a work was published or

on the date of registration, if the work was registered in unpublished form. In either case, the copyright endured for a first term of twenty-eight years from the date it was secured. During the last (twenty-eighth) year of the first term, the copyright was eligible for renewal.

The Copyright Act of 1976 extended the renewal term from twenty-eight to forty-seven years for copyrights that were in effect on January 1, 1978, or for pre–1978 copyrights, making these works eligible for a total term of protection of seventy-five years. Public Law 105-298, enacted on October 27, 1998, further extended the renewal term of copyrights still subsisting on that date by an additional twenty years, providing for a renewal term of sixty-seven years and a total term of protection of ninety-five years.

There is no longer a need to officially file for a renewal in order to extend the original twenty-eight-year copyright term to the full term. However, some benefits accrue to making a renewal registration during the twenty-eighth year of the original term. The author or his estate must file a claim for the renewal of an existing copyright and pay a twenty-dollar registration fee to the Copyright Office.

For more detailed information on the duration of copyrights regarding specific dates of creation, refer to Circular 15a, *Provisions of the Law Dealing with the Length of Copyright Protection,* published by the Copyright Office and available on the Web.[5]

Public Domain

Copyrights are not eternal. When a copyright expires, the work it protected falls into the *public domain*, a state, or condition, whereby anyone is free to use it without permission and without having to pay a licensing fee to its creator. That is what the Constitution intended. The work ultimately belongs to society, to the public. The government-protected monopoly is gone.

Certain conditions must apply before photographs can pass into the public domain, and under routine circumstances, it is not likely that that will happen, either inadvertently or against your will, for the duration of the term of copyright under the law.

note Just because a work was posted, published, or distributed over the Internet does not place it into the public domain. Copyright law extends to electronic media as well as print media.

What Is Copyrightable

To quote an official publication of the United States Copyright Office, "Copyright in a work of the visual arts protects those pictorial, graphic, or sculptural elements—a work's contents, if you will—that, either alone or in combination, represent an 'original work of authorship.'"

As the legal author of a photograph, no one can deny you your rights (your copyrights) unless you either give them away or sell them, or arguably, unless you broke the law to obtain a copyrighted image, i.e., if you committed an infringement in creating a photograph or, perhaps, trespassed on private property to gain access to the subject of a photograph. The only way to lose your legitimate copyright is with your consent.

Originality and Uniqueness

Additionally, to be copyrightable, an image must be both original and unique. One person's copy of another person's photograph has no originality and cannot be copyrighted. In fact, permission to copy the first photo would be required from its author, or else the second photo would have to be considered a counterfeit, a phony. It would represent an infringement, subject to legal action. So, whether an image was copied deliberately and exactly (i.e., plagiarized) or whether it is a so-called innocent appropriation published under the guise of an homage or an adaptation contributing to a derivation of the original work, it has no merit under the law. If it is substantially similar to an original image, the copy is considered to have no originality itself; it cannot be copyrighted.

Even if an alleged infringer claims never to have seen the copyrighted image in question, insisting that any similarity is purely coincidental, copying is considered the only reasonable explanation for similarity when two images are compared side-by-side and found to closely resemble each other. The law says that no other conclusion may be drawn, and no other proof is necessary. The original copyright is the only copyright.

What Is Not Copyrightable

Copyright protects only the particular manner in which ideas are expressed, or executed; it does not protect the ideas themselves.

The Copyright Act declares unequivocally by statute: "In no case does copyright protection for an original work of authorship extend to any idea, procedure, process, system, method of operation, concept, principle, or discovery, regardless of the form in which it is described, explained, illustrated, or embodied in such work." Only the original expression of an idea in tangible form can be copyrighted. In other words, you cannot protect your brilliant *idea* for a photo, no matter how detailed or unique your verbal or written description of it may be. You can only protect the actual, physical photo itself, which is the execution of that idea.

It is interesting to note, however, that you *can* copyright the actual text of a description. That means no one is free to copy the exact words you used to express your idea. Unfortunately, if someone reads your description and creates a photograph based upon your idea—if they beat you to the punch—you have no legal right to claim that an infringement occurred. In fact, it is not an infringement. It may be unfair, but any other photographer who executes your idea before you, either by creating a latent image or a print depicting that idea, will own its copyright.

Only after you have fixed your idea on film or digital media—or arguably, if you created a sketch of it first—is it protected by copyright law. Of course, it is assumed that you will eventually make a print or publish your picture. The deciding criterion is proof that you were the first person to manifest a tangible and original photograph representing the idea in question, even if you only snapped the shutter, leaving the image inside a camera, either film or digital.

When Copyright Does Not Apply to a Photo

There are circumstances where copyright does not apply to photographs that you make yourself. For instance, if you make a photograph while you are employed by another party and your job description includes making photographs, then that other party owns the copyright to any photograph you make.

Another way you can take a picture but not own its copyright is to sign an agreement that waives your right to authorship and, thereby, the copyright along with it. *This is usually a very unwise thing to do.* The result of such an agreement, or more insidiously, the result of such a clause inserted into another agreement that you would otherwise be dis-

posed to sign, is a *work made for hire*, as described later in chapter 26 of this part.

Sharing Copyrights

If you are working with art directors who have been feeding you their own ideas, either verbally or in writing, they are not automatically entitled to share your copyright. However, the possibility of sharing a copyright is not excluded, if you agree to such an arrangement before the works in question have been created. A legal agreement must stipulate in writing your willingness to share the copyright. But that's between you and your partners or business associates. The issue is as negotiable as is a price, and you are under no legal obligation to share your copyright.

It gets a little trickier—and supposedly this is what justifies a lawyer's job—when, say, an art director assigns you to work from a sketch that *he* has made, and he subsequently claims copyright ownership based on his authorship of that original sketch. The copyright, otherwise, belongs exclusively to the photographer who executes the tangible expression of an idea so that it becomes a photograph.

Joint Works

It is legal for any number of persons to share a copyright. Such an arrangement must simply be spelled out in a written agreement beforehand, as stated earlier. But working with clients aside, there are plenty of examples of photographic teams, whereby two photographers marshal their creativity and marketing expertise in a joint effort. They are the co-owners of a business. It is a partnership. They each take a salary, and the business itself works to earn a profit.

It is also conceivable for photographer to enter into a joint work with a client. The client can make that a condition of hiring. Such a condition is tantamount to a work made for hire, except that the copyright is shared instead of relinquished entirely. This is probably a very rare circumstance.

Corporate Ownership

If you have incorporated your business, your business owns the copyrights, not you personally. However, you may own 100 percent of the corporation's stock and all of its other assets, including copy-

rights. If other investors own shares of stock in your corporation, they will participate in the ownership of all its assets, including copyrights. If the business is sold, the copyrights go with it! The proceeds must be shared proportionally with the shareholders of the corporation.

Trademarks

Trademarks (also known as brand names or logos) are described here merely to avoid their confusion with copyrights. They rarely have application to commercial photography.

Trademarks are words, symbols, graphic designs, or a combination of any or all of those elements that distinguishes one product or group of products from another. Some examples are Kodak, Hasselblad, Pentium, Windex, Kleenex, Harley-Davidson—trademarks so familiar, you probably picture them immediately in your mind's eye. Also, picture the Pillsbury Doughboy, the Michelin Man, The Playboy Rabbit, McDonald's Golden Arches, the NBC Peacock, or listen to the three NBC chimes. Even the way the colors yellow and red are associated and used together graphically will always refer to Kodak. These are all examples of trademarks. A trademarked name is accompanied by a registration symbol, e.g., PhotoByte®. It took a lot of time and money for the companies that own trademarks to establish that kind of readily identifiable presence in the marketplace.

Another kind of business identifier that is sometimes mistaken for a trademark is called a *trade name*. A trade name is the word or phrase under which a company legally conducts business. For example, *Procter & Gamble* is a trade name, while *Ivory* is the trademark used by the Procter & Gamble company to differentiate its soap from other soaps.

A company is legally entitled to have trademark protection under the law, even if a trademark has not been registered. But for the most part, leaving a trademark unregistered is dangerous, much more so than allowing a photograph to remain merely copyrighted, but unregistered. The stakes are usually higher; one could lose an entire company identity. Just like copyright protection, though, the law recognizes that a company that uses a distinctive mark on its goods is entitled to legal protection from those who try to pass off counterfeit goods as their own.

While the registration of a trademark under federal law entitles the registrant to additional legal rights and benefits, the technicalities involved in obtaining a registered trademark (unlike the simple procedure for registering copyrights) usually require you to retain an attorney. Furthermore, it's likely that if you need to register a trademark, your business needs to be incorporated. So, generally speaking, trademarks are of small concern to the business of freelance photography, unless you plan to found a corporation and establish products with brand names. But that is the subject of another book.

International Copyright Protection

There is no such thing as an "international copyright" that will protect your photos from unauthorized use in foreign countries. Usually, jurisdiction pertaining to copyright disputes is deferred to the laws of the nation in which the alleged infringement occurred. For example, if your photograph is used in Canada by a Canadian-owned publication without permission, you must rely on the Canadian courts to resolve your problem.

Most countries offer copyright protection for foreign photographers. Their statutes differ, not necessarily in principle from U.S. law, but are implemented differently or might involve different registration procedures. If you are an American photographer, you should review the copyright laws per-

taining to the country of origin of the hiring or publishing party, and try to secure your rights under U.S. law by written contract. Nevertheless, foreign protection has been greatly simplified over the years by international copyright treaties and conventions such as the Berne Convention, an international copyright treaty signed in Berne, Switzerland, by many countries, including the United States.

For further information and a list of countries that maintain copyright relations with the United States, refer to Circular 38a, *International Copyright Relations of the United States*, available on the Web.[6]

NOTES

1 Article I, § 8, clause 8 of the Constitution of the United States of America.

2 The complete U. S. Code, and many reference articles specifically related to Title 17 and copyright law, may be found in HTML format on the Web site of the Legal Information Institute, established by the Cornell University Law School: *wwwsecure.law.cornell.edu/topics/copyright.html*.

3 Section 106A: *www.loc.gov/copyright/title17/92chap1.html #106a*.

4 According to Peter W. Martin, Codirector of the Legal Information Institute at the Cornell Law School, in the autumn of 1998, Congress passed a number of major amendments to the Copyright Act, including one that increased the term of copyright from life-plus-fifty to life-plus-seventy years. See: *www.loc.gov/gov.copyright/title17/92chap3.html*.

5 See: *www.loc.gov/copyright/circs/circ15a.pdf*.

6 See: *www.loc.gov/copyright/circs/circ38a.pdf*.

24

The Business
Model for
Photographers

As much as photography has some things in common with just about any other kind of small business, from basic bookkeeping to paying for permits and maintaining customer relations, it has its peculiarities, too. Primarily, they have to do with the way revenue is collected. The operational routine for running a photo business—in fact, its entire rationale for making money—is different. Clearly, copyright bears a significant influence on the business of photography.

A Rationale for Making Money

In defining commercial photography, it is insufficient to say you're going to shoot pictures and sell them for a living. That is too simplistic.

Unlike a business that manufactures toothbrushes and sells them to consumers (everyone uses a toothbrush), commercial photographers create products and services that have value only to other, certain kinds of businesses.[7] Those business are not allowed to dispose of your work by any which way they please in exchange for paying one low price, as a person who buys a toothbrush will use it, throw it away after a while, and buy a new one. For one thing, they have to give it back (return your film or prints).

Furthermore, if toothbrushes were regulated like photographs, you could limit your customers to brushing only one tooth at a time for only three mornings per week and prohibit evening brushes altogether. Sound strange? Well, if you disregard the personal hygiene implications of that whimsical analogy, it is nonetheless true.

It's easy to understand how you could exchange something tangible like a toothbrush for cash by selling it outright; you wouldn't expect or care to see it again. You also understand that the business of photography means turning something *intangible* like an idea into a publishable image, which is merely a facsimile of something real: a photograph. You learned that in part 2. But what kind of mechanism exists for turning intangible facsimiles—images, that is—into cash? It must be an arrangement that allows them to be exchanged over and over again. Moreover, it must satisfy buyers without letting them keep anything.

As improbable as that sounds, there is such a mechanism. It is exemplified by the back-office administrative procedures, a unique set of activities and paperwork, that support the photo business. All creative and technical aspects aside, that means it's what goes on behind the scenes that sets photogra-

phy apart from other professions. This mechanism lends structure to the business side. It also explains how it is possible to make money by fitting photography into the overall economic scheme of things, in this case by turning ideas into images and then into cash. Such a rationale exists for every profession. It is called a *business model*.

A business model doesn't make the rules for commercial transactions. It describes the rules that already exist, the ones that tend to work historically. To play the game successfully, to participate profitably, it is necessary to know the rules and to follow them.

Think of a business model as a flowchart or a diagram, like the schematic diagram for the wiring of an electrical appliance—a toaster for example— only instead of outlining the flow of electricity through wires and resistors that results in an English muffin, a business model describes the flow of commerce through a series of documents that results in a photo assignment.[8] Each document is a milestone along the way to the completion of an assignment and its subsequent publication. At the end of this virtual paper trail, one expects to be rewarded with a check.

A business model allows photographers to attach a value to each of the various products and services they provide for their clients. In that way, it explains not only *why* photographers get paid, but it supports the *how-much*-they-get-paid part, too. Copyright is fundamentally important to the commercial-photography business model, because it spells out exactly what clients are supposed to receive in exchange for paying photographers to shoot pictures. (The "how-much-they-get-paid part" will be explained in part 6.) The business model provides a framework for the relationship that exists between publishers and photographers. It defines the very nature of what photographers do for a living:

> The business model for commercial photography is not to *sell* photographs, but to *license* photographic *copy*rights to other businesses, so they can use them temporarily for their own purposes.

It almost goes without saying that the incentive for this or any other business model is profit. All of the services you provide to shoot photo assignments and all of the time you commit to their fulfillment, as well as the administrative duties you perform, are merely in support of using the business model to earn financial rewards. What makes this business model interesting is that what you manufacture and exchange for money is so ephemeral. No physical products change hands, at least not permanently.

Licensing

To understand how the business model works, it is crucial, first, to understand the concept of licensing and its relationship to copyright law.

Licensing means giving other parties an opportunity to derive value from something you own, to let someone else use—or profit from the use of— your property while ensuring that you receive compensation for allowing them to do so. It means the same thing as renting or leasing, just like renting an apartment or leasing a car. However, instead of apartments and cars, the rentals referred to in this book pertain to copyrights—literally, the right to copy something. Actually, the invoices that photographers submit to their clients are licenses themselves. (Refer to chapter 45, part 8, The Paper Trail.)

The main point to grasp for now is that not just physical photographs, but the rights to control their reproduction, can be traded, bought, and sold just like any other kind of property you might own. You also have a right to protect your property by withholding it from use. In a commercial context, copyrights are no different than real estate, jewelry, stocks and bonds, automobiles, furniture . . . you name it.

Intellectual Property

If a thief steals your camera, it's clear that you will suffer a loss. But what if someone scans one of your photos out of a magazine or copies it from a Web site and, then, publishes it somewhere else without your permission? No one has deprived you of any physical property because you still possess the original negative or transparency and, maybe, some prints too. Moreover, you can continue to make money by further licensing the copyright to the photo in question. So what was actually stolen? What harm was done?

Before such questions can be answered, the issue of what constitutes private property, let alone its ownership, must be addressed. That leads to a

discussion about a particular kind of property called *intellectual property*, the phylum in which copyright belongs.

The notion of intellectual property has been around since Gutenberg's invention of moveable type, allowing publishers and authors alike to benefit commercially from the mass distribution of ideas. It was back then in the sixteenth century that ideas, in addition to physical possessions, became assets. So what's new? The Information Revolution has attributed a new currency to images in particular. The more images you have, the more assets you have. An accumulation of assets leads to an increase in net worth, a measure of personal wealth. But there is a practical limit to what one can accomplish with wealth, because it is not always easy to spend. Just having a lot of images does not automatically allow even the best photographer to cash out. Spendability, if you will, is determined by the effort required to transpose one's assets, images or otherwise, into hard currency. There is a word for that: *liquidity*.

Liquidity

If an asset is said to be *liquid*, it flows easily through conventional market channels. That means it is readily convertible into cash. The value of intellectual property can be characterized, generally, as being less liquid than other, more tangible assets.

To illustrate, a hundred-dollar is as liquid as liquid can be, whereas a stamp collection is much less so. That does not mean the stamp collection is less valuable. It just means that buyers aren't waving hundred-dollar bills at people selling stamp collections. Instead of buyers looking for you, you have to look for a single buyer. But you can easily trade that hundred-dollar bill for anything of equal value at any time.

Whenever you decide to *liquidate* a personal asset (e.g., to sell your car, your house, your old strobe lights, or your stamp collection) and there is no commonly accepted "sticker price," then either a mutually agreeable price must be negotiated between a seller and a buyer (after advertising in the newspaper or on the Internet), or you can make your property available at a public auction. (Now you can do that on the Internet, too.) Either way, it takes a little extra work to find a buyer if your asset is not liquid.

In an economy that is becoming ever more reliant upon technological innovations, intellectual property, i.e., content, has acquired new commercial significance. The Internet makes images more liquid, more easily convertible into cash. While they are not as liquid as shares of stock or money in the bank, it is a relatively straightforward proposition to siphon them into your cash flow. As journalist Charles C. Mann put it, "Because copyright is the mechanism for establishing ownership [of intellectual property], it is increasingly seen as the key to wealth in the Information Age."[9]

The Distribution of Intellectual Property

Perhaps a more modern definition for intellectual property should be stated as anything that can be mass produced, sold, and distributed electronically in the form of binary computer code; in short anything that can be digitized. E-commerce would be a much bigger deal if one could actually download a book, a suit of clothes, a bouquet of flowers, prescription drugs, or a trombone over the Internet. That may be the stuff of a Star Trek episode, *but you can certainly download images!* Images are one of the precious few kinds of assets that need not be tangible to be traded.

A consensus exists that IP is the primary commodity of the Information Age because it is so readily convertible into electronic "bits." That means it's easier to duplicate IP than physical property consisting of atoms,[10] and conventional means aren't necessary to transport it through cyberspace. Even a hybrid economy like the one we call e-commerce today relies on trains, fleets of planes, trucks, ships, bicycles, and even footwork to fulfill orders. This so-called electronic commerce cannot exist without FedEx, UPS, Airborne, and local messengers. The system remains cumbersome. But images are exempt from the shortcomings of a hybrid economy.

Even in a conventional economy, any product that is easier to manufacture and distribute will result in greater supplies at lower market prices. That's the law of supply and demand in action. It affirms that, as goods become cheaper, more people can afford to buy them. The best news is that, when you have more products to sell and there are more people to buy them, you rake in more money overall. The problem of lower prices is offset by increased sales volume and revenue. The inherent ease of manufacture (duplication) and distribution

of images makes them more valuable in spite of possibly lower per-transaction prices. With trading occurring on the scale of the World Wide Web, photographers have greater commercial clout than they ever had before. The market in images represents true e-commerce.

Ownership of Commissioned Works (Photo Assignments)

If the concept of copyright ownership had not already become established as a trade practice upheld by law, then anybody who might want to hire you could claim—and you may have heard this before anyway—"If I buy the film, then I own the photos, and I can do anything I want with them!" In fact, they cannot. As long as you are in business for yourself, the party that commissions a photographic work has no right whatsoever to claim ownership.

Ownership of Photographic Prints

Assume that someone wants to buy one of your prints to hang on the wall at home. This collector, or perhaps just an acquaintance, pays you for a print. The question is: Does he own it? The answer is not simple, and it may surprise you.

A print is a physical manifestation of the intellectual property represented by your photograph. But you have merely granted the buyer the right to display it for his personal enjoyment and entertainment, say, on his living room wall. No more, no less. He has no permission to copy the print, either for

sale or to give away copies. Neither is he allowed to make additional copies for himself to place elsewhere in his home or office. The collector bought a print with explicitly limited rights attached to its ownership.

Of course, the buyer has a right to keep and display the print indefinitely. Such a license is also transferable, which means that it may be sold to anyone else under the same conditions.[11] So "selling" a print transfers its physical possession, but not ownership of the copyrighted image it represents. No one may either copy or publish the print, no matter who owns it or for how long.

NOTES

7 The Internet changes that to some extent by allowing access for consumers, a far larger but harder-to-reach market, to purchase limited photographic reproduction rights at extremely low prices. This will be explained in chapter 35, Part 6 in the section called The Royalty-Free Business Model. Another limited exception is the sale of fine-art prints (see Ownership of Photographic Prints in this chapter).

8 This metaphorical schematic diagram is represented by the "virtual paper trail" of documents first mentioned in Part 2 and described in detail in Part 8.

9 The *Atlantic Monthly*; September 1998; Volume 282, Nº13; cover story" "Who Will Own Your Next Good Idea?

10 An often-referenced metaphor of Nicholas Negroponte, director of the MIT Media Lab, from his book, *Being Digital*, published in 1995 by Alfred A Knopf, Inc.

11 In California, the law goes further and stipulates how artwork may not be destroyed or altered without permission.

25

Licensing Photos to Publishers

Unlike the alchemists of the Middle Ages, who tried and failed to transmute ordinary elements into pure gold, photographers can quite successfully turn the ephemeral qualities of light into hard currency. All it takes is a camera, a lens, and an imagination. In more practical terms, you have the means to turn ideas into photographs, which are copyrightable, and copyrights are a bankable asset. The mechanism for this kind of modern sorcery is facilitated by the relationship of copyright to the publishing industry, which has an insatiable appetite for *content*, an unending need for photographs.

Your clients are in the business of communicating information to the public at large through a variety of channels. Content fills those channels, and photographers are "content providers," wholesalers to the industry, if you will. Content is the raw material of the publishing industry and the media. Photographers supply the talent and the labor to produce it. In turn, your clients' business is to package it and sell it to consumers. (Again, this is all part of the business model.) By granting them the rights to package, or use, your photos—meaning, to let them copy and distribute your work in print media, broadcast media, and online in cyberspace—you are renting your intellectual property in exchange for

cash. This is usually and quite logically called a *usage fee.*[12]

note A usage fee usually represents only a fraction of your overall price for either an assignment or a stock photo transaction. It may be buried (not in a pejorative sense) within a subtotal of all your "Creative Fees" on an invoice. The Creative Fees section on an invoice often includes both a usage fee and an assignment fee. Refer to part 6 for more information on this topic.

Copyright Is a Cash Cow

As the creator of the images you shoot, you own them lock, stock, and lens barrel. They are your private property. No trespassing allowed! As your personal reputation grows and your photographic services become more in demand, and as the market becomes more aware of the work you have already published and accumulated over time (i.e., the stock photos in your archive), an increasingly higher value will be attributed to your images. Any one of them has the potential to become a "cash cow," an annuity, a reliable and incremental source of income throughout your career and into retirement. For some photographers, this may be their

best plan for retirement. With the protection of copyright, you are free to milk those images for all they're worth and for as long as you can. You may eventually accumulate an entire herd of cash cows. They live in your filing cabinet instead of a barn. Each one of them will be branded with a "©" for copyright, because for every photograph you have made and for every photograph you will ever make in the future, you will own a corresponding copyright.

Your reputation will also help you obtain further assignments. Of course, it's up to you to sustain your reputation through marketing, i.e., "out of sight, out of mind." But obtaining new assignments will help you build an even bigger archive of images and to continue licensing them long into the future. Therefore, theoretically speaking:

> Photographers are in business to license copyrights, not to shoot pictures
> Photographers are paid to license copyrights, not to shoot pictures
> Photographers obtain copyrights by shooting pictures

Granting Clients Permission to Use Your Photos

The process of licensing intellectual property under the protection provided by copyright law keeps people from using your photographs without permission. You already know that. Well, that's what a license does; it grants permission in writing. It memorializes the terms of the rental of your property and authorizes its use. It is a legal contract.

note Copyright protection demands that your permission be obtained before a photo is used, not after the fact. If your permission is not obtained first, the party that published your photo has committed an infringement.

Using Explicit Terms

Copyright licenses, like all contracts, exist to prevent misunderstandings about mutual agreements. The language used to compose a license must, therefore, be explicit. It must include both a description of what the buyer is allowed to do with your photos and also what the buyer is *not* allowed to do with them. Nonetheless, any rights not specifically granted—not actually written into the terms of the license—

are excluded by their absence. In fact, the last sentence of any copyright license should read: "All rights not specifically granted in writing, including copyright, remain the exclusive property of the photographer." (You'll come across that sentence again, later in this part.)

Buyers cannot be considered legally at fault, or liable, for using commissioned photos in ways that you had neither intended nor permitted—and without additional payment—if you don't first put them on notice with the terms of a copyright license. If the terms of your licenses are not explicit, they may be misinterpreted or abused. Their purpose as a prophylactic for lawsuits will not have been achieved. The only way buyers know how they are permitted to use your photos, to confirm exactly what rights you intend for them to have, is for you to tell them in so many words. The words you use—and the ones you don't use—are critically important.

note In the Copyright Composer™ exercise found further along in this part, you will learn what terms to use in a copyright license and how to apply them.

Consistency

The seriousness of your intent to protect copyrights is only as convincing as how often you assert your right to do so. Therefore, a license is *always* necessary.

Because the terms of a copyright license must be spelled out in considerable detail, there is no such thing as overkill. You can never be too wordy. Either you have a license with all the proper terminology included, or you have no license at all. So, don't try to pare down the terms in some licenses while leaving others more extensively worded. And don't be afraid of offending a buyer because you think your relationship doesn't warrant the formality of a written agreement. That is precisely how to put such a relationship at risk. Every opportunity must be taken to reinforce your rights, *especially* with people you trust. After all, trust comes from letting people know exactly where you stand. For more on this topic, refer to part 8, The Paper Trail.

It is your responsibility to ask all clients to tell you precisely how they intend to use your photos—where they intend to use them, how many times, for how long, and so on. Then, those uses can be spelled out in the license. *Do not hesitate or forget to ask these*

questions at the beginning of discussions for every photo assignment! Your clients will not take offense. On the contrary, they will be impressed with your knowledge of the publishing industry and your professionalism. From a more practical standpoint, if you don't ask such questions, how can you compose a license in the first place? Moreover, how are you going to know what to shoot? You must have a clear definition of the scope of your assignment.

Use It or Lose It

Another problem with vague and inconsistent copyright licenses is that, on the rare and unfortunate occasion when you might have to engage in an infringement lawsuit, the defendant can point to any number of invoices with cloudy licensing language or no license at all by which he inferred a lack of intent on your part to protect your intellectual property. A judge might agree with the defendant's assertion that maintaining copyrights cannot be all that important to you, and that, thereby, you forfeited this one.

The good news is that, by habitually including a complete license *all the time*, it is far less likely that infringements will occur in the first place. Eliminate the chinks in your armor by including a thorough copyright license on each and every one of your commercial documents, especially invoices. Once in a while doesn't count! If there is no consistency in business practices, then, effectively, they don't exist.

The problem of being taken seriously becomes even more insidious when copyright-licensing language remains inconsistent *from one photographer to the next*. In that case, the prerogatives of *all* photographers begin to erode. Every individual loses just a little bit more of his power to enforce copyrights, and the trade groups that speak out for them collectively lose some of their influence, too. That makes it more likely for misunderstandings to occur on an industry-wide scale, leading to more infringements and increased demands from buyers for photographers to give up more of their rights.

The two most important criteria for a good copyright license are:

> Being explicit (clear and detailed)
> Being consistent (predictable and dependable)

EXERCISE----------------------------------

The Copyright Composer™

PhotoByte makes it easy to apply explicit and consistent copyright licensing terms on all of your estimates, confirmations, and invoices. It even helps you include this essential information on all of your ShootSheets™ (assignment logs) and assignment delivery memos. To do this, you will use the Copyright Composer feature.

This feature helps you define the reproduction rights required by your client, as well as set limits on those rights, to correspond with the usage fees you expect to be paid. It literally defines the business relationship you have with your client for each job.

The Copyright Composer actually writes the terms of copyright licenses. As you select blocks of boilerplate text by clicking on them with your mouse, it types complete phrases and puts them together for you on screen into meaningful copyright phrases, and then pastes them into the document you're working on. This licensing language will automatically flow into all subsequent documents related to the same job.

> From the Main Menu of PhotoByte, click the *Paper Trail* button.
> Then, click the *Invoices* button on the next screen.

You will see a screen depicting a list of invoices.

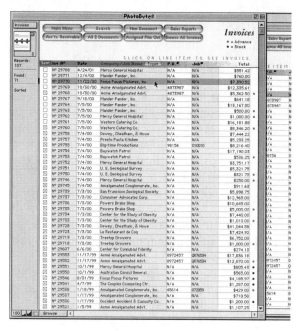

▶ Click on the second item in the list, which is an invoice addressed to Focus Pocus Pictures, Inc. for $7,390.52.

Next, you will see a facsimile of the invoice on screen.

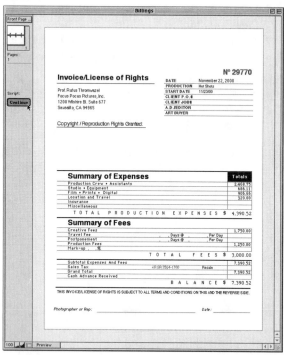

▶ Click the *Continue* button on the left to display the same invoice in Browse mode. (Browse

mode simply allows you to see some buttons that help you navigate from one document, or screen layout, to another.)

Here is the same invoice in Browse mode.

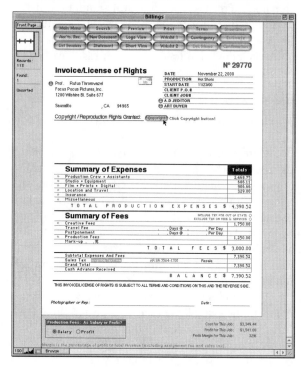

This is a complete Invoice/License of Rights, except that it does not include a copyright license in the *Copyright/Reproduction Rights Granted* field. You will, therefore, step through the process of creating one.

▶ Click the *Copyright* button.

Next you will see the Copyright Composer screen.

> Click the *Type of Rights Granted* field and hold down your mouse button. Select **for Advertising use and publication**.

> Click the *Media* field. Select **in a Consumer Magazine**.
> Click the *Language Rights* field. Select **English language rights only**.
> Click the *Geographical Area* field. Select **for distribution within the United States of America and Canada only**.
> Click the *Color or B&W* field. Select **as a Color illustration**.
> Click the *Number of Photos* field. Select **of one (1) photograph**.
> Click the *Duration of Use* field. Select **for a duration not to exceed one (1) year**.
> Click the *Frequency of Use* field. Select **Up To Seventy-five (75) Insert**s.
> Click the *Reproduction Size* field. Select **unspecified reproduction size**.
The *Subject Matter* field already contains the job

name taken from the *Production* field on the Front Page of the Invoice. It is called Hot Shots.

The *Client* field already "knows" the client is Focus Pocus Pictures, Inc.

> Click the *Apply* Button on your screen.

This arranges the component terms of the license into a meaningful paragraph.

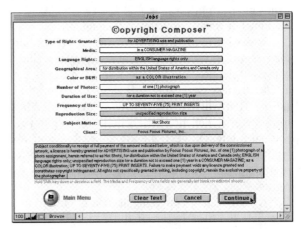

note All of the "boilerplate" terms in the copyright composer can be edited or customized. (In each pop-down menu, there is an **Edit** selection.) But almost all possible contingencies have already been included for you.

> Click the *Continue* button on screen. (The *Apply* button has changed to read *Continue*.)

The newly-composed copyright licensing terms are pasted directly onto the Front Page of the Invoice.

N° 29770

Invoice/License of Rights

DATE	November 22, 2000
PRODUCTION	Hot Shots
START DATE	11/23/00
CLIENT P.O.#	
CLIENT JOB#	
A.D./EDITOR	
ART BUYER	

Prof. Rufus Thromwazel
Focus Pocus Pictures, Inc.
1200 Wilshire Bl. Suite 677

Sausalito , CA 94965

Copyright / Reproduction Rights Granted: (copyright)

Subject conditionally to receipt of full payment of the amount indicated below, which is due upon delivery of the commissioned artwork, a license is hereby granted for ADVERTISING use and publication by Focus Pocus Pictures, Inc. of one (1) photograph of a photo assignment, herein referred to as Hot Shots, for distribution within the United States of America and Canada only; ENGLISH language rights only; unspecified reproduction size for a duration not to exceed one (1) year in a CONSUMER MAGAZINE; as a COLOR illustration; UP TO SEVENTY-FIVE (75) PRINT INSERTS. Failure to make payment voids any license granted and constitutes copyright infringement. All rights not specifically granted in writing, including copyright, remain the exclusive property of the photographer.

> Press Command/Ctrl–Q to quit PhotoByte.

Granting Only Necessary and Sufficient Rights

Buyers almost always demand more publication rights than they need. There are two reasons for that behavior. It's either: (1) a bargaining tactic, or (2) they are unacquainted with the practice of licensing.

If their demands are dictated by the intended use of your photo(s), it's usually easy to reach a mutually satisfying deal. As soon as it's clear that you both have an understanding of the copyright practices prevalent in the industry, it becomes a negotiation about money, not rights. On the other hand, when it becomes necessary to educate the buyer, negotiations can become more trying and time-consuming. (See part 6, the section, Understanding Buyers' Prerogatives in chapter 31.)

It is wise to remind buyers during preliminary discussions, prior to booking an assignment, that a copyright license should reflect only the rights that are both necessary and sufficient to cover their needs. That will save them money, since your bottom line price depends largely on usage. It's in your mutual interest to keep the job affordable, and you would have to charge more—much more—for granting indeterminate or virtually unlimited usage rights.

A well-written copyright license is tantamount to a detailed description of the assignment. That description-cum-license becomes an integral part of the paper trail. It reminds you and your clients exactly what they will get for their money.

note Provided you take advantage of PhotoByte, a copyright license that defines the reproduction rights granted will be included on the face of every Job Estimate, Job Confirmation, and Invoice that you create. In fact, it will appear on just about every job-related document you submit to your clients, including ShootSheets and Delivery Memos.

Granting So-Called Exclusive Rights

Be cautious when using the word *exclusive* in language that grants publication rights to your clients; it can be misconstrued. Under United States copyright law, it may imply that you mean to transfer all or part of your copyright to another party. You do not want that to happen inadvertently by granting blanket exclusive rights. Instead, limit the extent of exclusivity by attaching it to an explicitly defined set of criteria. Furthermore, you should prohibit the initial buyer from selling, trading, or otherwise transferring any rights granted, including the right of exclusivity, to anyone else without your permission.

If transferring ownership of copyright is not your intention, then only use the word *exclusive* when limiting either:

- The period of time the license applies
- The geographical area within which the license applies
- The one specific media client to whom the license applies
- All of the above

An example might read: "An exclusive license is hereby granted for a period not to exceed six months to publish 'XYZ Picture' in the California edition only of the *Daily Informer*." That means the *Daily Informer* will pay you a premium licensing fee to exclude their competition from buying the same reproduction rights from you. (So charge more!) If you wrote instead: "An exclusive license is hereby granted to publish 'XYZ Picture' in the *Daily Informer*," your license would be too vague. It could be interpreted to mean that the only entity ever allowed to publish that picture for all time would be the *Daily Informer*. If that mistaken license were ever enforced, you could lose income.

It is also wise in some circumstances to specifically exclude those media you do not wish to include in the license. Name them! The *Daily Informer* might own several other publications, and if they are not named, and if you do not want them to publish your photo, you're out of luck. They would be free to do so anyway.

Exclusivity means that you will allow only one buyer certain publishing privileges. It also means that all other potential buyers will be denied those privileges for the duration of the license. Therefore, it is up to you and your client to negotiate a reasonable expiration date. By setting a limit for the duration of a license, you can be assured that it will, in fact, expire. When it does (perhaps based on how long your client wishes to keep your photo[s] out of the hands of their competition), you are free to license them again, exclusively or otherwise, to anyone else or to however many other parties you choose.

To avoid a misunderstanding, i.e., if there is a possibility that the editor of the *Daily Informer* might

take it for granted that, by naming his parent company as exclusive licensee, you intended to grant the same rights to its subordinate publications, you should explicitly deny those rights (e.g., "All subsidiary parties, companies, periodicals, or publications, either owned or controlled by the *Daily Informer*, are hereby denied any grant of publication rights to the aforementioned photograph").

note Consider demanding higher fees than normal when a buyer demands exclusivity. If you grant exclusivity, even for a limited period of time, you have no possibility of collecting additional revenue from the photo(s) in question for the duration of the license. The buyer should compensate you for what you might have earned by granting nonexclusive rights to several different clients. (Exclusivity is a factor of pricing. See part 6.)

If the buyer demands an indefinite exclusive license, one with no end in sight, then you are prevented from earning additional revenue from those pictures ever again. Charge accordingly! It is usually better, however, to press the buyers to determine why they think they need exclusivity "in perpetuity." They probably don't. Try to persuade them that it's more economical to agree on a set period of time.

Once you agree on limited exclusivity, the buyer's contract with you (i.e., the copyright license on the invoice itself) will assure that the photos are kept out of circulation to other parties throughout the duration of the license. Just add a phrase or two to that effect in the licensing language to make the buyer comfortable, if you wish. The photos thereby retain their unique value to the client for as long as there is a reasonable need. (See the section on Buyouts and Unlimited Rights Agreements in chapter 31, part 6.)

Transfer of Copyright Ownership

Even though you have just read about how important it is to retain copyrights and to avoid buyouts, there is nothing inherently wrong about intentionally selling your copyright, so long as your financial interests are protected. Incidentally, "assigning" it to another party means practically the same thing as selling it. There is nothing inherently wrong with agreeing to a buyout either. Just make sure that, if you are willing to give up your ownership and con-

trol, you receive adequate compensation. Seldom, however, are buyers willing or financially able to accommodate such a transaction.

There is hardly ever any reason to consider selling the copyright to a photograph unless: 1) the photo is virtually worthless in terms of resale value, or 2) it is indeed so highly valuable that many future sales can be anticipated. If the latter is true, it is possible to command a one-time price that is roughly equal to the total of what that copyright might earn by licensing it over and over again for many years to come. That is a basis for negotiation.

It is easy to assign a copyright to another party. Again, copyrights are assets that can be bought and sold, or traded, for any currency. The only legal requirement is that a transfer of copyright ownership must be made in writing, and it must be signed by the owner of the copyright.

A copyright may also be bequeathed by will after death, or passed on as personal property by the laws of "intestate succession." Copyright is a personal property right, after all, and it is subject to the various state laws and regulations that govern the ownership, inheritance, or transfer of personal property in addition to contract law. For information about the laws relevant in your home state, consult an attorney.

The Copyright Office does not have any forms for the transfer of copyright. You must devise a contract of your own. The law does provide, however, for the recording of transfers of copyright ownership in the Copyright Office. Although officially recording is not required to make a transfer valid between parties, it does provide legal advantages under some circumstances. For information on officially recording transfers of copyright, refer to Circular 12, *Recordation of Transfers and Other Documents*,[13] a publication of the Copyright Office available on the Web.

Recapture of Copyright

Once you transfer a copyright, you can get it back after thirty-five years. This provision of the Copyright Act is called *recapture*. It is designed to allow all living artists, including photographers, or their estates and beneficiaries if not living, to eventually take back control over entire bodies of work.

The law permits termination of a grant of rights after thirty-five years under certain conditions by

serving written notice on the transferee within specified time limits. Possibly, its commercial value may have diminished after all that time. On the other hand, it may have increased. Either way, the artistic value remains.

For further information, request Circular 15a from the Copyright Office, available on the Web.[14]

EXERCISE

Copyright Transfer

Think of an assignment you might shoot, and describe three different circumstances under which you might want to transfer your copyright to another party.

Conditional Licensing

It is a common practice—and highly advisable—to include a specific condition in the copyright terms on each of your invoices, clearly stating that the right to use any photograph is withheld (i.e., permission to publish will not be granted) until full payment of your invoice has been received.

This practice is endorsed by many legal authorities and the major photo trade associations. Therefore, the Copyright Composer in PhotoByte adds these words to the beginning of every license: "Subject conditionally to receipt of full payment of the price indicated below, which is due upon delivery of the commissioned artwork, a license is hereby granted . . ." And two closing sentences have been added at the end: "Failure to make payment voids any license granted and constitutes copyright infringement. All rights not specifically granted in writing, including copyright, remain the exclusive property of the photographer." You can go back and see, if you wish, that this language was included in the exercise you completed earlier.

You will securely protect your legal rights by including those terms on all Job Estimates, Job Confirmations, Job Change Orders, and Film Delivery Memos that the buyer receives *before* you send a final invoice. In that way, the stipulation is enforceable in a court of law, because it was pre-sented before you began work on the client's behalf. It should become your "company policy," as well as a professional courtesy, to inform clients about this provision of the copyright law at your earliest possible convenience.

Myths about Copyright Debunked

> For a copyright to be valid, a photo must have a copyright notice posted with it
> If the client paid for the photo shoot, the client owns the copyrights to the photos
> If a photo is posted to the Internet, it falls into the public domain
> If someone copies your photo, but doesn't try to sell it to a third party, there was no infringement
> If you create a photo based on someone else's work, the new photo belongs to you
> *These are not true!*

Photographers license copyrights to publishers, of course. But that includes the copyrights to photos that publishers may have commissioned them to shoot in the first place. That's the nature of the photo business. That's how the business model works. It's what photographers do for a living. So don't think—and don't let anyone tell you!—that just because someone else pays for the cost of production, they own the results. Unequivocally, they do not. Since a self-employed photographer's ownership of copyright is sanctified by law,[15] ask yourself if it makes sense to undo the law by signing away your copyrights to anyone who demands them, simply because they say it is *their* "company policy" to do so. The law, not to mention your own policy, trumps theirs.

NOTES

12 In this book, the term *usage fee* will most often be used for the sake of consistency. But other terms that mean the same thing are *licensing fee, lease agreement, rental fee, reproduction fee, publication fee, license of rights, copyright license,* etc.

13 See: *www.loc.gov/copyright/circs/circ12.pdf.*

14 See: *www.loc.gov/copyright/circs/circ15a.pdf.*

15 Title 17 of the United States Code.

26

Violation of Copyright Ownership and Remedies

The laws pertaining to copyright are federal in jurisdiction, not local or state. That means you have the authority of the United States Government at your disposal to protect your rights. If someone violates your copyright, you have the power to enforce your control by filing a lawsuit in federal court—if that copyright is registered. (More about registration will follow.)

A violation of copyright is called an *infringement* in "legalese." With a lawsuit, you can make a claim against an infringer to recover financial damages and also to claim your moral rights to authorship. But to recover any money in a lawsuit, you must prove that you actually lost money as a result of the infringement.

Direct Copying

It is not hard to prove that an infringement occurred when a direct and unauthorized copy is made of a photograph; there is an assumption that your business suffered a loss when the infringer used your photo(s) without permission or payment. It is harder, though, to establish exactly *how much* revenue might have been lost.

Usually, the amount of money you can recover in a lawsuit is equal to what you would have been paid for a legitimate, authorized use of the photo(s) in question in the medium in which the infringement(s) occurred. In other words, if you would have normally billed a publisher $100, had he asked permission, you would probably receive $100 to cover the damage caused by the infringement.

What constitutes a legitimate payment is fairly easy to establish by showing a "track record" for similarly published photographs. For example, you can show your own past invoices and bank statements as evidence. If you are new to your photographic career and have not yet had time to establish a track record and, say, a magazine used your picture without permission on its cover and *they* have a track record of paying $5,000 for cover shots, you might expect to receive a judgment from the court for $5,000. If, on the other hand, you have considerable experience and a fine reputation, and if you can establish that you usually receive $10,000 for a magazine cover (by producing check stubs or other bank records), then you can probably expect to receive a judgment for the higher amount even if the magazine usually pays less.

Derivative Use

It is harder to prove that your business suffered a loss as the result of an infringement when the work in question merely looks similar to your own, but it is not absolutely identical. However, if you can prove that the work in question was *derived* from your photo, if you can show that in order to create the work in question, it would have been unavoidable to copy your photo, even partially, then you can prove an infringement occurred.

Hypothetical Case Study of a Derivative Use Infringement

Assume that a graphic designer has been given an assignment to create a poster display in a retail store. His deadline is imminent. He's sweating bullets, because if he cannot finish the job on time, he may lose his biggest client.

After working for hours trying to finalize his layout, he realizes that it needs one last touch: an image of white clouds wafting through a blue sky with mountains in the background. Looking for inspiration, he flips through the pages of some magazines lying around his office and sees exactly what he needs.

It just so happens that you are the photographer whose by-line accompanies the photo that caught his attention. He found it in a dog-eared, three-year-old travel magazine lying on an end table in the lobby. It depicts a man and a woman strolling along a country lane. Other elements in the background include, fortuitously for him, white cumulus clouds in a blue sky against a mountainous landscape. The designer doesn't know you and has no time to track you down to ask permission to copy your photo. Besides, he figures, he only intends to use a part of it. It's probably not even a recognizable part.

In his rush, he gives that matter little consideration. He places the magazine on a scanner and copies your photo. Then he saves it as an electronic file onto his hard drive and pastes it into an image-editing application (e.g., PhotoShop™). He uses just a tiny part of your image: the clouds-sky-and-moutain section from the top right corner of your appreciably larger composition. This is just what he needed to add the finishing touch to his poster.

The designer is happy. His poster looks terrific, and it was finished on time. He knows his client will be delighted. There is only one problem: He has committed a copyright infringement. Under federal copyright law, his appropriation of your image is what is legally referred to as a *derivative use* of the original photograph. There may, however, be several mitigating factors, or shades of gray, for both parties to consider.

With today's electronic digital technology, the boundaries between right and wrong, between inspiration and infringement, have become somewhat blurred. These are some of the issues in question:

> How likely is it that you can make a successful legal challenge to the designer who scanned that portion of your picture, just the clouds, sky, and mountain?

> Will you even be able to recognize that part of your original image that was included in the final poster?

> Do infringers feel invulnerable to prosecution if the penalty is merely a slap on the wrist?

The following points will always be considered by a judge in a copyright infringement case. The more of them that are fulfilled, the likelier are your chances of winning a cash settlement in a lawsuit. First:

> *Scanning:* You must prove that your image was indeed scanned. When a photo is scanned without permission, no matter how much or how little was eventually appropriated, it is an infringement.

> *Lifting or Adapting:* When even only a portion of your photo is lifted, it has been adapted, or modified, without your permission, which is another act of infringement. Only you, as copyright owner, have the right to adapt or modify your work.

> *Copying:* Once any portion of your image has been incorporated into another composition, every time a copy of that new image is made, your initial copyright is infringed.

But then:

> How distinctive, or representative of the your original composition as it appeared in the magazine, are the sky, clouds, and mountains as

they actually appear in the finished poster? In other words, how much does it look like your photo, or part of your photo?

> How important are the sky, clouds, and mountains to the *poster*? Can it stand as a creative work without them? Are they simply an incidental part of the background or its focal point?

> How important are the sky, clouds, and mountains to the *original photo*? Are they simply a part of *its* background or its focal point?

> How much, or what percentage, of your original photo was used in the poster?

> Was the color changed, the contrast, the composition, or was your photo otherwise unaltered?

> How likely is it that the infringer's use of your image has damaged your ability to earn further revenue from your original work?

If only one of the aforementioned criteria is considered in isolation, the presiding judge in a lawsuit might not find that an infringement occurred; he might rule against you. He may find that even though an infringement did occur, both technically and legally, it does not merit an award for damages. A judge is most likely to consider all of the above criteria together. If one or several of them remain unfulfilled, you might lose.

In the preceding example of a poster, it may be unlikely for you to win the case, particularly since the infringer appropriated only a small portion of your image. Such an infringement is not likely to have a negative impact on your ability to earn further income from the original photograph. But with an understanding that all photographers need to place penalties in the paths of infringers to prevent more widespread violations of copyrights in the first place—this was an infringement, after all!—a judge might rule in your favor just to set an example. It's a gamble.

If the portion of your photo that was appropriated is minimal, i.e., it is either not extensive enough to stand on its own as a photographic composition or it is not recognizable as your own creation, or if it is insignificant in its overall contribution to and influence on the infringer's new image, then you must decide whether or not it is economically worthwhile to pursue the matter by going to court. It may be a case of making a mountain out of a molehill. The situation may not rise to the moral equivalent of infringement, especially if there was no commercial damage done to you.

Minimal Use and Substantial Similarity

Relatively recent decisions in the music industry may offer some guidelines. In a 1991 lawsuit,[16] a pop singer-songwriter sued a rap performer and a number of associated record-company defendants for "sampling," or electronically copying and including without permission, a portion of his song exactly as it was recorded. The rap song sampled just three words within eight bars of music (i.e., sections of musical notation) from the songwriter's original hit,[17] but what it "borrowed," particularly the words, was an important part of the original tune. It was easily recognizable. It was not set apart from the rapper's tune as a musical "quote"—that is, it did not credit the original songwriter's composition. It was inserted into the rapper's music to become an integral part of his own composition instead.

The rapper's attorney defended this action on the grounds that stealing bits and pieces from songs is a common practice, a trade practice, in the music industry. But the court ruled against him. Had he sampled some less-recognizable or less-important parts of the original tune, it is possible that there would have been no judgment against him.

A Deterrent to Infringement

Unfortunately, the amount of a judgment in your favor can be offset by the cost of hiring an attorney to defend your copyright. A $5,000 judgment means little if your legal fees amount to $6,000. That's where copyright registration comes into play.

An infringement of a photo officially registered with the U.S. Copyright Office may oblige the culprit to pay additional penalties, significantly more than what he would have had to pay to offset publication fees alone. He would also be liable to pay your legal bills. Therefore, registration acts as a deterrent to infringement. When infringers look at the financial downside of violating a *registered* copyright, they'll think twice about getting away with it. You'll read more about the registration of copyrights in chapter 27, later in this part.

Fair Use

Under some circumstances, creators cannot control the use of copyrighted photos. The Fair Use provision of the Copyright Act allows photographs to be copied without permission and without penalty when they are used to fulfill a social purpose and when no commercial value is associated with that use. If the two criteria are met (i.e., providing social value without providing financial gain for any group or individual), no infringement will be deemed to exist.

The doctrine of Fair Use illustrates the government's intention to allow access to intellectual property by the whole of society. An invocation of fair use unlocks the gate in the copyright fence, bypassing the federal protection of a creator's monopoly.

Some examples of fair use include educational exercises in the classroom (e.g., students copying the layout of an advertising photo to study its composition and lighting techniques) and news reporting. Fair use applies to the latter only when the photographs or the photographer are involved as subjects of the news reporting itself, when they are a part of the story, not simply when the photographer has taken a picture illustrating a news event. In the latter case, the news broadcasters or publishers must pay, or otherwise receive permission from the photographer, to use his image(s).

The Effect of Employment Status

Typically, as you know, a photo business is a freelance operation. When photographers receive assignments, they do not routinely become the employees of the assigning parties. Photographers are hired as independent contractors instead.

Even though the term *hired* is used throughout this book, as in "the magazine hired the photographer to shoot the assignment," you are offering the services of your own company (even though that company may consist of you alone) from job to job and from client to client. The law is very clear about the status of independent contractors versus employees (see part 7, Operations).

Because you are not an employee, the photographs you create belong to you—period. That point was made clear earlier. Your employment status, or actually the lack thereof, is justification enough for your complete ownership of the photos you shoot.

Incidentally, that doesn't mean some buyers won't look for loopholes in the law to take your copyright away from you. There is, in fact, a major loophole, another gate in the fence, called *work-for-hire*.

Work-for-Hire

The term *work-for-hire* refers to an agreement, or a clause contained within a contract or client purchase order, that takes away your independent contractor status. It stipulates that you no longer have freelance status, and it makes you, legally, an employee. The insidious reality of all work-for-hire agreements is that you will not be offered any of the benefits that go along with being an employee. It means that you have been commissioned to shoot an assignment and that the commissioning party, in effect your legal employer, owns the copyright to everything you shoot.

When a work-for-hire clause is imposed—or forced—upon you with a lack of good faith in bargaining (i.e., by hiding it within the fine print of an otherwise standard purchase order), the resulting agreement may be determined to be a *contract of adhesion*, if the matter goes to court. It means that the principle of *unconscionability* may be involved, which means unscrupulous or dishonest behavior on the part of the party providing the terms of the contract. For instance, some buyers won't hire photographers who refuse to sign agreements that include a work-for-hire clause. It is possible that a court may not enforce such agreements when they are imposed by a stronger party in an unequal negotiation on a "take-it-or-leave-it" basis. This kind of situation should be discussed with your own attorney before you consider signing such an agreement.

The difference between work-for-hire and selling your ownership of a copyright outright (see Transfer of Copyright Ownership in chapter 25) is that, in a work-for-hire situation, you never did legally own the copyright, so it never was yours to sell in the first place. It can never automatically revert to you either. The commissioning party, or employer, can claim authorship for all of the photographs produced on assignment and owns all of the copyrights. That includes photos from the assignment that remain unpublished, too. None of them belong to the photographer who snapped the shutter. The photographer, in that case, is no more than a tool of the hiring party, just as the camera is a tool

of the photographer. Whoever signs a work-for-hire agreement has no legal right to claim ownership to the photographs in question. Legally, the employer can deny the photographer even the privilege to display the pictures in a portfolio or in an exhibition, although, frankly, that is not likely to happen.

So why would a freelance, independent contractor-photographer sign a work-for-hire agreement? Well, the answer is: There is no good reason at all.

In the case of a true employee making photographs for an employer, work-for-hire is a condition that exists by right, as the normal state of the employer-employee relationship. No agreement is necessary to impose work-for-hire when, according to the Copyright Act, "a work [is] prepared by an employee within the scope of his or her employment." The law maintains that any photographs taken were done so on behalf of the employer. For example, if someone drives a bakery delivery truck for a living, but it just so happens that one condition of employment is to photograph the delivery route, the bakery employing that person would own the copyrights to any and all photographs that that person produced while on the job, even if he stumbled upon the scene of a natural disaster or a beautiful sunset and recorded either of them for posterity. The employer still owns the copyrights.

Conditions for Work-for-Hire to Exist

If a photographer is not an employee to begin with, then work-for-hire exists only under carefully defined circumstances. Foremost, the work must be "specially ordered or commissioned [by another party] for use as a contribution to a collective work . . ." This is, of course, the standard condition for a photo assignment. The Copyright Act then goes on to list eight additional categories, any one of which may apply to a work made-for-hire. Just for the record, here are all nine of them:

- Contribution to a collective work
- Part of a motion picture or audiovisual work[18]
- Translation
- Supplementary work
- Compilation
- Instructional text
- Test
- Answer material for a test
- Atlas

Obviously, the most frequently invoked reason for a photographer to submit to work-for-hire is because he is making a contribution to a collective work. Collective works include such publications as magazines, books, and CD-ROMs. But before a work-for-hire agreement can take effect, and in order for it to be legally binding, it must be reduced to writing and signed by both the photographer and the commissioning party *before the work begins*.

Work-for-Hire: A Case Study

Lester LaRue was employed as a safety inspector by the Oklahoma Natural Gas Company. Charles H. Porter IV, an amateur photographer, worked as a credit specialist for Liberty Bancorp. Both men were nearby when the Murrah Federal Building in Oklahoma City suffered a terrorist bombing on April 19, 1995. Both men made photographs at the same moment of the same subject, and both of their similar photographs achieved widespread publication and notoriety.

The Porter photo is a close-up of a fireman carrying an injured child. LaRue's is a wider shot that, along with the fireman and the child, included another victim on a stretcher and more rescuers in the background. Porter's picture was published on the front pages of newspapers worldwide. LaRue's photo made the cover of *Newsweek*. Porter was awarded the Pulitzer Prize for spot-news photography. LaRue wound up in court, accused of copyright infringement.

As a full-time employee of the gas company, LaRue's duties included making photographs. He had driven a company car to the scene and had used a company-owned camera and company-bought film to make his photo. Immediately after the blast, he was approached by *Newsweek*. He had already informed his employer about *Newsweek*'s interest and was informed that publication of the photo might not be in the best interests of the company.[19] Nonetheless, six days later, he entered into a contract for its worldwide syndication with the Sygma Photo Agency.[20]

Understandably, emotions were running high in Oklahoma City. The bombing resulted in the death of 168 people, eighteen of whom were children. One of them was the dying child depicted in the photos made by Porter and LaRue. So it is not surprising

that just the appearance of profiting from the disaster would be seen in a negative light by Oklahoma Gas officials, who had already expressed their concern to LaRue about bad publicity. LaRue had received over $38,000 in royalties from Sygma. The gas company wanted that money donated to a relief fund for the victims.

The company notified LaRue that it claimed copyright ownership and sued him for infringement. When LaRue refused to donate the proceeds, he was fired, despite thirty-two years of service. LaRue then countersued the gas company for wrongful termination.

Both cases were tried in U.S. District Court, which found for the gas company in each one. LaRue filed an appeal, which resulted in upholding the decision of the lower court in favor of Oklahoma Gas on the infringement matter, but reversed the lower court's decision on wrongful termination. He got his job back. The company was awarded $34,623.50 in statutory and actual damages.

Porter did not realize the power of his photograph until he saw several clerks weeping over his prints when he arrived to pick up the processed film at a local Wal-Mart. Liberty Bancorp had not included photography amongst his duties as an employee, so Porter was free to exploit his photos. One of them has become the most recognized, dramatic symbol of the bombing. For Porter, the photo brought fortune and fame. For LaRue it brought much personal aggravation.

NOTES

16 Gilbert O'Sullivan vs. Biz Markie, 1991.

17 Each bar contains musical notation set to a specified time signature and rhythm. Each bar lasts just seconds. Strung together, they make a musical phrase that is usually part of a melody, or in musical vernacular, a recognizable *riff*.

18 It is assumed that this now applies also to what is commonly referred to as "multimedia" works on electronic, magnetic, or laser-optical digital media.

19 Mealey's Litigation Reports, "Employer owns Copyrights in Photos of Oklahoma city site, 10th Circuit Rules." *Academic Universe, Lexis-Nexis.*

20 Now Corbis-Sygma, at that time Sygma called itself "the world's leading photographic magazine press agency with 700,000 high resolution pictures online." They specialized in news- and celebrity-oriented photos.

27

Copyright Notice and Registration

Before March 1, 1989, the use of a copyright notice was mandatory on all published photos if you wanted to protect them from infringement. Today, notice is optional; protection is not.

All photographs are copyrighted by default. That is considered common knowledge in the publishing industry. A supposed ignorance of the law will no more get an infringer off the hook than it will dispose a traffic-court judge to cut some slack for a defendant who claims he didn't know the speed limit. As a legal defense, infringers cannot claim that they didn't know an image was copyrighted. Nonetheless, it is traditional for all photographs to carry a prominently visible copyright notice.

Although notice is no longer required to legally validate a copyright, you might limit your ability to collect monetary damages in court without it. Why offer the bad guys a loophole? Protect yourself! Stamp your copyright notice on all slide mounts! Put stickers on the sleeves of all larger transparencies! Stamp the backs of all your prints! Demand that publishers print a copyright notice with your photo credit! (See the section, Credit Where Credit Is Due, in chapter 41, part 7.)

Placing a copyright notice on your prints and transparencies—and now you can embed the digital equivalent of a "watermarked" copyright notice on electronic image files[21]—is a proclamation that you are prepared to defend your copyright to the fullest extent of the law. It's easy enough to do, so do it all the time!

Remember: If there is no consistency in business practices, then effectively, they do not exist. A copyright notice is enough to deter most people from trying to skip paying your publication fee, or worse yet, from counterfeiting your work. At the very least, they can't argue that they didn't know to whom to send a check, since your name is plainly visible somewhere on or adjacent to the picture.

This is the most commonly used format for a copyright notice:

© 2002 Rufus Thromwazel

It is accepted internationally as a legal and enforceable notice. It is, therefore, recommended because of its recognizability and brevity. It will fit almost anywhere, including on a text-crowded slide mount. It is a suitable convention to adopt formally, as it seems to have been already adopted by the international publishing community by default.

Just for the record, it is also acceptable to use the following three formats:

➤ Copyright 2002 Rufus Thromwazel
➤ *Copr. 2003 Rufus Thromwazel*
➤ (c) 2004 Rufus Thromwazel

note The year printed along with your copyright notice indicates the year of first publication. If the photograph is unpublished, the date must reflect the year it was created. It must not be changed, even if the photo is published again years later. Notice, too, that the date appears invariably after the word or the abbreviation of the word copyright or its symbol. And although its use may be a bit outmoded, you may also substitute Roman for Arabic numerals (i.e., MCMXCIX instead of 1999, MM instead of 2000).

For photographs first published on or after March 1, 1989, the law provides that a copyright notice in one of the specified forms above *"may* [author's emphasis] be placed on all publicly distributed copies from which the work can be visually perceived."* Use of the copyright notice is the responsibility of the copyright owner and does not require advance permission from the Copyright Office. Works first published before March 1, 1989, *must* carry the proper copyright notice or risk loss of copyright protection. That means your photo would fall into the public domain.

Copyright Registration

The publication of a copyright *notice*, as discussed earlier, is not the same as copyright registration.

As already made clear, you have established your copyright from the instant you express a photographic idea in a tangible form, with or without notice. That means, as soon as you have exposed your latent image on a roll or a sheet of film, or captured it electronically in a digital format, your copyright is protected by federal law from that moment on. Registration is not required to preserve a copyright. However, your *economic* interests are not necessarily as secure as your right to ownership without registration.

There are specific advantages to the official registration of a copyright, not the least of which is the establishment of a public record of your copyright claim. Moreover, if an infringement does occur, timely registration may give you a broader range of legal and financial remedies in a lawsuit. It gives

you more legal clout if you have to fight an infringer over money.

What is meant by "timely" is that, while you can register an image after an infringement has occurred, your financial recourse is limited to actual damages, i.e., you cannot recover legal fees or statutory damages if the image wasn't registered first, you can only recover what would have been a fair licensing fee for the infringed use. It should also be noted that you cannot sue *until* you have indeed registered the image in question.

Building Good Fences Builds Good Neighbors

Passive copyright protection, that is, relying on the default protections written into the law, is dangerous. Copyrights are always vulnerable to potential infringers, who look for legal loopholes to exploit that can rob you of income. Vigilance is required to plug those loopholes and to prevent infringements from occurring in the first place.

Federal registration of a copyright helps you to recover lost revenue, while reinforcing your claim of authorship. It provides further protection for your economic interests, even if your right-to-ownership is not questioned. Registration is the best deterrent to potential infringers. By registering your copyrights, you will avoid most problems. If they do occur, you are more likely to resolve them in your favor.

To register a copyright with the federal government is to build a higher fence around it. It is a defense that cannot be breached without considerable effort, and it lets others know that you are prepared to defend your property. It is a cheap form of insurance. You can register your copyright with the federal government through the United States Copyright Office in Washington, D.C.

How to Register a Copyright

The following instructions for registering your copyrights are excerpted from the *ASMP Business Bible*, published in 1994 by the American Society of Media Photographers, Inc. However, more recent developments may allow you to register your copyright electronically online. The U.S. Copyright Office Electronic Registration (CORD) procedure is explained on their Web site.[22]

Registration is simply the process of filing copies of photographs accompanied by an accurate

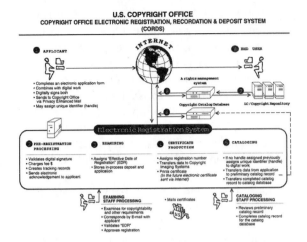

U.S. COPYRIGHT OFFICE
COPYRIGHT OFFICE ELECTRONIC REGISTRATION, RECORDATION & DEPOSIT SYSTEM
(CORDS)

and complete registration form with the U.S. Copyright Office, and then receiving a certificate of registration to show that such a deposit has been made. Any copyrightable work can be registered—a motion picture, a book, a painting, a CD-ROM, a slide show, and, yes, photographs. But just as the copyright law treats published and unpublished works differently, so do the regulations that govern registration. We'll examine these differences further on.

There is a $30 fee for registering (any number of copyrighted works at one time). Obviously the greater the number of photographs included in one registration, the less expensive the registration costs per image. If you consider that on a given day, a photographer can produce hundreds of separately copyrightable images, clearly, registration could cost thousands of dollars unless done in some bulk fashion.

Single-image registration is much the same for published and unpublished work. A photographer completes Copyright Registration Form VA, adds two copies of a published work or one copy of an unpublished work, and the $30 filing fee. This is sent to the Copyright Office in Washington, D.C. (The address can be found a the end of this section.)

When registering a group of photographs, things become more complicated. There are options for photographers, again divided by published or unpublished. And the relative ease of the process is influenced by whether the work has been published or not.

Published photographs will be accepted by the Copyright Office for registration in groups under these narrow conditions only:

➤ Each photograph in the group was first published as a contribution to a collective work within a twelve-month period (a collective work is a magazine, periodical, etc.)
➤ The author is an individual photographer, not an employer or other party for whom the photograph was made as a work-for-hire
➤ If published prior to May 1, 1989, each photograph as first published contained a separate copyright notice that names the applicant as the copyright owner
➤ Copies of the collective work(s) in which the group of photographs appeared must be filed with the registration (this is called the deposit)

As you can see, only a few published images meet these criteria. One could readily draw the conclusion that group registration of *published* photographs is not very feasible as a safeguard system to protect one's rights.

Still, there is a bright light of opportunity in the remaining option—the group registration of *unpublished* images. This opportunity lies in the regulations governing such registration, which are much broader than those for published works. Group registration of unpublished works is allowed under the following conditions:

➤ All the photographs must be by the same photographer
➤ They cannot have been published (as defined previously herein)
➤ Copies of the photographs must be in an acceptable form of deposit (which we will define)
➤ Each collection must be given an identifying title (any name will do, e.g., Photographs of Pat Photographer 1995)
➤ The entire copyrightable subject matter of each photograph has to be visible (i.e., full frame)

That's it. There are no other restrictions. A photographer can register thousands of unpublished images in a single application and for a single $30 fee. There is no time limit. The unpublished photographs could have been taken yesterday or over the last twenty years. These rules are very liberal when compared to the regulations for published works.

To make a bulk registration of unpublished images, a photographer must submit a completed

Form VA with the $30 fee. Also required is one copy of a deposit containing all the images to be registered. The deposit can be in any one of the several forms described below:

> A group of individual transparencies in protective plastic pages
> A group of contact sheets (color or black-and-white)
> A group of positive contact sheets made from slides ganged together, as when placed in protective plastic pages
> A group of color laser-copier reproductions of slides, ganged together as described above
> A videotape on VHS format containing as many images as the tape can hold while preserving the visibility of each image for a least two seconds per image. This means a 120-minute tape could hold thirty images per minute, for a total of 3,600 images per tape. Again, the full frame of the original must be visible.

note Each tape requires its own Form VA and $30 registration fee.

With an officially approved deposit form, easily downloadable online,[23] photographers now have a simple, affordable, easily managed system to register their unpublished images.

Preparing for Registration

Before establishing a system for registering your unpublished photographs, certain analysis is in order. First, one must recognize that most of a photographer's work is unpublished, and at some point, all work is unpublished. Now the simple fact is that any infringement is likely to be of a published work. So by registering all unpublished work, you will be protecting any photograph that is to be published later.

Second, one must recognize that many times, particularly in stock work, the photographer doesn't know which images have been published for months after that publication. When you add to that fact the difficulty of group registration of published work, it seems clear that the easiest, least expensive, and most timely choice is to register your unpublished work.

If you decide to register your unpublished work, you will have to consider that unpublished work is divided into four categories:

> Inventory of images on hand, but not considered viable for eventual publication (rejects).
> Inventory of images on hand that is part of your stock file and is likely to be sent to your stock agency. Remember—the sending of work to your stock agency constitutes publication, as offering your work to a party for further distribution. You should apply for registration before you send your submission to your stock agency.
> Assignment photographs that will be, as outtakes, sent into inventory.
> Assignment photographs that will be sent to the client for possible use.

While you might reasonably decide not to register images that fit into category 1 above, categories 2, 3, and 4 seem important to register.

There are no serious logistical problems for dealing with category 2 and 3 images. Regardless of the way that you create the deposit, you have time to get the work done. However, category 4 images, those waiting to go to a client for a job, present a greater problem, because the time available for creating the deposit is limited.

For the most part, if shooting black-and-white or color negative film, a color contact sheet can be made to serve as the deposit for registration. But when you have photographed with transparency film, the task of making the deposit is harder to plan.

Although a color contact sheet or a color laser copy of a group of transparencies is an acceptable form of deposit, the equipment to produce these is not readily available. The cost of these methods on a per-image basis is high, as only twenty 35mm slides can fit one sheet, and less when larger formats are used.

Clearly, a videotape deposit offers some distinct advantages. Not only does it reduce the cost per image registered, with the ability to put up to three thousand images onto a tape, which can cost as little as $5, but it also can be done by any photographer who owns either a video camera and recorder or a camcorder.

There are various devices readily available to those who want to build dedicated systems to record their work. They range from self-contained copy devices, such as Tamron's Fotovix, to inexpensive attachments for a slide projector, such as Vivitar's

Slide Duplicator. Many photography and video magazines contain ads for such devices.

The final consideration is to reduce the time it takes to create this registration deposit to avoid delays in delivering the edited photographs to your client. This process can be kept to a minimum by using the video option for a deposit.

Obviously, assignment photographs will have to be edited, and if the video registration deposit can be made immediately after processing, there will be little loss of time.

If the video recording is to be done after the edit, it is important to remember that those images to be sent to your client should be put on tape first, then sent on their way to the client. After that, the remainder of the images can be added. The final act is completing Form VA and sending the tape off to the Copyright Office.

Duplicates and Similar Photos

Many photographers create in-camera duplicates of photographs they take. Inasmuch as these photographs are identical to one another, only one of them needs to be registered to protect the group of duplicates.

However, similars, those photos which are like but not identical to another image, should be registered as unique images. While one could academically debate the extent of similarity and, therefore, the need to register some similars, it makes no sense to risk a loss of copyright protection when one considers the economy of bulk registration.

It is strongly suggested that similars be registered with your bulk application.

Obtaining Registration Forms

Samples are available in the *ASMP Business Bible*. Forms may be obtained directly from the United States Copyright Office:

› Register of Copyrights, Library of Congress, Washington, D.C. 20559; (202) 707-3000

A twenty-four-hour telephone number for obtaining registration forms is (202) 707-9100, or you can download the forms from the Copyright Office Web site at *www.loc.gov/copyright*.

Effective Date of Registration

Registration becomes effective on the date the Copyright Office receives all the required elements in acceptable form and finishes processing the application, regardless of how long that process takes.

When you apply for registration, you will receive no acknowledgment that your application has been received. The burden is too great to inform the six hundred thousand applicants each year. Nevertheless, you will receive a letter or a telephone call if further information is needed from you. If your application is rejected, you will receive a letter of explanation. Ultimately, you will receive a certificate of registration to make it official.

If you need to know exactly when the Copyright Office received your application, send it by registered or certified mail and request a return receipt.

note If first publication occurs in a separately copyrighted work, such as a magazine, you can still register the copyright in class VA as a contribution to a collective work, thus securing the advantages of statutory damages and legal fees in an infringement case. This procedure is safer than relying upon the registration of the collective work itself.

Litigation

It can cost a lot of money to defend or enforce a copyright, especially if an alleged infringer wants to put up a fight in court and can afford to retain a daunting team of attorneys. If it appears that photographers haven't registered their photos, infringers who are unscrupulous enough to use scare tactics by threatening to outspend their victims will violate copyrights with impunity. They are betting that they will get away with it, and unregistered photos mean that the odds are in their favor. That kind of brazenness poses a challenge.

Potential infringers may assume that individual freelance photographers, who by most accounts don't have much financial clout, will be discouraged from suing, because even if they win, they are not assured of reimbursement for legal costs—*unless a copyright was registered first*. So, in the absence of registration, your opponents know that any victory you may achieve will be of no financial consequence to them. Your lawyer's bill wipes out any money you might win in court. They couldn't care less about

losing the battle; they already know they've won the war.

If your copyright was not registered *before* the infringement (or within three months of its first date of publication), any possibility of collecting legal fees is ruled out by law, and there is no way around it. Your opponents know that. They also know that few lawyers will help you defend your case on a contingency basis; it's a cash-up-front proposition. That, unfortunately, leaves you with no choice but to choke on your own indignation if someone uses your work without permission. So without registration, the bad guys hold all the cards, and you are left holding the bag.

Statutory and Punitive Damages

The tables are turned dramatically in your favor if a copyright has been registered. Infringers, the defendants in a lawsuit, are taking a much bigger financial risk. The threat of their outspending you in litigation is diminished, because if they lose, they know that they have to pay your legal bills as well as their own. On top of that is the possibility of being forced to pay *statutory damages.*

Statutory damages represent, as their name implies, financial compensation paid to the victims of infringements up to a certain amount written into the law, i.e. by statute. Statutory damages may be awarded in amounts between $500 to $20,000 per work infringed.

The bad guys are very likely to settle out of court—or perhaps just by threatening to sue them— if you can produce a properly registered copyright or a written agreement clearly stating the terms of your license, or both. A Job Confirmation signed by the client, including the proper terms and conditions on the back (see chapter 45 in part 8, The Paper Trail) should do the trick. If you go to trial and win your case, the damage award will be determined by a ruling of the court. A judge will make that ruling after evaluating certain factors, including:

> ‣ Willfulness of the defendant to deprive the copyright owner of revenue
> ‣ Deliberateness of the act of copying the photo itself
> ‣ Extent of unauthorized use
> ‣ Actual commercial value of that use

Incidentally, statutory damages are limited by fed-

eral law to a maximum of $150,000 *per infringement,* i.e., if five photos were misused, the limit is raised to $750,000, and so on. But seldom do courts award that much money.

The actual commercial value of a use involving an infringement is the primary criterion used to determine a financial award. The commercial value of an infringed copyright is ascertained by how much money you would have actually earned if the photo in question had been licensed and used legitimately. That principle was explained earlier in this part. But the result of a judge's evaluation may also include *punitive damages.* He might decide to increase your total award up to the statutory limit to punish the infringer more severely, depending on the egregiousness of actions by the defendant in fulfilling the first three criteria: willfulness, deliberateness, and the extent of the infringement. And still, the infringer is liable for your legal fees and the court costs. So, if you win, any award will exceed the cost of trying the case in court. If you have registered your copyrights, you hold all the cards.

Exceptions

There is a difference in the way copyright law deals with published versus unpublished photographs, insofar as registration is concerned—registration being a prerequisite to collect statutory damages and attorney's fees.

You are ineligible to receive either statutory damages or attorney's fees for any infringement of copyright, even if you win the case, when either of the two following exceptions applies:

> ‣ The photo was unpublished at the time of the infringement, but you didn't register the copyright until after it was infringed
> ‣ The photo was published before the infringement, but you didn't register the copyright within three months of the date of its first publication (that does not mean three months after *any* publication)

These exceptions do not rule out the possibility of defending your copyright successfully, but they mean you cannot collect more money than you might have received from a routine publication. And you still have to prove how much money that might be, based on your track record. They do make it

impossible to collect additional financial damages.

It will help you to understand these exceptions if the meaning of the word *published* is clarified in the context of copyright law. It means the distribution of copies of your photo(s) to the general public either by *selling* them, *leasing* them, *lending* them, or by otherwise *transferring the ownership of physical copies*. This includes the distribution of copies to third parties for further distribution, with the ultimate intention of including them in a printed periodical, brochure, catalog, or other public display of some sort, but not necessarily including an exhibition.

It sounds like splitting hairs, but it is imperative to understand how this legalese protects your interests. For example, if you send an image (either an original or a copy, film or digital) to a stock agency that intends to submit it in turn to their own clients—whether it gets published by their clients or not—you have fulfilled the legal definition of publishing your work. It has been "distributed" with the intention of making it available to the public. If you merely hang some photos in the window of your studio or display them on a street corner, the definition of publishing is not fulfilled in the eyes of the law. However, if you arrange for the same prints to be exhibited in a gallery where they are offered for sale to the public (an example of "further distribution"), you have indeed fulfilled the government's definition of publishing.

In summary, and to further clarify the intent of the law:

> Unpublished photographs may be registered at any time you wish. If they are copied without your permission, you cannot sue for statutory damages and you cannot recover the cost of your prosecution of the case (legal fees) unless the infringement occurred *after* the registration. So, do not wait until an underhanded art director or a plagiarizing photographer sees a picture in your portfolio and copies it and *then* register your copyright with an intention to sue for damages. You cannot.

> If a work has already been published, you cannot sue for statutory damages and you cannot recover your legal costs unless the copyright was registered within three months of the *first* publication date. Otherwise you can recover only

statutory damages plus legal fees for infringements that were made *after* the date of registration, but not for the first infringement. The three-month allowance after first publication is intended to give you enough time to learn of the publication, obtain examples (tear sheets), and file the registration.

note Just for the record, it is relatively rare that unpublished photos, such as those in your portfolio, are infringed. But obviously, the best course of action is a preventative one. Register your copyrights before you show your photos to anyone, if not immediately after their first date of publication.

Since U.S. copyright law does not require you to register a photograph to establish copyright ownership, but only to ensure eligibility for statutory damages and reimbursement of legal costs if infringed, the best way to protect your images is to make infringement economically unattractive. If you are infringed anyway, willfully and maliciously or otherwise, it is far more likely that the culprits will offer you a cash settlement out of court as quickly as they discover that the photo in question was registered. You probably won't even have to file a lawsuit. They know they will most likely lose if you do.

Criminal Penalties for Copyright Infringements

The vast majority of copyright infringement cases, particularly those involving the photo business, will fall under civil law. Under civil law, there are no criminal penalties. An infringer can be fined, but he cannot be sent to jail.

Only relatively recently have criminal penalties been legislated by Congress (and some state governments, too) to thwart willful copyright infringers. But the operative word is *willful*. For a criminal case to be brought against an infringer, a government prosecutor must believe he can prove the infringer's fraudulent intent. It must be conceded, though, that these newer laws were conceived to stop piracy in the commercial software, motion picture, and music recording industries specifically. The criminal statutes aim to punish those who make knock-off merchandise and sell it through retail distribution channels, especially overseas. Such a problem is extremely rare in the photo business.

It's not likely that anyone would seek profit at a

photographer's expense by counterfeiting and distributing mass quantities of prints. It is improbable that the works of any single photographer are imbued with enough currency to make such a gamble worth the risk. Few corporations would act so stupidly, and few individuals would find enough profit in pirating pictures on a grand economic scale.

Not to say that such a situation is beyond possibility, but criminal law would almost certainly *not* apply to the case of one artist or photographer appropriating the work of another, either in part or in whole. In other words, it would be difficult, if not impossible, to prove criminal intent against either a corporation or an individual who used your picture on a poster without permission to advertise a product. But you could indeed pursue a lawsuit in civil court to recoup the money you would have earned for that poster, plus statutory damages if applicable.

Other Civil Remedies for Infringements

In the unlikely event of someone or some company literally counterfeiting your photos and selling them, further financial harm can be mitigated by having a judge forbid any further sale of the works in question. An example might be the reproduction of your portrait of a famous rock star on T-shirts for sale at concerts. Such a preventative measure is called a *preliminary injunction*, and it would take immediate effect, remaining in force until the case was resolved.

Ultimately a permanent injunction may be called for. Courts generally grant permanent injunctions where liability is clearly established and there is a threat of continuing infringement. Courts may also order the confiscation and impounding of all illegal copies at any time pending litigation. As part of a final judgment, the court may order the destruction (or any other "reasonable disposition") of the infringing copies. But keep in mind that such remedies— while they might find application in the commercial photo business in future cases—are still intended for issues pertaining to the entertainment industry.

Copyright Protection In the New E-Conomy

Some people wonder if the Internet will change copyright law. Thoughtful and influential scientists, businessmen, and philosophers have floated the idea that copyright should be abolished altogether, asserting that it may no longer serve a constructive purpose in cyberspace, that the monopoly introduced by the Constitution no longer protects the public's access to information nor acts as an incentive for further innovation.

Private, noncommercial copying, such as photocopying an atlas in a public library, has always been legal. It falls under the *fair use* provision of the copyright law mentioned earlier. In consideration of fair use, should commercial art buyers routinely "swipe" photos out of sourcebooks, magazines, and off the Web to use in comps?

The entire question of swiping could become academic if the same technology that allows art directors to so casually copy pictures can be modified to completely block the downloading and storage of images electronically unless fees are paid first. But will that be good or bad for business? Does taking that step spur creativity or hinder it? While some photographers are aggressive about protecting their work from swiping, others tolerate it as a form of self-promotion, as a cost of doing business. They assume that their volume will increase in the long run, as a result of art buyers becoming familiar with their work that way.

Nonetheless, technology that can block swiping is right around the corner. Congress has already debated the efficacy of a so-called "©-chip," similar to the "V-chip" that supposedly allows parents to set computers and televisions to filter out adult content and keep it from their children's on-screen view. If legislated, a ©-chip would be built into every new electronic storage device. A ©-chip in a hard drive, for instance, would prevent unauthorized parties from copying and storing images imbedded with a copyright watermark. Of course, the mechanism for getting paid has to be worked out. But that, too, is academic.

Opinions change over time. But, surely, because the Information Revolution is in its infancy, and because, as with any infant, patterns of behavior— including trade practices—are forged early on, should not society continue to grant exclusive control to individual innovators who see fit to invest their labor to create new works of intellectual property? Or is that kind of private interest outweighed by the public interest to use anything that can be gathered "freely" by combing through cyberspace?

Is the public interest better served—and, indeed, are your own financial interests better served—by loosening rather than tightening copyright controls? The fact is that the same technology that makes images more useful and more available to a larger market can also assure their creators a greater source of income. If supply and demand allows images to be licensed at lower prices, it is their cumulative value over time that must be protected.

The answers to the two questions posed earlier in this part—what was actually stolen, and what harm was done?—should be more obvious now. Images are no less valuable than real property. The unauthorized use of images under any circumstances is tantamount to theft. Copyright law applies no differently in the Information Age than during the Industrial Revolution. Victims of infringement still suffer a loss to their livelihood. Furthermore, and to the detriment of the economy in general, such thefts of intellectual property, if ignored and allowed to proliferate, will inhibit originality by diminishing the value of intellectual property and taking away the incentive to create new works.

The technology does exist to embed information such as copyright notices within a digitized image. They cannot be seen with the naked eye and, therefore, do not interfere with viewing the image. When an image is opened within Photoshop, for example, the software will notify the user of any copyright information and restrictions. This embedded annotation will even survive repeated downloading, cropping, and editing. But what makes that technology much more exciting is its potential for you to collect additional revenue.

Imagine that some day you can assign little software robots, or "bots," to roam the Internet, tirelessly and unceasingly searching for images with your mark embedded in them. When one is found, the robot automatically "dings" the user's electronic bank account and deposits a payment into your own!

The Royalty-Free Issue

Royalty-free is a term that applies to the licensing of clip art, collections of generic images intended for nonexclusive publication by multiple end users. It may be a misnomer, because photographers may indeed earn royalties from the sale of clip art. The "royalty-free" description refers only to a buyer's obligation, or lack thereof, to pay publication fees based on usage. A buyer pays a low, one-time fee to the distributor, and it is usually folded into the cost of purchasing a CD-ROM containing the images. There are no further per-use fees for the buyers to pay.

The distinction of clip art is that the photographers receive royalties based on usage fees *from the distributors instead of the end users*. In other words, photographers earn revenue from the clip-art distributors (sometimes based on the volume of CDs or online image collections sold), while the clip-art distributors earn their revenue from the end users. How this works is explained in detail in chapter 35 in part 6, in the section called The Royalty-Free Business Model.

NOTES

21 Digimarc is a company that has developed digital watermarking technologies. Its patented technologies allow digital data to be imperceptibly embedded in traditional and digital visual content, including movies, digitized photographs, prints, as well as valuable documents such as financial instruments, passports, and event tickets. These technologies are used in a wide variety of applications, including solutions that deter counterfeiting, piracy, and other unauthorized uses. Since 1996, the initial Digimarc product has allowed copyright owners to deter the use of digital imaging tools, such as PhotoShop™, to produce unauthorized copies of their images. Subsequent products allow photographers and other copyright holders to persistently identify their protected properties or locate these properties across the Internet, and thereby discourage unauthorized distribution and use. See: *www.digimarc.com.*

22 See: *www.loc.gov/copyright/cords/.*

23 See: *http://lcweb.loc.gov/copyright/formsvai.pdf* for the regular form and *http://lcweb.loc.gov/copyright/forms/formvas.pdf* for the short form.

Pricing
Photographic
Services

You are not in business to be a photographer;
you are in business to make money!

How much should I charge? That seems like a simple enough question. It demands a simple answer. But the answer is neither simple nor obvious. A host of variables must be considered to resolve what turns out to be a rather complex question. And the issue merits more than just a one-time consideration. You are obliged to reconsider pricing each time you start a new photo assignment, no matter how long you've been in business. While the criteria for pricing never change, prices always do.

28

What Is
a Picture
Worth?

Everyone knows that a picture is worth a thousand words. But isn't it also worth more than just the time it takes to make one?

It only takes $1/125$ of a second or so to snap a photo, and anyone with a camera can click the shutter. Nevertheless, some photographers make big bucks, while others, perhaps just as talented, merely scrape by. So why are some photos priced higher than others? Why does the work of some photographers seem to be inherently more valuable than others? What factors allow such disparities to exist? The following anecdote may give you some insight.

The story goes that a wealthy couple was honeymooning in the south of France in the early sixties. The groom was a connoisseur and collector of fine art. In fact, he owned several paintings by Pablo Picasso. By coincidence, they met an art dealer at their hotel who knew Picasso personally and offered an introduction. Arrangements were made for a rendezvous at Picasso's villa in Vallauris, just outside Cannes, the following day.

The party arrived at noon and was treated to a tour of Picasso's studio by the master himself. In the course of small talk, the groom gathered all of his nerve to ask Picasso if he would consider painting a portrait of his bride. To his surprise, Picasso agreed.

In their excitement, the couple began chattering about how long to extend their hotel reservation and about buying a special gown for the sitting . . . until Picasso brusquely interrupted to ask if a photograph of the young woman was available. Her husband took a snapshot from his wallet and handed it over. "Well," Picasso said, "just leave this with me and go find some lunch in the village. Come back in one hour. I will have a painting for you."

Astonished, the couple left with the art dealer for a bite to eat. They returned in one hour, just as Picasso was putting the finishing touches on a splendid, if rather theoretical likeness of the beautiful bride. (Incidentally, you may assume that Picasso did not commit copyright infringement by creating a derivative work from the snapshot; the groom took the photo!) Everyone was pleased.

The groom inquired casually about Picasso's fee, as he reached into his pocket for a checkbook. Picasso asked for $25,000 (in French francs). While price was no obstacle, the man joked about what a nice job it was to make $25,000 an hour painting pictures. Picasso's sober retort was, "You don't pay me by the hour. You pay for the years of hard work that made it possible for me to paint such a picture in only one hour!"

Uncertainty about Pricing

The story above suggests that the price you charge is hardly determined by how much time you spend behind a camera. Obviously, your time merits some consideration, but you already know it can't be the most important criterion, let alone the only one. So what else determines the price of published photographs? Is price entirely dependent upon how my clients publish my photos, or . . .

> Do my talent and the quality of my work count most of all?
> Should my personal experience dictate how much to charge? (If so, how long will it take before I start earning enough to support the lifestyle I want?)
> Does the difficulty of an assignment become a pricing factor?
> What if I run over budget or over schedule?
> Am I supposed to break even on production costs and bill for a day rate on top of that amount, or . . .
> Should I charge more than what it costs me to shoot the assignment *plus* a day rate?
> If the answer to the last question is "yes," how much more do I charge?
> How do I figure out ahead of time what all of my costs will be, so I don't get burned by estimating too low?
> Should I charge anything at all for the time it takes to shoot an assignment?

Deciding what price to charge is the single most demanding decision a photographer has to make, especially if you're just starting out. Nonetheless, you must make that decision over and over again for each and every assignment that comes your way throughout your career.

The Difference between a *Price* and a *Fee*

Price refers to the bottom line, literally, the final figure on a Job Estimate, Job Confirmation, or Invoice/License of Rights. The price of an assignment must not be confused with any one or more of the separate *fees* that are comprised within its total. It is, in fact, the grand total of *all* your fees, plus production costs, markup, and sales tax. When it comes

to billing, *price* means not just the whole enchilada, but the combination plate.

A day rate, for instance, is merely one particular kind of fee. It cannot be considered a price all by itself, because it represents only a fraction of the buyer's total cost. If you were to bill your clients for day rates alone, you would neglect to bill your expenses. You might also leave yourself exposed to severe government-imposed penalties for not collecting and remitting sales taxes. Moreover, you would not make any profit.

A price includes everything buyers have to pay for. They pay for:

> All of the production services you provide (at various fees) *plus* . . .
> The costs you've incurred to execute an assignment *plus* . . .
> A profitable markup *plus* . . .
> Applicable sales and use taxes *plus* . . .
> A license to publish the resulting photo(s)

The Complexity of Pricing

As you can see, pricing photography is no simple matter. But there isn't one person reading this book who cannot master the skill. Complexity becomes an issue only when you have to bill more than one kind of fee on a single invoice. Even though, frankly, that happens often, complexity does not mean difficulty, especially when you have business automation software to help you, such as PhotoByte.

As you progress through this Part, different kinds of fees will be discussed in detail. Each fee corresponds to one of the various services photographers offer. In addition, you will learn how and when to bill expenses that correspond to production costs. You will also learn how to make a profit. Guidelines will be presented to help you calculate a dollar amount for each component of your price and for any given assignment. You will learn how to put the components together and watch them take shape as a Job Estimate, a Job Confirmation, or an Invoice/License of Rights.

Since circumstances vary from job to job, some kinds of charges may not apply to every price. For example, you wouldn't add a specific line item charge for film and processing to a stock photo invoice. Nonetheless, you will learn how to charge

indirectly for such costs, because it still costs you money to shoot, and time to maintain, an archive of stock photos. Such a valuable resource made available to your clients demands a profitable return on your investment.

Overhead: How Cost Affects Price

The cost of doing business affects the prices you charge for every assignment. If your costs are too high, you may have to raise your prices, making it harder to compete against photographers with lower costs and, therefore, lower prices. If your business requires a large studio and a staff of assistants and technicians, you may not be able to accept the kinds of jobs that photographers who work out of a home office can produce more cheaply. That's why some photographers merely rent studios and hire contractors on an as-needed basis. It cuts overhead.

Overhead represents the money it takes to keep your doors open for business each day, whether a shoot is booked or not—and whether you have an office or a studio with a door or not. Even location photojournalists can rent studio space on an ad hoc basis if need be, billing it back to their clients. (That would be a *direct cost*, as explained below.) Without the financial burden of a full-time studio that must be factored into the price of all assignments, whether they require a studio or not, you can keep your prices down, allowing you to be more competitive.

A studio is merely one example of overhead. Whatever your reasons are for having one—or any other facility—it must pay its own way by earning a profit. If you pay for day rentals and don't mark them up for a profit, it's just a personal indulgence, not a business necessity. If you make use of a studio often enough, so that the cost of owning or leasing it can be amortized (i.e., spread out) over many assignments, even by renting it to other photographers, then you have kept a competitive advantage. (That would be an *indirect cost*, also explained below.)

Indirect Costs

Your overhead includes *indirect costs*. *Indirect* means costs that cannot be attributed to any one, specific assignment.

For example, when you buy a page in a sourcebook to advertise your work, the entire cost cannot be attributed to a single photo shoot, i.e., you can't bill it back to the first client who assigns you a job. So, you will amortize the ad by attaching a fraction of its cost to every assignment you shoot, by raising your prices a corresponding amount. For example, if it costs you $1,200 for an ad and you shoot fifty assignments per year, you would divide $1,200 by fifty and add the result ($24) to each price. Actually, in practice, you will accomplish the same result by increasing your profit margin. More about that later.

When an indirect cost is not billed back to your client as a line item expense, and it is included in your profit margin instead, it is commonly called a "buried" expense. To cite another example, the same principle applies to camera and liability insurance; a portion of your annual premium is applied to each photo shoot. However, insurance costs are not always buried. Many photographers bill their insurance premium as a prorated, line item expense. There are many similar examples.

Indirect costs also apply to the creation of self-assigned stock photos and portfolio samples. Call it shooting "on spec" if you will, but production costs and markups must still be built into your licensing fees. If you don't do that, you are not making a profit.

To each photo assignment you accept, you will add a small part of your budgeted costs for overall marketing and self-promotion. Besides sourcebook ads, those costs include picture postcards, business cards, postage, portfolios, and agent commissions. Then, you must consider the cost of ancillary services, such as legal, accounting, insurance, and graphic design. There are other hidden, or indirect, costs, too, ranging from office supplies to client entertainment. The list goes on and on.

Incidentally, all of these costs represent money well spent, because they help you find new work. Consider them as investments. As such, almost all of these costs are tax deductible. So don't forget to discuss them with your accountant. Don't neglect to consider the capital cost of your camera gear either. It's not going to be worth what you paid for it by the time you get it home and take it out of the box. But the difference between what you paid and what it's worth can be depreciated on your income tax returns. That saves you tax dollars. (See chapter 38, part 7, Operations, for more about tax depreciation.)

Camera equipment also requires repair and

replacement from time to time, and that takes cash. Therefore, indirect costs also include keeping your equipment in tip-top working order. You can't afford to have a camera, a lens, or a strobe light fail in the middle of a shoot unless you have backups. And backup equipment is also expensive to acquire and maintain. If you don't own backup gear, you may have to pay to rent it. But all of these items qualify for tax deductions, in spite of the fact that their costs may be factored into your pricing, so they are paid for indirectly by your clients in the form of profits.

Finally, you must factor in all the credit services you use each month to pay for services and supplies. You probably pay some rather hefty interest rates and fees to the banks that issue those plastic cards you rely on, and also to the vendors who provide you with open accounts, especially if you are ever late with a payment.

However much you pay for credit, that amount of cash is no longer available to earn interest in your bank account or to build equity in real estate or a mutual fund. Credit, too, represents an indirect cost for a service that must be factored into your pricing. So, you see, just as you must earn a fee for shooting pictures, your business must earn a fee for providing these ancillary services, financial and otherwise. If it does not, you will end up subsidizing your customers and losing money.

A partial list of indirect costs includes:

- Advertising, marketing, and promotion
- Camera equipment
- Commissions (to artists' rep)
- Dues and subscriptions
- Employee salaries and benefits
- Entertaining clients
- Insurance
- Interest payments (cost of credit)
- Legal and accounting
- Licenses and permits
- Maintenance and repairs (to photo equipment and office or studio)
- Office supplies and computer equipment
- Postage, shipping, and messengers
- Rent
- Security (burglar alarms, camera vaults, etc.)
- Taxes
- Telecommunications (ISP, cellular phone, telephone, fax, etc.)
- Transportation (automobile, taxi, trains, buses, rental cars and vans, etc.)
- Utilities (gas, water, electric, trash removal, etc.)
- Vacation time

Direct Costs

Direct costs are more conspicuous than, say, the postage you spend on mailing self-promo postcards each year. Direct costs are usually associated with and charged to a particular shoot. They include such things as the hiring and supervising of assistants, stylists, location scouts, and models, as well as the rental of special photo equipment and the film you shoot for each assignment. These costs are billed directly to your clients as distinct line items on every invoice. That is why they are called "direct" costs. They also include what you spend for film, processing, hotels, toll roads, gratuities, props . . . you name it. Direct costs include the commissions you might pay to modeling agencies, too. (Sometimes they bill commissions to you as markups.) By filling in the two PhotoByte Worksheets associated with each Job Estimate, Job Confirmation, and Invoice/License of Rights, you will be reminded about charging for direct costs. Don't forget to refer to your receipts, too!

Costs versus Expenses

A *cost* usually means a charge against your business, the amount you have to pay for a product or service. An *expense* usually means something you bill to a client; *they* pay. An expense is, in that context, part of your revenue. An expense is calculated as:

$$Cost + Markup$$

Finding a Starting Point

One of the most common mistakes made by new photographers is to price themselves too low. It's bad enough that they trust hearsay and rumors from photo assistants, lab technicians, and magazine pundits to determine what other, more established photographers are charging; those are not reliable sources of intelligence. But they do it anyway, deliberately pricing themselves below whatever figure they happen to hear on the street, presuming that

they can break into the market by offering bargain basement prices. They are mistaken. If you don't think you're good enough to demand top dollar for your work, neither will your customers.

Buyers do not pick photographers based on price alone. If you figure on establishing a foothold in the marketplace by pricing yourself below market levels, even by guessing what seems to you like a modest price for any given shoot, you could be shooting yourself in the foothold.

Review the exercises, Determining Your Break-Even Point and Using the Profit/Fee Calculator, in chapter 8, part 3, and refer to the Profit vs. Creative/Usage Fee Analysis screen to review your understanding of the relationship between costs and pricing. Going back to the Profit/Fee Calculator from time to time (accessible at the Sales Reports screen in PhotoByte) will keep you from forgetting to include all of your costs. It is especially helpful to remind you of indirect costs that are not listed as line items on Job Estimates and Invoices.

Market Price

There is no magic formula to help anyone arrive at a price, nor is there such a thing as a "standard price" for any kind of photo assignment. Just about every shoot is different and will have a different price, no matter what the subject matter. That goes for stock photos, too, because they are used in an infinite variety of ways. But there does exist a sense in the marketplace of what buyers are willing to pay, of how high they're willing to go. This theoretical limit is called a *market price*.

A market price is based upon what the preponderance of photographers has billed for similar assignments and stock photo sales in the past. Unfortunately, however, the market price can be too low when the majority of photographers don't know how to formulate a price. That's why a market price should not be held up as an industry-wide standard. It may, nonetheless, prevail because of how easily photographers have succumbed to the pressure of competition, some of it unfair.

That pressure will be leveraged against you to its fullest extent because of the greater economic power buyers have; they will pit you against other photographers. If those other photographers are unsophisticated about pricing, the only result you

can all count on is lower prices, lower revenue, and unprofitability.

In the end, pricing boils down to bargaining skill. *All fees are negotiable.* You don't have to settle for the first offer you get. Get as much as you can! Don't be embarrassed or afraid to ask for what you want. Once you start quoting low prices, it's hard to bargain them back up. Remember what George Foreman said: "Dog don't bark, dog don't eat!"

Even though it's tempting to simply charge what everyone else does—or at least what you think they are—based on what competitors and clients are willing to tell you, you can get into trouble that way. They don't always tell the truth! There are better ways to ascertain the market price. And there is no rule that says you can't push the envelope, driving it higher.

Pricing Surveys

It's easy to find sources of photo-pricing information. For instance, each of the national trade associations (ASMP, PPA, and APA) publishes member surveys from time to time. An e-mail or a telephone call will facilitate a request to see the most recent one. (A charge may or may not apply, and membership may be required.) They generally show a range of fees billed by those members who have responded to the survey. Examples of dollar amounts are separated into columns corresponding to various types of media uses (low, medium, and high), that is, under what circumstances the photos were published.

Corrupted Information

Beware that pricing surveys are not always accurate or complete:

- Surveys do not always account for more than a basic usage fee, yet there are usually additional fees and costs to factor into the bottom line price for a photo shoot.
- Surveys can be skewed by the number of respondents, which may include only a small percentage of those photographers who were actually polled.
- The respondents from one regional market may outnumber those in another. If you're not given that information, the survey will be tainted and misleading. What might be a tantalizingly high

fee in Schenectady might be low by New York City standards.

> Surveys become out-of-date quickly, because prices are susceptible to change.
> Finally, surveys do not single out photographers who have used best practices to determine pricing and profit structures. Consequently, any carelessness on the part of the respondents (especially when they are few in number) will lead to unrealistic and artificial prices, whether biased on the low side or the high side. You have no way of knowing how many—if any—of the respondents regularly mark up their billed expenses for a profit, let alone whether they billed any expenses at all. And you have no idea what their actual costs are.

Price Fixing

Please note that the trade associations that publish surveys are sensitive to charges of collusion, or price fixing, something that is forbidden by federal law. They are not allowed to set prices or even to provide guidelines for setting prices. They are only allowed to make public the information they have polled from their members. So never tell a buyer, for instance, that the ASMP recommended such and such a figure as a fair price. *There are no "ASMP minimums" and no "ASMP day rates!"* That applies to the other associations, too.

Downward Pressure on Prices

The upshot of surveys is that they can drive prices *down*. Here's how.

A problem arises when you try to bill a reasonably profitable fee and it is the *buyer*, ironically, who invokes the results of a survey to tell you that your price is too high, higher in fact than the last so-called "ASMP recommendation." It doesn't matter how outdated that survey may be; the buyer may demand that you adjust your price down to match its results, no matter that costs have risen dramatically since it was first published. That makes it hard for photographers to raise their fees in conjunction with inflation and the cost of living.

Surveys tend to establish the going rate for photographic services, whether the information they contain is realistic economically or not. They can be used to some extent to gauge what the market will bear, but only when examined intelligently and in conjunction with additional economic factors, such as the Five Competitive Pricing Factors listed in chapter 30 in this part.

Surveys may be an okay starting place for novices, but experienced professionals realize how their own pricing strategies can be compromised by their undue influence. One cannot rely on the results of a survey to indicate a price that will maximize profits, because fees vary so widely from one respondent to another and from one day to the next. So read surveys shrewdly, and don't depend on them exclusively. If buyers can beat you over the head with the results of a survey, they will. Therefore, keep in mind that a market price is not necessarily a "fair market price" when it comes to surveys.

Other sources of "ballpark" pricing information for various kinds of jobs include these three books:

> *Photographer's Market 2000*, edited by Megan Lane and published by Writers Digest Books
> *Pricing Photography: The Complete Guide to Assignment and Stock Prices* by Michal Heron and David MacTavish, published in 1997, revised edition 2001, by Allworth Press
> *Negotiating Stock Photo Prices* by James H. Pickerell, published in 1997 by Stock Connection

The Foremost Principle of Pricing Photography

You have learned what a price *is*, if not just yet how to come up with one. With that in mind, the first thing to understand about pricing photography is that you're not really pricing photographs at all. In fact, you already know that a photo business creates revenue by licensing intellectual property rights, not by selling photographs.

Since you can't rely on surveys to cover all of the elements of a price, there must be a practical criterion for putting a value on the actual work you produce, if not the services you provide. It must account for something beyond the time it takes and what it costs to shoot a photo assignment. It must acknowledge something more significant economically than talent, although these are all factors included in a total price. But in addition, there has to be some kind of yardstick for meting out the value of intellectual property itself.

Conveniently, there is such a yardstick. *Usage is the most important criterion in ascribing value to intellectual property*, and copyright is the yardstick for usage. Copyright allows you to measure and withhold publication rights by parceling them out, piece by piece, in exchange for payments.

Billing in Increments of Value

Since a copyright license defines the usage rights granted to a buyer, they can be apportioned incrementally according to every buyer's budget and the extent of their licensing needs. Instead of a prix fixé dinner, you are offering your clients a menu à la carte, mandating a relationship between budget and appetite. That means a separate fee may correspond to each separate use listed on an invoice, just like the food and drink itemized on a restaurant check.

The same principle applies when miscellaneous uses for the same photo(s) are billed consecutively over an extended period, perhaps necessitating several subsequent invoices.[1] Regardless of how many invoices a buyer receives (or when they are received), the principle of billing in increments of value makes it easier for photographers to see the value of the work they produce. They can see what else there is to bill for on any given assignment in addition to usage rights, such as time spent on the job and even their personal reputations. It also gives them a perspective on the relative value of one part of a price to any other part. In other words, if you can determine what the licensing component is worth, as set aside from the other parts of a price, you'll have a better handle on figuring out what to charge for those other parts.

Billing for the incremental uses of photographs keeps costs down for the benefit of the buyer. You have an opportunity to capitalize on that fact in your marketing message. By pointing it out to your clients, you will emphasize your professionalism and dedication to customer service.

Value to the Buyer

The importance of the incremental apportionment of usage rights becomes clear when you consider that, before you can determine a price for anything, you must gain some idea of its value to a buyer. In the photo business, the greater the extent of usage required, the greater is its value to a buyer.

There are five criteria for determining the extent of usage:

- Duration—the *length of time* that a license applies, e.g., the right to publish for one year, or six months, or only for one time.
- Frequency—*how many different times* an image is published, e.g., one time in each of twelve separate issues of a single magazine, or up to seventy-five advertising inserts in eight completely different magazines.
- Prevalence—*how many different places, formats, or versions* of media in which an image is published, e.g., in magazines and newspapers only, outdoor billboard display, exclusively on a Web site, broadcast on television, or all of the above. The size of circulation, or number of printed pieces, determines prevalence, too.
- Size—*how large* an image is published, relative to the size of the media in which it appears, e.g., it's logical to charge more for photos that dominate an ad on a printed page, computer screen, or billboard and to, perhaps, charge less for one that merely occupies a small percentage of space or shares that space with a number of other images. In the latter case, it may be merely supplemental to other pictures appearing in the same ad.
- Exclusivity—the *rarity* of an image.

Now that you appreciate how pricing depends in large part upon usage, and that usage is, arguably, the biggest variable involved in pricing, do not lose sight of the fact that there are other criteria involved. You will learn what they are and how they relate to each other in this part.

The Criteria for Pricing Photo Assignments

Price is influenced by eleven factors, broken out into four groups:

Group One: Usage Fees
- Duration—the length of time a photo is used.
- Frequency—the number of times a photo is used.
- Prevalence—the number of different places a photo is used.
- Size—how big, relative to the medium in which it is published.
- Exclusivity—the uniqueness of the photo.

Group Two: Creative and Production Fees

‣ Reputation—the photographer's experience, the degree of responsibility accompanying an assignment (its importance to the buyer), unusual or special skills required, a unique style of execution, perception of exclusivity.

‣ Complexity—ancillary services and production time necessitated by client for reshoots, consultations, location scouting, casting models, travel, postponements, editing, set construction, etc., and perhaps an unusual level of anticipated difficulty in execution, even the dangerousness of an assignment.

Group Three: Expenses

‣ Costs—job-related, billable expenses, or what the photographer pays for freelance assistant and stylist fees, messengers and shipping, film and processing, permits, travel, props, studio or location rental fees, insurance, photo-equipment rentals, etc. Don't forget your own salary!

‣ Markup—an additional fee, not always singled out for the client's perusal, but sometimes merely included, or embedded, within each line item expense; derived by multiplying each sepa-rate production cost by a percentage rate you and your accountant determine will sustain the profitable operation of your business.

‣ Overhead—the cost of doing business; while not itemized, it influences both creative and production fees; augments fees to the greatest extent allowable by prorating annual operating costs into each assignment.

Group Four: Taxes

‣ Sales and Use Tax—a percentage rate imposed by municipal, county, and state governments and applied to fees, expenses, or both, as applicable.

note The total of items 1–7 are often represented simply as an aggregate "creative fee" on the face of an invoice.

NOTE

1 In this example, there is not much difference from the way you would invoice a client for a stock photo, except in this case, the client also happens to have commissioned the photos in the first place.

29

Explanations
of All Fees

In addition to usage fees, the price of every photo shoot will take into account three factors:

> The time you spend on activities that are subordinate to shooting pictures
> Any special expertise you might have
> The actual cost of production

Think of the movie business. A photographer is often the producer, director, writer, and camera operator all rolled into one person who is responsible for tying together all of the disparate elements of a photo session. It can be as complex as a day on the set of a movie—without the "movie" part. It is apparent that professional photographers possess highly valued expertise in many areas extending beyond the scope of their image-making talent. Your price should reflect that expertise.

- - - - - - - - - - - - - - - - - - - -

The Responsibilities of a Photographer on Assignment

This is what you get paid for:

> Strategic Planning
 • Working with clients

• Administrative oversight
 – Hiring and supervising contractors, vendors, models, etc.
 – Scouting and booking locations or studios
 – Securing insurance, supplies, and travel accommodations
> Execution
 • Creative problem-solving
 – Directorial expertise
 · Working with people
 – Technical expertise
 · Lighting and camera gear
 · Special effects
> Delivery of Film
 • Editing and archiving film

- - - - - - - - - - - - - - - - - - - -

A Wide Range of Fees Means a Wider Range of Clientele

Each one of the many skills you have mastered corresponds to a fee that should be billed to your clients, either directly or indirectly. Depending on the difficulty of an assignment, some clients will need to utilize many of your skills, while other

clients will require fewer of them—hence the essentiality of devising various fees to accommodate various skills.

This sort of mix-and-match approach to fees and pricing is not haphazard. The practice of breaking down a price into a number of separate fees is designed to give buyers more choices. It also allows you to accept a broader range of assignments by giving you credibility with a broader range of buyers.

These choices are designed to fit buyers' budgets, in much the same way that assigning incremental value to reproduction rights makes it more economically feasible for photographers and publishers to do business together. By offering various sets of skills at different price points, you remain attractive to buyers who require your production expertise and supervisory capabilities for major photo shoots, yet competitive enough to accept lower-paying assignments with fewer responsibilities.

Smaller assignments, while no less profitable, demand less of your time, more modest usage rights, and are less complex to produce overall. Variable pricing, in effect, means offering different "brands" of photographic services for buyers to choose from.

The Creative Fee

Do not confuse the term "creative fee" with the use of a similar looking heading found on many billing documents—including the Worksheets in Photo-Byte—called "Creative Fees" (note the plural).

It certainly is confusing that some photographers have traditionally used "creative fee" synonymously with "day rate," "assignment fee," and its other equivalent terms, because it is common on Job Estimates, Job Confirmations, and Invoices to see a section heading that is also called "Creative Fees." But the latter merely represents a convenient place to list several subordinate assignment fees and usage fees and to give them a subtotal, so your client can more easily read the bill. It does not represent a single fee.

Further confusing the issue is that one of the line items listed under the "Creative Fees" heading might happen to read "Creative Fee" itself, instead of, say, "Assignment Fee." After all, it's your choice to call it whatever you wish. You simply have to decide what term you prefer and be consistent to avoid confusion.[2]

Incidentally, while it's normal for the Creative Fees subtotal to include both an assignment fee *and* a usage fee, it may contain just a usage fee alone.

The Usage Fee

In the photo business, "usage" is synonymous with the words "publication" and "reproduction," as in *usage rights, publication rights,* and *reproduction rights.* Payment for the combined duration, frequency, prevalence, size, and exclusivity pertaining to the use of an image is called a *usage fee.* Therein lies the direct correlation of usage to copyright licensing.

Usage is the dominant factor in pricing, but no single one of its five component parts has a dominant influence on the dollar amount of that usage fee. Each part must be considered in the context of and together with its four other parts.

note Only the usage fee component subtotaled under Creative Fees is reported as profit. (PhotoByte does this for you automatically.) Usage fees can be considered profit, because they are not a cost to your business. The reason that assignment fees are not reported as profit, too, is that they are considered a cost. They are paid out as your personal salary.

EXERCISE

Client Negotiation Role Play

Interacting and asking questions out loud with a friend or colleague pretending to be a buyer is a good way to achieve a level of comfort and confidence in dealing with clients. It will prepare you for real situations where you have to negotiate usage rights, whether for assigned photo shoots or for stock licenses. Incidentally, these rights should always be negotiated *before* you accept an assignment.

As previously mentioned, the ASMP publishes a curriculum that includes excellent guidelines for role-playing scenarios. It can be downloaded at this Web site: *www.asmp.org/foundation/curriculum.html.*

In your own words, formulate a series of questions to ask your role-playing partner about how he intends to use the photos he is about to commission. This process forces buyers to recognize their

own actual requirements, so that by limiting the rights you license to them, you can save them money. Making sure that they understand that principle makes it easier for you to negotiate with them. You should articulate that principle in each scenario with your partner. You should perform at least three separate scenarios, one for each type of buyer (i.e., advertising, corporate, and editorial).

Here are some questions you might ask. As your "client" responds, take notes!

- Is the work produced going to be used in an ad, a brochure, or as editorial content in a magazine?
- In what media will the work be reproduced?
- Will the work be published in any foreign language editions in addition to English?
- Is the work going to published regionally, nationally, or internationally?
- *The broader the distribution, the higher your fee should be.*
- How many photos will you publish?
- How long will you continue to publish the work produced; i.e., do you require merely a one-time use, or do you need a license that extends throughout a specific duration, say, three months or one full year?
- When will you publish the photo?
- *Sometimes a publisher's intended use may not take place right away, so the grant of an extended license is called for, even though the work is to be used only one time. If your license is to have a limited duration, you need to know when it starts and when it ends.*
- Is the publication limited to a specific print run (i.e., number of copies), and if so, what is the print run?
- *If the image is to appear in a periodical, the print run should apply to the circulation of one edition only.*
- In the case of an extended license, how many times do you intend to publish the work; i.e., how many *inserts* into various publications do you intend to make?
- *The answer to this question represents the number of editions of a periodical in which your photo will appear. Sometimes a single photo, if used in an advertisement, will be inserted into twelve separate, monthly editions of the same magazine Likewise, if your client wants to run an ad in the Sunday paper*

every week for one month, your license period would extend for one month, and the number of inserts would be four.

- *Alternatively, inserts may be placed in more than one publication throughout the duration of a license. So you might expect eighty-four inserts in seven completely different magazines—more if the license includes mixed media such as billboards and direct-mail brochures—during the course of a year-long or longer license. You can increase your negotiating power by invoking the number of inserts and attaching a fee to each instance of use.*
- What kind of placement do you intend for the image; i.e., what will the layout look like?
- *The more prominently featured your picture will be, the higher the price it should command.*
- *The actual size of an image relative to the size of a page doesn't count as much as its visual importance to the layout. If your photo is to be used in either a periodical or brochure, will it be a front cover, a double-truck spread, a back cover, inside cover, etc.? Alternatively, if a magazine wants to publish a single photo and your image takes up one quarter of an inside page, yet it is the only photo on the page with a large border, you are still entitled to a full-page rate. The same principle of prominence applies to advertising and corporate layouts.*
- Will I be allowed to relicense the work to other buyers, or will you require exclusive use?
- If you require exclusive use, does it apply only up to a certain time, after which I can relicense the work?
- *If you are prevented from re-licensing the image(s) to other buyers, you should jack up the fee to compensate for what might be lost from further sales.*
- How long will your periodical or brochure be in circulation?
- *For example, if you are printing a direct-mail piece that will be sent to a different group of people every month for a year, your circulation duration would be one year.*
- Will your publication be distributed to a trade group or to general consumers?
- *A mass-market use will usually command a higher fee than a use limited to within a certain demographic or a relatively small group of professionals.*

Do not feel obligated to quote a fee immediately. Tell your client that you need a little bit of time to

digest the answers to your questions and that you will get back to him right away with a figure. That final figure will, of course, be a *price*. It will also include any marked-up costs (billed as expenses, if this is an assignment) plus your assignment fee (the equivalent of your aggregate "day rate").

The final step in this exercise is to take the answers to your questions, again separately for each type of buyer, and apply them to the Copyright Composer in PhotoByte to create some examples of valid copyright licenses.

The Assignment Fee

An assignment fee corresponds to your personal photographic expertise and the performance of primary services. It has to do with your reputation and the work you perform personally on each assignment. It may also be thought of as that fraction of your overall price that corresponds to a personal salary. To put that into perspective, think of an assignment fee as what you are paid to shoot each assignment, just as if you had to hire a photographer to do the work for you.

It is both fair and appropriate to charge clients what your business would have had to pay another photographer of equal ability. Conversely, you should be paid what you could earn if you were a salaried employee shooting for someone else's studio. Indeed, an assignment fee is a cost to your business, insofar as bookkeeping is concerned. Therefore, the assignment fee is a billable expense to your client.[3]

An assignment fee might alternatively be called a *camera fee*, a *shoot fee*, an *editorial fee*, a *commercial fee*, or a *day rate*. Pick whichever flavor you like; they all mean the same thing.

note If your usage fees are much greater than your assignment fees most of the time, there is no reason not to count both types of fees as profit, provided that you allow the business to pay you a salary high enough to cover your personal needs. In other words, you may disassociate salary and assignment fee, as long as your business earns a substantial profit. Pay yourself as much as you want—as long as there is enough profit left over to sustain your professional operations.

A photographer's primary source of revenue comes through maintaining control over the intellectual property he creates. But it goes without saying that photographers should be compensated for their knowledge about how to use all of the different kinds of cameras and lenses, film formats, grip equipment, special effects equipment, and lighting gear they maintain, too.

Furthermore, all photographers act in an administrative capacity. They secure and supervise independently contracted service providers, such as assistants, models, stylists, photo-lab technicians, etc. They work with retail and wholesale vendors to obtain the supplies necessary to complete their assignments, too. These include film, rental props, special lenses, insurance binders, and travel arrangements. As a freelancer and a business owner, you should expect to be rewarded for utilizing your hard-won skills.

Finally, in addition to the planning, preparation, execution, and delivery of each photo assignment, photographers are obliged to archive each frame of film they shoot. They have to store it, catalog it, and protect it, so that the images are readily available to the buyer that commissioned them, in case subsequent publication demands arise. You, the photographer, are responsible for providing that service. Its costs are a part of your overhead. This must also be considered in pricing.

As you see, there is much going on behind the scenes of every photo shoot. Photographers are expected to have a considerable amount of production expertise, in addition to their knowledge about f-stops and shutter speeds, to satisfy their customers' demands. Any doctor or lawyer surely expects to earn fees that compensate for the years of training it took to become a reliable expert. Photographers are no exception. The creative, problem-solving skills relevant to shooting photo assignments should, indeed, have an influence on the amount of income you earn. As your reputation grows, so, too, should your assignment fee. Even early on, you should expect to be compensated reasonably for exercising the skills you have had to learn.

Remember: It's not as easy to take pictures as some people might think—at least not good ones, especially consistently. The singular difference between an amateur and a professional (aside from getting paid) is that a professional will always deliver

a publishable photograph at the end of an assignment; an amateur may or may not get lucky. So the next time someone says, "You cost too much. I can get my nephew to shoot that picture," let him. He'll come back.

note If you are legitimately an employee of your own corporation, then assignment fees, insofar as they are paid to you as salary, are tax deductible.

There are four simple steps for determining a basis for your assignment fee:

1. Decide on a fiscal year, usually January 1 to December 31.
2. Figure out how much money you want (or need) to earn annually in salary; i.e., "I want to earn $60,000 per year." *You might want to consult with your accountant to decide on a number that is pertinent to your own financial circumstances and reputation.*
3. Figure out how many assignments you anticipate shooting annually. *Remember: Some assignments last for a couple of hours, some last a whole day, and others last for several days or even weeks. Balance the number of these different kinds of jobs, and make an educated guess. If you are just starting out, get some advice from a seasoned pro. A reasonable guess will suffice. You don't have to come up with a true number of assignments.*
4. Divide the figure in step 2 by the number of assignments in step 3.

The result is your assignment fee. It can be pro-rated when assignments last longer than a single day. For example, if you believe your reputation commands an annual salary of $60,000 and you believe you are capable of shooting fifty assignments per year, then your assignment fee will be $1,200 (exclusive of taxes, profits, usage fees, and production charges). But if you can shoot one hundred assignments per year, then you can try to make yourself more competitive by billing only $600 per assignment. You'll still reach your overall salary goal, assuming that you can keep up the pace of work without letting its quality suffer. If the quality of your work suffers from spreading yourself too thin, by not putting enough effort into each assignment, your customers will notice. You'll have to back off

and shoot fewer jobs. They might not give you a choice in the matter; they won't hire you if they think the quality of your work has deteriorated.

If you can balance your workload successfully, then obviously, the idea is to shoot one hundred assignments (or more) at the $1,200 figure (or higher). And that's how to give yourself, essentially, a "raise." Alternatively, you may find it necessary to raise prices to compensate for shooting fewer assignments. But if you do, you may lose some of your competitiveness.

The seesaw effect of raising assignment fees and lowering competitiveness, and vice versa, illustrates how the natural forces of the marketplace operate. It is evident that you must find a competitive balance to suit your own circumstances and reputation. If you have a wonderful reputation, the opposite end of the seesaw can handle higher assignment fees. If your stature in the competitive pecking order hasn't quite been established yet, you'll have to balance it with lower assignment fees.

note To give yourself a raise without raising your bottom line prices, you must shoot more assignments. If you pay yourself a higher salary without increasing either your volume of work or your prices, the difference has to come out of profits. That makes it harder to sustain operations.

Consider how billing a separate assignment fee attributed to salary affects your overall revenue:

▸ If you bill an assignment fee without marking up any expenses, you have made no profit.
▸ If you bill a usage fee without an assignment fee and without marking up expenses, your business *has* made a profit, albeit a smaller one than if you had billed a markup, too. But you have made no salary. Remember: Usage fees are profit, too.
▸ If you bill an assignment fee plus marked-up expenses, you have made a salary, and your business has made a profit, too.
▸ If you bill an assignment fee plus marked-up expenses plus a usage fee, you have earned a salary, and your business has earned a bigger profit.

You decide which is the smartest way to work.

The Production Fee

In addition to a usage fee and an assignment fee, photographers often include a third kind of fee to cover the amount of time they spend planning, preparing, and performing activities in support of the actual shoot. This fee compensates them for time spent on the job in addition to their picture-taking duties.

Only ancillary services, those that are secondary to actually working behind the camera, have a financial relationship to how much time you devote to an assignment. Ancillary services include pre- and post-production activities—all the "grunt work," if you will. The fees that correspond to ancillary services are called *production fees.* They produce revenue in direct proportion to the complexity of execution for any given photo assignment.

Since each outside contractor who performs a secondary service will be marked up and billed as a line item expense (in the Crew Members section of Worksheet 1 in PhotoByte), only those services performed directly by you, the photographer, will be billed as production fees. They will not be marked up, because they do not represent a cash outlay. They are not part of your overhead.

The Pre- and Post-Production Fee

Remember: It only takes about $^{1}/_{125}$ of a second to snap the shutter, but a whole lot of work takes place before you even pick up a camera to make that "snapshot" possible. Much goes on after you put down the camera, too.

Usually, when production support services are performed on a separate day, before or after the actual day of the shoot, such work is called *pre-production* and *post-production,* respectively. Some photographers distinguish pre- and post-production from services performed on the day of the shoot by billing them as separate line items. Some do not. But that's basically the only difference. Any fees for those kinds of activities are also included in and subtotaled in the Production Fees section on Worksheet 2.

Pre-production tasks might include purchasing props and wardrobe or traipsing around town on errands to obtain special equipment rentals, from smoke machines and sandbags to arguably the most expensive tripod in existence, a helicopter. They also include telephone consultations and personal meetings with the client, specifically to discuss the assignment.

Post-production fees might include the time it takes to edit an extraordinarily large amount of shot film, to return props, tear down sets, or to repaint studio walls and cycloramas. You might be obliged to bill a *travel fee* for the time it took you to drive or fly to and from an assignment on location. Travel fees also fall under the Production Fees section on the Worksheet.

Production Fees and Their Relationship to Salary

Some photographers count production fees as part of their salaries when they perform ancillary services personally. (Obviously, that is not the case when hiring assistants and outside contractors.) In that case, they pay themselves by taking whatever production fees they bill as a personal draw *in addition* to their assignment fee. Only when the principal of the business performs ancillary services and pockets the revenue as personal income is a production fee considered a business cost. Make sure, if you follow that practice, that you are making enough profit to keep your business running on all cylinders without those production fees. The alternative is to treat production fees just like usage fees, including them under the profit column that goes directly into the business bank account.

EXERCISE ----------------------------------

Production Fees: Profit versus Salary

In this exercise, you will use the *Profit and Salary* button on the Front Page of an Invoice/License of Rights in PhotoByte to toggle between two separate methods of accounting for production fees, either as profit or salary.

> ‣ From the Main Menu, click the *Billings* button.
> ‣ Click the *Invoices* button on the very next screen. You will see a list of Invoices.
> ‣ Click on the fifth invoice down from the top, N° 29769.
> You will see the same Invoice in Preview mode.
> ‣ Click the *Continue* button to enter Browse mode.
> ‣ Scroll to the bottom of the screen where you will see both the *Salary* and *Profit* buttons.

> ‣ Toggle between each button by clicking on one and then the other, and watch how the figure on the right (Profit for This Job) changes each time.
>
> ‣ To see the actual amounts billed for creative fees versus production fees, scroll to the top of the screen, and click the *Wrksht 2* button. Then, scroll to the bottom of the screen.

	Creative Fees			Estimated Amount: $7,000.00	Amount
78	Assignment Fee	3	,DAYS @	$1,500 , PER DAY	4,500.00
79	Usage Fee		refer to copyright license on Front Page		2,500.00
80	Job Change Order		See accompanying document for details		1,000.00
81					
			S U B T O T A L $		8,000.00
	Production Fees			Estimated Amount: $450.00	Amount
82	Consultation / Meeting		,DAYS @	, PER DAY	
83	Casting		,DAYS @	, PER DAY	
84	Location Scouting	1	,DAYS @	$450 , PER DAY	450.00
85					
			S U B T O T A L $		450.00

- - - - - - - - - - - - - - - - - - - -

When to Bill Production Fees

It is highly recommended that you include a corresponding production fee for each increment of additional time and for each application of special ingenuity required of you personally to complete an assignment. That means you should bill separately—and in addition to your assignment fee—for scouting locations, acquiring props, hiring outside contractors, casting models, negotiating permissions and releases, traveling to and from remote locations, waiting through delays caused by weather conditions, and so on.

Many photographers bill as much as their entire assignment fee for each extra day required for production. Some assignments might even involve an element of danger or difficulty that requires special expertise, such as shooting from an open aircraft or entering a war zone. All of these kinds of activities call for compensation *in addition* to assignment and usage fees.

Each individual production service should be itemized and billed as a separate line item, e.g., a casting fee, a location-scouting fee, a weather-postponement fee, a travel fee, a consultation fee, etc. Sometimes a single line item charge called simply "Production Fee" is used to cover all of the disparate services you've performed without itemizing them.

That's between you and your clients. Work it out ahead of time to decide how much detail you want to show on your billing documents.

Production fees for ancillary services are not used to calculate usage fees. In fact, production fees have nothing to do with usage fees at all. Therefore, they are not grouped or subtotaled in the Creative Fees section of the Worksheets. Instead, they are grouped and subtotaled exclusively in the Production Fees section of Worksheet 2, as illustrated above.

An Exception to Production Fees for Editorial Assignments

The complexity of a shoot and the amount of time it takes to prepare for it are not always factored into your price, especially if an assignment is accomplished quickly and without unforeseen delays. Therefore, it is not the norm to bill a separate production fee for editorial shoots. Magazine assignments, for instance, are often straightforward enough to bill only an assignment fee, leaving out production fees altogether. A longer-lasting or more complex magazine assignment, however, may indeed justify a production fee. But whether a shoot is brief and simple or long and complex, travel days and weather delays always warrant a production fee on top of your assignment fee.

Billing for Travel Time and Weather Delays

One rationale to bill for time spent both during travel and whiling away the hours begging Mother Nature to let you continue with an interrupted shoot is that you are not free to accept other assignments. You are committed to your current client. Even if you had no real expectations for shooting another job during this "off" period, your time could be put to use attending to your marketing campaign, looking for new assignments.

This principle must be understood up front with your clients. In fact, terms and conditions that define such understandings are described in chapter 47, Finalizing Legal Agreements, in part 8, The Paper Trail. The only waiting periods for which you have no right to charge are those caused by your own mistakes. That includes reshoots.

Expenses and Markups

When you receive an invoice from a freelance photo assistant, you pass that amount on to your client, naturally. It is a direct cost, so you itemize your assistant's fee (plus any additional expenses he might have billed you) as an expense on your invoice. No doubt, if you work for corporate design firms and advertising agencies, your invoices will be passed along to their clients the same way. (Not so with magazines; they are end users.)

The total price you bill your client for an assignment, including all of your fees and marked-up costs, will be expensed as a line item cost on the invoice they submit in turn to their own client. They will not only re-bill the whole ball of wax, but you can depend on the fact that it will be marked up even further. After all, they are not in business just to recoup what they paid to hire you, but to make a profit themselves.

As far as you are concerned, it takes time and expertise to search for and then select the best freelance personnel, including photo assistants, for any assignment. Your business has a right to charge for that time and expertise. You should have no compunctions about adding a markup, say 10 or 20 percent, to the amount that you were billed by your crew, and perhaps even a higher markup for other costs, such as film and processing. Every roll of gaffer's tape must be marked up and re-billed. The fewer items you mark up, the less profit your business earns. If you don't feel guilty, you're not charging enough!

Buyers should expect a markup on all direct costs—in addition to your billed creative fees—for every assignment. In fact, your markup *is* a fee itself. That fee compensates your business for "fronting the money" to pay your production costs. You are, in effect, functioning as a banker on your client's behalf. If you have to wait to receive payment for any length of time at all, you are entitled to a service fee. It's called a markup. Obviously, if you are paid an advance against billed expenses, you should not mark up any costs that correspond to the amount of the advance you received.

note Make sure that an advance invoice is paid before you begin the assignment!

How to Apply a Markup

The client is expected to pay the entire cost of producing and shooting an assignment. Each direct cost is represented on your billing documents as a line item expense. *A total of all costs billed to the client will include a percentage of those costs added on top as a markup.*

For example, multiply the total of your costs by a percentage (e.g., 33 percent). If total costs come to $543.11, multiply 543.11 × .33, yielding a product of $179.23. Finally, you will add $543.11 + $179.23 to give you a total of $722.34, which is billed to the client as a line item expense. In this case, your profit on the billed expense equals $179.23.

The Wrong Way to Bill Expenses

For lack of a better understanding about the relationship of pricing to profitability, some photographers bill all of their expenses—except for film and processing—back to the client *at cost* (exactly what they paid). But at the same time, they artificially inflate their markup on film and processing to as much as 300 percent! Finally, they take an arbitrary fraction of their total revenue for any given assignment and apply it towards their personal living costs. In other words, without any kind of plan whatsoever, they just pocket any available cash they need for their own use at any opportune time. Such a seat-of-your-pants approach to finance will inevitably lead to unpleasant results.

Separate Billing of Assignment Fee and Usage Fee

Whenever a usage fee is billed as a separate line item for a photo assignment, it follows that an assignment fee must be billed, too, and vice versa.[4]

The issue of paying yourself a regular salary notwithstanding, if both a usage fee and an assignment fee are *not* broken out and billed as separate line items, you have little choice but to blow up film and processing markups to triple-digit rates. That's the only way to compensate for not legitimately marking up your other expenses. That means your *only* source of profit would be film and processing. However, with film markups as high as 300 percent, it's no wonder why publishers balk at paying higher assignment fees or, in the case of magazines, higher day rates.

The practice of blowing up film prices has

become widespread. It is unfortunate, because buyers who become less tolerant and more suspicious about bloated film prices start demanding receipts. Inevitably, many photographers feel obliged to start forging phony ones to account for more film than they really shot, in spite of the fact that buyers have no legal right to demand receipts in the first place.

Of course, you must try to prevent customer dissatisfaction by making your business as competitive as possible. If they don't like your bottom line price, they are free to buy elsewhere. But the practice of forging receipts is unprofessional and untenable. It is also self-defeating and just plain unnecessary.

To correct this situation, it is only necessary to charge a more modest and realistic markup on film, *but at the same time, include a modest markup on the rest of your billed expenses.* If you do so, the bottom line price of an assignment will usually remain unchanged. As the billing process becomes more legitimized, it allows you to account for genuine profit. And who's to say that, after adding a markup to all of your other costs, you can't leave film and processing prices on the high side anyway? That's fine, as long as buyers are willing to pay. At least it's an honest way to do business.

Balancing Assignment Fees with Usage Fees

Suppose you have completed a one-day assignment to shoot an annual report. You have billed an assignment fee of $1,000 and a separate usage fee of $2,500, for a total of $3,500. If you acted wisely, your copyright license included only "one-time, first-exclusive" usage rights in exchange for that $2,500. (The $1,000 is basically just for showing up to shoot the job.) So what happens if the client wants to publish the same photos again in next year's annual report?

If you hadn't limited your copyright license, you couldn't get more money. Your client would be free to continue using the pictures without paying you any additional fees. But you did use the Copyright Composer, and you did properly limit the client's reproduction rights to just what they were willing to pay for at the time. Moreover, if you hadn't separated your assignment and usage, it would be harder to justify billing subsequent and additional uses of the photos in the next year's annual report. Since your

initial usage fee was $2,500, now you can easily stipulate that amount to the client when you bill again. You're on record, so to speak, for that amount.

But here's something else to look out for. What if you had billed $2,500 for your assignment fee and $1,000 for your usage fee, instead of the other way around? You would have earned the same amount of gross revenue for the initial assignment, but it might be harder to negotiate the higher usage rate for next year's annual report. The lesson is to be aware of what you expect to bill as salary and what you need to bill for usage. You have to protect your prerogative to bill additional usage fees in the future.

note A usage fee is calculated by PhotoByte as profit. If you were to delete the usage fee amount temporarily on any Worksheet, just as a test, you'd see the green, nonprinting, running profit total at the top right of the Worksheet's Amount column go down by a corresponding amount.

The Problem with "Reimbursable" Expenses

It is unheard of for professionals in any other industry to be admonished by their clients for earning a profit. But the fact is that photographers are often denied a profit on costs that are billed as line item expenses, including film and processing. This practice is insidious, unjustified, and maybe illegal.

It wouldn't matter if Kodak or Fuji gave you your film for free; you are still entitled to charge a fair market price for that commodity and for every other kind of merchandise you bill to your clients. To be prevented from doing so might be considered a *restraint of trade* in legal parlance. No matter what your source happens to be for photo supplies, including film, finding a way to pay less than other photographers and still bill as much as you can is a time-honored and legitimate competitive practice.

If you want to charge a 300 percent markup or even higher on film and processing and someone is willing pay your price, more power to you! But any client's demands for receipts, whether ostensibly for tax auditing purposes or for any other reason, are mendacious. Buyers need only show their auditors and the IRS your final invoice to back up their own itemized expense deductions.

Buyers do have a right, however, to take their business elsewhere if they feel your prices are too

high. That's the nature of competition at work. Nevertheless, the point is that *marking up expenses is a necessity*. It can be done intelligently and reasonably. Markups should be based on a reasonable profit margin, *reasonable* being determined by what the market will bear and in consideration of your actual costs of doing business. Only the market can impose limits. Charge as much as the market will bear.

EXERCISE

Marking Up Expenses on a Worksheet

In this exercise, you will create an invoice Worksheet with at least seven line item expenses and use the *Profit* button feature in PhotoByte to mark up three of them.

> From the Main Menu, click the *New Document* button.

> Click the *Estimate* button on the next screen that appears.

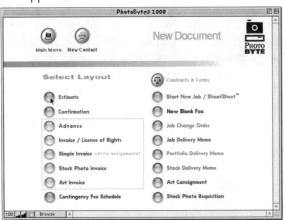

You will see Worksheet 1 appear on screen.

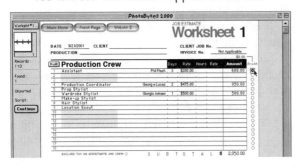

> Type on your Worksheet what you see in the illustration above.

> Now, click on the radio button in the right column adjacent to each line item on the Worksheet.

This will add a markup percentage. It is looked up from the preferences you entered in the exercise, How to Enter Data in PhotoByte, in part 2. Watch the total change in the green figure just above the Amount column in the header of the Worksheet. Incidentally, this figure showing the cumulative profit of your Job Estimate only appears on screen; it will not print. Your clients won't see it.

tip To toggle between adding profit and deleting it for each line item individually, hold down the Shift key on your keyboard while clicking on the radio button adjacent to each line item with your mouse.

The alternative to using *Profit* buttons to indicate markup is to earmark a designated line item specifically for that purpose, not on an expense-by-expense basis, but for the aggregate of all billed expenses. There is such a line item located directly under the Summary of Fees section on the face of a Job Estimate, Job Confirmation, or Invoice/License of Rights. This line item represents a flat-rate percentage applied across the board to all of your itemized, billed expenses, as illustrated here.[5]

Summary of Fees		INCLUDE TAX FOR OUT OF STATE ○
		EXCLUDE TAX ON FEES & SERVICES ○
Creative Fees		
Travel Fee	, Days @ ,	Per Day
Postponement	, Days @ ,	Per Day
Production Fees		
Mark-up 17 %		389.30
	T O T A L F E E S $	389.30

When using the *Profit* buttons, PhotoByte needs to know your *rate* of profit to mark up expenses. But you only have to enter that figure once (or whenever you decide to change it) in the Preferences > General Company Info screen the first time you "boot up" the software, as you did in part 2.

A percentage of profit is calculated by multiplying each line item by the figure you entered in Preferences. This figure should be chosen after consulting with your accountant or financial planner, as

directed in part 3, to make sure that your aggregate profit returns enough cash to your company to sustain its operations annually.

By clicking the *Profit* button adjacent to either the Production Crew section on Worksheet 1 or the Location and Travel section on Worksheet 2, you can change the markup percentage for each one.

Production Crew		Days	Rate	Hours	Rate	Amount	Profit
1	Assistant	3	$280.00			840.00	
2							
3							
4	Production Coordinator	George Lucas	2	$475.00		950.00	
5	Prop Stylist						
6	Wardrobe Stylist	Giorgio Armani	1	$500.00		500.00	
7	Make-up Stylist						
8	Hair Stylist						
9	Location Scout						
10							
11							
12							
13							
14							
15							
16							
17							
18							

EXCLUDE TAX ON ASSISTANTS AND CREW ○ S U B T O T A L **$** 2,290.00

Marked up or not, *every cost must be itemized as an expense and billed to the client.*

Getting a Late Start with Markups

If you have been shooting professionally for a while and have not been marking up your billed expenses all along, and if you are afraid you might alienate your clients by starting now, there is a way to increase the likelihood that they will accept the practice gracefully. It involves a little benign subterfuge.

You can adjust your assignment fee *down* for the time being! Although it will be a lesser figure, it will be offset by marking up your expenses. The bottom line prices on all your invoices will stay roughly the same. Eventually, your clients will get used to the idea of markups, just as they are already used to marking up expenses to their own clients. As your reputation grows, you can gradually raise your assignment fee.

Taxes

Finally, of course, the government takes a piece of the action.

All but five of the fifty states collect either a sales tax or a use tax (or both) for any commercial transaction involving an "end user." The end user always pays the tax. But it is *your* responsibility to collect it on behalf of the government. That's why you bill sales tax on invoices.

note An end user is the party that receives the product or service you have sold and does not pass it along (i.e., does not "resell" it) to a third party.

Sales tax is normally billed only to clients whose businesses are situated in your own state and to clients to whom tangible goods have been delivered within your state. But the rules and regulations regarding what is taxable and what is not are often hard to understand. They also vary from state to state. Sometimes they seem arbitrary and open to dubious interpretations, depending upon which bureaucrat you ask for an opinion on any given day.

Some states demand that sales and use taxes be billed as a percentage of your total invoice price, including each and every one of your billed expenses plus all of your fees. However, some states require a tax on only one total or the other (i.e., either total fees or total expenses, but not both). Some states make a distinction that excludes tax on expensed costs for hiring independent contractors, such as the re-billing of an assistant's or stylist's fee on your invoice. Other states exclude all "services" from being taxed, relying solely on revenue from the sale of tangible goods, where physical property changes hands. The issue of transferring intangible intellectual property rights has, therefore, opened up a few cans of worms. So has the issue of transacting commerce over the Internet. Therefore, for your own protection, it remains imperative that you consult an attorney or CPA to obtain a clarification of the rules in your own state.

The penalties for failing to collect sales taxes from your customers, whether accidentally or intentionally, can bode serious financial consequences. So make absolutely certain that you follow the experts' advice to the letter, and document everything you do to the point of being obsessive. Always be prepared to be audited by your state government's board of examiners.

note Refer to chapter 38 in part 7, Operations, for detailed information about collecting and remitting state taxes on your invoices.

How to Apply Sales Tax

Whether or not you will include sales tax on an invoice depends upon the ordinances of the state,

county, and municipality in which your business is located. Separate cities or counties within any given state may impose different rates. Sometimes they must be added together to obtain the final rate of sales tax to bill your clients. In other words, your state may impose a 6-percent sales tax, and your county an additional ½ percent, while your municipal government demands another ½ percent. Added together, you have a sales tax rate of 7 percent. An adjacent county may likely impose a higher or lower rate.

If you live in a non–sales-tax state, you probably already know it, or else your accountant will tell you. Your accountant will also inform you about what rate of sales tax, if any, applies to your specific location. If he cannot provide that information, call your state sales tax office. They are bound to have a branch in your county. If you can't find it in the telephone book, look on the World Wide Web using any search engine (e.g., Google, Yahoo!) by entering the name of your state and county.[6]

Nontaxable Invoices

If your clients are not end users, you may not be required to bill any sales tax at all; they will bill it to their own clients instead. Basically, the last guy in line is left holding the bag. For example, if you do a shoot for an ad agency, the agency is not the end user, so long as it represents a manufacturer who is ultimately responsible for publishing a product advertisement. Therefore, the manufacturer is the end user and must pay the sales tax.

If any of your clients wish to legitimately avoid paying sales tax, they must provide you with their reseller's permit number on a signed certificate *before* the tax is added onto your invoice. It is your responsibility to keep that document on file in your office and submit it to the state sales-tax authority in case of an audit.[7]

To your clients, you are a vendor. You have no choice but to charge sales tax, unless they present you with proof that they are resellers, or unless you are based in a non-sales-tax state.

If you cannot provide proof that your non-taxpaying customers are legitimate resellers, not tax evaders, the government may force *you*—not necessarily your clients—to pay the tax, plus any applicable penalties and fines. You are therefore obliged to collect a resale document from each and every client

who refuses to pay sales tax. Find out before you shoot the assignment and bill it.

There are other exceptions to sales and use tax:

> ‣ Nonprofit clients
> ‣ Non-taxable labor
> ‣ U.S. Government
> ‣ Foreign Sales

note Make sure you retain proof of delivery for any tangible goods sent out-of-state (e.g., a Federal Express air bill), because even if you live in California and your client is based in Michigan, that delivery of prints he accepted from you personally in San Francisco obliges you to bill sales tax. You will be held responsible for paying it. It's up to you to prove that your client didn't accept delivery locally.

EXERCISE ------------------------------

Applying Sales Tax

You'll be pleased to know that the process of including—or knowing when *not* to include—sales and use taxes on your invoices, as well as submitting statements to the government (see chapter 38, part 7, Operations), is automated by PhotoByte.

> ‣ First, make sure that you have already entered the appropriate sales-tax rate into the PhotoByte Preferences > General screen.

Don't forget to total any separate state, county, and municipal rates. The total percentage rate applies only to the location of your business, not the location(s) of your client(s).

PhotoByte will automatically skip the inclusion of sales tax on an invoice if it sees a reseller's number entered in its corresponding field on a client's Profile screen, as illustrated below.

If the *Sales Tax/Resale#* field is left blank, sales tax will automatically be included on any invoice addressed to the party corresponding to that Profile

screen—*unless that party is located in a state other than your own.* If the party is based out-of-state, no sales tax will be billed. If your client has a reseller's permit number entered in the Profile screen, that number will appear on the sales-tax line of your invoice in lieu of sales tax.

Subtotal Expenses And Fees			7,390.52
Sales Tax	AR SR 3564-1700	Resale	
Grand Total			7,390.52
Cash Advance Received			
		B A L A N C E $	7,390.52

THIS INVOICE/LICENSE OF RIGHTS IS SUBJECT TO ALL TERMS AND CONDITIONS ON THIS AND THE REVERSE SIDE.

- - - - - - - - - - - - - - - - - - -

The Components of a Price

Considering all of the different kinds of fees, expenses, markups, and taxes, the criteria for pricing break down like this:

WHAT YOU BILL	COMPONENT FACTORS
Assignment Fee =	Reputation
Usage Fee =	Duration + Frequency + Prevalence + Size + Exclusivity
Markup =	Costs × Markup Percent
Creative Fees =	Assignment Fee + Usage Fee + ([Overhead ÷ Number of Jobs] ÷ 2)
Production Fees =	Complexity + [(Overhead ÷ Number of Jobs) ÷ 2]
Expenses =	Total Cost + Markup
Tax =	(Creative Fees + Production Fees + Expenses + Markup) × Government Percent
Total Price =	Creative Fees + Production Fees + Expenses + Markup + Tax

note The administrative costs of doing business (overhead) influence both creative fees and production fees, as illustrated in the chart above. Overhead is never billed as a separate line item. It is integrated into your profit margin.

- - - - - - - - - - - - - - - - - - -

A Smorgasbord of Fees

❭ Creative Fees

Based on Experience and Reputation
- Assignment fee
- Camera fee
- Commercial fee
- Creative fee
- Day rate
- Editorial fee
- Photography fee
- Shooting fee

Usually, only one of the eight examples above is billed on a single invoice. They are all synonyms.
- Experimental fee—shooting on spec with a guaranteed minimum payment; usage is not yet determined
- Reshoot fee—the client goofed and wants another try

Based on Licensing Copyrights (Usage)
- Copyright fee
- Licensing fee
- Main illustration fee
- Publication fee
- Reproduction fee
- Stock photo licensing fee
- Usage fee

Usually, only one of the seven examples above is billed on a single invoice.
- Additional usage fee
- Secondary illustration fee

❭ Production Fees

Based on Time Devoted to Rendering Non-Camera Services
- Bidding fee
- Casting fee
- Client cancellation fee
- Client postponement fee
- Consultation fee
- Holding fee
- Late fee
- Lighting and prop setup fee
- Lighting and prop strike fee
- Location scout fee
- Post-production fee
- Pre-production fee
- Research fee
- Travel fee
- Weather postponement fee

> ▸ Markup Fees
> *Based on Costs Paid by Photographer and Re-billed to Client as Expenses*
> • Markup fee billed overall as a separate line item
> • Markup integrated into each billed expense
> *Usually, only one or the other is billed on a single invoice.*

note **Expenses and taxes (where applicable) are not fees, although they are included in the price of the invoice.**

NOTES

2 Using PhotoByte software will help you develop clear and consistent communications with the people who buy your work.

3 It is not marked up, however, because there was no cash outlay on your part.

4 Some magazines offer a so-called flat "day rate" (synony-mous with "assignment fee") plus expenses. But you are expected to bill a single fee that, in effect, covers both the assignment and usage fees lumped together. The principle remains the same, however, as billing two separate fees, because the day rate is merely a guaranteed minimum payment for a correspondingly minimal use of whatever photos you produce. Additional usage rights may still apply if more than the minimum publication option is exercised. This practice is explained in detail later in this part.

5 In PhotoByte, the flat-rate mark-up percentage applies to all billed expenses except film, for which a mark-up rate is specified separately in the Preferences section, as indicated in Part 2 in the exercise How to Enter Data in PhotoByte.

6 Most of the fifty states have a Web site address (URL) that includes its name or abbreviation followed by *.gov* (e.g., www.*alaska.gov* or *www.ak.gov*). Don't forget that some cities impose a separate sales tax to be applied in addition to the state sales tax. However, there is usually no separate return to fill out.

7 As a convenient service for your clients, PhotoByte creates blank certificates on demand for them to sign and leave with you. See chapter 38 in Part 7, Operations.

30

Competitive
Pricing

Although price is seldom the only factor considered in hiring a photographer, it always plays a role in determining where and when you pop up on a buyer's radar screen. If publishers are looking for the highest quality, they're not likely to start out by looking for the lowest prices. Therefore, up to a point, the higher the prices you charge, the greater will be the perception of the quality of your work.

Still, some buyers are influenced by low prices more than others. (Please note, however, that this kind of consideration is based on *overall* price, not just your assignment fee, or day rate.) Some buyers might not be sophisticated enough to realize the difference between a great shot and merely a good one, so quality is less of a factor. However, even with top-echelon buyers, when all other things are equal (i.e., photographic talent, studio facilities, personality—your caterer!—whatever), price can indeed become the deciding factor.

In spite of making your initial "sales pitch" on the combined proposition of professionalism, talent, and even high-priced exclusivity, you still have to come up with a figure that doesn't knock you out of the running. For example, are you priced lower than what the market is used to paying (as if you're just trying to break in to the business), or is your price right on the money? Are you pushing the envelope to see how much the market will bear, raising your prices to attract a more exclusive, but smaller clientele who expect to pay more for topmost talent?

Before you can develop a pricing strategy in step with your marketing plan, you must find a comfortable niche for yourself amongst your competitors, a place where you want your customers to look and expect to find you. Your goal should be to stake out a "position." Do you want to set up shop between JC Penny and Wal-Mart, or would you rather be Neiman Marcus? Are you a Spago, or just another Jack-in-the-Box franchise?

The Five Factors of Competitive Pricing

Careful consideration of the following five factors will help you find your spot in the marketplace. You must learn to maximize your:

- Competitive advantage
- Market penetration
- Market share
- Volume of business
- Profitability

Maximize Your Competitive Advantage

There are two kinds of competitive advantage to achieve in the marketplace:

> Temporary
> Sustainable

Only a temporary advantage can be achieved through pricing. In other words, lowering your price below market standards just to beat out the competition can only give you a short-term edge on the competition. It will be unsustainable. You still have to be profitable in the long run or face the possibility of going out of business.

The idea of gaining an advantage by lowering prices, even temporarily, can also lure you into the dangerous trap of "lowballing." That practice may help you land a few jobs in the short run, but with the undesirable long-term effect of holding fees at the level to which you lowered them. There is little chance of raising them back up again. (Lowballing is detailed in chapter 31.)

A sustainable competitive advantage can be achieved only by carefully exercising a combination of talent, professionalism, and marketing skills. To think that you can launch yourself successfully into the market by charging less money than everyone else is naïve; you'll simply make less money than everyone else. Few people will hire you—surely not those whom you *want* to hire you—solely on the basis of being the cheapest photographer in town.

Maximize Your Penetration of the Market

Penetration is determined by how fast you can accumulate a set of prospective clients and convert them into *paying customers*. One-time customers don't count; eventually, that well runs dry. A real customer is one who will help sustain your business with subsequent jobs on a continual basis. Penetration is achieved by winning over customers with the marketing techniques you learned in part 4.

Market penetration is best pictured as a graph, the slope of a line representing the number of buyers measured against time. The steeper the slope of the line, the better your penetration. The critical question is: If you can achieve maximum penetration quickly enough by pricing yourself lower than the competition *and still remain profitable* for the time being, can you raise your prices later on and retain whatever market share you might have gained? You may not be able to answer that question until you try it. But knowing your rate of market penetration will give you an idea of how much time you have to break into the market before you start running out of cash. If you can't sustain profitability where there is no barrier for other photographers to enter the marketplace (there isn't), then it is impossible to retain market share, and your customers will go away looking for yet another cheap photographer.

Since most start-up businesses are not likely to generate revenue and profits right out of the gate, the amount of capital funds you have on hand at the outset is also a factor in maximizing market penetration. It will take you a while to generate cash-flow momentum. This is the time during which many vulnerable new businesses tend to go south, when there isn't enough money to reach critical mass, to keep going until there are enough customers to sustain a cash flow. (Refer to part 3, Starting a Photo Business.) That's why simply lowering prices won't help you to penetrate the market; it's impossible to sustain operations for very long without sufficient cash flow from revenue. Lowering prices *temporarily* may help you achieve penetration more quickly, but only if you have a war chest to start out with and you can trust your clients not to feel uncomfortable when you raise prices to a more realistic level.

Ask a CPA or a financial planner for help in creating your own market-penetration graph. A session or two with a professional photo-marketing consultant might be useful, too.

Maximize Your Share of the Market

Market share is represented as a percentage of the total number of available assignments awarded to you instead of your competitors. It represents your share of the pie. This percentage fluctuates continually and, therefore, is expressed as a snapshot in time, e.g., "a 35 percent market share for the first quarter of fiscal year 2001."

Normally, this percentage of market share refers to what is called the *served market* or *eligible market*. The served market is focused exclusively on buyers who are predisposed to want what you have to offer. That puts the odds in your favor. In principle, if you are a landscape photographer, you will not compete for market share with those who specialize in shooting portraits.

Obviously, there are markets within markets. These are called specialties and subspecialties. The narrower the focus of your market, the fewer your competitors, and the better your chances will be to maximize market share and increase your profitability. If there are lots of portrait photographers and fewer landscape photographers, you can charge more.

Be as focused as you can in defining what segment of the market you will try to conquer. Don't try to tackle portraiture, sports, underwater, and tabletop all at the same time; you'll have a harder time making yourself stand out in a crowd. That advice overlaps with marketing issues, of course. But insofar as pricing is concerned, you'll want to stake your ground in territory that's not too crowded, because by specializing in a subject matter and style for which there is little competition and great demand, you can name your own price. It is not impossible, however, to make a reputation as a "generalist." That is the kind of marketing decision you will arrive at after creating a marketing plan, as described in part 4.

As an alternative to the served market, you can look at what is called *total* market share. It's less interesting, though, because it doesn't help you to decide how to target your precious marketing dollars at a specific kind of clientele. Total market share doesn't point to buyers who are predisposed to want the kinds of pictures you most want to shoot. Instead of zeroing in on the fashion media, for instance, you would calculate a share based on the market for *all* kinds of pictures. That's not very realistic for a fashion photographer. There's too much competition.

It must be understood that any one of a number of specific markets might become saturated with pictures when there are too many photographers shooting the same subject matter. This is especially true if you plan to maintain a stock photo archive. If there is a glut of pictures of the Golden Gate Bridge, to use perhaps too obvious an example, their value will decrease as market demand goes down. If the price that the market is willing to pay falls below a level that will sustain your profitability, your only choice is to exit the market for pictures of the Golden Gate Bridge and concentrate on shooting something else.

Maximize Your Volume of Business

If your price point is just low enough to attract new clients, you will increase bookings. But if you lower it too much, you run the risk of critically lowering your revenue to a point where profitability is unsustainable. To get around that problem, it is necessary to shoot more assignments. All things considered, the more you shoot, the less you have to charge to make the same amount of money.

And the more you shoot, the more costs there are to mark up, and the more profit you can make. So it follows that with increased bookings, you can mark up billed expenses at a lower percentage rate and still make just as much—or even more—profit. That technique is called lowering your *profit margin*. For example, if you are billing 10 percent more jobs, your business can earn just as much profit by marking up costs, say, 30 percent instead of at a previous rate of 40 percent. That will lower your prices and raise your salary at the same time, because assignment fees are unaffected by lowering margin. If you shoot 10 percent more assignments, you collect 10 percent more take-home pay. That's like giving yourself a raise. You can't do that by simply cutting prices across the board.

Incidentally, if you can shoot fewer jobs at a very high profit margin without worrying about encroachment by your competition, more power to you! There are always exceptions.

Maximize Your Profit

Even without increasing the volume of your business and cutting margins, there is another way to increase profits. You can cut your prices by cutting your fixed overhead. Shooting assignments that cost less to produce allows you to increase profits without raising prices. In other words, just because you've found a cheaper source for film and supplies, or you pay less for a new stylist or assistant, doesn't mean you have to charge less than before. You may continue to bill your expenses at the same rate you have all along. That will increase your gross profit. Enjoy the savings!

There is another strategy that may work to your advantage. If you can trim your overhead, you can pass the savings on to your clients. That will lower your prices without decreasing either your profit margin or your creative fees. The difference might be just enough to stimulate new business. Put

another way, if two shooters bid for the same job, there's no reason why their fees can't be close together, if not the same. But the one who has lower costs, the one who can shoot the job for less money, can also bill less and will probably be awarded the assignment on the basis of a lower-priced estimate. The best news is that, in spite of undercutting his colleague, best practices will not have been compromised, because he'll still be earning a legitimate profit. That's the smart way to compete.

Still another alternative, or one to use in combination with lowering your profit margin, is to lower your assignment fee. If you're shooting more, it won't reduce your overall take-home pay. But if it turns out that the volume of your work has not increased, make sure your *personal* overhead requirements can sustain the reduction (e.g., Do you need to drive a Porsche, or will a Chevy suffice? Will your vacation be limited to two weeks this year instead of a month?).

Cutting Nonessential Services

The previous examples apply to cutting costs on services and supplies that you cannot do without. But you can minimize your costs and lower your prices by eliminating nonessential overhead entirely, especially if both your market research and your gut instincts tell you to target only budget-conscious buyers, e.g., small-town ad agencies and regional magazines instead of the big Madison Avenue media moguls. If you lease a studio, but find that most of your assignments are on location, get rid of the studio. If you don't require a full-time assistant, use freelancers. There's no sense in paying for megawatt-seconds of strobe lights, grip equipment, and sheet-film cameras if you only shoot news stories. Why have a darkroom if you seldom use it? Tailor the services you provide specifically to the clientele you serve.

A Balancing Act

Making sure the price is right requires continual tinkering and experimentation. As you gain experience, you'll become adept at fine-tuning a bottom line that looks like a bargain to the buyer, but is no less profitable for you. You must also search for equilibrium between price and the quality of your services. For instance, if you increase volume too much by shooting too many assignments, the quality of your work may suffer. So learn to recognize your own capacity to perform well. If you spread yourself too thin, no one will hire you at any price.

Don't base your pricing policy on any one factor. Always consider the five competitive factors as a whole. It will be easier to hold your ground against fierce pressure from other photographers and the leverage of a buyers' market. And finally, it cannot be overemphasized that keeping your prices as low as possible does not mean lowering your salary.

The Relationship of Trade Practices to Maximizing Prices

Publishers and buyers do not conspire to impose practices such as demanding receipts for film and setting arbitrary day rates. Photographers keep punching holes in the bottoms of their own boats by either tacitly accepting such practices or simply by persevering in the false belief that they can survive without understanding the principles of profitability. The publishing industry cannot impose guidelines for photographers unless you acquiesce. On the other hand, photographers *can* impose guidelines on the publishing industry if enough of you simply use them. Your clients play by the rules of capitalism. Will you?

Net Profit

At this point, it is appropriate to include a more academic definition of profit.

Profit is a percentage of gross revenues. Gross revenues are revenues from all of your sales, including all the money your business collects from assignments, stock photo licensing, royalties from publishers and agencies, even simply renting your studio to another photographer or selling a used camera. So the highest level formula looks like this:

Gross Revenue – Direct Costs = Gross Margin

Of course, the Direct Costs in that formula include your assignment fees—your salary. The next step in the calculation is to subtract Indirect Costs,[8] or overhead. Now the formula looks like this:

Gross Margin – Indirect Costs = Gross Profit

Finally, you must subtract the taxes and interest you have to pay:

$$Gross\ Profit - (Interest + Taxes) = Net\ Profit$$

Net Profit (also called *net earnings, net income,* or *bottom line*) is the figure you are truly looking for. And there it is—also called the Holy Grail.

EXERCISE -------------------------------

Reporting Gross Profitability of Jobs by Category

PhotoByte lets you automatically assign a category to all assignments and stock photo sales. It indicates the type of buyer, either in a general sense (i.e., corporate, editorial, or advertising) or, more specifically, by the nature of the subject matter (i.e., aerial, annual report, architecture, fashion, food, manufacturing, public relations, sports, still life, travel, etc.). If you are shooting for more than one particular type of media clientele, it is useful to know which is the most profitable and which provides the greatest revenue (not necessarily the same thing). You might want to limit your marketing message to only those that are most profitable, or extend it to those that are less so, trying to increase assignments from that sector of the market. This report will show you that kind of information.

> From the Main Menu in PhotoByte, click the *Sales Reports* button.

> Click the % *Profitability* button next.
> Select the year 2000 to report from the pop-up menu field, then click *Continue*.

As illustrated below, PhotoByte "knows" how to report this information because of data you entered in the *Client Type* field on the Profile screen when you first entered a new contact.

Profitability		
		September 22, 2001

Report by Type of Assignment

Gross Sales / Profits		Percent of Gross Margin
2000 TOTAL NUMBER of INVOICED ASSIGNMENTS: 18		
Advertising $19,760.53 / $9,083.08	Profit % Occurrence 2 Jobs	9%
Corporate $112,907.45 / $62,532.54	Profit % Occurrence 9 Jobs	61%
Editorial $39,270.66 / $20,596.00	Profit % Occurrence 3 Jobs	20%
Government $5,321.75 / $4,388.00	Profit % Occurrence 1 Jobs	4%
No ShootSheet $12,053.32 / $5,759.38	Profit % Occurrence 3 Jobs	6%

NOTE

8 Examples of indirect costs include: rent, electric, office supplies, telephone, salaries and benefits, interest, travel, entertainment, advertising, legal and accounting, licenses and permits, dues and subscriptions, maintenance and repairs, postage, insurance, and credit card services.

31

Giving Clients
Their Money's
Worth

The marketplace mirrors the competitiveness of human behavior. Sellers demand the highest prices they can get, while buyers try to keep their costs down. Everyone is looking for the best deal. The parties negotiate to agree on a price, which may sometimes be reached by compromise.

Each one of us has sat on one side of the bargaining table or the other, at one time or another. Generally speaking, each one of us hopes to be better off as the result of any given transaction, whether we are the buyer or the seller. That's the nature of commerce, as well as human nature. In fact, the best deals are those in which all parties find themselves better off.

Even a trip to the grocery store results, typically, in a deal that's good for two parties: You are better off, having exchanged money for food that will sustain your health, and the store makes a profit. If you buy a new cellular telephone, you increase your capability to communicate. If you buy a new pair of eyeglasses, you can see better. If you buy a new suit of clothes, you look and feel better. If someone purchases the right to use your photo, either by direct assignment or as a stock photo, they hope it will: (1) help to increase the sales of their services or merchandise through print advertisements and public

relations literature, or (2) sell magazines by using your photo to add value to editorial content, thereby adding value to their readers' lives, and so on. Everybody is supposed to make a profit of one sort or another along the way. That's how the economy works. But some of us sometimes feel an overwhelming urge to *win*, and all too often, winning implies that there must be a loser. That's not really necessary.

While there is nothing wrong with trying to squeeze as much value or as much use as possible out of everything we pay for, remember that your customers feel the same way when they come to you for a photograph. They want their money's worth, too. Sometimes we bump heads if it seems like someone is trying to take an unfair advantage in negotiations, or trying to get something for nothing.

Some buyers earnestly believe that they are merely trying to get a fair deal. Unfortunately, "fair" sometimes means protecting the interests of their corporate shareholders at your expense. Be vigilant. Don't let your guard down. They will push and prod and probe the boundaries of fairness, and sometimes cross the line. But that's the nature of business. It's an economic competition. You must expect that some participants will declare war. If you are

prepared, not only can you fend off defeat, you can declare victory simply by being profitable.

Coping with Costs: The Worksheets

You cannot determine a price until you know, first, how much it will cost you to shoot an assignment.

PhotoByte will take the uncertainty and fear out of the estimating and billing processes. It will remind you what to bill for. It will look up the costs of repeatedly billed items and enter them automatically when you create new Worksheets (see part 7, Operations).

The Worksheets in PhotoByte resemble a production report. In fact, they actually serve in that capacity. They represent a list of all the possibilities to consider when planning and pricing a photo assignment. Not only will they help to ensure that the job is priced right, but they serve as a backup, a demonstration of costs that explains your price to the buyer. The Worksheets are the first forms you'll see on screen when it's time to create a new Job Estimate, Job Confirmation, or Invoice/License of Rights.

There are two pages of Worksheets to look at. By scrutinizing the default list of line item expenses that appear on the Worksheets and selecting only those items that you intend to bill, you won't forget anything. You may also edit these lists to either include items that are particularly important to you or to exclude some items that are never billed in your practice. The best news is that you only need to enter data once for any job (unless you wish to make changes, of course). By filling in the Worksheets for an Job Estimate, for example, the corresponding Worksheets for a subsequent Job Confirmation, followed by an Invoice/License of Rights, are done automatically.

All documents are linked together seamlessly. The whole process of estimating an assignment takes minutes instead of hours. And you don't have to remember how you did it the last time, which might tend to increase the likelihood of agonized procrastination. When you are ready to create a final invoice, all you have to do is click a button that says either *Convert to Invoice, Invoice This,* or *Invoice Job* (depending on which type of document it is) and—

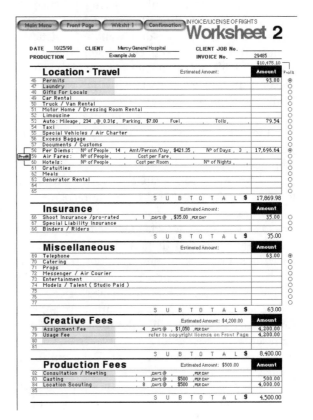

voila!—it's finished. The appropriate button will always appear on screen, just where you would expect it to be, to prompt you.

Further along in this part you will find information and exercises to help you determine how much to bill for the services you perform *in addition* to expensing your production costs. You do have to make that determination yourself, because neither the software nor this text can guess what your actual overhead is or how much profit you wish to earn.

note Clicking with your mouse on a line item will display a pop-up list of additional expense choices. Selecting any item in the list automatically types it on the corresponding line.

Lowballing

Charging lower prices and still making a profit, because it doesn't cost you as much as it costs someone else to do the same job, is called good, old-fashioned competition. Billing an assignment for less than it costs to produce, however, is called *lowballing*.

Lowballing is an unfair pricing practice. It means hitting below the belt, taking jobs away from other photographers by radically and unrealistically undercutting the market. The photographer who lowballs a job has a corrupt idea of what it means to be competitive. He will try to win a job at all costs. While there's nothing inherently wrong with that as a figure of speech, the lowballer makes it literal. Whether he has his way or simply forces his competitors to match his price, someone will win the job, indeed, *at all costs*. What could have been profit for the "winning" photographer is, instead, forfeited to the client. It is a gift that will go unrecognized.

The long-term consequences of lowballing have less to do with one photographer's self-inflicted misfortune than with their impact on the whole industry. When one foolish photographer forfeits his profit, the loss is felt for a long time afterward by everyone else, because the lowballed price sets a precedent. Such precedents are cumulative and can cause prices to tumble like dominos. Lowballing represents a perverted idea of market freedom, one that is selfish and short-sighted. That's putting it politely; it's stupid.

Ultimately, market prices will fall below sustainable levels of profitability for even the most business-savvy photographers, as they become obliged to compete with each other for increasingly lower-priced assignments. It's hard to reverse that kind of momentum, because once buyers see prices drop, they will fight to keep them down. That fact will come back to haunt the culprits who have kept the lowball rolling downhill. Sooner or later, they, too, will find it impossible to stay in businesses. They will fail, taking other, more scrupulous shooters over the cliff with them. It is delusional to believe that you can undercut jobs for any reason whatsoever and survive. The lowballer destroys the marketplace, in effect demanding that everyone else share the cost of his foolhardy behavior. That is an ethical issue.

The Issue of the "Free" Portfolio Piece

It is just as unethical—let alone unwise—to shoot an assignment solely to recover your "out-of-pocket" costs with the intention of creating a slick, new portfolio piece. That, too, is lowballing, assuming the resulting photo(s) are used commercially by the client.

Don't kid yourself; that portfolio piece is not free. But as far as the client is concerned, you are! Any unprofitable job sets a bad precedent and jeopardizes your future financial success. There is no rationale for lowballing whatsoever. It is a deplorable practice.

Understanding Buyers' Prerogatives

Often, a buyer will come to you with a tight budget. But just as often, that budget will have been derived by no more scientific or fiscally prudent a method than to hold one finger up to the wind. You might be—as many photographers often are—offered a fee that has nothing to do with the reality of how the photos will be used, but only with how much money they care to spend. That's not indicative of a tight budget; that simply represents a buyer who doesn't understand how the photo business works.

It may be argued that photographers put themselves at a disadvantage when they force potential buyers to work harder by making them wrestle with realistic budgets based on actual needs versus capital resources. On the contrary, those are the kinds of photographers who turn potential buyers into paying customers. Buyers who don't put some thought

into purchasing photography make bad customers; they seldom turn into repeat customers.

A smaller budget can often be accommodated by scrutinizing the requirements of the shoot and eliminating nonessential production costs. You can limit the buyer's usage rights, too, granting only those rights that are both necessary and sufficient (as described under Billing in Increments of Value in chapter 28 earlier in this part). Additional rights may always be purchased later. That way, at least, you can proceed with the assignment without losing the opportunity. Besides, why cave in to a buyer's first offer? There are ways to deal fairly with a budget that is tight for legitimate reasons, when the buyer's needs seem to cost more than the money he has to spend.

When the alternative to a bad booking is to turn it down and be paid nothing at all, it's hard to understand the worse consequence of not being paid *enough*. But sometimes nothing is better than being forced to accept something less-than-profitable. When buyers demand too many usage rights, but don't have a budget big enough to satisfy their appetites, either just say "No!" or point to your copyright-licensing yardstick and suggest a smaller, but more adequate portion for a lesser fee. They will usually see the logic in this approach and come back with either a bigger budget or lesser, more reasonable demands. At the very least, this will create a starting point for earnest negotiations. But if they really can't afford to hire you, it's not wise to lower your standards just to avoid losing the job. If you lower your standards, you will find it nearly impossible to raise them again. You've been marked.

EXERCISE

Negotiating Usage Rights

This exercise involves another role-playing scenario. With a partner acting as your client, discuss the budget for a job using the criteria described in the copyright license created with the Copyright Composer. (You may refer to a license created in a previous exercise or create a new one.)

The client says that he does not have a budget big enough to pay for every use the license demands. Try saying "no" to the client's first offer. Then, ask him to be more specific about his company's needs. Maybe he doesn't need all the rights originally requested. Suggest some ways to lower your usage fee without hampering his goals.

Buyouts and Unlimited Rights Agreements

If you fly out-of-town for business, it doesn't make much sense to buy a new car when you reach your destination. You'll rent one instead. The rental car company will have you sign a contract whereby you agree to pay for using their car at a rate based on how long and where you intend to drive it. And a Cadillac will cost more than a Chevrolet. The *licensor* (the company that owns the car and offers it for rent) will not relinquish its ownership to you, the *licensee*. You will simply pay for the right to use their property for a specified length of time.

That illustrates the difference between a license and a buyout. Nevertheless, the term "buyout" can mean a dozen different things to a dozen different people. It has no recognized legal definition whatsoever, and frankly, if it can't be eliminated altogether from the vocabulary of the photo marketplace, it is preferable to keep its meaning vague. Keep your licensing language specific instead. Still, the term is very much in use, so it merits discussion.

Some people believe that a buyout applies to an entire shoot, to every exposed frame of film, including outtakes. Others think it applies to just a single image, the one that was actually published. There are also some people who believe that buyouts last in perpetuity, while others subscribe to the belief that it lasts for only a limited time. Still others think it means the absolute transfer off all publication rights, including copyright, and so they demand physical possession of the exposed film. But generally speaking, most publishers think that a buyout means exclusive ownership of all the rights to your images—including physical possession of the original transparencies or negatives—for the price they paid on your invoice. Effectively, they are demanding that you give up your copyright for a ridiculous and paltry fee.

Buyouts and Bullies

The demand for a buyout is often a bullying tactic. The buyer is too lazy to determine his specific needs,

so he insists on the whole ball of wax for one low price, an all-or-nothing-at-all approach. But no matter what fee you might be offered for a buyout, even if you hold on to the copyright, you will lose control over the use of your photos and receive no further financial compensation for their continued use and publication. All you can do is claim authorship, maintaining the right to display them in your portfolio. You can derive no further income from licensing those images.

Instead of capitulating to an absolute buyout, you might offer your client a "buyout in the State of Rhode Island exclusively," if the company does business in that state alone. Or how about an exclusive license for all rights, but lasting for only six months (after which they revert back to you)? Alternatively, might they consider an "all-rights buyout in the Portuguese language?" And so on . . .

Always ask buyers what their exact needs are. After a little bit of friendly coaxing, it can usually be determined that their needs are not so broad and comprehensive after all. Give your clients some alternative suggestions for limited rights purchases. Explain that, if they want to buy an entire steer, it will cost more than the price of a couple of T-bone steaks. Do they need to feed an army or just put dinner for two on the table? Once you have the answers to some simple questions, you can quote an appropriate and reasonable fee for just what the client needs, not necessarily what they *ask* for right out of the gate.

Sometimes, however, it is reasonable for you to consider selling "unlimited rights" for use in all media. But that does not mean you have to relinquish your ownership and copyright, not even to grant such broad leeway to the buyer. A buyout might be justified, for example, for the publication of photos of a specific brand of dog food for an ad campaign; there would be little or no possibility of future sales to other clients. But if you intend to grant unlimited usage rights, make sure the price is right!

Reasons Cited for Buyouts

Any one of dozens of reasons may be invoked when a client demands a buyout. A common reason, but a fallacious one, is that the client should own the pictures because the assignment was his idea in the first place. But you have already learned that owner-ship rests with the creator of the tangible work, that only the material expression of an idea—turning it into a photograph—is copyrightable, not the idea itself. He is simply not legally entitled to ownership of the photos.

Your clients want their businesses to prosper just as much as you do. They may operate on a bigger scale, but they just want to allow their employees to earn a decent living and their shareholders to make a reasonable return on their investments. Their goals are basically the same as your own. So what else are they after? What are their real needs, photographically?

Protecting the Client's Corporate Prerogatives

Your clients have invested a tremendous amount of money in branding their corporate and product identities. In fact, the ways in which companies present themselves to the public can be construed as intellectual property, just like a photograph. They have legitimate needs to protect the value of their assets, including their corporate images. A professional photographer must be sensitive to this issue and cooperate as much as possible.

In seeking control through a buyout, clients may be trying to prevent images they commissioned from being used by their competitors, or in any other way that could be harmful to their proprietary interests. However, sometimes their attempts to control photos are unjustified.

For instance, you could be hired by a company to photograph its CEO for an annual report. Later, you might receive a request from a magazine to publish that same CEO portrait, which, you find out, will be used to illustrate a less-than-complimentary article about his leadership of the company. While this editorial use might cause some embarrassment and distress to the public relations director at the company who hired you in the first place, he should take up his issue with the magazine, not with you.

Sure, the company's PR department might try to control the "spin" on a given news story, and they might want to control the distribution of your photo in that regard. But if there was nothing embarrassing per se about the photograph itself, i.e., the subject isn't looking cross-eyed, picking his nose, or wearing a goofy tie at your request, they have no moral right to control it. They can *buy* the right to control its distribution, however.

If clients are concerned about who else might have access to pictures for publication, they should pay for exclusivity.

note Many photographers edit their film takes to exclude, and sometimes destroy, potentially embarrassing photos before submitting them to their clients.

Another reason often cited for a buyout is an objection to paying for subsequent uses of photos on an à la carte basis. Buyers sometimes argue that it is an administrative annoyance to determine the whereabouts of a photographer, negotiate a new fee, and cut a check every time they decide to use a photo, one they commissioned some time ago for an unforeseen use in the future.

These are all legitimate concerns. But you can quite easily and equitably address them. The trick is to act professionally and not to get defensive.

Contingency Licensing Fees

Consider the á la carte complaint. The buyer is thinking about commissioning you to create a photograph for an ad campaign. His company is unsure about how or even *if* they expect to run more ads in the future, beyond the initial insert in one edition of one magazine.

The campaign in question is for a new product, untried in the marketplace. The buyer doesn't know if it will catch on. However, if the product launch is more successful than anticipated, he might want to run your photo for a longer period of time and in additional magazines. He might later decide to use it on billboards and in TV commercials that were not included in your initial price. He may, at some point in the future, go national instead of just local.

Another possibility is that you and he might have agreed on the use of only one picture, but now he sees that you have created enough images in just one photo session to use throughout an entire ad campaign lasting many weeks or even years. He is dead set, however, against the prospect of having to find you and ask your permission to publish the photo(s) again and again. He doesn't like the idea of having to renegotiate a separate fee each time either. But he is unwilling to pay in advance for rights he is not sure he will need to use.

As you read in chapter 25 in part 5, it is a universally accepted trade practice that the bigger and wider the scope of use, the more money the photographer will be paid. So why should any photographer be expected to give up all possibility of earning additional revenue just because the buyer can't decide what he wants to do? The answer is: You should not give up a thing. And there is a simple solution to avoid doing so while still making your client happy.

It would be inopportune to include prices for hypothetical uses in an Job Estimate; it would inflate the bottom line. And if your price was misconstrued to be too high, you might lose the assignment. But consider the predicament of the buyer: He may not be able to afford to pay for extended and additional uses right away, at least not until his product launch has gone successfully. So one way to keep the actual costs down and still keep the buyer apprised of possible future costs for hypothetical uses is to quote such costs in a *Contingency Fee Schedule*.

This is a document that accompanies either a Job Estimate, Job Confirmation, or Invoice/License of Rights, and it will lock in prices for future uses to the buyer's satisfaction without necessitating a financial commitment in the present. It makes matters simpler for your client by precluding the need for further negotiations. He'll know what his costs are for additional usage fees up front. He'll only have to pay if and when such uses are actually executed. It isn't hard to anticipate what uses there might be. In fact, PhotoByte will give you a list on the Contingency Fee Schedule itself.

EXERCISE

Creating a Contingency Fee Schedule

> Select **List Estimates** from the Shortcuts menu.

- ‣ Select any Estimate in the ensuing list on screen.
- ‣ When the Job Estimate appears on screen in Preview mode, click the *Continue* button to enter the Browse mode.
- ‣ Click the *Contingency* button at the top of the screen.

You will see a Contingency Fee Schedule.

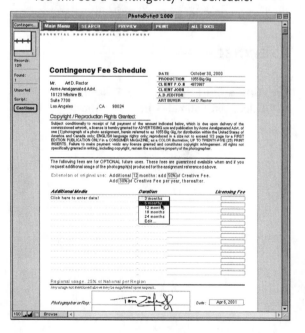

That's all there is to it. Just read it and fill in some of the records for practice.

Click the *Continue* button when you are finished to return to the Estimate you were browsing. The next time you click the *Contingency* button on that same Job Estimate, the Contingency Fee Schedule will appear with all the data you entered saved.

Confidentiality

Every company has an obligation to protect its processes, manufacturing techniques, and products in development that are scheduled for introduction sometime in the future. These are called *trade secrets.* For the time being, they may need to be kept "under wraps." But the behind-the-scenes preparations that take place before releasing a product to the public cannot be impeded. Such preparations might include photographing the soon-to-be-released product. Any unintended "sneak peeks" in a magazine or on a Web site before the targeted release date could jeopardize a marketing campaign that cost millions of dollars to produce.

Here's another example: While you're shooting, say, a corporate annual report, a drawing depicting a secret new package design, the body style of a new automobile, or an untrademarked brand name in development could appear inadvertently, but conspicuously in the background of an employee's portrait. If published, it might spill the beans to your client's competitors.

A legitimate right exists to control access to photos that might give away trade secrets. In that regard, your clients may also have strategic concerns about controlling how often or in what context photographs may be seen. Even matters of national security may necessitate keeping photos under wraps to some extent.

There is the example of a photographer shooting an enlistment campaign for the United States Navy aboard a nuclear submarine. The photos had to be screened so as not to inadvertently divulge any top-secret information. The question of secrecy was resolved without turning over the film to the Navy by discreetly placing black tape over all the dials and gauges that indicated "how far, how deep, and how fast" before the photos were even shot.

Non-Disclosure Agreements

Many companies are in tough competition with each other. Some of them even spend great sums of money to guard against industrial espionage. A photographer might seem to be a weak link in their defenses. How can you persuade them that you are not a security risk?

For one thing, you can agree to sign a *non-disclosure agreement*, or NDA. If you are asked to sign an NDA, it may include terms that restrict your rights to indiscriminately publish commissioned photos and make you liable for financial damages if you show them to other parties to whom they are forbidden.

If you sign an NDA, you are morally, ethically, and legally bound to honor it. But if it restricts your right to earn revenue, the client should be willing to compensate you financially. You should demand higher fees. This is subject to negotiation and will depend on whether or not the photos in question might otherwise have any residual value. In other words, even if they didn't contain secret information, could you realistically expect to license them as stock photos to other buyers? Perhaps a higher fee is not in order if the NDA has an expiration date, freeing you to license the photos after a certain time has elapsed.

If signing an NDA does not assuage the client's concerns about confidentiality, there are other options to avoid buyout discussions. For instance, you might agree to leave the film, the original negatives or transparencies, in the client's custody, either indefinitely or for a limited time. Again, this is subject to negotiation depending upon how long the client really needs to maintain secrecy and the degree of residual value of the photos to you.

By agreeing to leave your photos in a client's custody, you are not giving up your copyright. Physical possession, or even the transferred ownership of negatives and transparencies, is not the same as ownership of the intellectual property they represent. You learned that in part 5. If, after a given amount of time has gone by and either the exclusivity of the pictures or their secrecy is no longer relevant, the possession of all negatives and transparencies—and, perhaps, even prints, too—should revert back to the photographer. Those terms should be included in the licensing language on your Invoice.

note The Job Delivery Memo in PhotoByte will remind you to get your original material back when it is due.

Protecting Your Own Trade Secrets

If you have spent a lot of money and burned the midnight oil for many weeks to develop a new lighting technique that is difficult to duplicate, you certainly wouldn't want to let other photographers in on the secret of your success. Nonetheless, it will be nearly impossible to prevent your business associates from seeing how you do it. Many of the same assistants, stylists, and models who might have had an opportunity to witness the private and protected goings-on in your office or studio are hired by competing photographers. The same principle applies to viewing private marketing lists and other proprietary information stored in your computer or filing cabinet. It might not even be advisable to let your competitors know about a planned trip to Bora-Bora to shoot new images for the stock photo archives you plan to market to a select group of buyers. So put your associates on notice that they can be held liable for loose lips. Insist that they sign a non-disclosure agreement. They will be legally bound to treat their responsibility for discretion with the seriousness it deserves.

EXERCISE --------------------------------

Creating a Non-Disclosure Agreement
- Click the *New Documents* button on PhotoByte's Main Menu.
- Click the *Contracts & Terms* button on the New Documents screen.

▶ Click the *Non-disclosure Agreement* button.

▶ Click *Continue* to print the document.

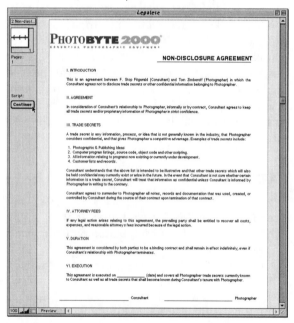

note This agreement can be customized. Go to the preferences>Legalese screen and click the Non-discloure Agreement button.

Avoiding Liability

You might find that some buyers insist on owning the copyright to your photos because they are afraid of being sued in case they accidentally damage or lose your property. They may not want that respon-

sibility because they are obliged to entrust your photos to third-party contractors on the pre-press side. But they simply must accept it. It will cost them too much to buy your copyright. Besides, they can initiate their own liability agreements with third parties.

You might explain that it is highly unlikely that you would sue, even if they did lose your original work. It would be hard to make a winning case against the party who commissioned the photos in the first place, unless there was fraud involved, e.g., the loss or destruction was premeditated and then misrepresented to you. But if you cannot convince them of your integrity, then offer to include terms in your copyright license that provide indemnification for any legitimate loss. That means they will not be held financially responsible—for assigned work only; this suggestion should never apply to stock photo submissions. (See The (Stock Photo) Delivery Memo in chapter 45, part 8, The Paper Trail.) Yes, you will be taking a risk, but it is minimal. You might consider protecting both your investment and the client's, too, by making duplicates of some of the most important images and keeping them yourself.

Dealing with Stubborn Clients

Finally, there are some companies that are absolutely adamant about owning copyright or getting a buyout. They don't even care to give you a reason; it's just "company policy." Although you may desperately want to shoot for such a company, because they might have a great art-direction staff, make sure you are fairly compensated for relinquishing your copyrights. If not, just say "no"! It's just not good for business otherwise. You *will* get burned eventually when they use your pictures again and you don't get paid. It could be at a time when you really need the money.

When Billing a Lower Fee Is Appropriate

In fairness, it must be said that there are circumstances when it is neither unethical nor self-defeating financially to accept a relatively low fee. One such circumstance might be when the pictures from an assignment will be published inconspicuously or for only a brief time. If, in the case of an advertising agency, only a tiny proportion of their overall budget is to be spent on media space, let's say a one-time, eighth-of-a-page insert in a regional magazine,

charging a low fee is probably reasonable. But surely, you must get the point by now that if an ad agency spends many hundreds of thousands of dollars to buy full-page advertising space in national magazines and major metropolitan newspapers for a twelve-month run, you should demand a commensurate usage fee. You should also expect to make a hefty profit on your production costs.

If you must, you certainly may negotiate a lower creative fee with a client. But to avoid lowballing, just remember not to go below the level that will support you and your business, taking into account all the fees you are likely to earn throughout the year on a prorated basis. As a rule of thumb, base your fee on the total amount of money the client has budgeted for media space.

Can you get by without this mumbo-jumbo and usage-rights stuff? Sure. But again, you will only survive instead of thrive, because you will have no other way to stimulate the growth of your business. It may be great one year and lousy for the next two, terrific for two years after that and tank for three more. It's a roller-coaster ride that brings sleeplessness and indigestion instead of greater wealth. In the final analysis, your clients are just trying to keep their costs down. There's nothing wrong with that per se. Just don't lie down so they can walk all over you.

32

Your
Salary

The aggregate assignment fees you earn throughout any given year should be at least equivalent to the annual salary of an employee doing the same kind of work for someone else.

Suppose you have a friend named Fred who works for a graphic design company and earns $35 per hour. Then you should be making at least that much, *plus* enough extra to cover the overhead of running your own business, *plus a* profit. Otherwise, you are making considerably less money than Fred. And don't forget that Fred has all of his health insurance and other benefits paid by his employer, too.

Because of all the time you are obliged to spend on administrative, supervisory, marketing, and menial chores that Fred doesn't have to do, you need to make *more* money than he does to have a net personal income that is roughly the same.

The extra time and money you spend on marketing and administrative duties are what make it possible for you to keep your business afloat; you must constantly seek and find new work. Nobody else is going to do it for you. The same reasoning obviously applies, even if you pay someone to do it for you; you'll require a source of additional revenue for any employees of your own. But those kinds of activities do not bring in immediate cash. Only performing photo shoots does that. Those other kinds of expenditures are represented by the indirect costs discussed earlier.

So consider that while you are trying to reel in new and better assignments and not getting paid for your time, Fred is collecting a regular paycheck. He doesn't have to worry about looking for new sources of revenue day in and day out; the company he works for pays other employees to do that kind of work. His employer also makes a profit on what those employees are paid to do. Therefore, you should be earning at least what both Fred and the other employee earn *put together*, plus some profit on top of that!

Here is an exercise to illustrate how to find a starting point for both the amount of profit your business needs and to calculate a reasonable compensation for your freelance photographic services (an assignment fee).[9] To reiterate, since many people employed at larger companies work at an hourly wage, their example will be used for the sake of comparison, even though it is recognized that photographers do not work by the clock.

EXERCISE -

Determining Your Assignment Fee

Let's make up a term called "shoot rate." There really is no such term. But for the sake of this exercise, a shoot rate is what you might charge per hour, if you could work and survive that way. It will help you arrive at a ballpark figure that measures what you earn versus other salaried professionals. It will give you a starting point to arrive at a competitive margin of profit.

▸ Take your monthly average of billed expenses[10] (costs passed along to clients plus a mark-up) and divide by 172 (4.3 weeks × 40 hours).
▸ Add your fixed monthly overhead (business-related only!), including such items as rent, insurance, automobile, telecommunications, etc., and divide by 172.
▸ Add the rate per hour that you think you would be entitled to as an employee. Use someone you know and respect as a model, someone who works for a large company. If you wish, use Fred's hypothetical $35 per hour figure.
▸ Now, estimate what you think is a reasonable percentage of profit, and add that into the equation. (Average Monthly Billed Expenses × Profit %).

The result looks like this:

Average Monthly Billed Expenses Per Hour:
$$\$7,000 \div 172 = \$40.67$$
Fixed Monthly Overhead Per Hour:
$$\$3,750 \div 172 = \$21.80$$

Comparative Hourly Wage:	$35.00
Profit on Expenses (20 percent):	$8.13
Total	$105.60

This exercise indicates that you would have to charge a hypothetical shoot rate of $105.60 per hour, assuming you could bill for a full forty hours each week. You would earn the same amount of take-home pay as your friend who makes $35 per hour at a "regular" job. (That's far less than an average attorney might earn, and only a bit closer to what a carpenter or a plumber might pull in. And it doesn't include benefits such as medical insurance or a pension.)

If you determined that you could bill only thirty hours per week, you would have to charge more per hour to earn the same amount as your friend in the example. Using the table above, that means you would have to charge $129.18 per hour (40 hours × $105.60 = $4,224 ÷ 30 = $140.80).

The term "shoot rate" is, as you recall, is a complete fabrication. It was made up to suit our exercise. Once you've figured out the math, though, you need to look at the competitive situation in your marketplace. If you find out, for instance, that another photographer has a shoot rate of $125 per hour, or maybe an even lower rate of $80 per hour, you will need to readjust your profit percentage. You must either increase or decrease your own shoot rate to arrive at a final figure that puts you in a favorable competitive situation when the buyer compares your bottom line-price to that of someone else. It is recommended that you adjust the profit percentage and not any of the other items in the equation.

But what if your bottom line goes over the top? What if lowering your profit still doesn't get your "shoot rate" down to a competitive level? That tells you at least one of the following two things:

▸ You must cut your overhead costs to the bone, because you are spending too much for wholesale materials and administrative services.
▸ Your competitors are engaged with you in a price war. One or more of them might be lowballing, and the first photographer to "chicken out" of the battle loses the client. If no one cries "Uncle!" you will probably *all* go out of business sooner or later.

note You can also figure out a hypothetical shoot rate on an annual basis by using this formula: (Annual Overhead + Desired Salary + Profit) ÷ Actual Hours Billed = Shoot Rate.

- - - - - - - - - - - - - - - - - - - -

Keeping Up a Competitive Effort

In general, you can refer to the following principles to stay competitive:

▸ Ascertain that a market exists for the kind of photographs you want to make
▸ Learn the size of the market

> Determine the market price
> Decide how much profit you need to earn on the services you offer to grow your business
> For each job, determine the bottom line price (factoring in your salary) that meets your profitability goals
> Continually compare your prices to the range of prices in the marketplace; continually adjust higher or lower, based on profit margin, not fees
> Maximize your price through marketing communications, developing credible arguments for the value of your products and services

> Don't shoot unprofitable assignments

NOTES

9 This method is more sophisticated that the one cited earlier in this Part.

10 This information is available in PhotoByte. After you have billed a few assignments, you can click the *Billed Expenses* button on the Sales Reports screen. Business reports are covered in, Part 7, Operations, for an example of how to do such a report.

33

A Name Game:
The Real Meaning
of Day Rates

Many photographers have inconsistent ideas about what the term *day rate* actually means. And sometimes those ideas are incompatible with their clients' understanding of the term. In this text, the term "day rate" is simply a synonym for an assignment fee.

All too commonly, at least in the worlds of advertising and corporate assignments, "day rate" is touted as some kind of almighty remunerative quotient that determines a photographer's pecking order. It's a medal that some photographers seem proudly to pin to their chests, as in "I'm a $500-a-day shooter," or "I'm a $3,000-a-day shooter," or I'm an $18,000-a-day shooter!" That's from the photographers' perspective. From the clients' perspective, it can be used to impose price ceilings in markets where there is a lot of competition for assignments, as in, "I don't care if you are Richard Avedon; this magazine only pays a day rate of $250!"

Both sides must be reminded that day rates do not reflect what it costs to produce and execute a photo assignment, nor do they economically address the overhead of running a business in competition with every other photographer in the world.

Most photographers don't get to shoot assignments every day. You might wear an $18,000 day rate like a medal of honor, because that's what you got for your last assignment. But that might have been the last job you shot, and it might have been twelve weeks ago.

Photographers are obliged to spend a tremendous amount of time and money to promote their businesses just to stay in the game competitively, just to get buyers to pay attention to them. And frankly, while how much money a photographer spends or earns is none of his customers' business, a photographer's job is to make as much money as the marketplace will allow, day rates notwithstanding.

No Such Thing as a Half-Day Rate

Commercial photographers don't rely on factory punch clocks to tally up wages. They are not paid by the hour like plumbers and auto mechanics. And *there is no such thing as a "half-day rate."* That is a ploy used by some buyers to cut your assignment fee in half. If confronted with a demand to work at a half-day rate, you may politely explain that your fee will be based in large part on their use of your photos, not how long it takes you to make them. Whether it takes you thirty minutes or eight hours

to complete an assignment, the buyer derives the same benefits from the use of your photos. That's what buyers pay for. Your day rate is merely a minimum booking fee, as far as they are concerned.

If their response is, "But we only have a budget for half a day rate," tell them, politely, how sorry you are, but remain firm. It is your livelihood at stake; you can't be expected to perform charity work. You might suggest that such a budget-impaired customer should check out one of the commercially available royalty-free stock photo collections instead. But if buyers want to commission original photographic artwork and maintain any degree of exclusivity, they must pay a fair price.

Package Deals

Quite a few photographers, primarily those who shoot corporate assignments, have instituted the practice of placing the sum of a usage fee and an assignment fee under a nominal umbrella, which they call, for the sake of simplicity, a day rate. But this day rate is almost always higher than an editorial day rate, because it combines two separate fees, and the usage contingent of that sum is almost always more extensive than a typical editorial use.

In corporate assignments, the buyers' use of photos is rather uniform: the one-time publication of either an annual report or a capability brochure, including, perhaps, some secondary distribution of photos to the business-news media for public relations purposes. The license granted in exchange for this *kind* of day rate usually applies to all of the photos shot during the course of the assignment. It doesn't matter how many days it took to shoot, and there is no limit imposed on the number of images that the buyer may publish at one time or in one print publication. But to counter that, the photographer's license will limit the number of copies printed, unless an additional usage fee is paid, and the reproduction rights are typically granted for a limited amount of time, too. And finally, this type of license is usually *nonexclusive*. The photographer is free to offer these images to other buyers, e.g., a business magazine might ask to publish the portrait you made of the company's CEO, or that great picture you took of a manufacturing plant might be used to illustrate a textbook, and so on.

In effect, this kind of day rate represents a package deal. But the photographer is still in charge, because you set the day rate, and *you will still bill separate line items for expenses, plus a markup*, too.

Flat Fees

Another circumstance quite similar to the one described directly above involves quoting a package price without separating out the expenses and the markup fee. This is called a *flat fee*.

A flat fee is one price that includes all creative fees, production fees, expenses, and markup. Only one figure is priced on the final invoice. No charges are itemized whatsoever, not even film and processing. (Don't leave off the sales tax, though, because you will be required to pay it to the government based on whatever amount you collect from the customer, whether you billed specifically for sales tax or not.)[11]

Remember, too, that while you won't bill a discrete line item for markup, you are still obliged to build some profit into your flat fee. Not to do so will starve your business of operating capital. It also has to be "padded" enough to include your prorated salary, or assignment fee.

Frankly, there is no difference between a flat fee and billing the conventional way (i.e., itemizing all fees and expenses), except that you, the photographer, will be the only person who knows how all of the separate items break out. You will simply present one number on the invoice you submit to your client (with no backup) that represents the grand total. Some clients appreciate that kind of simplicity, while most of them want to see the billing details.

Sometimes, the term "flat fee" is directly confused with day rate. The truth is, a flat fee is definitely *not* a day's fee. If any kind of useful definition can indeed be applied, *a day rate represents the minimum amount of money for which you will accept an assignment on a prorated basis, billed expenses notwithstanding*; it is the threshold at which you will accept an assignment or turn it down.

A day rate may include *hidden* production fees or, in effect, do away with them altogether by discounting them; it's your decision to make. But a day rate will *always exclude* your costs plus a markup on those costs. If it does not exclude costs and markup, then you really *are* describing a flat fee. But watch out! Your flat fee absolutely must be big enough to

include your salary and a profit, even though they are not itemized on the invoice you submit.

How does one account for travel time if you are used to charging—or your clients are used to paying—a flat fee? The same rationale applies. If you expect to lose time in transit, that represents a cost to you. As costs go up, you must raise your flat fee to offset those costs.

note Weather delays are usually billed on top of a flat fee, unless you have agreed otherwise in writing with the client. Either way, you should reach an accord on this issue before you book the assignment.

A flat fee is simply a mask that makes invoices seem simpler to the buyer. But in the end, the buyer pays the same price, exactly as if all fees and expenses were itemized. Day rates, flat fees, package deals . . . it's just a name game.

The Origin of "Day Rate"

By now, you understand that "day rate" is just a name. Its use has become common for the sake of convenience, but it has been applied to so many different circumstances indiscriminately that its meaning has become vague.

The origin of "day rate" comes from a trade practice that evolved in the magazine-publishing industry decades ago. Its initial meaning attests to the fact that a magazine publisher will guarantee a minimum payment to any photographer who has been hired to shoot an assignment, even if no photo from that assignment winds up published in the magazine. It also means that if one or more photos *is* published, then the minimum payment (accrued for the total number of days spent shooting) will be applied against a *space rate* in the magazine.

Space Rates

A *space rate* refers to how big a percentage of a page is occupied by an image. The greater the relative space occupied, the higher the corresponding fee.

A space rate is sometimes called a *page rate*. Both terms mean the same thing, although the latter obviously was meant to refer to print media exclusively, as opposed to, say, the relative size of a Web page.

As far as the amount of "real estate" allocated to a single photograph, the larger its size in proportion to the size of the media on which it is reproduced, the more money the photographer will be paid. Therefore, one photo occupying an entire page commands a higher fee than a photo covering one-eighth of a page. Alternatively, the greater the number of photos published on any number of pages within one periodical, the greater the pay also. The total fee for publishing three quarter-page-size pictures (whether on the same page or on three separate pages) will earn more than a single half-page picture, and so on. Incidentally, space is not always measured literally. Full-page usage is always assumed when it is obvious that an image is being featured in a singular context and as the center of interest, even though it may be surrounded by a large border or other design elements, including text.

Space rates may be negotiated on a job-by-job basis, or alternatively, the photographer may accept a rate preestablished by the publisher. Either way, if it turns out that you worked for only one day, but the magazine published six pictures plus a cover, you will be paid for that cover *plus* the five *additional* pictures that ran inside. On a lucky assignment, you can earn many thousands of dollars for your "day rate."

Just about every magazine establishes its own day rate and space rate, although both or either of these rates may be negotiated between the publisher and the photographer; such rates are *not* written in stone. The concept of "space rate" is particularly susceptible to negotiation because of its inextricable link to usage fees and exclusivity. In that context, editorial clients, news and feature magazines in particular, engage in stiff, almost bitter, competition for feature stories. They are willing to negotiate extraordinarily large sums to "scoop" their rivals. For example, if you happen to have shot the only existing photos of a plane crash or a celebrity committing an indiscretion (okay, even doing something nice!), you can find yourself, or an agent on your behalf, conducting a bidding war. Any material that helps sell more magazines, which in turn helps sell more advertising space, will drive fees astronomically high. In such a case, "space rates" go out the window.

Back to Earth . . . it is a widely accepted trade

practice that payment of a day rate entitles a magazine to publish only one photograph, assuming the photographer worked for only one day (or any fraction of a day). If the photographer worked for two days, then up to two photos may be published, three days, up to three photos, and so on. It is also traditional for stock shooters to bill a minimum space rate of one-quarter page, no matter how small the photograph is published on a page. Most photographers take that principle a step further and demand a minimum page rate for stock, no matter how small the circulation of the periodical.

note As of this writing, the space and/or day rates promulgated by many American magazines can be found on a Web site sponsored by an ad hoc group of photographers in San Francisco called Editorial Photographers, or EP: *www.jranderson.com/php/splashpage.php3.*

Under the terms of a typical editorial assignment, the resulting photo(s) may be used only *one time* inside *one issue* of *one magazine,* and each instance of publication is limited in size to a fraction of a page. An editorial day rate does not typically include full-page use without additional space-rate compensation.

Sometimes, the photo(s) will be published in various foreign-language editions or in international editions, supplementary to the flagship edition. That essentially means your pictures will be distributed to a larger circulation. That might be reason enough to negotiate for a higher day rate. But even if your day rate stays the same, to qualify as a single issue or single use, all editions must be distributed to newsstands simultaneously. Otherwise, additional usage fees will apply.

Photographers should resist publishers' demands to include electronic republishing rights as part of the day rate/space rate deal. There is no implied agreement on the part of photographers when accepting a day rate to make such an inclusion. Do not let clients take it for granted that by licensing your photos to publish in print, they are entitled to use them in electronic media, even as "revisions of a collective work," or in *any* other medium that has not been specifically agreed to beforehand. That includes a prohibition to publish in any other magazines the publisher might own. The United States Supreme Court has affirmed that

prerogative as the law of the land in *Tasini vs. New York Times,* 2001.

When working for a day rate, your final fee will be determined by three factors:[12]

› Number of days spent shooting
› Number of pictures published in one edition
› Size and placement of pictures published

The photographer will be paid the highest figure that corresponds to one of the three criteria listed above for any assignment.

Pricing a Magazine Assignment

Whizbang magazine has established a day rate of $475. Their policy also applies space rates as follows: $1,000 per full page, $500 per half-page, $250 per quarter-page, $125 per eighth-page, and a cover rate of $3,500.

Photographer Otto Focus worked for two days. The magazine published four of his pictures, including one on the cover and a full-page opening spread. Here is how much Otto will be paid for that "day rate" assignment:

Magazine cover	$3,500
Full-page opener	$1,000
Inside quarter page	$250
Inside eighth page	$125
Total	$4,875

Had *Whizbang* published no pictures at all, Otto would have received only $950 for the two days he worked on assignment. His day rate, as you can see, is not added on top of the total space rate.

As an alternative example, pretend that Otto worked for eleven days on this assignment. In that case, he would have been paid $5,225 (11 × $475), and just as many pictures, including the cover, would have been published.

note Neither of the above examples includes a profit or reimbursement for expenses. Those will always be added to the bottom line price of your invoice.

In the magazine business, as you can see, using day rates still works out according to the philosophy of licensing for usage. Here is a more thorough explanation and rationale for how licensing works in the context of day rates and editorial publishing:

A publisher needs to "cover" many "stories" for each edition of a magazine. Many features and news events are unfolding concurrently, twenty-four hours a day, seven days a week, all over the world. Therefore, any number of photographers are given assignments to cover those stories. But in the magazine business, especially news magazines, it can never be assured that every assignment will make it into the pages of the magazine. Not every story gets published. One story or another may get "bumped" to a later edition because something more newsworthy or deadline-sensitive happened in the time since it was shot, or perhaps, a story will get "canned," or dismissed altogether. So, because there is a need to continually commission new pictures, a mechanism was established whereby the investments of both the publisher's financial resources and the photographer's time could be protected. There has to be a way to keep the wheels of commerce turning, to continually manufacture new editorial content, even without assurances that the content—the product—will have immediate use, if ever at all.

The publisher's concern is the expense of paying so many different freelance photographers to work on so many different assignments all at the same time. The photographers, on the other hand, have to be assured that they will get paid something, even if their pictures are not used. Obviously, the publisher has an option to put staff photographers on the payroll. But even that can be too great an expense. The day-rate system is a good compromise.

Editorial day rates are usually lower than advertising and corporate day rates (no matter what they are called), because they typically refer to first-time, one-time, and nonexclusive uses. Karen Mullarkey, a former picture editor of *Newsweek*, once spoke out about pricing in another way: "News magazines are another ball game. There are *guarantees*. There are *holding fees*. There's a little this. There's a little that. It is a maze; and only the wise know their way around it. Anyway, I can make a deal, I will make a deal. We're like rug merchants."[13]

note In spite of the fact that editorial day rates have evolved as a trade practice, you might ask yourself how it is that photography is the only profession, so it seems, in which business owners allow their customers to tell them how much they will be paid. Magazine publishers can only make such "policy" decisions as long as photographers are willing to accept them.

Corporate Day-Rate Assignments

Photographers who specialize in shooting corporate annual reports (see chapter 41, part 7: What It Means to Be a Corporate Photographer) often use the term "day rate" to negotiate their assignment fees, too. But this is merely a tool of semantic convenience, because buyers in the corporate-photography market do not try to set minimum payments against space rates, as editorial buyers do. Your fee is whatever the market will bear. It's the "dog-don't-bark" theory of pricing.

In corporate work, assignment fees change with the nature of the assignment and the predilections of the buyer, as well as with the photographer. Corporate photographers are, nonetheless, obliged to negotiate prices large enough to accommodate a "built-in" usage fee, plus as much as they can get on top of that by virtue of their reputations. That means a usage fee plus an assignment fee rolled into one. (See Package Deals above.)

A final assignment fee is prorated for the number of days it takes to shoot, and corporate assignments often last longer than a single day. That's one reason why they are often more lucrative than editorial assignments. In other words, if you shoot an annual report at a rate of $3,000 per day for six days, you have earned an $18,000 fee. That usually entitles the buyer, either a public corporation or a design firm contracted by another company, to use as many photographs as you can produce during the course of that assignment. But that means *for one time only and only in the particular annual report*[14] *specified in your Job Confirmation or contract*. If the pictures are expected to be used for additional purposes, such as public relations, or if they are to be used in next year's annual report, too, or in another brochure sometime later on, you have a right to demand additional money.

Since corporate assignments can last for any number of days or even weeks, it is not unusual for

a photographer to give a price break to the buyer. This might be a discounted day rate for extended assignments. Conversely, however, you should feel no misgivings to charge a *higher* day rate than "normal" for assignments that last only one day or a few days.

note Make it a routine point to ask for samples of the corporate publications in which your work appears. This should be considered part of your price, but definitely not in lieu of any monetary part of it! Obtaining samples is especially important with corporate assignments, because they are not available commercially to the public, nor are they produced in the same mass quantities as ads and editorial content in magazines. Moreover, they are often quite beautifully designed. If, for instance, an annual report features your work exclusively, it can serve as a promo piece and, in some cases, as a portfolio itself. Make sure you ask for enough copies.

NOTES

11 Except in the states that do not collect sales tax and use taxes.

12 This applies to magazine assignments only. In other cases, there are the Five Factors discussed in chapter 30 that determine your creative fee.

13 ASMP White Paper, *Magazine Photography*, published October 1988.

14 A brochure containing financial information that is required by law to be distributed by a publicly-owned corporation to its stockholders

34

Charging
Special
Fees

In addition to creative fees, usage fees, the marked-up expenses that comprise production fees, and fees for travel time and weather delays, there are a few special fees that don't fall into any particular category, because they neither represent a direct cost nor have they a direct correlation to the production of an assignment. Nonetheless, they are legitimate fees that you can and should bill at every opportunity.

Bid Submission Fees

Some advertising agencies have a policy that requires at least three separate photographers to bid on any job that comes up. But it sometimes happens that an art director already has a strong opinion about which photographer to choose. His reasons are based on creativity. Nevertheless, he has an obligation to submit all three bids to his boss, because his boss, a bean counter, only cares about how much money will be spent.

This situation has led, unfortunately, to the unethical practice of asking an informal pool of photographers for bids on every job that comes up. Some of the solicited photographers are expected to bid too high, and have already been surreptitiously excluded from consideration. The practice is even more egregious when an art director informs his already-chosen "favorite" photographer who the other competitors are, so he has an advantage in bidding.

One way to counter this kind of dishonest and unfair behavior is for every photographer who is asked for a bid to demand a fee for the time it takes to prepare one. By the way, that preparation time can be considerable when you have to make telephone calls to suppliers, location and production managers, assistants, and stylists to determine their availability. In fact, it sometimes comes to light that a particular art director and his photo-buddy have conspired on a phony request for bids when a photographer makes inquiries with several different contractors, only to discover that one or more of them has already been booked for the job in question.

So, when you are asked to bid on an assignment, not only is it a good idea to ask who you are bidding against, and not only is it a good idea ask the art director or art buyer what his budget is—it might be too low for you to bother with anyway, if you can't earn a profit—it is a good idea to have your own policy of asking for a reasonable bidding fee.

That might discourage insincere requests. If enough photographers do so, it will become a trade practice. Many photographers already demand such a fee as routinely as they do a research fee for stock photo submissions.

Research Fees

A high percentage of stock photo requests do not result in sales. To discourage frivolous requests, it has become a trade practice to bill a research fee for the time that either you or your assistants spend to locate, package, and submit photos solicited by potential buyers.

Some photographers make the research fee contingent upon publication of the pictures submitted. That means the photographer charges a minimal administrative fee, but only if the party having requested the submission decides not to publish anything. Other photographers charge a research fee whether the pictures get published or not. The choice is yours. It is your obligation, however, to make your policy known to the buyer *before* you submit the photos. As well, the terms of your research fee should be spelled out clearly on the face of your Delivery Memo. (See chapter 45, part 8, The Paper Trail.)

A research fee of $100 will be invoiced separately, if no photo from this submission is published.
A pro-rated fee of $9 per week shall apply to photos kept beyond the deadline as noted on this Delivery Memo.

Total minimum value of photos submitted for purpose of liquidation due to loss or damage: $3,000.00

Received by : _____ _____

Signature 3 Images in this Submission Title

EXERCISE --------------------------------

Selecting a Mandatory or Conditional Stock Research Fee

The terms posted on the face of a Delivery Memo are placed there automatically by PhotoByte. Whether the terms state that a research fee is either mandatory or conditional is predicated on your selection of a radio button on one of the Preferences screens.

> ▸ From the PhotoByte Main Menu, click the *Preferences* button.

▸ Click the *Stock Licensing* button on the next screen.

General Company Information

Logo & Signature

Letters

Stock Licensing

Stock Valuations
for Delivery Memos

Printers

Legalese

That will take you to the Sales > Preferences screen, where you will see the *Stock Photo Research Fee* buttons.

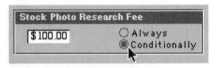

▸ Make your selection, either *Always* or *Conditionally*.

Shipping Fees

It is a trade practice for the party requesting a submission—the recipient—to pay all shipping costs. Photographers will usually ask recipients for their Federal Express, Airborne Express, or other carrier account number *before* sending the package containing photos. They are, thereby, sent "collect."

Minimum Liability and Excess Valuation Fees

If you are shipping original negatives or transparencies, your financial assets must be duly protected. It is the recipient's responsibility to pay for any extra insurance costs imposed by the carrier.[15]

Again, you must inform the recipient about any additional costs for insurance before you send a package. If insurance costs are high, they may decline to pay. If that happens, or if the recipient refuses to pay any other costs associated with the safekeeping of your photos in transit, it is likely that they have little respect for the value of your intellectual property. *You will assume a huge and unnecessary risk if you send your pictures anyway.* It is probably

wiser for you to decline their request under such circumstances.

Some carriers impose their own financial liability limitations on the shipment of goods. Such limitations are linked to the cost of replacing the goods shipped, if damaged, lost, or delayed in delivery—after all, when shipping film, you might have to consider the possibility of a publication deadline. If you miss the deadline, you could lose a sale—and possibly a client, too.

Before accepting any financial liability beyond their own declared minimum, the carrier will require you, the shipper, to pay a fee based on the value of the goods shipped. This fee, also passed on to the recipient as part of the shipping cost, will establish an "excess valuation" for the purpose of liquidating any potential insurance claims.

When you purchase excess valuation on behalf of your recipient, you are not actually paying for insurance. Since the carrier is the insured party, they pay their own insurance costs. You are simply declaring that your shipment is worth more than the minimum amount covered by default. The extra cost is a fee that the shipper demands to accept that higher risk.

It is your responsibility to make carriers understand that intellectual property is more valuable than the cost of a roll of film, that film is merely the recording media. Some carriers, such as Federal Express, try to dodge the issue of liability by refusing to value "artwork," including photography, for more than $500.[16] However, it can be argued that the declared value of your photographs is not based on intrinsic or artistic value, but the actual costs (you've got receipts!) of recreating the product. The cost of replacement, therefore, is equal to the cost of recreating an entire photo shoot.

It need not be called "art." It is a *commercial* product. (You may have to talk to an attorney about this, if the need arises.) Nonetheless, it behooves all photographers to lobby their carriers to accept the excess valuation of commercial photography for what it is, separate from artwork. Make certain that you understand their policy, and they yours.

Late Return Fees (for Stock Photos)

The idea behind imposing a late fee (also called a *holding fee*) is to deter recipients from keeping your photos for inordinate lengths of time, which puts them at greater risk of becoming lost or damaged. Furthermore, by not having your photos returned when promised, you are kept from licensing them to other parties. If, for any reason, they are kept out of circulation by the recipient, you are entitled to compensation for that kind of constraint on your ability to trade. (Have you ever tried to argue your way out of a late fee for returning a rental car several hours late?) It is an accepted trade practice to bill a penalty fee for the late return of submissions.

There is no rule to establish how much that penalty should be, but it is traditionally quite modest. However, to maintain its usefulness as a deterrent, it should be applied cumulatively and with a commitment to collect it. That is, you can set a reasonable fee that is applied both by the day and by the number of images returned late. So, for example, if your late fee is $7 per image per week (or $1 per image per day) and you submitted three images that were returned three weeks late, you would bill $63 ($7 × 3 images × 3 weeks).

Examples:

> 3 images @ $7/week = $21 × 3 weeks = $63
> 1 image @ $7/week = $ 7 × 1 week = $ 7
> 5 images @ $7/week = $35 × 2 weeks = $70
> 1 image @ $1/day = $1 × 10 days = $10
> 4 images @ $1/day = $4 × 10 days = $40

Here is another example. Although such a situation might rarely occur, if you really did lose a further sale, having been denied the use of your own photographs, you are entitled to bill the equivalent of an entire usage fee. Of course, you are obliged to have already made a request for the return of your photos beforehand, and a return date demand must have been plainly marked on your Delivery Memo.

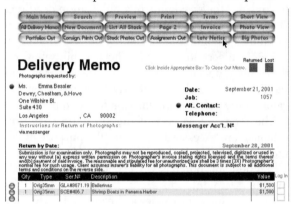

Finally, a Delivery Memo can generate a reminder letter, prompting the recipient to return your photos. This letter can be mailed, faxed, or attached to an e-mail to the recipient. Just click the *Late Notice* button at the top of any Delivery Memo that is past due. That letter will be filed automatically in the Profile > Correspondence screen of the recipient.

note PhotoByte automatically prompts you to choose a return date when you create a Delivery Memo. It also calculates and posts a late fee, or holding fee, when you create a Stock Photo Invoice, whether your pictures were published or not, if the transparencies or prints were returned late.

Refer to chapter 46 in part 8, The Paper Trail, to learn how to create a Delivery Memo.

When a Stock Photo Invoice is printed, the Holding Fee Calculator disappears (as do the navigation buttons on the screen layout), and just the information that the buyer needs to see remains visible on the document.

NOTES

15 If the shipment is local, you may use a messenger or bicycle courier service. Make sure that the service is reputable, dependable, and bonded to cover the damage or loss of your shipment. The recipient will pay for local delivery service, too.

16 See: *www.fedex.com/us/services/conditions/domestic/declared_value.html.* Airborne has published no such limits on its Web site as of this writing.

35

Stock
Photography

Since stock photography has already been shot—it is "in stock"—there are no shooting or assignment fees involved in its licensing. Neither are there any production expenses directly billable to the buyer for a stock photo license; usage rights alone will normally apply. And while a photographer's reputation and talent may add a premium to the creative fees for any given assignment (the demand for a "name brand"), the rarity and quality of a stock image, also taken into consideration, may add additional remuneration to the usage fee.

Pricing Stock Shot on Speculation

In addition to those photographers who work on assignment and put commissioned photos into their stock catalogs for subsequent licensing opportunities, some photographers undertake "self-assignments."

Self-assignments are not commissioned by a client. Photographers shoot photos on their own initiative and pay for the costs themselves. In the vernacular, this is called working "on spec." To minimize the risk of their financial investment in creating the photos, they pick only subject matter that is in demand. They speculate on making a profit

on the back end by prorating, or spreading out, their total production costs and building them into however many licensing fees they may expect to bill annually. In other words, your production costs will usually have an influence on pricing, even though no production costs can be itemized on your invoice.

For example, if a set of pictures on, say, Formula I racecars required you to spend a considerable amount of cash on travel to follow the racing circuit from Europe across the Americas, a fraction of the overall cost should be reflected in the price of each stock photo sale you make. Each licensing sale should be priced proportionately higher than if you had shot only one race in your hometown. Eventually, after the pictures have been licensed and published many times, you will recover the cost of producing them and earn a profit, too. Such costs will not be billed as distinct line items, but the costs are divided and absorbed—hidden, if you will—within the bottom line of each sale.

After such time as a stock photographer has recovered his production costs through sales, or in the case of an assignment photographer who puts his images into a stock catalog, production costs need not be factored in at all, since the initial shoot was already "in the can." It was already complete.

The production costs were already paid, and the rest is gravy. At that point, you can bill more aggressively competitive prices (i.e., lower prices) without sacrificing your profit.

Clip Art

The proliferation of small businesses and individuals using desktop publishing technology at home is accelerating in direct correlation with the coming of age of the Internet and the World Wide Web. What that means to you is that the size of the market for publishable content (illustrations, photographic and otherwise) has dramatically increased. The extended demand for content has spun off of a new kind of product in the stock photography marketplace called *clip art*.

Clip art refers to large collections of images that are either sold outright or licensed to distributors for a one-time, all-inclusive fee. The distributors, in turn, package these collections (usually categorized by a common theme) and relicense their publication rights en masse with very few limitations to anyone who wants them. Buyers are as anonymous as any consumer. The means of distribution is either by CD-ROM or broadband download from a Web site.

The subject matter of clip art is usually generic, e.g., couples walking on the beach, babies with puppies, sunsets, landscapes, transportation scenes, industrial scenes, depictions of everyday objects, etc. They are well executed images, but certainly not unique. They do not satisfy the demands of buyers who want exclusivity and a uniqueness of style beyond a professional quality of execution. Usually those who buy clip art receive a blanket license to use the pictures any way and as often as they see fit. But no party is granted an *exclusive* right to do so. Anyone and everyone else who purchases the same collection of images has the same rights to publish it. That fact imposes its own limitations on buyers, because it narrows the usefulness of the product.

New ways to use clip art will surely evolve. However, the principles of usage rights still apply. While the availability of clip art doesn't rule out the possibility of an ad agency or graphic designer using it to illustrate an advertisement or an annual report, it isn't likely that they would want to do so. They will still pay a premium to obtain exclusive rights to unique images. Clip art is cheap precisely because its use is self-limiting.

A Wary Reception

Initially, clip art was greeted with disdain by many photographers who saw it as a threat to their livelihoods. It made it seem like photography was quickly becoming a bargain-basement commodity. It certainly took some of the glamour away.

The advent of clip art seemed like an infernal way for the publishing industry to exploit photographers and erode their ability to earn reasonable usage fees. Photographers saw the consolidation of smaller agencies into bigger, more powerful ones as a corporate ploy to take a bigger share of their royalties away. Some of them felt like they were being sold out by unscrupulous colleagues who were desperate to make a fast buck by selling the rights to their photo archives at bulk rates. Indeed, how the clip-art market works isn't obvious to the uninitiated. But it certainly is not what it first appeared to be to the most cynically minded photographers.

Negotiating a clip-art deal with an agency usually means giving up the possibility of higher per-image prices over the long haul to take advantage of a sure thing right now: the volume sale of lots of images. That's a reasonable choice to make—"a bird in the hand . . ." and so on. But on—or in—the other hand, there are other kinds of clip-art deals to be made. A brief explanation of how the clip-art market works follows.

The Internet Influence

As stated in the previous part, the Internet created a new kind of "e-conomy" that moves almost literally at the speed of light. It relies on adopting new marketing strategies that can be adapted quickly to fit new technologies, and vice versa.

The Internet will ultimately enable a channel of distribution for images that is more efficient by at least two orders of magnitude by removing both shipping costs and time in transit from the economic equation. (See the section, Digital Distribution, in chapter 3 in part 2.) Because their ease of distribution makes images inherently more marketable, they become correspondingly more valuable, too, in spite of possibly lower per-unit or per-transaction prices.

To review further, like all other forms of intel-

lectual property, images are particularly easy to copy and distribute over the vast network of electronic pipelines we call the Internet (or the World Wide Web). In the world of "real things" (made of atoms with physical mass instead of electronic bits), lowering the cost of distribution leads to lower market prices. That's a good thing, because as the cost of goods becomes cheaper, more people can afford to buy them, and the size of the market grows correspondingly larger. The problem of lower prices is offset by increased revenue overall, because there are more customers. This process unequivocally conforms to the Law of Supply and Demand.

A New Kind of Customer

The market is not just growing, it is differentiating. There aren't that many more ad agencies, designers, and magazines. But clip-art images, inexpensive as they are, will become increasingly available to a broader group of ordinary consumers, not just media publishers.

Images, the electronic facsimiles of photographs, are consummately suited to electronic commerce. The market for images has increased exponentially precisely because of the Internet. Whereas commercial photographers could previously only sell to their clients in the media (and, indeed, these were the only kinds of buyers they sought), they can now market directly to the public at large. Well, perhaps not "directly," because the capital cost of reaching consumers is so much higher (as described in part 2, The Role of Technology in Your Career). But that's where stock photo agents come into play, with their marketing muscle. But that's also another story. For now, let it suffice to say that if Jimmy Jones wants to download your picture of the pyramids in Egypt to illustrate his sixth grade homework assignment and can do so impulsively for 25¢, you should be thrilled about letting him. There must be tens of thousands of other sixth graders who would be willing to do the same thing. And yet, that does not preclude the sale of a similar—if not the same—picture to an advertiser for thousands of dollars for a single use if exclusivity is not a factor. But hundreds, if not thousands, of shrewd photographers produce stock photos specifically with a mind to license them as stock, on a non-exclusive basis. This is in addition, perhaps, to their regular work. Nothing has changed in that regard.

Think about what kinds of customers have been in the market for commercial photography in the past: primarily Fortune 500 media companies and other smaller corporations, often represented by the graphic design firms and ad agencies for whom you shoot directly. Now, consider the fact that desktop publishing technologies, which have been available since long before the Internet exploded onto the commercial scene, have made it easier for mom-and-pop companies to publish their own promotional literature, both in print and online. These same technologies also enable consumers to use your images on personal greeting cards, create their own wall calendars, etc.

These are "unsophisticated" buyers, who don't appreciate the exigencies of paying royalties for copyrighted intellectual property; they just want to create party invitations, newsletters, special-offer flyers, and so on. In short, they don't care about your copyright, and you'd go nuts trying to police every infringement they might make. Nonetheless, that seemingly bad situation has created a fabulous opportunity.

The conjunction of desktop publishing with clip art (again, a new *product* brought forth by the "e-conomy") and the World Wide Web (a new *distribution channel* in the "e-conomy") will ultimately allow photographers to increase their revenue by selling images to consumers.

The e-commerce business model does not cannibalize existing markets. They will continue to coexist, side by side, just as film coexists with digital-capture cameras. And in theory, because of the online sales capabilities of the agents who represent them, photographers can sell the same image for $3 (likely to invite an impulsive sale) to one private, nonmedia buyer for a one-time personal use and for $30,000 to a major advertising agency. It's up to you to make the best of this opportunity. You won't benefit if you cynically reject it.

In spite of the fact that consumers will never pay any mind to the infringement of copyrights, copyright will still exist to protect your prerogatives. The stock photo agents themselves retain flocks of legal eagles to defend intellectual property rights—not just their own, but yours, too—and prosecute infringers. Just make sure you retain your copyright ownership to the images they license on your behalf. Remember: Only sell your copyright if the price is too good to turn down.

The Royalty-Free Business Model

It was inevitable that generic images, electronically duplicated and distributed, would fetch lower prices and attract a greater volume of sales. This economic reality is best illustrated by the "royalty-free" pricing model. But royalty-free was the effect, not the cause.

Royalty-free is a new way to get that newly enlarged market of consumers and low-end media publishers to license images, as well as for both photographers and the agencies that do their marketing to create new streams of revenue. New products beget new pricing. Just because General Motors added Saturn[17] to its line of cars didn't make Cadillac disappear.

Royalty-free is not a market in which all photographers will choose to participate. It takes a certain kind of knack to create "elevator music," difficult for those whose intent is to create only high art. But if there's a market. . . . There are, after all, a lot of elevators.

Often, the term "royalty-free" is used synonymously with "clip art." That's because the ultimate end users of packaged clip art pay a one-time fee to the marketing and distribution agents instead of directly to the photographers (whether for a CD or an electronic "key" to download from a Web site collection). And since the photographers have already been paid, they do not participate in the revenue stream from further use of their images. But that is not the only way clip art works.

A Misnomer

Some clip-art distributors will commission photographers, usually specialists in various styles, to produce an entire collection of images on a single topic or theme. The photographer pays for the cost of production, but receives an advance against—guess what?—royalties! So *royalty-free* does not literally mean royalty-free after all. The "royalty-free" part refers only to the end-user's obligation, or lack thereof. The only difference is that, in this case, photographers receive royalties (still based on usage fees) *from the distributors instead of the end users.*

Sometimes a photographer may negotiate a relatively low fee in exchange for royalties on the sales of each collection of images or, alternatively, a higher fee with no royalties at all. Other kinds of royalty-free clip-art deals may be construed as advances against future royalties. Either way, the distributor

earns revenue by selling lots of images to lots of end users, each of whom is entitled to the relatively unlimited use of the pictures for either the price of a CD or a subscription fee to a Web site, a one-time charge.[18] The distributor pays royalties on each one of those sales to the photographer. If a collection of images is very successful and sales skyrocket, the photographer and the distributor will both make money. If sales are disappointing, the distributor has not made a disproportionate outlay of cash up front. That's a win-win-win situation for the three parties involved: the clip-art company, the photographer, and the end user who eventually publishes the work.

Depending on the contract, all rights may revert to the photographer after a time. That frees the photographer to relicense all or part of the entire clip-art collection to the initial distributor or to a different one altogether for additional revenue. *The photographer has not relinquished any copyrights.* This allows all photographers to enter the expanding royalty-free market without losing control over their work.

Some distributors have claimed to promote photographers by including their biographical and contact information along with each collection sold, so end users may feel free to contact photographers directly with new assignments. Other clip-art distributors pay fees to photographers up front in lieu of royalties. This has already become a viable way for some photographers to increase their net worth immediately and, in a few cases, dramatically. The receipt of a big check, even though it represents a lower per-image price for a large number of images, can help capitalize the expansion of your own marketing activities. You can buy new cameras or fund the creation of whole new bodies of work. It's one way to cash in on the intrinsic value of your personal photo library, instead of allowing your catalog of slides and negatives to languish unused in a filing cabinet. That would be like having too much cash in a low- or no-interest checking account. A royalty-free deal with a photo agent can make your archives liquid.

An End to CD-ROMs?

Incidentally, clip art will probably cease to be distributed on CD-ROMs altogether. CDs are already a bottleneck in the distribution process. As the proliferation of high-speed cable modems and similar

high-bandwidth distribution devices increases, a critical mass of customers will come to demand more images more quickly over the Web. As content can be more speedily downloaded directly from a distributor's Web site, there will be no need for CDs.

Exploitation versus Competition

While the market for clip art was initially created by low-end publishers looking for low-end content at rock-bottom prices, there are no doubt a number of high-end design firms and ad agencies that exploit the use of royalty-free images. Yes, that does take business away from some photographers. *But there is absolutely nothing that can be done to take clip art away; the forces of the marketplace are inexorably at work.* And those same marketplace forces have ordained that the only photographers who will lose business to clip art are those who refuse to compete in the clip-art market.

No Agency Middlemen

You may be able to provide innovative pricing structures to exploit the royalty-free model all by yourself, without going through a third-party distributor, just as some photographers already license traditional stock photos directly to buyers without an agent. The alternatives are limited only by your imagination.

The demands of this new market do not necessarily include broad publication rights or exclusively commissioned images of the highest quality. The same ©-chip technology[19] that may ultimately block the unwelcome practice of "swiping" by commercial art directors (see part 5, Copyright) will probably enable you to market and distribute low-cost images directly to design firms and ad agencies over the Web. That means you can compete head-to-head with clip art, if you have the wherewithal.

To illustrate how that might work for you in a competitive sense, imagine having your own "pay-per-view" cable channel, so to speak, only this channel operates on the Internet, offering still-photographic images instead of movies and live sports events. You may even decide to shoot images on spec with a low-end, high-volume market in mind, keeping higher prices reserved for higher-quality images (i.e., creating two separate brands for your work) and, thereby, guaranteeing varying degrees of exclusivity to your clients. That is called *diversifying,*

a tried-and-true method of expanding business opportunities.

This is emerging technology. It is not fully enabled yet on a broad scale. But it is likely that you will someday be able to collect usage fees automatically from anyone who downloads one of your images, including the folks who simply publish neighborhood newsletters and help their kids print illustrated homework reports. The ©–chip may help in that regard. Still, it's worth considering that, if you let a photo agent do some of the heavy lifting in terms of marketing your images, policing accounts receivable, and collecting payments, it may be worth the share of revenue they take. You might still be able to earn more that way than you could on your own.

Photo agents, whether they distribute clip art or not, may be thought of simply as a way to outsource some of your marketing and sales. If you are a particularly good producer of generic images, clip art may be just the thing for you. The only question is whether or not it is more profitable to do the work yourself. You can do a cost/benefit analysis, as described in part 3, chapter 8, to find out.[20]

If you ignore this new market, others will exploit it instead. While some photographers may complain about losing business to clip art, they might just as well complain about losing business to any other kind of competition, including any one of the myriad existing stock photo agencies. If you stand still too long, you may become roadkill on the information superhighway.

This may all be academic to you right now, because it takes a long time—perhaps as long as an entire career—to build a file of pictures that might be worth a sizeable investment from a clip-art distributor. Maybe you can make a deal to shoot custom "theme collections." But in the meantime, think about your photo archives the same way investors think about accumulating stocks and bonds: They appreciate in value as time goes on. You are building equity in your investment with every photo you add to your portfolio of assets (pun intended).

Photographers who participate in this new market, instead of naively wringing their hands over it, can maximize their revenue to at least some degree. Some will do better than others. And some lucky or shrewd photographers may liquidate their entire archives of stock photos for an immediate capital gain, quickly converting dormant intellectual

property (images) into relatively large amounts of cash. They may let the clip art companies market and distribute their images on their behalf. Every participant's motivation in this market is profit.

Yes, some photographers will go belly up. Unfortunately, success is never guaranteed in a capitalistic enterprise. But their failure will not have been *caused* by clip art. The only guarantee you have is one of opportunity, and opportunity is always created by a combination of adversity and diversity, by looking for solutions to new problems. And isn't that a good definition for competition?

NOTES

17 Saturn is a mid-price, mid-size car for the masses. It is not an exclusive luxury item. Unlike the sales practices of other automobile brands, Saturn sales reps do not negotiate prices. Saturns are supposedly priced modestly to sell at sticker price.

18 As an example, the end-users may be allowed, royalty free, to publish photos from a clip-art collection in electronic media only (e.g., their Web sites) for a specific number of months or years—or even indefinitely. Such a deal might specifically exclude the use of the photos on point-of-purchase merchandise, music CDs, book covers, etc. It all depends upon the deal each photographer negotiates with the distributor of the clip-art collection.

19 A technological device similar to the "V-chip" being debated in Congress that, if legislated, would be required in the manufacture of new electronic storage devices. Installation of a ©-chip in a hard drive would prevent unauthorized parties from storing or retrieving images imbedded with copyright information.

20 The context in chapter 8 was an equipment purchase, but you (or your accountant) can perform the same kind of analysis, weighing the costs against the benefits of a marketing campaign and the setup of an electronic fulfillment system for customers on the Web.

Operations

*If you've got nothing but talent,
you've got no business in photography.*

Now that you have trudged through the minutiae of starting a photo business, studied its roots in copyright law, learned how to market and price your work competitively, and read about how technology can help you run things more profitably, it's time to get down to the nitty-gritty of conducting business from one day to the next. This part is all about the practical stuff: what to do when a buyer calls with a stock photo request, how to estimate a photo assignment, hire employees, collect payments, deal with taxes, and analyze your financial performance. This is where you put your knowledge and skills together, along with a few new tricks, and take action to make a living.

36

Basic
Accounting
Principles

Before delving into an extended treatise on book-keeping, it should be pointed out that there is no difference between the way photographers and other professional practitioners do it. You pay bills and taxes and balance a checkbook exactly the same way as any other self-employed person.

Setting Up the Books

All businesses share the practice of keeping a set of books. These are records indicating how much is earned and how much is spent. The books also show exactly what the money you spent was used to buy and when purchases were made. A set of "books" may consist of no more than a balanced checkbook, but in the case of a photo business with lots of tax deductible costs, you need to be more thorough to avoid paying too much to Uncle Sam.

The only reason to keep books at all is to prove that you're not shirking your taxes by making unsubstantiated deductions. That's why you have to reconcile what you earn with what you spend. Actually, the most common reason the IRS invokes for disallowing deductions is a taxpayer's inability to corroborate expenses with a set of records, i.e., sloppy bookkeeping.

Records, books, ledgers, journals, registers. . . . These words are all synonymous. They each refer to a method of showing proof to back up the claims you make at tax time. There will be situations when obtaining a receipt is impossible, or when records become lost or destroyed. There are ways to deal with these problems to satisfy the IRS, and your tax accountant is prepared advise you. All in all, accurate bookkeeping is a hedge against the consequences of a tax audit.

Keeping Timely Records

Keeping tax records means more than filing receipts, whether systematically or by the shoebox method, and producing them on April 14th, the day before returns are due to be filed. Instead, you must keep your records up-to-date by logging every instance of income and every cost incurred *as soon as it arises*. You will find it easier to do that than trying to backtrack. The government refers to this process as "contemporaneous" record keeping.

If you log each expenditure at or near the time it was made, your documentation will have greater credibility than records prepared later, with less-than-accurate recall. For example, if you travel often

and pay gratuities at hotels and airports, you don't have to show receipts. But if you don't log them contemporaneously, you'll have a hard time backdating a year's worth of tipping to correspond with the amounts paid out each day and to whom. If you merely indicate an annual lump sum, the IRS may not believe you. Maintaining a weekly log is generally considered sufficient to show timeliness. If you submit expense statements to your clients with each assignment Invoice/License of Rights, they will be considered timely-kept records. The corresponding PhotoByte Worksheets will do nicely.

Maintaining scrupulous records is not as tedious as it used to be. Not too many years ago, you would have been advised to go to the stationery store to buy a ledger. Actually, you would have needed two ledgers, one for income and one for expenses. You would have had to record each and every transaction by hand every day—not once, but twice—using a system called "double-entry" accounting. It ensures accuracy by reconciling *credits* and *debits*, a couple of accounting terms that you need not bother to learn right now, unless you're the type who enjoys using a slide rule when you have a pocket calculator handy. Today, the best advice is to buy some computer software.[1] It automates double-entry accounting, a necessity for business owners. If you do decide to keep the books yourself—as recommended—having a professional set them up for you in the beginning will save endless hours of trouble down the road.

It's only the daily data entry duties that you should take over yourself anyway. You may still need a bookkeeper to prepare the kinds of reports mentioned previously on a monthly or, at least, a quarterly basis. But to have a CPA do such preparatory work would be unnecessarily expensive. In the end, bookkeeping is necessary for three things. It will instantly tell you:

> How much money is owed to creditors
> How much money is owed to the tax collector
> That you can back up your deductions with recorded expenditures

The Difference between Bookkeeping and Accounting

The terms "bookkeeping" and "accounting" are often used interchangeably. They shouldn't be. They mean two different things.

Bookkeeping is the simpler practice of systematically logging debits and credits to prove deductible expenses and to show profits and losses. It is a clerical job, simply tracking money in and money out. Whoever keeps the books is responsible for recording expenditures, registering bank deposits, making sure that bills are paid on time, balancing checkbooks, and filing away receipts for retrieval in case of an audit. Accounting, on the other hand, is practically a black art. There are libraries chock full of books about the topic and college degrees awarded for mastering it.

Accounting is the process of analyzing the results of a bookkeeper's records and using them to interpret the relative financial success of a business. This analysis is used to predict future financial performance, to help you plan growth strategies. It also helps you avoid paying too much tax. Bookkeeping *records* results. Accounting *produces* results.

Whereas it's relatively simple for you to do your own bookkeeping, a trained professional should be relied upon for accounting. It is unfortunate that many businesses approach their accountants as income tax specialists only, rarely asking them for advice about daily financial operations. But if you take the time to consult with a CPA on a regular basis, not waiting until a tax deadline looms ahead, you will establish a relationship that increases your chances for profitability and success.

You already know how to make creative decisions about what cameras, lenses, and films to use and how to express yourself as an artist. Seeking the regular advice of a CPA will ensure that the financial decisions you make are just as sound, based upon economic principles, not the seat of your pants. These kinds of decisions have to do with the legal structure of your business (as discussed in part 3), salary compensation, taxes, buying equipment, leasing studio and office space, raising or lowering prices, etc. This is an ongoing process, not a one-time task.

The objective of working with an accountant is to make sure that you manage your capital wisely. A typical bookkeeper has not been trained to do that. And, of course, an accountant will help you prepare the seemingly arcane financial reports that are so critically important to your business plan. The extra cost of an accountant is frequently offset by the sav-

ings found in the tax avoidance strategies he recommends.

At regularly scheduled intervals, you and your CPA should sit down to analyze financial statements and reports.[2] You will look at such statistics as:

> Statement of income (monthly, quarterly, or annually)
> Statement of change (rate of growth or decline)
> Overhead expenditures report (to indicate that your costs are in line with previous periods, or to compare them with industry norms)
> Margin of profit (helps keep prices reasonable, but profitable)
> Cash flow report
> Balance sheet
> Profit-and-loss statement
> Various account summaries, such as a total of tax deductible expenses

There are seven tasks to perform in setting up your books:

1. *Decide which software to buy.* It is an exercise in futility to try to do bookkeeping manually in this day and age. Even the pros use software. This kind of bookkeeping software is so common that it often comes bundled with your computer.

2. *Make a list (schedule) of the accounts you will be recording.* To accomplish this, you can copy the items listed on the Profit/Fee Analysis screen in PhotoByte that were used to determine the break-even point (see the exercise, Determining Your Break-even Point, in chapter 8). With or without that schedule, you will separately list the categories of items you pay money for and those you receive money for. The software you choose will give you a basic list to start with. You can add your own photo-specific items. The software surely comes with a user's guide that will lead you through the process. In your initial discussions with a CPA, ask for help creating this schedule of accounts.

3. *Choose whether to keep the books yourself or hire a part-time bookkeeper.*

4. *Prepare in advance with your accountant to file estimated tax returns.* Some small businesses find quarterly filing too tedious. They prefer to pay the IRS a modest penalty come April 15th to make a single filing, with no estimated payments in between.

Some people consider that tantamount to receiving a low-cost loan from the government to add to your cash flow. The penalty may be comparable to the interest you might otherwise pay a bank, if this really were a loan. This is another matter for you to talk about with a CPA. Nonetheless, more information on the topic can be found in IRS Publication 505, *Tax Withholding and Declaration of Job Estimated Tax.*[3]

5. *Choose a "tax year."* This is simple. Just decide if you want to start keeping your books on January 1st and go through December 31st (a natural calendar year) or begin a fiscal year somewhere in between. Your accountant will advise you. Almost all photographers use a natural calendar year.

6. *Choose either one of two methods of bookkeeping:* accrual or cash *(see below).*

7. *Choose a payroll system, if you expect to hire employees.*

Additional Accounting Categories

Just for the record, some additional accounting categories to discuss with your CPA (not on the Profit/Fee Analysis screen)[4] include:

> Current assets
> Cash in bank
> Petty cash
> Accounts receivable
> Allowance for bad debts
> Merchandise inventory
> Fixed assets
> Depreciation allowance
> Furniture and fixtures
> Leasehold improvements
> Amortization allowance
> Current liabilities
> Accounts payable
> Notes payable
> Income taxes
> Social Security payable
> Sales tax payable
> Long-term liability
> Profit and loss

Cash versus Accrual

Bookkeeping on an *accrual* basis is the practice of recording income as it is earned and recording expenses as they are incurred, even though the cash may not be received or paid until later. In other words, income is claimed immediately, simply by the act of submitting an invoice. Likewise, you can buy something on credit, without having to pay for it right away. The *cash* basis reports income when it is actually received and records expenses when the money to pay for them is actually disbursed.

For all practical purposes, insofar as the photo business is concerned, the distinction between accrual and cash reporting refers to sales tax and its relationship to your accounts receivable.[5] In effect, you must make a decision, either to count invoices as income from the time they are written or at the time you receive payment.

Remember: The accounts receivable (i.e., unpaid invoices) that belong to a business are considered assets. They represent earned revenue that is "on the books," so to speak. That means they have value, even though you haven't been paid yet. Receivables have value, because they can be traded, used as collateral, or even sold (e.g., to a factoring agent, a company that buys invoices at a fraction of face value and takes over the responsibility for their collection). Invoices are property that you own in somewhat the same sense that you own copyrights.

In reality, a considerable length of time may elapse between the date you send an invoice and when you finally receive a check. (Of course, it's not supposed to take much time at all. See chapter 37 in this part.) The accrual method demands that each invoice be counted as income from the date it is written. The cash method allows you to wait until you are actually paid before reporting the income. Why is this important? Because the state in which you practice your trade may demand one method or the other when you file sales and use tax returns.

Some states that require sales tax demand that you remit the tax for every invoice you have written at a predetermined interval, for instance on a quarterly basis, whether you have collected any payments from your clients yet or not. That is the accrual method. (Yes, there is a pun lurking in there: It is a cruel method.) Is it fair? Well, unfortunately, it doesn't matter. Your CPA can tell you which method to use.

note　Whichever method you choose, PhotoByte will automate the sales tax reporting procedure to a large extent. While the default method is accrual, there is a Cash button in the top left corner of the Sales Tax screen. Click this button to toggle to the cash method, and vice versa. The complete procedure for reporting sales tax will be discussed in chapter 38.

NOTES

1　Quicken™ and QuickBooks™ from Intuit Software (*www.shopintuit.com/quicken_store/*) and M.Y.O.B. (*www.myob.com/us/products/index.htm*) come to mind.

2　Many such reports are created automatically by PhotoByte. They are available with a couple of button clicks. Your CPA can help you interpret them. More is explained about this procedure later in this part.

3　See: *www.irs.ustreas.gov/prod/forms_pubs/pubs/p505toc.htm.*

4　These are not found on the Profit/Fee Analysis screen because they do not represent business overhead, or costs.

5　While you may be required by state law to use the accrual method as it applies to sales and use tax, most photographers use the simpler cash method for preparing federal and state income tax returns.

37

Managing
Accounts
Receivable

Without a doubt, you have as much natural desire to plunge into the planning and execution of your next photo shoot as you have an inherent aversion to preparing invoices and collecting payments. But you cannot dodge that responsibility by passing the buck to either a bookkeeper or an accountant. There are two reasons not to:

1. Plainly, the management of accounts receivable is not part of the bookkeeping process. Only the end result, a number representing the total amount of money you are owed at any given time, is of any interest to a bookkeeper or accountant.

2. Neither bookkeepers nor accountants have the expertise required to manage the collections side of a photo business. There are too many complex and idiosyncratic tasks to perform that only a photographer would understand.

Number crunchers have no particular knowledge about invoicing photo shoots. You could spend weeks just teaching them to understand the jargon. Heaven knows how a "civilian" would remember to bill for a cuckaloris, a 1200-watt-second flash head, a boom, some sandbags, and a Super-angulon, let alone figure out the intricacies of crafting a copy-

right license. How would he know what services performed during a shoot were either billable or not? Billing a photo shoot requires a tremendous amount of knowledge about the technical details of photography and the principles of licensing intellectual property. A bookkeeper's responsibility is not to become involved with invoicing, other than to record when they are paid and the checks deposited. Nor is it is a bookkeeper's job to learn how to use Photo-Byte.[6]

Cash Flow

A familiar maxim of business states that you have to spend money to make money. It's absolutely true. Spending is a catalyst for earning revenue. It primes the pump. It is the fundamental principle of capitalism. The whole idea, however, is to make more than you spend. That's the profit part.

The ebb and flow of your bank balance must not be allowed to become haphazard. It must be managed. Revenue collections must match the pace of spending, and spending should never be excessive. It should be just enough to keep your business sailing smoothly along. If you spend money too fast or spend too much, you'll find yourself bailing out a

flood of bills. But if you want to float your boat, it takes a sea of cash. If the tide doesn't come in at the same rate or faster than it goes out, you will run aground. That is essentially what cash flow means.

If you consistently spend more than you earn, you have created more than just a cash flow problem; you've got a leak in your boat. If your clients don't pay you quickly enough and regularly enough—that is, if checks come in too slowly to keep up with the bills you have to pay—you'll experience a typical cash flow crunch. Cash flow is never innately dependable. That's why it requires careful management.

The net result of poor cash flow is that your ability to shoot new assignments can be either interrupted or severely curtailed, even if your clients owe you boatloads of money, because you won't have enough cash to pay your own suppliers, creditors, and employees. And you won't have enough cash to pay yourself a salary.

Managing Cash Flow

Shrewd business owners think about cash flow all the time. They forecast it and try to improve it. Improving your cash flow—unclogging the arteries, so to speak—will unquestionably make your business more successful.

Accelerating cash inflow and delaying cash outflow are the keys to cash flow management. Understanding how to delay cash outflow is elemental: Don't pay anyone until you have to! That doesn't mean deliberately withholding payments until they are late; that is both unethical and costly in itself. But you should always take advantage of as much time as your creditors allow in their billing cycles.

Delaying cash outflow means acting in a conservative manner when making purchasing decisions. If you give close attention to your budget, for instance, you should never have to spend more than "just enough" to pay for your overhead. As for making major equipment purchases, giving your salary a raise, or expanding your facilities, talk to your accountant and do some analysis first. Instead of spending blindly, determine, first, how buying now will affect operations several months later. (Refer to the section, Deciding on a Major Purchase, in chapter 11, part 3, Starting a Photo Business.)

Understanding how to accelerate cash inflow is just as easy. It means decreasing the amount of time it takes to turn a booked assignment into a cashed check. Practically speaking, you need to bill as quickly and as often as possible. The amount of time this takes is called a *cash conversion period*.

Cash Conversion Period

The cash conversion period measures the amount of time it takes to turn ideas into images and, ultimately, into revenue available for cash outflow. It takes into account all the events that occur before the booking is confirmed, as well as events occurring after the job is done. How long it takes to complete each event in the conversion period may surprise you. It can be quite long, from your first conversation with the client about an assignment, to submitting an estimate (if required), to invoicing, film delivery, and receipt of payment. Your goal is to shorten that span of time as much as possible. Of course, much of this book is devoted to explaining how business automation software does exactly that for you. Plainly speaking, if you can invoice faster, you will get paid faster.

Credit Decisions

Your clients have their own cash flows to manage, too. They all want to decrease outflow just as much as you do. Of course, you want to make your clients happy, and, so, you extend them credit. That means acquiescing to wait a while to be paid after you turn over the photos. However, since the business model of copyright licensing predicates the granting of usage rights on the receipt of payment (i.e., cash on delivery), can you be sanguine about that practice? It is reasonable to offer a little leeway, perhaps a week or two, but never longer than thirty days. Do not allow clients to take advantage of your generosity, as some are accustomed to doing. They only do so because so few photographers speak up and demand prompt payment.

The decision to extend credit to your clients, and for how long, is based upon whatever policy you choose. Yes, photographers often wait long periods of time to get paid after turning in assignments, especially with ad agencies. But you can help change that by, among other things, demanding advance payments, especially on bigger budget productions. You can withhold the delivery of film until you receive payment. You can start calling and sending

late notices the very day invoices become due. And you can keep on top of all that by looking at the Accounts Receivable screen and the aging reports in PhotoByte every day. Every other kind of business observes those practices. There is no reason for photographers to be remiss.

When an invoice is late, it takes only seconds to generate late notices and new invoices demanding fees for late payment (there are exercises in part 8 to illustrate this concept). If you are worried about the possibility of art buyers becoming annoyed and not hiring you because of an aggressive position on receivables, get over it! How patient are your creditors with you? Remember: If you don't act like a businessperson, you won't be treated like one.

Cash Crunch

Almost every business experiences a need for more cash than it has on hand at one time or another. Rarely do outflows and inflows coincide conveniently. Inflows usually lag behind outflows, leaving you short of operating funds every once in a while. This is what is typically described as a "temporary bind" or a "cash crunch." If you find yourself in this position, you may have to borrow money.

A cash crunch is the result of excessive outflow coinciding with inflow that lags for several weeks, or even months, even though you are working steadily and incurring production costs. Sometimes your biggest clients will run into a cash crunch themselves and fall behind paying what they owe you. Things like that happen due to dips in the economy and—heaven forbid!—recessions. Someone else's financial problems, then, become your problems, too. It's another way to look at the "trickle-down" theory of economics.

Just because a business goes through a cash crunch once in a while doesn't mean it is in dire financial trouble. Some cash flow gaps are actually created intentionally when a business decides to spend more than its predicted inflow, just to achieve a specific result. For example, you might accelerate outflow to take advantage of a big sale. If you had an opportunity to acquire all the equipment you'll need for the next five years at less than half price, that would be a prudent decision. Or perhaps you'll decide to expand the size of your studio and finance some construction costs before winter weather sets in. Maybe you'll discover a cache of special film at

the camera store and decide to buy the entire emulsion run, plus a freezer in which to store it. Who knows?

Sometimes, cash crunches are unavoidable. If you are an annual report shooter, for example, your work is seasonal. You may be sailing along with assignments through the winter and be dead in the water when spring comes around. Unless you find other kinds of assignments to augment revenue in the off-season, you are bound to suffer through a slump. This will cause a cash shortage. It's unavoidable, because if you're a typical one-man band, and you're on the road much of the time, it becomes more difficult to line up new jobs far enough in advance. Unless you can find a rep to market your services while you're out shooting assignments, you will probably encounter a seasonal slowdown.

In case you find yourself in a cash crunch, you'll be glad that you have maintained trade credit in good standing with your suppliers. That is one way to keep your business running smoothly. You can charge the supplies you need for upcoming shoots, if you expect to be paid before you have to pay your suppliers. Make sure you stay friendly with them, in case you don't get paid in time! You'll also be happy if you arranged ahead of time for a revolving line of credit with a bank. That's something to do ahead of time, when you don't really need the money. But only use that line of credit (i.e., borrow the money) to take advantage of opportunities to increase profits. If you try, instead, to borrow your way out of a financial hole, the hole will just get deeper and the crunch will turn into a crushing blow.

Cash Surplus

Cherish the times when your clients have all paid on time, you have already booked your next six assignments, and there is enough money in the bank account to cover overhead for several months to come. But know that handling a cash surplus is just as important as the management of a cash crunch, or deficit. With frugal management of your cash flow, you might find yourself with enough extra capital to invest in growth (e.g., putting more money into marketing), to earn even more revenue.

Paying down business debts is generally the first option to consider if you have a cash surplus. Think of it in the same context as the federal government paying down the national debt to stimulate

the economy. It certainly makes sense for a small business like yours to do the same, because leaving your cash surplus in a bank account will not yield a big enough return to offset the rate of interest on any existing debt you might have. In other words, it would cost you money to continue earning interest at, say, a typical 3-percent rate in a checking or savings account when you are already paying interest on a credit card at 18 percent. Not even a short-term investment in the stock market is likely to compete with paying down debt. However, paying down debt may not be the best thing to do in every case. Here's why.

A key advantage to managing cash flow is the ability to predict the future cash requirements for your business. It helps you determine if, or when, your business needs to borrow cash. The need for a loan may result from plans to expand your marketing activities, purchase new cameras, or just to get through a normal seasonal downswing. Whatever reason there might be, preparing a cash flow budget is the best way to predict future cash needs. And if you do foresee a need for a loan, and interest rates are lower now than you expect them to be sometime in the near future, you may want to invest your cash surplus right away to offset higher interest rates on bank loans later on. In other words, it might be too expensive to finance your expansion or equipment purchase if you wait too long to buy what you need. So, in this case, spending more cash is better than paying off existing debt. Money has its own price, and it goes up and down just like everything else.

Collecting Payments

It's obvious that the prompt receipt of payments for services rendered is essential for maintaining a healthy cash flow. Nonetheless, there are some photographers who believe that the "aggressive" pursuit of money, even if it's money they worked hard to earn, will alienate them from clients. So they wait months to get paid sometimes. But that attitude is clearly unproductive. Wouldn't it be better to put that money to work for your own benefit instead of for your clients?

Other, more prudent photographers may want to collect receivables more quickly, but they simply don't know how. The most common reason why collections get out of hand is poor organization. The

key to efficient collection of receivables is to develop an effective means of flagging accounts when they become due and to keep track of who pays on time and who doesn't. PhotoByte does that for you.

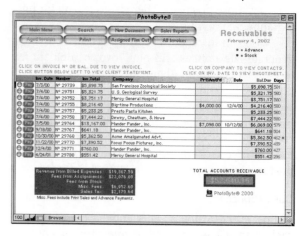

Notice in the illustration above that the PhotoByte Accounts Receivable screen displays not only who owes you how much and for how long, but also a breakout of cash flow, such as how much of what is owed to you is attributable to sales tax.

EXERCISE ----------------------------------

Showing a Client's Payment History
Before you book a job from Art D. Rector, it might be a good idea to see what kind of payment history he has with you. Has he been a slow payer in the past?
 ‣ From Artie's Profile > Client/Keywords screen, click the *Pymt History* button.

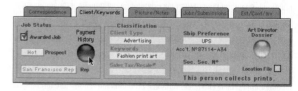

You will next see a screen representing the payment history of Artie's company.

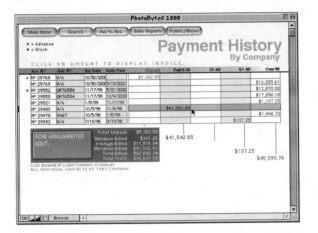

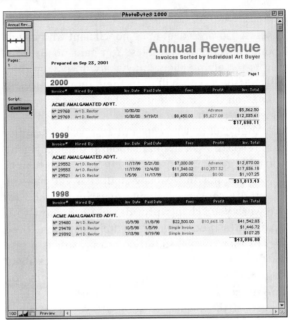

You can see at a glance that Acme Amalgamated has not usually been faithful about paying bills within thirty days. Look at the number of invoices in the far right column that took over ninety days to pay. Just as importantly—right in front of your eyes—is information that you probably never had access to before as a freelance entrepreneur. In the gray box, you can see the total of any unpaid invoices plus the maximum, average, and minimum amounts you have billed in the past. You can also see the total amount of business you have billed to this company and exactly how much profit you have earned throughout the history of your relationship.

If you want to look at the details of any invoice you sent to Artie in the past, click on the balance due for that invoice where it appears in the list. You will see the actual invoice displayed on screen. It looks just like it does on your letterhead, just as Artie has held it in his hands.

Since this report lists all of the invoices that were billed to Artie's company, including other buyers at that company, you might want to see a breakdown of only those invoices sent to Artie personally instead. These data are useful, because they stay with a single person, even if he switches companies. The data in this report are cumulative and sorted annually.

▸ Click the *Pymts/Buyer* button at the top of the screen.

The *Annual Revenue Report* appears, sorted by the individual buyers working for this company.[7]

This report can be printed, if you choose, unlike the former screen, which was strictly an on-screen list.

▸ Click the *Continue* button to go to the printer dialogue box, where you will either continue to print the report or click *Cancel* to return to the Profile.

tip This report may also be accessed from the Sales Reports screen by clicking the Client Pymt History button. Then, you will see the following screen, on which to select the name of a company instead of an individual.

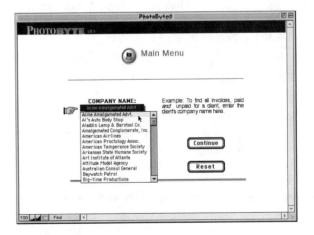

Improving Your Collection Cycle

It sets a bad precedent to be nonchalant with clients about collecting receivables. You gain no Brownie points for giving clients any slack on paying their bills. At best, you will gain their indifference. At worst, you may lose their respect. Either way, you'll wait longer to be paid.

Your clients will keep your cash as long as they can. If you are not adamant about prompt payment, you will find yourself subsidizing their cash flow, as if you were making loans without charging interest. If you are concerned about appearing grateful for the work your clients provide, you can show your gratitude by producing excellent photographs. If you feel further compelled, an occasional gift is a nice touch. But you literally cannot afford to be lax about demanding payment. The creditors to whom you owe money hardly let you off the hook.

So, if you neglect to submit invoices immediately upon the completion of jobs and, just as importantly, to demand timely payment—even to ask for advances when appropriate—you will be in no financial position to accept further work from those "good" clients. If you have a negative cash flow and the opportunity of a lifetime comes knocking at your door—it may even be the photo assignment of your dreams—you will have no choice but to turn it down if you don't have enough money to pay for film. Even if you manage to buy the materials you need on credit to shoot your next assignment, you could go bust before the pictures get published if it takes too long to get paid. That predicament has befallen many photographers. For each individual, it only has to happen once.

EXERCISE ------------------------------

Viewing Aged Accounts Receivable

This exercise will illustrate a method you can use to monitor how long it typically takes to get paid. For instance, if you can see that it usually takes longer than thirty days to clear most invoices, you will have to revise your remittance policy and demand faster payments. If that is not an alternative, you will have to renegotiate your own payments to suppliers to balance the flow of cash in and out. Another alternative is to demand partial payments in advance of photo assignments, to offset your overhead.

▶ From the PhotoByte Main Menu, click the *Accounts Receivable* button.

▶ From the Accounts Receivable screen, click the *Aged Invoices* button at the top of the screen. You will see the Aged Unpaid Invoices screen.

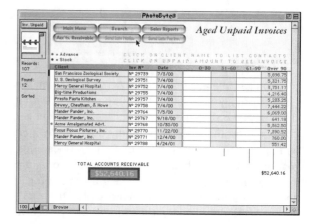

In the illustration above, it is evident that too many clients are taking way too long to pay their invoices: all over ninety days. Now you know it's time to start collection procedures and to revise your remittance policy. You have, in fact, decided to send one of these clients a late payment notice, along with a bill demanding an additional fee for overdue payment. (In a real situation, you would send to all the overdue payers on the list.) If a telephone call has not produced fast enough results, this might induce them to take action.

note When there are only a few unpaid invoices appearing on screen, it is still a good idea to check on aging by looking at paid invoices as well. In that case, you would click the **Aged Invoice PAID** button, located on the Sales Reports screen.

You can select individual line item invoices from this list by using the Flip Book at the top left of the screen to move the small black vertical bar up and down. When the bar is adjacent to the left side of an item on the list, it is selected.

▶ Select the third item in the list, **Mercy General Hospital**. (Do not click on the line itself. Use the

Flip Book. Otherwise, you will open the document, instead of simply selecting it.)

> Click the *Send Late Notice* button at the top of the screen.

You will see a letter addressed to Ms. Sarah Bellum of Mercy General Hospital. It will, at first, appear in Browse mode, in which the text may be edited, if you wish.

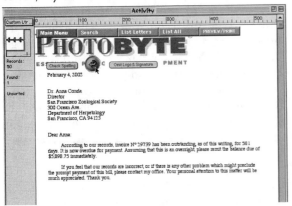

> Click the *Preview/Print* button at the top to see what it will look like in print.

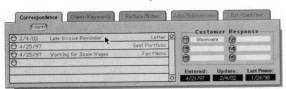

Since this letter contains your logo from the Preferences lookup file, it can be faxed or e-mailed without the need to print it first, if you have a fax modem.

Now, you will create a late fee invoice.

> Click *Continue* to leave the Preview mode.
> Bypass the printer driver window by clicking the *Cancel* button. You don't need to print or fax for the sake if this exercise, unless you want to.
> Click the Return arrow.

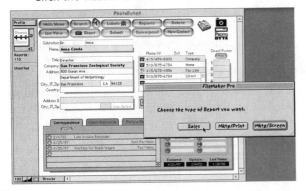

You will see Sarah Bellum's Profile > Correspondence screen. Notice that the list of correspondence has automatically been updated to include the letter you just sent.

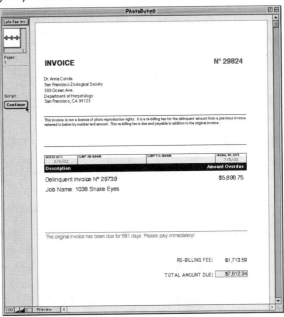

> Click *Reports* at the top of the screen and then *Sales* in the dialogue box that ensues.

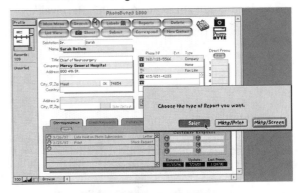

You will see the Sales Reports screen.

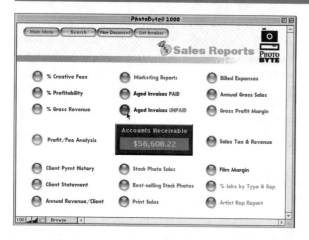

▶ Click *Aged Invoices UNPAID* in the middle of the screen.

You will once again see the Aged Unpaid Invoices screen.

▶ Click the *Send Late Fee Inv.* button at the top of the screen.

You will see a late fee invoice appear on screen in Preview mode. Notice that this invoice shows the rebilling fee, the amount of the original invoice, and the total of the two. The correct amount is automatically calculated from a lookup percentage in the Preferences screen that you entered previously. It is also added automatically to Accounts Receivable.

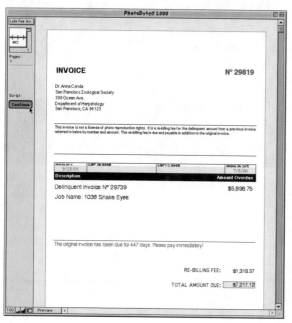

What to Do about "Uncollectable" Debts

If a client tells you that he has no intention of paying a debt and will not tell you why, you have reached the point where you need to turn the account over to an attorney or a collections agent, assuming the debt is large enough to warrant further action. You also have an option to file a small claims lawsuit in municipal court.

Attorneys are forbidden to be present in small claims court. You're on your own in front of the judge. But an attorney can advise you before you get there. If cash flow is tight, many court districts provide free small claims advisory services. Contact your local courthouse to find out if that kind of service is available or look in the local telephone directory. Sometimes, this information is listed in the front of the phone book under *City* or *County Government Offices.*

Generally, there is a $5,000 limit on small claims cases. You will also have to pay a nominal filing charge and fill out some minor paperwork stating the nature and amount of your claim in layman's language. You are allowed to have witnesses and provide evidence in addition to your verbal testimony. You must share any evidence you have with the defendant in the courtroom, prior to arguing your case before the judge. You will be given some time to take care of this transaction after you are sworn in by the bailiff. It's a good idea to have your testimony written down, so you can hand it to the judge if he wants to take your case "under advisement." That means he won't decide right away, but will "sleep on it" after hearing both sides of the case. He'll read the testimony, look over his notes, and consider the evidence. You'll receive his decision later in the mail.

If you want a sheriff or marshal to serve a court summons to the defendant, there will be another charge. If you win, you can obtain a lien on the defendants assets or have a law enforcement officer seize cash from the defendant to cover this charge.

Small claims rules differ from state to state, so get some advice from one of the sources mentioned earlier before you proceed. Incidentally, if you win, the defendant has a right to appeal. An appeal is tried in regular municipal court, where attorneys are allowed to be present to represent both you and the defendant. If you lose, you cannot appeal, since you sued in the first place.

If a client declares bankruptcy, the law may require you to stop your collection efforts. At this point, you should discuss your options with an attorney.

If a client gives you the impression of wanting to cooperate, but never seems to come up with a check, your decision is more difficult. The most prudent thing to do is offer an ultimatum. Tell him you intend to turn the matter over to a collection agency after a specific deadline. If he ever so slowly pays just enough to try to keep you off his back, but never gets around to paying the full amount, you have another kind of dilemma. If you give the account to a collection agency, the customer may stop paying altogether. But if you don't turn it over or sue, it's likely you'll never receive the balance due. Here, again, an ultimatum is helpful. It will be useless if you don't stick to it though.

If there is absolutely no possibility of collecting a past-due invoice, you cannot write off the amount on your tax return as a deduction, because you cannot deduct against income you never received. Void the invoice in PhotoByte. There is an exception though—there is always an exception—if your accounting is done on the accrual basis. But very few freelancers handle their accounting in that manner, so it probably won't apply to you, unless you have incorporated your business. If you do use the accrual method, ask your accountant if you can take a "bad-debt deduction."

Incidentally, you are prevented from deleting invoices in PhotoByte. (If you make a mistake entering data, you can simply change it.) However, simply voiding the invoice will preserve its number with a zero balance, which also preserves your audit trail. It may look suspicious to have a completely missing invoice, number and all.

EXERCISE --------------------------------

Voiding an Invoice
▶ From the Main Menu, click the *Paper Trail* button.
▶ Then click the *Invoices* button at the top of the Virtual Paper Trail screen.
▶ Click on invoice Nº 29764.

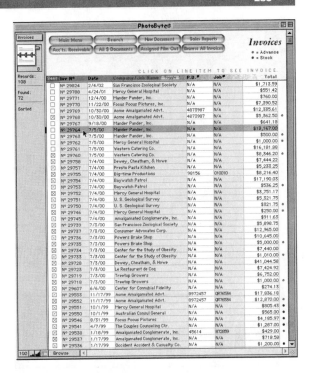

You will see an invoice appear on screen in Preview mode.

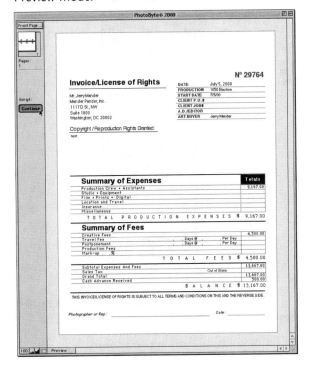

▶ Click the Continue button to enter Browse mode.

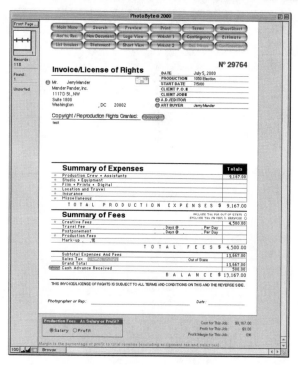

> From the Shortcuts menu at the top of your screen, select **Void Selected Invoice**.

Follow the instructions on the Void screen that appears next.

Factoring Accounts Receivable

Since unpaid invoices listed as accounts receivable are business assets, *factoring* is the process of selling

them to obtain quick cash. The best advice is never to factor your invoices. It is a sign of poor financial planning. If you have to resort to this kind of financing, your business is in trouble. Your profit margin has probably dropped to a level equal to no more than the factor's fee, which means, if you are lucky, you may break even instead of lose money. But your cash flow will be so hard pressed that you may not be able to cover your overhead much longer. You should seek business counseling to avoid going bankrupt.

Consider this tactic for a crisis only. Factoring is far more expensive than using credit cards to fund your cash flow. Nonetheless, here's how it works.

The *factor*, a finance company that specializes in buying accounts receivable, will pay immediate cash for you to *assign* your invoices. That means to legally transfer your ownership of the invoices to them. After you complete a job, instead of sending an invoice to your client, you give it to the factor instead. It must correspond to a signed purchase order or an equivalent Job Confirmation from the client to make the transaction enforceable. The factor will forward your invoice to the client, made payable to themselves, and pay you roughly 60 percent of the bottom line up front. When your client pays the factor, you get the balance of the invoice total less the factor's hefty service charge. That service charge is tantamount to an annual interest rate of anywhere from 30 to 50 percent.

To summarize the most important principles of cash flow:

> Bookkeeping and managing your accounts receivable are not the same thing
> Cash flow can be managed
> Maximize inflow, minimize outflow
> Waiting too long to invoice jobs will minimize or interrupt cash flow
> Sometimes, it's cheaper to pay off debt than keep cash in the bank

You must be dogged in your collections!

NOTES

6 Whether or not billing becomes the responsibility of a studio manager or a rep will be a decision you must make later. For now, it is not a factor.

7 In this example, Art D. Rector was the only hiring party at Acme Amalgamated Advertising.

38

More
About
Taxes

You have already read about the choices to make between the cash and accrual accounting methods, and how most small businesses pick a natural calendar year instead of a fiscal year to file statements. You know, too, that you will need either manual ledgers or computer software to keep the books, whether you hire someone to do it for you or not.

The information in this chapter will *not* tell you everything you need to know about taxes; tax laws change with the weather anyway. Besides, how tax laws apply to your own business depends on the formal structure you have chosen, i.e., sole proprietorship, partnership, corporation, or LLC (refer to chapter 7, part 3). This is a briefing about what you need to discuss when you sit down with a CPA. It will help you to understand what he has to say.

Filing Tax Statements

Most likely, your accountant will translate your bookkeeping records onto two IRS forms called *Schedule C, Profit and Loss From Business* and *Form SE, Social Security Self-employment Tax*. They will both be filed with your personal income tax return on the universal Form 1040.

Most accountants will provide you with written guidelines for submitting the information they need to complete your tax returns and to offer you advice. Those guidelines may come in the form of a kit containing a questionnaire to fill out before the end of the year. It is designed to save the accountant's time—and your money. The alternative is to hand over a shoebox filled with receipts that will cost a fortune to sort out and file before they can be tallied as deductions for your tax return.

If you use software for keeping the books, you can prepare a detailed report of your income and deductions with a button click or two. This convenience becomes even more practical when the tax information prepared by your bookkeeper (or bookkeeping software) is augmented by marketing and cash flow reports created with PhotoByte. Some bookkeeping software will actually transpose your computerized records onto the requisite IRS forms automatically for electronic filing.[8] Either a bookkeeper or a CPA can advise you about that capability.

Income Tax

Insofar as taxes are concerned, income means all the revenue you receive. It is the total of all your invoices, plus every additional dime that comes in,

including royalties, print sales, the proceeds from selling a used camera, consulting fees, honoraria for speaking engagements to local ASMP chapters or college classes, and even a winning lottery ticket if you should be so lucky.

If you are a sole proprietor, an LLC member, or a partner, the IRS considers you and your business one and the same. There is no separate entity. The salary you pay yourself, in effect, will not be taxed separately,[9] as it would be in a full-blown corporation. If your business *is* incorporated, however, it will file a separate tax return, and you will file an additional, personal tax return.

If you happen to win any professionally connected prize money without soliciting it (e.g., you didn't enter a contest or fill out any other kind of application), it may not be subject to tax. For example, if, happily, you found yourself the recipient of a MacArthur Fellowship[10] and the $500,000 stipend it comes with, you're home free.

Grants received for the purpose of allowing you to complete artistic endeavors may also be excluded from taxability, as long as you don't provide services directly in return for the party that provides the grant money. If you receive a grant while you're working toward a higher education degree, you may deduct its full amount. If you are not pursuing a degree, deductions may only be taken under these conditions:

> Up to $300 per month
> Up to a thirty-six month limit, not necessarily consecutive, during your lifetime
> The grant must come from a nonprofit organization or the government

While incurred costs related to a grant may also be deducted, they will not reduce the $300 limit per month. More information about grants may be found at the IRS interactive Web site.[11]

Any proceeds from an insurance claim for lost photos or cameras will also be counted as income by the IRS. If you barter photographic services or actual photographic prints for other products or services, the value of what you receive in kind will also be counted as income. For instance, if you trade a print for the services of a graphic artist to design your logo, the fee that he would normally charge for that logo should be declared as income.

How often taxpayers comply with that rule is anybody's guess. But consider this: The graphic artist would, likewise, be obliged to declare the value of your print. To offset that income, he might deduct an amount corresponding to his fee as a business expense for acquiring the print. If, for any reason, he was audited by the IRS, it might come to their attention that you received the equivalent value as income. If you were subsequently audited, you would be liable for not having declared that as income. On the other hand, since the print and the logo could be considered to be of equal value, the declarations of income and their subsequent write-offs on both sides would, theoretically, cancel each other out. This becomes no more than a matter of satisfying the IRS's bureaucratic requirements. How to handle such situations is up to your own discretion.

Types of Income

Not all income is taxed at the same rate. It falls under various IRS categories as follows:

> Earned Ordinary Income—salary, fees, royalties, used camera sales, and print sales
> Unearned Ordinary Income—interest on savings accounts and stock dividends
> Short-Term Capital Gains—proceeds from the sale of stocks and bonds, real estate, works of art, or any capital asset you have owned for less than one year
> Long-Term Capital Gains—same as short-term, but owned for longer than one year

The rates at which different types of income are taxed can change whenever Congress revamps the tax codes. This is another reason why it is so important to consult with a CPA to prepare your tax returns. However, just to generalize, you can really get "dinged" if you sell off any assets you've held for less than a year. Just one calendar day can make a difference of thousands of dollars in avoided taxes. So watch out for the capital gains tax when it comes to selling off assets. Long-term capital gains are taxed at a much lower rate.

Furthermore, income is taxed at progressive rates. This type of tax takes a larger percentage of income from higher income groups than from low income groups. The more you earn, the higher the rate and the more tax you pay. Nonetheless, the

higher rate of tax (a percentage) applies only to each additional step you take up the earnings ladder, i.e., the higher rate only applies to every dollar you earn above the threshold. The rates can vary from 28 percent to 70 percent of your taxable income. Keep track of those deductible expenses. And keep those receipts!

Deductible Expenses

A tax deduction represents an amount of money that a person or a business can subtract from their taxable income. The more you can deduct, the less you have to pay.

For tax purposes, an expense is any operating cost, such as rent, utilities, payroll, travel, film and processing, stylists, assistants, postage, rep commissions, legal and accounting bills, etc. Expenses are distinguished from capital expenditures. The latter represents money spent to pay for property and equipment held for a long term. (That's why, for example, cameras are depreciated, not expensed.) An expense represents a cost of doing business. Costs reduce your income. All of your costs are listed, or "scheduled," on a form called Schedule C, a part of your income tax return already mentioned above. For all intents and purposes, it is an itemization. One of the most important and complex of these itemized deductions is the home-office deduction.

note If you take out a loan for the purpose of starting a new business, no immediate deduction is allowed for start-up expenditures. Once you begin to operate your business, and you can demonstrate that it has become active earning revenue, you may amortize your interest expense over a period of sixty months. Amortization is the gradual elimination of a liability, such as a business loan, by making regular payments throughout a specified period of time. Such payments must be sufficient to cover both principal and interest. Refer to part 3, chapter 7: Raising Money to Start Your Business.

The IRS and Your Home-Office or Studio

As the sole proprietor of a photo business, you can probably deduct the costs of a home-office from your personal income. If you use a different business structure, please consult with a CPA to determine the rules that apply to you.

To qualify for a home-office deduction, a part of your residence must be used as follows:

> *It must be your principal place of business.* Even in photography, it is possible to have more than one business location or office, including one in your home. Perhaps you will grow into a busy, bicoastal shooter with studios in both New York City and Los Angeles. But you cannot take a home-office deduction if you conduct administrative and management activities somewhere other than in your home.
> *It must be used exclusively for the management of professional photographic activities.* The IRS takes the word "exclusive" literally. Due to the exclusive-use rule, you cannot deduct business costs for any portion of your home that is used, even occasionally, for personal purposes. That means you do not qualify for a deduction if your office area is sometimes used as a family den or a place to sort the laundry. You cannot deduct your bedroom, since you sleep in it, and you cannot deduct a spare bedroom if anyone else ever sleeps in it. You cannot deduct your garage if you park your car in it. You cannot deduct a home-office if you use it solely to make stock market trades instead of practicing the business of photography.
> *It must be used regularly.* That means you must use this specific area of your home for business on a continual basis. You do not qualify for a deduction if your business use of the area is only occasional, even if you do not use that area for any other purpose.

Many activities are administrative or managerial in nature. The following list provides some obvious examples. If you perform these duties in your home-office, they will help qualify it as your principal place of business:

> Billing clients
> Keeping books and records
> Ordering supplies
> Setting up appointments
> Writing reports and estimates
> Conducting marketing activities
> Shooting pictures

The following activities, whether performed by you or by others, will not disqualify your home-office as your principal place of business. You are allowed to:

> Hire contractors to conduct administrative or management activities on your behalf at locations other than in your home-office, such as hiring a bookkeeper or a business manager to do your billing from their own places of business
> Conduct administrative or management activities at places that are not fixed locations, such as in a hotel room on a location assignment or on an airplane when you have your laptop computer with you
> Occasionally conduct minimal administrative or management activities at a fixed location outside your home, such as in a studio at a separate location
> Conduct substantial nonadministrative or nonmanagement business activities at a fixed location outside your home, such as shooting pictures on location or in a studio outside your home
> Use your home-office for administrative and management activities, even though you chose not to use a suitable space already at your disposal elsewhere

How Much to Deduct for Home-Office Space

The amount you are allowed to deduct depends on the percentage of floor space in your home used exclusively for business.

To calculate this percentage, divide the number of square feet used just for business by the total size of your home, also measured in square feet. Alternatively, if the rooms are approximately the same size, simply divide the number of rooms used for business by the total number of rooms in your home. Apply this percentage to the total of each business expense you wish to deduct.

For example, if you rent a two-bedroom apartment with a kitchen, a dining room, and a single bathroom, you have five rooms total. If one of the two bedrooms is used exclusively as an office, you may deduct one-fifth of your total cost for living in that apartment, or 20 percent. If you live in a one-thousand-square-foot apartment with a two-hundred-square-foot room used as an office, you will use this equation:

$$200 \div 1,000 = .20$$

That result also equals 20 percent. Therefore, if your rent is $1,000 per month, you can deduct $200, or 20 percent of that amount. Multiplied by twelve for the entire year, that's a $2,400 tax deduction.

A Limit on Deductions for Home-Office Space

If gross revenue (income) from your business in photography turns out to be less what it cost you to operate your business (overhead), any deduction you might take for the business use of your home is limited by the amount of that gross income. In other words you may not deduct more than you make. If you earned $20,000 in total income from your business in photography and claimed a $25,000 home-office deduction, you could not write off that additional $5,000. However, those business costs that are not deducted because of the limit (including that $5,000) can be carried forward as part of the following year's write-offs.

note If you own your own home, make certain to consult a CPA before taking the home-office deduction. It may affect your right to be taxed at favorable long-term capital gains rate when you sell your home, or to avoid the tax altogether if you purchase another home within a specific period of time, or if you are above a certain age.

Deductible costs (at a proportionate rate) for a home-office may include:

> Depreciation
> Insurance
> Mortgage interest
> Interior painting
> Property taxes
> Rent
> Repairs
> Utilities
> Waste disposal

note You may not deduct the costs of cosmetic care for any part of the structure of your dwelling. For instance, you cannot apply even a portion of your gardening or outdoor painting costs as a deduction.

Exceptions to the Principal-Place-of-Business Rule

If you have at least one office in addition to that in your home, the following two mitigating circumstances may still allow the deduction:

‣ The relative importance of the activities performed at each location
‣ The time spent at each location

If, after considering multiple locations, your home is obviously your principal place of business operation, you'll still have to provide convincing documentation to that effect if the IRS contests your filing of that deduction.

There is another exception. If you use a separate structure—in the architectural sense, not the legal one—as your place of business, it doesn't have to be your principal place of business to qualify for a deduction. It can be a building not attached to your residence but on the same property, used either as a studio or as a place to meet with clients. In other words, you can have as many offices as you like and deduct their costs, as long as none of them is physically attached to the main structure of your dwelling.

A Place to Meet Clients

It's not unreasonable for a photographer to meet with clients in a home-office, especially if you live in your studio. If you meet clients in your home in the normal course of your business, even though you also do business at another location, you can deduct your expenses for the part of your home used exclusively and regularly for business if you meet the following test:

‣ Your clients' use of your home must be substantial and integral to the operation of your business. This is certainly true if you maintain a studio at home (or a home in your studio) in addition to a strictly administrative office away from your shooting space, where art directors and subjects routinely visit.

Any part of your home that is used exclusively and regularly for clients does not have to be your principal place of business to qualify for the deduction.

A Separate Office Structure

You can deduct the costs for maintaining a freestanding structure, such as a separate studio, garage, or barn, if you use it exclusively and regularly for your business. The structure does not have to be your principal place of business or a place where you meet clients.

An Exception to the Exclusivity Rule

If you use a room in your home to store slides and prints (material that both the IRS and you can reasonably consider to be a retail or wholesale inventory or product samples, such as portfolios), you may deduct that part of your home as an office expense, even though it might sometimes be used for personal purposes, too. However, it must meet the following tests:

‣ The inventory or product samples are for specific use in the photo business.
‣ Your trade or business is the wholesale or retail selling of products. *This criterion is subject to interpretation, since you may be considered to sell only services and not products. However, some tax experts may agree that publication-usage licenses are products. Please consult with your CPA.*
‣ Your home is the only fixed location of your trade or business.
‣ You use the storage space on a regular basis.
‣ The space you use is an identifiably separate space suitable for storage.

IRS Publication N° 587, *Business Use of Your Home*,[12] contains more detailed information on the business use of your home and the rules that apply, including examples of administrative activities and situations that satisfy the government's "no-other-fixed-location" requirement.

If you are self-employed, you will use IRS Form 8829 to figure your business-use-of-the-home deductions and report those deductions on Schedule C, Form 1040. More information can also be found at the IRS' interactive Web site.[13]

Deducting Educational Expenses

For the smartest professionals, education never ends. From time to time, you may want to enroll in seminars of both the business and creative kind. As long as you can prove a history of professional practice,

you can deduct the cost of educational expenses and seminars directly related to improving your skills, including tuition, the cost of books, and travel. Your expenses must be related to photography. You cannot, for instance, deduct the cost of competitive driving classes, unless you have a very confident and creative accountant and you plan to shoot a documentary on stock car racing. An argument could probably be made to legitimize such a write-off. But you had better produce the pictures! Perhaps a more appropriate example might be trying to deduct the cost of a series of seminars on, say, cabinetmaking, cooking, or golf. Sorry. You can't do that.

You must report your qualified educational expenses on the form used to report business income and expenses (IRS Schedule C, C-EZ, or F). If your educational expenses include a vehicle, travel fares, or meals, report them the same way you report similar business expenses. If you have a creative accountant who believes that you qualify as a performing artist who is paid in whole or in part on a fee basis, you can deduct your educational expenses as an adjustment to gross income rather than as itemized deductions.

Incidentally, if you are a college student or any other kind of wannabe pro photographer, forget about deducting the cost of your tuition. You have no history as a practicing professional. That is the prerequisite.

Deductions for Professional Equipment

One of the biggest—if not the biggest—capital outlay you will make is for cameras, lenses, lights, strobes, and all the gadgets that go with them. These are the tools of your trade. All of them are expected to last for a long time, certainly longer than one year. Because of that, the IRS generally forbids you to write off their full cost the same year you buy them. Instead, typically, you will allocate the cost of these assets systematically over a period of time. In other words, the deductions are spread out, covering the useful life of the assets for tax-accounting purposes. This is called *depreciation*.

Depreciation of Property

The government wants all small business entrepreneurs, including photographers, to invigorate the economy by hiring workers, creating cash flow, and increasing productivity in general. It is assumed that new equipment will help you do that. So what if buying and using cameras is fun! The government has provided an incentive for you to make such investments by giving you a tax break on capital equipment purchases. But that doesn't give you a license to spend hog wild. Make sure that you run your buying decisions through the cash flow management criteria discussed earlier in this part.

Since equipment tends to decline in value—or depreciate—due to normal wear and tear or obsolescence, the amount depreciated and deducted each year is not necessarily uniform. It is expected to lessen in succeeding years. Your CPA will advise you about various methods of depreciating your business property, including vehicles, office furniture, computers, and, of course, your cameras, and, then, set up schedules for that depreciation over time.

There is an alternative to depreciation. As of this writing, if you purchase equipment valued at $24,000 or less in the course of one tax year, you may choose to deduct the full amount that very same year. However, you may still depreciate it as described above, if you and your accountant see an advantage. It often depends upon your cash-flow situation.

For instance, if your tax bill looks like it's going to be particularly high one year, you will want to offset it with every deduction you can think of to avoid paying too much tax. If you deduct the full $24,000 purchase the same year your taxes are really high, the government is, in effect, subsidizing your purchase, because otherwise, you would have had to pay that money to the IRS. With that large $24,000 deduction, your tax bill is lowered. However, if deducting the whole $24,000 purchase would give your business a net loss instead of a profit, you will probably be better off depreciating it over five years.

Deductions for Travel

As a business owner and a photographer, you may be obliged to travel, perhaps extensively. Whether it's an assignment on location in Siberia, a trip to show your portfolio in a far-off city, a voyage to the Caribbean to shoot bathing-suit models for stock, or a seminar in Sheboygan, you can deduct all of your travel-related costs. That includes lodging, meals, gratuities, gifts, laundry, airfares, excess baggage, entertaining the models, yacht charters, helicopter rentals, in fact the whole enchilada, as long as you can prove they're legitimately related to your busi-

ness and not for your personal pleasure. You can even write off all of your expenses during travel days, to and from your destinations, including layovers. If there are delays in between shooting and conducting other business, you can write off those expenses, too.

Corroboration of Travel Expenses

Don't get too giddy. The IRS looks very carefully at travel deductions. You must comply with stringent record keeping requirements. You cannot deduct estimated or approximate amounts. You must corroborate the following with records and receipts:

> Amount of each expense
> Date and location of each expense (including descriptions of any gifts)
> Brief explanation of the importance to your business of each expense
> Business relationship of persons entertained or receiving gifts

Keeping a Trip/Assignment Envelope

The best plan for corroborating travel expenses is to keep receipts and to write notes on them as you receive them. It only takes a moment, if you do it as you go along, and you have protected yourself from the consequences of an IRS audit.

The next step is to immediately file these receipts in an envelope carried with you, a separate one corresponding to each travel assignment or client on a business trip. This envelope should be clearly labeled with a title referring to the trip and the date. If you're smart, you'll have a laptop computer with you. At an opportune moment, say, while you are waiting in an airport transit lounge or during a flight, this trip envelope should be opened, and all of the receipts it contains should be recorded in your bookkeeping software. The software can automatically flag them as deductions, so your bookkeeper will notice them when your tax returns are prepared.

note If you travel with one or more photo assistants, you may deduct all of their travel expenses, too—those that you pay for, of course. A spouse's expenses are not deductible unless you can prove that you were accompanied solely for legitimate and indispensable business purposes. Incidental services, such as typing, don't count. For com-

plete information on deducting travel, entertainment, gift, and car expenses, see IRS Publication 463.[14]

EXERCISE

Creating a Trip Envelope

> From the Main Menu, click the *Paper Trail* button.
> Then, click the *ShootSheets* button at the top of the screen.
> You will see a list of ShootSheets.

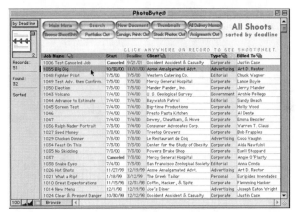

> Click on the first item in the list, **1055 Big Gig**.
> You will see the ShootSheet for this assignment (in Preview mode).

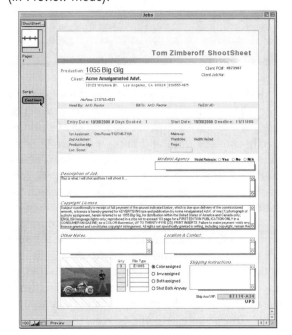

‣ Click *Continue* to enter Browse mode, and then click the *Expense Rpt.* button at the top right side of the screen.

You will now see the Expense Report screen. Don't forget that you can scroll to see the bottom-most part of the document, if any of it is not visible. That depends, of course, on the size of your monitor.

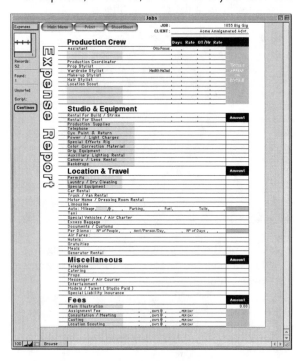

Before your departure, both the ShootSheet, a job log clearly displaying all of your pre-production notes, and the blank Expense Report may be printed directly onto the front and back, respectively, of an envelope.[15] This becomes the "trip envelope." Now, you have a neat filing system for all of your receipts. On it, you can log cash expenses for which no receipts exist, if you wish (e.g., tips), by writing on the printed form which is now part of the envelope itself. Of course, you can actually enter the expense information directly into PhotoByte on your laptop (or desktop, when you get home). If you do that, all expense records will automatically be tallied when you click the Invoice button at the end of your assignment. Furthermore, at your convenience, you can

scan a Polaroid® test print or, later yet, a transparency and paste it directly onto the ShootSheet in your computer.

‣ Scan a print or slide using the directions that came with your scanner.
‣ Copy the scanned image to your Clipboard (in memory).
‣ Browse the ShootSheet and scroll to the bottom of the screen.
‣ Click inside the *Photo* field.
‣ Paste the image into the field.
‣ If an image file you wish to include already exists as a file on your hard drive, click the *Acquire* button to select the file. It is right next to the *Image* field. The image will appear in the Photo field.

When you reprint the envelope after your trip, the visual record of your job will be complete, including an image representing what you shot and all of your last minute records about the trip. Not only do you have one envelope containing all of your expense receipts, it is already labeled for filing. Along with receipts, you can also use it to store the film you shot. The best news is that the entire job is already catalogued inside PhotoByte on your computer. You can place the physical envelope into a file drawer and refer to PhotoByte to tell you exactly where it is. When you go to the drawer, you can see the whole job at a glance, photo and all, right on the envelope. And think about what kind of impression you'll make on a tax auditor, if it ever comes to that. You'll be out the door and on your way in minutes.

Deductions for Your Automobile and Other Transportation

A *transportation* deduction, for instance, is entirely different from a *travel* deduction. Whereas the former refers to commuting, the latter refers to trips made farther away from home, and usually pertaining to overnight stays.

Commuting expenses are not deductible. Commuting from your home to a studio, for instance, whether it is accomplished via car or subway, is considered a personal expense. If you have an assignment that obliges you to travel away from home or office, but still allows you to return that same day or night, you can deduct the costs of transportation, including taxis, trains, planes, buses, or

rickshaws, but not meals or other travel expenses listed earlier.

If you use your vehicle for both business and personal purposes, you can deduct expenses corresponding to the percentage of use it receives for business. You can use the number of miles driven to make the calculation. For instance, if you drove a van 20,000 miles during the year, 16,000 miles transporting camera gear to locations and 4,000 miles for a personal vacation, you can claim only 80 percent (16,000 ÷ 20,000) of the total cost of operating your van as a business expense.

Standard Mileage Rate

Instead of figuring actual expenses, you may want to use the IRS's *standard mileage rate* to calculate the deductible costs of operating your vehicle for business purposes. You may use the standard mileage rate for owned and leased vehicles alike. It refers to a specified sum of money that may be deducted for each business mile you drive. The rate is published annually by the IRS (usually around 33¢ per mile). To figure your deduction, multiply your *business* miles by the standard mileage rate for the year.

If you use the standard mileage rate, you cannot deduct *actual* expenses, as described above. However, you may be able to deduct business-related parking fees, tolls, interest on your car loan, and certain state and local taxes. If you decide to use the standard mileage rate for a vehicle you own, you must choose to do so within the first year the vehicle is available for use by your business. In later years, you can choose between either the standard mileage rate or actual expenses. If you want to use the standard mileage rate for a leased vehicle, you must use it for the entire lease period.

Generally speaking, if you use your car for business purposes 50 percent of the time, you can probably deduct half of your mileage, multiplied by whatever rate the IRS currently stipulates, along with interest payments on your car loan, parking costs, tolls, state and local registration and taxes, and any existing investment credit. You may not deduct the cost of gasoline though. If you lease a car, you can deduct the entire cost of the lease if the vehicle in question is used exclusively for business.

There is an alternative to the standard mileage deduction described above. You can depreciate your car as a capital asset over three years and keep track of gas and oil, repairs, licenses, and insurance. Take whichever deduction your accountant shows you will give you the bigger deduction.

Deductions for Entertainment and Business Gifts

Entertainment, in this context, means providing amusement or recreation for clients. Examples include diversions at nightclubs, social and athletic clubs, theaters, sports events, yacht charters, hunting and fishing trips, and similar activities. It may also include accommodating the personal needs of individuals, such as providing meals, a hotel suite, or even a car to clients or their families. With some exceptions, as noted later in this chapter, a 50 percent limit applies to deductions for entertainment expenses.

Meals as Entertainment

Entertainment includes the cost of meals you provide to clients, whether they are incidental to other entertainment or not. The cost of a meal includes food, beverages, taxes, and tips. To deduct an entertainment-related meal, you, or your employee, must be present when the food or beverages are served.

You cannot claim the cost of your meal both as an entertainment expense *and* as a travel expense. Pick one or the other. Furthermore, meals purchased in the normal course of doing business, such as lunch during a shoot not involving travel, are not considered entertainment by the IRS. It's another matter, however, if you have to hire a caterer to serve the models, client representatives, and crew. That's 100 percent deductible.

Meal expenses are *not* deductible when a group of photographers, or even groups of photographers accompanied by clients, take turns picking up each others' checks without regard to whether any business purposes are satisfied.

Extravagant Entertainment

You may not deduct extravagant entertainment expenses, i.e., those lavish beyond your apparent means. You are within bounds if the deduction seems reasonable considering your particular circumstances and income. A deduction will not be disallowed simply because it exceeds a predetermined dollar amount or because the entertaining

took place at a deluxe restaurant, hotel, club, or resort. Just use good judgment.

Mixing Business with Pleasure

If you happen to be entertaining both business and nonbusiness associates at the same time, you must separate your expenses, deducting only the business part. If you cannot figure out what fraction is attributable to whom, it's okay to allocate the expense to each participant on a pro rata basis.

For example, if you entertain a group of people including four potential buyers, two social guests, and yourself, that represents a total of seven individuals. Excluding your two friends, only five-sevenths ($5/7$) of the expense qualifies as business entertainment.

Deductions for Trade Conferences

You may deduct entertainment expenses that are directly related to and necessary for attending business meetings or conventions. These expenses are subject to the 50 percent limit on entertainment expenses.

Deductions for Tickets to Events

You may not deduct more than the face value of a ticket purchased for entertainment purposes, even if you paid a higher price. That means you cannot deduct service fees paid to ticket agencies, and you certainly can't deduct anything extra paid to a scalper.

Different rules apply when the cost of a ticket benefits a qualified charitable organization. You can deduct the full cost of the ticket, even if it is more than face value, if all of the following conditions apply:

> The purpose of the event is to benefit a qualified charity
> The entire net proceeds go to the charity
> The event uses volunteers to perform substantially all the event's work
> You are, indeed, entertaining clients

Again, there is an exception. Suppose you bought two tickets to a college basketball game through a broker, paying a 20 percent commission above face value. After a business meeting, you take your client to the game. Both colleges playing ball qualify as charitable organizations, and they receive the net proceeds of ticket sales. However, the colleges also pay coaches and recruiters to perform services, so you can only deduct the face value of the tickets. You can forget about what you had to pay the broker. Your deduction is also subject to the 50 percent limit.

The 50 Percent Limit on Deductions

For the most part, you may deduct only 50 percent of any business-related meal or entertainment expense. This limit applies to your employees, as well as to any independent contractors you hire who incur expenses on your behalf. If you are a sole proprietor, the limit still applies to you personally.

The 50 percent limit applies to business meals or entertainment expenses you have while:

> Traveling away from home (whether dining alone or with others) on business
> Entertaining customers at your place of business, a restaurant, or any other location
> Attending a business convention, reception, business meeting, or dining at a club

note The 50 percent limit on entertainment does not apply to any expense related to a package deal, one that might include a ticket to a charitable event.

Deductions for Advertising Expenses

You are not subject to the 50 percent limit if you provide meals, entertainment, or recreational facilities to the general public as a means of advertising or promoting goodwill in the community. For example, the expense of sponsoring a Little League ball game is completely deductible. So is the expense of distributing free food and beverages to the general public. So is the cost of a double-page spread in a photo sourcebook.

You may deduct parties to celebrate the opening of your new studio or the publication of a book. You may deduct 100 percent of the cost of promo pieces and the postage for mailing them. You may also deduct the cost of gifts to as many clients as you wish, as long as the cost of each one doesn't exceed the exorbitant amount of $25.

Deductions for Charitable Contributions

Charitable donations are tax deductible. You must fill out Section A of IRS Form 8283, *Non-Cash Charitable Contributions*, if your total deduction for all non-cash contributions is greater than $500. If you make a contribution of non-cash property worth more than $5,000, generally an appraisal must be done. In that case, you must also fill out Section B of Form 8283. For contributions of $250 or more, you may claim a deduction only if you obtain a written receipt from a qualified organization.

There is an unfair twist to this part that pertains to copyright law. If you are the creator of a donated item, the amount of your deduction is limited to the actual cost you incurred to create it. That means if you donate a print to a museum and that print cost $15 to make, you may only deduct $15. Under that IRS criterion, a picture frame is often worth more than the artwork itself. What's really unfair is that if you sell your print for $1,000 to a collector who turns around and donates it to the same museum, he can write off the full $1,000 plus the cost of the frame.

For more details about charitable contribution deductions, refer to the IRS Web page on this topic[16] or the IRS's Publication 526, *Charitable Contributions*.

note One of the most serendipitous deductions of all is the cost of a financial advisor or a CPA to show you how best to manage your money. If you're a business owner, tax preparation fees can be deducted as business expenses, possibly not only reducing your income tax, but your Social Security and Medicare taxes, too.

Deductions for Retirement Accounts

The IRS encourages self-employed, small business owners to sock away part of their income for retirement by offering significant tax advantages in exchange. Both you and your employees, if any, may benefit from either of several different kinds of retirement investment accounts. The three most common plans available are:

> The 401(k)
> The Individual Retirement Arrangement
> The Keogh Plan

The government encourages these plans so that small businesses will provide the same economic and retirement benefits for their employees as for their owners. A more detailed description of these plans is provided later in this Part in chapter 40, Human Resources.

Self-Employment Tax

If you are a sole proprietor, partner, or LLC member (i.e., are self-employed), you must pay a Social Security and Medicare tax to be eligible for benefits when you retire or become disabled. This is not an option. You cannot elect *not* to accept Social Security, because the payments you make now help finance the entire system, allowing the government to pay current retirees. The amount you pay into the system may also affect the dollar amount of your benefits later.

The self-employment tax rate is 15.3 percent. It consists of two parts:

> 12.4 percent for Social Security (old age, survivors, and disability insurance)
> 2.9 percent for Medicare (hospital insurance)

As of this writing, only the first $80,200 of your net earnings is subject to the 12.4 percent Social Security part of the self-employment tax. All your earnings are subject to the 2.9 percent Medicare part of the tax. This tax is figured on Schedule SE, *Computation of Social Security Self-Employment Tax*. Once you have computed your tax liability based on your *adjusted gross income*,[17] you can deduct 50 percent of your self-employment tax. This deduction only affects your income tax, not your net earnings from self-employment. That means you deduct it from the amount of tax you owe, not your total net income before the tax is computed.

Income Averaging

If, after your first year in business, your income climbs steeply the next, you'll find yourself in a higher tax bracket. That's the kind of problem you *hope* to have, even though it increases your tax liability substantially. On the other hand, you might have made large profits three years in a row, only to lose revenue for the following two years. In the past, the IRS allowed taxpayers to average the bad years

with the better ones over a five-year stretch. It helped keep you in a lower tax bracket. Unfortunately, the IRS discontinued that practice in 1986 for most people (except ranchers and farmers). The tax laws may change again. They often do. Talk to your CPA for further advice.

How Long To Keep Records and Receipts

Generally, you must keep records that support your income and deductions for three years from the date you file a tax return for the items in question. A return filed early is considered filed on the later due date. Of course, if you either fail to file a return or file a fraudulent return, there is no statute of limitation on retention.

Some additional retention guidelines are listed below. The periods indicated begin with the filing of applicable tax returns:

- ▸ Permanent Retention
 - Year-end financial statements
 - Federal, state, and local income tax returns
 - General ledger
 - Books of original entry
 - Cancelled checks for income tax payments
 - Sales and use tax returns
 - Pension and profit-sharing plan and trust agreements, financial statements of plan, actuarial reports, Internal Revenue Service approval letters, associated ledgers and journals, and plan tax returns
 - Corporate records, including articles of incorporation, bylaws, capital stock records, contracts and agreements, copyrights and trademark registrations, legal correspondence, and minutes
- ▸ Six Years
 - Insurance records, including accident reports, fire inspection reports, group disability records, etc.
 - Mortgages and note agreements
 - Detailed accounts receivable and accounts payable records
- ▸ Four Years
 - Employee payroll records, including W-2, W-4, annual earnings records, etc.
 - Payroll tax returns, including cancelled checks for the payment of payroll taxes

- ▸ Three Years
 - Bank statements and bank deposit slips
 - Miscellaneous cancelled checks
 - Interim financial statements
 - Inventory lists
 - Sales invoices and cash register tapes
 - Purchase invoices
 - Petty cash vouchers
 - Time cards
 - Personnel files
 - Employee expense reports
 - Freight bills
 - Settled insurance claims
- ▸ Two years
 - Budgets
 - Cash projections

Proof of Professional Status

How does the government distinguish between a business and a hobby? Generally, a hobby is an activity for personal pleasure or recreation. It is not pursued with the intention of making a profit. If you are a pro, you can still have fun, but you are certainly trying to make a profit.

It was alluded to in part 1 that if you pursue the activities of a photographer, but can't seem to make any money at it, the IRS could classify you as a hobbyist instead of a professional. That would do more than simply rain on your parade. It would disallow any deductions related to photography from your income tax liability. But if you follow the precepts in this book, it should never come to that. Furthermore, just about any accountant or attorney worth his salt should be able to help you prove your professionalism, even if you find yourself in a pickle with the IRS. Nonetheless, you should be personally aware of the specific criteria the IRS uses to assume its villainous role in this predicament.

There is no presumption of hobbyist status just because you've been unprofitable. The main test is: Did you *intend* to make a profit? There is, however, an automatic presumption of professional status if you have earned a profit in three out of five adjacent years. If you fail to do this, the IRS looks at nine questions to clarify your status. No single one of them can disprove your professionalism; they are examined together:

> *Do you carry on the activity in a businesslike manner?* Good record keeping, including bookkeeping methods, is a key criterion. Membership in a professional trade associate is another good indication.

> *Do the time and effort you put into the activity indicate that you intend to make it profitable?* The IRS will look at the marketing activities you have pursued. These are a good indication of professionalism. If you can show that you either have or are looking for an agent, whether for personal representation or for gallery and stock photo sales, it will be looked at as an intent to market your work.

> *Do you depend on income from the activity for your livelihood?*

> *Are your losses due to circumstances beyond your control, or, alternatively, are they normal in the start-up phase of your type of business?*

> *Do you change your methods of operation in an attempt to improve profitability?*

> *Do you, or your advisors, have the knowledge needed to carry on the activity as a successful business?* Your portfolio and your résumé will certainly indicate your expertise. If you are represented in an audit by your accountant or attorney, that speaks for itself (and they should certainly speak for themselves).

> *Were you successful in making a profit in similar activities in the past?*

> *Does the activity make a profit in some years, and how much?* New businesses are likely to lose money at first. That is to be expected. The IRS wants to see that losses are getting smaller and revenue is gradually increasing.

> *Do you have a reasonable expectation to make future profits from the appreciation of assets used in the activity?* By extension, that might include the assets you create, i.e., copyrights to stock photos in your archive and original, limited edition prints.

Withholding Taxes and Payroll Services

Have you ever been an employee? Do you remember receiving your first paycheck? You may recall being shocked when you first saw that the amount of the check was less than you expected. In fact, the pay stub indicated that your employer withheld significant amounts of money on behalf of the federal and state governments. Employers are required by law to, in effect, force you to pay taxes incrementally as you earn income. The IRS colloquially refers to this withholding practice as "pay-as-you-earn" taxation.

Withholding is necessary for the government to manage its own cash flow. Employees are credited for withheld taxes against the actual totals they calculate when they file their annual returns. If one earns more than expected, additional taxes are owed. If one earns less, then a refund is usually in order.

If you plan to have any employees at all, even only one other than yourself, you will have to withhold taxes and deposit them with the appropriate government agencies. For specifics, as with all other revenue- and tax-related matters, you should discuss withholding with a CPA. This text is does not offer specific tax or legal advice.

The taxes you are required to withhold, as well as those you are required to pay directly, are generally called payroll taxes. They include federal, state, and sometimes, local income taxes, as well as Social Security and Medicare taxes. They may include federal and state unemployment taxes, too. In some states, disability insurance taxes are included. Your accountant will either have to set up a payroll accounting system for you (or your bookkeeper) or help you enlist an outside payroll service to take care of payroll tax deposits, filings, and W-2 forms.

IRS Form W-2 is used to report payroll information to your employees at the end of each year. As an employer, you must furnish each person you employed during the year with a copy of his Form W-2. Employees need W-2s to document their income. Information reported on Form W-2 includes:

> Wages, tips and other compensation
> Federal income tax withheld
> Social Security tax withheld
> Medicare tax withheld
> State income tax withheld

Your final responsibility is a requirement to send IRS Form 1099 to every independent contractor to whom you have paid $600 (as of this writing) or more in any given tax year. That figure may change. As always, check with your accountant. Employees do not receive 1099s.

Doing payroll is a rather complex responsibility for solo practitioners like you to handle, although computer software is available to make the task easier. But the IRS isn't known for allowing excuses if you make a mistake. About one out of every three businesses pays a penalty each year for mistaken payroll tax reporting. Any one of a number of companies that specialize in payroll processing can help you avoid penalties by taking over your payroll duties. Some payroll processing services guarantee their work by offering to pay any penalties attributable to their own error.

Think about this: It's the day of a big shoot and, coincidentally, the same day that employee-with-holding payments are due to the government. Who is going to prepare a remittance statement and a check, or will you be paying a fine later? If you find yourself lax in your payroll responsibilities, the fine you pay might equal what you would have had to pay a payroll company to do the work for you in the first place.

A payroll service generally offers the following services:

> Computing and preparing payroll checks for your employees
> Preparing federal and state payroll tax deposits
> Seeing that you make them on time
> Preparing federal and state payroll reporting forms, including W-2s

Reporting State Sales and Use Taxes

You learned how to invoice your clients for sales and use tax in part 6. However, once you've collected the tax, you still have to file a return and remit the funds to the proper tax authority.

Each one of the forty-five states that imposes a sales tax has its own forms and deadlines.[18] While the forms all look different, the information they require is uniform. That's where PhotoByte comes in.

Because you've submitted invoices to your clients created with PhotoByte, your sales tax reporting chores are, for the most part, already done. You don't even need a bookkeeper to tell you what the numbers are. PhotoByte has done all the number crunching in the background. All you have to do is copy the numbers onto your state form and mail it in (usually with a check, of course).

EXERCISE -----------------------------------

Creating a Sales Tax Report

The fact that one or more invoices exist, because you had to create them to get paid, means that your sales tax report is virtually done already.

> From the Main Menu, click the *Sales Reports* button.
> Then, click the *Sales Tax & Revenue* button in the right column.

You will see the Sales Tax & Gross Revenue Screen.

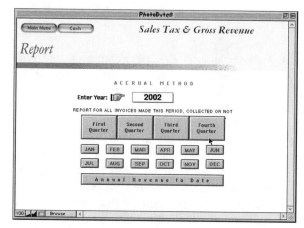

In order to accommodate this example with sample data, you will examine sales from the fourth quarter of the year 2000.

> Click the *Enter Year* button, and hold down your mouse button to reset the year to **2000**.

> Next, click the *Fourth Quarter* button.

Then, you will see a report that looks like this:

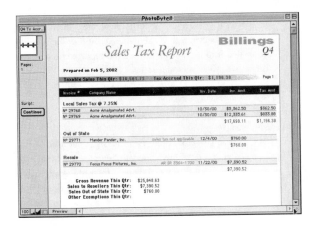

> ‣ Click the *Continue* button to go to the Print dialogue box and make a hard copy.

The following information is clearly available for you to transpose to your particular state's sales tax reporting form:

> ‣ Taxable Sales This Quarter—sales on which sales tax applies
> ‣ Tax Accrued This Quarter—amount of tax collected, or the amount you are responsible to pay the government
> ‣ Gross Revenue This Quarter—total amount of money collected, including nontaxable sales
> ‣ Sales to Resellers This Quarter—sales exempt from sales tax, if you have a resale certificate on file
> ‣ Sales Out-of-State This Quarter—you must be able to prove out-of-state delivery with a postal receipt
> ‣ Other Exemptions This Quarter—includes government and foreign sales

Of course, you have a complete breakdown of billings, invoice by invoice, too.

Legally Avoiding Sales Tax Payments

If you want to legally avoid paying sales tax on professional supplies, you must provide proof to your vendors that you are a legitimate reseller. (See Obtaining a Reseller's Permit in chapter, 7, part 3, Starting a Photo Business.) You can't blame merchants for demanding proof.[19] You must be just as stern with your own clients, because you are vending products and services to them. You, too, are a merchant. That means you must demand a resale

card from every one of your clients who claims a sales tax exemption. There are no exceptions.

Conversely, some of your clients might be resellers themselves, with the same obligation to pass along sales taxes to third parties. (It's the end user, the "last guy out of the pool," who gets stuck paying the tax.) If your clients are certified resellers, you do not have to bill them for sales tax when you invoice them. But they cannot legitimately refuse to pay the tax—and you are still legally bound to bill it, collect it, and remit it—unless they provide you with a reseller's number on a signed resale certificate, promising to pass along the tax to their own end users.

EXERCISE ---------------------------------

Creating a Reseller's Card

> ‣ From the Main Menu, click the *Preferences* button.
> ‣ On the next screen, click the *Legalese* button at the bottom of the left column.
> ‣ Click the *Resellers' Cards* button, bottom right column of the next screen.

You'll see the screen illustrated below. It should already show your company name.

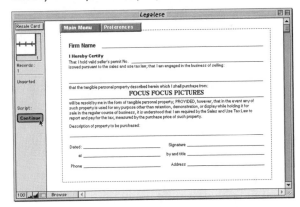

> ‣ Click the *Continue* button, which will display your printer's dialogue box, where you may specify as many copies as you wish to print. Each one of your tax-paying clients should be given a copy to fill out, sign, and *return to you*. The client does not need to keep a copy (but may, of course, be allowed to do so).

note This card is based on the California version. Ask your accountant or an official of your state tax bureau if this

**version will suffice. This form is provided within Photo-
Byte as a convenience.**

As a vendor, you are responsible for ensuring that your clients' resale certificates are valid and properly filled out. You can verify the authenticity of a reseller's permit number over the Web in some states by linking to the site representing the state tax board.

Complete specifications for the reporting of sales and use taxes by photographers in the State of California are explained in an official publication available at the following Web site: *www.boe.ca.gov/ pdf/pub68.pdf*. It should provide a useful example for other states.

NOTES

8 Instructions for filing your taxes electronically with the IRS and a list of software products that support this procedure are available at these Web sites, respectively: *www.irs.gov/elec_svs/ss-pin.html* and *www.irs.gov/elec_svs/ company.html*.

9 As it has been advised throughout this book, you should have a separate bank account for your business, as well as a personal account, whether you incorporate or not.

However, if you are not incorporated, the IRS makes no distinction between these separate accounts. The income deposited into both of them must be reported on a single tax return, your personal 1040.

10 See: *www.macfdn.org/programs/fel/fel_overview.htm*.

11 See: *www.irs.gov/taxi/*.

12 See: *http://ftp.fedworld.gov/pub/irs-pdf/p587.pdf*.

13 See: *www.irs.gov/taxi/*.

14 See: *www.irs.gov/prod/forms_pubs/pubs/p463toc.htm*.

15 Usually, an 8" × 10" envelope will be optimal. If that size envelope will not fit through your printer, the Avery Label Company makes self-adhesive labels that large that will work with your printer. They are available at almost any stationer.

16 See: *www.irs.ustreas.gov/tax_edu/teletax/tc506.html*.

17 Adjusted gross income means all the revenue you've received minus adjustments allowed by the tax code. Adjustments allowed change over time, but currently, individual retirement account contributions, alimony paid, a portion of a self-employed individual's medical insurance and social security tax are examples of allowed adjustments.

18 The following Web site is a resource from which you may obtain the sales tax forms from every state (or, at least, see what they look like): *www.taxadmin.org/fta/forms.ssi*.

19 Here is an example of reseller's certificate from the State of California and all the corresponding legalese: *www.boe. ca.gov/pdf/reg1668.pdf*.

39

Working with Suppliers and Vendors

You, together with your vendors, service providers, and independent contractors, are involved in strategic and synergetic relationships, as described in part 3. This informal network of suppliers and support personnel is critically important to the successful operation of a business.

Outsourcing

Generally speaking, few commercial photographers find it profitable anymore to process their own film, make prints in the darkroom, or to do any kind of retouching or photo finishing, digitally or otherwise. They consider their time better spent shooting pictures and conducting marketing activities aimed at procuring assignments. While that is often the most prudent strategy economically, it doesn't mean that you shouldn't process your own film if you enjoy doing it or that it isn't possible to make money performing such activities. But for the most part, when film has to be processed, when prints must be made, or when a Photoshop™ file must be "tweaked," most commercial photographers routinely turn such jobs over to either a commercial photo lab or a digital service bureau.

In business, the practice of hiring a third party to help out with production tasks is called *outsourcing*. When you hire freelance stylists, assistants, and location scouts, you are outsourcing. In fact, there is almost always some outsourcing involved in every assignment. But sometimes the reason to hire outside help isn't solely because you can't do the work yourself. Outsourcing can be a source of revenue and a profit center.

Just by sending your film to a lab, you avoid the necessity of investing reserve capital in all that expensive plumbing and hardware to outfit a darkroom. You don't need to rent any extra space or invest any time either—yours or a paid assistant's—to do the work. You can reduce your overhead costs and still maintain the prerogative to charge your client a profitable markup on the cost of processing film and digital images.

Billing clients more than what you pay the lab is no less ethical than charging a fee to cover the overhead of operating a lab within your own studio. It is not only your right, but your responsibility to do so. In the same sense, when you hire a production staff or a photo assistant, you are working with independent contractors, not employees, so you have a right to mark up their fees, too. That further contributes to the profitability of your business by avoid-

ing the extra costs of employee health insurance premiums and payroll tax accounting services. In short, you can make more money.

If you decide to look into the possibility of making a cash investment to set up your own in-house digital service bureau or even a chemical-based photo lab, you might find that the cost of time, labor, equipment, space, and material is higher than the cost of farming it out. To cover the overhead of an in-house lab and still make a profit, you might have to charge more than what your clients are willing to pay. That means your competitiveness will suffer, and you will have to lower your prices. That could jeopardize profitability. If you lower your prices too much, to the point of making too little or no profit at all, you'll be giving your clients a free ride, subsidizing their costs.

But, you say, many advertisers and designers expect jobs to be delivered in digital format these days. That's true. But it is also irrelevant. They don't usually expect photographers to deliver raw, unprocessed film either. They expect prints or transparencies to be delivered as the final product. They are certainly used to being billed for lab services, even though it is implicit that they were outsourced to a commercial photo lab or service bureau. That is standard procedure. That is a trade practice.

Actually, it is none of the client's business to know whether you outsourced a service or performed it in-house. (Do you think that General Motors makes all the parts in the cars it sells?) Your only obligation is to deliver high quality products and services at reasonable prices. Whichever method allows your business to earn the most profit is ultimately the only criterion that you should use to determine whether to outsource or not. As Andrew Carnegie once said, "Keep an eye on the costs; the profits will take care of themselves." Your responsibility is to your business, to keep costs as low as possible and profit margins as high as possible.

Keeping costs low and profits high is a balance you will have to learn to maintain. Said another way, you will probably win more assignments if you have the best prices. *But even if you charge less than the competition, you should still be making at least as much profit as they are, if not more.* You don't have to lower your *salary* (i.e., assignment fees) to compete effectively.

Even if you decide to outsource the photo finishing of film and prints, just to cite one example, you will be held personally responsible by your clients for the quality of the work. This responsibility must not be taken lightly. Your reputation hinges on it. A cordial, professional, and direct means of communication must be worked out between you and the people responsible for doing all this behind-the-scenes work on your behalf. Therefore, discriminate when choosing your service providers. Be as careful as if you were choosing your own employees. Examine all the choices carefully before you pick a vendor or service provider. You may find, for example, that one lab is better at souping film, while another is better at making prints. And don't forget to include the way you are treated as a major criterion.

Give your business to vendors who understand the importance of your creative work and are consistently willing to go the extra mile to help you meet the needs of your clients. Do they call you right away if something goes wrong? Do they pick up and deliver? Are they easy to work with? Do they answer questions clearly? You will discover that the people working behind the counters, the individuals who take your orders, those with whom you most often communicate, are some of the most important people to your career.

Customer service is not a pleasantry; it is a necessity. From camera store to digital service bureau to film lab, work only with those who are as eager to satisfy you as you are eager to please your own customers.

Buying from Local Vendors versus E-Commerce

It only makes good sense to look for the best price when shopping for photo equipment. Mail-order vendors typically sell for less than local camera stores. Nevertheless, don't put a premium on price when it competes with good service. You will sometimes—but not always—find that the savings in price you might get from an impersonal mail order or online transaction does not compensate for the keen interest another business owner, such as your local camera store proprietor, can take in your own success. He realizes not only that happy customers make good customers, but successful customers have more money to spend. You're not likely to get

an online vendor to let you try before you buy or help you locate something hard-to-find that you *really* need.

The money you spend in a friend's store is an expression of your appreciation for a mutually beneficial relationship. You cannot expect this kind of service if you are not willing to invest in it. That said, when efficiency and price are factors that will have an effect on your cash flow and bottom line profitability, your decision must be a prudent one.

40

Human Resources

If you can think of an esoteric need, from a mobile dressing room with toilets to a pyrotechnics expert, there's someone out there who runs a business that specializes in fulfilling that need. Such experts charge a range of fees, based on their credentials, and they may bill either by the day or by the project. If your project is complex, it is best to assemble your production crew early and include them in the planning stages, well before the execution of your shoot. That way you can take full advantage of their expertise and advice. Incidentally, even administrative specialists may be hired on an as-needed basis. Now you must learn how to inaugurate relationships with these invaluable professional practitioners.[20]

Stylists and Special Service Providers

The job of a stylist is to help you solve every conceivable kind of creative problem that doesn't have to do with the camera itself. You may require the services of someone to cook and set the table for a meal that *looks* good enough to eat, or a model-maker who can re-create the *Titanic* in your studio. You may need wardrobe for a Roman centurion, an astronaut, a western desperado, or a ballerina. You may need to create a dense ground fog in a desert environment. In fact, you don't yet know what you'll need on the set. But you sure need to be prepared for every possible contingency that can fall into your lap. To that end there are stylists (e.g., makeup, food, props, and wardrobe), model builders, set designers, location scouts and permit finders, casting agents, animal wranglers, special effects wizards, and—you name it!—for any imaginable situation, and then some. Whatever you can see in your mind's eye, they can make it look real on film. It's your job to know where to find them, because they can make or break your shoot. (See Finding Freelance Personnel below.)

Incidentally, you will discover that photo-illustrators who work on large-scale location and studio productions are not the only kind of photographers who find stylists indispensable; even a typical news-magazine shooter will need a make-up artist, a prop, or a special effect at one time or another to turn an ordinary photo into a prize winner.

Production Managers

A good production manager (also called a producer) has a knack for anticipating and solving the most difficult and unexpected problems that arise in pre-

production, on a set during a shoot, and in post-production too. He is like the assistant director on a movie set. He reports directly to you.[21]

Whether a production manager becomes a full-time employee or is contracted on an as-needed basis depends on the volume and complexity of the work flowing through your enterprise (or studio). Even though you may seldom need a producer, don't rule out the idea if suddenly your shooting schedule heats up. Even a freelance producer, hired for one big shoot, can coordinate the hiring of additional crew members, book travel, cast models, and obtain location permits while freeing you from these distractions. Some producers may even double as camera assistants.

Finding Freelance Personnel

Creative directories fulfill the role of a specialized yellow pages used by photographers and other industry professionals to locate personnel and support services expressly for film, video, and still photo productions. Any service provider can obtain a free listing, as these books generate revenue for their publishers through retail sales and advertising. But you will see that some stylists and other service providers pay for self-promotional advertising layouts to stand out from the crowd.

Directories provide contact information (names, addresses, telephone numbers, Web sites) for all kinds of production services, from makeup stylists to location scouts and casting agents. They are updated annually. Some are limited to specific geographic areas or media. The best place to obtain one, or just to look through one, is to ask at your local professional camera store. Read the photo trade magazines, too; they often list a variety of nationally available directories. They may even publish their own directories online. One such example is *PDN*'s *PDN Online PhotoSource*.[22]

Working with Photo Assistants

Freelance assistants are usually trying to become professional photographers themselves. Often, they are just out of school and still learning their trade. For the best of them, assisting is an apprenticeship, not a way to make a living. They'll assist established pros for a year or two—or three—and then go into

business on their own. These soon-to-be professionals are vital to your business. Don't think of them as mules hired merely to lug and load your cameras; they will often be a sounding board for your creative ideas. They will make your job easier in all respects. Treat them well.

Mentoring Assistants

What there is to running a photo business is explained right here in this book. There are no secrets. It's silly to try to hide information from an assistant, even about pricing and accounts receivable information. In fact, the more your assistant knows about how to price himself in the market intelligently, assuming you are astute in that department yourself, the less harm he will do to you as a competitor when he goes out on his own. You've got nothing to lose by mentoring a talented assistant, helping him to become a competent professional. It can only help to have one more photographer out there working ethically, one who is not likely to undercut you.

Paying Assistants

Assistants work for assignment fees, usually a flat fee for an eight-hour day. Like you, they can demand as much as they can get. Assistant's fees, for all practical purposes, however, are governed more strictly by the prevailing market price, because there is no basis for negotiations based on usage. And, don't forget that assisting shouldn't be considered a way to make a living, but a way to provide a stipend for an ambitious, future pro to learn the trade. It allows aspiring photographers to gain experience by working in the trenches under fire.

Pay your assistants a reasonable fee. Pay them as well as you can. But remember, still, that they are a cost to your business. You have to keep your costs down and your profits high. You should always mark up your assistant's fees as billed expenses to your clients.

Unlike a pro photographer, it is traditional for an assistant to bill in half-day increments, especially if, on any given day, he is put to work preparing for a forthcoming shoot or running errands. However, you should respect the prerogative of any assistant who refuses half days on the premise that he has set aside an entire work day at your disposal. Some assistants will bill you for overtime by the hour if a shoot lasts

longer than eight or ten hours. This, too, is reasonable. But these terms should be clarified ahead of time. Whatever financial arrangements your assistants make with you, bear in mind that they are not working under the same profit imperative that governs your business, unless they have become full-time, career photo assistants. There are few assistants who fall into that category. If you find one, you must decide if that arrangement works for you.

Choosing Assistants

Photographers use different criteria for picking assistants. Some want to know that an assistant is a talented shooter in his own right, so they'll ask to see a portfolio. Some couldn't care less if the assistant knows which end of a camera to look through, as long as he has a strong back and can take orders. Others will choose an assistant with a particular knack for lighting, because they lack that experience themselves.

By the way, if you decide to assist before starting your own business, that's not the ideal kind of person to work for—the kind who would exploit you for the expertise he lacks—unless there is something else he can teach you. That kind of photographer will lean on his assistants to compensate for his own lack of talent. But who knows? If he's really good at finding jobs, maybe you can take over the shooting responsibilities and partner with him as your business manager. At least, you should ask for a lot more money during your stint as an assistant.

Finding Assistants

If you are hiring assistants, you should expect them to have a reasonable amount of technical competence and familiarity with various types of photographic equipment. They will have either taught themselves or learned it in school. But while you should expect some degree of skill, don't be completely averse to hiring someone with little experience if they show an eagerness to work hard and to learn. It may be worth your while to train someone like that to use and set up your equipment just the way you like things done. There are lots of resourceful and ambitious people who would like to become photographers, but haven't had an opportunity to study the techniques in school. You might consider negotiating with such a novice assistant to work for a lower fee in exchange for your mentorship and the opportunity to work hands-on with your equipment.

If you don't actually hire one or more assistants as full-time employees, you need to develop a "stable" of assistants you can call on as needed. Once your name gets "out there" as a photographer, you will probably receive regular calls from assistants looking for work anyway. It's not a bad idea, though, to actively search for the best ones yourself. Calling schools and community colleges that offer photo courses is a good place to start looking. Ask to speak with the head of the photo department. He may be able to recommend some excellent people, especially recent graduates. Interview as many candidates as you can, and add the best ones to your list.

The best freelance assistants will be in demand by other photographers, too. If the first one you call is already booked, you have to know who to call next. By keeping a relatively short list of available assistants (e.g., perhaps a dozen names) and continually rotating work between them, at least one of them should be available at any given time, someone who is already familiar with your equipment and with you personally. As the more experienced assistants matriculate into the professional world to become your competitors, you will add new assistants to your list.

If you travel, you will want to develop a network of assistants in other locations, too. A good way to track down assistants outside your home town is to contact members of the APA, ASMP, or PPA in the area you're headed for. Some trade association chapters have compiled lists of assistants for just that purpose. Call the chapter office or look at their Web site. Camera stores near the location site may also be able to recommend some able helpers.

Just because assistants are not yet practicing professionals does not mean they cannot act professionally. Conversely, it does not mean you should treat them with less than the highest professional respect. As for the nagging conundrum of determining whether the IRS will categorize your "freelance" assistants as employees versus independent contractors, you can do any one or more of several things to influence their decision favorably.

Asking your assistants to sign a standard contract will help. If you are going to assist, it's a good idea to have your own contract to submit to each photographer you work for. It also looks good if your assistants bring a set of their own tools to work,

such as an "assistant's kit" consisting of gloves, gaffer's tape, clips, light meter, etc. Each assistant's kit may vary.

In addition to the day rate, you are expected to pay for any costs your assistants incur on the job, i.e., travel, lodging, meals, transportation, and so forth. Of course, these, too, will be billed back to your clients as expenses, often marked up. It's also only fair to pay your assistants right away, without necessarily waiting until you get paid by your clients. You'll earn their loyalty, and, frankly, they need the money.

Earlier it was mentioned that there are no secrets in photography. That's true insofar as techniques and pricing are concerned. There are, however, legitimate trade secrets that need protection, such as a client's new logo or product release date. If you are concerned that legitimate trade secrets may be vulnerable to the scrutiny of freelance assistants who work for one or more of your competitors, you should ask them to sign nondisclosure agreements. Refer to chapter 31 in part 6 for more information on issues of confidentiality.

The Perennial Assistant

Some assistants feel comfortable breaking into the business gradually. They get their feet wet by accepting small assignments, while continuing to assist other photographers. There is an inherent problem with this tactic.

For them, it might seem like the necessary thing to do: keep revenue flowing while trying to start up a business. But if you think about it, any assisting that a person continues to do while trying to become a pro is only a distraction from the responsibilities of running a real business. It is also a poor reflection on one's professional status if one continues to assist legitimate working pros on the side while pretending to be one. And he won't get away with moonlighting jobs for very long. The pros he works for will learn about it. They will stop hiring him.

It seems like some assistants have made it a permanent way of life. If it really is, that should be okay with you. Just be wary about working with assistants who go after commercial assignments, only to return to assisting whenever it's convenient, usually when cash runs out. It's foolish to hire an assistant who is competing with you, especially if he cannot do so successfully.

Some photographers may reason: "Well, he will be competing with me eventually anyway, and I need the help now. I'll just keep him at arm's length, so he won't learn all my secrets." Again, there are no secrets in photography. A good photographer can figure out how just about any shot was made simply by studying the light falling on the subject matter. It's only personal style that makes a difference, along with a capacity for intelligent marketing. You can bet that the assistant who keeps going out and coming back will be a lowballer on price.

It may seem harsh or brutal, but once an assistant has learned the ropes (certainly once he has read a book like this about business practices) and set out to make his mark within the community of working photographers, he has an obligation act in a professional manner. If he does, and he has any talent at all, he will find work without contributing to a decline in market prices. If he can't cut it, he shouldn't *undercut* it. You don't need to be his security blanket.

The Legal Criteria for Employment

As a business owner, you are essentially self-employed. Regardless, you will be considered an *independent contractor* by your clients. "Independent contractor" is just a term for someone who has no legal status as an employee. This distinction is of utmost importance to you, more so in your guise as a business owner than as one who is hired to shoot pictures. You will no doubt be hiring people yourself, either on a full- or part-time basis. To avoid severe financial penalties, you must treat them correctly from the standpoint of the IRS.

In recent years, the IRS has scrutinized the issue of employment status. This scrutiny has become a serious problem for photographers who regularly rely on freelancers to assist them in their work. You can define "freelance" anyway you want, but in order avoid tax problems, you had better use the IRS's definition. Whether the government considers the people you hire employees or independent contractors will affect your administrative responsibilities, your tax burden, and determine whether or not you are legally obligated to provide special benefits to which employees are entitled. You must carefully consider the legal status of the help you hire, even if they all claim to be freelance, independent contractors.

Defining the Status of Hired Help

Is your assistant a freelance worker or an employee? It turns out to be a thornier question than you might think. No matter what you or your assistant believe, the IRS may or may not agree with you. You may have hired a total stranger to assistant for a three-day shoot, never to see him again, but that doesn't mean he was not technically your employee.

Conventional wisdom says that a freelancer is someone you hire on a temporary basis, usually for a specific assignment at a flat fee, and he works for lots of other photographers too. An employee works for one employer at regular hours for regular wages and receives benefits. Employees can be fired, but freelancers—independent contractors—cannot be fired if they were never employees to begin with.

Employees have the right to quit a job at any time without incurring liability. Independent contractors, having agreed to carry out specific tasks, are responsible for completing them satisfactorily. If they screw up, they are exposed to lawsuits; that is, they are legally obligated to make good for any financial damage they may have caused you. Nevertheless, while you may decide not to work with a freelancer again because you don't like the manner in which he carries out his job, he must be paid in full if he produced results that met the specifications of his contract.

An employer must generally withhold and pay taxes on wages paid to employees. One does not, however, withhold or pay any taxes on fees paid to independent contractors. Independent contractors, in fact, do not receive *wages*.

The IRS Criteria for Determining Employee Status

To determine employee versus independent contractor status, the IRS examines the relationship of the work someone performs in the context of the business for which it is performed, in this case photography. The relationship must be clearly defined.

Independent contractors are supposed to be autonomous, to have control over how, where, and when they perform their work. In determining a worker's status as either contractor or employee, all of the evidence regarding his degree of freedom will be taken into account. Such evidence falls into three categories:

‣ Behavioral control
‣ Financial control
‣ Type of relationship between hiring party and worker

Exerting Behavioral Control

Behavioral control covers facts that show whether you have the authority to direct and control how work is performed. If you give instructions or training to the worker, it will be assumed that you have authority over his actions. If a worker is subject to the following kinds of instructions, he is usually classified by the IRS as an employee:

‣ Told when and where to do the work
‣ Told what tools or equipment to use
‣ Told what workers to hire or to assist with the work
‣ Told where to purchase supplies and services
‣ Told what work must be performed by a specified individual
‣ Told what order or sequence to follow
‣ Told when to show up for work
‣ Given training to do the work

The amount of instruction needed varies among different jobs. Even if you give no specific instructions, behavioral control may be deemed by the IRS to exist if you still have the right to control how the results of the work are achieved. To prove independent contractor status, you will probably have to show that you lack the knowledge and capacity to instruct another highly specialized professional. Whereas an employee may be trained to perform services in a particular manner, independent contractors are free to use their own methods. When working with a contractor, your control is limited to accepting or rejecting the final results that an independent contractor achieves. The key criterion is whether you have retained the right to control the details of a worker's performance or if you have given up that right.

Exerting Financial Control

Financial control refers to evidence indicating the extent of your influence over a worker's income. It includes:

> The extent of the worker's unreimbursed business expenses. Independent contractors are more likely to have unreimbursed expenses than employees. Just like you, they have fixed overhead costs that are incurred whether work is currently being done or not. This criterion is especially important to the IRS.

> The extent of a worker's stake in his own business. An independent contractor often has a big investment in the facilities he uses to perform services for someone else. However, a big investment isn't necessary to qualify for independent contractor status. A stylist, or even an assistant, for example, may do his own self-promotion, establish a business identity and structure, and cultivate a list of client photographers. The fact that, say, your assistant has filed a DBA goes a long way toward establishing his status as an independent contractor.

> The extent to which the worker makes his services available to the relevant market. An independent contractor is free to seek out work from as many other photographers as he can. If he's booked up, he can refuse work. He will work as often for your competitors as for you.

> How the worker is paid. An employee is generally guaranteed an hourly, weekly, or monthly wage. This is indication enough of employee status, even when the wage or salary is supplemented by additional revenue from other sources. An independent contractor is usually paid a flat fee for any given job.

> The extent to which a worker can realize a profit and loss. As a sole proprietor or business owner himself, an independent contractor can incur a profit or loss. That is a tax issue that is of no concern to an employee who doesn't own a business.

Influencing the Type of Relationship

Evidence used to determine the type of relationship includes:

> Written contracts describing the relationship the parties intended to create

> The extent to which a worker is available to perform services for other photographers

> The extent to which services performed by the worker are a key aspect your business. If a worker provides services that are a key aspect of your regular business activity, it is more likely that you will have the right to direct and control his activities (see Exerting Behavioral Control above). As a photographer, however, you might argue that the assistant you hire does not actually shoot pictures for you.

> Whether you provide the worker with health and retirement benefits

> The permanency of the relationship. If you engage a worker with the expectation that the relationship will continue indefinitely, rather than for a specific project or period, this is generally considered evidence that your intent was to create an employer-employee relationship.

The IRS looks at all of the above factors as a whole when determining whether a worker is an employee or an independent contractor. The picture isn't always clear. As an employer, you or your company, depending on the business's legal status, will be held liable for taxes that are supposed to be withheld, and if the IRS determines that the assistant you have been paying on a freelance basis is really your *employee*, you are liable for significant penalties. Some photographers have gotten around this problem by executing contracts with their assistants. The contract defines the assistant as an independent contractor stipulating all of the above criteria.

Managing Employees

Now that you understand the difference between independent contractors and employees, there are additional responsibilities to be aware of when dealing on a personal level with the employees you may hire.

Interviewing

When interviewing potential employees—the full-time variety as opposed to freelancers—provide a form for each applicant to fill out. This is one form not currently included in PhotoByte; but you can find an employment application form in any office supply store. You can even download a free template, courtesy of Office Depot, at its Web site.[23]

The form will tell you what kinds of questions to ask applicants. Read it yourself. When you interview a job applicant, be sure to spell out all of the

duties expected of your employees. Do what you can to ensure that you will both be pleased with the arrangement, because it's a lot easier to hire someone than to fire him later. A thorough interview will get most objections out of the way and help you make the right choice of personnel. Incidentally, if you promise someone to make an employment decision within a given deadline, keep your word, not only because it's the considerate thing to do, but so you won't be pestered by frequent callbacks. Finally, make sure you take notes during each interview to attach to the corresponding application, so you can study them carefully at your convenience.

State Your Employment Policy

Provide a written notice, which you can either give to an employee or post publicly somewhere in your office, stating up front what your policy is regarding hours of work, when overtime kicks in and at what rate, vacation and holiday pay (or no pay), sick leave, and performance reviews. There are certain obligations with which you must comply according to state and federal laws, too, including the posting of regulations in a conspicuous area of your workplace, be it a studio or a home-office. Some of these responsibilities, such as obtaining workers' comp insurance (part 2, chapter 8) and submitting payroll taxes (in this part, chapter 38) should be reviewed personally with both your accountant and insurance agent. You must also make it clear to your employees—before you hire them—what job training will be provided and what benefits, if any, will be available. If there are any shared costs—health insurance, for instance—they should be disclosed up front.

Motivating Employees

You should make your employees feel like part of a team, even if there is only one of them. Make sure they understand your goals. Let them read the mission statement from your business plan. It's a good idea to post it, too, not only to motivate employees, but to motivate yourself.

Employees are there to help you. That's what they get paid for. But money is not the only thing they appreciate. Acknowledge the good work they do. Give them more than just a pat on the back, if you can. Reward them for extra effort. The same goes for contractors who do a great job. If you can't

afford to pay your assistants bonuses or to give them raises, give them signed, framed prints or find some other tangible expression of your personal gratitude. Take them to lunch or dinner from time to time. Make sure that their work environment is comfortable. Listen to their suggestions, weigh them carefully, and implement them if they are conducive to increased productivity. If suggestions are not proffered, ask for them. That shows you care.

On a more practical level, you may be obliged to provide more specific benefits to your employees. Read the section on Retirement Plans coming up in this chapter and refer to part 3, chapter 12 about Workers Comp insurance.

Hiring a Full-time Office/Studio Manager

The trick to running a business efficiently when you are busy shooting pictures most of the time is to delegate responsibility. At some point, even with business automation, you may find it necessary to let someone else take over some of the administrative chores. That does not include estimating and billing jobs, unless you have trained someone who truly understands the intricacies of the photo business, someone who knows as much about pricing and the licensing of intellectual property as you do. That person must also be dependable enough—and well paid enough—to stick around for a while. It is not practical to keep training new people for a job of this importance.

If you don't think you can afford to pay for this service full-time, think again about how much it may be costing you *not* to have such help. If you are not shooting at your optimal capacity, but the assignments are out there, then you can't afford to be without help.

A full-time office manager or administrative assistant can help you:

> Answer the phone
> File photographs for retrieval
> Fulfill stock photo requests
> Interview and hire freelance assistants and production crews
> Keep a calendar of appointments and photo productions up-to-date
> Manage direct mailings
> Organize office supplies and inventory
> Perform basic bookkeeping and bill paying

> Research new client prospects
> Ship and drop off portfolios
> Update client database
> Write press releases
> Do your shopping!

To find an office manager, you can place an ad in the local newspaper or post it with an online employment service. Referrals from friends and associates sometimes pan out, too. Retirees reentering the job market are a wonderful resource for the wealth of experience they bring to the job. Finally, community colleges are a promising source of employees, too. But look for someone graduating from the accounting or business department, not the photo department. Save the photo grads for assisting on shoots.

Pay scales vary with experience and expertise. Figure somewhere in the neighborhood of $10 to $20 per hour for competent help. A lower hourly wage may be offset by incentive bonuses and perks, such as you may provide at your discretion. If you share a studio with another photographer, you may also share an office manager—a great way to save on overhead.

Employee Benefits

As discussed earlier, despite the additional administrative headaches, it's likely that you will be required—at least sometimes—to treat your assistants as employees instead of contractors. In many businesses, retirement benefits, which offer employees an opportunity to invest in their own futures and to enjoy the attendant tax advantages offered by the IRS, are a wonderful incentive to attract and, then, retain the highest caliber of people. In the case of photography, however, retaining the long-time services of assistants (i.e., for more than two years) may neither be practical nor desirable; they are itinerant and they often work for a number of different photographers at the same time. Furthermore, it is desirable for assistants to matriculate into the world of professionals shooters themselves—their service being more of a paid apprenticeship than a job. Nevertheless, you may employ lab technicians and studio administrators who more aptly fit the typical employee profile than do photo assistants. That said, if you initiate a retirement plan for yourself, you

may in some cases become legally obligated to offer the same plan to anyone who works for you, including photo assistants.

Setting up and administering an employees' plan will almost certainly require the help of an accountant and, maybe, an attorney too. That will take some time and cost some money. It's not a happy prospect, considering retirement seems to be such a long time away, especially at start-up. But it's prudent to think ahead. And while you're at it, since you still have insurance issues to concern yourself with, you might consider offering the same insurance benefits to future employees too.

Talk over the pros and cons of offering employee benefits with both your insurance agent and your CPA. If you do it early, you won't be slowed down by changes as your business grows. In the end, the tax savings you enjoy both personally and for your business will probably outweigh the inconvenience of administering an employee-benefits package, especially a retirement plan.

Retirement Plans

Administrative details and differences aside, all retirement plans available to self-employed business owners provide the same fundamental benefit: a tax-sheltered savings account. Generally, some of the money you earn in salary is set aside to be invested in various interest- and dividend-earning accounts until you retire. The earnings on your investments as well as the capital amounts invested over time (i.e., that part of your salary periodically set aside) will not be subject to taxation while it remains in the account. Early withdrawals, subject to the age limitation stipulated in a particular plan, are subject to stiff penalties *in addition* to the taxes that would come due.

The following descriptions of specific plans are not complete in every detail. The purpose, here as always, is merely to provide you with a basis for discussion with an accountant or financial planner who is qualified to give you expert advice.

The 401(k) Plan

You may open a 401(k)—named after the section of 1978 tax code that legislated it into existence—whether your business is incorporated or not. If you start a 401(k) for yourself, you must offer the same plan to your employees. You and they may

each contribute a percentage of your salaries. Your accountant will tell you what limitations are currently imposed on the amount of individual contributions. Because contributions are set aside before any taxes are deducted from your salary, your taxable income is reduced by one dollar for every dollar you put into the plan; a sizeable incentive to get you to save. As an employer, you may also, at your discretion, match each employee's contribution either dollar for dollar or by a lesser amount (e.g., fifty cents for each dollar your employee puts in) to receive a corresponding, additional tax savings.

The extra cost and administrative responsibilities can be overwhelming. As a start up, the extra administrative rules and costs might severely hamper your core business. But such a plan makes great sense if your economic circumstances warrant it. For example, for a few thousand dollars to set up a plan and $1,400 a year to administer it, a business owner can put away tax-free in the range of $30,000 per year, which is a $15,000 tax saving if the owner is in the 50% tax bracket. That more than overcomes the cost to start and run the plan, plus the cost of contributions for employees.

With a 401(k) you and your employees are free to decide where to invest your funds. A 401(k) is also portable, so employees may take their accounts with them when they switch jobs. However, if you have been making contributions in kind to your employees 401(k) accounts, there have to be some restrictions imposed to prevent them from walking off with more than they deserve.

No doubt, you've heard the expression "vested interest." When an employee becomes vested in a retirement plan, it means that he has worked long enough to be entitled not only to his personal contributions, but also to those made by the employer—you. However, your plan may not qualify as a 401(k) if it requires that an employee work longer than one year with you before he can avail himself of your contributions to his account. Therefore, due to the itinerancy of photo assistants, a 401(k) might not be the way to go.

Although it's not likely you'll need to concern yourself with septuagenarian assistants, your own 401(k) plan must be paid out, or distributed, to you by the time you reach 70½ years of age. You don't have to withdraw the whole shebang, but you must begin to take out periodic distributions at that time.

All of these kinds of rules, among many others, are required to be written into a formal plan that must be promulgated to employees. As well, periodic reports must be filed with the IRS, the Department of Labor, and the Pension Benefit Guaranty Corporation, while other reports must be furnished to your employees themselves and their beneficiaries.

The (IRA) Individual Retirement Arrangement

Usually referred to by its acronym, an IRA is a personal retirement savings plan that offers tax advantages as well as, in certain cases, benefits for education.

You may open an IRA account whether your business is incorporated or not. With a personal IRA, you are not required to set up corresponding accounts for employees, which might make this a good choice for self-employed photographers just starting out.

Like a 401(k), an IRA provides for tax-deferred savings; however, the set-aside limit for contributions is smaller, and there is no provision for matching contributions from an employer, since that would be yourself. Contributions of up to $3,000 per year, plus additional "catch-up" amounts for people over 50, are allowable.

IRAs are easy to set up. Just walk into any bank, savings and loan, or brokerage house and ask for the forms to fill out. Deposit your contribution into the account, and it will be managed for you by that financial institution.

The rules regarding the timing of your IRA contribution allow you to invest after a tax year has ended, up until the April 15th filing date. You need not contribute every year—in fact, you may skip without penalty— and there is no minimum dollar-amount requirement for contributions. You are still limited by a maximum, overall contribution amount each year, but you are entitled to have more than a single IRA account. You also have the freedom to "roll over" an account. This gives you the freedom—but only once per year—to change your investment strategy by moving your funds from a bank to a stock brokerage, or even within the same institution, from a mutual fund to individual stocks. Penalties still apply, of course, for early withdrawals. Under most circumstances—ask your CPA—you must begin taking distributions from an IRA no

later than April 1st of the year after you reach age 70½, or the year in which you retire, whichever is later. The only real drawback to an IRA compared to a 401(k) is the limitation on how much you can contribute annually.

There are different kinds of IRAs, including *Simple* IRAs, *Roth* IRAs, *education* IRAs, and SEPs (*simplified employee pensions*), under which IRAs can indeed be set up to distribute contributions to your employees. Your CPA will advise you about how to choose the right one.

The Keogh Plan

This plan was named after the congressman who championed its legislation in the early 1960s. It was the first means for self-employed individuals to obtain the same benefits available to employees enrolled in corporate pension plans. If you have a Keogh, you must offer the plan to your employees. But it is not an option if you have a corporate structure in mind for your business.

Like an IRA, a Keogh can be set up under the custodianship of any financial institution, but administering it is considerably more complex, as tangled as any large corporate pension plan. A Keogh is more financially flexible than an IRA though, and is well suited to high income earners. But you can fund both types of accounts at once, if you want to. No doubt, that can boost your tax savings.

With a Keogh, like a 401(k), the amount you may contribute, with commensurate tax savings, is substantially higher than an IRA. Your CPA or financial planner will advise you about how big a percentage of your self-employed earnings may be contributed and what the ceiling is.

There are two types of Keogh plans: *profit sharing* and *money purchase* (known alternatively as *defined benefit* and *defined contribution*). The money-purchase Keogh requires you to open the plan by declaring the percentage of earnings you intend to contribute. You must contribute at the rate you first declared year after year, whether your business does well or not. This seems to make sense only for businesses that maintain steadily growing profitability; again, less likely for start-ups. The profit-sharing Keogh lets you fund a certain percentage of your total self-employed earnings, up to a limited dollar amount. It makes more sense for a photography practice whose profitability is likely to fluctuate.

Like both 401(k)s and IRAs, there are penalties for early withdrawal of funds from a Keogh. You must wait until you are 59½. You are required to begin taking distributions (i.e., withdrawing money) by April 1 of the calendar year after you reach age 70½.

NOTES

20 A list of support-personnel categories appears in Part 3 on page 45

21 See *Secrets of Photo Producers* in *PDN,* November 2000, page 48.

22 See: *http://photosource.netsville.com/pscripts/ps.pl?SEARCH =directories&x=16&y=4.*

23 Go to: *www.officedepot.com/.* Click on the tab marked "Business Tools," then click on "Free Downloadable Forms."

41

Shooting
Assignments

Regardless of what kinds of subject matter you prefer to shoot, the clients who hire you fall into three categories. You will work within one or all of these categories, no matter what your photographic specialty:

> Advertising
> Corporate
> Editorial

Just think of the acronym "ACE." These categories refer not to what you shoot, but to the context in which it will be published, i.e., how each client intends to publish your photos. For example, an editorial client may just as well hire you to shoot a still life illustration as an advertising client may hire you to shoot sports action. Therefore, specialties are useful for describing *what* you shoot, not where it will be published.

These are the titles (with various, minor modifications) of people who buy stock photos and hire photographers to shoot assignments:

> Art buyer
> Art director
> Corporate communications director

> Creative director
> Graphic designer
> Marketing director
> Photo editor
> Public relations director

What It Means to Be an Advertising Photographer

If you intend to shoot advertising assignments, your work will be published in the mass media and used to sell a vast array of products and services manufactured and distributed by corporate clients. While your work will be published right alongside that of editorial shooters, most notably in magazines and newspapers, you may receive higher fees than they do in exchange for giving up additional licensing rights. In other words, clients are willing to pay higher fees for exclusivity, whereas editorial photographers earn less per assignment, but retain more rights to resell later.

Stylistically, the work of an advertising photographer may not differ much from an editorial shooter; but it can. What distinguishes advertising assignments more than anything else from other shoots is that you will usually be asked to follow a

strict layout. Advertising usually involves the illustration of someone else's concept.

Although advertising photography is usually illustrative in nature, some trends dictate that advertisements have an "editorial look." It's a form of contrived spontaneity, a fake realism utilizing models, sets, and props that is required to satisfy the demands of a marketing campaign. As long as it is labeled as such, not to intentionally confuse the viewer (consumer) with genuine editorial content, there is nothing wrong with that ploy.

As an advertising photographer, you may not always work directly for the advertiser. As often as not, you will be hired (as an independent contractor) by a middleman, a large company itself, perhaps, but nonetheless, an agent of the end user of your photos. Indeed, they are called advertising *agencies.* Other times, the advertiser, be it a large company or a small one, may hire you directly.

Within agencies, you must often deal with a hierarchy of management, including art buyers, creative directors, account managers, and art directors. There is also an entire retinue of both client representatives and production subordinates with whom you may have to deal at one time or another during a shoot. Working with smaller agencies and direct advertisers sometimes allows you to work with a single executive who is responsible for the entire project and who may, in turn, allow you more creative latitude. There is less red tape to cut through when there are fewer people to report to. Titles vary, so this person may be called a marketing director, a public relations manager, a corporate communications director, or some other variant on that theme.

Your own marketing efforts may become more focused, too, if one person instead of a committee is responsible for hiring you, overseeing production, and managing an ad campaign. Speaking of marketing, don't overlook the smaller companies, even the *really* small ones. If you land some assignments working directly for the owners of mere retail stores, local manufacturers, and service businesses, they pay the same color of money for usage rights as any Fortune 500 corporation or Madison Avenue ad agency. They may have smaller budgets and require more limited licensing rights (meaning smaller fees), but, if you are adept at sales, you can find enough assignments like that to make up in volume for what revenue and profits you might earn shoot-ing fewer jobs for bigger clients. Don't look at the net result of shooting for smaller clients as working harder for less pay. Instead, the result can be a bigger and, possibly, better portfolio of tear sheets.

A somewhat greater quantity of paperwork is required for a typical advertising assignment than for corporate or editorial work. That stands to reason, because whatever the size of the client or end user, in advertising, there is usually more money on the table and there are more rights to be licensed. That also means more rights to protect. Your clients, too, will be concerned about protecting the proprietary nature of the photos used in their campaigns. Photographers and clients alike put more at risk by agreeing to collaborate on advertising campaigns, which can easily cost tens of millions of dollars when you include the media buy. All the more reason for written agreements. The *t*'s must be crossed and the *i*'s dotted. For instance, you are more likely to need either a Job Confirmation or a Job Change Order, due to the inherent complexity and, sometimes, volatility of an advertising job.

note In part 8, you will perform an exercise that takes you through the "virtual paper trail" for a typical advertising assignment, encompassing most of the paperwork generally required.

What It Means to Be a Corporate Photographer

Corporate assignments have something in common with both advertising and editorial assignments, as far as paperwork is concerned. They have more in common with editorial assignments, as far as freedom of interpretation and execution are concerned. Corporate clients are just as concerned about proprietary rights and branding—or image—as are advertising clients. Therefore, they are willing to pay more to obtain broader publication rights. They are also likely to want to use more photos.

It is less likely that you will be following a layout for corporate assignments. You will usually have as much latitude as with editorial assignments, insofar as relicensing the pictures you create, as long as the subject matter is generic enough to warrant its further demand in the marketplace.

The best-known type of corporate assignment is shooting an annual report. What is an annual

report? By law, every publicly traded corporation (those that sell shares of stock to the public) is required to publish a detailed financial report once each year.[24] Since the late 1950s, when a small group of avant garde graphic artists first inspired a trend, many companies continue to look at this obligation as an opportunity to spruce up their corporate images. They embellish drab financial spreadsheets with well-written narratives about corporate "do-gooding" and financial accomplishments in an illustrated magazine format with lustrous photographs and stylish typography printed on fancy paper. They began by hiring the same photographers who worked for big magazines like *Life*, *Look*, and *National Geographic*. The corporations wanted that glossy look for themselves. It captured peoples' attention. It made great publicity. The trend continues to this day, and the opportunities for talented photographers have grown. But the scope and apparent ostentation of each assignment hinges on the ups and downs of the stock market.

In addition to annual reports, corporations publish capability brochures aimed primarily at their customers, rather than shareholders. Such brochures are as much a part of their marketing campaigns as photographic portfolios are to your own. They range in production quality, size, and circulation from simple product catalogs to hardcover, coffe-table corporate history books. Furthermore, most corporate executives need to distribute "head-shots" to the media. They will often commission freelancers with a history of working in the media themselves to shoot these kinds of portraits, in an effort to control what appears in the press. To stimulate positive press coverage, they will often maintain a public relations, or media affairs, department to generate their own "stories" of special interest to their clients and of general interest to the public at large. They hire photographers to help produce press releases that are regularly sent to publishing outlets, from business magazines to newspapers and television stations. The public relations department will cover special events sponsored by the corporation and try to see that they are published as "news" stories. It's still advertising; it's just "free" advertising, because they don't have to buy media space.

It's not always glamorous work. Many photographers who may never get to shoot an annual report

make a good living by shooting a continuous stream of "grip-and-grin" shots to memorialize corporate events for in-house newsletters. Sometimes an assignment is generated to document a new manufacturing process or to publicize the grand opening of a new assembly plant. But even some of the more appealing and lucrative assignments involve shooting industrial plants and the people who work in them.

A Corporate Sidekick

Always work with an assistant on corporate shoots, especially if you will be shooting executive portraits, and even if you don't think you need one and want to keep your costs down. Without an assistant, by the time you walk into the CEO's office to shake hands and start shooting pictures, he will have already equated you in status with the janitor coming in to change a light bulb. You won't get the kind of cooperation you need to do your best work.

Even if your assistant is there to do no more than to carry a tripod, you will have an opportunity to chat with your subject while the tripod is being set up and while cameras are taken out of a bag and deferentially handed to you. Use this bit of showmanship as an excuse to impress your subject with your knowledge about his company and its achievements. Try to impress him with some of your own accomplishments, too. Let your subject see that you are more than just a hack. Put your best foot forward, and it may lead to further opportunities with this company. CEOs tend to make suggestions about whom they like to work with, the next time they have to be photographed.

How Corporate Clients Use Photography

While broader publication rights are typically required by corporate clients than by editorial clients, they are usually more limited in scope than a typical advertiser might demand. Rarely are buy-outs expected, for instance.

Corporate assignments are often of an extended duration. In the course of a three-week long shoot for an annual report, for instance, you may produce hundreds of usable photographs, not including out-

takes. Typically, clients are entitled to use as many images as they want, as many times as they want, in exchange for your fees. Still, it is routine to limit their use to a duration of one year, or one time, whichever comes first. Photos may be relicensed throughout subsequent years, earning additional revenue for you. Furthermore, as long as you are not divulging any proprietary secrets, you may usually place outtakes in your stock photo catalog immediately.

Working with Graphic Designers as Clients

Because corporate clients want, both literally and figuratively, to create the best images for themselves that they can, they often hire graphic design firms that specialize in creating print periodicals, catalogs, brochures, and multimedia presentations. These are the same people who also create corporate identities, packaging, and logos. They put a consistent and easily recognizable face on corporate communications. All of these activities are aimed at generating positive public relations. In fact, it is just as often that PR firms are hired to oversee the production of corporate print projects. In either case, the intent is to increase the value of a company's stock.

Typically, the plum annual report photo assignments come from within a tightly knit community of designers' studios. They are given full responsibility to produce the annual report, from choosing the right color inks, papers, and typography, to supervising the final press run, as well as hiring the most appropriate photographer. The principal owner of the design firm reports directly to the public relations manager (a.k.a. communications director or some such VP involved with media) of the company that commissioned the annual report. Individual designers report to the principal of the firm. Since photographers are hired and supervised by individual designers, who are essentially art directors, this arrangement is not unlike working for art directors at advertising agencies. Sometimes, but much more rarely than in advertising, you will have to follow a layout.

The larger the corporation, the grander the scope a photographer's assignment may be. These kinds of jobs are plum, because they sometimes entail work lasting many days, or even weeks, at very lucrative rates of pay. They may include large expense accounts and travel to exotic locations in foreign countries. Depending on the specific gravity of the stock market in relation to the economy, designers may be allowed to give carte blanche to the photographers they hire in order to produce the finest and most unusual pictorial results.

Don't kid yourself, though; this is extremely hard work. You may be allowed to bill for first class travel and accommodations, but that's only because these are necessities. Then again, you may be sleeping with the chickens on the floor of a train traveling through Kazakhstan.

While corporate assignments include every kind of subject matter you can think of, from executive portraiture, to architectural renderings, to 35mm black-and-white social documentary, to landscape and nature photography, to still life studio illustrations with a view camera, they quite often mean shooting either grimy industrial facilities or people working in sterile office cubicles. You are the magician on call. You must walk cold turkey into an unfamiliar environment that is either grossly disorganized, noisy, dirty, or visually barren, where nothing seems to go as planned, no matter how many arrangements you make in advance, and make whatever you find, wherever you find it, look exciting and beautiful—on a deadline! *That* takes a very special talent.

The designers who hire you have a lot at stake in these assignments, too. Their own marketing campaigns depend to a large extent on the print and multimedia productions they create, which are subjected annually to the judgment of their peers in prestigious competitions. The winners are published in annuals that spotlight the winning designs in various categories. They are scrutinized by corporate buyers, who may or may not hire them next season, based on what they see. If you don't turn in exquisite pictures for them to work with, their name is mud.[25]

Working with designers can be one of the most fulfilling aspects of your career. These are artists themselves of consummate good taste and style. If anyone can show off your photographs in their best light, they can. The samples you can show, if you work with top tier graphic designers, can be simply gorgeous. It is also sometimes possible to barter smaller assignments, say, making portraits of the designers themselves for their own publicity use, in exchange for their help in designing a logo or a

promo piece for you. They can help you design your business cards, mailing labels, stationery, and a more imaginative portfolio presentation or Web site. That means you can create your own company identity with the help of the same people who do it for Fortune 500 companies.

What It Means To Be an Editorial Photographer

Whether you decide to shoot fashion, tabletop, sports, politics, paparazzi, portraits, or mortal combat, you can be categorized as an editorial photographer. More than either corporate or advertising, this classification depends on the context in which your photographs are published, rather than what you decide to shoot. That means the nature of your work is defined by being published in commercial media, including books, magazines, newspapers—any conceivable periodical—as well as on television or on the Web. There are so many kinds of publications worldwide that the likelihood of your finding some work in this genre is almost inevitable.

Editorial photography can be further subdivided into the categories of *photojournalism* and *photo illustration*. If the preponderance of your assignments fall into the category of pictorially reporting news events on deadline or documenting social events of a timeless nature, the reputation you develop may allow you to call yourself a photojournalist.[26] If you shoot primarily to illustrate feature stories in periodicals about people, events, places, and things in general—more often than not describing either particular themes or personalities within an infinite variety of contexts—you may call yourself a photo illustrator. Well, you may call yourself anything you like, really. Whatever title appears on your business card will probably boil down to describing whatever subject matter you specialize in shooting.

As an editorial photographer, you take on a new responsibility. You have become your client's representative to the public at large. Those who hire you have gone to extraordinary lengths to create public esteem and good will by consistently providing factual information, so you have an obligation to tell the truth. Unless they are clearly labeled as illustrating a particular point of view, or in cases where it is obvious that you have taken "editorial license" to exaggerate, your pictures must not lie.[27]

There is no argument that reporting can never be absolutely objective. But if your pictures dare to deliberately slant the story you are telling, if you are trying to enlist the support of your viewers to a particular cause or opinion instead of reporting the news objectively, they become propaganda. They risk losing the authority and sanctity of the truth they purport to convey if you go too far. If that happened, it could end your career in a heartbeat. It should be noted, however, that the art of *documentary* photography, a somewhat different pursuit, acknowledges a particular point of view, but it is clearly stated as such.

If you shoot for periodicals, you may find yourself spending a lot of time on the road or in the air, living out of a suitcase. Most editorial photographers have developed a knack for savvy traveling techniques, especially when working internationally. They have learned how to extricate themselves and their cameras from all kinds of inhospitable circumstances, ranging from unfriendly customs agents to wild animals, temperamental technology, irritable prima donnas, and *really* unfriendly people pointing guns. They keep an invaluable network of resources, including well connected friends from all over the world, at their ready disposal, enabling them to solve the most diverse and unanticipated kinds of problems, both creative and tactical. There is a great deal of freewheeling adventurism associated with being an editorial photographer. You may report to a photo editor, but you are left pretty much to your own devices to turn in pictures that make readers' hearts skip a beat.

Editorial decisions are made spontaneously in reaction to breaking news events, as well as for commercial reasons. Since assignments are usually handed out on a moment's notice, only a minimal amount of paperwork is routine. The "virtual" paperwork requirements for all three types of assignments will be discussed in part 8, The Paper Trail.

Credit Where Credit is Due

It is a long-standing trade practice for freelance photographers to receive a *photo credit*, sometimes called a *byline*, usually consisting of a copyright notice (i.e., © 2001) and the photographer's name displayed legibly and adjacent to any photo published in a magazine, newspaper, or other editorial print media. Often, but not necessarily so, corporate publications

include photo credits, too. The practice is less common for advertising and catalog illustrations.

Some periodicals maintain the practice of publishing all of the credits for an entire edition—burying them, really—on a single back page, to the lesser delight of the contributing artists. That practice is not preferred, because clearly, a credit is less effective if it isn't readily visible and associated directly with a particular picture. Some publishers, however, are proud enough of their contributing photographers—or, at least, some of them—to feature a prominent byline on the title page of an article[28] or to print some biographical information along with that of other freelance contributors near the table of contents up front. Web sites and CD-ROMs also include photo credits.

Regardless of the media in which a photograph is reproduced, the display of a photo credit is expected by photographers who shoot for editorial media. And there is something more important at stake than the satisfaction of seeing one's name in print. The photo credit has become a commercially valuable commodity.

A credit line is vitally important to a photographer's ability to earn residual revenue. Furthermore, it advertises your availability to other publishers for assigned work. And of course, the more often a photographer's name is seen in print, the more it may increase demand for his work.

Sometimes, but rarely, a photographer will negotiate for a credit line to accompany an advertisement. If you anticipate some kind of beneficial marketing impact as a result of your association with the product being advertised, you might consider accepting a lower usage fee in exchange for a photo credit. But make sure it's a fair trade. Don't do it just because the buyer can't afford to pay your regular fee. First, determine to your satisfaction that the ad itself is high profile enough to merit a trade by generating some personal publicity. Conversely, if a photographer has already become well known or even famous, the publication of a photo credit can benefit the advertisers. It shows that they only work with top-name talent, or that top-name talents use their products. It may be considered an implied endorsement. Only a handful of photographers can use their fame to negotiate higher assignment fees by allowing the advertiser to publish their bylines. Ordinarily, advertising clients keep creative contributors anonymous, paying them well to boost the profile of their products, not to draw attention to themselves.

In corporate publications, such as brochures and annual reports, it is acceptable to have credits displayed in a discrete area, instead of adjacent to each photo. It often appears along with a designer's credit rather inconspicuously in the "gutter," near the binding, or spine, and towards the back cover of the publication. This practice is acceptable, because people are used to looking there for credits. It's traditional. But it never hurts to ask for a credit line to be displayed more conspicuously. It is always an issue for negotiation.

Penalties for Omitting Photo Credits

Photo credits play a role in the copyright equation by protecting you from potential infringers, as well as by helping you to collect residual income through intellectual property rights. Bylines should be considered to be an integral part of your marketing campaign, because they advertise your name and your work. There is no reason *not* to consider a photo credit as an integral part of your fee. That should be *your* company policy.

In the editorial world, if a photo credit is denied to you for any reason, including negligence, standard trade practice calls for you to receive additional compensation: traditionally, three times your normal fee. This practice is not binding by law unless it is stipulated in the terms and conditions of your documentation.

Be courteous. Don't forget to remind your clients verbally that you expect a photo credit if it's not their common practice. That's not the same as telling them that you *will* be billing them three times your normal fee if they neglect it. It's one thing to put publishers on notice, so they are less likely to forget, and quite another—less successful—tactic to threaten them.

The exact instructions for printing a copyright notice adjacent to your published photos should be stipulated in the terms and conditions of the paperwork accompanying each photo assignment, usually printed on the back of each Job Estimate, Job Confirmation, and Invoice. (Refer to chapter 47, Finalizing Legal Agreements, in part 8, The Paper Trail.)

Expendability versus Availability

While it was said that there is so much work available in editorial photography that you are bound to get a piece of the action at one time or another, its very competitiveness makes your services expendable. This is a fickle business.

Fickleness, unfortunately, is fostered by the exigencies of the marketplace, not a lack of character on the part of the people who hire you. Loyalty (to you) is an unaffordable luxury when the pressure of a deadline is weighing heavily on a photo editor.

News happens fast. By the time it is reported and before it is published, it is time to move on to the next story. Photo editors will pick the first photographer who answers the telephone. Not just at random, however; they must already to be familiar with you and your work through your marketing efforts and photo credits from previous assignments. It's just that, if you don't pick up the phone right away or answer a page, they are prepared to go right down a list of names in their database. They usually won't bother to track you down. Deadlines demand your immediate availablility.

It's hard to tell what your pecking order is on that list. While it might have been high one day, it might be surpassed by the next photographer who answers the call before you do and produces an award-winning set of pictures. The best advice: Carry a pager and a cellular telephone.

NOTES

24 Under the Securities Exchange Act of 1934, Congress created the Securities and Exchange Commission (SEC) to oversee and regulate corporations selling stock to the public. The SEC is an independent, nonpartisan, quasi-judicial agency. For further information look at their Web site: *www.sec.gov/index.htm*

25 As discussed in Part 4, these annuals are a terrific resource for aspiring photographers to examine creative trends and to see who the top designers are and how to reach them.

26 For more information about becoming a photojournalist, which sometime requires you to become a full-time employee instead of running your own business, refer to the National Press Photographers Association (NPPA) Web site (*www.nppa.org*).

27 See *Faking Images in Photojournalism*, an essay published on the Web at *http://commfaculty.fullerton.edu/lester/writings/faking.html*.

28 In this case, copyright notice is not given. It would look odd in the layout, and the magazine itself provides reasonable protection for the entire contents of the edition as a copyrighted collective work. (See Part 5.)

42

Professionalism and Ethics

In the United States of America, anyone can call oneself a "commercial photographer," a "professional photographer," or both, because there is no official license or certification required to take pictures for a living. There is no regulatory agency, either in the government or in the private sector, to assure the public that one photographer or another is competent. All one needs to get started is a camera, some film, and a business card. There are no "photo police," nor is there an enforceable standard of quality. That's not to imply that there should be. But unlike doctors and lawyers, or even hair stylists, plumbers, electricians, and morticians, photographers do not need official permission to practice their trade. Because of the ease with which one can throw one's lens cap into the ring, there are a tremendous number of photographers competing for a wide range of media assignments. That makes room for as wide a range of professional behavior as there is a wide range of talent amongst competitors.

With no official regulation of standards, buyers have little protection from those few photographers whose irresponsible behavior reflects poorly on— and out of all proportion to—the many more conscientious photographers at work in the marketplace. It may be inevitable that there will be some

rotten apples in the barrel, but even without malicious intent, anyone is capable of bungling an assignment or missing a deadline. That does not excuse the photographer who gets in over his head by accepting more responsibility than he knows how to handle, or by promising more than he is sure he can deliver.

note No matter what the circumstances, a pro will always deliver a publishable picture to his client. A pro will never deliver excuses.

If a photo assignment seems to be beyond your level of expertise, it may be best for all parties concerned that you decline it. You will earn respect, not derision, for the honesty of your decision. You'll have plenty of opportunities in the future to learn how to handle what you don't already know about the finer points of producing complex photo assignments. You'll gain experience with time. But make no mistake about it, neither innocence nor ignorance can excuse incompetence. There are few second chances in this business.

An advertising agency, a corporate design firm, or a magazine is often taking a huge financial risk in hiring a new photographer, in trusting that you

are who you say you are and that, based on a portfolio of work you've done in the past, you can produce more of the same quality of work on demand. If a photographer fails to complete an assignment successfully, misses a deadline, or otherwise makes mistakes that cost a client time, money, or public embarrassment, it is almost impossible for the hiring party to file a lawsuit for malpractice. Buyers must ultimately rely on the initial impression you make and hope that you can consistently tap into the reservoir of talent depicted in your portfolio. When it comes to ethical considerations and the responsibilities of doing business, you are an unknown quantity. The only rule they have to follow is "caveat emptor," or, let the buyer beware!

The sword cuts both ways though, of course. Undoubtedly, you will meet some disreputable or unprofessional clients in your career. But this text is designed to help you learn how to recognize them before you get in too deep and to protect you from being unnecessarily disadvantaged. It will teach you not just how to hold on to your rights, but to conscientiously assert your prerogatives as a businessperson and to avoid becoming entangled in bad commercial relationships in the first place.

The Relationship of Trade Associations to Professionalism

What about all of those photographers who regularly pay hard earned dues to belong to the PPA, the APA, the ASMP, and the NPPA? Does membership in any one or more of these organizations automatically confer upon them—or upon you—the status of a professional? Does it prevent anyone from engaging in unscrupulous business practices? The answer to both of those questions is "no." Membership does imply, however, that each member has been judged by his peers. Membership demands a modicum of creative competency and, it is assumed, some degree of professionalism, too. But who regulates the regulators?

In the absence of an official standard for professionalism or a sanctioning body, most photographers simply grant themselves an investiture. You can call yourself a pro, whether you act professionally or not, by virtue of the fact that you receive payments for taking pictures. So in the end, when the topic of discussion is professionalism, it is really about individual responsibility. It takes only one dishonest act by one person to put the "screw" in "scrupulous."

Even if it is assumed that the major photo trade groups have achieved some measure of success in putting knowledge about ethics into the hands of working photographers, knowledge alone does not make you ethical. You can lead a photographer to knowledge, but you can't make him think! Only action has any impact in the marketplace, not rhetoric and philosophy.

Competition can be unfair. It can blindside you. From out of the blue, someone using an antiquated, beat-up camera body with only a lens or two, whose office is the trunk of a car, who never studied business administration, has no sense of personal responsibility, has learned photography literally at the expense of his clients, and charges fees so low that they couldn't sustain a living wage for anyone else may start competing for *your* clients. Despite his lack of ethics, he may be a gifted shooter, someone just starting out perhaps. So what will you do when your livelihood seems threatened by such an individual? Will you stoop to lower standards in a vain attempt to compete with him? Or are you wise enough to use your business skills to achieve success in spite of such effrontery?

Conscientious photographers understand that they do not work in a vacuum. They know that success is built in part upon the goodwill and professionalism of others. Therefore, they will always seek like-minded allies, colleagues, and customers with whom to form strategic relationships. That is one of the benefits of joining a trade association; your fellow photographers are indeed strategic allies, even though you compete with them. Best practices are encouraged by interacting with other shooters.

While no single photographer has the power to impose, let alone enforce, best practices, neither do trade associations. The power of the professional photographic community exists in direct proportion to the number of individuals who assert their rights. Success is contagious!

43

Business
Reports

Since profit is the lifeblood of business, reports allow you to keep your finger on its pulse. Reports give you the kind of information you need— when you need it—to act decisively and in the best interests of your business. When an important decision must be made, you can rely on facts, not hapless guesswork, to further your marketing and financial goals.

Creating Reports with PhotoByte

Reports are created from data you have already entered into PhotoByte, so there is no further work to do but analyze the results. You can do that all by yourself or with the help of an accountant. The information in these reports might almost be considered a fringe benefit of using PhotoByte to create Shoot-Sheets, Job Estimates, Invoices, contact lists, etc. All you have to do is click a button or two and be rewarded will all kinds of statistics.

Reports fall into two categories: marketing and sales. Marketing reports have to do with making contact and communicating with your clients and prospects. Sales reports tell you something about the income that results from your marketing activities. Communications and income. That's basically

it. You have already seen examples of both kinds of reports throughout this text. You have performed exercises that included some of these reports, too. For instance, you should already be familiar with the following reports, having looked at them in this and in previous Parts:

> - Aged Accounts Receivable
> - Client Payment History Report
> - Gross Profitability by Type of Job Report
> - Photo Equipment List
> - Profit/Fee Analysis
> - Sales Tax Report
> - Tracking Promotional Mailings

There are two buttons in PhotoByte that provide access to all of its reporting capabilities. They are the *Marketing Reports* and *Sales Reports* buttons. Both are accessible from the Main Menu, as well as elsewhere in PhotoByte via links on other screens throughout the software.

When you click the *Marketing Reports* button on the Main Menu, you will see this screen:

Obviously, it splits into two further screens, one for displaying lists (that do not print) and one for printing reports on paper.

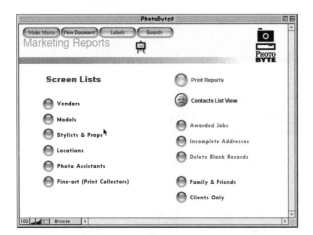

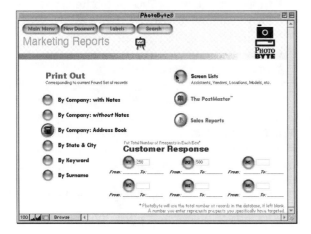

note On the Print Marketing Reports screen, you have access to the same Client Response reports that are also available on the Profile > Correspondence screen.

When you click the *Sales Reports* button on the Main Menu, you will see this screen.

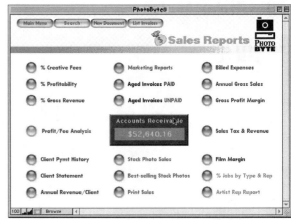

Take a few moments to familiarize yourself with the buttons on each of the screens illustrated above, remembering the difference between *lists* and *reports*: Only the latter are printable. Lists are viewed only on screen. Since you are still working with sample records in PhotoByte, clicking randomly on various buttons will produce some reports for you to look at. You may print them out to study them, if you wish, or simply view them on screen. Review these reports and the roles they play in your business with an accountant.

Screen Lists

A screen list works like this: If you want to view a list of photo assistants on screen, simply clicking the *Photo Assistants* button on the (Screen Lists) Marketing Screen will present you with a list of names in a Found Set of records. You can click on any name to display that person's Profile. This is a handy means to pull up a list of assistants and call them one by one to assess their availability for an assignment.

PhotoByte performs an automated search using keywords. You would have already entered the words "assistant" or "photo assistant" in the *Keywords* field on a contact's Profile screen when you first created the record. Such preformatted reporting capabilities save you the trouble of remembering new search criteria and entering them each time you want to view

an often-used list. The same holds true for lists of vendors, models, stylists, photo locations, and even a list of people who buy and collect your art prints. By clicking on the *Awarded Jobs* button, you'll see a list of clients who might warrant a special gift when the year-end holiday season comes around for having kept you gainfully employed. Certainly, if your budget is tight, it will help you decide between who merely gets a card and who gets a special present. Incidentally, PhotoByte "knows" whom to include in this list simply by means of the fact that you've sent invoices to these individuals in the past, even if they've changed companies and addresses several times. The software helps you keep tabs on people and their whereabouts. On a marketing note, going through this list from time to time is a great way for you to solicit repeat business. Clients must have hired you for good reasons previously. Don't let them forget what they were!

Print Reports

If you wish to *print* the Found Set of assistants used as an example above, go to the *Print* Marketing Reports screen.

When you click a button on that screen, such as *By Company: with Notes*, you will see a formatted list on screen that displays the records already listed in your current Found Set, in this case, assistants. They are formatted for printing and viewing on a piece of paper to be taken with you, away from your computer.

Notice that the list is sorted by company name, even if it's a list of assistants. If there is more than one contact at a company, all of them will be listed, including any personal notes you entered on the Preferences > Picture/Notes screen, plus a record of the promo pieces each person was sent, their titles, and direct telephone numbers. Try experimenting with the different buttons on this screen to see how they vary the layout of the report for the same Found Set of records. You'll notice that here, too, there is a button to activate the PostMaster feature. If you recall, you learned in chapter 21, part 4 how to use this feature to send form letters.

note There is a Reports button accessible at the top of the Profile and List View screens as well.

Accounts Receivable

This is probably the most common report you will look at, let alone the most important. That's why you are given such immediate access to it. Not only is the total amount of all unpaid invoices owed to you displayed on the PhotoByte Main Menu, but that display itself is a button, as you saw earlier in chapter 37 in this Part. Incidentally, every Job Estimate, Job Confirmation, and Invoice/Licensed Rights has an *Accounts Receivable* button displayed on its face when viewed in Browse mode. There is also an *Accounts Receivable* button in the middle of the Sales Reports screen.

Simple directions are visible in the header of the Accounts Receivable screen suggesting the means to see additional reports based on the figures in your accounts receivable. Try following some of those suggestions.

In this context, even viewing a ShootSheet may be considered the same thing as looking at a report, since it contains so much information.

The Accounts Receivable report can be printed. (There is a *Print* button at the top of the screen.) But it is more commonly viewed as a list on screen. Either way, it can tell you all sorts of information, such as how long it has been since you created or sent a given invoice, when a partial payment was made, or how much of the total amount of your receivables is comprised of assignment fees versus billed expenses, stock licensing fees, sales taxes, or miscellaneous income.

Miscellaneous income, by the way, runs the gamut from renting out your studio to selling a used camera. These kinds of transactions are represented by a Simple Invoice, not an Invoice/License of

Rights, since no intellectual property licensing is involved. Simple Invoices are used strictly for selling or renting physical "things."

The Accounts Receivable report lists all kinds of invoices. It will tell you at a glance which ones were billed as advances against expenses instead of for the completion of an assignment. If you need more specific information about any invoice in the list, simply click on the invoice number or the balance due of that item, and PhotoByte will show you the virtual document on screen, exactly as it would appear on your letterhead stationery. You can even see its backup figures on Worksheets 1 and 2, which accompany every Invoice/License of Rights.

The Client Statement

The Client Statement is similar to the Payment History report that you created in an exercise in chapter 37, earlier in this Part. It differs in that it is designed to be submitted to a client in addition to an invoice, and not necessarily at the same time. It lists all previous invoices with their balances due. Some clients ask for statements, and some do not. (Remember: A Payment History report is for your eyes only, to determine if the buyer is a good risk to pay on time.)

A statement will indicate, at your choice, either all of the invoices ever sent to a particular client or only those with a balance due, including partially paid invoices.

EXERCISE -------------------------------

Creating a Client Statement
> Click the *Sales Reports* button on the PhotoByte Main Menu.
> Next, click the *Client Statement* button on the Sales Report screen.

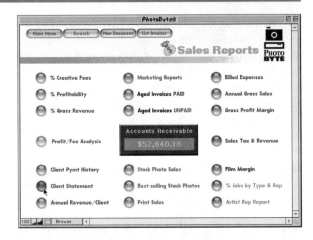

> On the next screen, select **Acme Amalgamated Advt.** by placing the cursor on the *Company Name* field and clicking.

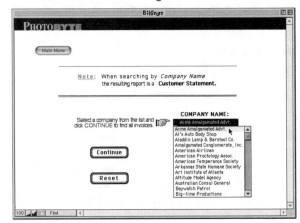

> Click *Continue.*

You will be given a choice with a dialogue box to view all invoices or just those unpaid.

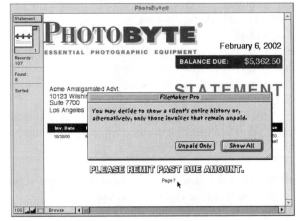

> Click *Show All.*

You will see the report on screen.

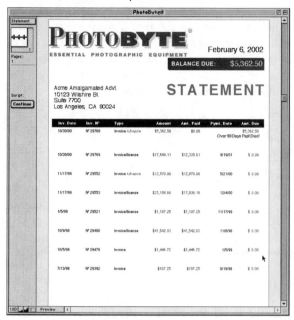

> Click *Continue* to print the report and return to the Sales Reports screen.

Artist Rep Reports

If you are represented for assignments by one or more agents, it is useful to periodically view a report that tells you what percentage of work comes from which one. Such a report can be used to help evaluate the performance of your reps, to see which agent is most effective, or even if you are more effective than a rep at bringing in assignments. Furthermore, this report breaks out individual jobs by type (i.e.; advertising, corporate, or editorial) to tell you if a rep is better with one kind of clientele than another.

Another kind of rep report will tell you at a glance how much money you owe in commissions and, if you have more than a single rep, how much you owe each one.

EXERCISE -------------------------------

Creating a Percentage of Jobs by Type & Rep Report

> Open PhotoByte to the Main Menu, and click the *Sales Reports* button.

> From the Sales Reports screen, click the *%Jobs by Type & Rep* button.

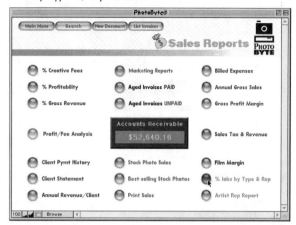

The Assignment Source report will appear on screen.

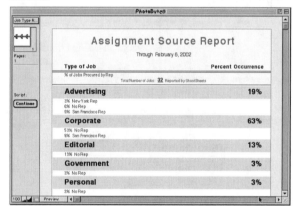

> Click *Continue* to print the report and return to the Sales Reports screen.

EXERCISE -------------------------------

Creating a Report of Artist Rep Commissions

> Open PhotoByte to the Main Menu, and click the *Sales Reports* button again.

> From the Sales Reports screen, this time, click the *Artist Rep Report* button in the bottom right corner.

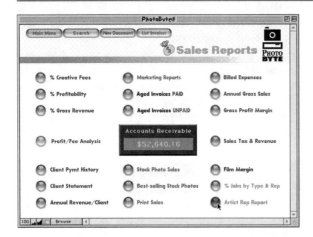

On the next screen, choose either the month or quarter and the year you wish to report. For this example, select the year **2000** and then click the *Fourth Quarter* button.

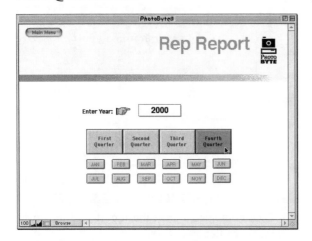

The report will appear on screen.

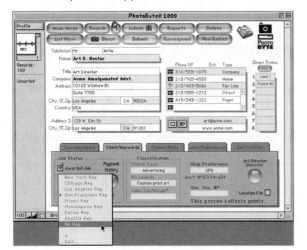

It will illustrate that some of your jobs were "in-house" (no commission due). If any invoices are listed in the *No Rep* column, it means that you did not associate a rep with the client to whom they were billed. That is accomplished by indicating the name of a rep—or else you would select **No Rep**—on the Profile > Client/Keywords screen.

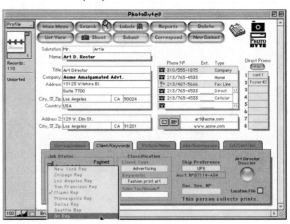

Those assignments for which a rep's commission is due will be so indicated and will display the amount you owe automatically when you create the report.

note Refer to the exercise called First Call/Data Entry, in chapter 18, part 4, to see an alternative method for entering information about representation into a client's Profile.

The Paper Trail

*Contracts memorialize agreements,
not disagreements.*

The quotation is, by now, more famous than the man who first uttered the words decades ago, Hollywood movie mogul Samuel Goldwyn: "A verbal contract isn't worth the paper it's printed on." And, as you might suppose, the fundamental lesson of this part is to *get it in writing!*

44

Why You
Need the
Paper Trail

The paper trail exists to help you plot a safe course through a minefield of potential problems. It keeps you connected to a tried-and-true method of transacting business, one that has evolved over time. It is a sequence of documents, forms, memos, agreements, covenants, contracts—whatever you wish to call them—that, when grouped together, protects your right to operate a business and to do so profitably. As that implies, its whole is greater than the sum of its parts.

The paper trail literally spells out the way photographers conduct business. It also clarifies individual commercial relationships by memorializing the instructions given to you by your clients with regard to each photo assignment. Thereby, it upholds the integrity of your commitments, both the commercial and the artistic kind, from the time an assignment first comes up for discussion through the final delivery of film, its publication, and ultimately, its return to you.[1] Coincidentally, it also represents a de facto history of your career, because it electronically catalogs each and every thing you shoot, along with a description of how you did it.

Use It or Lose It

When paperwork is put on hold every time a new shoot comes up, it piles up faster than any photographer can deal with it. This kind of inadvertent neglect makes photographers as vulnerable to economic forces as leaves blown by the wind, especially because economic forces are determined by which way the wind blows, the whims of the marketplace. But that's not to say you have no influence. You simply have to make some effort to exercise that which you have. If you don't step up to the plate, you can't hit the ball. Only half of the market is comprised of buyers. The other half is made up of sellers who provide content. Buyers need content. That gives you some clout.

There is no doubt that photographers have considerable economic influence in the marketplace. But that power is diminished to the extent it is ignored. It's a perfect example of "use it or lose it." Unfortunately, however, and for no apparent reason, photographers tend to surrender their prerogatives at the first sign of conflict, real or imagined. It usually is imagined. That's the most regrettable part. Conflict is just assumed to exist between freelance

photographers and "corporate America." But that is just not true. How can your customers be your enemy? Photographers who persevere in that belief will remain their own worst enemies. Corporate America represents opportunity!

Defining Relationships with Clients

With comprehensive yet easy-to-prepare paperwork, you are giving notice that your business operates on principles of fairness, professionalism, and the rule of law. It shows that you have no intention of forfeiting your rights and that, by extension, you respect your clients' rights, too. You might say that the paper trail represents the physical manifestation of best practices. By "getting it in writing," you are building a solid foundation that will uphold every assignment you shoot, literally, on good terms.

Once you commit a job to the paper trail, those buyers who were once prospects then become clients. A new relationship exists. The documents in the paper trail individually and collectively define that relationship, along with its corresponding legal and financial responsibilities, for both sides.

Negotiations

Surely, your clients have different priorities and goals than you do. They have no reason to place your interests ahead of their own, nor should they be expected to do so. But business has always been a game of balance, of give and take. It's not a blood war. Everyone wants the best terms and the best price. That's what negotiating is all about. Actually, the ideal result of bargaining and haggling is a good deal for *both* parties.

If, while negotiating the terms of a photo assignment, you happen to make a demand your client doesn't like, you'll hear about it. But don't take that as a personal assault on your rights. It's just time to make a counterproposal. Maybe a compromise is in order.

Every negotiation, ideally, should result in a win-win situation. Of course, you'll lose some battles along the way. But don't cave in at the first sign of resistance. Don't settle for whatever terms you are offered right off the bat. Tell your customers what you want in exchange for your valuable services. You'll be surprised how often you get it. Yet, being an assertive negotiator does not mean that you have

to be pushy or demanding. But it is totally reasonable to let clients know up front that you expect to be treated as a professional.

Few people are born good negotiators; it is a learned skill. You can learn it, too. Without getting into specific techniques here, since they don't belong exclusively to the realm of photography, let it suffice to say that any number of publications are available in libraries and on the Web that will help you become a proficient and successful negotiator. Never engage in a battle of wits when you're only half prepared!

Contracts

An invoice is the written record of a commercial transaction. Its importance extends beyond a simple demand for payment. It also describes how your photos may or may not be published according to the terms of the copyright license written on its face. It makes your client's use of your intellectual property conditional upon payment. (See part 5, Copyright, the section, Conditional Licensing in chapter 25.)

An invoice further describes exactly what your clients get for their money. That usually includes some explicit limitations to protect you from losing control over the use of your photographs. As such, it is a contract.

Avoiding Miscommunications

The paper trail defines each party's commercial responsibilities by formalizing mutual understandings that apply to a whole range of transactions, from dropping off a portfolio to invoicing a photo shoot and ensuring that you get paid. But the paper trail helps define other kinds of relationships, too, those with business associates other than clients. These include assistants, stylists, and models, to name the most obvious examples. Clarifying such relationships—getting it in writing—will avoid becoming mired in misunderstandings.

Good documentation is an expression of confidence and of your willingness to exercise the power you have to enforce copyrights. It should prevent infringements from occurring in the first place. But if something does go wrong, you have the legal means at your disposal to enforce claims of financial damage against those who would use your pictures without permission.

The paper trail can also protect you from the consequences of someone else's mistakes. For instance, a publisher might not have intended to use your pictures improperly, but circumstances do arise where inadvertent misuse can cause harm to someone else. For instance, a photo in which a person's likeness appears could be used in an advertisement, but no model release was obtained for that purpose. Although you excluded advertising from the publication rights granted in your copyright license, some bureaucrat might not have paid attention to that restriction. Unless you are indemnified or otherwise protected by proper paperwork, you may still be held liable for financial damages by the person depicted in the ad. Such liability can put you out of business if you lose a big lawsuit.

The Handshake

Countless anecdotes tell of photographers who are afraid to offend their clients by "smothering them with paperwork." They even refer to new clients with whom there is no history of trustworthiness to fall back on. Nonetheless, they believe it shows a lack of good faith to "shove contracts under a client's nose." But a signed agreement is an affirmation of good faith, never an insult.

Still, some photographers maintain that they are on such good terms with their clients that contracts seem like unnecessary impediments to existing relationships. They do not want to "let business stand in the way of friendship." Indeed, their clients are honest people of good character. But, in spite of that fact, relationships are built on trust. They can quickly become strained when even the slightest disagreement arises unexpectedly.

Just because a mutual understanding might exist—that is to say, when both parties believe they have reached an agreement in good faith verbally—there can just as easily be a mutual *mis*-understanding at some later juncture. That's why copyright licenses in particular are put in writing. The issue of whether or not to provide written agreements has less to do with trust than the frailty of memory. There is no doubt, whatsoever, that either yours or someone else's will fail.

If you enjoy consummating business agreements with no more than a handshake, you are putting your relationships, both business and friendship, at risk. Instead, consider a signed agree-ment as the memorialization of a handshake. It elevates the handshake and endorses its significance. Good documentation will outlast anyone's memory. It lets no one misinterpret what the handshake was all about in the first place.

Paperwork is not a barrier; it is the mortar that binds together the kinds of business relationships that can—and do—include friendship. Paperwork memorializes agreements, not disagreements. It does not promote adversarial relationships. It promotes credibility. Nor should it be presumed that paperwork is introduced to protect you from dunces and crooks. Rather, it helps you avoid them altogether. Crooks will never sign on the dotted line. Trustworthy clients will.

The Evolution of Trade Practices

No one set out to write trade practices into law. They evolved slowly over time and continue to do so. All in all, they merely represent the conventional way of doing things. It is hoped that they come to represent the *best* way of doing things for all parties involved in commercial transactions. Inevitably, a group of photographers or a group of publishers will "push the envelope" to find out what works best to their advantage. If equilibrium is lost, a struggle ensues to find it again. That's what happens when something like clip art comes along, or when buyers start demanding to see receipts for film.

The Role of Trade Associations

Good business practices are reinforced by the collective experience and moral authority of professionals who have learned from their past mistakes. Therefore, the best way to expose yourself to best practices is to associate personally with your peers and, especially, your predecessors. That will lead you directly to the four national trade associations mentioned previously throughout this book: PPA, APA, NPPA, and ASMP.

Each one of these associations makes a strong case for industry-wide standards by recommending ways to create a safe, productive, and stable working environment. Between them, they practically invented the paper trail. It has evolved into the most prudent way to do business. But that is as far as they can go. They can only advise photographers to follow the guidelines they recommend. They cannot

enforce their use. That is how it should be. Professional trade associations are, in fact, prohibited from enforcing policies on behalf of their members by federal law. Nevertheless, direct communication between like-minded and responsible individuals is a prerequisite for the evolution and proliferation of best practices in any profession, and certainly for the photo business. These associations do a good job reminding photographers about their ethical, legal, and financial responsibilities, both to their clients and among themselves.

Trade Unions

Trade associations are not unions. In 1976, the National Labor Relations Board[2] was petitioned by the ASMP for union status to represent its members in collective bargaining agreements with magazine publishers. (Incidentally, the ASMP was known then as the American Society of *Magazine* Photographers, instead of *Media* Photographers.) In a precedent-setting ruling, the NLRB denied union status to the ASMP on the grounds that its members were not employees of the publishers with whom they wished to bargain. It ruled that they are self-employed, independent contractors and cannot, therefore, engage in collective bargaining.

From Individualist to Entrepreneur

For whatever reasons one leans toward the vocation of photography, they always include a zealous individualism, a burning desire to do things one's own way. But being independent-minded becomes a liability when it leaves you without a compass. While the culture of photography rejoices in individuality, it does not celebrate anarchy. To achieve credibility in the world of business, you have to abide by established rules. Without rules, you are left at the mercy of the marketplace, which has little mercy to spare. That is definitely *not* good for business. While you can and should be inventive with your cameras, business administration does not lend itself well to improvisation. An anonymous Zen pundit put it this way: "In the beginner's mind, there are many possibilities, but in the expert's mind there are few."

The good news is that, if you mix a maverick into a bowl of best business practices, a chemical reaction occurs. The result is an entrepreneur. You learned about the entrepreneurial spirit in part 3, Starting a Business, so you already know that entrepreneurs are rare birds who are willing to take large risks to bring creative ideas to fruition. But they reap the financial and cultural rewards of doing so. An entrepreneur is someone who never loses touch with his wilder side, but understands the value of structure. Whereas your maverick side allows you to stand out in a crowd, you must fit a certain mold to be an entrepreneur. The structure of business practices, which is represented and upheld by the paper trail, is what sets the mold.

Steps along the Paper Trail

For every photo assignment, you will use the following documents in varying combinations. Sometimes you will use all of them. Sometimes you may use as few as a single one.

> ShootSheet
> Job Estimate
> Job Confirmation
> Contingency Fee Schedule
> Advance Invoice
> Job Change Order
> Invoice/License of Rights
> Assignment Delivery Memo
> Correspondence & Late Notices
> Late Fee Invoice

These other useful documents are available, as well:

> Portfolio Receipt
> Model and Property Releases
> Artists/Rep Agreement
> Reseller Cards for Sales Tax
> Taxpayer ID Request Form
> Unlimited Use Agreement
> Independent Contractor Agreement
> Indemnification Agreement
> Nondisclosure Agreement

note For every assignment or stock photo (licensing) sale, you will always use at least one of the documents in the paper

trail, and sometimes, you will use all of them. Editorial shooters are least likely to use all of the documents for a single assignment. That makes the ones they do use that much more important. Corporate and advertising shooters are more likely to use all of these documents for a single job at one time or another.

The (shorter) stock photo paper trail:

> Stock Photo Requisition
> Delivery Memo

> Late Notice
> Stock Invoice

NOTES

1 All of the documents in the paper trail are listed at the end of this chapter.

2 The NLRB is an independent federal agency created in 1935 to enforce the National Labor Relations Act. It conducts secret-ballot elections to determine whether employees want union representation and investigates and remedies unfair labor practices by employers and unions.

45

Creating the Paper Trail

The ShootSheet

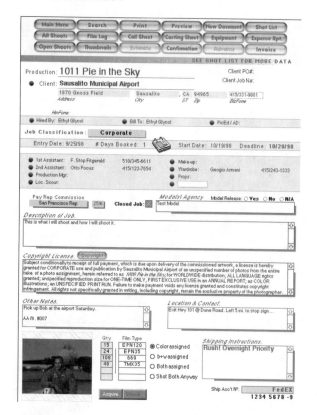

A ShootSheet will appear whenever you click the *New Shoot* button from either the Main Menu or any Profile screen in PhotoByte. You will learn how to create a ShootSheet in chapter 46.

A ShootSheet is a job log. Some photographers may call it a production report. Each one contains fields in which to enter information about every aspect of an assignment, from its name, start date and deadline, technical specification, directions to a location, a list of crew members, to pertinent copyright licensing language. You are free to include as much information or as little as you wish. The more you include, however, the more useful a ShootSheet is.

A Photographic Memory

It's worthwhile to start a ShootSheet even for self-assigned stock photo productions and portfolio test shots, as well as for commissioned assignments. That's because, having created a number of ShootSheets to look back at over time, they represent a de facto reference library, a history of your career. It comes complete with pictorial references to each "take" of photographs you've created (as many as you wish to digitize). You can attach images electronically to ShootSheets.

With ShootSheets. you can look up both technical and creative data about any shot you've made in the past. That information may be applicable to work you intend to do in the future. A great benefit is the capability to link stock photo records electronically back to the ShootSheet from which they were derived. All it takes is a button click when you need to verify publishing restrictions or previous licensing information—even to know who assisted you on a particular shoot and what the technical and creative parameters were when you did it, no matter how long ago. Even when, occasionally, a job is cancelled, all of the "who, what, when, where, why, and how" it took to get to the point at which you left off will remain available for future reference. An electronic collection of ShootSheets is your "photographic memory." The best news is that it takes absolutely no extra effort on your part to create one—or hundreds of them.

Clicking the *See Job* button takes you to the ShootSheet associated with a particular stock photo record.

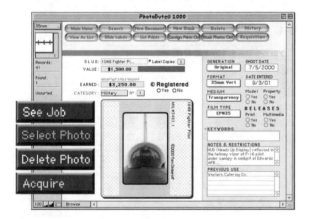

Updating Information

ShootSheets can be updated before, during, or after the completion of assignments. And while they are primarily useful as internal reference documents, your clients may find them helpful, too. By submitting a completed ShootSheet along with your film at the end of an assignment, it will serve as an illustrated caption sheet or a detailed job description supplementing the copyright license printed on your invoice. It is the most detailed job description you can provide for a client.

The following documents radiate from the ShootSheet, giving you (and optionally, your clients) easy access to deeper levels of detail. That means you can click a button (e.g., *Shot List, Casting Sheet, Equipment,* etc.) at the top of any ShootSheet to open the corresponding form.

The Shot List

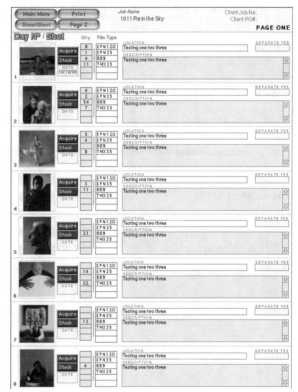

The Shot List is particularly useful to:

> Submit an illustrated caption sheet to clients
> Provide visual reference for transparencies or negatives filed in job envelopes
> Define payment based on either number of shots executed or number of days worked

If you have a one-day-long job that includes multiple shots or, alternatively, a job that lasts longer than one day with different shots to do each day, you can keep track of each one or each day's work, as the case may be.

If you have negotiated separate fees for each one of multiple shots instead of one overall assignment fee, they can be attributed to each corresponding shot or day by indicating the amount in an

adjacent field. The total of these separate fees will be included in the grand total on your final Invoice/License of Rights automatically. You don't have to remember to include them. The Front Page of the Invoice/License of Rights displays a line item reference to the Shot List. Specifically, on line 81 of Worksheet 2, you will see that a reference to a Shot List has been indicated as backup for the subtotal of creative fees.

note The Shot Lists let you capture digitized thumbnails in fields adjacent to each description. Clients appreciate the submission of the Shot List(s) along with your film as the equivalent of an illustrated caption sheet.

The Casting Sheet

This form is used at casting sessions with models. Multiple casting sheets may be associated with a single ShootSheet, one for each model interviewed.

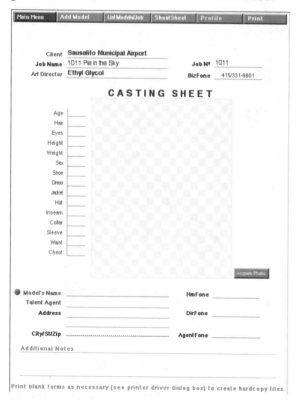

As each new Casting Sheet is filled in, includ-

ing a scanned Polaroid™ or electronically-captured thumbnail photo of the model, a record is automatically added to your Contacts database. If you type the names of the models that were actually booked in the *Models/Agency* field on the face of a ShootSheet, PhotoByte will display its corresponding Casting Sheets for each model. For more detailed instructions, refer to the onscreen PhotoByte User's Guide.

The Expense Report

If you print out a copy of your ShootSheet to keep with you on set or on location, the Expense Report may be printed on the reverse side. That way you can write down and keep track of job costs to be re-billed later.

When you return to your computer, transpose the information to this form in PhotoByte, and when you create an Invoice/License of Rights, the data will automatically be copied and updated.

The Call Sheet

If you are shooting a large-scale production, one involving more than a single assistant and a crew of

independent contractors, their names and telephone numbers will be automatically transposed onto this form. It will also pick up the name of your client. You may then add additional information, including directions one or more locations and the specific times everyone is expected to show up on the set.

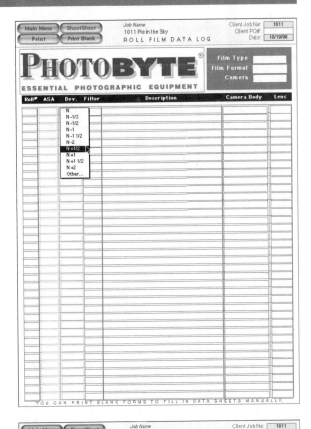

By making multiple printouts and distributing them to the parties involved, you can increase your efficiency and organization.

The Film Log

There are two versions of the Film Log. One is a ledger for roll film and the other for sheet film. The latter may also be used to record data for each frame on a single roll of film. (*See right.*)

Either version may be used as a template to print blank film logs on which to record technical data, such as ASA, developer and filter used, which camera body and lens, and a brief description of subject matter. When recording sheet film, you may indicate holder numbers, time of day, shutter speed, f-stop, and lens for each sheet. By correlating these data between camera and film, any mechanical problems can be quickly identified. These also stand in

for detailed caption lists as needed. Incidentally, any data entered on screen will stay with the ShootSheet to which it is linked.

The Equipment List

When you click the *Equipment* button at the top of any ShootSheet, you are prompted to check off any items slated for use on a particular assignment. (These will come from the same list used for insurance purposes. See the exercise, Creating a Schedule of Camera Equipment for an Insurance Agent, in chapter 12, part 3.)

	September 26, 2001 Page 1	PHOTO EQUIPMENT LOCATION LIST Total Value: $18,110.00					
	Manufacturer	**Type of Item**	**Serial N°**	**Model N°**	**Country**	**kg**	**Value**
Travel Case N° 1							
35MM							
1	NIKON	Camera body	#9201375	F2 Titanium Camera			$1,320.00
2	NIKON	Camera body	#9201412	F2 Titanium Camera			$1,320.00
3	NIKON	Lens/Normal	#211612	55mm f 3.5 Micro			$390.00
4	NIKON	lens/special	#179152	35mm f 2.8 PC			$640.00
							$3,670.00
DARKROOM							
5	NIKON	lens/enlarger	#519511	150mm f5.6			$440.00
							$440.00
GENERAL PHOTOGRAPHIC USE							
6	HASSELBLAD	magazine	#UC 311890	70mm Film Back			$960.00
7	HASSELBLAD	magazine	#UU 520400	A12 Film Back			$360.00
8	NIKON	Camera body	#3730019				$110.00
9	NIKON	lens/special	#177756	28mm f 4 PC			$975.00
10	NIKON	lens/special/normal	#718988	45mm GN Auto			$155.00
							$2,560.00
MEDIUM FORMAT							
11	HASSELBLAD	Camera body	#UE 1219208	500 C/M Camera			$1,400.00
12	HASSELBLAD	Camera body	#RT 1331619	500 ELX Camera			$1,400.00
13	HASSELBLAD	Film Magazine/Holder	#RE 3338223	A12 Film Back			$360.00
14	HASSELBLAD	magazine	#RS 3174381	A12 Film Back			$360.00
15	HASSELBLAD	magazine	#3720141	Polaroid back			$420.00
16	ROLLEI	Camera body	#2829683	Rolleiflex Twin Lens			$1,350.00
							$5,290.00
Travel Case N° 2							
MEDIUM FORMAT							
17	ZEISS	lens	#NR 5909422	80mm f2.8 Planar			$1,350.00
18	ZEISS	Lens/Long	#NR 591227	250mm f5.6 Sonnar			$1,350.00
19	ZEISS	Lens/Long	#NR 6108326	150mm f4 Sonnar			$1,550.00
20	ZEISS	lens/tele	5152113	100mm f3.5 Planar			$800.00
21	ZEISS	Lens/Wide	#NR 5713443	50mm f4 Distagon			$1,100.00
							$6,150.00

When printed, you have a list that is sorted by type of equipment (i.e., what it's used for) and manufacturer. It even designates the number of the carrying case in which each piece of gear is packed. This becomes useful for location shoots, where it becomes essential to keep track of what goes out of the studio and what goes back in. It also makes it easier for your assistant to find what you need. (See the exercise, Creating a Location Equipment List, in chapter 46 later in this Part.)

note Don't put your name or address on this list. If you lose it, it becomes a neon sign and road map for burglars!

EXERCISE ----------------------------------

Creating a New Stock Photo Record from a ShootSheet

One normally creates a new stock photo record (or records) at the end of an assignment, adding photos from that take into the stock archive. So, it's likely that you have already created a ShootSheet to log the assignment. For the purpose of this exercise, you will choose an example in PhotoByte that has already been logged and invoiced.

 ▸ Click the *Paper Trail* button from the PhotoByte Main Menu.

 ▸ Click the *ShootSheets* button on the Virtual Paper Trail screen. You will see a list of all assignments.

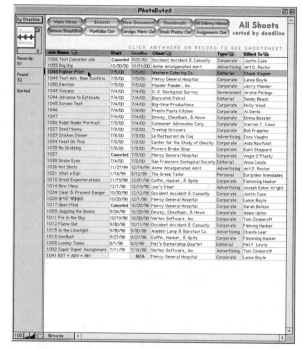

 ▸ Click on the title of the third assignment in the list, **Fighter Pilot**.

You will see the ShootSheet for this assignment in Preview mode.

 ▸ Click the *Continue* button on the left to view the ShootSheet in Browse mode.

Notice that there is a picture at the bottom-left corner of your screen. It got there because you either scanned a Polaroid print or a slide from the take, then cut and pasted it into the ShootSheet. Next to the picture, slightly below it and to the right, is the

Stock button. (You may need to scroll down to see the bottommost part of your screen.)

> Click the *Stock* button.

You will see a new stock photo record.

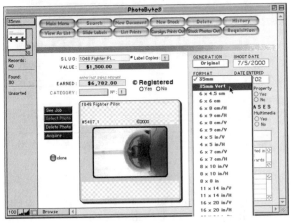

Now that you are looking at the new stock photo record, notice that the picture of the airplane canopy appears on its side. By default, the photo is added in a 35mm, horizontal format. However, you can accommodate any format you choose.

> Click on the pop-up *Format* field on the Stock Photo screen.
> Select **35mm Vert.**
> Click on the picture itself.

Now the image appears in the correct, vertical format.

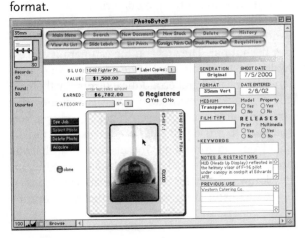

Notice that, in the *Earned* field, the initial usage fee was looked up from the Invoice for this assignment. It can be augmented as the image is licensed further. From now on, when you click the *Stock* button at the bottom of the ShootSheet, instead of creating another new record, it will return you to the one you already created.

note You can return to the ShootSheet by clicking the See Job button. From there, you can navigate to any other document in the paper trail pertaining to this stock photo record.

tip Click on the vertically oriented caption field, and it will then appear in a horizontal format, so you can type captions. This works on both the top and bottom "labels." Remember: Whatever you type will appear just as you see it on your printed slide labels.

> From the Stock Photo screen, click the *Category* button.
> Select **Military** from the pop-up View Index window.

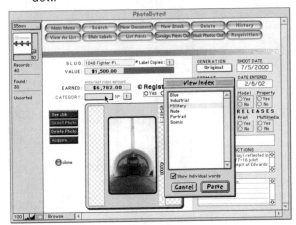

This will help identify a unique serial number (as explained in the exercise, Learning the PhotoByte Image-Filing System, in chapter 6 in part 3).

> Click on the *Film Type* button, and select **EPN35 . . .**

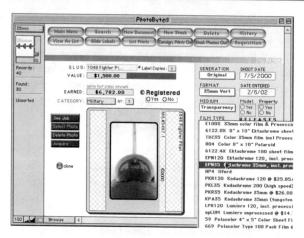

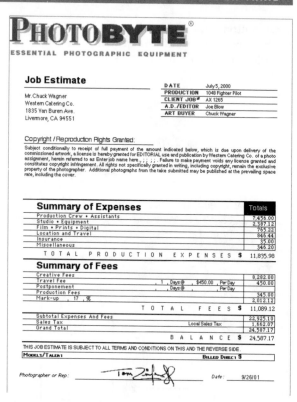

This list is derived from the film preferences you learned how to enter in the exercise, How to Set a New Film Lookup, in chapter 4 in part 2.

> Finally, click on the *Keywords* field and select **airplane** from the View Index window that appears. You can continue to type additional keywords that define the image, e.g., canopy, HUD, pilot, USAF, jet, fighter, green, etc.

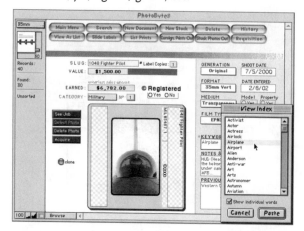

The Job Estimate

"Knowing how to produce rapidly an accurate, detailed job estimate is no longer an option for the professional photographer; it is a matter of economic survival! Projecting assignment fees and expenses within a narrow margin of error can mean the difference between getting the job, making a profit and continuing in business, or going broke." So says *ASMP Professional Business Practices in Photography*.[3] It should be noted that this would be a

daunting task if you had to remember all of the elements that go into a job each time you created a new estimate, and had to do it under the pressure of a deadline. But with computer software to guide you through the process, all you have to do is fill in the blanks—the costs on each line.

What many photographers have failed to understand in the past is that clients don't go right to the price. Of just as much importance to them is how you *arrive* at a price. By looking at the details, almost literally between the lines (i.e., the line item expenses), they can determine whether you have what it takes to get the job done right.

Shrewd buyers look at an estimate as though it were the skeleton of a job. They want to see how you can flesh it out. They rely on the estimating process to demonstrate your skill at describing visual problems in practical and economical terms. By the time you are asked to estimate a job, it is assumed that someone already believes you've got a good eye. Now you need to prove that you have the skills to build a shot from the ground up. You need to show that you are a competent production manager—read: this guy knows his business!—not just an artist.

Good estimating skills show that you compre-

hend what it takes to turn a layout, or just an idea, into an image that gets the client's message across; that you not only know what camera, film, and f-stop to use, but that you know whether it will be costlier to shoot on location instead of in a studio (or vice versa). Perhaps you can show how to save time and money by prevailing upon, say, your airline-industry contacts to shoot inside a 747 during downtime in a hangar, instead of recreating a jumbo-jet interior in a studio. A well-done Job Estimate will show an art director that you can "read" the details in a layout; that is, you immediately noticed that the woman in the layout was wearing a gaudy diamond ring, so you added it to the budget as a prop rental. Moreover, you might have recommend a stylist who knows where to rent a Cartier gem for less than it would cost to spend time looking for costume jewelry. Those are the kinds of things that earn kudos with art directors.

Attention to detail will make or break a photographer's estimating ability and, thereby, his chances of landing an assignment. When such details are outlined in a Job Estimate, buyers are assured that you're not—and they're not—getting in over their heads. A Job Estimate helps buyers better gauge your capabilities than by looking at a portfolio alone, because anyone can show beautiful photos without admitting that they were all dumb luck.

This may not be the most creative part of being a photographer, but estimating illustrates that you can take a concept all the way to the substance of creation. That's what your clients care about. Incidentally, there are three additional rules to remember whenever you are ready to create a new Job Estimate[4]:

▸ Never accept a job *at any price* before you have given yourself an opportunity to determine if it makes economic sense to move forward, i.e., you are assured of making both a profit and a reasonable assignment fee.
▸ No matter how urgently you are asked, *never* give a buyer a "ballpark" figure.
▸ Demand an advance to cover your estimated expenses. You are not a banker. Don't make interest-free, short-term loans to your clients.

It is relatively easy to estimate an assignment with the help of a computer, because you simply enter the amounts you actually have to pay for goods and services, while the software reminds you what they are. Surely, you know how much your assistant is going to bill you. Enter that amount on its designated line. The tricky part, as described above, is reading into the layout, or interpreting the art director's verbal description of the assignment, well enough to budget for any less-than-obvious items. That's the part that takes experience. There is no substitute for it.

As for all of the other routine items that go into a Job Estimate—well, you have already determined what it costs to buy a roll of film at the camera store, and you copied that figure and others like it into PhotoByte when you entered your lookup preferences (see chapter 4, part 2). If it's a new cost, one you've never incurred before, just pick up the telephone and call the vendor—or the hotel for a room cost, a travel agent for an airline ticket, a foreign consulate for a visa. Ask for a price for whatever it is you think you might need to buy. Whatever it costs is what you will enter on a given line. Then, simply mark it up, as appropriate, by clicking the *Profit* button right next to it.

Once you click the *Profit* button, the actual expensed amount billed to your client will appear in its place. In other words, you enter your cost, and PhotoByte figures out the billing price. Of course, you still have to determine how much markup to apply (at what percentage of cost) and what your assignment and usage fees will be. (Those topics were covered in part 6, Pricing Photographic Services.)

Incidentally, the Front Page of the Job Estimate (as well as the Job Confirmation and the Invoice/ License of Rights) is filled in automatically. All data entry (i.e., that which is not looked up from a ShootSheet) is made on the two accompanying Worksheets (*see next page*). The figures on the Front Page cannot be—and don't need to be—edited directly. You may, however, enter textual descriptions on line items on the Front Page.

Worksheet 1

JOB ESTIMATE

(Main Menu) (Front Page) (Wrksht 2)

DATE 10/25/98 CLIENT Mercy General Hospital CLIENT JOB No. _____

PRODUCTION _____ Example Job INVOICE No. 29485

$10,475.10

Profit? Production Crew Est. Amount: $250.00

#			Days	Rate	Hours	Rate	Amount	Profit
1	Assistant	Tom Zimberoff	1	$350.00			350.00	
2	2nd Assistant	Otto Focus	1	$210.00			210.00	
3								
4	Production Coordinator							
5	Prop Stylist							
6	Wardrobe Stylist							
7	Make-up Stylist	Max Factor	1	$630.00			630.00	
8	Hair Stylist							
9	Location Scout							
10–18								

EXCLUDE TAX ON ASSISTANTS AND CREW ○ S U B T O T A L $ 1,190.00

Studio · Equipment Estimated Amount: **Amount**

19	Rental for Build/Strike/Casting		days @	per day	
20	Rental For Shoot	1	days @	$450 per day	450.00
21	Production Supplies				
22	Telephone				
23	Cyc Paint & Return				
24	Power / Light Charges				
25	Special Effects Rig				
26	Color Correction Material	CC40M gel			18.13
27	Grip Equipment				
28	Auxiliary Lighting Rental				
29	Optiglass	1000mn f1.0 Darklux telephoto lens.			639.45
30	Backdrops				
31–32					

S U B T O T A L $ 1,107.58

Film · Prints · Digital Estimated Amount: $25.73 **Amount**

FILM	QTY	CODE		Amount
33	90	EPN120	Ektachrome 120, incl. processing @ $25.73/roll	2,058.40
34	25	669	Polacolor Type 100 Pack Film @ $2.81/sheet	72.00
35–38				

DIGITAL	QTY	CODE	
39–45			

S U B T O T A L $ 2,130.40

Worksheet 2

JOB ESTIMATE

(Main Menu) (Front Page) (Wrksht 1)

DATE 10/25/98 CLIENT Mercy General Hospital CLIENT JOB No. _____

PRODUCTION _____ Example Job INVOICE No. 29485

$10,475.10

Location · Travel Estimated Amount: **Amount** Profit

46	Permits		93.80
47	Laundry		
48	Gifts For Locals		
49	Car Rental		
50	Truck / Van Rental		
51	Motor Home / Dressing Room Rental		
52	Limousine		
53	Auto: Mileage, 234 ,@,0.31¢, Parking, $7.00 , Fuel, , Tolls,		79.54
54	Taxi		
55	Special Vehicles / Air Charter		
56	Excess Baggage		
57	Documents / Customs		
58	Per Diems: Nº of People , 14 , Amt/Person/Day, $421.35 , Nº of Days , 3 ,		17,696.64
59	Air Fares: Nº of People , Cost per Fare,		
60	Hotels: Nº of People , Cost per Room, Nº of Nights ,		
61	Gratuities		
62	Meals		
63	Generator Rental		
64–65			

S U B T O T A L $ 17,869.98

Insurance Estimated Amount: **Amount**

66	Shoot Insurance /pro-rated	1 DAYS @ $35.00 PER DAY	35.00
67	Special Liability Insurance		
68	Binders / Riders		

S U B T O T A L $ 35.00

Miscellaneous Estimated Amount: **Amount**

69	Telephone		63.00
70	Catering		
71	Props		
72	Messenger / Air Courier		
73	Entertainment		
74	Models / Talent (Studio Paid)		
75–77			

S U B T O T A L $ 63.00

Creative Fees Estimated Amount: $4,200.00 **Amount**

78	Assignment Fee	4 DAYS @ $1,050 PER DAY	4,200.00
79	Usage Fee	refer to copyright license on Front Page	4,200.00
80–81			

S U B T O T A L $ 8,400.00

Production Fees Estimated Amount: $500.00 **Amount**

82	Consultation / Meeting	DAYS @ PER DAY	
83	Casting	1 DAYS @ $500 PER DAY	500.00
84	Location Scouting	8 DAYS @ $500 PER DAY	4,000.00
85			

S U B T O T A L $ 4,500.00

The Worksheets are particularly useful to:

‣ Keep you from forgetting to include billable expenses on your final invoice
‣ Submit as backup itemization for production expenses
‣ Help apply profitable markups
‣ Look up prices and descriptions of often-utilized equipment and commodities, such as film[5]

PhotoByte will address the face of the Job Estimate for you, as well as (optionally, at your discretion) an envelope to mail it in. It will also allow you the option of faxing it by switching to another layout that includes your signature and company logo.

After the Worksheets are filled in, the Job Estimate can be displayed or printed as any one of three different layouts at any time, with varying degrees of line item detail. For instance, you can submit a summary Job Estimate that includes only those line items actually used. Just click the appropriate button, in this case, *Short View*.

PHOTOBYTE®

ESSENTIAL PHOTOGRAPHIC EQUIPMENT

Job Estimate

Bill to:

Mr. Chuck Wagner
Western Catering Co.
1835 Van Buren Ave.
Livermore, CA 94551

Copyright/Reproduction Rights Granted:

Subject conditionally to receipt of full payment of the amount indicated below, which is due upon delivery of the commissioned artwork, a license is hereby granted for EDITORIAL use and publication by Western Catering Co. of a photo assignment, herein referred to as Enter job name here . , , , , . Failure to make payment voids any license granted and constitutes copyright infringement. All rights not specifically granted in writing, including copyright, remain the exclusive property of the photographer. Additional photographs from the take submitted may be published at the prevailing space rate, including the cover.

THIS JOB EST MAY E SUBJECT TO ALL TERMS AND CONDITIONS ON THIS AND THE REVERSE SIDE.

ESTIMATE DATE	CLIENT JOB NUMBER	SALES TAX RATE
July 5, 2000	AX 1265	Local Sales Tax

DESCRIPTION		AMOUNT
Assistants & Production Crew		7,456.00
		2,387.12
Additional Lab Charges		765.22
Location/Transportation		846.44
Insurance		35.00
Miscellaneous		346.20
TOTAL PRODUCTION EXPENSES		**$11,835.98**
Creative Fees		8,282.00
Pre/Post Production	Usage Fees of $6782.00 plus 1 day @ $1500	345.00
Travel Fee		450.00
Markup Fee		2,012.12
TOTAL FEES		**$11,089.12**
Sub Total		22,925.10
Sales Tax	7.25%	1,662.07
GRAND TOTAL		24,587.17
BALANCE OF ESTIMATE		**$24,587.17**

Photographer or Rep: _Tom Zimberoff_ Date: Sep 26, 2001

A Job Estimate may be submitted as a single-page document using either of the available layouts (standard or short). These separate layouts (or views) are illustrated in this part in the exercise, Create the

Paper Trail for an Entire Assignment. Each layout may be accessed and viewed by means of clearly labeled buttons on the face of the document when viewed in Browse mode. However, you may wish to include the Worksheets as backup. The variations for the two available layouts for a Job Estimate are:

> Front Page (standard view)
> Short View
> Short View Suppressed Detail
> Logo View (standard view with logo and signature)
> Short View with logo and signature
> Short View Suppressed Detail with logo and signature

note All PhotoByte documents can be faxed, but there is no internal mechanism within the software to do so. Faxing works in conjunction with whatever brand of fax software you have installed separately on your computer. What makes PhotoByte documents uniquely practical for this purpose is that you can easily switch from a layout that is formatted to print onto your letterhead stationery to one that contains your logo and signature to take advantage of paperless distribution, as illustrated above with the Short View.

Fax forms notwithstanding, the Worksheets, like other examples of PhotoByte documents, are graphical metaphors for paper forms. What you see on screen is exactly what you will see on paper, assuming they will ultimately be printed to send to your clients. You can type anywhere on them (except in the margins, of course). You can enter a line item description—or leave a line blank if you wish—wherever there is enough "real estate" to type into. Such an extensive data entry capability allows you to be either as obsessive about entering descriptive details (e.g., an assistant's name, a shipping air bill number, etc.) or as general as you wish. Once you have filled in the information about your billable expenses in the Worksheets, the Job Estimate is finished.

Incidentally, the Worksheets will show your cumulative profit as you continue to click the *Profit* buttons. It is indicated at the top of the Amount column (in green). This figure does not print, so only you can see it on your screen. You can track profit on each job as it accumulates line item by line item.

note Entire Job Estimates from previous jobs can be duplicated and adapted to a new job, to avoid repetitive research and typing. Click the Duplicate button displayed at the top of the original Job Estimate.

The Difference between an Estimate and a Bid

Job estimates and bids are often misconstrued to mean the same thing. Clients and photographers alike make this mistake.

A bid is not an estimate. It is a document that commits you to deliver an assignment at a price that is binding. The price of a bid job must still be determined by estimating what your costs are. But if the assignment is awarded to you, the price you bid puts a cap on compensation. During the shoot, if your expenses increase unexpectedly and you go over budget, you will not be reimbursed for the difference. The difference comes out of your creative fees and profit.

An estimate, conversely, is not a bid. It is an appraisal, simply a prediction of the costs to be incurred in producing a forthcoming assignment. There is an assumption that you will be awarded the assignment and that the client merely needs a clear picture of what it will cost.

note PhotoByte does not contain a form specifically for creating bids. If your particular situation calls for a bid, you will use another document called a Job Confirmation to accomplish the same purpose. It will be discussed shortly.

As you are asked to estimate more jobs, you will come to rely on your growing base of knowledge and experience to become more accurate. Nevertheless, estimating, unlike bidding, allows some leeway for going over budget. Trade practice traditionally allows a variance of 10 percent. It can be somewhat higher or lower, depending on your personal relationships with clients. In contrast, with a bid, if you have not carefully anticipated your costs to the penny, you may not make a profit, assuming you get the job. It

is quite important, when asked to submit a bid, to ask whether it shall be a *competitive* bid or a *comparative* one.

Competitive Bids

Being asked to submit a bid instead of an estimate is generally less desirable; it is usually analyzed in a competitive context. That is to say, a number of other photographers were no doubt invited by the buyer to submit bids for the same assignment. The assumption is that the lowest bid gets the job. The bottom line of the bid is predicated on your best-informed efforts at determining costs and cutting profit margins to the bone without sacrificing your assignment fee or cutting profit altogether. It may be smaller, but you must still, always, make a profit.

Before submitting a competitive bid, always ask the buyer against whom you are bidding. If you recognize the name(s), and expect to be undercut, don't waste your time. (See part 6, Pricing Photographic Services, and the section, Bid Submission Fees, in chapter 34.)

Comparative Bids

Whereas a competitive bid simply means the lowest bidder gets the job, a comparative bid means stacking your price up against other bids with an emphasis on how each of you applies production costs to achieving creative goals. A lower bid may reflect one photographer's greater efficiency and management skills. It can present a financially attractive choice for the client who is shrewd enough to see just how efficient you are by the way you anticipate the not-so-obvious costs and how you predict they will affect production—or how you can find alternative means to accomplish the same thing by shaving costs off the bottom line instead.

It takes a more knowledgeable buyer to analyze a comparative bid. He will look carefully at the details in the Worksheets, not just at the bottom line. That buyer may not necessarily award the shot to the lowest bidder, but to whoever best illustrates that he understands how to get the job done with fewer complications. For example, the photographer who forgot to estimate the cost of hiring a calligrapher for a shoot that required a hand-painted sign might not get the job, even though he bid a lower price. Again, this is not an estimate, because you will be held to your bid price.

Price Quotes

If an estimated price is made conditional, i.e., if it is valid for only a limited time, it is referred to as a *quote*. When submitting a quote, you are not necessarily concerned with offering the lowest bid. It's basically a Job Estimate with an expiration date. It is often provided as an incentive for the buyer to hire you, if he knows that the price may go up after the deadline.

The Job Confirmation

A Job Confirmation is a contract between you and your client. What makes it different from a Job Estimate (they look almost identical except for some language on the face of the document) is that *you* sign Job Estimates, but your *clients* sign Job Confirmations.

It's the client's obligation to sign a Job Confirmation just as you are obliged to sign an agreement when you hire a mechanic, a plumber, an attorney, or an architect to perform work for you. It is in every photographer's best commercial interest to have each buyer sign a Job Confirmation *before* undertaking an assignment.

Make sure your Job Confirmation trumps any purchase order you may be asked to sign. Carefully peruse each P.O. for language that is detrimental to your economic interests. If you find any, cross it out and initial where you did so before signing it. (See part 2, the section, More Help from Technology, in chapter 3.) The most obvious thing to watch out for, of course, is a work-for-hire clause. But also look for any language stipulating that the client's purchase order takes precedence over your Job Confirmation. If you have any questions about this at all, consult an attorney immediately—before you sign. You'll quickly learn to recognize problems yourself after an initial legal consultation or two.

Everything you've already put into a Job Estimate will appear on the Job Confirmation automatically when you use PhotoByte. You can make changes as required, of course. However, a Job Confirmation is more like a bid, because while a Job Estimate is merely an appraisal—an intelligent guess about your costs with a statement of your fees—a Job Confirmation represents a firm understanding of what you will actually bill. Conversely, it is also a commitment from the client—a contract—to pay you the stipulated amount. So, if you are asked to "bid" on a job, you might want to skip the Job Estimate and go straight to the Job Confirmation.

Once your client signs the Job Confirmation, the job is yours. You should collect your fees even if it is cancelled. Of course, there will be no expenses to bill or to collect, unless you had already begun work on the assignment before it was cancelled.

A Job Confirmation is created by clicking the *Confirmation* button at the top of either a ShootSheet or a Job Estimate. To go directly to a Job Confirmation, for example in a bidding situation, start from the *New Document* button on the Main Menu of PhotoByte. Then click the *Confirmation* button on the New Document screen.

note If you wish, you may skip the Job Confirmation and go straight to an Invoice from either a Job Estimate or a ShootSheet. You might not need a Job Confirmation for editorial jobs, unless they are large and long-lasting productions. However, for most corporate and advertising jobs, it is recommended that you obtain a signed Job Confirmation from the client.

The Contingency Fee Schedule

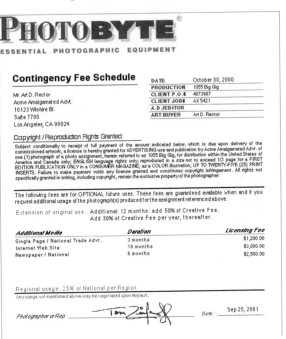

This document outlines and defines what your fees will be for subsequent publications, or any kind of usage of your work at the client's option, after the original copyright license expires. You can create this document at any time if either a Job Estimate, Job Confirmation, or Invoice/License of Rights exists for a job.

Refer to the section, Contingency Licensing Fees, in chapter 31, part 6, Pricing Photographic Services, for more information, including an exercise.

The Job Change Order

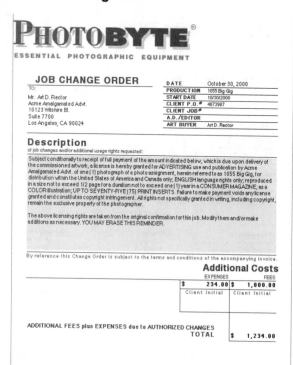

This document can be created only if you already have a Job Confirmation. The time to create a Job Change Order (by clicking the *Job Change* button at the top of a Job Confirmation) is when the client decides to change the terms to which he's already agreed, whether they affect either the usage or the creative nature of the shoot, which might incur additional costs. For example, you're in the middle of a shoot and the art director likes what you're doing so much that he suggests a few extra shots. Those extra shots mean you'll be shooting extra film. So, who's going to pay for it? Spell it out now so there are no questions later. What if an additional shot results in an extra advertisement or the cover of a magazine instead of merely an inside illustration? Are you entitled to any additional fees? Spell it out!

Whatever additional expenses are incurred will be logged in the Job Change Order. PhotoByte will look them up and include them automatically in the total of your Invoice/License of Rights, which will also display a line item reference for the Job Change Order. (You will create a sample Job Change Order in chapter 46 in the exercise called Creating the Paper Trail for an Assignment.)

Invoices

There are six separate kinds of invoices in the paper trail (and in PhotoByte)[6]:

> ❯ The Advance Invoice
> ❯ The Invoice/License of Rights
> ❯ The Stock Invoice
> ❯ The Simple Invoice
> ❯ The Art Invoice
> ❯ The Late Fee Invoice

Each one corresponds to a particular kind of billing situation, as described below.

The Advance Invoice

A photo assignment can be expensive to produce, especially if it involves many days, or even weeks, of shooting. Of course, it is usually the photographer who directly pays production costs for crew, travel, film and processing, etc. Full reimbursement (including profit) doesn't come until the job is concluded. Then, you must wait however long it takes to receive a check in the mail after you have submitted a final Invoice/License of Rights. Therefore, if a production is not likely to conclude for some length of time, or if it involves extraordinary out-of-pocket costs, you have to find a way to cover your overhead and other financial responsibilities in the meantime. It's time to ask your client for an advance.

If you plan to bill your client for an advance against expenses or fees, you must create a separate invoice for the amount of the advance. *This invoice must also include any applicable sales and use taxes.* PhotoByte will take care of that automatically. By creating an Advance Invoice, PhotoByte "knows" not to calculate the amount of the advance twice into the total revenue for the job, since the grand total of your final invoice will not and should not reflect the amount of the advance; nor should it include the amount of tax already paid (if applicable) on the advance. As indicated on the Invoice/License of Rights, an advance is a separate line item expense, which is deducted automatically from the grand total, leaving only the balance due for the client to pay.

An Advance Invoice should be submitted to your client immediately upon booking the assignment. You should also be paid immediately. In fact, you should politely decline to begin the assignment until the check has been deposited in your bank account and cleared.

Advances should be invoiced from either a ShootSheet or Job Confirmation, although it is possible to create one as a stand-alone document from the New Document screen (not recommended). In fact, if the job is complex enough or costly enough to require an advance payment, it will probably require a Job Confirmation be signed by your client anyway. To learn how and when to create an Advance Invoice, refer to the exercise, Creating the Paper Trail for an Assignment, in chapter 46.

The Invoice/License of Rights

A photo-assignment invoice not only demands payment for the products and services you have rendered to your client, it actually grants and withholds reproduction rights according to the terms written on its face upon payment in full. Therefore, as stated earlier, it is a contract.

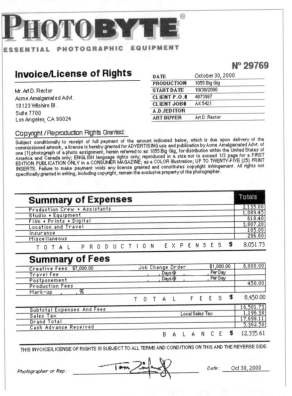

The Invoice/License of Rights—as are all invoices created with PhotoByte—is automatically added to your list of accounts receivable. Fees and expenses from any preceding Job Estimate, Shot List, Job Confirmation, or Job Change Order have been included in the invoice total. So, too, any licensing terms and conditions entered previously.

PhotoByte guides you through the process of invoicing, beginning with the Worksheets, so no billable expenses are neglected. But you will see that a number of line item expenses have automatically been filled in and are ready for any final changes or additions you may wish to make.

The Worksheets associated with an Invoice/License of Rights created from a Job Confirmation will display a button at the top that allows you to toggle back and forth.

INVOICE/LICENSE OF RIGHTS **Worksheet 1**

If there is no corresponding Job Confirmation, the Worksheets will display no button. Again, like the Job Estimate or Job Confirmation preceding it, you may choose to submit a long version, an abbreviated version (showing only those line items actually

billed), or a summary version (showing only line item headings with no detailed descriptions). All you have to do is click the appropriate button at the top of your Invoice. You may, as already mentioned, submit the Worksheets as backup to accompany any version of the Invoice, long or short.

The Stock Invoice

This document applies specifically to licensing stock images. You can create a Stock Invoice (which looks different than the Invoice/License of Rights) from the New Record screen.

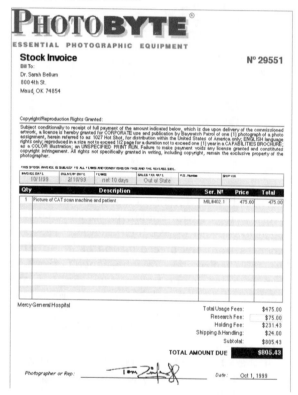

Alternatively, the *Invoice This* button on any Delivery Memo will create a Stock Invoice that will remain linked to the data in the Delivery Memo and automatically addressed to the party to whom the Delivery Memo was submitted.

From a Stock Invoice, you may click the *Copyright* button to access the Copyright Composer, add or delete captions pertaining to the specific license granted for the images copied from the Delivery Memo, and proceed however you wish from there. The Stock Invoice is automatically added to your accounts receivable.

note You can toggle back and forth between a Delivery Memo and its corresponding Stock Invoice.

The Simple Invoice

This invoice is not related to the structure of the Invoice/License of Rights or the Stock Invoice. Instead, it is used to bill, say, another photographer for the rental of your studio or, perhaps, the sale of a used camera. It may also be used to bill a client for any additional expenses related to a job that has already been billed or paid.

For example, your client may wish to purchase some additional prints from a shoot that has already been paid for, to give away as gifts to the subjects portrayed. You can, at any time, create a Simple Invoice from the New Record screen or from a button found on the Profile > Est/Conf/Inv screen.

The Simple Invoice has no Worksheets attached to it and no lookup capabilities beyond name and address. It is filled in just like an ordinary paper invoice.

note If you intend to create an Invoice directly from the New Documents screen, never use a Simple Invoice to bill for a photo assignment! Only the Invoice/License of Rights will suffice. A Simple Invoice does not include a copyright license.

EXERCISE --------------------------------

Creating a Simple Invoice

Assume that you have just rented your studio to another photographer. If you lease the studio yourself, you may prorate your monthly payment (divided by the number of days in a month, e.g., $3,000 per month divided by thirty equals $300 per day) and bill a daily rental fee. If you add a 50 percent markup, you would rent your studio out for $450 per day. Here is how to invoice that transaction.

> ‣ From the PhotoByte Main Menu, click the *New Documents* button.
> ‣ Click the *Simple Invoice* button.

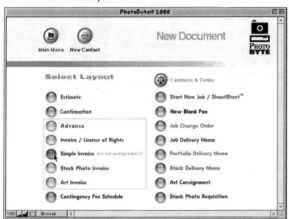

A Simple Invoice will appear on screen with instructions to select a name from a pop-up list.

> ‣ Type the letter *H*.

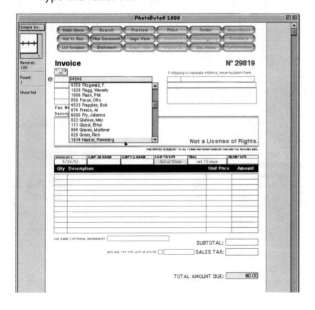

The name Flemming Hacker will be selected in the field.

> ‣ Press *Enter* on your keyboard.
> His address will be filled in.
> ‣ Tab to the description field, and add whatever information you feel is pertinent.
> ‣ Tab through the remaining fields.

This invoice will appear in your accounts receivable just like any other, but it won't count as an assignment.

The Art Invoice

This invoice is applied only to the sale of fine-art photographic prints, which are tracked separately from the licensing of stock photos and prints destined for commercial reproduction.

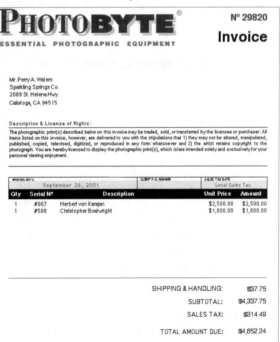

The Art Invoice looks very much like a Simple Invoice. The main difference is that it is linked to the catalog of fine-art prints in PhotoByte, which looks up serial numbers and captions automatically. It also displays the correct "legalese" for consummating the sale of a print. (See part 5, Copyright, the section, Ownership of Photographic Prints, in chapter 24.)

The Art Invoice is accessed from the New Document screen by clicking the *New Document* button

on the Main Menu of PhotoByte, just like the Simple Invoice described above.

EXERCISE

Creating an Art Invoice

> From the PhotoByte Main Menu, click the *New Documents* button.

You will see the New Documents screen.

> Click the *Art Invoice* button.

You will see an Art Invoice ready to be filled in.

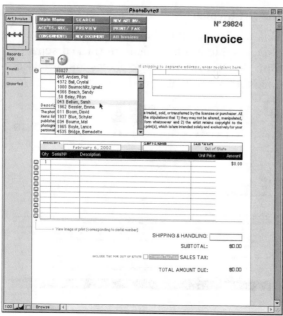

> Select a name (an addressee/purchaser) from the pop-up menu.
> Fill in the rest of the information on the invoice as needed.

note By clicking the small, gray button adjacent to each line item, you will display the image corresponding to your serial number and description.

Creating a New Print Record

> To create a new record for a fine-art print in your catalog, click the *Photos* button on the Main Menu.

You will see this screen:

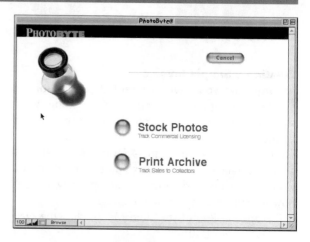

> Click the *Print Archive* button.

You will see the Collector Prints screen.

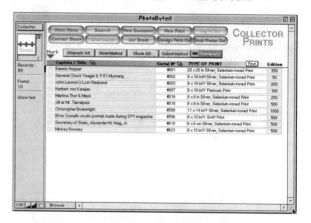

> Click the *New Print* button.

A dialogue box will appear, asking you to select a graphic file (i.e., a scan representing one of your prints). Continue with the script, and fill in as much additional information about your print, its edition and size, etc., as you wish.

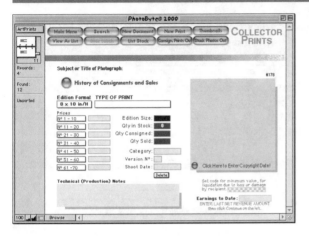

- - - - - - - - - - - - - - - - - - - -

The Late Fee Invoice

Only financial lending institutions such as banks and credit card companies are legally permitted to bill *interest* charges on top of unpaid balances, such as loans. As far as you are concerned, when clients are tardy with payments, they can be billed *late fees*. It is wise to include a stipulation to that effect in the terms and conditions on the reverse side of all your Job Estimates, Job Confirmations, and Invoices. (It is included by default in the terms and conditions on PhotoByte documents.)

A late fee is calculated on the balance due of an invoice at the "re-billed invoice rate" percentage you specified on your Preferences > General screen when you started using PhotoByte. It is generally 1.5 or 2 percent compounded monthly and automatically accounts for partial payments.

The Late Fee Invoice states on its face that it is not a license of rights. It also indicates that the amount due is *in addition* to the balance due on your Invoice/License of Rights, to which it refers by both number and amount. The Late Fee Invoice is automatically added to your list of accounts receivable. It can only be created from the Aged Unpaid Invoices screen, as indicated in the exercise below.

It is prudent to send a Late Fee Invoice immediately after a due date has lapsed. Sometimes clients ignore these invoices, but they are strident reminders that you expect to be paid on time. Sometimes, the arrival of a separate invoice indicating that a late fee has accrued is enough to prod the client to mail the outstanding balance of the original invoice.

It's up to you how hard you wish to press the matter of collecting late fees. It is recommended that you do demand their payment, because they are your only financial compensation for letting clients use what is essentially *your money* for their own purposes, and for substantial periods of time in some cases. To become a trade practice, more photographers need to do this, and to keep billing them until they are paid.

EXERCISE -

Creating a Late Fee Invoice

▸ Click the *Accounts Receivable* button on the PhotoByte Main Menu.

▸ Click the *Aged Invoices* button at the top left of the Accounts Receivable screen.

You will see the Aged Invoices screen.

PHOTOBYTE®

ESSENTIAL PHOTOGRAPHIC EQUIPMENT

INVOICE N° 29767

Mr. Jerry Mander
Mander Pander, Inc.
1117 D St., NW
Suite 1800
Washington, DC 20002

This invoice is not a license of photo reproduction rights. It is a re-billing fee for the delinquent amount from a previous invoice referred to below by number and amount. This re-billing fee is due and payable in addition to the original invoice.

INVOICE DATE 9/18/00	CLIENT JOB NUMBER	CLIENT P.O. NUMBER	ORIGINAL INV. DATE 7/5/00
Description			**Amount Overdue**
Delinquent invoice N° 29764			$17,098.00
Job Name: 1050 Election			

The original invoice has been due for 75 days. Please pay immediately!

RE-BILLING FEE:	$641.18
TOTAL AMOUNT DUE:	$17,739.18

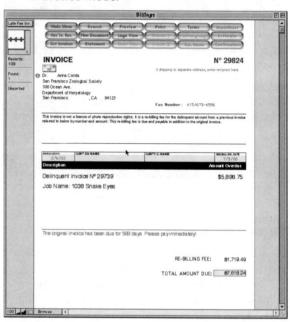

> Click *Continue* to see the same Late Fee Invoice in Browse mode.

Obviously, from this screen, now that you can access the various buttons, you can navigate anywhere else you want to go in PhotoByte, or you can print the Invoice. You may even click the *Logo View* button to see what it will look like when faxed or e-mailed. If you click the *Accounts Receivable* button, you will see that this Late Fee Invoice has been added to your total of invoices due. If it turns out that it is not going to be possible to get your client to pay a Late Fee Invoice, it must be voided. Follow the directions in the exercise in chapter 37, part 7, to void an invoice.

- - - - - - - - - - - - - - - - - - - -

The Late Payment Notice

As you know, PhotoByte logs all job-related faxes, letters, and phone calls for quick reference. They are listed on the Profile > Correspondence screen for each contact in your database. This includes Late Notices for both invoices and stock photo submissions. Items in this list serve as "ticklers" to remind you to follow up on Job Estimates and other letters, faxes, and memos. This kind of information is, perhaps, just as relevant to your marketing activities, but it is worthwhile to mention especially the Late Notice as a part of the paper trail.

> Select any invoice in the list that is overdue (i.e., indicated in red in the columns at the right by number of days due).

To *select* an invoice in the list, you do not want to click on it. That will open the invoice. Instead, use the Flip Book to move up or down the tiny, black vertical bar adjacent to the left side of the first line item in the list. The Flip Book is located in the top left corner of the Aged Unpaid Invoices screen.

> Click the *Send Late Fee Inv.* button at the top.

You will see a Late Fee Invoice appear in Preview mode.

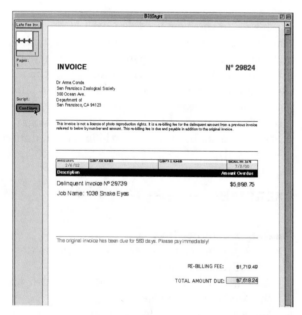

note The dates (and the number of days overdue) in the examples illustrated in this book will not agree with your copy of PhotoByte, since the sample records were created before the publication date and distribution of the book.

Before you send a Late Fee *Invoice,* it's a good idea to at least remind the client that a payment is due by sending a Late Payment Notice first.

EXERCISE ---------------------------------

Creating a Late Payment Notice

‣ Click the *Accounts Receivable* button on the Main Menu.

‣ Click the *Aged Invoices* button at the top left of the Accounts Receivable screen.

You will see the Aged Invoices screen again.

‣ Select any invoice in the list that is overdue, as indicated in the columns at the right. Use the Flip Book as described in the previous exercise.

‣ Click the *Send Late Notice* button this time, *not* the *Send Late Fee Inv.* button.

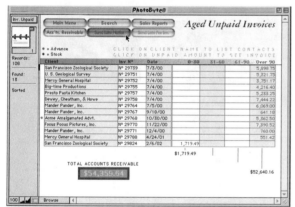

A letter will be generated demanding payment for the balance due. It will include your logo and signature for faxing, or you can exclude your logo and signature and print the letter on your stationery instead, using the U.S. Postal Service for delivery.

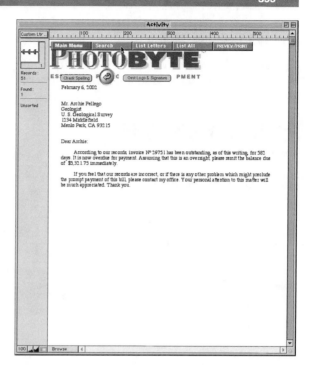

‣ Click the *Preview/Print* button at the top of the screen.

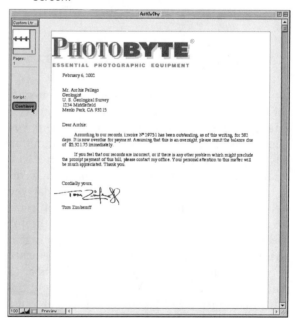

Click *Continue* to print or fax the letter.

The Job Delivery Memo

Immediately upon the completion of every photo assignment, you should send a Job Delivery Memo along with your film.

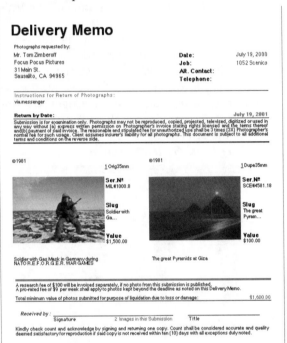

As a matter of fact, on the premise that no photographer hesitates to deliver his assignment as quickly as possible for the benefit of his client, you should just as conscientiously strive to submit an Invoice/License of Rights at the same time. Notwithstanding the importance of the copyright terms it represents, literally its face value, every day you delay sending an invoice is another day you must wait to be paid. The benefit of including the Job Delivery Memo as the triple crown in this package is that you can ensure that your film will be returned to you promptly by tracking its whereabouts at all times. That's a difficult task to manage without this particular capability of PhotoByte's, if you are busy shooting lots of assignments. How this kind of tracking is accomplished will become obvious as you read on, in particular with regard to how one tracks stock photo submissions.

The (Stock Photo) Delivery Memo

A Delivery Memo is a document that accompanies the submission of negatives, prints, or transparencies to buyers on approval, almost always at the client's request. It itemizes the submission and ascribes a value for the commercial liquidation of each item submitted. In short, it is an acknowledgment of receipt.

Some photographers are disinclined to submit Delivery Memos. They are loathe to do so, because they may have to display a liquidation value as large as five or six digits on the bottom line. They fear that buyers will balk at such an ostensibly exorbitant number. Nevertheless, the value of every submission is determined by its potential to earn additional revenue in the future. It is not made arbitrarily.

It's not hard to imagine how a single photograph can be licensed over and over again, whether to the same publisher or different publishers. Even at relatively modest licensing fees, it has a potential to earn tens of thousands—if not hundreds of thousands—of dollars throughout the course of a lifetime or the lifetime of a photographer's copyright, whichever comes first. If a photo is lost or destroyed, either the photographer or his estate could be deprived of further income. If someone is at fault for such an accident, he must compensate for the

financial loss. (It should be noted, as described in part 2, that this kind of situation no longer poses a problem once technology allows photographers to routinely submit electronic facsimiles, or high-resolution digital images, through cyberspace, instead of shipping actual film.)

The whole idea behind a Delivery Memo is to impress clients with the value of your work, so that they will be careful with it, and to provide a mechanism for compensation *just in case* the worst happens. Besides, *a Delivery Memo is not an invoice.* It does not demand payment of the amount indicated. The total on the bottom line—or any fraction thereof—represents a contingency. If you are coy about the value of your work, it is more likely that you will have a hard time—a very hard time—collecting restitution if something happens to your precious film.

When clients are put on notice routinely about their responsibility to treat your film and prints safely, they will think twice before putting a coffee cup on top of a page of slides or otherwise leaving them vulnerable. *If a client is not willing to accept that responsibility, you do not want to do business with him or his firm!*

There is another reason for prominently declaring the value of your submissions on a Delivery Memo: your personal stature. You wouldn't want your clients to think your work was cheap, a mere commodity that is easily replaced. It is not. If that were the case, it would be impossible to negotiate higher usage and assignment fees. It is not likely that any responsible client would refuse to accept and sign a Delivery Memo.

Loss or Damage of Exposed Film

It has already been established that, if the recipient of a submission is responsible for damaging or losing an original frame or sheet of film (i.e., negatives or transparencies), he must compensate the photographer for the economic loss. This practice does not represent direct compensation for the intrinsic value of the film itself. Rather, it offsets the loss of further income that would predictably ensue from the licensing of the images represented by the film. This practice applies the principle of liquidity to your film, as explained in part 5, Copyright.

Minimum Valuation

A minimum valuation suggested years ago by the ASMP of $1,500 per transparency (or negative) set a precedent that has withstood legal challenges over time. This value is usually designated for each individual frame or sheet of film submitted along with a Delivery Memo.

It must be noted that the $1,500 figure is a *minimum* valuation, designated as such to avoid quibbling over damage amounts.[7] If it seems reasonable that more than $1,500 in losses might be sustained due to the loss or damage of a special image, a higher valuation may be assigned at your discretion before the film is delivered.

As you might imagine, a submission containing one hundred color slides (with a valuation of $150,000) should be adequately protected by assigning the minimum valuation to the entire submission, perhaps less if the images are all similar. On the other hand, says photographer Michal Heron, "A lost or damaged slide is a de facto buyout, and should be billed accordingly."[8]

EXERCISE ---------------------------------

Submitting and Tracking Stock Photos
Finding and Submitting Photos
Here's the scenario: Mr. Justin Case of the Occident Accident & Casualty Company has asked to see some stock photos for possible use in a corporate capabilities brochure. But before you send any of your original transparencies or negatives, it is wise to ask him to sign a Stock Photo Requisition form.

This is sometimes referred to as a "Predelivery Memo." It merely acknowledges his request, so that he cannot later claim that the submission of your pictures was unsolicited if they become lost or damaged, and that he agrees to be bound by the terms and conditions of a standard Delivery Memo *once he receives your property.* If he refuses to sign this document and return it to you, you can be assured that he is a bad risk for protecting your slides from loss or damage. He has no intention of treating your intellectual and physical property with the respect it deserves. Chances are increased that you may have to file a lawsuit to reclaim your photographs or to recover financial damages.

You'll start this time by using an alternative method to search for a contact's Profile.

> From the Main Menu, click the *Search Records* button.
> Click the *People, Companies, Locations* button on the Search screen.

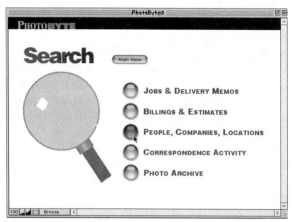

The cursor is blinking in the *Name* field of the Find screen.

> Type **j case**. Press Tab.
> Type **occi** in the *Company* field.
> Click the *Continue* button.

PhotoByte will display a dialogue box informing you that one record was found. Proceed, and you will see the Profile for Justin Case of Occident Accident & Casualty:

> Click the *Submit* button at the top of the Profile screen.
> Then, click the *New Stock Photo Submission* button on the next screen.

You will see the Stock Photo Requisition.

Since this document is meant to be faxed, and then faxed back to you as if it had originated with the buyer, you may want to leave the largest field empty (i.e., the one named *I Request to See the Photos . . .*), so that the client may enter his own description. However, if you wish, you may type a description for him. Either way, make sure you get a signed copy by return fax—immediately! Only then is it safe to send your original transparencies, negatives, or prints along with a printed-out Delivery Memo. (You'll cre-

ate the Delivery Memo in a moment.) Right now, you will search for the pictures that the buyer asked you to submit.

▸ Click the *Do Delivery Memo* button at the top of the Stock Photo Requisition.

▸ Click the *Search Stock Library* button, the bottom one, on the very next screen.

The cursor will be blinking in the *Keywords* field of the StkPhoto Find screen.

▸ Type **celebrity**. Click *Continue*.

Next, you will see the Stock Photo Captions List screen. Nine matches were found for the keyword *celebrity*. They are displayed as a Found Set in a list.

You can see that six of the images in the list are already logged out. The word *out* appears adjacent to each of those three images in a column on the right side. The next thing to do is mark this entire Found Set so you can quickly find them again, if you need to.

▸ Click inside the *Refind* field corresponding to each line item, placing a check mark in the field for each record.

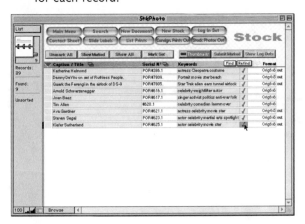

▸ Now, click on the first caption in the list, **Katherine Helmond**. Click directly on her name. This is the Stock Photo Profile screen.

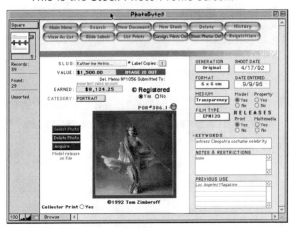

Notice that the image is displayed in the format in which the photograph exists in a real filing cabinet. Here you see a 6cm × 6cm (2¼" square) transparency. Other images will appear alternatively as 35mm slides, black-and-white prints, or panoramas.

As you can see, this image is already logged out. So, you will check its status before you go on.

▸ Click the *History* button at the top-right of the screen.

This is the Stock History screen:

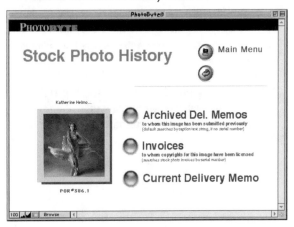

▸ Click the *Current Delivery Memo* button.

This is the Delivery Memo on which the photo of Katherine Helmond was previously included in a two-photo submission to another client.

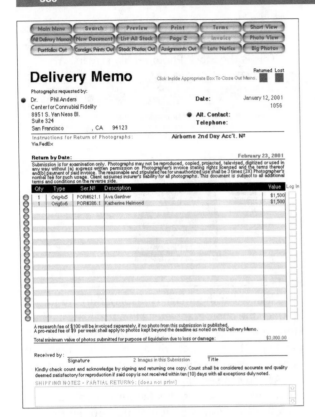

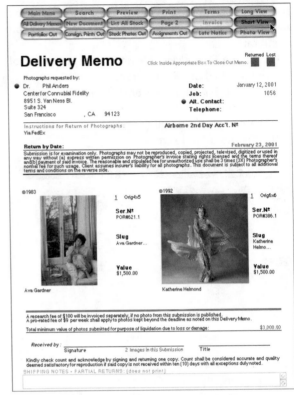

tip When you are browsing a stock photo record, and an image is already logged out, and a Delivery Memo number with a client's name is indicated underneath the red field displaying the words Image Is Out , clicking on that field will display onscreen the Delivery Memo linked to that image.

➤ Click the *Big Photos* button in the top right corner of this Delivery Memo layout.

Here, you will see an alternate view of the same Delivery Memo.

The Big Photos layout may be displayed in Preview mode, if you wish, to see how it will look printed on your letterhead.

➤ Click the *Short View* button in the top right corner of the screen.

This is yet another view of the same Delivery Memo, with fewer line items to fill in.

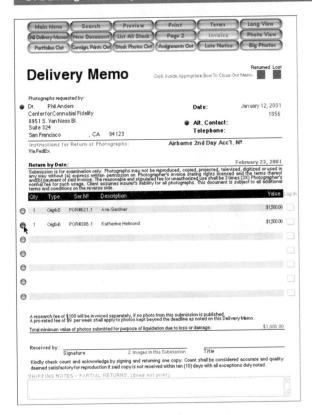

> Click on the small yellow button in the left margin, next to the line item entry for Katherine Helmond.
> You are returned to the Stock Photo Profile.
> Click the *View As List* button at the top of the screen.
> Click the *Refind* button at the top of the *Refind* field column.

You are returned to the Found Set that you marked earlier, the one matching the keyword *celebrity*. Now you will choose the photos to be sent to Occidental Accident & Casualty and Mr. Justin Case.

You will choose the subjects Tim Allen and Joan Baez, both of which are 6cm × 6cm color transparencies.

> Click your mouse in the column next to Tim

Allen's name and again next to Joan Baez's name. This will place an "X" next to each one.

> Click the gray *Show Marked* button in the header.
> Click the *Submit Marked* button to the right in the same row of buttons.

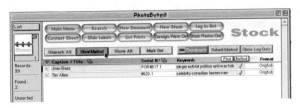

Now you will see the layout for a new Delivery Memo. A pop-up menu displays a list of all the names in your Contacts database.

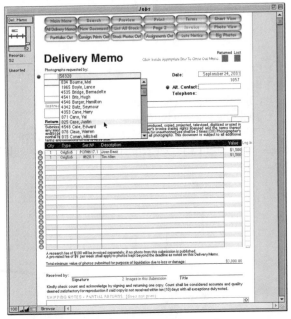

> Type the letter **c**, and scroll down, if necessary, to Mr. Case's name. Press Return.
> Justin Case's name and company address are entered for you.

› Click inside the large field called *Instructions for Return of Photographs*. Type **via messenger**. Press Tab.

› Another pop-up menu displays a range of submission intervals.

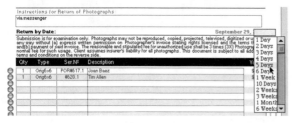

› Select **5 days**.

Notice that there is a number in the *Job* field near the top of the layout. That is the default job number. You are going to add a name to it.

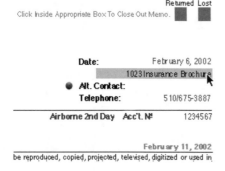

› Click on that number, and type **Insurance Brochure**.

› Click the *Big Photos* button.

› Click the *Preview* button.

This is what a Delivery Memo will look like, ready to be printed on your letterhead and sent along with your film.

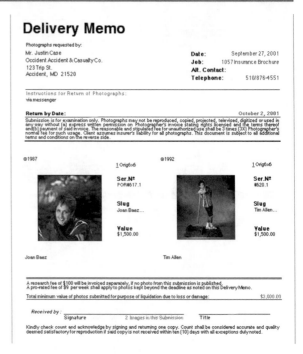

Notice that the serial numbers and captions have been automatically looked up and entered from the Stock Photo Archive and that their valuations have been looked up from the Preferences file, based on their physical nature, i.e. originals versus dupes.

› Click *Continue* to return to the Browse mode.

› Click the *Stock Photos Out* button at the top of the screen.

This is the Delivery Memos List screen.

› Click on the "Insurance Brochure" job name. (Your job number may vary from the one printed in this tutorial. That's okay.) You will see a Preview of the Delivery Memo you saw before.

› Click *Continue* to enter the Browse mode.

When you are ready to print this Delivery Memo, don't forget to include the Terms & Conditions! There is a *Terms* button at the top of the screen to include them, printed on the back.

note Some time has elapsed since these sample data were created in the PhotoByte software. Therefore, it is likely that all of the Delivery Memos in this list are past due.

Logging in Returned Photos

Mr. Case has decided to publish one of the pictures you sent him: Joan Baez. He has already returned the Tim Allen transparency.

> Click your mouse on the *Log In* field in the column next to the Tim Allen line item.

Afterward, this image will be marked "returned." (This process marks the record in the Stock Photo Archive as having been returned, too.)

Tracking and Managing Submissions

For the same reasons that you track submissions of assigned film, it's imperative to know where your stock submissions are at all times—not only to hold publishers responsible for keeping your film safe, but to make sure you can keep it in circulation to continue earning revenue. That holds true for dupes as well as originals. Having already created a Delivery Memo listing each image, tracking submissions and returns is easy.

Whenever you start running PhotoByte, say each morning when you arrive in your office or studio, simply click the *Submissions Out* button on the Main Menu.

You will see the following screen, which obviously gives you a number of choices.

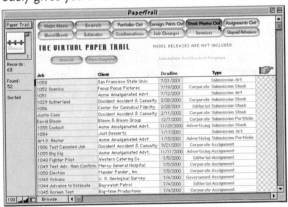

While you should experiment with the other buttons later, including the one that allows you to track assignments submitted after completion, you will gain an understanding of how they function by sticking with the *Stock Photos* button for now.

> Click the *Stock Photos* button.

Again, you will see a list of submissions that have not been returned. Some records may be marked as having been partially returned, as per the column of green buttons adjacent to each line on the right side of the screen.

> Open **1052 Scenics** by clicking on the job name in the list.

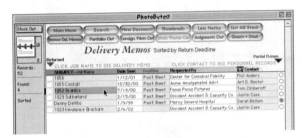

You will see a Delivery Memo for that submission in Preview mode.

> Click *Continue* to enter Browse mode.

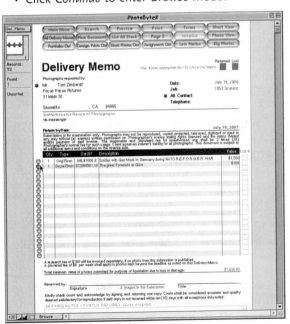

You are going to log in one of the two images in this submission. The client has retained the 35mm original (#MIL#1000.8) and has returned the dupe (#SCE4581.18), having chosen the former for

publication. First, you decide to examine the image returned by the client.

> Click the small yellow button on the left, adjacent to the Quantity column that corresponds to the second image listed on the Delivery Memo.

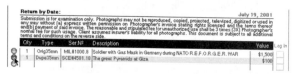

That will take you to the corresponding stock photo screen for this image.

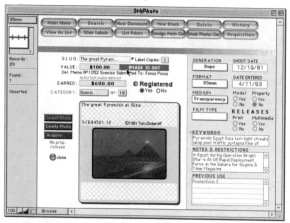

Notice that the legend *Image is Out* is displayed prominently on this record. After you log it in, that legend will disappear, and the image will be available for further distribution.

> Click on the words *Image Is Out* in the white-on-red field.

You will return to the Browse mode of the Delivery Memo.

> Click on the *Log In* field (small box) on the right side, adjacent to the line item for the dupe (#SCE4581.18).

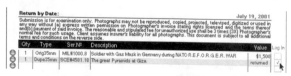

Notice that the word *returned* appears in the Value column, and a check mark appears in the *Log In* field.

Now you will bill the client for the image he intends to publish.

> Click the (red-on-green) *Invoice* button at the top of the screen.

You will see a partially completed Stock Invoice on your screen in Browse mode.

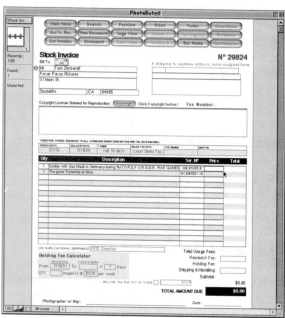

The first thing to do is enter a fee in the *Price* field, where the cursor is blinking.

> Type **1000**, and press Tab.

Notice that the *Quantity* field on the next line, the one representing the returned dupe, is now highlighted (selected).

> Press Delete (or Backspace), then Tab again.

The caption for the returned item is highlighted.

> Press Delete, then Tab.

The serial number is highlighted.

> Press Delete, then Tab.

Look at the Holding Fee Calculator at the bottom left of your screen.

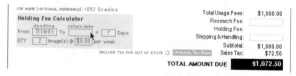

> Enter today's date in the *Return Date* field.

You will see that a holding fee has been added to the balance due of this invoice, based on the number of days the images was held past the deadline on its corresponding Delivery Memo. Don't worry if it's a large amount. The sample records were created long before you started using PhotoByte, and so, the elapsed time is a bit unrealistic. You will also notice that sales tax has been added if you entered a

California address in the Preferences section of PhotoByte when you first started using it.

Finally, you are ready to enter a copyright license using the Copyright Composer. (If you need to refresh your memory, instructions are given in chapter 25, part 5.)

> Click the *Copyright* button.
> Once you have finished creating a copyright license and returned to the Stock Invoice screen, click the *Del. Memo* button at the top.

You are right back to the original Delivery Memo from which the Stock Invoice was created. Both documents are now linked together.

That's all it takes to bill a Stock Invoice directly from a Delivery Memo. You can track the past and future licensing of any image, now that you know this procedure. It will help your marketing efforts, too, by letting you know what types of images a particular publisher has requested and accepted or rejected in the past. Do you remember the Stock Photo History screen discussed earlier in this exercise?

tip From the Sales Report screen, you can click the Stock Photo Sales button to see a report of your best-selling images.

The Art Consignment

If you sell hang-on-the-wall prints to people who admire your work (in addition to licensing copyrights to publishers), you should keep a list of collectors corresponding to the prints they have purchased. It will help you with marketing future print editions. It will also be necessary to create an inventory of prints to consign to dealers and galleries. Any prints not sold must be returned. Therefore, this memorandum must accompany every consignment. A standard Delivery Memo won't do, since it deals with images submitted for publication. Instead, an Art Consignment establishes the replacement value for lost or damaged prints exclusively.

The reason for creating a separate tracking system for the disposition of prints is simple, but important: to avoid mixing up a distinctly different source of income with your commercial licensing business. Marketing and sales reports would be less accurate, because essentially, you are dealing with

two separate business models. Remember: Commercial photography is a business-to-business enterprise working within the confines of the publishing media, while the marketing of prints, fine-art or otherwise, is a retail, or business-to-consumer enterprise.

EXERCISE --------------------------------

Tracking Art (Print) Consignments and Sales

> From PhotoByte's Main Menu, click the *Paper Trail* button.
> On the next screen, click the *Consign-Prints Out* button.

You will see a list of Art Consignments:

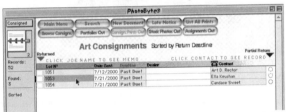

> Click on **Lot N° 1053** (click directly on top of the name in the *Lot N°* column), submitted to San Francisco State Univ.

You will see a facsimile on screen of the Art Consignment itself in Preview mode:

> Click the *Continue* button to display the same document in Browse mode:

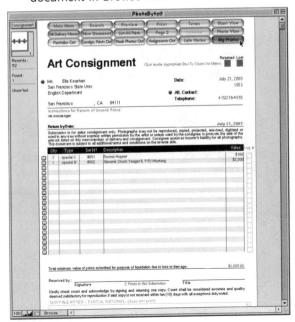

› Click the *Big Photos* button near the top right corner to display an alternate view of the same Art Consignment.

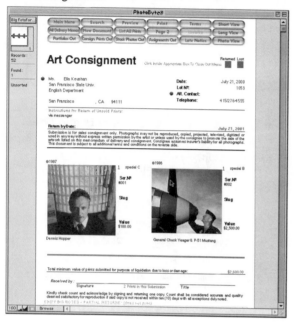

note You would alternatively click the *Photo View* button if there were more than two and up to six images displayed on this Art Consignment. A longer consigned list is available by clicking the *Long View* button; but it contains no illustrations. There is no room on the virtual sheet of paper.

› Click the *Long View* button.

From the Long View, it is possible to directly reference individual images, even though they are not visible on the document itself.

› Click the first gray button that appears in a column on the left side, adjacent to the listing for a Dennis Hopper print.

You will see a record corresponding to that image.

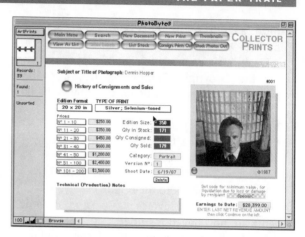

› Click the *History of Consignment and Sales* button to track every buyer who has ever received a copy of this print, as well as a list of those collectors who have purchased one.

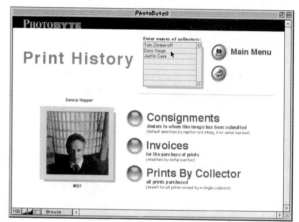

Looking at the screen illustrated above, you will see a field called *Enter Names of Collectors*. So, for example, if Coco Vaughn bought one of your prints, you might type her name in this field. For each subsequent collector, you would simply type a name in the field, pressing Return to enter another person's name on the line below. Then, when you click the *Prints by Collector* button, you will display a Found Set (in List View) of people who own a print that corresponds to the record you were just looking at. Similarly, if you've ever invoiced someone for one of the prints in that edition, or even delivered one on consignment in the past (returned or not), the respective *Consignments* and *Invoices* buttons will take you to a corresponding list.

note It might seem logical that, just like the link between a Delivery Memo and a Stock Invoice, you should be able to create an Art Invoice directly from an Art Consignment. However, that is neither desirable nor possible. The Delivery Memo accompanies submissions directly to buyers (end users), while the Art Consignment accompanies submissions to agents or galleries for sale to third parties. They are not end users. Therefore, you must create Art Invoices independently of consignments.

NOTES

3 Published by Allworth Press, 2001.

4 These refer, obviously, to larger productions, usually advertising assignments.

5 An example is given in the exercise Creating the Paper Trail for an Entire Assignment in chapter 46.

6 That number does not take into account additional layouts in PhotoByte, e.g., the Short View and the Suppress Line Item Detail view of the Invoice/License of Rights.

7 This minimum applies to originals. Dupes should, obviously, be valued at their cost of reproduction.

8 ASMP White Paper, *Magazine Photography*, published October 1988.

46

Following through an Entire Assignment

In this chapter, you'll see how PhotoByte helps you practice what you have learned on a day-by-day basis.

When you begin discussing a new assignment with a buyer, even if it hasn't been booked yet, you are taking the first steps along the virtual paper trail. The process usually begins with taking notes about your forthcoming assignment. For that, you use a ShootSheet. This process applies even for simple magazine assignments, where the only step beyond the ShootSheet is to create an invoice. A button click on the ShootSheet takes care of that for you automatically.

If you click the *New Shoot* button directly on a buyer's Profile screen, his name, address, and phone number, along with additional information, is transposed onto a new ShootSheet. You're off and running. Even the client type (i.e., advertising, corporate, or editorial) and an indication of whether or not your rep—if you have one—gets a commission on this job are entered automatically. If, alternatively, you start by clicking the *New Shoot* button on the Main Menu instead of a Profile screen, you have to select a name from a pop-up list. Then the address and the other information will be filled in for you. But that's all it takes to get started.

The following exercise represents a typical photo assignment. The paper trail may be simpler for some kinds than others, especially magazine assignments. Nevertheless, so as to support all kinds of photographers who work under all kinds of conditions—and because editorial shooters will take on the occasional advertising or corporate job—it is for practical reasons that an advertising assignment is illustrated here.

EXERCISE -

Creating the Paper Trail for an Entire Assignment

This example starts with a Profile screen. You will once again work with Artie Rector of Acme Amalgamated Advertising.

Starting a New ShootSheet

> Find Art D. Rector's card on the Main Menu. Click on the card, which will take you to his Profile. Then click the *Shoot* button at the top of Artie's Profile.[9]

The cursor will blink in the *Production* field of a new ShootSheet, where you will enter a job name. The number to the left is a default job number.

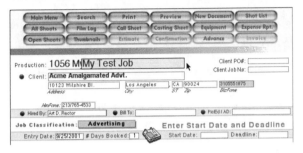

> Type **My Test Job**, then press Tab.

tip You can change the Job Number by clicking on the word Production (next to the Job Name field on the left), which will make the field active. It's a hidden feature.

note Job numbers are an anachronism, not really necessary in the computer age. They are included in PhotoByte for those photographers who prefer to have one.

The only reason for job numbers to have existed in the past was because there were no computers to help you find paperwork in filing cabinets. With PhotoByte, not only are ShootSheets stored sequentially, but you can find any one of them by infinitely more criteria than a job number. You can search on the name of the job, the date, the deadline, the client, your assistant's name. Virtually any criterion represented by a field on the ShootSheet screen may be used in a search.

> Click on the *#Days Booked* field and type **3** in place of the default number "1."
> Press Tab.
The cursor is now in the *Start Date* field.
> Press Command/Ctrl–minus sign to enter today's date.
> Tab, and enter a deadline in the *Deadline* field. Make it one week from today. (Use the month/date/year format.)
For now, you will leave the other fields empty. You will come back to the ShootSheet and fill them in later. First, you will create a Job Estimate.

Creating a Job Estimate from a ShootSheet
> Click the (red-on-green) *Estimate* button at the top of the ShootSheet.
The first of two Worksheet pages appears.

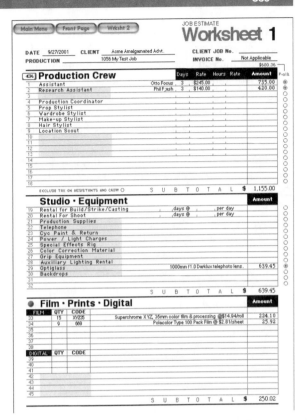

tip If you're using a smaller-size monitor, press the Page Down and Page Up keys to toggle between the top and bottom halves of the Worksheet, or if part of the page is cut off by your monitor for any other reason.

> On line 1, click right next to where it says *Assistant*, where you would obviously choose to write something on a piece of paper. A window called a *View Index* will appear.

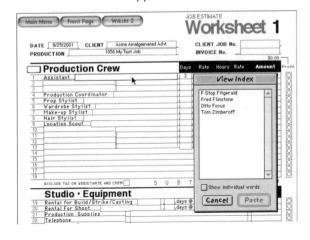

In this window are listed the names of every assistant who has been entered on this line before. The first time you type an assistant's name on line 1, PhotoByte remembers it and adds it to the View Index. This feature helps avoid typographical errors.

> Select the name **Otto Focus**, and click Paste. (Alternatively, you can double-click on Otto's name.) Now, press Tab.

Otto will be working for three days at $175 per day. The number "3" will already be entered in the *Days* field.

> Press Tab.
> Type **175** in the *Rate* field, and press Tab again.
> Click the *Add Profit* button adjacent to line 1 in the right margin of the page. (Remember: You have already set the *Markup for Profit on Billed Expenses* field in the Preferences section.)
> Click on line 2 in the gray area. (If you don't see the gray area at first, click in the margin of the Worksheet.)

A pop-up list of additional choices for crew members appears.

> Type the letter r.

You will see that the selection *Research Assistant* is highlighted.

> Press the Return key, and press Tab.

The cursor is blinking on line 2, at the right of where it reads "Research Assistant."

> Type **Phil Flash**, then press Tab again.

Phil will be working for 3 days at $100. The number "3" should already be entered in the *Days* field.

> Press Tab. Type **100**. Press Tab again.
> Click the *Add Profit* button adjacent to line 2.

Notice how the line item changes in the Amount column. The total amount of profit is accumulated and displayed at the top of the Amount column in green type.

To shoot this job, you need to rent a special lens. It will be billed back to your client with a markup.

> Click on line 29 exactly on top of the words *Camera/Lens Rental*.

The pop-up field lists every item that has previously appeared on that line before. (In our example, there are only two items.)

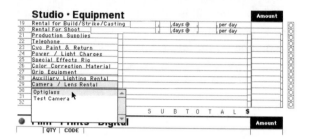

note This, too, you'll notice, is a gray field, indicating that additional descriptions are available when you click on it.)

> Select **Optiglass**.

PhotoByte enters a description and a price for you. This is an example of a "lookup." PhotoByte looks up information in the Equipment database and applies it to this line item. Do you remember the XYZ35 film you added to the film list in part 2? That was also a PhotoByte lookup. (For information about creating photo equipment records, refer to the on-screen User's Guide topic, Create Equipment Records.)

> Click the adjacent *Add Profit* button, and watch the billed amount go up.

Now, you will estimate how much film you will need. Look at the Film•Prints•Digital Services section at the bottom of the Worksheet. (If you can only see the top half of the Worksheet, press Page Down on your keyboard.)

You estimate shooting fifteen rolls of XYZ35 film for this assignment.

> Click inside the *QTY* field on line 33, and Type **15**. Then, press Tab on your keyboard.

A list of film codes appears.

> Type the letter **X**.
> Press Return.

"XYZ35" is selected and entered for you. The description and total amount are looked up and calculated. Notice that your profit has again increased (see the Amount column at the top of the Worksheet), even though there is no *Add Profit* button in this section.

> On line 34, enter the number **9** in the *Quantity* field, and select **669** in the *Code* field to represent Polaroid 669.
> Press Return.

tip You may also change the price of film "on the fly." Click the red button next to the section heading, Film • Prints • Digital.

Film · Prints · Digital

	QTY	CODE		Amount
33	15	XYZ35		0.00
34				
35				
36				
37				
38				
	QTY	CODE		
39				
40				
41				
42				
43				
44				
45				
			S U B T O T A L $	0.00

Manual Pricing @ Unit Cost of Film & Prints

Film and Prints				Amount
FILM	QTY	PRICE		
33	15	$33.12	35mm color film & processing @$33.12/roll	496.80
34				
35				
36				
37				
38				
DIGITAL	QTY	PRICE		
39				
40				
41				

note Film and print prices that are entered "on the fly" are not permanently added to the database, so they will not be available for future lookups. Neither can PhotoByte calculate their contribution to markup and profit in that regard.

▸ It's time to go on to Worksheet 2. Click the *Continue* button. (If you used the "film-on-the-fly" feature mentioned above, you won't see the *Continue* button. Instead, click the *Wrksht 2* button at the top of the screen.

Main Menu	Front Page	Wrksht 1	JOB ESTIMATE		

Worksheet 2

DATE 9/27/2001	CLIENT Acme Amalgamated Advt.	CLIENT JOB No.	
PRODUCTION	1056 My Test Job	INVOICE No.	Not Applicable
			$5,140.60

Location · Travel						Amount	Profit
46	Permits						○
47	Laundry						○
48	Gifts For Locals						○
49	Car Rental						○
50	Truck / Van Rental						○
51	Motor Home / Dressing Room Rental						○
52	Limousine						○
53	Auto : Mileage , .@. , Parking , Fuel , Tolls ,						○
54	Taxi						○
55	Special Vehicles / Air Charter						○
56	Excess Baggage						○
57	Documents / Customs						○
58	Per Diems : Nº of People , 4 , Amt/Person/Day , $445.26 , Nº of Days , 3 ,					5,343.07	●
59	Air Fares : Nº of People , Cost per Fare ,						○
60	Hotels : Nº of People , Cost per Room , Nº of Nights ,						○
61	Gratuities						○
62	Meals						○
63	Generator Rental						○
64							○
65							○
			S U B T O T A L $			5,343.07	

Insurance				Amount	
66	Shoot Insurance / pro-rated	3 DAYS @ $35 PER DAY	105.00		○
67	Special Liability Insurance				○
68	Binders / Riders				○
		S U B T O T A L $	105.00		

Miscellaneous				Amount	
69	Telephone				○
70	Catering				○
71	Props				○
72	Messenger / Air Courier	Airborne Express Airbill #1234567	47.75		●
73	Entertainment				○
74	Models / Talent (Studio Paid)				○
75					○
76					○
77					○
		S U B T O T A L $	47.75		

Creative Fees			Amount
78	Assignment Fee	3 DAYS @ $1,500 PER DAY	4,500.00
79	Usage Fee	refer to copyright license on Front Page	3,000.00
80			
81			
		S U B T O T A L $	7,500.00

Production Fees			Amount
82	Pre-production	1 DAYS @ $750 PER DAY	750.00
83	Casting	DAYS @ PER DAY	
84	Location Scouting	DAYS @ PER DAY	
85			
		S U B T O T A L $	750.00

Let's say you need to hire a small crew to build a set on location. You need four people at $318.04 per day for 3 days.

▸ Click in the field to the right of *Nº of People* on line 58.
▸ Type **4**. Press Tab.
▸ Type **318.04**. Press Tab.
▸ Type **3**. Press Tab.
▸ Click the *Add Profit* button.

Look at the next section, Insurance.

▸ Click in the field just to the left of *Days @* on line 66, and type **3**, for three days.
▸ Press Tab, and type **35**, for $35.

You won't use the Add Profit feature on this line item.

Look at the following Miscellaneous section (Page Down, if necessary).

▸ On line 72, type **Airborne Express Air Bill #1234567**
▸ Press Tab and type **34.11**.
▸ Click the *Add Profit* button.

Go to the bottom of the page to enter an assignment fee and a usage fee in the Creative Fees section. Notice that the Assignment Fee line item is calculated by the day. Some photographers might choose to call this a "day rate." Remember: Day rate is simply one name for one kind of creative fee. It does not include profit, and it does not imply that you are getting paid by the clock. There are other creative fees listed on line 79. For the purposes of this exercise, however, you will use "Assignment Fee."

▸ Click on the name of the default creative fee, *Assignment Fee,* on line 79 to see a list.

Your fee is $1,500 per day for this job. You are working at this rate for three days. The number "3" is already entered. It was looked up from the Shoot-Sheet.

▸ Click in the field just to the left of *per day* on line 78.
▸ Type **1500**.

Notice that you need not enter a comma or other formatting.

▸ Press Tab two times to place your cursor in the Amount column on line 79.

You have negotiated a separate usage fee of $3,000.

▸ Type **3000**.

Notice that you need not enter a comma or other formatting.

Now, look below at the Production Fees section. You are going to spend one pre-production day setting up the shoot at $750 per day.

> ‣ Click line 82 directly on top of the word *Travel*.
> ‣ Select **Pre-production** to change the line title.

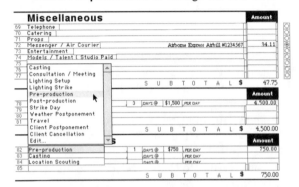

> ‣ Click the field in front of *Days @*. Type **1**. Press Tab.
> ‣ Type **750**. Press Tab.

At this point, the Job Estimate is basically done.

> ‣ Click the *Continue* button (or the *Front Page* button at the top of the screen, if you see no *Continue* button).

This takes you to the Front Page of the Job Estimate. You can see that it is just about complete. You'll notice that the Front Page shows totals for all of the expensed items you entered in the Worksheets. But you also see a big, empty field called *Job Description/Reproduction Rights Granted*.

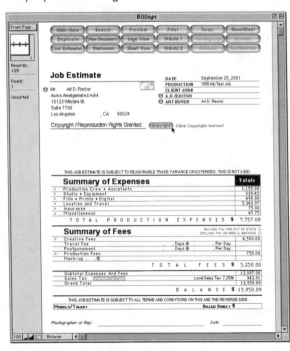

note In this example, the Job Estimate will include sales tax, but only if you live in California, because Artie's company is located in California, too.

tip You have an option to type additional descriptions onto line items on the Front Page of the Job Estimate, if you wish. It is not usually necessary. Alternatively, you may submit the Worksheets along with your estimate, as backup.

You will again use the Copyright Composer feature you tried out earlier.

> ‣ Click the *Copyright* button.

This is the Copyright Composer screen.

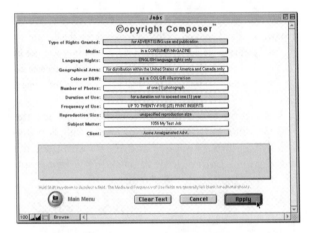

> ‣ Click the *Type of Rights Granted* field. Select **for ADVERTISING use and publication**.
> ‣ Click the *Media* field. Select **in a CONSUMER MAGAZINE**.
> ‣ Click the *Language Rights* field. Select **ENGLISH language rights only**.
> ‣ Click the *Geographical Area* field. Select **for distribution within the United States of America and Canada only**.
> ‣ Click the *Color or B&W* field. Select as a **COLOR illustration**.
> ‣ Click the *Number of Photos* field. Select **of one (1) photograph**.
> ‣ Click the *Duration of Use* field. Select **for a duration not to exceed one (1) year**.
> ‣ Click the *Frequency of Use* field. Select **UP TO TWENTY-FIVE (25) INSERTS**.
> ‣ Click the *Reproduction Size* field. Select **unspecified reproduction size**.

The *Subject Matter* field already contains the

name you entered in the *Production* field on the Front Page of the Job Estimate, *My Test Job*.

The *Client* field already "knows" our client's company is *Acme Amalgamated Advt.*

‣ Click the *Apply* Button.

This arranges the component terms of the license into a meaningful paragraph.

note You can edit any part of this license by typing over it. You can also edit any of the boilerplate terms in the Copyright Composer by selecting **Edit**, instead of an existing term while you are filling it in.

‣ Click the *Continue* button. (The *Apply* button turns into a *Continue* button.)

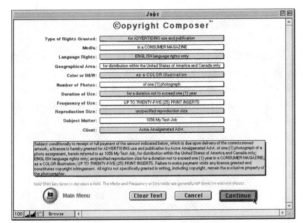

You will again see the Front Page of the Job Estimate; it will now contain a complete copyright license.

Next, you will create and send an abbreviated version of the Job Estimate.

‣ Click the *Short View* button in the header of the Job Estimate.

Here is the Short View of the same Job Estimate as it appears in Preview mode.

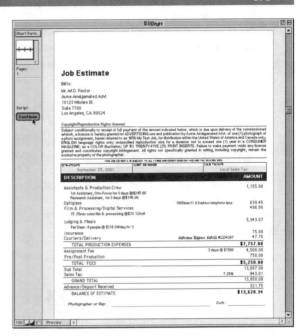

‣ Click the *Continue* button to enter Browse mode.
‣ Click the *Suppress Line Item Detail* button.

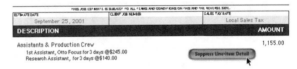

You will now see an even further-abbreviated version of the Job Estimate, showing only heading summaries for each section of billed expenses.

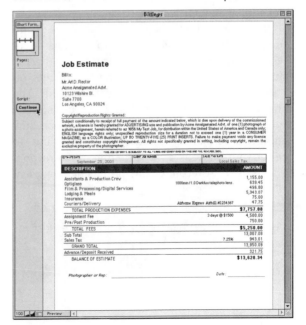

note The Suppress Detail button is visible only in Browse mode. When any document is displayed in Preview mode, you will see a Continue button on the left side of your screen. Click the Continue Button to enter the Browse mode.

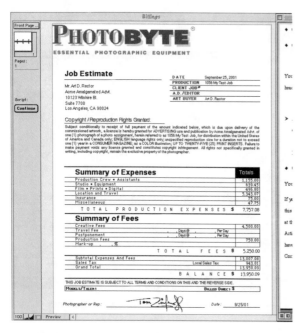

> Click the *Front Page* button (not the *Main Menu* button) at the top right of the screen.

You have returned to the Front Page view of the Job Estimate, completed.

If you have a fax modem connected to your computer, click the *Logo View* button to use this document in conjunction with your fax modem software. PhotoByte places your logo at the top of the Job Estimate and signs your name at the bottom. The estimate can be on Artie's desk in seconds, even though you have never used a piece of paper. Still, you have a permanent record of this transaction. To see for yourself, look at Artie's Profile > Correspondence screen. A record of this fax having been sent will already be there!

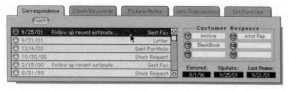

Every subsequent document you create for My Test Job retains the information you have already entered, so you don't have to remember or retype anything. You may make changes, of course. But you have already begun the "virtual paper trail," and information about My Test Job will flow through each and every document related to this assignment.

Modifying the Job Estimate

> Click the little red button next to Artie's name on the Job Estimate to return to his Profile.

Let's say that Artie calls you some time later and says, "I want to talk to you about your estimate." Now it's time to use a shortcut to find and view it.

> Select **List Estimates** from the Shortcuts menu at the top of your screen.

Shortcuts	
Main Menu	⌘1
Contacts: List View	⌘2
Contacts: Profile	⌘3
Marketing Reports	⌘4
Sales Reports/Receivables	⌘5
List Jobs Pending	⌘6
Calls to Make Today	⌘7
Set PhotoByte Preferences	⌘8
Stock Photo Archive	⌘9
Panic Button! (1st Call)	⌘0
Assigned Film Out	
Portfolios Out	
Stock Photos Out	
List Estimates	
List Confirmations	
List Job Change Orders	
List Invoices	
List All Billing Records	
List All Jobs & Submissions	
Print Blank Film Log	
Print Blank Casting Sheet	
Models	
Vendors	
Photo Assistants	
Invoices or Jobs to Ship	
Edit Merge Letter Boilerplate	
Delete Found Set	
Find Omitted Records	
Edit Company Database	

A list will appear on screen. The most recently dated estimate is always at the top of the list.

> Click anywhere on the line item for My Test Job to view it.

> Press *Continue* to exit Preview mode and enter Browse mode.

To clarify communications between the two of you, you are looking at a document on screen that is virtually identical to the paper copy Artie is holding in his hands. Artie says to you, "This estimate looks pretty good. But $5,343.07 for location and travel seems pretty steep. Can we shave that down a bit?"

> From the Front Page of the Job Estimate, click on the *red dot* next to the words *Location and Travel* under the Summary of Production Expenses section.

Summary of Expenses	Totals
Production Crew • Assistants	1,155.00
Studio • Equipment	639.45
Film • Prints • Digital	496.80
Location and Travel	5,343.07
Insurance	75.00
Miscellaneous	47.75
TOTAL PRODUCTION EXPENSES $	7,757.08

The Location and Travel section of Worksheet 1 is displayed on screen.

Worksheet 2

JOB ESTIMATE

| Main Menu | Front Page | Wrksht 1 |

DATE 9/25/2001 CLIENT Acme Amalgamated Advt. CLIENT JOB No.
PRODUCTION 1056 My Test Job INVOICE No. Not Applicable

$2,052.94

	Location • Travel	Amount	Profit
46	Permits		
47	Laundry		
48	Gifts For Locals		
49	Car Rental		
50	Truck / Van Rental		
51	Motor Home / Dressing Room Rental		
52	Limousine		
53	Auto : Mileage @ Parking, Fuel, Tolls		
54	Taxi		
55	Special Vehicles / Air Charter		
56	Excess Baggage		
57	Documents / Customs		
58	Per Diems : N° of People 4 Amt/Person/Day, $445.26 N° of Days 3	5,343.07	
59	Air Fares : N° of People Cost per Fare,		
60	Hotels : N° of People Cost per Room, N° of Nights		
61	Gratuities		
62	Meals		
63	Generator Rental		
64			
65			
	SUBTOTAL $	5,343.07	

You tell Artie that this expense is necessary for set construction. Labor costs are high, but perhaps you can get by with one less crew member. He agrees. Artie says, "Okay, you've got the job. Book it!"

note When you agree to change a Job Estimate, you can—to continue with our example—edit the Worksheet by changing the number of people from "4" to "3" and go on from there. But the value of maintaining a paper trail could be compromised. It might be wiser to click the Duplicate button on the Front Page of the Job Estimate instead, and make your changes on Worksheet 2 of a

completely new, duplicated estimate. For now, however, make the change to the original Job Estimate on line 58. And of course, you can always go back and add or change line items at will.

Creating a Production Call Sheet

> Click the *ShootSheet* button at the top of the Front Page of the Job Estimate.

Notice on screen that the fields for *First Assistant* and *Second Assistant* are filled in.

> Click the *Call Sheet* button at the top of the ShootSheet.

This is the Production Call Sheet.

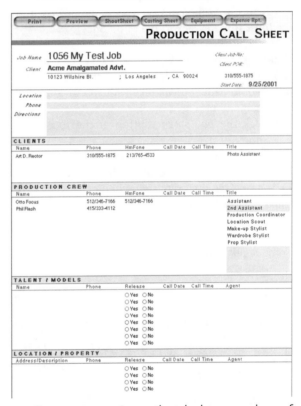

For your convenience, the telephone numbers of your production crew, clients, and models, if any were entered previously, are listed. There are fields into which you may enter the address of the location and directions to arrive there, too. You may then print copies of the Call Sheet for yourself and to distribute to each member of your crew.

note Refer to the on-screen User's Guide (under the Help menu) for a description and instructions for using a Casting Sheet if you work with models.

‣ Click the *ShootSheet* button at the top of the Call Sheet to return to the ShootSheet.

‣ Place your cursor in the *Description of Job* field.

‣ You may wish to change the data you enter into this field later, but for now, type **This is what I will shoot and how I will shoot it.**

When the job is completed, you may want to come back and update the crucial steps you took to shoot it. You may type a little, or you may type a lot. You may type the text of *War and Peace* if you like! This description should includes all of the who, what, when, why, and how of the shoot, any information you may wish to recall in the future.

Notice that the copyright language flowed from the Job Estimate back to the ShootSheet.

Creating a Location Equipment List

Next, you need to decide what cameras, lenses, and other equipment you will take with you on this location assignment.

‣ Click the *Equipment* button at the top of the ShootSheet.

A message reminds you how to select equipment from the list by clicking in the box at the left of each item (see the exercise in chapter 12, part 3, on Creating a List for Insurance).

‣ Click *OK*.

You will see the List View of your photo equipment. Some regularly used items are already checked off.

‣ Click the boxes adjacent to lines 25 through 28 to select these additional Nikon lenses:

‣ Click the *Continue* button. PhotoByte will display a preview of the equipment list about to be printed.

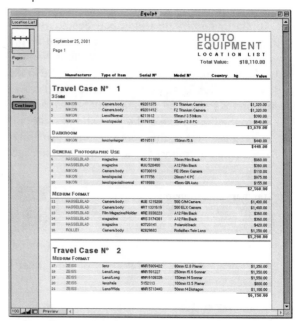

If you assigned carrying cases for your equipment (refer to the topic *Photo Gear* in the on-screen help), each item is sorted by the case in which it is packed.

‣ Click the *Continue* button.

‣ Click *Cancel* in the printer dialogue box that appears next to return to where you left off in the ShootSheet.

Creating a Job Confirmation

Once an assignment is booked and you have a start date, especially for either an advertising or a corporate assignment, you should create a Job Confirmation. It is not always practical to obtain a written Job Confirmation for a fast-breaking editorial assignment, but it can't hurt if you can do so.

You should be looking at the ShootSheet for My Test Job on your screen in Browse mode.

note The Estimate button at the top of the ShootSheet has changed from red-on-green to gray-on-green. This indicates that a Job Estimate already exists and that you can view it by clicking on the button.

▸ Click the (red-on-green) *Confirmation* button at the top of the ShootSheet. (There is also a *Confirmation* button on the Front Page of the Job Estimate itself for My Test Job.)

An on-screen message reminds you that both a Job Estimate and a ShootSheet exist for this job.

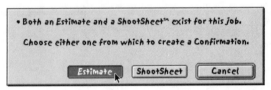

Therefore, you have a choice: The Job Confirmation you are about to create can look up information from one or the other, whichever has been most recently updated. For example, if you had filled in some additional costs on an Expense Report attached to the ShootSheet after having, earlier, created a Job Estimate (there is an *Expense Rpt.* button at the top of every ShootSheet), you might want the Job Confirmation to reflect those more recent data. In this exercise, you will use the Job Estimate as a lookup source.

▸ Click the *Estimate* button.

Another message pops up on screen to remind you that, while this Job Confirmation opens to a completed Front Page, you are free to open the Worksheets and make changes at any time.

The expenses and fees you estimated earlier will be displayed next to the figures for the Job Confirmation on the Worksheets. So, if you make changes to the Job Confirmation, you can compare. This is the Front Page of the Job Confirmation.

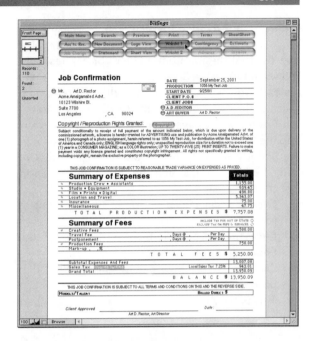

▸ Click the *Wrksht 1* button.

Estimated amounts appear in green on the Worksheets for comparison to the subtotals on its corresponding Job Confirmation. The comparison of figures allows you to track production costs between the time you estimated and confirmed the job. These figures appear only on screen. They do not print.

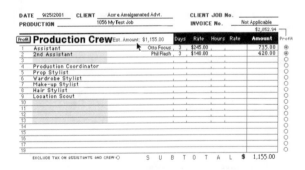

▸ From the Worksheet, click the *Front Page* button.

Artie has given you a purchase order number for this job.

▸ Place your cursor in the *Client P.O.#* field and type **AAA00123**. Press Tab.

Creating an Advance Invoice

While it's possible to create an Advance Invoice directly from the Job Confirmation for My Test Job, you will return to the ShootSheet and do it from there instead. You will discover something interesting: Much of the data from both the Job Estimate and the Job Confirmation have been entered automatically into the ShootSheet. If you had typed these data onto the ShootSheet first, they would have appeared on both the Job Estimate and the Job Confirmation in just the same way.

› Click the *ShootSheet* button at the top right of your screen.

› Click the *Advance* button at the top of the ShootSheet screen.

› Click the *Proceed* button in the dialogue box that pops up next.

This is the Advance Invoice.

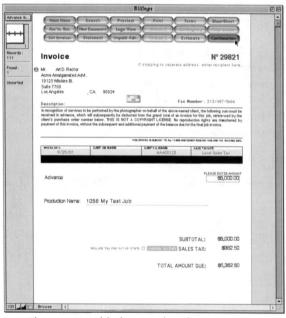

The cursor is blinking in the *Please Enter Amount* field.

› Type **5000**.

Click the *Confirmation* button at the top of the page.

note The Advance Invoice should be submitted immediately. You should not have to wait for payment either. In fact, you should politely refuse to commence work on the assignment until a check has been deposited in your bank account and cleared.

There have been no other changes, so the Job Confirmation is ready to fax, mail, or drop off in person for a signature. Of course, you will want to include the Advance Invoice along with it. Notice that there is a line at the bottom of the document indicating that the client should sign it.

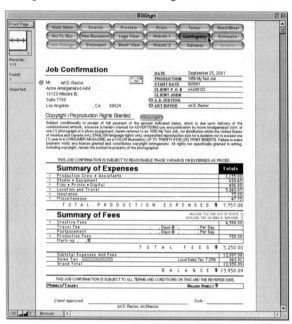

tip Notice that the Estimate button at the top of the Job Confirmation has changed from red-on-blue to gray-on-blue, which means that you can click on it to view the existing document. The same goes for both the Advance and ShootSheet buttons. In fact, you can always return to any existing document pertaining to an assignment in the virtual paper trail. The Invoice button is still red, because you haven't created it yet.

Creating a Contingency Fee Schedule

› Click the *Contingency* button at the top of the Job Confirmation.

This is the Contingency Fee Schedule. (Don't forget to press Page Down if you can't see the whole page.)

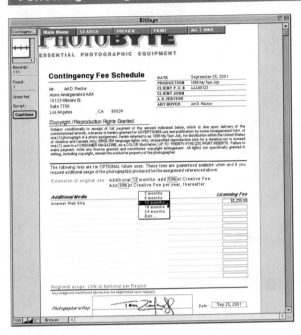

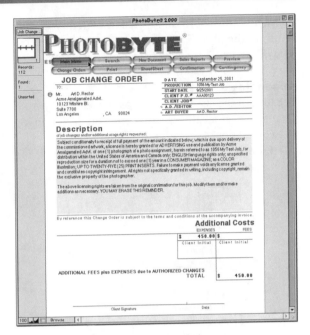

The default formula is to charge 50 percent of your initial creative fee for the first additional year and 30 percent for subsequent years. You may use any figure you wish, of course. For the purposes of this exercise, you will charge $2,250.

> Click on the first line item, and select **Internet Web Site**.
> Click on the *Duration* field in the first row.
> Select **12 months**.
> Place your cursor in the *Licensing Fee* box.
> Type **2250**. Press Tab.

To print the schedule, you would click the *Print* button. It already has your logo at the top and is ready to send. It is a now part of the paper trail for this assignment.

> Click the *Continue* button to return to the Job Confirmation.

Creating a Job Change Order

> Click the (red-on-blue) *Job Change* button at the top of the Job Confirmation.

> Click *OK* when the next message pops up on screen.
> This is a Job Change Order.

You are expecting to incur an additional $450 charge for film, marked up and billed to the client.

> Below the *Description* field, under "Additional Costs," type **450** in the *Expenses* field.

The client requires two additional shots, for which you will charge additionally. So you must annotate your copyright license accordingly.

> In the *Description* field of the Job Change Order, change the text from "one (1) photograph" to **three (3) photographs**.

Description

of job changes and/or additional usage rights requested:

Subject conditionally to receipt of full payment of the amount indicated below, which is due upon delivery of the commissioned artwork, a license is hereby granted for ADVERTISING use and publication by Acme Amalgamated Advt. of one (1) photograph of a photo assignment, herein referred to as 1056 My Test Job, for distribution within the United States of America and Canada only; ENGLISH language rights only; unspecified reproduction size for a duration not to exceed one (1) year in a CONSUMER MAGAZINE; as a COLOR illustration; UP TO TWENTY-FIVE (25) PRINT INSERTS. Failure to make payment voids any license granted and constitutes copyright infringement. All rights not specifically granted in writing, including copyright, remain the exclusive property of the photographer.

The above licensing rights are taken from the original confirmation for this job. Modify them and/or make additions as necessary. YOU MAY ERASE THIS REMINDER.

By reference this Change Order is subject to the terms and conditions of the accompanying invoice.

> Below the *Description* field, under "Additional Costs," type **3000** in the *Fees* field.
> Click the *Preview* button to see how it will print.
> Click *Continue* to return to Browse mode.

Your responsibility is, of course, to print the Job Change Order and have the client initial the additional costs and sign at the bottom.

> Click the *Main Menu* button at the top of the Job Change Order.

When the photo shoot is completed, you may return to the ShootSheet to make changes as necessary in the *Job Description* field, Shot Lists, etc.

Appending a Shot List

Because of the client's wishes, as reflected in the Job Change Order for this assignment, you decide to log in two additional shots on the ShootSheet.

> From the Main Menu of PhotoByte, click the *Shoots in Progress* button.

If PhotoByte finds more than one job pending, a list will be displayed. (If My Test Job is the only open job, PhotoByte will take you right to it.)

> Click on *My Test Job* in the list. The ShootSheet will again be displayed in Preview mode.
> Click the *Continue* button to enter Browse mode.

You are now looking at the ShootSheet for My Test Job again.

> Click the *Shot List* button at the top of the ShootSheet.
> In rows 2 and 3, in their respective *Separate Fee* fields, type **1500** (formatting is automatic), as in the illustration below.

You may also enter some additional descriptive text, or even paste some scanned Polaroid prints into the appropriate fields. The *Separate Fee* field in row 1 is left blank, because your assignment and usage fees entered in the Job Estimate already cover the first shot.

> Return to the Main Menu.

Now, you are finally ready to invoice the job.

Creating an Invoice/License of Rights

> From the Main Menu of PhotoByte, click the *Search Records* button.
> Click the *Jobs & Delivery Memos* button on the next screen.

You will find the cursor blinking in the *Job Name* field on the Search screen.

> Type **My Test Job**.
> Click the *Continue button*, then the *OK* button that pops up next.

You will now be looking at the ShootSheet for My Test Job. If you happened to have actually pasted in the scanned images, as suggested in the exercise above, you will see the first one at the bottom-left corner of the ShootSheet. Additionally, the Shoot-Sheet displays legends in its header reminding you to review the Shot List for more information about this assignment.

> Click the (red-on-green) *Invoice* button at the top of the ShootSheet.

> A reminder pops up on screen. Read it, then click *Proceed*.

The final invoice should look familiar. It is much like both the Job Estimate and the Job Confirmation that came before it. You may make any changes you wish in the Worksheets for this invoice, just as you could with the Job Estimate and the Job Confirmation. Any changes you make will be reflected on the Front Page of the Invoice/License of Rights without affecting either the Job Estimate or the Job Confirmation. You also have an option to create a Logo View (for faxing) or Short View of the invoice—or both—if you wish.

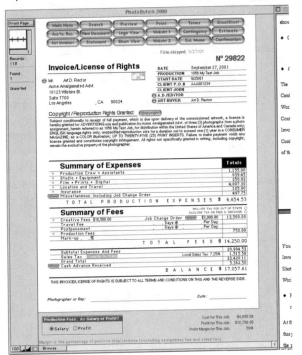

PHOTO**BYTE**®
ESSENTIAL PHOTOGRAPHIC EQUIPMENT

Invoice/License of Rights Nº 29822

Mr. Art D. Rector
Acme Amalgamated Advt.
10123 Wilshire Bl.
Suite 7700
Los Angeles, CA 90024

DATE	September 27, 2001
PRODUCTION	1056 My Test Job
START DATE	9/25/2001
CLIENT P.O.#	AAA001234
CLIENT JOB#	
A.D./EDITOR	
ART BUYER	Art D. Rector

Copyright / Reproduction Rights Granted:

Subject conditionally to receipt of full payment, which is due upon delivery of the commissioned artwork, a license is hereby granted for ADVERTISING use and publication by Acme Amalgamated Advt. of three (3) photographs from a photo assignment, herein referred to as 1056 My Test Job, for distribution within the United States of America and Canada only; ENGLISH language rights only; unspecified reproduction size for a duration not to exceed one (1) year in a CONSUMER MAGAZINE; as a COLOR illustration; UP TO TWENTY-FIVE (25) PRINT INSERTS. Failure to make payment voids any license granted and constitutes copyright infringement. All rights not specifically granted in writing, including copyright, remain the exclusive property of the photographer.

Summary of Expenses	Totals
Production Crew • Assistants	1,155.00
Studio • Equipment	639.45
Film • Prints • Digital	250.02
Location and Travel	4,007.30
Insurance	105.00
Miscellaneous	497.75
TOTAL PRODUCTION EXPENSES $	**6,654.53**

Summary of Fees			
Creative Fees $10,500.00	Job Change Order	$3,000.00	13,500.00
Travel Fee	Days @	Per Day	
Postponement	Days @	Per Day	
Production Fees			750.00
Mark-up . %			
	TOTAL FEES $		**14,250.00**

Subtotal Expenses And Fees		20,904.53
Sales Tax	Local Sales Tax	1,515.58
Grand Total		22,420.11
Cash Advance Received		5,362.50
	BALANCE $	**17,057.61**

THIS INVOICE/LICENSE OF RIGHTS IS SUBJECT TO ALL TERMS AND CONDITIONS ON THIS AND THE REVERSE SIDE.

Photographer or Rep: _____ Date: _____

PHOTO**BYTE**®
ESSENTIAL PHOTOGRAPHIC EQUIPMENT

Invoice/License of Rights Nº 29822

Bill to:
Mr. Art D. Rector
Acme Amalgamated Advt.
10123 Wilshire Bl.
Suite 7700
Los Angeles, CA 90024

Copyright / Reproduction Rights Granted

Subject conditionally to receipt of full payment, which is due upon delivery of the commissioned artwork, a license is hereby granted for ADVERTISING use and publication by Acme Amalgamated Advt. of three (3) photographs from a photo assignment, herein referred to as 1056 My Test Job, for distribution within the United States of America and Canada only; ENGLISH language rights only; unspecified reproduction size for a duration not to exceed one (1) year in a CONSUMER MAGAZINE; as a COLOR illustration; UP TO TWENTY-FIVE (25) PRINT INSERTS. Failure to make payment voids any license granted and constitutes copyright infringement. All rights not specifically granted in writing, including copyright, remain the exclusive property of the photographer.

INVOICE DATE	CLIENT JOB NUMBER	CLIENT P.O. NUMBER	SALES TAX RATE	DELIVERY DATE
9/27/01		AAA001234	Local Sales Tax	

DESCRIPTION		AMOUNT
Assistants & Production Crew		1,155.00
1st Assistant, Otto Focus for 3 days @$245.00		
2nd Assistant, Phil Flash for 3 days @$140.00		
Camera / Lens Rental	1000mm f1.0 Darkluxtelephoto lens.	639.45
Film & Processing/Digital Services		250.02
15 Superchrome XYZ, 35mm color film & processing @$14.94/roll		
9 Polacolor Type 100 Pack Film @ $2.81/sheet		
Lodging & Meals		4,007.30
Per Diem: 3 people @ $318.04/day for 3		
Insurance		105.00
Couriers/Delivery	Airborne Express Airbill #1234567	47.75
Job Change Order Expenses		450.00
TOTAL PRODUCTION EXPENSES		$6,654.53
	Usage Fees of $9000.00 plus 3 days @ $1500	10,500.00
Pre/Post Production		750.00
Additional Usage Fee	Including Job Change Order	3,000.00
TOTAL FEES		$14,250.00
		20,904.53
Sub Total		1,515.58
Sales Tax	7.25%	
GRAND TOTAL		22,420.11
Advance/Deposit Received		5,362.50
BALANCE DUE	Due upon Receipt of Invoice	$17,057.61

Photographer or Rep: _____ Date: _____

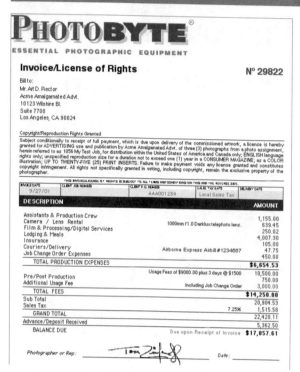

PHOTOBYTE®
ESSENTIAL PHOTOGRAPHIC EQUIPMENT

Invoice/License of Rights № 29822

Bill to:
Mr. Art D. Rector
Acme Amalgamated Advt.
10123 Wilshire Bl.
Suite 7700
Los Angeles, CA 90024

Copyright/Reproduction Rights Granted
Subject conditionally to receipt of full payment, which is due upon delivery of the commissioned artwork, a license is hereby granted for ADVERTISING use and publication by Acme Amalgamated Advt. of three (3) photographs from a photo assignment, herein referred to as 1056 My Test Job, for distribution within the United States of America and Canada only; ENGLISH language rights only; unspecified reproduction size for a duration not to exceed one (1) year in a CONSUMER MAGAZINE; as a COLOR illustration; UP TO TWENTY-FIVE (25) PRINT INSERTS. Failure to make payment voids any license granted and constitutes copyright infringement. All rights not specifically granted in writing, including copyright, remain the exclusive property of the photographer.

INVOICE DATE	CLIENT JOB NUMBER	CLIENT P.O. NUMBER	SALES TAX RATE	DELIVERY DATE
9/27/01		AAA001234	Local Sales Tax	

DESCRIPTION		AMOUNT
Assistants & Production Crew		1,155.00
Camera / Lens Rental	1000mm f1.0 Darklux telephoto lens.	639.45
Film & Processing/Digital Services		250.02
Lodging & Meals		4,007.30
Insurance		105.00
Couriers/Delivery	Airborne Express Airbill #1234567	47.75
Job Change Order Expenses		450.00
TOTAL PRODUCTION EXPENSES		**$6,654.53**
Pre/Post Production	Usage Fees of $9000.00 plus 3 days @ $1500	10,500.00
Additional Usage Fee	Including Job Change Order	750.00
		3,000.00
TOTAL FEES		**$14,250.00**
Sub Total		20,904.53
Sales Tax	7.25%	1,515.58
GRAND TOTAL		22,420.11
Advance/Deposit Received		5,362.50
BALANCE DUE	Due upon Receipt of Invoice	**$17,057.61**

Photographer or Rep: _____ Date: _____

You can see that PhotoByte "remembered" to account for the totals from your Advance Invoice, your Job Change Order, and it even added the individual shot fees from your Shot List. Bet you forgot! Of course, you may update these totals, if necessary, on the Worksheets to finalize your Invoice/License of Rights.

▸ Press the Page Down key to read all of the text on the page. (If you have a full-page monitor, you won't have to do that.)

At the very bottom of the invoice, for your eyes only, is listed the total cost of producing this job, the amount of profit your business earned from it, and the margin of profit, i.e., the percentage of profit to total revenue, not including creative fees. The higher the margin, the better you did.

The margin figure is useful, because if it is regularly high and you are concerned about competitive pricing (i.e., your prices are too high), you may lower your margin without lowering you creative fees. (See the section, The Five Factors of Competitive Pricing, in chapter 30, part 6.) You can find ways (through better marketing and sales efforts) to shoot more assignments at a lower margin instead. That's how you make up for the loss of profit without lowering your "salary." This was discussed in detail in part 6, Pricing.

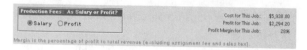

Production Fees: As Salary or Profit?		
◉ Salary ○ Profit	Cost for This Job:	$5,938.80
	Profit for This Job:	$2,294.20
	Profit Margin for This Job:	28%

Margin is the percentage of profit to total revenue (excluding assignment fee and sales tax).

note If you click on the Wrksht 1 button at the top of the page, you will see some profitability information specifically regarding the film you shot for this job, too. It is located in the bottom margin of the page.

Film · Prints · Digital Estimated Amount: $496.80

FILM	QTY	CODE		Amount
33	15	XYZ35	35mm color film & processing @$33.12/roll	496.80
34	9	669	Polacolor Type 100 Pack Film @ $2.81/sheet	25.92
35				
36				
37				
38				
DIGITAL	QTY	CODE		
39				
40				
41				
42				
43				
44				
45				
			SUBTOTAL $	522.72

$281.46	paid for film		Profit on Film for This Job:	$241.26
$522.72	billed to client		Average Markup on Film for This Job:	86%
			Average Margin on Film for This Job:	46%

Look at the notice near the bottom of the document that reads, "This Invoice/License of Rights is subject to all terms and conditions on this and the reverse side." Do you remember the Legalese view of Preferences? The Job Invoice Terms and Conditions should be printed on the reverse side of the invoice. It is very easy to do this; you don't need to go to another screen.

▸ Click the *Terms* button at the top of the Front Page of the Invoice/License of Rights.
▸ Click the *Continue* button to print the Job Invoice Terms and Conditions.
▸ Click the *Print* button to print the Invoice itself. (Don't forget to turn over the paper in your printer!)

note Don't forget to print the terms and conditions on the backs of your Job Estimates and Job Confirmations, too! You'll find a Terms button on both of the those documents in Browse mode at the top of the screen.

You're almost through. There is one last document to create.

Creating a Job Delivery Memo
▸ Click the (red-on-blue) *Del. Memo* button at the top of the Front Page of the Invoice/License of Rights.

This is the Job Delivery Memo that will accompany the film and the invoice you send to your client,

Artie Rector. It will ensure the return of your original film. Notice that it contains both the job description from your ShootSheet and the *final* copyright license from the Invoice/License of Rights, incorporating the changes you made on the Job Change Order.

PHOTOBYTE®
ESSENTIAL PHOTOGRAPHIC EQUIPMENT

Job Delivery Memo
DATE: September 27, 2001

Sent to:
Art D. Rector
Acme Amalgamated Advt.
10123 Wilshire Bl.
Suite 7700
Los Angeles, CA 90024

JOB NAME: 1056 My Test Job
CLIENT P.O.: AAA001234
BILLED TO: Art D. Rector
HIRED BY: Art D. Rector

ALL PHOTOGRAPHS NEGATIVES TRANSPARENCIES AND PRINTS MUST BE RETURNED TO PHOTOGRAPHER IMMEDIATELY AFTER PUBLICATION. PHOTO CREDIT AND/OR COPYRIGHT NOTICE MUST BE PUBLISHED.

LICENSING INFORMATION:
Subject conditionally to receipt of full payment, which is due upon delivery of the commissioned artwork, a license is hereby granted for ADVERTISING use and publication by Acme Amalgamated Advt. of three (3) photographs from a photo assignment, herein referred to as 1056 My Test Job, for distribution within the United States of America and Canada only; ENGLISH language rights only; unspecified reproduction size for a duration not to exceed one (1) year in a CONSUMER MAGAZINE; as a COLOR illustration; UP TO TWENTY-FIVE (25) PRINT INSERTS. Failure to make payment voids any license granted and constitutes copyright infringement. All rights not specifically granted in writing, including copyright, remain the exclusive property of the photographer.

DESCRIPTION:
This is what I will shoot and how I will shoot it ...

QUANTITY OF FILM:
I sent the whole take ...

UPS Shp Acct N°:87114-A54

Photographs may not be reproduced, copied, projected, televised, scanned, digitized or used in any way whatsoever without express written permission on Photographer's invoice, which accompanies this memorandum of delivery. Publication rights and licenses thereto are subject to the terms and conditions stated on the reverse of said invoice. The reasonable and stipulated fee for unauthorized use shall be 3x (3 times) Photographer's normal fee for such usage. Client assumes insurer's liability for the safe return of all photographs delivered.

Received by: _____
Signature Title

Kindly check the count and acknowledge that by signing and returning one copy of this document. The count shall be considered accurate and quality deemed satisfactory for reproduction if said copy is not received by return mail, facsimile or courier within seven (7) working days with all exceptions duly noted. THIS IS NOT AN INVOICE.

> Put your cursor in the *Quantity of Film* field and type **Forty (40) transparencies**.
> Press Tab.
> Place your cursor in the *Date* field near the top of the document and type the date of actual delivery.

Job Delivery Memo
DATE: 10/1/2001

Sent to:
Art D. Rector
Acme Amalgamated Advt.
10123 Wilshire Bl.
Suite 7700
Los Angeles , CA 90024

JOB NAME: 1056 My Test Job
CLIENT P.O.: AAA00123
BILLED TO: Art D. Rector
HIRED BY: Art D. Rector

> Press the *Print* button.

Now you can send the Invoice/License of Rights, the Job Delivery Memo, and the film itself to your client all at once. It is assumed that you have already submitted your Advance Invoice and been paid. It is also assumed that the client has a copy of the Job Change Order, which was delivered while the job was still in progress.

Navigate the other documents related to My Test Job by clicking buttons on the Invoice/License of Rights. Go ahead and experiment! You can't break anything. Notice how easily you can review the Job Change Order and the Advance Invoice, because there are buttons on the Front Page of the Invoice/License of Rights to get you there and back. Had there been no Job Change Order and no Advance Invoice, those tiny *Show* buttons would not be visible.

	Location and Travel	
	Insurance	
show	Miscellaneous Including Job Change Order	

TOTAL PRODUCTION EXPENS

Summary of Fees
INCL
EXCLUC

Creative Fees $7,000.00		Job Change Order	show
Travel Fee		, Days @	
Postponement		, Days @	
Production Fees			
Mark-up , .%			

TOTAL FE

Subtotal Expenses And Fees	
Sales Tax Override Tax Rate	Local Sales
Grand Total	
show Cash Advance Received	

Of particular interest is what happens when you click the *ShootSheet* button at the top of your invoice.

> Click the *ShootSheet* button now.

Notice that the ShootSheet, which was left almost empty of data when you started this exercise, is now very complete. It is also marked as being "closed," since the job has been invoiced and delivered.

NOTE

9 While it is acceptable to start the paper trail for a new assignment with a Job Estimate and create a ShootSheet later, it is recommended that you simply click the *New Shoot* button on either the Main Menu or the client's Profile screen to start the paper trail with a ShootSheet. It is always preferable to have a ShootSheet attached to each assignment (even if it's a self-assignment) to give you a history of all your shoots.

47

Finalizing Legal Agreements

The film-submission and billing documents you exchange with clients (i.e., Delivery Memos, Job Estimates, Job Confirmations, and Invoices of all kinds) are all agreements of one sort or another. They are no less than contracts, and all contracts must spell out their terms and conditions. Therefore, on the reverse side of each document is the fine print that explicitly defines the details pertaining to each agreement in a list of numbered paragraphs. Some terms and conditions appear on the face of these documents instead of the reverse and may, in fact, direct the reader to additional language on the back. The purpose of that is to preclude the possibility of one party denying that they were made aware of the exact language of the terms and conditions in case of controversy.

The terms and conditions you use should reflect the best practices referred to throughout this book. Moreover, the greater the standardization of the language used to define these terms amongst all photographers, the greater their impact will be within the industry. Although each one of the terms and conditions articulated on the reverse of a document is generally self-explanatory, they should be reviewed with your attorney to determine the language that best suits the goals of your own business.

That said, each of the three national trade associations publishes its own set of terms and conditions, any of which provides an excellent starting-off point. The terms and conditions promulgated by the ASMP are used in PhotoByte.[10] Make it a point to read all of them. Different sets correspond to the various documents and forms used throughout PhotoByte. They can be found by returning to the Preferences > Legalese screen and printing a copy of each set. Do so! Your livelihood may depend on it.

EXERCISE -

Editing Terms and Conditions
> Click the *Preferences* button on the PhotoByte Main Menu.
> Click the *Legalese* button at the bottom of the left column on the next screen.

You will see the Preferences > Legalese screen. (*See image at top right.*)

There are three sets of terms and conditions that are used more often than others. They are labeled in green. You will see a button corresponding to each one: *Job Inv. Terms & Cond., Stock Inv. Terms & Cond.,* and *Del. Memo Terms & Cond.*

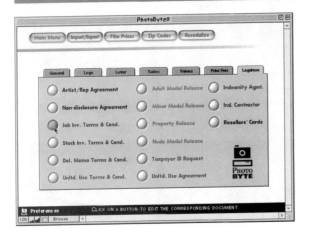

> Click the *Job Inv. Terms & Cond.* button.

You will see the Invoice Terms and Conditions data entry screen.

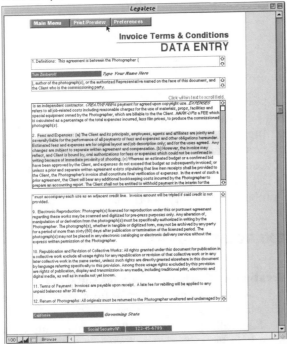

This screen contains text in several large fields that can be edited like a word processor. You can cut and paste the text within the fields. When the terms and conditions are ready to be printed on the reverse side of, in this case, an Invoice/License of Rights, they will automatically be formatted for appearance and fit neatly on the paper.

If you scroll to the very bottom of the screen, you will also see a field in which to enter either your Social Security or Federal Tax ID number, which will appear

at the bottom of the pages as a convenience for your clients, whose accounts payable departments need to have that information for tax reporting purposes.

It is not necessary to return to the Preferences > Legalese screen each time you have to print the terms and conditions on the back of a document. Each document screen has a *Terms* button that automatically links to the correct terms and conditions and sets up your printer when you click it.

When you click the *Terms* button on a document, you will see the correct terms and conditions in Preview mode.

> For now, click the *Print/Preview* button at the top of the Terms and Conditions data entry screen.

> Click the *Continue* button.

You will see the printer dialogue box that corresponds to your printer.

> Print the terms and conditions.
> Place a printed copy of an Invoice/License of Rights upside down in your printer, so it passes through a second time. Click the *Print* button on the document, and you will have the appropriate terms and conditions printed on the back.

- - - - - - - - - - - - - - - - - - - -

NOTE

10 ASMP members may download late revisions from the ASMP's Web site (*http://asmp.org*), then copy and paste them into PhotoByte, where they will be automatically formatted to fit on your documents.

48

Special Travel
and Customs
Requirements

Obviously, when you travel abroad on business, you will need a passport, and probably a visa, too. When carrying professional photographic equipment, you are advised to register each piece of equipment with the United States Customs Service before your departure, especially if any of your gear was manufactured overseas. (How much of your equipment is American-made?) If you take foreign-made cameras and accessories abroad, you will be required to show proof when you return that you owned them before you left home. There is a U.S. Customs office located at every American airport hosting international flights.

A customs agent will examine your equipment, which must be itemized on a list including serial numbers.[11] Don't show up with just a list. You must actually go through the trouble of bringing everything on that list with you to the customs office for registration. Make sure you allow plenty of time. If you have an early flight, take care of this matter several days or weeks before your departure date. The agent will notarize your list with an ink stamp, much like stamping your passport. In fact, you should carry this document list with your passport at all times, so you don't lose it. That way, when you come back into the country and pass through customs

inspection, you can prove that your equipment was not purchased abroad, which could make it subject to import duty.

As for creating a list, PhotoByte will do it for you, sorting each piece of equipment by which case it is packed in, as well as by manufacturer, serial number, and country of origin.

EXERCISE -------------------------------

Creating an Equipment List for Customs
> Click the *Equipment* button from the PhotoByte Main Menu.

You will see a list of the sample equipment records in PhotoByte. This looks very much like the Location List described previously.

note For instructions on how to enter your own equipment, refer to the section in chapter 12 in part 3, Starting a Photo Business, called Creating a Schedule of Camera Equipment for an Insurance Agent, and to the exercise on Creating a Location Equipment List in chapter 46.

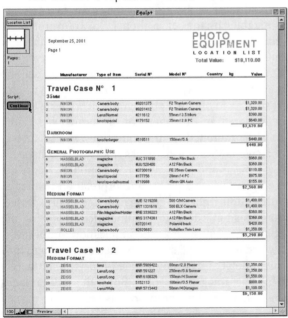

> Click the *Loc. List* button at the top of the screen. You will see a report in Preview mode.

> Click *Continue* to print this report.

You can present this list to the U.S. Customs Service in person, along with all of the equipment listed, and have it notarized.

Entering a foreign country with your cameras and lights is another story. If you are traveling with a minimal amount of gear, you should have no problems, especially if it shows some professional wear and tear, or if you look like a tourist and not a pro. But it mustn't appear to the foreign customs agents that you are likely to sell any of this equipment in their country. If you carry several cases of equipment, you may be obliged to obtain a document called an *ATA carnet* before you leave the United States.

ATA Carnet

ATA stands for the combined French and English words *Admission Temporaire* and *Temporary Admission*. An ATA carnet, simply referred to as a carnet (carnay), is like a passport for your professional equipment. It is an internationally accepted customs document that guarantees the temporary, duty-free "importation" of goods into a country and simplifies the process of moving through customs. Without a carnet, you may be subject to a 20-percent value-added tax in some European countries, if a customs inspector suspects that you intend to leave your equipment behind (for sale) when you leave the country. It is not likely, however, that you will need a carnet unless you are traveling with an extensive amount of equipment across the borders of numerous countries.

A carnet is valid for one year. However, you may make as many trips as desired throughout that year, provided you carry sufficient document pages, one for each country on your itinerary. To obtain a carnet, contact the following organization:

> United States Council for International Business, 1212 Avenue of the Americas, New York, NY 10036; (212) 354-4480; *www.uscib.org/frame5.htm*

You will be required to pay a modest fee, based on the total value of the equipment you will be traveling with. You will also be required to pay a security deposit. It is like an insurance policy for the U.S. Council for International Business, the carnet issuer, which is financially liable for all duties and taxes if you violate the terms of the carnet.

NOTE

11 A bill of sale for each piece of equipment is also considered adequate proof.

49

Invasion
of Privacy
and Releases

As a photographer, you have a right to photograph just about anything you want. However, the nature of how and where you *publish* your pictures is another matter. If they contain recognizable images of people or private property, your right to publish them is conditional upon either obtaining permission or by adhering to certain restrictions.

The right of free expression entitles no photographer to distort the truth, create financial gain at the expense of others against their wills, or to invade their privacy indiscriminately. As in every other aspect of the photo business, there are rules to follow. With every rule, there are also exceptions. This chapter deals with how to avoid taking unnecessary risks and to stay within the bounds of both the law and moral rectitude.

Photographing People and Property

Just as photographers have rights to protect, so, too, do the people you photograph. Sometimes, their rights come into conflict with your own. But it is unreasonable to expect that the photographers' point of view is the only correct one. People on the other side of the lens have rights to personal privacy, as well as to be portrayed in a truthful and dignified

manner. They also have a right to protect the commercial value of the property they own, i.e., any recognizable image of a house, a monument, a champion race horse, an exclusive golf course, a one-of-a-kind piece of furniture, or what have you. Usually, they are protected by rights of access; they're hard to get to. For instance, if a photographer trespasses to obtain a photograph, it will most likely be declared an infringement of the owner's rights and be prohibited from publication, or else subject to a civil lawsuit for damages if already published.

Objects and property that are publicly accessible are open to a broader legal interpretation insofar as publication right are concerned. Generally, protection does not extend to circumstances involving the public interest, such as the publication of newsworthy and educational subject matter, even though they might depict images of private property and the recognizable images of people. But if the same images are used strictly commercially, to make money through advertising or the promotion of trade in any way, that's another story. A photographer may be exposed to liability and litigation by the property owner.

Celebrities, many of whom earn their livings by capitalizing on a carefully cultivated personal image,

maintain the right to protect that particular form of intellectual property. Nonetheless, photographers are given greater latitude in photographing celebrities, as well as in portraying public figures such as politicians. But again, commercial uses are not tolerated without having first received permission. The latter usually involves the payment of a licensing fee of some kind to the subject(s) of the photos. Photographers must continually be mindful of the context of their actions pursuant to photographing people and private property to avoid running afoul of the law.

Almost universally in this country, the law forbids the use of a person's likeness, famous or anonymous, living or deceased (heirs have rights, too), to be used in promoting any cause, commercial or otherwise, without permission. That usually means advertising, but the right extends just the same to any kind of unauthorized endorsement, as well as the adornment of products for sale, such as printed cards, calendars, posters, and packaging.

Depending on the state in which you live and work, the right of privacy may be extended either by statute, court rulings and precedents, or common law. Some states are more specific than others, and their laws are subject to varying interpretation. But that's how lawyers make their livings. And that's why you need to maintain a relationship with a good one. Every case is subject to the vagaries of human perception. So, the safest solution is to always seek permission when photographing for commercial purposes. That's where releases and permits come into play. More about that later.

Newsworthiness and Educational Value

Commercial publications, such as magazines and newspapers, books, and some electronic media, are made exceptions to the right-of-privacy statutes and common laws, but *only* if a redeeming public interest is evident in the publication of a photograph involving the likeness of a person or that person's private property. In such cases, permission of the subject or property owner is not required. This exception is dependant on the fact that this kind of editorial use must portray the subject in a factual manner without taking artistic license.

Truth or Consequences

For example, you might have photographed an individual, without his knowledge in a public place,

whose demeanor and clothing happened to be—unbeknownst to you—uncharacteristically disheveled. Your stock agent licensed the photo some time later to a magazine that used it to illustrate a story about homeless people. You, your agent, and the publisher would probably be exposed to liability if that person turned out to be someone of upstanding economic means—perhaps under any means, if he was indignant enough and found a sympathetic lawyer. That's why making assumptions is dangerous. That's also why it's a good idea to ask the subject of just such a picture to sign a release.

In the course the simple negotiation for a photo release, you can, at least, discover if your assumptions were mistaken or correct. Your best course of action is to make the picture, and then approach the subject to politely explain your intentions while asking the person to sign a standard model release. Of course, if he really was homeless, and the photo was used exclusively in an editorial or educational context, and it was made in a public place, the subject would have no say in the matter. Furthermore, if the person you photographed was not physically recognizable to anyone other than himself, even if he was a corporate CEO, no right-of-privacy would likely be determined to have been infringed, and you would probably be protected. But this book does not purport to give legal advice. Consult an attorney to be sure.

Just to cite one more example, if you licensed a stock photo of a young woman in tears to a magazine that published it with a story about sexual assault, it could be inferred that the illustration represented the victim of an actual assault. Editorial use or not, it would be false. Both you and the publisher would be exposed to liability for invasion-of-privacy or libel.

Indemnification

One of the terms that should be included with every Invoice/License of Rights and Stock Invoice is an *indemnification* clause that protects you, the photographer, from uses of your photograph by the publisher that are beyond your control and contrary to the uses stipulated in the copyright licensing language on the face of the invoice. Not only is this a matter to discuss with your attorney when initially drafting or reviewing your terms and conditions, but

you might want to bring it up with your insurance agent, too.

The Model Release

A model release, too, is a contract. It transfers a license of rights *from* the owner of intellectual property, be it an image of the person himself or property he owns, to you, the photographer. It doesn't grant you the right to capture an image; that is a given. But it specifies how the resulting image may be published. Since ordinary people don't generally run around with model or property releases tucked into their pockets, it's up to you to provide the proper documentation in most cases. Carry some with you when you're out shooting.

The language in model releases varies tremendously, as does the degree of protection they provide for either party. It has to be flexible though. If it includes too much "legalese" biased in your favor, it may very well protect you, but dissuade most people from signing. A compromise is, therefore, often in the interests of both parties to keep the protections in the language from reaching a point of diminishing returns. Therefore, property and model releases are often written in plain English that is concise and easy to understand by a layperson. You might consider archiving several different kinds of releases, each one describing a specific kind of subject matter and intended use.

EXERCISE ------------------------------

Creating a Model Release

Many different examples exist of model releases. They are usually available in tear-off pads at any camera store. However, several convenient examples are found within PhotoByte that preclude the need to buy preprinted forms. Furthermore, they can be edited and printed in any quantity to suit your particular needs. There are four different releases in PhotoByte:

1. Standard adult model release
2. Minor model release (for a child's guardian or parent to sign)
3. Standard property release
4. Nude model release

▸ Click the *New Document* button on the PhotoByte Main Menu.
▸ Click the *Contracts & Terms* button on the New Document screen that appears next.
You will see the Contracts and Forms screen.

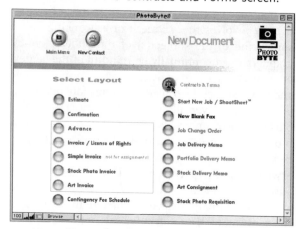

You will see the Contracts & Forms screen.

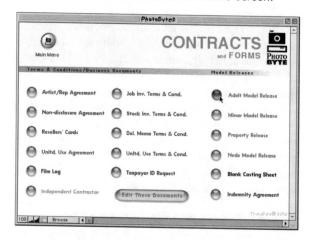

▸ Click the *Adult Model Release* button.

The Model Release will appear on screen looking like this, ready to print with your logo at the top:

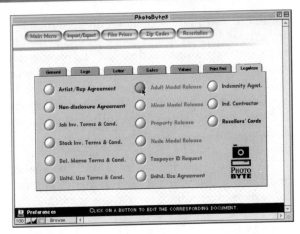

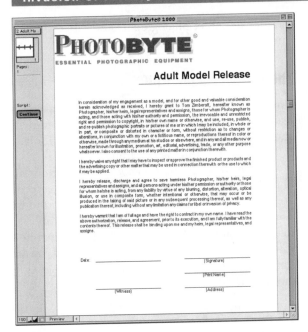

> Click the *Continue* button to print it.

note The same procedure works for each of the other three release forms in PhotoByte. To edit any of the releases, return to the Contracts and Forms screen illustrated above by following the same steps.

> Return to the Contracts and Forms screen.
> This time click the large, red, oblong *Edit These Documents* button at the bottom-middle of the Contracts and Forms screen.

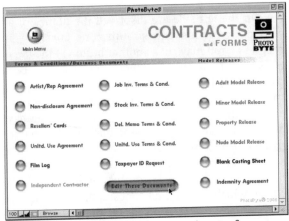

This will take you back to the *Preferences > Legalese* screen, with which you should already be familiar.

> Click on the *Adult Model Release* button.

You will see the Data Entry screen for the Adult Model Release.

Any text you edit within the fields on this screen will automatically be formatted to appear on your printed model release just as illustrated in the previous example, complete with lines for signatures and dates. The same directions apply for the other releases in PhotoByte.

- - - - - - - - - - - - - - - - - - - -

A model release can never completely protect you from being sued. But it will make lawsuits less likely. No one waives their right to sue just because they've signed a release, unless that is a term written into the release itself. If it is, it's not likely to be signed, assuming someone reads it first. Incidentally, if you intend to do much stock photo licensing, either directly or through an agent, the importance of obtaining model releases increases exponentially. In fact, the lack of a release may prevent you or your agent from licensing a photo to a buyer, because the buyer will insist on indemnification from potential lawsuits, especially because the photos are likely to be used commercially. If you routinely neglect to obtain releases, you may find yourself in a compromised position when trying to find representation.

Special Considerations Related to Photographing Property

The law is vague regarding photographing and publishing pictures of private property. But it's safe to

say that if you make a photograph of someone's property, and were commissioned by that person to do so, then turn around and exploit that photograph for your personal financial gain, you will probably be held liable. That means, for example, if someone hires you to photograph a collection of paintings and you later decide to market each image as a set of commercial posters, you will probably be sued, unless you obtained a release in advance.

People will always try to control the use of images of their property if there is money at stake. Property owners cannot prevent the publication of photos that have newsworthiness, nor can they demand licensing fees in such a case. But when rules are as unclear about what is protected as about the prospect of high claims, any lawyer will tell you to obtain a release just to play it safe.

Many specific cases involving photographic intrusions into private places, trespassing to obtain a photograph, the photography of public figures, the photographic disclosure of embarrassing circumstances, as well as photographing in public places are discussed in depth in a book by arts attorneys Arie Kopelman and Tad Crawford, *Selling Your Photography*, published by Allworth Press.

Obtaining Location Permits

Only somewhat related to property releases are location permits. A location permit is usually issued by a federal, state, or municipal authority (e.g., the City Film Commission, the National Parks Bureau, etc.) for the purpose of allowing you to make photographs on public property specifically for commercial purposes. Obtaining such a permit usually involves the payment of a modest fee, but may also require you, in some circumstances, to hire off-duty police officers for "crowd control."

In advertising circles, there are many location scouts who are knowledgeable about obtaining permits and will make all the necessary arrangements for a fee. Location scouts, if they're good, maintain a loose-leaf file of Polaroids or an electronic image database of many places to chose from, including private homes and estates, office buildings, gardens, theaters, scenic spots, as well as urban spaces. They will be available to negotiate property releases on your behalf, too. Location scouts can usually be found referenced in sourcebooks or by word of mouth from other photographers, art directors, and camera stores.

The Virtual Paper Trail™

One of the most productive—and late-breaking—features of PhotoByte has not received prominent attention in the text so far. The best is saved for last. It is called the Virtual Paper Trail.

When you click the *Paper Trail* button on PhotoByte's Main Menu, a screen displaying records of all your in-progress assignments and submissions is displayed in a spreadsheet-like manner of rows and columns. If you have a large-size monitor, you can see the whole thing at once. If you have a standard-screen monitor, you may have to scroll to the right to see the rest of the screen.

On the left side are displayed the names of all your assignments and submissions currently in progress. (You may click another button at the top of the screen to display only those jobs that have been completed.) Following along each row to the right (you may have to scroll) are columns representing each document in the paper trail that you either have or have not created for a particular job. The names (types) of documents are arrayed at the top of the screen and are represented by vertical columns. If a button appears in a column that intersects with the row in which a job name appears, then a document of that type does exist on file. If there is no button in that intersection of row and column, then no document exists. This feature allows you to see at a glance where you stand administratively with every shoot, film submission, and portfolio drop. For that

reason, the Virtual Paper Trail is a great screen to visit first thing every day. (It wouldn't hurt to follow up with a few sales and marketing reports on their respective screens, too!)

When you click on an existing—small, round, and yellow—button at a column row intersection, the corresponding document will appear on screen. From there, of course, you can create additional documents until the paper trail is complete. When an assignment's or submission's paper trail is complete, it will automatically disappear from the default view of the Virtual Paper Trail screen. It, along with other completed jobs, can, then, only be seen when you click the *Show Complete* button at the top of the screen.

Finally, at the top of the Virtual Paper Trail screen are some buttons that correspond to entire categories of documents. For instance, if you want to see a list of all ShootSheets, or all invoices, or all estimates, there is a corresponding button at the top of the Virtual Paper Trail screen that will satisfy your demand.

note It may take longer to graphically draw the Virtual Paper Trail on screen while PhotoByte contains sample records than when you enter your own business records. That's because it isn't likely that you will have as many jobs open at the same time as there are open sample records already in PhotoByte for demonstration purposes.

Conclusion: Your Success Is Inevitable

Knowledge comes from asking questions. Wisdom comes from making mistakes. You *will* make mistakes. But by now, you are—if not steeped in knowledge about the business of photography—well enough prepared to gain the experience you need without losing sleep—or your shirt.

There is much more to learn as you begin—or continue—to compete in the marketplace, developing your administrative skills along with your creative style. By no means has this text exhausted all the information there is to know about business, nor has it taken you through each and every one of the myriad pathways available to explore with and within PhotoByte. That is left up to you. So, never stop asking questions, and don't be afraid to make mistakes.

Although becoming a commercial photographer means making money by making images, you have learned that that alone does not define one's career. If you find that photography gives voice to your life, and you can find harmony by combining that passion, the obligations of business administration, and the ethical scrutiny of both your conscience and your colleagues, then you will have learned what it means to augment commercial motivation with a professional demeanor. With that combination, it will be hard *not* to become successful.

appendix

PhotoByte®
Installation

Welcome to *PhotoByte® Essential Photographic Equipment!*

With your use of PhotoByte, you are participating in the creation of a new standard for professional photographic business management.

Getting Started

PhotoByte is not bookkeeping software. Consider it a document processor and marketing tool that is designed to help you manage and grow your business. Because the documents it creates are logical, consistent, and graphically appealing, they make it easier, too, for your clients who have to read them. PhotoByte makes rookies and seasoned professionals alike look sharp.

With PhotoByte, you can:

- ▶ Produce the essential documents in the "virtual paper trail" *at the same time* you shoot assignments and stock, so you don't have to put off administrative tasks that assure you of getting paid for your work
- ▶ Determine how much profit your business earns and monitor cash flow to plan for growth

- ▶ Keep track of clients, to simplify correspondence and marketing activities
- ▶ Monitor submissions of assigned film, stock photos, and portfolios
- ▶ Produce reports that keep your finger on the pulse of your business, so you can make informed decisions that increase profits
- ▶ Create business documents and legal agreements that keep you in control of the work you create
- ▶ Catalog and label your prints and slides, while tracking their distribution and licensing
- ▶ Organize and itemize your equipment records for packing lists, port-of-entry customs and carnets, and insurance schedules

Learning to Use PhotoByte

The best way to learn to use PhotoByte is to follow these basic steps:

- ▶ Read the instructions in this appendix to install PhotoByte.
- ▶ PhotoByte comes with a number of sample records installed. After finishing reading the

395

text of *Photography: Focus on Profit*, use the sample records to experiment with PhotoByte's capabilities as you read the book.

▸ When you are ready to get down to "real" business, *you must delete all of the sample records before entering real ones!* (See directions under Final Instructions below.)

▸ When you need help, look up specific topics in the on-screen User's Guide by selecting the Help menu.

▸ The files in the PhotoByte folder (or directory) *are* the "virtual paper trail." Never move or rename these files. In fact, it's a good idea not to open this folder, or directory, so as not to lose your data.

You Can't Break It!

As long as you never move or rename files in the PhotoByte folder, it is really, really hard to "break" PhotoByte. (And if you do, you've always got a backup copy to fall back on. See Backing Up below.) In fact, the only way you can hurt PhotoByte is to continually turn your computer off—or if there's something else wrong with your computer that makes it continually crash—while PhotoByte is still running. Even if that happens, there is a good possibility that your files can be recovered, according to the instructions in the Tech Support FAQs folder on your PhotoByte installation CD. At any rate, PhotoByte itself cannot cause your computer to crash. *Always QUIT PhotoByte before you shut down your computer.*

The software is robust. So please do not feel afraid to experiment with its various features before you delete the sample records. Click some buttons that you've never tried before! Doing so will cause no harm. Even with your "real" data, if you make a mistake on any particular document or form, you can simply go back and fix it by reentering the correct data. It is best, however, to make a complete copy of the entire PhotoByte folder and *experiment only with the copy*, then throw it in the trash—delete it—before returning to your "real" PhotoByte folder of business records.

Technical Support

No direct technical support is provided as of this writing. As noted above, an online users' forum for technical information and feedback is provided. Through this forum, qualified photo instructors may obtain information about direct technical support which they may, then, pass along to their students.

Backing Up

As you begin to create and store your "real" data inside these electronic files, they become increasingly valuable. They are your records of doing business. Treat them and treat the PhotoByte software that contains them with as much care and respect as you would any other essential piece of photographic equipment. You rely on your equipment to earn a living.

The files in the PhotoByte folder or directory will be absolutely indispensable to the day-to-day operation of your business. Therefore, it is recommended that you back up your entire PhotoByte folder/directory immediately after each and every use.

important!

> Never back up individual files. Always back up (i.e., copy) the whole folder.

Backing up is simple. Just make a copy of the entire PhotoByte folder, and store it on separate media, i.e., a Zip™ disk, a tape backup system, another computer hard drive, or burn CDs. Anything other than your main hard drive will do. Simply drag the icon for the PhotoByte folder from your hard drive to the icon representing the other storage device. It takes about one minute to copy.

If you lose your business records because of a hardware malfunction, recurring power failures, a system software glitch, or even a computer virus, you can find yourself in serious trouble, unable to collect receivables, contact clients, or to reclaim slides for which a delivery memo no longer exists. An IRS audit won't seem like too much fun either without any records to back you up.

This does not mean that you must print a hard copy of each and every document you create with PhotoByte. In fact, that is not recommended.

PhotoByte files are very safe and stable in their electronic form. If you simply copy the entire PhotoByte folder regularly after each use onto a backup disk, you will always be protected.

It is best to rotate three backup copies, and keep one of them off the premises of your office or studio. That way, in case of fire, flood, or theft, your invaluable and irreplaceable business files can be recovered. Talk to your computer dealer about backup options.

Installation

You can use PhotoByte on both Macintosh and IBM-compatible computers that meet these basic requirements:

- Any Macintosh-compatible computer capable of running Mac OS 7 through OS X, with at least 30MB of free space for the installation of new software
- Any IBM-compatible PC capable of running Windows 2000, Windows Millennium Edition, or greater with at least 30MB free of space for the installation of new software

Installing PhotoByte for Macintosh

- Insert the PhotoByte CD-ROM into your CD-ROM drive.
- Double-click the CD-ROM icon on the desktop.
- Locate the folder: *Install PhotoByte®*. Double click on it to open it.
- Double click the *Install* icon.

Installer

- When you see the Welcome to PhotoByte Screen, press any key or click the *Continue* button.

- Drag the recommended "Camputer" icon you will see in the installer application (on the left) onto the hard drive icon of your choice represented in the installer in the column on the right side of the Install window.

- Follow the remaining on-screen directions.
- When installation is complete, Quit the Installer application, and select *PhotoByte* from the Apple menu to start running the solution.

Starting PhotoByte from the Apple menu is the best method, because leaving the folder alone precludes any possibility of inadvertently moving, deleting, or renaming the files inside, which will prevent PhotoByte from working.

tip (Mac OS only) To substitute a camera motor-drive sound for the beep or other sound used by your computer, drag the Camera Sound icon on top of System folder icon. Open the Monitors & Sound or Sound Control Panel, and select Camera Sound as the default alert.

Installing PhotoByte for Windows

There is no installer for this version of PhotoByte. Simply drag the entire folder (directory) onto your hard drive from the CD-ROM.

With Microsoft Windows, you have to open the folder and double-click the program icon (i.e., PhotoByte® 2000 v5.0.exe) to start the software. Open the PhotoByte® 2000 v5.0 folder, and create a "Shortcut" icon to place on your Desktop or in the Start menu. You may then place the PhotoByte folder anywhere on your hard drive you wish.

Important Final Instructions

It is recommended that, with the exception of using the Help and Shortcuts menus, you refrain from using menus at all, relying instead on the navigation buttons found on each PhotoByte screen.

Furthermore, it is *not* recommended that you open windows found minimized at the bottom of your screen. Doing so will not "break" anything, but may cause confusion, because they bypass Photo-Byte's conventional user interface. The maximization and minimization of windows will be disabled for your own protection in the final release version of PhotoByte. When that upgrade is available, you will be able to obtain a free copy via the Web.

Delete Sample Records

When you begin to use PhotoByte "for real," that is, after you have experimented with the sample data, you *must* delete the sample records.

Here's how to do that:

> Open PhotoByte.
> From the Main Menu, click the *Preferences* button on the Main Menu.

> Click the *Import/Export* button.
> Click the *Delete Sample Records* button.

important!

You must fill in the Company Info data in PhotoByte Preferences, including your name, sales tax rate, and markup rate before entering any data! You will be prompted to do so when you first begin to use the software.

important!

PhotoByte files are linked together, so that information from one file is automatically exchanged with information in other files. This process is called either a lookup or a relation in "techno" parlance. Since PhotoByte performs lookups and relations by recognizing file names, PhotoByte will not work correctly if you either move or rename any of its constituent files.

Now, you are ready to use PhotoByte.

Your feedback is welcome. Please e-mail comments about PhotoByte to *tom@zimberoff.com*

index

 books from Allworth Press

Talking Photography: Viewpoints on the Art, Craft, and Business *by Frank Van Riper* (paperback, 6 × 9, 320 pages, $19.95)

ASMP Professional Business Practices in Photography, Sixth Edition *by the American Society of Media Photographers* (paperback, 6³/₄ × 9⁷/₈, 432 pages, $29.95)

Pricing Photography, Third Edition *by Michal Heron and David MacTavish* (paperback, 8¹/₂ × 11, 160 pages, $24.95)

Business and Legal forms for Photographers, Third Edition *by Tad Crawford* (paperback with CD-ROM, 8¹/₂ × 11, 192 pages, $24.95)

The Photographer's Guide to Marketing and Self-Promotion, Third Edition *by Maria Piscopo* (paperback, 6³/₄ × 9⁷/₈, 208 pages, $19.95)

How to Shoot Stock Photos That Sell, Third Edition *by Michal Heron* (paperback, 8 × 10, 224 pages, $19.95)

Law (in Plain English) for Photographers, Revised Edition *by Leonard DuBoff* (paperback, 6 × 9, 224 pages, $19.95)

The Photographer's Internet Handbook, Revised Edition *by Joe Farace* (paperback, 6 × 9, 232 pages, $19.95)

The Photographer's Assistant, Revised Edition *by John Kieffer* (paperback, 6³/₄ × 9⁷/₈, 256 pages, $19.95)

Stock Photography Business Forms: Everything You Need to Succeed in Stock Photography *by Michal Heron* (paperback, 8¹/₂ × 11, 144 pages, $18.95)

The Photojournalist's Guide to Making Money *by Michael Sedge* (paperback, 6 × 9, 256 pages, $18.95)

The Business of Studio Photography: How to Start and Run a Successful Photography Studio *by Edward R. Lilley* (paperback, 6³/₄ × 9⁷/₈, 304 pages, $19.95)

Photography Your Way: A Career Guide to Satisfaction and Success *by Chuck DeLaney* (paperback, 6 × 9, 304 pages, $18.95)

Historic Photographic Processes: A Guide to Creating Handmade Photographic Images *by Richard Farber* (paperback, 8¹/₂ × 11, 256 pages, $29.95)

Creative Black-and-White Photography: Advanced Camera and Darkroom Techniques *by Bernhard J Suess* (paperback, 8¹/₂ × 11, 192 pages, $24.95)

Travel Photography, Second Edition *by Susan McCartney* (paperback, 6³/₄ × 9⁷/₈, 360 pages, $22.95)

Overexposure: Health Hazards in Photography, Second Edition *by Susan D. Shaw and Monona Rossol* (paperback, 6³/₄ × 9⁷/₈, 320 pages, $18.95)
